The Art of Renaissance

VENICE

The Art of Renaissance

VENICE

Architecture, Sculpture, and
Painting, 1460–1590

Norbert Huse
Wolfgang Wolters

Translated by Edmund Jephcott

The University of Chicago Press
Chicago and London

Norbert Huse is professor of European art history at the Technische Universität in Munich.

Wolfgang Wolters is professor of art history at the Technische Universität in Berlin.

Originally published as *Venedig: Die Kunst der Renaissance—Architektur Skulptur, Malerei 1460–1590,* © C. H. Beck'sche Verlagsbuchhandlung (Oscar Beck), Müchen 1986.

The University of Chicago Press, Chicago 60637
The University of Chicago Press, Ltd., London
© 1990 by The University of Chicago
All rights reserved. Published 1990
Printed in the United States of America

99 98 97 96 95 94 93 92 91 90 5 4 3 2 1

Library of Congress Cataloging in Publication Data

Huse, Norbert.
 [Venedig, die Kunst der Renaissance. English]
 The art of Renaissance Venice : architecture, sculpture,
and painting, 1460–1590 / Norbert Huse, Wolfgang Wolters.
 p. cm.
 Translation of: Venedig, die Kunst der Renaissance.
 Includes bibliographical references.
 ISBN 0-226-36107-1 (alk. paper)
 1. Art, Italian—Italy—Venice. 2. Art, Renaissance—
Italy—Venice. 3. Venice (Italy)—Buildings, structures,
etc. I. Wolters, Wolfgang. II. Title.
N6921.V5H8713 1990
709'.45'3109024—dc20 90-31341
 CIP

This book is printed on acid-free paper.

CONTENTS

Authors' Note

The English translation corresponds to the German version of 1986. A few errors have been corrected.

We are grateful to all those who have contributed to the realization of this edition, and in particular to the translator, Edmund Jephcott.

Munich/Berlin, July 1989

Publisher's Note

We are very grateful to Professor Debra Pincus of the Department of Fine Arts at the University of British Columbia for her help in evaluating the overall translation, and also to Professor Philip J. Jacks of the Department of the History of Art at Yale University, for his help with the translation of a large number of technical terms.

ARCHITECTURE & SCULPTURE

Wolfgang Wolters

1 *FORMA URBIS*

In 1500 the Nuremberg merchant Anton Kolb published a "large format" woodcut by Jacopo de' Barbari showing a bird's-eye view of Venice (figs. 10, 25, 26, 100).[1] To support his petition for the privilege of selling the work, he argued that it would enhance the city's fame. So a picture of the unique city—more eloquent than compendious volumes—joined the written eulogies and the first guidebooks. In this woodcut Venice's situation in the lagoon not far from the mainland, some of the islands, the churches, houses, and palaces, the squares, *calli,* and bridges, as well as the shipyards and open spaces, are minutely documented, providing the historian with an inexhaustible fund of visual information on the form of the city about 1500.

Barbari's picture of Venice as an agglomerate of buildings, streets, squares, and waterways was soon to be followed by other large-scale works depicting daily life in the city. The connection between the traditional festivals and processions and the everyday life of Venice is vividly conveyed by an anonymous woodcut from the time of Doge Leonardo Loredan (1501–21), showing the doge's ceremonial barge (the *Bucintoro,* fig. 1), and by Titian's lost woodcut of the Piazza, copied by Jost Amman about 1560.[2] There may have been other high-quality depictions of city life in the sixteenth century, but the many small prints by Giacomo Franco and Cesare Vecellio from the end of that century were addressed to a less discerning public.

The location of Venice (*sito*) and the peculiarities of its urban layout and architecture are the subject of numerous accounts from the fifteenth and sixteenth centuries. Unequalled even today for his concise formulations and wide knowledge is Francesco Sansovino, who published in 1581 a description of the city, entitled *Venetia, città nobilissima et singolare.*

For Sansovino, Venice was a city that had coalesced from a large number of small settlements (*più città separate*).[3] These settlements or islands (he also called them *contrade*) were independent of each other in terms of infrastructure. They all had several churches, a square with a well, and bakeries and wine cellars. Tailors, grocers, apothecaries, teachers, wood merchants, cobblers,

and all the other necessary trades were represented in large numbers. To leave such a *contrada,* Sansovino wrote, felt like leaving one town and entering another. However, Sansovino's detailed account, based on a study of history and living traditions and addressed specifically to the discriminating reader, was not primarily concerned with the factors that divided the city. The canals, he stressed, were spanned by numerous bridges linking the islands to form the fabric, or *corpo,* of Venice.

The division into little settlements described by Sansovino is reflected in the general appearance of the city. While there were privileged residential areas like the Grand Canal, palaces were to be found in all quarters of the city. But there were also considerable differences between areas. On the edge of the town facing the mainland, Sansovino remarked, there was a predominance of simple buildings. They were built like the dwellings of the first inhabitants of Venice, with few small windows, indicating the parsimony of the city founders.[4] But even in these more remote areas state-controlled building projects like the Fondamente Nuove (1590–95), where Doge Leonardo Donà (1609) built his palace, brought profound changes.[5] Outlying areas still sparsely populated in 1500, such as S. Maria Maggiore, were at once opened up and built upon by private citizens and confraternities.[6]

A special development was initiated by the senate's decree of 1516 ordering the settlement of a part of the Jewish population on an island isolated within the city and previously thinly populated, the Ghetto. The confined space within this area, and the discriminatory laws forbidding all property ownership, gave rise to very tall but architecturally unostentatious houses. In 1528–29 the Scuola Grande Tedesca was built as the first synagogue, soon followed by others as it became clear that the segregation was not to be revoked.[7]

Apart from the "islands" (*contrade*), the smallest elements of the city, Sansovino distinguished six districts (*sestieri*), S. Marco, S. Polo, S. Croce, Cannaregio, Dorsoduro, and Castello, giving particular importance to the Sestiere di Castello on the eastern edge of the city, since the cathedral of the patriarch was situated there. This "island" of Castello was separated from the inner city, the

corpo, by a broad canal (the Canale di S. Pietro) but linked to it by a wide-spanned bridge, wrote Sansovino. He thus drew attention to the decentralized position of the seat of the patriarch[8] and its spatial separation from the seat of the Venetian government on the Piazza S. Marco, a distance that had its counterpart in the realities of Venetian church politics.

Today the many islands in the lagoon (figs. 2, 3) play only a small part in the life of the city. This was different in earlier times, when buildings such as hospitals and some important monasteries were situated there. How-ever, Francesco Sansovino[9] excluded Murano (which had its own *podestà,* or council and administration), Burano, Mazzorbo, and Torcello from his description, re-ferring to them as "città e terre" like the Venetian pos-sessions outside the lagoon, whereas he devoted many pages to the other islands with their churches, monas-teries, hospitals, and powder magazines. Following the zoning of the Venetian authority for public health (Uffi-cio della Sanità), he placed all these islands under the Sestiere di S. Croce. S. Elena has in the meantime become a modern city quarter. S. Cristoforo and S. Michele have

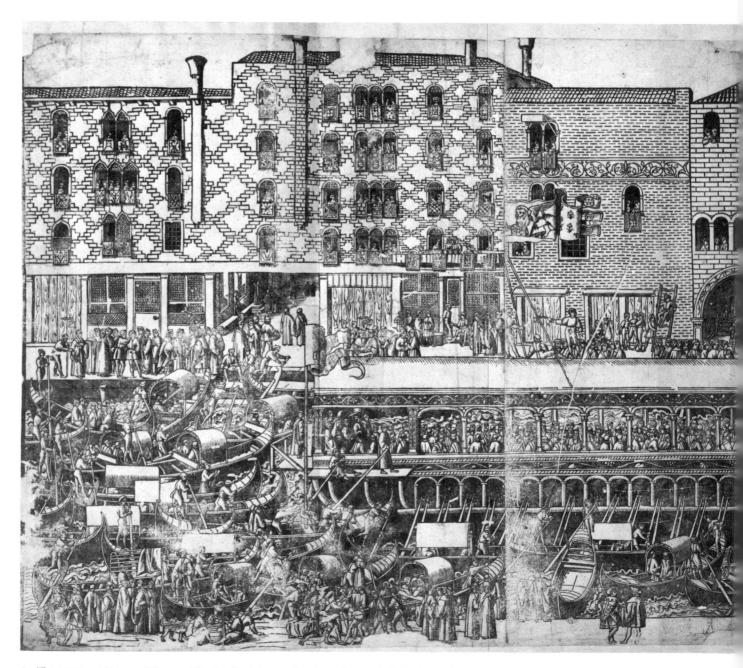

1 The ceremonial barge of the republic, the *Bucintoro,* going through a canal. Early sixteenth century. London, British Museum

grown together to form a cemetery island, hospitals are situated on S. Clemente and La Grazia, and a training center for craftsmen has been installed on S. Servolo. S. Giorgio with its institutes and schools and S. Lazzaro with its monastery are to this day models of proper land use. The buildings or ruins on S. Andrea della Certosa, Santo Spirito, S. Giacomo di Paludo, Lazzaretto Vecchio (a home for dogs and cats), Lazzaretto Nuovo, S. Giorgio in Alga, S. Angelo della Polvere, S. Secondo—to mention only a few of the islands abandoned in recent decades—have been left to decay.[10]

By 1450 the concentration of residential buildings in the city was well advanced, and the ponds and marshes (*paludi* or *pantani*) within the city confines had largely been drained. The demand for building land was considerable, land prices high. The government had succeeded in making more and more private land available for public works by numerous laws and decrees and by controlling the land market. This applies both to bridges and wells[11] and to streets and squares, the latter being called *campi,* as distinct from the Piazza S. Marco.[12] The modern observer can hardly form a conception of the often

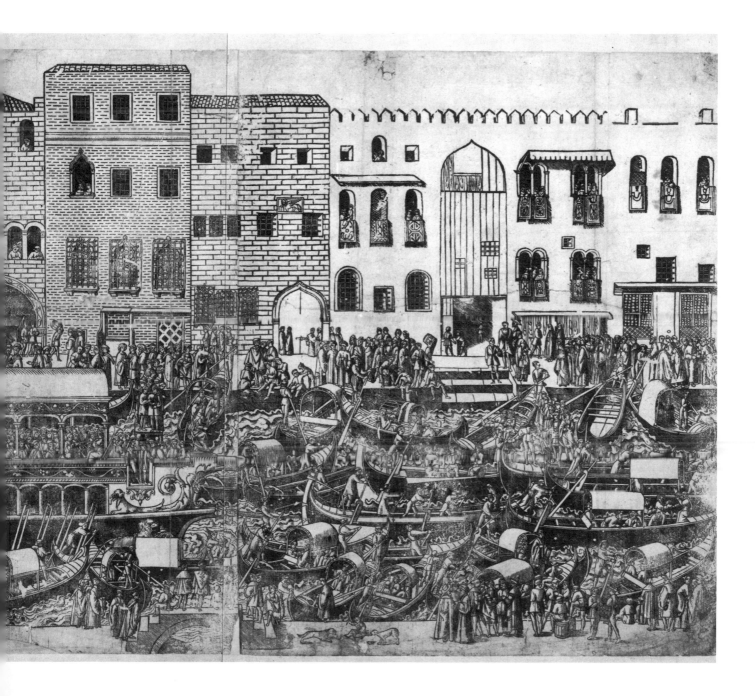

intricate property relations that applied to the campi.[13] Today monotonous paving covers what were once cemeteries (as with the Campo dei Frari), ponds, marshes, meadows, canals, streets, and temporary buildings. Paved public walks could cross a graveyard (S. Maria della Carità), though this was regarded as unseemly.[14] As late as 1483 there stood in the churchyard of S. Maria dei Frari, later abandoned, a "large" tomb of a member of the noble Ziani family, with four porphyry columns.[15]

In the fifteenth and sixteenth centuries, the development of the city's streets and waterways was not centrally planned, even though control was entrusted to authorities (Provveditori di Comun, Giudici del Piovego) and the state could contribute financial aid. Thus, in 1486 numerous stone bridges were erected at the decree of the senate, in conjunction with extensive improvements to streets, canal banks, and bridges.[16] However, the upkeep of bridges was usually the affair of the neighborhoods and therefore "private,"[17] or of religious orders,[18] although the chiefs (*capi*) of the *contrade* were formally responsible. Today coats of arms, usually mounted at the

apex of the arch, still show to whom we owe these bridges. At the beginning of the sixteenth century there were still many wooden bridges that were then systematically replaced by stone structures.[19]

Some of the privately built bridges were part of private access ways—even if they did not lead directly to a house entrance—and could be closed by their owners. In the fifteenth and sixteenth centuries state ownership was extended to private bridges too, with a view to improving a public street network that did not meet the rising demand for short routes. The ideal way of developing a residential area, as understood about 1500, can be seen in districts such as Cannaregio and in an area of 300 by 230 meters next to S. Maria Maggiore,[20] both of which were intensively renovated and expanded at that time: parallel canals with walkways on one bank, and narrow waterways communicating between canals. The not very numerous bridges in Cannaregio are so arranged that the quarter can be crossed from north to south without detours. Conflicts arose from the proximity of private buildings to a public street system still in need of im-

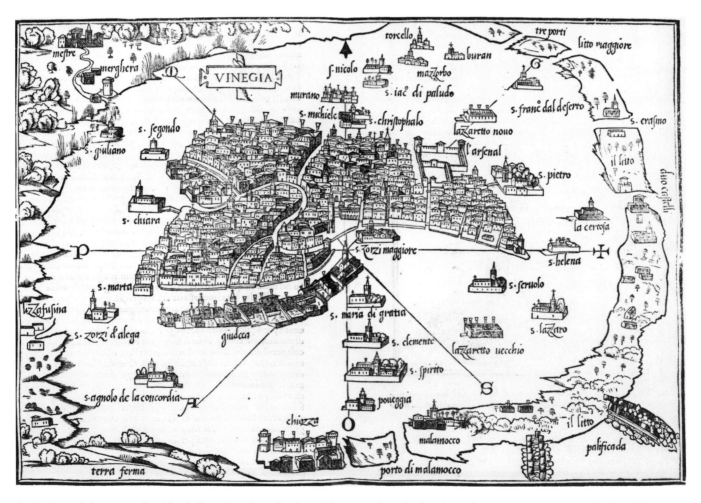

2 Venice and the surrounding islands. From Benedetto Bordone, *Libro . . . nel quale si ragiona di tutte le isole del mondo,* Venice 1528

provement. The Scuola Grande della Misericordia was forced to sacrifice part of its site to a canalside footpath, which passed under the building as a portico.[21] In conjunction with this, the square, previously closed by a gate, was opened to the public. In 1532 the senate even had the campanile of S. Giovanni Crisostomo demolished to widen a heavily used street.[22] Decades were to pass before a new campanile was built.[23]

Frequently, low and usually very dark passageways branch off from the streets, leading to other streets and courtyards or to canals—the *sottoportici*. These openings, part of the original street plan, often lead to row houses (*case a schiera*). In the courtyards (*corti*), the concern to maximize the use of land was combined with a desire to distinguish from the public streets an area used by several families.

In the course of the fifteenth and, above all, the sixteenth century, streets along canals (*fondamente*) gained considerably in importance. By providing steep embankments to the canals they regulated and accelerated the flow of water, improving the self-cleaning properties of canals that were always prone to silt up. In addition, these footpaths gave easy access to the less accessible residential areas. This is true of the Riva degli Schiavoni, though its present width and extensiveness are a work of later centuries.[24]

Some dates have been recorded:[25] in 1519–31 the Zattere *fondamente* were reinforced (from S. Marta to the Dogana); in 1536 numerous *fondamente* were built or renovated, the residents bearing half the cost, a substantial increase compared to the preceding years, when they only had to pay a quarter. In 1563 it was ordained that private citizens could not construct their own *fondamente*. In 1569 further canal banks were reinforced, although the number of banks still in need of consolidation seems to have remained high. In 1589 all property owners on the Giudecca whose land extended to the waterfront at the back of the island were obliged to reinforce the bank (though without building footpaths). The same was required of the island monasteries.[26] Finally, in 1590 the construction of the Fondamente Nuove facing Murano began.

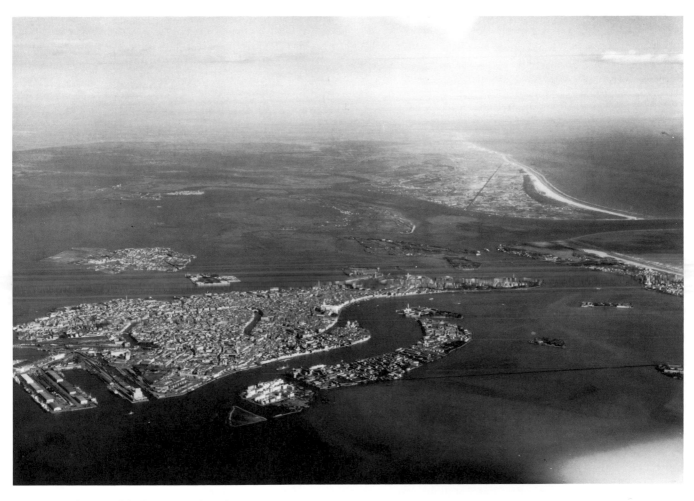

3 Venice with parts of the lagoon and the Lido

In this context mention should be made of a by no means utopian project undertaken by Cristoforo Sabbadino[27] (at that time, in 1557, *proto* of the Ufficio delle Acque). He set out to reclaim extensive terrain for Venice by dredging the heavily silted Grand Canal,[28] among other waterways, and depositing the mud at the periphery of the city, particularly in the area of the bays (*sacche*). The bank, thus straightened, was to be reinforced all around the city and made accessible by a kind of annular road that would also have led across a wide-span bridge, from S. Chiara (not far from the present railway station) to Corpus Domini. Land was also to be reclaimed at the back of the Giudecca, so that crafts that disturbed the residents by noise and smell, above all the shipyards (*squeri*), could be moved there. The latter had already been removed from the Grand Canal by the Council of Forty in 1333, though not with complete success.[29] The displeasure of the owners of villa palaces on Murano at the use of parts of their island as an "industrial area"[30] is not recorded in the documents. But the illicit building of shipyards in unsuitable areas was immediately stopped by the Council of Ten.[31]

The building projects that have been mentioned make it clear—and a perusal of Jacopo de' Barbari's view of the city confirms this—that not all the canals had the reinforced embankments familiar to us, the natural banks providing more contrasts and transitions in the relation between buildings and water than is the case today. It could be seen that the houses were built in the water on sandy islands. At that time the streets, squares, and courtyards were not covered, as they are now, with the uniform paving of rectangular blocks of volcanic trachyte. Many streets and courtyards[32] had no hard surface at all, while others were paved with much smaller, rust-red bricks, which gave a very different impression. Often only the parts of squares adjoining particular buildings were paved.[33] The few surviving examples include the squares in front of the Madonna dell'Orto and the Scuola Vecchia della Misericordia. In this respect too, as in the embellishment of streets, squares, and facades, the city is poorer today than it was in the fifteenth and sixteenth centuries.

Much lamented in those centuries was the neglected state of the Grand Canal, "the most beautiful street that exists, so I believe, in the whole world, and with the finest houses" (Commynes 1494).[34] Shortly after 1460 Marco Corner[35] castigated both his nephew of the same name, the builder of the Cà del Duca, and Doge Francesco Foscari for their irresponsibility in leaving the earth dikes needed to protect their building sites in place. As a result, Marco Corner was forced in 1462 to have the building rubble removed from the Grand Canal. Probably little had changed since the late fourteenth century, when an observer commented that one might lay out a

garden on the silted-up borders of the Grand Canal. Similar complaints, perhaps couched in less eloquent language and in legal orders, recur throughout the entire sixteenth century. In 1520, to improve the self-cleaning of the waterways, stakes driven into the canal beds had to be removed. Stonemasons were allowed to ply their trade only at a fitting distance from the banks. The silting affected all the canals. As a result, there were a number of small islands without buildings (*polexini*) in the canal between Venice and the Giudecca.[36] Even today, at low tide a tiny island shows above the water between S. Giorgio and the Riva degli Schiavoni.

The building of steep embankments along the sides of the canals, separating them from the footpaths on the banks, necessitated stairways for access. In their many variations they all solve the same problem: to allow easy boarding and disembarcation at different water levels and a sure footing for the person holding the unsteady craft.[37] Stairways with narrow platforms, sometimes straight and sometimes rounded, are the elements making up these landings, which naturally also form part of the more imposing buildings. Confraternities (*scuole*) like the Scuola Grande della Misericordia or the Scuola Grande di S. Rocco enlarged these landings into wide, inviting steps, of the kind that lead up to the Piazza S. Marco or to Il Redentore and other churches.

Broad quayside walks like the Zattere affected the disposition of churches that, when rebuilt or newly constructed, now had their façades facing the *fondamente*. Thus in 1520 the apse of Spirito Santo, just then in the course of construction, was demolished and the church rotated through 180 degrees to face the embankment walk that had just been begun.[38] In her important study of the Venetian campi, Wichmann has demonstrated comparable changes in the orientation of numerous churches facing canals and campi.

In the planning and execution of civil engineering works—where public interests were involved—control was exercised by several state institutions. Among them the Collegio Solenne delle Acque founded in 1505, on which the doge had a seat, became preeminent. The foundation document underlines the collegio's enormous responsibility in a city placed in a lagoon: a single word on this matter could decide the future of Venice.[39] It had been preceded by less influential institutions with very limited personnel, responsible for all matters relating to the lagoon and the canals and the removal of illicit buildings from public land.[40] In the sixteenth century, the upkeep of canals and *fondamente* was the concern of the Provveditori di Comun,[41] who also maintained the streets, wells, and bridges. The role of water for the republic was summed up in unsurpassable fashion in an inscription by the Magistrato alle Acque of 1553: "Venice, founded at God's command among the waves, surrounded by water,

protected by walls of water. Whoever dares to despoil this asset of the community shall be no less severely punished than he who damages the walls of his native city. This edict shall stand for all time." [42]

In 1554 the senate elected from among its members three *provveditori sopra l'ornamento delle strade della città,* a kind of commision for what we would call the beautification of the city, whose responsibilities included the Rialto bridge. [43] Two *provveditori* had been elected in 1535, but as one had declined the post, the initiative, which clearly was not regarded as urgent, came to nothing. With prudence and expert knowledge ("prudentia et pratica"), the officials were to endeavor to beautify streets and other places where they found ugliness. However, the wishes of those affected were also to be respected—a task that, as everyone knows, is like squaring the circle. Although the duties of the commission are not precisely defined in the surviving documents, they are likely to have involved mainly collaborating in or advising on the improvement of areas through rebuilding. Few writs were issued against Venetian landlords, however. Apart from obligations to construct or maintain canal walls and to share in the cost of streets and bridges, legal constraints seem to have been few in Venice. They included the enforcement of strict respect for the building line, which was laid down bindingly as early as 1278. There are several reports of the building line of houses being fixed or corrected by stretching a rope. [44] Thus came into being the continuum of rhythmically fenestrated street and canal fronts that characterizes the appearance of Venice today. Andrea Palladio's attempt, in two designs for palaces on the Grand Canal, to evade this practice by bringing foward the line of the facade was doomed to failure from the outset. The ill-lit narrowness of many passageways, which resulted from the density of building, did not prevent numerous house owners from allowing upper stories to project beyond the ground floor. These stories rest on closely spaced open beams, *barbacani,* which, with their elaborate carving, shape the character of entire streets. The Calle del Paradiso at S. Lio is a particularly fine example of this.

Among the pressing problems with which Venice was always confronted was not only the management of the lagoon water but the provision of drinking water for the inhabitants. Countless wells in squares and streets, in courtyards, and even inside buildings [45] helped to solve this problem in a city with over 100,000 inhabitants, "which is situated in water and has no water" (Marin Sanudo). [46] The Venetian wells (the technical aspects of which cannot be discussed here) all had an artistically formed wellhead that could be embellished in different ways. All the Venetian wells were fed by rainwater sinking through the soil. To combat the danger of salt contamination at high tide, the central part of the campi (as

in S. Trovaso) or the cloisters (S. Stefano, fig. 81) could be raised. In 1858 there were still 6,782 wellheads in Venice, many of which were sold in the following decades, usually abroad.

For many wellheads, particularly in the early Middle Ages, a cubic or cylindrical trough was chosen, while the shape of a capital was frequently used in the Gothic and Renaissance periods. Coats of arms identify the donor or owner; a St. Mark's lion or the arms of the Provveditori di Comun, who, with the Provveditori alle Acque and the Provveditori alla Sanità, were responsible for wells after 1487, indicate public wells. The great wells in the cloisters of the mendicant orders were open to the public at certain hours. The inscription of 1511 on a well in the Campo S. Leonardo tersely reminds well builders and stonemasons of their true task: COMODITATI PUBLICAE NEC NON URBIS ORNAMENTO.

Given the extreme density of building, with gardens accessible only to a few, the campi were places for the inhabitants to meet and hold celebrations, fulfilling important social and—not least—hygienic functions. None of these campi is the result of planning that extended to several buildings at once. A symmetrical, uniform plan was suggested by Fra Giocondo for the Rialto square in 1514 but characteristically was never put into effect. The Venetian campi are fronted by buildings the style of which was decided by the individual owners. The façades of private palaces might display painted or sculpted representations making a statement about the occupants or their families; the façades of parish churches might be turned into monuments of self-aggrandizement for individuals or entire families. However, freestanding monuments to Venetian families were prohibited, the equestrian monument dedicated to the Bergamask *condottiere* Bartolomeo Colleoni (fig. 4) being the exception that proves the rule.

The very extensive loss of Venetian façade paintings, as well as the impoverishment of houses and public halls by the removal of graphic signs like family arms or those of scuole, mottoes [47] or edicts, or pictures of saints carved in stone, called *capitelli* [48]—all make the walls of squares seem much more uniform than they originally were. Today disused wells are usually the only furniture of squares. In the fifteenth and sixteenth centuries they often contained shooting targets (the *bersaglio*) [49] and refuse containers (*caselle di scoazze*), which gave off offensive smells and posed hygienic problems. Some were removed after protests by residents, but were later replaced. In 1609 there was a plan to construct an underground refuse container at the Fondamente Nuove, on the model of the fish market, an arrangement that would have been hardly less disagreeable for the residents. [50]

Nearly all the campi had originally been bordered on one side by a canal (*rio*) giving access to them; many of

4 Antonio Visentini, Campo dei SS. Giovanni e Paolo in the eighteenth century

the *rii* were later filled in. The winding course of the Rio S. Antonio, filled in 1761, gave rise to the buildings flanking the wall of the Campo S. Polo opposite the magnificent apse of the church, prior to an ill-fated "restoration" early in the nineteenth century. The designation of part of a square as "rio terrà" (*rio interrato*), as in the Campo S. Margherita, indicates the earlier presence of a canal. The bridges did not normally lead directly or in a straight line to the main entrance of the church, even when, as in the case of the Frari, that solution was possible.

If the scuole had their assembly halls fronting on campi—as was often the case—they were able to fly their flags from stone plinths, *abati* (figs. 4, 90).[51] Many of these bases, adorned with carvings, have been preserved. However, the most impressive flagstaff plinths were not those of the scuole, but the ones erected in 1505 by the influential procurators in front of the basilica in the Piazza S. Marco (plate 13).

Along the Venetian streets, on bridges and gondola stations (*traghetti*), there had been since the Middle Ages very numerous images of saints (*capitelli*), before which a candle always burned at night. Felix Faber of Ulm noted this as a speciality in his travel journal of 1486/87. Some of these images, often mounted in dark

passageways, were supposed to discourage immoral behavior by creating a sacred area.[52] A freestanding canopy with octagonal drum and dome opposite the entrance of the Arsenal, which is shown in de' Barbari's view of the city, may have been a monumental *capitello*.

There were similar problems with the porticoes (*portici*) of churches, still numerous at that time. In 1488 the portico of St. Maria Mater Domini was fenced in with a wooden grating, and the door was locked at night. Almost a hundred years later, a visiting bishop recommended the demolition of these porticoes in the interests of public morality. Today, only that of S. Giacomo di Rialto has been preserved intact.[53]

The situation of buildings on sandy islands often reclaimed from the sea promoted the development of special building techniques.[54] Pile foundations below the rising masonry, linked by stabilizing layers of beams laid across them, were used especially for expensive buildings. The frequent reuse of foundations minimized changes in ground plan when buildings were replaced or converted.

To arrest rising damp in brick masonry, several courses of stone were inserted in the socle area of buildings situated on canals, which also had a stabilizing effect. The

relatively low load that could be borne by the foundations or the subsoil led to a lightweight mode of construction using brick, the façades of prominent buildings often being faced with ashlar. Thus it was the peculiarities of the sandy subsoil that made vaulted ceilings the exception in Venetian civil architecture and flat beam ceilings the rule.

Building was influenced not only by the unsure foundations, however, but also by the stable internal political conditions. The large openings in the generally thin-walled residential buildings and in the Doge's Palace, and the absence of all elements that might have afforded the inhabitants protection in times of unrest, testify to the internal harmony that played a central part in the public image of the republic.

In the fifteenth and sixteenth centuries the visual image of Venice was defined by two building materials: brick and the fine-pored, very hard Istrian limestone.[55] However, many brick façades were ornamented by painting the joints between bricks, and many areas of brickwork that today have a bare appearance were originally plastered (plates 2, 3). Marble was rare, and for a relatively brief postmedieval period it was confined to the facing of a few outstanding buildings or their sculptural ornamentation. Soft sandstone such as was quarried in the Paduan region found little use, because it lacked durability. A few exceptions, as in buildings on the Campo S. Maria Formosa, confirm the rule. In 1581 Francesco Sansovino gave a well-informed account of the advantages and applications of the stones used in Venice:

> The stone quarried in Istria near Rovigno and Brioni is particularly beautiful. In color it resembles white marble, and yet it is resistant to heat and cold. When smoothed and polished for statues like marble, it bears a strong resemblance to that material. Church façades and palaces are faced with Istrian stone, and columns formed of one piece are to be found. There are also façades covered in Greek marble, above all from Paros. This material differs in color from the usual white marble and from that from the quarries in Carrara. The red Veronese stone is highly valued, and is used especially for the floors of churches and palaces, and for basins, fireplaces, cornices, and suchlike. However, the red stone quarried at Cattaro in Dalmatia is more beautiful and much more durable.[56]

The heavy grime accumulated on all Venetian façades, in conjunction with the devastating corrosion of the surfaces—both being the result of serious environmental pollution—have wrought major changes in the appearance of Venetian architecture and made it more difficult to evaluate. An irregular black-and-white pattern distorts all the proportions. Cautious attempts at cleaning, as in the case of the Procuratie or, recently, the Doge's Palace, make the deterioration particularly clear. On the other hand, there is a danger that radical cleaning will damage the substance of buildings. In Venice, too, a "vandalisme restaurateur" is still more to be feared than time.

2 *THE BEGINNINGS*

As early as the first half of the fifteenth century a number of works were produced in Venice that have a place in the history of Renaissance art. It would nevertheless be mistaken to date the beginning of the Venetian Renaissance in architecture and sculpture earlier than the middle of the century. And traditional styles still had their friends well after 1450. For example, the commissioning of the Florentine architect and sculptor Michelozzo to build a library for the Benedictine monastery of S. Giorgio (1433–34) was probably an attempt by the patron, Cosimo de' Medici, to demonstrate while in exile in Venice the superiority of his native idiom. This library has disappeared almost without trace, and there is no record of its design. Cosimo's attempt to have the façade of S. Giorgio redesigned as well appears, at least according to a later source, to have been considered presumptuous in Venice and rejected.[1] It was undoubtedly national pride, too, that induced the authorities of the Florentine confraternity (Scuola dei Fiorentini) to award a commission to their famous compatriot Donatello. Donatello's wood statue of *John the Baptist* (1438),[2] a figure conveying a peculiar sense of stillness and fragility, does not seem to have impressed Venetian sculptors. In 1453 a Madonna by Donatello was installed over a door in S. Maria della Carità.[3] A large number of works by Florentine sculptors who worked in Venice after about 1420, some of them probably making their homes there, have been preserved.[4] Both the figures on the altar of the Cappella dei Mascoli in S. Marco (1430), based on works by Lorenzo Ghiberti and probably imported from Florence, and the lunette over the portal of the Cappella Corner at S. Maria dei Frari (ca. 1420) surpass the sculptures by Giovanni di Martino da Fiesole, Niccolò di Pietro Lamberti, and his ungifted son Pietro di Niccolò. Their statues together with Venetian and Lombard figures populate the crowning tympana of the façades of S. Marco. Nor do the sculptures on the tomb of Doge Tommaso Mocenigo (died 1423, SS. Giovanni e Paolo), signed by Pietro di Niccolò Lamberti and Giovanni di Martino da Fiesole, and including a crude copy of Donatello's "St. George" (Or S. Michele), deserve to be regarded as the vanguard of the Renaissance in Venice. None of these im-

migrant sculptors could rival the leading Venetian architect and sculptor Bartolomeo Buon,[5] who, in the Porta della Carta (1438–42) and the *Judgment of Solomon* for the Doge's Palace, was awarded two especially desirable state commissions. Bartolomeo's ability to render extreme psychological situations as well as the finest emotional nuances in stone links him on one hand with the Venetian Filippo Calendario, documented from 1340 to 1355, and also with his Florentine contemporary Donatello. Nevertheless, Bartolomeo's art, leaving aside his late architectural works, has its roots in Gothic traditions.

It would be interesting to know who commissioned a sculptor from Donatello's circle to supply a modern head and sword, thus turning an ancient statue into a St. Paul.[6] This occurred between 1440 and 1450 when the church of S. Polo received its handsome portal. In a similar way during the fourteenth century, the St. Theodore or "Todaro" for one of the two columns in the Piazza had been put together from ancient fragments.

In 1424 a decision was taken that was to have repercussions for other patrons and architects. This was the reconstruction of the west or "Piazzetta" facade of the Doge's Palace in the style of the fourteenth-century building. The tracery designed by Filippo Calendario in 1340 was to be the example for many buildings in the first half of the fifteenth century, including the private palace of Doge Francesco Foscari (under construction from 1457). Nevertheless, the arcades of the west wing facing the courtyard (in which the architect was not obliged to follow earlier models) show a new orientation. The unknown architect conceived two alternating systems of supports, one consisting of five freestanding columns, four being slender and one more massive, and the other with supports composed of four columns placed in front of the bevelled corners of an irregular polygonal core. A similar five-column support had been prefigured on the southwest corner of S. Marco. Soon afterwards, the combination of a wall core with joined or detached columns of classical proportions would be found in the Arco Foscari and the Cortiletto dei Senatori in the Doge's Palace (fig. 6).

In the 1450s a change is discernible in architecture. In it, Bartolomeo Buon played the most influential part. In particular, the palace he designed for Andrea Corner, unfortunately unfinished, now known as the Cà del Duca (begun in 1456?, fig. 5),[7] as well as his portal for SS. Giovanni e Paolo (1458; fig. 89),[8] make it clear that we are not concerned with unoriginal reflections of central Italian buildings but with the first products of an autonomous Venetian Renaissance. This was already apparent to informed contemporaries, as is seen from a letter by the duke of Milan, in which the spatial proportions and the façade style are recognized as "Venetian" and distinguished from "Lombard" (Milanese) practice.

Towards the end of the 1450s two pieces of triumphal architecture were erected in Venice, the Arco Foscari[9]—a triumphal arch in the courtyard of the Doge's Palace (fig. 15)—and the portal of the Arsenal.[10] While the architect of the Arco Foscari, perhaps Paolo Bregno, followed local tradition and particularly the style of S. Marco, the anonymous architect of the Arsenal portal chose the ancient Arco dei Sergii in Pula, Yugoslavia, as his model, though not without making use of spoils already at hand. If one remembers that among Roman virtues military prowess was unreservedly prized in Venice, the portal of the Venetian arms factory becomes a vivid symbol of a virtue that some critics accused the Venetians of lacking. The Arco Foscari was quite different. Crowned by the city's patron saint bestowing blessings, by the liberal arts, and by angels, adorned with a statue of two doges kneeling before the Lion of St. Mark, and Adam and Eve, it was a stage on the way from the Piazza or church of S. Marco to the palace. Triumphal motifs are lacking in this architecture, even though the doges' processions were described as triumphal ("andate in trionfo"). All the more revealing are the allusions, in the Arco Foscari and the adjoining façade of the Cortiletto dei Senatori (fig. 6), to characteristic elements of the architecture of S. Marco: the niches, the columns, the contours of the roofline—motifs that represented visually the functional interrelationship between the state church and the seat of government. This is probably also the reason for the use of columns in the arcaded walk, which linked the Porta della Carta and the Arco Foscari. At almost the same time, in the Arco Foscari, we meet with the "engaged column" (a column partly embedded in a wall surface). Engaged columns were found previously in classical architecture, for example, the tomb of Annia Regilla,[11] and in numerous postclassical buildings, particularly Romanesque ones, so that the source of the Venetian architects' inspiration can no longer be clearly established.

The choice of a column of classical proportions (the discovery of the other parts of the orders was yet to be made) was not a stage on the way to the rediscovery of classical architecture. The prime concern of the patrons seems to have been with the column as a dignified form.

This applies both to the columns of the tomb of Doge Francesco Foscari and to those of the main portal of SS. Giovanni e Paolo. In the latter, as in the portal of the Arsenal, the columns were taken from the seemingly inexhaustible reservoir of abandoned buildings on the lagoon, in this case from Torcello, continuing the tradition of using spoils from ruins, which had its climax in the façade of S. Marco in the thirteenth century. The abruptly terminated sides of the portal of SS. Giovanni e Paolo make it clear that the columns were to be extended laterally, perhaps to cover the entire lower part of the façade. Perhaps the Dominicans lacked the columns, which

5 Bartolomeo Buon, Palazzo Corner ("Cà del Duca"), detail

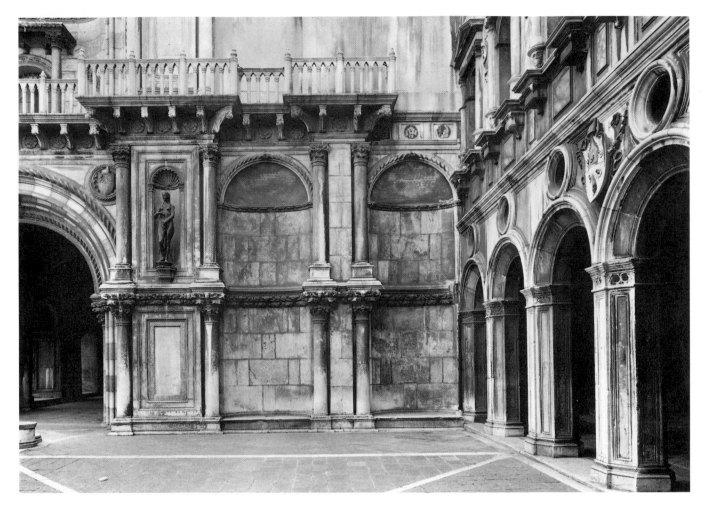

6 Doge's Palace, Cortiletto dei Senatori

they wanted to obtain from the demolition of S. Severo at Ravenna but which Doge Cristoforo Moro was obliged to deny them in 1465 following a vehement protest by the citizens of Ravenna.[12] In Bartolomeo's portal, unlike the earlier portal of S. Stefano and the ground floor of S. Zaccaria (designed in 1458 by Antonio Gambello, fig. 58), the coupled column is predominant. In the repetition of this motif there are similarities with the façade of S. Marco that can scarely be accidental.

After 1438 the Scuola Grande di S. Marco had its new building on the square of SS. Giovanni e Paolo; of its ornamentation, the relief over the portal and a number of figure sculptures have survived the fire of 1485 (fig. 88). It is likely that the style of the façade of SS. Giovanni e Paolo should be seen in relation to this new building and the enhanced value it gave the campo. However, one column does not make a Renaissance, and the walls of Bartolomeo's portal are still articulated in the traditional manner, the tympanum being framed by a pointed arch comparable to those of the only slightly older portals of S. Maria dei Frari.[13] But the heterogeneous element in

this work is probably not only a characteristic of this phase when new directions were being sought, but an inevitable result of the Venetian practice of allowing considerable freedom to individual collaborators in carrying out commissions. The Dominicans entrusted the frieze over the door lintel and the capital zone to the Florentine Domenico, a very gifted stonemason[14] who ignored the lush, "windswept" foliage of the capitals and the naturalistic festoons around the arch, introducing a delicate, filigreed vegetal ornamentation based on classical models.

In hardly any other area of art history is there so much perplexity as in the dating of the Gothic palaces of Venice. It is clear that long after Bartolomeo Buon's Cà del Duca the traditional Gothic style matched the ideas of many patrons. As late as 1581 Francesco Sansovino lamented the predominance of "German," that is, Gothic, architecture in Venice.[15] In one fundamental respect Bartolomeo's palace contradicted the Venetian aristocracy's style of architectural self-display, by showing them ways of making their houses stand out from the mass of build-

ings of similar rank. In 1581 Francesco Sansovino named four sixteenth-century palaces distinguished from the rest by their architecture, by the artistic use of stone, the mastery of the architects, and their size and cost.[16] I am sure that he would have begun his list with the Cà del Duca, had that building not remained a torso.[17] Against the background of Bartolomeo's edifice, tradition-bound buildings like the Palazzo Soranzo–van Axel (1473–79) or the Palazzo Giustiniani at S. Moisé (1474)[18] can be recogized as expressing their patrons' tireless obeisance to the homogeneity of the ruling class. Thus the Venetian Domenico Morosin,[19] who began a treatise in 1497 (*De bene instituta Re Publica*), demanded uniformity of houses as a sign of the ostensibly equal social status of the residents of his native city. A thoroughly utopian demand, it nevertheless showed a heightened awareness of the role of architecture in the self-image of Venetian families and of the republic.

The question of the meaning of the recourse to earlier forms is also posed by Antonio Gambello's design for S. Zaccaria, the church of the Benedictine convent (1458, fig. 58). Here the architect's task was influenced by the function of the building as a church of the holy sepulcher and the goal of an ages-old Easter procession.[20] In addition, the convent had close ties to the doges that had been consolidated over centuries. The decision in favor of an ambulatory with radiating chapels (fig. 62) based on Gothic models is linked to the veneration of a holy sepulcher destroyed in the sixteenth century. The niches recall the choir chapels of S. Marco, as well as the early parts of the Cortiletto dei Senatori (fig. 6), while the windows, as far as they are based on Gambello's design, show simple Gothic tracery. In 1458 these windows, at the express wish of the nuns, were designed by Bertuccio di Giacomo on the model of Bartolomeo Buon's windows in S. Maria della Carità.[21] This was not an isolated case. In 1450 the magnificent windows of the façade of the Carità had been specified to Antonio da Cremona as models for the church of S. Gregorio.[22] Such copies, many more of which can be demonstrated from written sources,[23] teach us not to read into such buildings a stylistic unity that is not there.

Of Gambello's design for the façade of S. Zaccaria, only the first floor was executed. Instead of the traditional Venetian incrustation with framed marble slabs combined symmetrically, Gambello chose a combination of squares enclosing geometrical forms in red, white, and green marble, the fields being framed by strips of inlaid marble and by slender twisted columns. Models for this kind of incrustation are not to be found in Venice. Similarities exist, however, with façades of the Tuscan and especially the Florentine proto-Renaissance. Perhaps similar geometrical patterns had been seen previously in Venetian façade painting. The façade of S. Zaccaria, articulated by four robust piers, is distinguished from the brick façades of Venetian churches by the costliness of its revetment. Gambello's incrustation was not imitated in Venice, and later architects like the Lombardi went back to local models, particularly S. Marco.

The 1450s were a period of searching for a specific Venetian style to replace Gothic forms. External circumstances caused the buildings pointing most clearly towards the future to be broken off when only partly executed, so that it is difficult now to grasp this phase, which was also rich in contradictions, in its full complexity and importance.

3 CIVIC ARCHITECTURE

House and Palace

Visitors to the city have always been fascinated not only by the great number of Venetian palaces but by their unusual architectural form. In 1581 Francesco Sansovino counted more than a hundred, whereas other towns, he claimed, had only five or six. Although this was a tendentious estimate, the Venetian palaces certainly outnumbered those of other Italian cities.[1] Defining what a *palazzo* is presents difficulties not only for the modern historian. Sansovino offers a solution, although, characteristically, he does not adhere to it in practice. Only the Doge's Palace deserved the name, he asserted, while the other buildings of the Venetian aristocracy were, "out of modesty," to be referred to as houses (*case*). By entitling his chapter on these *case* "Palazzi di Venezia" he highlighted the persistent tension between an ideology that idealized the social order of Venice, and the reality of building as a means of self-aggrandizement. Sansovino then pointed to the traditional idea that all houses in Venice had originally been the same height, to show the unity and equality of its inhabitants; only at a late stage had the *appetito* of owners led to buildings that rose conspicuously above the general roofline. The palaces named in this context, those of the Loredan (Vendramin-Calergi, plate 4), Corner (fig. 42), Dolfin (fig. 40), and Grimani (fig. 48), all date from the sixteenth century. Sansovino's criteria in this regard resemble those of Giovanni Pontano (1426–1503), who attempted to characterize magnificence, naming four characteristics that enhanced the dignity of an edifice: ornamentation, which ought to be somewhat overdone; size, which should be kept within bounds; excellence of materials as proof that no expense had been spared; and everlastingness.[2] In 1615 the Venetian architect Vincenzo Scamozzi drew a similarly direct connection between buildings and Venetian society. As all aristocrats considered themselves equal even when their financial means differed, he wrote, there were in Venice countless houses of medium size and very few that stood above the rest. Prosperity (*facoltà*) was spread among many in Venice and not, as in the towns on the mainland, limited to a few.[3]

The Venetian palaces were built and furnished by rich aristocrats (*nobili*) and rich bourgeois (*cittadini*); the differences between the ruling aristocrats and the *cittadini*, who were largely without political influence, could be effaced by the architecture, though for this wealth was certainly a prerequisite. To be well-off in the sixteenth century was to have an income of 1,000 ducats and more; to be rich was to enjoy more than 10,000 ducats in income.

In 1540 Venice had 129,971 inhabitants in all, 4,457 being aristocrats residing in Venice, and probably not many more *cittadini*, while all the rest were classified as *popolani* (commoners). In 1576, shortly before the outbreak of the murderous plague, as many as 170,000 inhabitants were counted, by the end of it only about 120,000. In 1581 the aristocrats accounted for 4.5 percent, the *cittadini* 5.3 percent, while the *popolani* made up 90.2 percent of the total population.[4] In addition there were 1,631 monks and priests, 2,568 nuns, and 1,500 Jews living in the Ghetto. Not only within the aristocracy, part of which was impoverished, but among the *cittadini* and *popolani* there were, as could be expected, considerable social differences. Merchants, doctors, lawyers, and notaries were included among the *cittadini*, who also provided the Venetian bureaucracy.

Sebastiano Serlio and Vincenzo Scamozzi, who were both theoreticians and practicing architects, attempted, partly by means of very subtle distinctions in the architectonic treatment of residences and villas, to demonstrate the owner's rank (here equated with position) and the financial possibilities resulting from this social position. Scamozzi was aware that to perceive and evaluate the "majesty and beauty"[5] that commanded esteem in an edifice required the discrimination of an educated person, and that the distinctions (*gradi*) reflected in architecture could be very subtle. He noted that the hierarchy of buildings was also expressed in the choice of ornamentation. Serlio distinguished buildings with the characteristic Venetian ground plan, which he thought appropriate to the "privato gentiluomo," from the palace of the *nobile*, which should have a courtyard.[6] What it was to be an aristocrat was clearly understood in Venice. More

difficult is the definition of a Venetian "privato gentil-uomo." Machiavelli described the *gentiluomo* as a rich person living effortlessly on the revenue from his property,[7] a class of clients to which Serlio would certainly have wanted to appeal. Nevertheless, he stressed at the same time that in Venice, unlike other regions, "dignity and reputation" were decisive. In building there was no regulation of cost by the government, and so no control. Thus the documents of the Magistrato alle Pompe, who supervised the laws on luxury, contain no references to guidelines.

Art history has concerned itself almost exclusively with the few outstanding buildings by Mauro Codussi, Jacopo Sansovino, and Michele Sanmicheli, paying scant attention to the great majority of typically Venetian residences. Yet Alvise Cornaro, an aristocrat and amateur of architecture, remarked that these "countless" simple buildings made up the city, even though the architects—he was probably thinking in the first place of Vitruvius and Alberti—had written little about them. In a polemical passage of his fragmentary architectural treatise he appealed to Venetian patrons (he called them *cittadini*),

not to architects, to attach greater value to the durability of an edifice rather than mere beauty, and to traditional forms (*uso*) rather than scholarly expertise (*ragione*).[8] These "middle-sized" buildings, as Scamozzi termed them, are usually divided up internally in the same way as the "preeminent" ones and are often of the same size. Residential buildings like those at S. Basegio (fig. 7), the Palazzi Michiel (Calle dei Botteri), or the Contarini's houses on the Rio Marin (second half of the sixteenth century, figs. 8, 9)[9] offered well-to-do families spacious and well-tailored apartments. As even some of the well-known palaces of particularly prosperous Venetians on the Grand Canal were rented by floor from the outset, the differences—apart from the usually simpler treatment of the façades—lay in the relationships between owner and tenant. One was either a house owner or one lived, like most Venetians, in rented property, often at great expense as befitted one's opportunities and pretensions. Many of these apartment buildings erected by private persons or institutions (e.g., Castelforte at S. Rocco) were adorned with elaborate façade paintings by distinguished artists, which obscured the differences between

7 Apartment house at S. Basegio

8 Residential buildings on the Calle Contarina

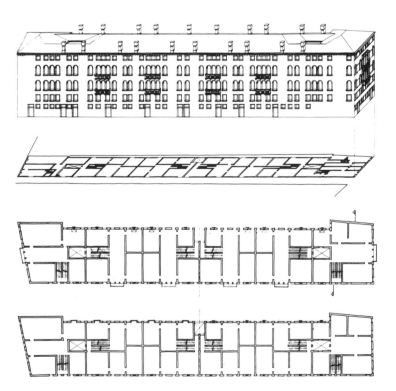

9 Residential buildings on the Calle Contarina, with ground plan, first and second piano nobile (middle), first and second mezzanine (bottom). (Gianighian)

more modest and grander palaces, at least as regards formal opulence.

The need to provide as many dwellings as possible for all social classes, and the very high prices of building land favored the emergence of compact apartment buildings and row houses, for whose design Venice evolved trend-setting solutions. In the many surviving row houses (plate 1) the builders made clear distinctions among the occupants. Buildings for wealthy aristocrats or *cittadini* and those for poorer people differ not only in size but usually in ground plan as well. So the Castelforte complex, or that in the Calle Contarina (figs. 8, 9), possesses in the transverse central hall (*sala*) and the characteristic window grouping essential features of the palace, as occupied by aristocrats and rich *cittadini.* Building configuration and room layout indicate in many, though not all, cases the status of the occupants.

Castelforte was erected in 1547 by the Scuola Grande di S. Rocco from plans by Scarpagnino. Next to it the scuola, like the other scuole grandi, built large numbers of cheap or rent-free dwellings (*case amore Dei*). Towards the end of the sixteenth century the Venetian scuole grandi owned 206 such *case amore Dei,* that of S. Rocco 44, S. Giovanni Evangelista 76, S. Marco 26, and the Scuola Grande della Misericordia, which was in a shaky financial position because of its new building, 60.[10] The occupants of these houses usually had some income, but not enough to cover living costs. They differed in this from the destitute and the sick, who were accommodated gratis in *ospedali;* their appearance and plans can be reconstructed only with difficulty today.

Some of the simple *amore Dei* dwellings erected by the scuole seem to have already had elementary furnishings when first rented. Surviving inventories[11] also indicate that it was not only the better-off tenants who, besides their furniture, often owned pictures, usually on religious themes, which could explain the mass production of devotional pictures. Merchants seem often to have played musical instruments, and a substantial number of Venetians had maps of the world, as wall ornaments.[12]

The builders of apartments also included the procurators, who owned two hundred *case,* housing units that were allocated to, among others, poor seamen and foreigners who had deserved well of the republic. In 1498 impoverished aristocrats took up residence, without paying rent, in thirty-six apartments that Niccolò Morosini had erected for them. Also known are the houses of the Corte Colonne, which already show up in the bird's-eye view of the city by Jacopo de' Barbari (fig. 10).[13] Despite later alterations their ground plan and elevation are still clearly recognizable. Striking and seemingly unique were three monumental tondi on the front of the buildings, a motif otherwise to be found only on the façades of

churches and scuole (e.g., the Church and Scuola dello Spirito Santo, fig. 65). The Corte Colonne residential buildings comprise fifty-five self-contained apartments each of which, as is not infrequent in Venice, embraces several floors. Each apartment has its own entrance, the *porta unica* still so prized today. The kitchen was normally located on the ground floor, the living rooms on the upper floors.

Row houses of the simpler kind often adjoined a street (*calle*) or a courtyard (*corte*) on two sides. Their unified planning not only led to serial repetitions in their ground plans and elevations, but allowed the blocks to be closed off from the outside. This could be by means of high walls (as in the Corte Nuova, Castello) or by a tympanum (as in the Calle del Paradiso). Separation from the public street network was much more common in Venice at that time than today, seeming to reflect a need both for security and for social cohesion. Thus the portal to the Campo S. Zaccaria in front of the convent was locked at night, and many alleys were barred. Between the row houses in the streets, widened into elongated courtyards, often several wells provided an adequate water supply for the residents.

Row houses were erected by individuals and institutions not only for charitable purposes, however, but as profitable investments. Such buildings included, along with many others, the houses with shops on the Calle del Paradiso at S. Lio, the row houses on the Calle Riello (plate 1) and the "Palazzo" Moro.[14] This last was made up of four rows of houses and a large, square internal courtyard, the dimensions of which suggest it should rather be called a campo. Such four-winged layouts were also chosen here and there in Venice for simple *case amore Dei*.[15] Francesco Sansovino names the patron Leonardo Moro as the architect of the complex started soon after 1540, which on account of a configuration unusual in Venice

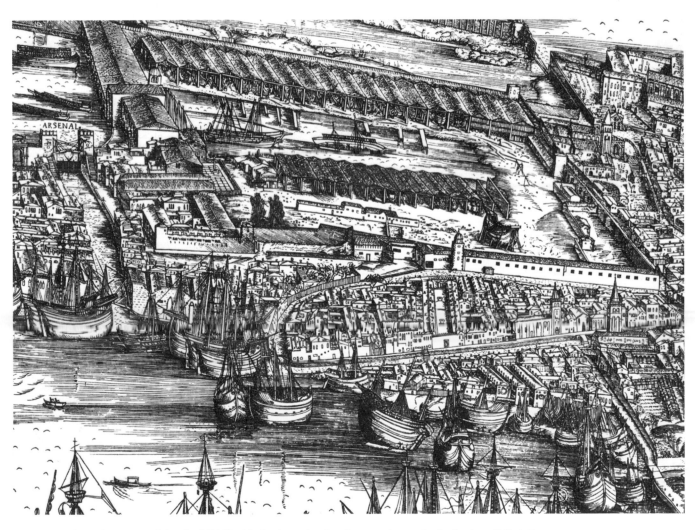

10 Jacopo de' Barbari, view of the city (1500) with the Arsenal and various row houses in the Sestiere di Castello

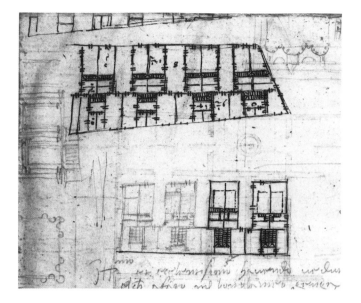

11 Andrea Palladio, design for residential buildings. London, Royal
Institute of British Architects

was designated by contemporaries as a *castello.* Jacopo
Sansovino, to whom Vasari in 1568 attributed this awk-
ward building, can at most have been an adviser. The
learned architects Sanmicheli, Sansovino, and Palladio
probably also designed row houses. A sketch by Palladio
(fig. 11) shows, by its irregular plan, that he was work-
ing on a problem connected with serial building for a
given site.[16]

Analyses of the dwellings of unprivileged Venetians, of
Venezia minore, usually overlook the fact that many of
them were decorated with superb façade paintings,[17]
which would have elevated them not only in the eyes of
their occupants. Across the façades of the simple row
houses of the Corte Nuova at S. Lorenzo, for example,
were painted frescoes probably executed in the six-
teenth century that imitated the façade decoration of the
Doge's Palace dating from the fourteenth century. Similar
patterns seem to have been popular in Venice in the
early sixteenth century, as recent investigations of Vene-
tian façades and the woodcut of the *Bucintoro* (fig. 1)
show. But there was much variety here as well. Row
houses like those in the Calle S. Antonio in the diocese of
S. Luca were painted with architectonic and vegetal
motifs still preserved today.

The question as to what made up the distinctive char-
acter of Venetian secular architecture was posed as early
as the sixteenth century and received a variety of an-
swers. While Serlio made only some very superficial
comments in his Fourth Book of 1537, he later, in the
manuscript of his unpublished Sixth Book, pointed to
some, if not all, of the characteristic elements of the Ve-
netian palace: the portico on the ground floor and the
sala on the upper floors, opening up the building from

front to back and windowed on the short sides, as well as
the balconies, whose usefulness for the building was
clearly a subject of controversy among experts at the
time. In connection with Serlio's own designs in the
Sixth Book,[18] which were never realized, there is a refer-
ence to the particularly high real estate prices in Venice,
the lack of courtyards and gardens for most buildings, as
well as the difficult task of providing sufficient lighting
for the portico, the staircases, and the living rooms situ-
ated away from the façade on the upper floors. Here he
does not fail to mention the traditional solution of insert-
ing one or more narrow, sometimes almost shaftlike,
courtyards into the block, which at least allowed air and
dim light to penetrate. By and large, he said, in the design
of most palaces the architects had taken liberties and not
strictly followed the rules.[19]

Far more complete is the account of the Venetian pal-
ace given by Francesco, son of the architect Jacopo San-
sovino, who as a Venetian speaks from daily practical
experience with such buildings.[20] He too mentions the
long *sale,* reminiscent in extreme cases of a covered
street, mentioning that they had earlier been T-shaped
("in crocciola," like a crutch). There were, he said, no
porticos in the exterior walls (which in that categorical
form was incorrect), and so no shelter from rain. All
buildings, even the simplest, were glazed, and the distri-
bution of the rooms, particularly the position of the sala,
could be inferred from the disposition of the windows.
The loggia, which by the sixteenth century was only oc-
casionally on the ground floor, originally had served for
unloading goods. Sansovino also mentions the character-
istic rooftop belvederes (*altane*), which fulfilled an im-
portant function (along with the gardens still numerous
at the time) by providing the pleasure of a fresh breeze,
not to mention a place to dry clothes. Dressed-stone[21]
gutters and wells complete Sansovino's catalog. Nor did
he forget to mention the roof structures customary in
Venice, resembling very shallow pyramids and hipped on
all four sides, which were not only good at dispersing
rainwater but also enhanced the building's appearance in
contemporary eyes.[22]

On these roofs were to be found, as a rule, several or-
nately formed chimneys.[23] Erhard Reuwich pointed to
their importance for the town's skyline as early as 1486,
and Vittore Carpaccio (plate 2) and Gentile Bellini
(plate 3) have documented further examples, some of
them richly painted, in their pictures. These chimneys
were not standardized, there being a great variety of so-
lutions. Sansovino's rusticated chimney for the Venetian
mint (Zecca) is probably the most artistic surviving ex-
ample today. With serial building the regular sequence of
uniform chimneys became a characteristic feature.
Scamozzi (1615)[24] was the first to make recommenda-
tions regarding their form, opting for obelisks or slender
vases. In the case of the obelisk, he turned to profane use

an august ornamental motif of public buildings (Libreria, fig. 29) and private palaces.

A striking feature of all the contemporary pronouncements on secular architecture is how little is said about the functions of individual rooms. Here Scamozzi is of some help, if not much. According to him the habits of the Venetian aristocrat were so different from those of the inhabitants of other cities that the architecture (the "forma della casa") also differed. Like the Greeks, Venetians were not in the habit of inviting friends or numerous relatives into their houses. Visitors were received in the mezzanine, reached from the first landing of the staircase or by secret stairways, where family affairs were also dealt with. This reversion to a supposedly "Greek" mode of life by some Venetians is in notable contrast to the connection far more often postulated between the civic life of Venice and that of ancient Rome. Furthermore, there was in Venice a type of palace that, on account of its courtyard, contemporaries spoke of as *alla romana.* Next to the portico, Scamozzi tells us, were storerooms.[25] The sala—here Scamozzi was at one with Andrea Palladio—served for special occasions such as weddings, banquets, or other feasts, to which the entire nobility was invited. The adjoining rooms of the "senators" and their wives were the same height as the sala, while those of the children and nursemaids, and sometimes the kitchens as well, were half height. The servants were housed in the mezzanine above them. Furthermore, he insisted, the quarters of the male and female servants were to be kept apart like fire and tinder. Scamozzi likewise, in the new building he designed for the procurators, separated them from their wives, again on the example of Greece. Only by such measures, he contended, could they live free and unmolested by the women.[26]

During the construction of the palace for Andrea Corner, the Cà del Duca (fig. 5), the peculiarities of Venetian building had already been a source of controversy between the Venetian architect Bartolomeo Buon and the Milanese Duke Sforza, the purchaser of the building, and his architect Benedetto Ferrini. The duke seemed prepared to allow the façade, which had already been begun, to be completed in the Venetian manner, but required the rest to be built *a la moderna,* that is, as building was practiced in Milan. He did not doubt, he wrote in a letter to his Venetian agent, that the design he favored would please everyone in Venice as something new.[27] Unfortunately Bartolomeo Buon's design has not been preserved; its Venetian character and traditional elements can be inferred only fragmentarily from the grandiose torso, which consists of parts of the ground story. One may surmise that they included the fenestration of the upper-floor front wall of the sala and the distribution of windows in the walls of the projecting corners. The ornamental motifs, judging from the ground floor, were entirely new in Venice. Bartolomeo Buon distinguished the

two corners from the long side frontages by means of rustication. This is a fundamental departure from earlier domestic building practice.

The development of a short side-façade can have civic, functional, and aesthetic motives, and we find the façade pattern continued "around the corner," though only for one axis, in a few later examples, such as the Corner (fig. 42) and Dolfin (fig. 40) palaces by Jacopo Sansovino. Michele Sanmicheli's Palazzo Grimani (figs. 48, 49), with its two-axes-deep projection, is an exception. The contrast to the smooth rendering of the side frontage, often divided by horizontal bands in the sixteenth century, was thus retained; the corner window—and the highly valued rooms behind it—was ideal for a diagonal view; instead of the traditional façade a projecting bay (*avancorpo*) was chosen.

A brief description of the project from the pen of Marco Corner allows us to deduce some further elements of the Cà del Duca. A drawing in Filarete's architectural treatise, which is often cited in comparison, might have been suggested by Bartolomeo's design, but still does not allow a reconstruction. Between the two projecting corners, monumental columns were planned—announcing a clear departure from the usual practice of the time and a return to the pre-Gothic tradition of the twelfth and thirteenth centuries. Other recapitulations of pre-Gothic forms at the same time are to be found on a wall of the Cortiletto dei Senatori in the courtyard of the Doge's Palace (fig. 6), perhaps designed by Paolo Bregno.

The interior of the Cà del Duca, too, was meant to be unusual. While the enormous portico, over 55 meters long and almost 11 meters high, would have made all previous palaces apart from the doge's seem small, the introduction of two courtyards between the sala and the lateral wings made it possible for the architect to light the sala, at 9.10 meters only slightly lower than the portico, from four sides—an idea that was taken up later by Serlio among others, in an unrealized project in his Sixth Book (fig. 23d).

The projecting corners, unusual in Gothic Venice, were referred to as towers by one contemporary, and compared to the palace of the marquis of Ferrara, later the Fondaco dei Turchi, a building from the twelfth century. Two "towers"[28] were also a feature of the earlier Palazzo Foscari at the bend of the Grand Canal, and of the Palazzo Molin at S. Sepolcro,[29] described by Petrarch. The reference by a contemporary to the Fondaco dei Turchi is worthy of special attention, since citations from S. Marco and so from the local architecture of the twelfth and thirteenth centuries are unmistakable in other buildings of the Venetian Renaissance as well. This revival of native styles from a much earlier period is comparable to Filippo Brunelleschi's study of Romanesque buildings in Florence, even though the buildings chosen as models in Venice were not, like the Florence Baptistry, believed by

the architects to originate in antiquity. Unlike many towns in its territory, such as Padua and Verona, Venice was not founded in antiquity, and there would always be influential people and groups for whom Roman antiquity was not an acceptable paradigm. Also, there were other individuals or families, usually with closer links to papal Rome, who, like the Grimani of S. Maria Formosa, preferred decorations in the classical style and artists trained in Rome. The tension that is discernible here can be resolved neither within the framework of a history of styles nor solely by reference to the different training, origins, or orientation of the artists.

The achievement of Bartolomeo Buon and the other architects active in the second half of the fifteenth century is made clearer if we compare their works with more traditional buildings designed only a short time before or, in some cases, perhaps at the same time, like the Palazzi Foscari, Bernardo, and Pisani-Moretta.

Common to all is a base of large stone blocks, very often chamfered, giving an impression of a secure foundation and usually topped by a strongly profiled cornice. The socle of the palace, its base, was a preoccupation of all the architects active in Venice, on aesthetic as well as technical grounds,[30] and one that, given the location of the canals and the dependence of the water level on the tides, was apt to produce visual surprises at low tide. While Bartolomeo Buon revetted the socle in rusticated slabs, the anonymous architect of the Palazzo Gussoni (near S. Lio) chose rich carvings, using the rosettes traditional in Venice since the Doge's Palace, and guilloche. The architect of the Palazzo Contarini (S. Vio, fig. 12), also anonymous, added a molding of red marble to provide a delicate yet striking horizontal. A particularly extravagant solution was found in 1481 by Pietro Lombardo for the side frontage of S. Maria dei Miracoli (plate 5); he attached consoles beneath the socle zone.

12 Palazzo Contarini (S. Vio) on the Grand Canal

The portico of the palaces is linked to the canal by a staircase, usually semicircular and extending far out into the water; its architectonic significance in relation to the façade can only be appreciated at low tide today. In buildings situated on dry land the base is generally simpler. Stone benches (*requia*) as part of the façade, so popular in Florence, remained a rare exception in Venice.[31]

Most of the Gothic palaces built in the first half of the fifteenth century had brickwork walls. In views by Carpaccio and Gentile Bellini, of the Rialto for example (plate 2), or the vicinity of S. Lorenzo (plate 3), the whole spectrum of sumptuous façade painting is to be found. In the absence of studies on the painting of Venetian buildings, informed comment on the aesthetic quality of the walls is all but impossible. The stone facing (Istrian limestone and/or marble) chosen for several buildings in the second half of the century seems to have been a reversion to "pre-Gothic" models of the twelfth and thirteenth centuries. After Bartolomeo Buon's Cà del Duca this tradition became obligatory for prestigious buildings. However, rustication of the ground floor remained a rarity. Mauro Codussi, in the rio façade of the Doge's Palace (after 1483, fig. 17) and in the Palazzo Lando-Corner-Spinelli (fig. 18), took up Bartolomeo's idea, though he may also have been recalling Tuscan works by Alberti (Palazzo Rucellai in Florence) or Rossellino (Palazzo Piccolomini in Pienza).

By using an ashlar facing a very close approximation between the sculpted parts and the plain wall surface could be achieved. But even here dirt deposited in the interval is deceptive. Many buildings are faced with slabs of different colored marble, so that the rich and comparatively cheap painting has been replaced by expensive marble with its prominent color and veining. That S. Marco was entirely faced in marble may have played a part in this development, but the decisive factor was probably the facing of old Venetian palaces in several colors, of which only a few, like the Loredan palaces (Riva di Ferro) and the Palazzo Dandolo adjacent to it, which have in any case been changed by renovations in the last century, give a faint idea. Moreover, Venetian patrons and architects were well aware of what Vincenzo Scamozzi wrote in 1615, that marble reacts far more sensitively to sea air than the Istrian limestone popular in Venice. The decision in favor of the expensive and less durable marble was thus an affirmation of distant architectural traditions, which still carried little weight in the first half of the fifteenth century. The most famous example of these marble-faced palaces is probably the so-called Cà Dario on the Grand Canal. This building is usually attributed to Pietro Lombardo and dated 1480–90.[32] Compared to the "calm" designs of the "Gothic" architects of the first half of the century, with their sure articulation of the façade, and even against the background of Pietro's principal work, S. Maria dei Miracoli,

this façade gives an agitated, unresolved impression, relying for its effect on the sheer luminosity of the materials and the fascinating variety of ornamentation. The choice of endless guilloche reminiscent of that in Roman and Romanesque floor designs to decorate the tondi in the spaces between the windows, and of the many-colored tondi beside the window arches and in the socle area of the upper floors, again draws on formal devices from a time long past.

As compared to the buildings of the first half of the century, the palaces that followed the Cà del Duca differ more clearly from each other. The idea of showing membership of the Venetian upper class by literal quotation from the outmoded tracery of the Doge's Palace in the architecture of a private palace no longer seems to have occurred to anybody. On the contrary, several patrons decided on a distinctive, imposing residence, the choice of architects such as Pietro Lombardo or Mauro Codussi preempting decisions regarding the treatment of the façades. Only at the start of the sixteenth century do Venetian palaces begin to resemble each other more strongly again, and a renewal of the tradition of the clear and rather simply organized façades of the late-Gothic palaces seems possible.

A "critical" element of the Venetian palace façade is its framing. In the late-Gothic palace the "colonnette" or twisted rope, in numerous often-playful variations, had taken on functions of framing as well as dividing. Bartolomeo Buon then replaced the colonnette with large columns of classical proportions so that they seemed freestanding. However, none of the later palaces, not even those of the sixteenth century, show columns of dimensions comparable to those of the Cà del Duca, whereas pilasters and even the traditional colonnette were common. Colonnette or twisted rope had adorned the corners of Gothic palaces and delimited façades, but was not repeated as vertical subdivisions within the façade. The grouping of the windows and the opening of the sala, and the size and proportion of the spaces between the Gothic windows, which often had rectangular surrounds, were sufficient. Bartolomeo's accentuation of the projecting corners and the traditional principle of framing the façade by ornamental moldings can both be found in the plain façades of the second half of the fifteenth century. Mauro Codussi, in his Palazzo Lando-Corner-Spinelli (fig. 18), still placed pilasters solely at the corners of the building.

In the Renaissance the entrance area of the Venetian palace seems to have undergone a fundamental reassessment. The discomfort associated with using the ground-floor rooms for living purposes, and the need to store goods and supplies had meant that the ground floor had become primarily a storage area. It is referred to as a *casafondaco,* and attempts have been made to link it historically to the Arabian *funduk* (Ital. *fondaco*).[33] That

such a use of the entrance area did not in the long run satisfy architectural patrons interested in self-aggrandizement will surprise no one. The extremely sparse sources give very little insight into the stages of the revaluation of this area. Originally coats of arms and weapons appear to have been hung in the portico,[34] the goods stored there also testifying to the owner's prosperity. The development had reached a turning point soon after 1500 with Mauro Codussi's design for the portico of the Palazzo Loredan (now Vendramin-Calergi, plate 4). Sanudo cites a statement by the doge stressing that he, the doge, had been one of the first to remove the weapons display (lanziera) and set up a table for festivities.[35] This upgrading, which was immediately imitated, demanded appropriate furnishing and appointments. The commissioning of Giorgione to paint allegories of industriousness and vigilance on the walls makes the transformation clear.[36] From now on the treatment of the portico took on increased significance for architects as well. Nevertheless, most of the buildings continued to have porticos of the traditional type, although the issue is confused by the almost total loss of the decorative painting today. In 1648 Ridolfi recorded the decoration of the portico of the no longer extant Palazzo Morosini del Giardin by Paolo Veronese and Alessandro Vittoria, in which Veronese is said to have not only depicted classical buildings and landscapes but also modelled a stucco figure of Mars.[37] That the traditional entrance area no longer met the expectations of all patrons by the middle of the sixteenth century is also shown by Michele Sanmicheli's costly design for the ground floor of the Palazzo Lando-Corner-Spinelli (about 1542, fig. 46).

Apart from the entrance from the canal, the Venetian palace naturally also had an entrance connecting it to the street network. As a rule this entrance was at the back, but it was not uncommonly at the side of the building, which could have implications for the ground plan of the portico. In Gothic palaces the property was often entered via a courtyard enclosed by high walls. The Cà d'Oro is a particularly well-known example, although in many details is no longer original. An external staircase led from the courtyard to the first floor. This space-saving and architecturally imposing mode of access no longer seems to have corresponded to the ideas of most patrons and architects during the Renaissance. The staircase was moved inside the building, although the concentration of buildings and the resulting lack of light created problems for architects and users. The outcome was dim shifts, often with insufficient lighting of the landings as well, with entrances accentuated by portals. Leone Battista Alberti's complaint that staircases disrupted buildings (and taxed architects' minds) is especially understand-

able in Venice. Only in the sixteenth century were attempts made here and there to match the staircases in a building to its architectural splendors. In the second half of the century there were also owners who opted for the traditional type of outside staircase in a new guise. The superb staircase in the Corte de la Teraza[38] and, above all, the Scala dei Giganti in the courtyard of the Doge's Palace (after 1483, fig. 15) are outstanding examples. Here and there towerlike spiral staircases were erected, among which that designed by Giovanni Candi for the Palazzo Contarini del Bovolo (ca. 1497–99, fig. 13), with its opening on to ascending arcades, has rightly become famous.[39] Almost a century later, in the Palazzo Balbi, Alessandro Vittoria integrated two round staircase towers symmetrically into the rear of the building.

After walking up the dimly lit staircase the visitor entered, from one of the long sides, the broad and usually well-lit sala. Palladio described it (in 1570), together with the portico on the ground floor, as a quasi-"public" area,[40] reserved for festivities, banquets, theatricals, wedding celebrations, and similar occasions. The furnishing of this area accessible to a restricted public is known to us through inventories. Apart from large tables and numerous chairs, weapons and trophies that had previously been accommodated in the portico are mentioned here. By a decree of 1509 these private arsenals were henceforth to be inspected by the Council of Ten, who also supervised the state collection of weapons and trophies in the Doge's Palace, which was accessible to very few.[41] In addition, the sala was adorned with pictures. Giovanni Bellini's *Portrait of Doge Agostino Barbarigo before the Madonna* (today in S. Pietro Martire, Murano) hung originally in the sala of the family palace.

The sala, like the other rooms, usually had a colorfully painted, raftered wooden ceiling; Jacopo Sansovino seems to have developed a tighter construction for it, so that Venetians often speak of a ceiling *alla Sansovino* today. The lateral beams were usually spaced with a gap of one- to one-and-a-half-beam thicknesses. This form of ceiling has been characteristic of Venetian civic architecture since the Middle Ages. Andrea Palladio devoted a passage of his architectural treatise to it.[42]

The floors of the upper stories of the Venetian palace were of terrazzo, a material already known in antiquity and resembling expensive marble; its color composition, like that of polished multicolored stucco, could be suited to particular wishes by the selection of materials.[43]

From the sala one could, in numerous buildings, step out onto a shallow balcony, not only to have a good view of the surroundings but to enjoy the blessings of a fresh breeze. Usually the balconies adjoined windows or groups of windows whose openings extended to floor level. What a difference between the windows of a Florentine palace, designed to guarantee privacy and often starting above eye level, and these wide windows open

13 (*Opposite*) Palazzo Contarini del Bovolo, courtyard

to the air and eyes! In 1615 Scamozzi, basing himself on Vitruvius, traced these traditional floor-level Venetian windows back to ancient models.[44]

The balconies are usually rectangular in form. They are enclosed by a balustrade or openwork (*trafori*). Fine examples of the latter are the balconies of the Moro-Lin, Dario, and Contarini delle Figure palaces, the solution in the Palazzo Dario being a special case in that the columns of the sala windows do not extend to floor level but only to a low barrier, so that balconies were eliminated. These panels can be traced back to early Christian and medieval traditions and seem to have been considered an especially costly and socially prestigious form of embellishment; otherwise the senate would hardly have stipulated that the new building of the Fondaco dei Tedeschi (1505) should dispense with them.[45] The members of Pietro Lombardo's workshop seem to have specialized in such work; they also carved the magnificent altar rails in S. Maria dei Miracoli (fig. 63). In general, carved openwork was long used in the interior of churches, especially for organ balconies. There were patrons who clung to Gothic traditions as late as the second half of the fifteenth century, as is shown by the tracery of the balconies of the Palazzo Contarini-Fasan (ca. 1470).[46] An especially beautiful invention of Mauro Codussi, the balconies of the Palazzo Lando-Corner-Spinelli (fig. 18) that project in a cloverleaf formation found no imitators in Venice. Possibly the building supervisors intervened after the event to prohibit balconies projecting to this extent. However, it would be mistaken to try to reduce the diversity of possible solutions to a single hypothetical façade type. Often balconies were used only in front of the sala, the windows of the adjacent rooms opening above a low section of wall. A third and popular solution was to frame the window openings in front of the sala by balustrades; apparently few people were disturbed by the problems arising from the abutment of horizontal balconies to columns and the juxtaposition of the balusters to columns of classical proportions.

A further question occupied the experts with regard to façade organization, although written documentation of it exists only for the sixteenth century. Alvise Cornaro, within the framework of his critical comments on the expense of building, also raised an exclusively aesthetic question concerning the number of window openings for the sala.[47] It should, he argued, be an odd number, so that there would be an opening, not a column, at the center. Examples of both arrangements are to be found in Gothic architecture, the different effect being, of course, particularly pronounced with a small number of bays: an even number emphasizes the wall, an odd one the window opening. In the ensuing decades the architects continued to proceed in an undogmatic way, Mauro Codussi making use of both solutions. Perhaps Alvise Cornaro was here trying to confer written authority on some

ideas of his friend Serlio, whose Serlian arch emphasized the window openings and corresponded ideally to Cornaro's preferences.

But it was not only convention and aesthetic considerations that governed the style of Venetian palaces and their façades; the shape of the plot, with its often irregular boundaries was also an important factor. The limits set to the size of the portico and the sala resulted, when the plot was very narrow, in buildings that had rooms on only one side of the sala; when the plot was very broad, the dimensions of the adjacent rooms were increased (as in the Palazzo Donà on the Fondamente Nuove). In the latter case, because the rooms at the side of the building were usually lit by two windows spaced far apart, the wall area between the windows was very wide, so that horizontals predominated, embodied in and emphasized by cornices and entablatures.

In the façades of Gothic palaces the two windows of the rooms beside the sala were placed, as a rule, close to the sala windows on one hand and the corners of the building on the other. In some cases the window next to the sala might even be linked to it by an arcade (as in the Palazzo Soranzo on the Campo S. Polo). The placing of the windows close to the corners of the building gave the architects an opportunity to provide oriels at these corners, giving the occupants an unfamiliar view to the side (Palazzo Cicogna, formerly Arian; Cà Mastelli). That this solution was seldom used was undoubtedly due in part to the fact that most palaces formed part of a continuous front. Biagio Rossetti, who made allusions to Venetian building traditions in a number of his Ferrarese buildings, took full advantage of the architectural possibilities arising from the accentuation of the corners of buildings.

The form of Venetian houses and palaces remained constant by and large until the fall of the republic in 1797. Attempts by some owners and architects to make fundamental changes to the living pattern in palaces by a different arrangement of rooms remained mere episodes. The continuity always stressed in the republic's conception of itself is seen particularly clearly in Venetian secular architecture.

Mauro Codussi

Two architects had a decisive influence on Venetian civic architecture in the period before Sansovino: Bartolomeo Buon (died between 1464 and 1467) and Mauro Codussi (ca. 1440–1504). Whereas Bartolomeo Buon's Cà del Duca remained a fragment, Codussi was able to complete a number of important commissions, including the east wing of the Doge's Palace. His works are a high point of Venetian Renaissance architecture.[48]

Codussi seems to have received commissions for secu-

lar buildings only after working in Venice for more than a decade. They were preceded by the Camaldolese church of S. Michele at Isola (begun in 1468, fig. 57), the campanile of S. Pietro di Castello (begun in 1482), and the continuation of work at S. Zaccaria (from 1483, fig. 58). In the absence of precise information, it is hardly possible now to ascertain which palace he designed first. His close contacts with influential Venetian aristocrats had grown out of the building of S. Michele in particular and may have played a part in the selection of Codussi's proposal for rebuilding after the fire at the Doge's Palace in 1483. On the other hand, there was little serious competition to be feared in Venice. Pietro Lombardo, who may have taken part in the competition, had earned his reputation primarily as a sculptor and a designer of tombs and chapels. The church of S. Maria dei Miracoli (fig. 61), which had been under construction since 1481, does not seem to have qualified Pietro for the task.

Codussi was a native of Lenna, a small town in the Val Brembana, not far from Bergamo. We have no record of where he was trained or how he qualified himself in the eyes of the demanding patrons of S. Michele. Perhaps he had worked previously for the Camaldolesians

in Ravenna. Ravenna was definitely not the right place to become acquainted with new developments in architecture, however, so that it is conceivable that Mauro Codussi had studied Leone Battista Alberti's Tempio Malatestiano in Rimini. But Ravenna and the Marches did permit an acquaintance with both classical and early Christian architecture—an excellent preparation for an architect who was to be confronted in Venice with the living traditions of medieval architecture. Codussi's work does not provide compelling evidence that he travelled in Tuscany during these years.

In 1483 the east wing of the Doge's Palace, which contained the doge's living quarters, had burned down. The short deadline of the competition announced in 1484 probably made it impossible for participants to submit adequately detailed proposals for the reconstruction. In the sources, Antonio Rizzo is mentioned several times in connection with the rebuilding, so that it has been almost unanimously attributed to him up to now. However, Rizzo seems to have been only the *proto*, the person responsible for executing the work, while the design, for stylistic reasons, can be attributed to Codussi.[49]

Codussi designed two entirely different façades, one facing east (fig. 17) on the Rio di Palazzo, and a second facing the courtyard (figs. 15, 16). The differences are explained not so much by the formal links to the opposite wing of the Doge's Palace in the case of the court façade as by the greater freedom in designing the external façade. Starting from the function of the courtyard as the setting for public appearances by the signoria and probably intending to give the new palace an especially magnificent front towards this courtyard, Codussi designed decorations for the wall surface that were, for him, unusually sumptuous, possibly acting on instructions from the patrons. There is strong reason to suppose that painted façade decoration characteristic of Venetian façades may have played a determining role. From the Gothic wing opposite Codussi took over the arcade in the loggia area, but changed the form of the supports. While he retained the combination of columns and piers of the side facing the courtyard, he covered the piers of the loggia side with coupled pilasters. The contrast formed by the round arches of the arcades on the ground floor and the "Gothic" pointed arches of the loggia was carried over to the south wing in the early seventeenth century.

The upper stories respect the arrangement of the rooms spared by the fire. High entablatures divide the façade horizontally. The windows and the wall areas between them are not treated uniformly. Codussi turned the irregularity of the existing structure into a picturesque feature by the variety of ornamentation. The east façade seems to be covered by a net with unequal-sized meshes. On the second floor, Codussi uses a freestanding column, while others are half embedded in it. Contrary

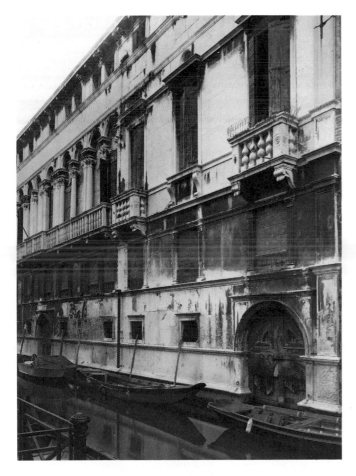

14 Mauro Codussi, Palazzo Zorzi near S. Severo

to all orthodoxies and delighting in experiment, he composed architectural elements into complex formations.

Codussi's wall seems to be built up in layers. The surface forms the front layer, while the slender round-arched windows make a second plane behind it. The volume and density of the ornamentation covering the wall surface increases in the upper part of the façade, compensating for the flattening effect produced by the increasing distance, an artifice that would have its proper place in a chapter on the use of perspective in buildings ("prospectiva aedificandi"). It is an open question how much influence Codussi had on the details of the wall ornamentation, which is unusually rich for his work. Possibly the Lombard stonemasons worked to their own designs under the supervision of the *proto* Antonio Rizzo. However, some of the details are certainly from Codussi's repertory. The frames of the tondi with their chain motif reminiscent of goldsmiths' work are found in numerous buildings by him from S. Michele in Isola onwards

(fig. 57). But nothing connects this architecture with Antonio Rizzo's tomb of Doge Tron (fig. 115) or with his Scala dei Giganti.

The rio façade (fig. 17), usually neglected by architectural historians, shows a motif that Bartolomeo Buon had introduced to Venice in his Palazzo Corner (the Cà del Duca, fig. 5)—the rustication of the bottom third of the ground floor. Instead of the contrasting flat rusticated slabs on the high socle and sharp-edged "diamonds" on the ground floor of Buon's Cà del Duca, Codussi confined himself here to square "diamonds" alternating in convex and concave forms. In 1485, about a year after building had started, the Ferrarese architect Biagio Rossetti visited Venice at the request of the Este and is likely to have inspected the building site. His Palazzo dei Diamanti seems to have been influenced by Codussi's design.

The ground floor of the Doge's Palace already displays the linking and interpenetration of forms characteristic of Codussi. Segmental pediments over a continuous cor-

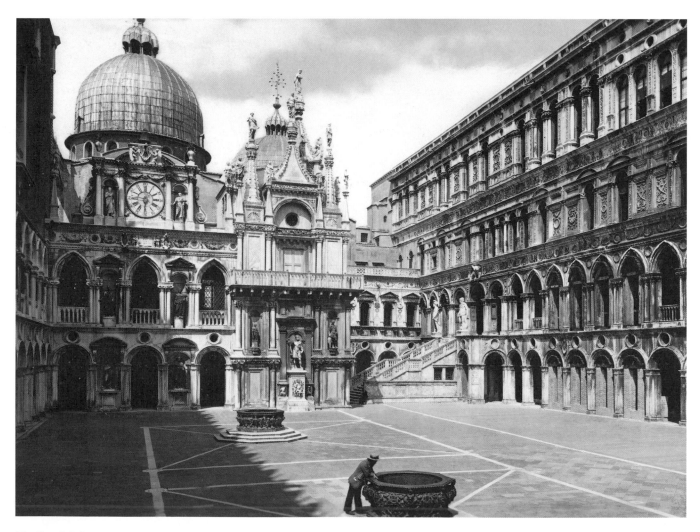

15 Doge's Palace, courtyard with Arco Foscari and Scala dei Giganti

nice are related to the rectangular windows, while the spaces above them sometimes contain tondi and sometimes windows. The network of verticals and horizontals is flexibly used; the irregularities (spaces of unequal width asymmetrically distributed) do not trouble the eye and are a skillful adaptation to the existing walls as well as solving the problems of adequate lighting, as also in the Palazzo Zorzi on the Rio S. Severo (fig. 14). To this end Codussi, possibly influenced by ancient sarcophagi, included recessed fictive windows with crossed bars, using this artifice to give some uniformity to a window distribution that would otherwise have seemed capricious.

As in the case of the Doge's Palace, in the Palazzo Zorzi Codussi had to contend with an existing building that was to be given modern dress. Marco Zorzi, the patron, had known Codussi as the architect of his family chapel in S. Michele in Isola (1475). Possibly the commission was awarded before the fire at the Doge's Palace. As in the latter, the mezzanine is incorporated into a ground floor with a number of horizontal divisions and topped by an entablature, the pilasters framing the windows that link cornice and entablature. A similar bracing was used in the Procuratie Vecchie on the Piazza S. Marco.

Interlocking, bracing, and linking devices are found throughout this façade. The almost square windows between the three doors facing the water rest on a continuous cornice starting at the bottom of the arches of the broad, rather stout doors. This cornice looks much like a border to a socle, though it actually starts above it. The same principles govern the first floor. Horizontal moldings project to form window sills or are used to surmount the high rectangular window openings.

For the openings on the upper floor Codussi did not design a continuous arcade but created a rhythm. This too is typical of his style and distinguishes him from the indigenous "Gothic" tradition. The blind windows are a result of the need to accommodate the ground plan of the existing building while producing a unified façade.

16 Mauro Codussi, east façade on the courtyard, Doge's Palace, detail

Each pair of openings is embraced by framework consisting of short pilaster strips above the pilaster forming a rectangular frame around bifore (as with the bifore in the inner courtyard). Similar pilaster strips were to be seen at that time in the façade of the Procuratie Vecchie from the twelfth century. A central window is brought forward by coupled pilasters, the accentuation being made particularly clear by a projection in the balcony. In Venice, only the Doge's Palace had such an emphasized central window. The relatively high section of wall, bordered by two slightly projecting moldings, looks like the frieze of an entablature: this is a further indication of Codussi's flexible design, which carefully calculates the proportions of unarticulated areas. A very similar arrangement was to be found in an anonymous palace dating from the thirteenth (?) century near S. Moisé (demolished in 1844), as recorded in a view by Pividor.[50] Mauro Codussi may well have been inspired by this or similar pre-Gothic buildings.

The same design principles as in the Palazzo Zorzi—though enriched with new motifs—are found in the Palazzo Lando (known as the Palazzo Corner-Spinelli, fig. 18). The socle and ground floor are adorned by shallow, smooth rusticated blocks like those that Codussi had used to decorate the façade of S. Michele in Isola and Bartolomeo Buon had used for his Cà del Duca. Motifs like the porphyry circles traditional in Venice add color and animation while recalling, in combination with rectangular frames and torches, classical trophies of the kind found in book illustrations, like those of the *Hypnerotomachia Polifili* published in 1499. The bifore to either side are framed, like the windows of Gothic palaces in Venice, to form rectangles. A slight projecting of the moldings of the windows and window groups relative to the cornices noticeably enlivens the façade's relief. The bifore show a clear derivation from Gothic buildings. Codussi designed a window that is found in similar form yet with a different origin in buildings by Leone Battista Alberti and Bernardo Rossellino. Just as the different versions of the Tuscan bifore were evolved from the Gothic windows of that region, Mauro Codussi took the tracery of the Doge's Palace as his starting point. Characteristic, and differing from all the Tuscan examples, is the lobed oculus extending between the lunettes of the bifore; this was developed from the framework of the Gothic quatrefoils and those of the Doge's Palace. Here too, therefore, there is no simple adoption of single forms but a further development of traditional principles. However, it is not impossible that Codussi had been stimulated by a Tuscan journey—to Pienza, for example—to modernize the Venetian bifora. Later, in the Palazzo Loredan-Vendramin-Calergi (plate 4), Codussi abandoned the Venetian solution in favor of the Tuscan one. In S. Maria del Carmine another architect, Sebastiano Miani, attempted (between 1507 and 1514) to follow the windows of the Gothic

nave in the presbytery,[51] though without copying their forms.

In his last secular building, the palace for Andrea Loredan (now the Palazzo Vendramin-Calergi, probably begun in 1502, plate 4), Codussi again found a surprisingly new solution for the façade. Unlike the architects of the Gothic palaces, whose façades follow the outline of the building, Codussi placed a higher and wider wall in front of it. Its effect is produced by traditional Venetian polychrome stone inlay and by colonnades derived ultimately from buildings of antiquity. The capitals, identical on all three stories, are not derived from classical orders in the manner of, say, Palladio, but follow an indigenous tradition. If, however, they are compared with Cesare Cesariano's reconstruction of the Corinthian "genus"[52] or order (1521, fig. 60), it is clear that learned contemporaries could have classified the capitals of the Palazzo Loredan as Corinthian. Visitors to the city would probably have been struck first by the relationship of windows to wall, traditional in Venice, and by the façade's colorfulness.

Pilasters and columns flanking the outermost windows are arranged in pairs and are further linked on the ground and second floors by festoons under the entablature. On the first floor these festoons, which are applied to the wall, adorn the whole length of the capital zone. The areas of wall between the pilasters and columns are framed on the ground floor by a sculpted molding, while the yellowish marble slabs on the upper floor have a gray-green frame like those we know from the façades of S. Marco, S. Zaccaria, and some buildings by Pietro Lombardo. In monochrome areas Codussi used moldings, and in polychrome contexts he defined and distinguished areas by using different materials.

Contemporaries seem to have been aware of the upgrading of the ground-floor portico by the patron and the architect. No longer a mere passage to the living quarters and storerooms, it broadened towards the façade and was well lit by three large openings. The forbidding character of the porticos of the Lando-Corner-Spinelli or Zorzi palaces was abandoned, and the opening of the façade by identical windows (as in Gothic palaces earlier) could hardly be taken further. The use of the same window as in the Palazzo Lando-Corner-Spinelli leads us to suppose that some people, probably including Codussi, believed they had discovered a substitute for tracery in these bifore. This would explain the revision to the Gothic Palazzo Manolesso-Ferro, in which the modern bifore were incorporated on the first floor—but only there.

Codussi developed his style primarily by studying and adapting the Venetian architecture of the Middle Ages, but without excluding contemporary influences. His pal-

17 (*Opposite*) Mauro Codussi, façade on the Rio di Palazzo, Doge's Palace

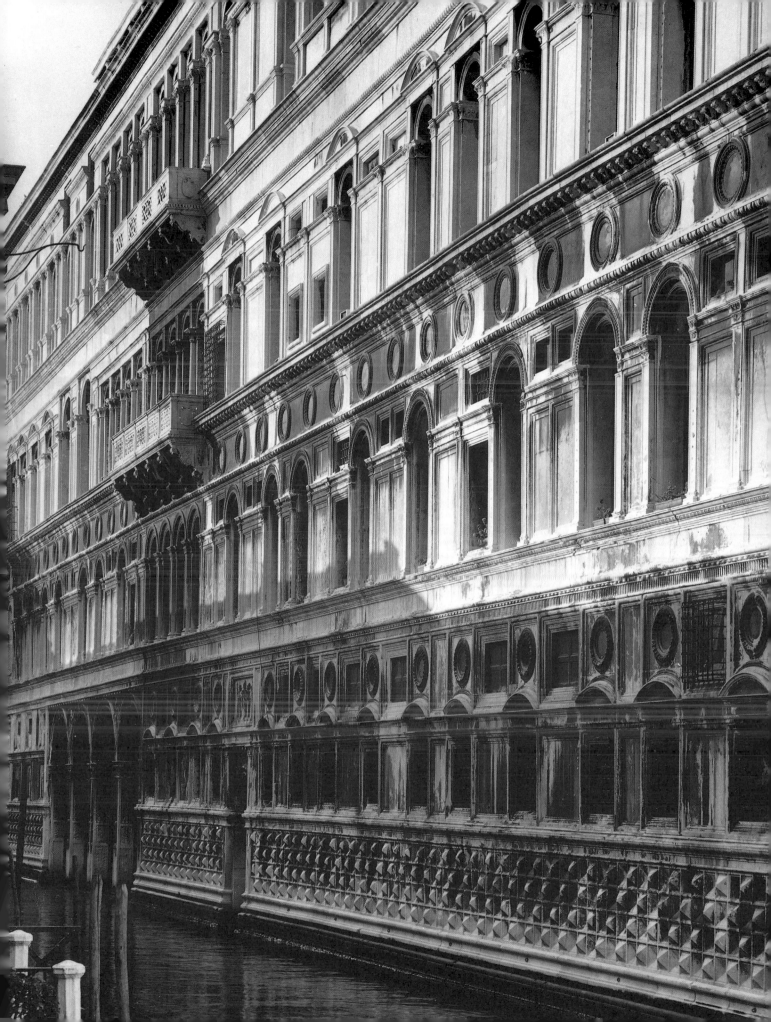

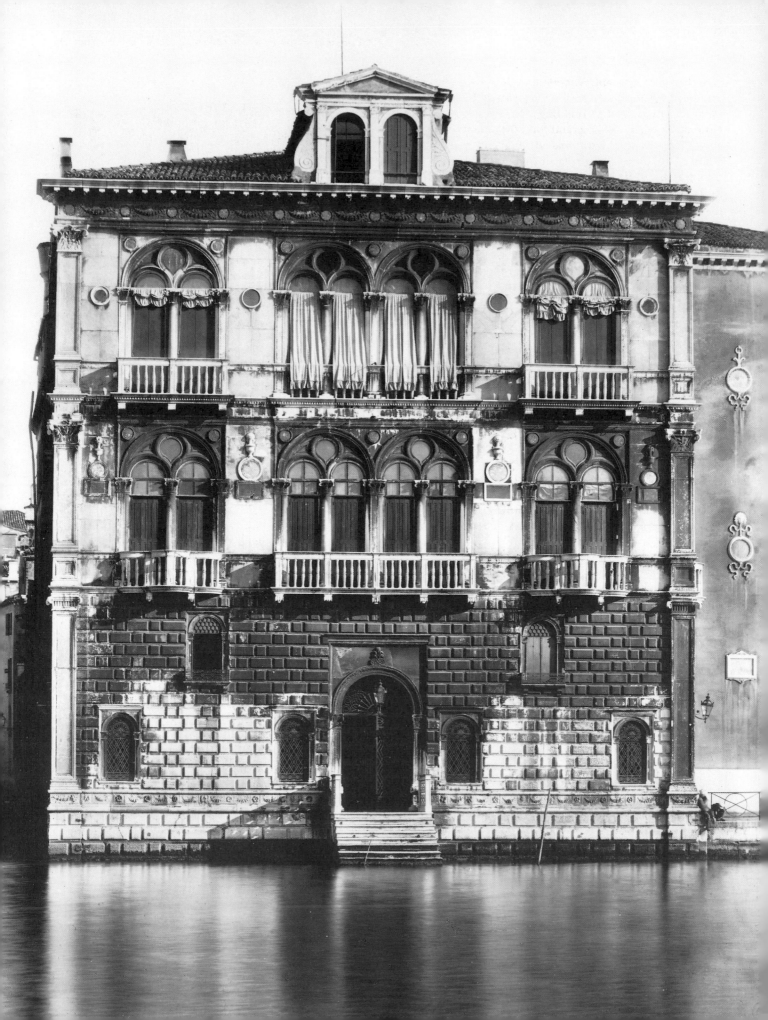

aces were recognizably Venetian, as they are today, even though their façades diverged very clearly from those of the preceding Gothic buildings. His allusions to pre-Gothic Venetian buildings and their ornamentation probably reflected the traditional attitudes of many of his clients. The Venetians' pride in their own history and a strong sense of its special character found a counterpart in these architectural works.

The Palazzo Loredan brings to an end a period marked by a few very individual solutions. The artistically outstanding palaces were created by Bartolomeo Buon, who prepared the way, and above all by Codussi. A number of very bizarre buildings were also created, like the Cà Dario, overloaded with marble, or the Palazzo Gussoni on the Rio della Fava, buildings in which the patrons' desire for magnificent ornamentation appears to have been realized without the control of an architect of any talent.

Buildings of the First Half of the Sixteenth Century

The disastrous military defeat at Agnadello in 1509 put Venice under heavy political and economic burdens. Nevertheless, palaces and churches continued to be built in the following years; the work on the Doge's Palace progressed, the restoration of the burned Procuratie (from 1512) and of the Rialto (from 1514) began at once. Nor did private building activity come to a standstill, although precise estimates of its extent are made very difficult by the absence of sound data.[53]

Unlike the situation in the years before Agnadello, when Mauro Codussi, above all, had created a series of "unique" buildings, in the two decades between Agnadello and the Peace of Bologna (1530) a certain uniformity becomes apparent in palace design. This may have been the result of a changed idea of appropriate self-aggrandizement among patrons, since in other spheres—the scuole, for example—a distinctive architectural style continued to be used confidently as an important instrument of prestige. The polemic against luxury conducted by Doge Leonardo Loredan was not, it appears, without effect.[54] The difficulty encountered by architectural historians in attributing these palaces is partly a result of this increasing uniformity of buildings. A number of them are attributed to Scarpagnino, Giovanni Buora, Bartolomeo Buon the Younger, and Sante Lombardo. But they were certainly not the only architects designing secular buildings at that time. In none of these cases has it been possible up to now to support the attribution by documentary evidence.

The strength of the adherence to traditional elements

18 (*Opposite*) Mauro Codussi, Palazzo Lando-Corner-Spinelli on the Grand Canal

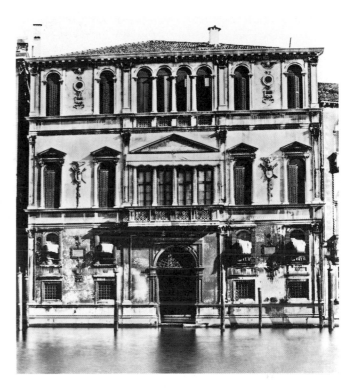

19 Palazzo Contarini delle Figure on the Grand Canal

about the end of the fifteenth century is shown by the Palazzo Contarini (S. Vio; fig. 12).[55] Pairs of narrow windows with round arches light the living rooms and storerooms situated behind the façade, the area of wall between them being about as wide as the windows. The Gothic Bernardo or Pisani-Moretta palaces are similar in the disposition of their windows, and the Contarini delle Figure and Grimani (S. Polo) palaces built at the beginning of the sixteenth century follow the same type. What is new is the extensive fenestration of the ground floor. This floor is clearly distinguished by the carefully joined facing in Istrian limestone slabs, reminiscent of ashlar, from the marble-clad upper floors, the quality and color of the marble being different on the two upper floors. The hierarchy of stories is indicated less clearly by the different proportions of windows to wall than by the ornamentation. This gives rise to a perceptible discrepancy between the use of most of the ground-floor rooms for storage and the façade treatment, which suggests a residential or administrative use, as was usual in the case of mezzanines. That the quest for an appropriate solution to a changing task was a major preoccupation of architects is also shown by the Palazzo Contarini delle Figure (begun in 1504, fig. 19),[56] which has a relatively high ground floor opened at the sides by very low storeroom windows and relatively tall mezzanine windows. In this palace the anonymous architect linked the windows of rooms widely different in their uses by a common frame-

work, a solution adopted by Sansovino about the middle of the century in the Palazzo Corner della Cà Grande (fig. 42).

In Bartolomeo Buon's Cà del Duca the corners of the projecting wings were partially replaced on the ground floor by columns of classical proportions. In the Palazzo Contarini (S. Vio), as in many other buildings, the corners were finished with pilasters and a further pilaster was placed in the space between the openings of the sala and the living rooms; pilasters frame the two side sections as well as the middle part. While the façade of the late Gothic palace was broken up rhythmically by the series of openings, pilasters were now added as articulating and decorative elements. However, there was little idea of coherent "order" underlying these measures, as is shown by Codussi's Palazzo Lando-Corner-Spinelli (fig. 18), in which a pair of pilasters frames each floor, replacing the twisted ropes or colonnettes of Gothic palaces. This solution seems to have found some favor, but did not become obligatory (Palazzo Trevisan-Cappello, fig. 20, Palazzo Grimani [S. Polo], and the Palazzo Contarini delle Figure). A quite large number of architects stuck to astylar facades (Palazzo Nani, Palazzo Malipiero-Trevisan on the Campo S. Maria Formosa). Within the traditional proportions of openings to wall the architects could improvise freely. Serlio's charge[57] that the majority of the forms of ornamentation used in Venice deviated from the rules of good architecture is understandable from his viewpoint, even though he used some of them himself. Thus we find in one building different frames around identical windows, round-topped windows next to windows extended to form a rectangle, as in Gothic times (in the Palazzo Contarini [S. Vio]), round-topped windows framed by an aedicula with a triangular pediment next to round-topped windows wedged between shallow pilasters (in the Palazzo Contarini delle Figure). There are many examples of such undoctrinaire design. Decorative elements are often applied to the façade. Particularly popular were tondi with porphyry circles, placed side by side in friezes or linked in groups. Innumerable ancient columns must have been sliced up in Venice at that time. Tondi on façades had a long tradition in Venice, so that here too the harking back to pre-Gothic architecture is obvious. Whether the choice of porphyry was also meant to make a nonaesthetic statement about the rank of the occupants is not clear from the written sources.

In a number of outstanding buildings like the Palazzo Contarini delle Figure, reliefs were mounted in the spaces between windows: trophies, cartouches, or paterae seemingly hung from the wall, closely related in their motifs to book illustrations like those of the *Hypnerotomachia Polifili*. But there were also empty niches in the spaces between windows, or classicizing busts in a frieze, as in the Palazzo Malipiero-Trevisan (S. Maria Formosa),[58]

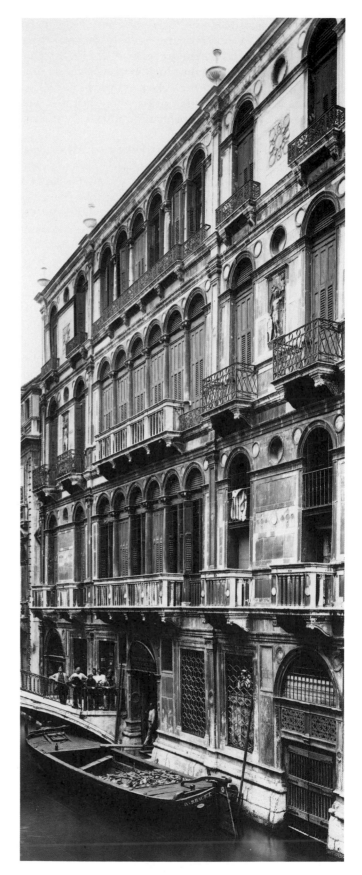

20 Palazzo Trevisan-Cappello on the Rio della Canonica

a motif that also adorns the Palazzo Contarini (S. Beneto, ca. 1560–66). However, figural sculpture is seldom found on palace façades. The trecentesque sculptures of the Palazzo Loredan and the shield-bearers dating from the late quattrocento on the Palazzo Loredan (dell'Ambasciatore) and on the Palazzo Trevisan-Cappello (fig. 20) are exceptions. Figural decoration remained, by and large, the domain of painters.

Apart from these brick-built houses faced with ashlar and marble, there were some that had their masonry covered with dazzling white *marmorino* which, if it did not abolish the difference between them and the stone façades, at least reduced it for the eye. This form of facing is documented in the written sources from 1473 on and soon after the middle of the fifteenth century was quite clearly developed as a substitute for the stone façades, which were particularly costly in Venice. Because of its great durability, Alvise Cornaro recommended *marmorino,* which he called "stucco," as a facing for a theater that he wished to build on an island between the Giudecca and the Dogana. The application of this material, which was obtained by mixing ground Istrian stone or, more rarely, powdered marble with the *intonaco,* required experienced artisans and a very careful treatment of surfaces. The result was a façade made of exceptionally long-lasting material as well as one of great beauty because of its silky surface.

Other buildings had their façades richly painted.[59] The untold losses of these paintings, so important to the image of the city and to the self-esteem of its inhabitants, make informed comment difficult. Scenes from the cycle of the Scuola Grande di S. Giovanni Evangelista show more clearly than the surviving remnants that about 1500 many sacred and profane buildings were painted with a diversity of ornamentation (plates 2, 3). However, the tradition of façade painting in Venice has its origins much earlier than the fifteenth century. In his *Memoirs* Philippe de Commynes, who visited Venice in 1494, noted a difference between "old" houses which were all (!) painted, and newer ones—he meant those built in the previous hundred years—which were clad in white "marble" and in porphyry and serpentine.[60] The costly facing of many buildings with ashlar slabs and colored *disks* in the second half of the fifteenth century should be seen against the background of painted façades.[61] The impoverishment of most Venetian façades through the almost total loss of the painting unavoidably distorts the evaluation of architectural "innovations." Commynes was not commenting as a historian, and he overlooked that even in pre-Gothic times there had been marble-faced façades in Venice, some of which have survived, though defaced by renovation in the nineteenth century. Thus, when Giorgione painted the façade of his house with figures (which were even then difficult to interpret), it was hardly a modest gesture but certainly not an exceptional event for the first decade of the sixteenth century. Ridolfi, as if to justify them, remarked in 1648 on the practice at that time of painting the houses of eminent citizens *per pompa.*

This work brought in further commissions to Giorgione. He modernized the Gothic façade of the Palazzo Soranzo on the Campo S. Polo with friezes of putti and narrative pictures (*istorie*). At that time modernization was an important task not only for painters but often for architects as well. Codussi's façade for the Palazzo Zorzi is only one example. In the seventh book of his architectural treatise Sebastiano Serlio offered recipes for modernization. It would probably be an oversimplification to stress with Ridolfi that façade paintings were cheaper and therefore less prestigious than stone facing. After all, they gave an opportunity, within a framework of conventions, to make statements about the occupants, their origins, and their ideals, the latter by means of allegories. Serlio (1537) left it to the patron to decide whether to have the embellishment executed in (expensive) stone or in painting as imitation of stone.[62] Dolce (1557) upheld façade paintings by an experienced painter against polychrome or gilded marble facing.[63] At that time, after the mid-sixteenth century, marble facing had finally gone out of fashion. Here too a few exceptions, like the Palazzo Contarini (S. Beneto), prove the rule.

Exceptionally well known is the prehistory of the painting of the Fondaco dei Tedeschi, the German commercial center at Rialto. The senate had decreed that neither marble nor stone openwork (*trafori*) could be used on the façades. Instead, Giorgione and Titian were commissioned to provide paintings, which must have transformed the building into a breathtaking spectacle. In the face of such painting, the architecture receded into the background; the proportions of windows to wall were changed, painted niches and friezes peopled by more-than-life-size figures being the preponderant elements; features of contemporary "stone" architecture are lacking. In the sixteenth century painters and architects went entirely separate ways. In 1537 Serlio described the irresolvable contrasts between painted ornamentation and the architecture supporting it and, as usual, was not sparing with advice. He writes,

> If a façade is to be painted, openings that simulate the air are inappropriate, as are landscapes. Both undermine the building. They change it, transforming a firm, corporeal edifice into something transparent and insubstantial, as if it were incomplete or a ruin. It is equally inadvisable to depict persons or animals in paint unless they are placed in a simulated window. But one should take care that these people appear calm, not agitated. The same applies to the depiction of animals. If the patron or painter wishes to take pleasure in beautiful colors, they can simulate tapestries—removable objects—hanging on the wall. On these fictive tapestries they can paint whatever they please. In this way the painter

will not destroy the order of the building, imitating reality while preserving the building's decorum.[64]

The interior decoration of the Venetian palaces of the second half of the fifteenth and the first decades of the sixteenth century has been little investigated. Almost all the painted decorations have been lost, but if even the Benedictines of S. Giorgio had a frieze of grotesques painted in their dormitory in 1507,[65] some of the palaces are sure to have had similar modern ornamentation. In some rooms in the Doge's Palace (ca. 1490–1500) the magnificent chimney-pieces, which can be documented as the product of the Lombardi's workshop, are still in their original places.[66] The sculptors chose classicizing scrolls of the kind familiar to us from column entablatures, but they also included as yet undeciphered scenes with putti that, like the closely related drawings by Marco Zoppo, go back to ancient sources.[67] Perhaps the Lomabardi had acquired graphic material left behind by Zoppo.

A number of splendid carved wooden ceilings are preserved in the Doge's Palace (fig. 21).[68] One of these, in the Sala dell'Udienza, was chosen in 1497 by the monks of S. Antonio in Padua as the model for the ceiling of the Cappella dell'Arca.[69] Similar ceilings have not been

21 Doge's Palace, Sala Erizzo, wood ceiling

preserved in private palaces, but still adorn the Scuola Grande di S. Marco. It is not known whether the wood-carvers mentioned by name in several documents worked to their own designs or those of others. Gilded rosettes and bosses on a blue background are arranged on the ceilings of the Doge's Palace in patterns similar to those on the vaulting of the mausoleum of the Galla Placidia in Ravenna. The heterogeneous quality of Venetian architecture in the period before Sansovino is apparent from the different sources of architecture and interior decoration of the Doge's Palace.

It might be supposed that the transfer of Jacopo Sansovino (1527) and Sebastiano Serlio (1528) from Rome to Venice would have been a turning point in the history of the Venetian palace. Although it appears that Serlio did not realize any of his own designs, the woodcuts and texts in his Fourth Book, published in 1537, had a broad influence on architects and patrons.[70]

Before his Palazzo Dolfin (built about 1540) Sansovino does not seem to have received any commissions for palaces, if one disregards the hypothetical attribution of a design for the Palazzo Corner (Cà del Duca), begun by Bartolomeo Buon. It was with public buildings like the Forte di S. Andrea, the Zecca (mint), the Libreria, and the Loggetta that a new architectural language based on Roman buildings was inaugurated in Venice after 1535. These were preceded on the mainland by buildings by Giovanni Maria Falconetto (above all in Padua) and Michele Sanmicheli (Verona). While the clients, architects, and dates of almost all the public buildings are known, the names of the architects of most Venetian palaces have not been recorded, and hardly a single building can be exactly dated. With a few exceptions, private building in the sixteenth century is still terra incognita. We are aware of a few outstanding palaces by Sansovino and Sanmicheli, but the roles of Bartolomeo Buon the Younger, of Tullio Lombardo, Scarpagnino, Sante Lombardo, Guglielmo de' Grigi and his son Giangiacomo in Venetian civic architecture still need to be established.

It is hardly conceivable that Serlio did not attempt in his Venetian years to translate his experiences of central Italy, primarily Rome, into buildings. As early as 1528, in collaboration with the engraver Agostino Veneziano, he published a series of architectural details (fig. 22),[71] which are sure to have appealed to collectors with antiquarian interests but had little that was really new to offer to Venetian architects and stonemasons, as can be seen from entablatures by Pietro Lombardo. Serlio's designs for interior decoration were probably more highly thought of than the ones for buildings, as is shown by the commissions for the immense wooden ceiling of the Sala dello Scrutinio, embellished with canvases by Pordenone, in the Doge's Palace (burned in 1577), and for a wooden ceiling in the Scuola Grande di S. Rocco (before 1535).[72]

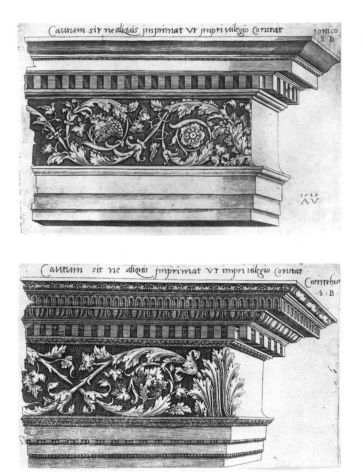

22 Sebastiano Serlio, Ionic and Corinthian entablature (1528)

Serlio realized that Venetian patrons attached great importance to tradition. His attempt to impress his merits on them with designs for palaces in the Venetian manner ("al costume di Venetia," fig. 23 a–c), misfired. His references to very simple, numerical proportions suggest that he was attempting to impose rules on the unruly growth of building in Venice, and at the same time to offer a remedy. What is Venetian in his drawings is the disposition of rooms, the use of the ground floor for storerooms and mezzanines, and the fact that the arrangement of the rooms, and particularly the size of the sala, could be read from the façade. What was new was the Serlian arch, or serliana, in front of the sala, a brilliant solution to a problem that the architect of the Palazzo Contarini delle Figure had labored in vain to solve. Because of the amount of light it let through and its ability to be easily adapted to openings of different proportions, this arrangement of windows was an ideal substitute for Gothic tracery, which could form a single tableau and be adapted to any end wall of a sala. With the rectangular framing of his round-arched windows on the second floor, Serlio followed Venetian traditions.

Serlio also expressed strong views on the Venetian balconies; he eloquently praised their usefulness while damning them because they jutted from the façades in a way the ancients, he alleged, would never have tolerated.[73] Not long after, Alvise Cornaro supported in his architectural treatise Serlio's judgment.[74] All the same, both were well aware that most Venetian patrons would never relinquish the opportunity balconies gave of observing the goings-on in front of their houses, taking the air, and being seen. Serlio designed a palace with a rusticated socle that (like that of the Roman Palazzo Caffarelli-Vidoni by Lorenzetti) was broader than the first floor by the depth of the indispensable balcony. Furthermore—in another innovation that had no success—he used a sharply projecting central bay as wide as the sala and rising only as high as the first floor. The rest of the façade was without projections or angulations.

The wood engravers who reproduced Serlio's drawings for publication did not always have the necessary architectural knowledge. However, some of the details deserve attention. The *ornamenti,* according to Serlio, could be made of marble or stone when not simulated in paint. They appear to include, in the surrounds of the round windows of one design (fig. 23b), veined marble that is distinct from the evenly hatched areas of the wall. These panels were seen by contemporaries as projecting, as is shown by numerous examples from the following decades, including the Palazzo Coccina (fig. 54).

In the spring of 1541 Serlio left Venice—probably in resignation—to seek new commissions in France. In his Sixth Book, written in France between 1541 and 1545 and never published by Serlio, there are two further designs for Venetian palaces, perhaps conceived in Venice, which give an idea of the kinds of solutions being discussed at the time. The portico, sala, and courtyard are the predominant motifs, Serlio ranking the traditional layout lower than one with a courtyard. In a further design *alla veneziana* (fig. 23d) he reverted to the old-fashioned T-shaped sala (*in crocciola*) on the grounds that unless widened in this way the sala would seem too long. To improve the lighting of the adjacent rooms he provided two courtyards within the building beside the portico and the sala above it, as Bartolomeo Buon had done in his Palazzo Corner (Cà del Duca). Running symmetrically round the courtyards are two external staircases, although their connection with the wall elevation of the living rooms was badly worked out, as Serlio himself conceded.

The main façade no longer coincides exactly with the arrangement of rooms behind it, as was normal in Venice at the time, the serliana being related to the middle part of the sala while the two adjacent windows light the two arms of the T. It is not surprising that Serlio could make no headway in Venice with patchwork designs of this

DELL'ORDINE CORINTHIO

a

b

c

d

23 Sebastiano Serlio, designs for Venetian palaces. a–c) Fourth Book (1537), d) Sixth Book

kind. Even the many designs he offered for rooms unusual in Venice—"for baths and chapels, a *studiolo,* and for other purposes"—brought little success.

Serlio's *alla veneziana* designs were studied with interest in Venice but never built. Sanmicheli used the serliana in his Venetian palaces, and this together with the projecting stone panels soon became part of the Venetian tradition. In his dealings with Venetian patrons and artists Serlio undoubtedly passed on ideas and information that were incorporated into designs. The Palazzo Zen (fig. 24), which is given a rather ludicrous aspect by the citation of Gothic window frames in the context of a Renaissance façade, is one of the buildings on which Serlio supposedly had an advisory function. His contribution to palace building in Renaissance Venice was consequently more influential, despite his professional misfortune, than that of Sansovino, whose buildings did not find imitators until the baroque period, above all in the works of Baldassare Longhena.

Public Buildings

The Venetian state, represented by its various councils and governing bodies, constantly provided its architects with important commissions. These included—to name only the foremost—the Doge's Palace, the Fondaco dei Tedeschi, the Procuratie Vecchie, numerous buildings on the Rialto including the splendid office of the city treasurers (*camerlenghi*), the clock tower, the Zecca, the Libreria (which included the offices of the procurators), the Loggetta, as well as the Forte di S. Andrea, "industrial" architecture in the Arsenal, the prisons, the Rialto Bridge, and the Procuratie Nuove. There were also anonymous commissions no less important for the outward appearance and functioning of civic life, like the provision of bridges, wells, canals, and streets, which was entrusted to special magistrates or supervised by them. Finally, civil engineering works like the regulation of the rivers flowing into the lagoon tied up substantial sums. In

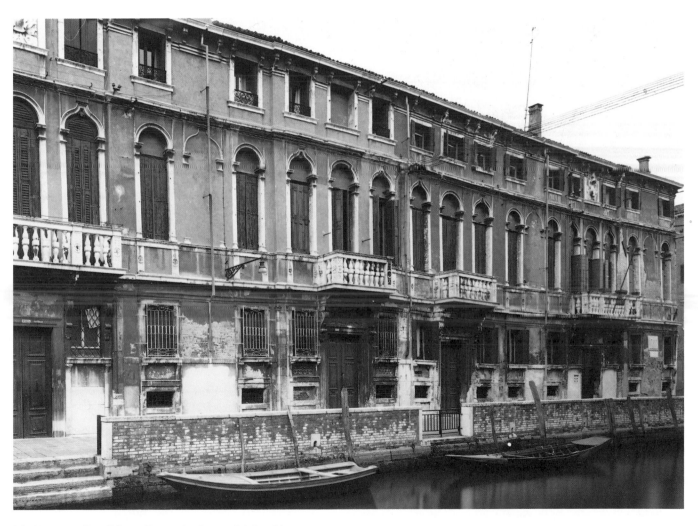

24 Francesco Zen, Palazzo Zen on the Campo dei Gesuiti

these areas too, architects could participate as engineers. On account of his successful regulation of the Brenta, Fra Giocondo was acclaimed by Vasari[75] as Venice's second founder.

The buildings financed by the state cannot, however, be considered merely against the background of private or ecclesiastical building activities. The *cittadini,* influential citizens not belonging to the "closed" aristocracy, had organized themselves into confraternities (*scuole*) which generated building activity, sometimes at a hectic pace. Thus we can frequently observe interaction between the confraternities' building projects and those of the aristocratically governed state.

The extent to which the preexisting urban structure could influence a building is shown by the Fondaco della Farina, built in 1493 as the seat of the Magistratura del Fondaco della Farina and adjoining the gigantic granaries close to the Piazza S. Marco.[76] The ground-floor portico, uncommon in Venice and closed off today, incorporated a public footpath.

Far more difficult was the erection of the German trade center built at the expense of the Venetian state, the Fondaco dei Tedeschi on the Rialto.[77] Its planning probably bore the mark of the emphatically stated wishes of its future users, and indeed, an architect from Germany named Hieronymus (whose portrait appears in Dürer's *Madonna of the Rose Garlands* for the church of S. Bartolomeo) was involved in the planning. In 1505 his project was chosen from several models by the senate; however, the building, in the present rather purified appearance of its exterior and its courtyard, reveals no trans-Alpine elements. Everything is kept within the simple Venetian forms, only the projecting wings of the Grand Canal façade, originally emphasized by lateral turrets, being prominent, though not new in Venice at the time. The German architect's role was probably confined to specifying the wishes of the future occupants as regards the layout of the smaller apartments, numbering about seventy-six.

The ever-reliable Sanudo mentions a model for the same building by Giorgio Spavento. Since 1486, Spavento had been the architect of the influential Procuratori di Supra; in 1489 he had produced a model for the top of the Campanile, in 1501 for the Rialto, and soon after, shortly before his death in 1509, he was to draw up the plan of S. Salvatore. Since a contemporary source also mentions the architect Scarpagnino in connection with the Fondaco, the following seems a likely hypothesis: Hieronymus designed the building in collaboration with Spavento, while Scarpagnino was responsible for the practical execution.[78] The organization of the trading houses referred to by the Arabian *funduk* may have been taken over with this term, but as residential apartments were included in the building, the architectural elements of the Fondaco dei Tedeschi cannot be traced di-

rectly to Alexandria, for example. The courtyard, with its arcades and several floors, may well have been a part of the preceding building, as Jacopo de' Barberi's bird's-eye view of 1500 (fig. 25) suggests.[79] On the ground floor, as in the public buildings of Rialto and the Piazza, there were shops rented to Venetians. This assured an optimal use of space and a suitable return for the republic.

One of the functions of the Fondaco dei Tedeschi was to accommodate a large number of often eminent people in a single building for long periods. This would be consonant with their status and with Venetian interests. In its row housing Venice already had a long tradition of buildings of this kind. However, the extremely confined dimensions of the apartments did not follow normal Venetian practice.

A residential building with especially impressive architectural qualities is the Procuratie Vecchie on the Piazza S. Marco (begun in 1512, fig. 75).[80] Behind a uniform façade, above the shops on the ground floor, apartments with individual entrances were concealed, in one of which lived Jacopo Sansovino. Privacy was guaranteed by individual staircases. The designer of the building has not yet been identified. In contrast to the situation with most Venetian buildings of these years, too many names are recorded: a Tuscan, Giovanni Celestro (for a *modello*), Bartolomeo Buon the Younger, and Guglielmo de' Grigi are mentioned in documents. The architect was subject to preconditions that seriously restricted his freedom. A part of the commission appears to have been to provide a replacement for (and almost a copy of) the dilapidated twelfth-century façade (fig. 26), a condition that seems to owe much to the influence of Procurator Antonio Grimani (doge from 1521 to 1523). The adding of a story to the building and its modernization did not change the north side of the Piazza to a significant extent, as the loggias were preserved as part of a covered way around the square and the wall remained unbroken.

However, in erecting the clock tower about the end of the century (it was completed in 1499), the Serenissima Signoria had already brought about a considerable change to the appearance of the Piazza. In 1581 Francesco Sansovino compared the tower, with some restrictions, to a town gateway, though without meaning to imply a separation of the Piazza from the city. Town gates contradicted the Venetians' image of themselves, according to which only the lagoon served as a gateless "salty wall" to their city. From the start the clock tower had had other functions besides housing a sophisticated clock:[81] it marked the entrance to an important street, the Merceria; it could carry pictures (including the portrait of Doge Agostino Barbarigo kneeling before the lion of St. Mark),[82] and it was a landmark for people entering the Piazza from the colonnades.

When this building was put up the Piazza was still paved (40 cm lower than at present) in rust-colored

brick, divided into rectangular fields by narrow-looking strips of Istrian stone. A similar herringbone pattern of brick is still to be found in the squares in front of the Scuola Vecchia della Misericordia and the Madonna dell'Orto. The building's effect on this rust-red ground was incomparably more vivid than on the grey paving that dates from 1732. A chronicler has given a striking description of the paving of the Piazza, which was renewed in 1494 on the old pattern: "These brick squares made a fine spectacle. As they were edged by strips of stone and were slightly raised at the center, they looked like a multitude of small hills. Of course, the unevenness was irksome underfoot, particularly on a leisurely stroll." [83] But it is not only by the changed paving that the Piazza has been impoverished since the sixteenth century. At that time, like the Venetian campi, it contained two wellheads, although the badly polluted water was a constant source of hygiene problems.

In 1512 there had been a fire at the Procuratie Vecchie building, and in 1514 almost the entire "island" of the Rialto burned down, causing serious difficulties for Venetian trade and placing a further financial burden on a republic shaken by wars. Since only the palace of the city treasurers, the *camerlenghi*,[84] and the *Razon nuove,* the audit office, had survived the blaze, there was a theoretical possibility of reconstructing the entire district.[85] However, there was no unanimity regarding the goals of reconstruction—how else were such controversial projects as those of Fra Giacondo and Scarpagnino to be explained? The competition announced soon after the fire, in which ten architects including Giovanni Celestro and Alessandro Leopardi took part, yielded no acceptable result, so that the senate finally took control of the whole affair and decided a few days later to rebuild on the old foundations to Scarpagnino's designs. Responsibility for the execution was given to a specially constituted board, the Provveditori sopra la Fabbrica di Rialto. This decision reflected commercial sense as well as Venetian tradition. The reuse of the foundations was an obvious solution if time-consuming and expensive

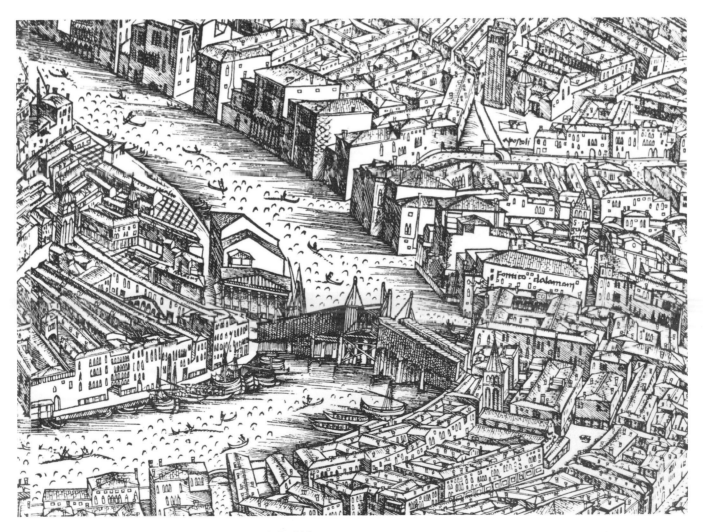

25 Jacopo de' Barbari, view of the city in 1500, detail, the Rialto area

groundwork was to be avoided, while property relations would remain almost unaffected, speeding up the process of reconstruction. Finally, the decision went against a project submitted by someone not residing in Venice who paid scant attention to local conditions, as Sanudo pointed out in a lapidary comment. Vasari on the other hand, no less partisan in his views, found none but scathing words for Scarpagnino's reconstruction.

Scarpagnino's primary achievement lay in the optimal use of traditional infrastructures, streets, and campi. His buildings are sparsely ornamented, though suited in their dimensions to the needs of the occupants: shops on the ground floor, storerooms on the first floor. Fra Giocondo, by contrast, had proposed a large square, with two rows of buildings flanking a shopping street lined with loggias. At the center of the complex he wanted to rebuild the church of S. Matteo. Finally, the whole area was to be set far back from the adjoining canals, so as to leave spaces on all sides that could be used for loading and unloading

boats. One can hardly believe that as experienced a man as Fra Giocondo could have seriously expected to revolutionize Venetian building practice in such a fundamental way. His design has a utopian and polemical character, comparable in this to Andrea Palladio's Rialto and Venetian palace designs, which likewise went unrealized.

When in 1529 Jacopo Sansovino took up his prestigious office as architect to the procurators responsible for S. Marco (Procuratori de Supra), the Piazza presented an "untidy" picture (fig. 26).[86] In several buildings opposite the Doge's Palace there were taverns and butchers' shops, the two monumental columns were disfigured by booths, and the south front of the Piazza was made up of an agglomerate of buildings of diverse periods and uses. The hospice founded by Doge Orseolo, shops, and administrative rooms of the procurators were housed behind a single facade. On the west side of the Piazza rose the Gothic façade of the parish church of S. Geminiano, while the north side had long been occupied by build-

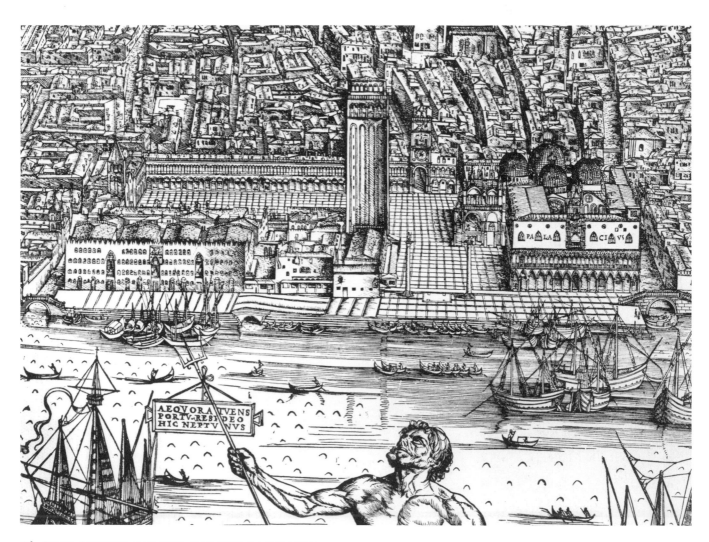

26 Jacopo de' Barbari, view of the city in 1500, detail, the Piazza

27 Jacopo Sansovino, Zecca

28 Jacopo Sansovino, Zecca, courtyard

ings. Next to the clock tower with its two annexes the old (then still new) Procuratie had been under construction since 1514 under the direction of Bartolomeo Buon the Younger, while the present-day Piazzetta dei Leoncini (then facing the parish church of S. Basso) looked as it does in the picture by Gentile Bellini.

The prospects for urban reorganization were particularly good in this area. Comprehensive planning was possible because the procurators could make decisions as sole owners; their initial difficulties with the authorities responsible for the Zecca, the Provveditori della Zecca, were regarding the traditional rights over the shops, which are still to be found in situ. These difficulties were solved by a compromise that proved elegant rather than durable.

It is not known when the procurators decided to entrust Sansovino with the design of their new administrative building, which was also to house the state library and an elite school. The available records suggest a possibility that the state, represented by the Provveditori della Zecca, took the initiative with plans for the rebuilding of the Zecca (1535, figs. 27, 28). The Zecca, the Libreria, and the Loggetta, built by Sansovino under the auspices of the procurators, were part of a more compre-

hensive plan of which Sansovino was to be the author. Manfredi (1602) records that the procurators and Sansovino planned to put modern buildings on all three sides of the Piazza, taking the basic elements of the façade of the Libreria as a model. This would have involved the demolition of the still unfinished Procuratie Vecchie, and the result would have been a unified design for the square that recalled ancient forums more strongly than at present. Whether such considerations already played a part in the design of the Zecca is not known. Shortly afterwards, Sansovino began building the Libreria, the alignment of which allowed it to be extended as far as the façade of the Zecca, but the unharmonious conjunction of the two façades makes it clear that Sansovino did not take the consequences seriously.

The Zecca's position near the center of government on the Piazza was expressly described as desirable by Daniele Barbaro in his commentary on Vitruvius (1567).[87] The furnaces needed for the production of coins and medals prohibited the use of wood in the construction, a circumstance that Sansovino took advantage of in providing stone vaulting and richly carved ceilings. Entering the building from the Piazzetta or the narrow canal on the opposite side, one reaches the interior via a vaulted corridor with entirely rusticated walls. From one side of it broad staircases lead off in opposite directions to the first floor, while an arcaded courtyard rusticated on the ground floor opens on the other side, originally adorned by a beautiful well with a sculpture of Apollo (now in the courtyward of the Cà Pesaro) by Danese Cattaneo. This courtyard may have shown many a potential patron how imposing a courtyard *alla romana* could look within a palace.

In the façade there is a marked difference between the rusticated ground floor, which originally accommodated shops, and the Doric first floor (the second floor was added later). Rusticated columns press against their frames, and the windows seem wedged in. In its deliberate use of such contrasts, Sansovino's project is related to Michelangelo's staircase for the Biblioteca Laurenziana in Florence. A diagonal view of the building, which originally was not quite so exposed as at present, shows a facade conceived as a tableau, something familiar to us from earlier Venetian palaces such as Palazzo Loredan (Vendramin-Calergi).

Soon after work started on the Zecca, Sansovino designed the Libreria[88] for the procurators (fig. 29). This building housed not only the procurators' administrative offices but the state library and an aristocratic school. In accommodating various institutions behind a unified façade, the procurators followed the tradition of communal palaces.

Sansovino was able to arouse interest by an "academic" discussion of the construction of the corners of his building, showing off his intellectual powers by a "sensational" solution to an age-old problem. The problem arose from the position of the triglyphs of the Doric order. Sansovino widened the pier, put a pilaster in front of it, and so gained the possibility of having a triglyph above the final Doric capital and a split metope on the corner. It was a clever solution but somewhat "impure" as regards details, particularly at the pier's base, but it was tolerable in unorthodox Venice. With it Sansovino prepared the way for similarly undogmatic corner solutions of palaces and public buildings (such as the *prigioni*), which delighted the eye but often confused the intellect.

In 1570 Palladio described the Libreria, perhaps not uncritically, as the most ornate building in Italy, thereby stressing one of its essential features. The facade, influenced by ancient models like the Theater of Marcellus in Rome, is enriched by the windows and by fluted, freestanding Ionic columns set one behind the other, the façade relief looking particularly dense in this area. Viewed from the side, for example from S. Marco, the columns and the straight entablature are the dominant elements. The vaulting of the ground-floor portico is also richly adorned.[89] The decorative system that Sansovino evolved here, with linked "communicating" frames, was subsequently taken up by numerous Venetian architects, sculptors, and decorators. The same system, enriched with stucco figures and ornamentation by Alessandro Vittoria as well as paintings by Battista Franco, adorns the imposing staircase of the procurators' offices, the school, and the library under construction from 1555. This ceremonial treatment of the entrance to the official residence of the influential procurators was taken as a challenge by the Venetian government, for as early as 1556 the same team of decorators was commissioned to produce a show staircase for the Doge's Palace, the Scala d'Oro, which resembles the procurators' staircase in its style of decoration. However, Sansovino's staircase for the Libreria, with its landings surmounted by cupolas and in the positioning of its columns at the openings, is architectually far superior to the Scala d'Oro of the Doge's Palace.

The rich ornamentation of the façade increases towards the top. In the frieze of the Ionic entablature, putti swirl as in a dance while holding heavy festoons of fruit. Similar motifs had been used previously by Sansovino in the courtyard of the Palazzo Gaddi (ca. 1518) and by Baldassare Peruzzi in the Farnesina (both in Rome). The balconies, rented at a high price when there were festivities in the Piazzetta, would have delighted Serlio, since Sansovino supported them directly (in the style of Bramante and Raphael) on the Doric entablature. The balustrade crowning the building, with its ornamental sculptures, looks like a "reply" to the crenellations of the Doge's Pal-

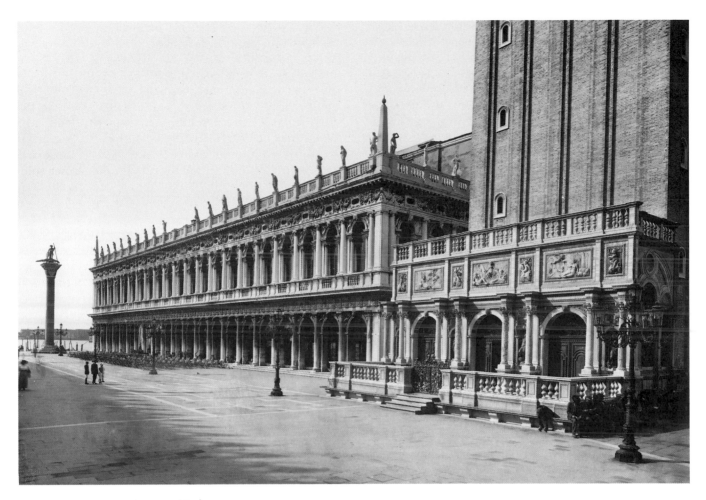

29 Jacopo Sansovino, Libreria and Loggetta

ace, the obelisks being perhaps intended to signal to the educated that the "fame of princes" should be seen in conjunction with their building activities.[90]

The redesigning of the Piazza made a replacement of the old Loggia at the foot of the Campanile inevitable. In this Procurator Antonio Cappello seems to have been the driving force, although at first the building of new shops was also entertained. There were models in Venice for the function of Sansovino's Loggetta (fig. 29). Not only the old Campanile loggia but also the one at the Rialto (fig. 25; burned in 1514) was reserved for Venetian aristocrats, and even the loggia of S. Basso[91] (demolished in 1568), facing the north side of S. Marco, served at least for a time as a meeting place for the aristocrats. Isolated from the bustle in the Piazza, with five steps leading up to it and with ornamental figures relating to the state and its government, Sansovino's Loggetta demonstrated the self-confidence of the ruling class. His design was impaired by alterations, however. The original gradation of the attic linked the Loggetta better to the sheer wall of the Campanile, while now the projecting terrace distorts the

façade. The side fronts, originally simpler in treatment, were considerably altered during rebuilding in 1903.[92]

Sansovino placed freestanding composite columns in front of pilasters, putting niches for his bronze figures and reliefs in the spaces between them. Freestanding columns in front of pilasters had been found previously not only in classical structures like the Arch of Constantine and the Arch of Septimius Severus but, since 1536, in the façade of the Scuola Grande di S. Rocco (fig. 92). The interlocking moldings were familiar in Venice since the time of Codussi, and the niches of the bronze figures are composed of multicolored marble (figs. 144, 145). Sansovino's decision in favor of a polychrome architecture may have been influenced by the relation of the building to the Doge's Palace and to the Porta della Carta.

It is possible that Sansovino also wanted to allude to ancient triumphal arches. Vasari described the temporary façade of Florence Cathedral, which Sansovino designed and which must have resembled our Loggia in many respects, as being "in the manner of a triumphal arch." If a triumphal mood is detectable in the sculpture

program of the Loggia, it does not constitute its essence. Harmony, wisdom, and concord among the rulers, the love of peace, and the eloquence needed to promote beneficent ideas are some of the themes incorporated in Sansovino's figures. The conditions necessary to the existence of the unique state of Venice and allusions to its territorial claims are at the center of a pictorial program that can only be deciphered with the help of contemporary sources.

Shortly before his death, the ambitious Doge Andrea Gritti (1523–38) seems to have taken up a plan, already discussed in 1478, to build himself a palace next to the Doge's Palace as if he were an absolute ruler.[93] There are references to designs, and the possibility cannot be ruled out that Jacopo Sansovino found himself with another important project at this time.

In the same years the citizens of Venice began to think seriously about fortifying their city against attack.[94] The fortification of the subject cities on the mainland was well advanced, as can be seen from the architecturally distinguished town gates of Padua, Treviso, and Verona. In 1536 Francesco Maria della Rovere, the *capitano generale* of the Serenissima, drew up a detailed report

that pronounced a negative judgment on Michele Sanmicheli's plan to erect two citidals (*fortezze*) at the entrance to the lagoon opposite S. Niccolò. They were militarily useless, he argued, as well as inappropriate in a city with Venice's reputation and freedom. Francesco Maria della Rovere saw citadels as contradicting the spirit of the republic, as symbols of an authoritarian regime and an opportunity to put tyrannical intentions into practice. The Fortezza da Basso in Florence, created for the tyrant Duke Alessandro de' Medici, was designed to protect the ruler from his subjects and was therefore a negative example in Venice. Instead, della Rovere recommended a construction that in its strength would meet the requirements of defense and in its weakness reflect the peaceful life of the republic. In 1543 work started, based on revised plans by Michele Sanmicheli (fig. 30) for a building that was open and vulnerable on the town side but presented a martial, rusticated façade to those approaching from the sea. While the question of functional but ideologically acceptable fortifications was being discussed, the Arsenal near S. Maria della Celestia was enlarged in 1535 and, in 1539, secured by high walls from indiscreet eyes. The concern about spies came to

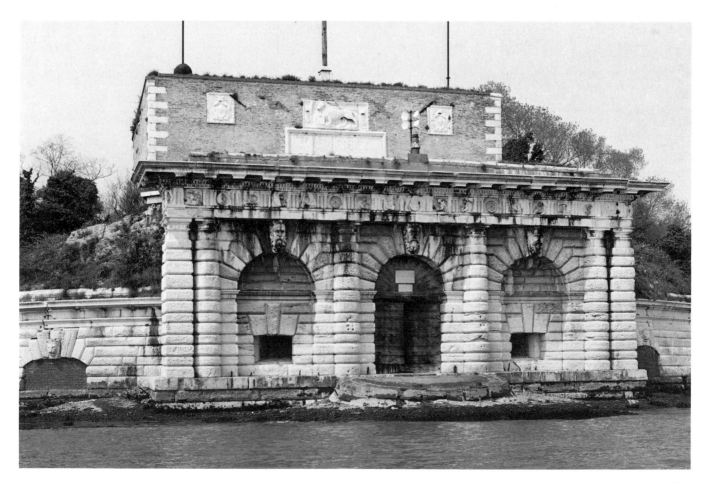

30 Michele Sanmicheli, Forte di S. Andrea, middle part of the façade

31 Arsenal, shipyard "alla Gagiandra"

32 Arsenal, ropewalk (Corderie della Tana), as it was in the nineteenth century

a head in 1581 with the decision to brick up the openings facing the Arsenal in the belfry of the campanile of S. Francesco della Vigna, which had just been completed.

Among the outstanding buildings of the sixteenth century to be found in the Arsenal are the shipyard (completed 1574) for several large galleys with its sturdy, very Gothic-looking pillars and low capitals (the so-called Gagiandra, fig. 31) and the hall, 316 meters long and designed by Antonio da Ponte, for rope making, the Corderie della Tana (1578ff.; fig. 32).[95]

Apart from the buildings for institutions in the Piazza and Rialto areas, the authorities were constantly concerned with town-planning decisions. Some were seriously based on actual needs, like the plan by Sabbadino of 1557 already discussed, and some were utopian, like that of Alvise Cornaro (ca. 1560).[96] Cornaro played with the idea of completely restructuring the area between the Piazza, S. Giorgio, and the Giudecca, which had grown over the centuries. His project was probably no more intended to be put into practice than Fra Giocondo's Rialto project, being rather a form of critical and even polemical debate with Sansovino's modernization of the public area around the Piazza.

Alvise Cornaro proposed that a theater be built on an island between the Dogana and Giudecca and that a tree-covered artificial hill should be created between S. Giorgio and S. Marco. On it there should be promenades, a fountain with drinking water, and at the summit a loggia open on all sides (one is reminded of Palladio's Villa Rotonda). Thus one would be able to take in—in a single view from the Piazza, which would also have a drinking fountain—the fountain, the hill, the theater, and the ships coming into port; a more enticing spectacle, he maintained, could not be imagined. He also proposed that Venice be surrounded by suitable fortifications and gates, these being placed in the lagoon about seven hundred meters from the city. Within these walls, about seventy meters out, a canal should be dug, the dredged material being used to form new terrain which could be planted with trees and used for picnics.[97]

Cornaro's vision remained what it probably always was: a provocation, from which those responsible for building and planning could pass unhindered to more pressing matters. These included neither a theater nor an artificial hill with promenades and loggia, but practical buildings on the Rialto like the bridge, the construction

33 Antonio da Ponte, prison

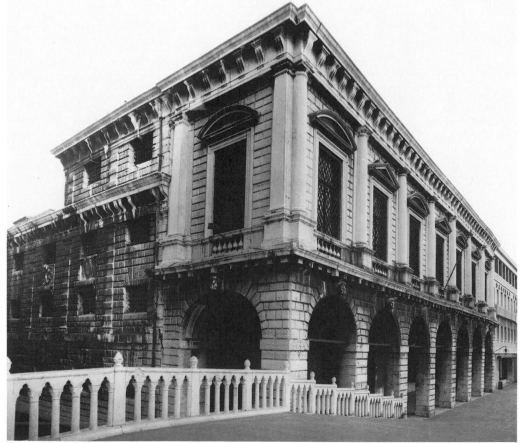

of *fabbriche nuove* to plans by Sansovino (begun in 1552), the improvement of the street network, and—not least—the prison (fig. 33).[98]

Before the new building was completed (initial planning stage in 1563, construction started in 1591), cells for prisoners were on the ground floor of the Doge's Palace, among other places. The decision to erect a special building next to the Doge's Palace corresponded to the suggestions of both Vitruvius and Andrea Palladio (in his *Quattro Libri* 1570).[99] In fact Palladio, probably basing himself on Vitruvius, wrote that prisons should be placed next to the ruler's palace and as a pendant to the mint. The decision in favor of this prominent position in the city's façade was probably part of a building program that took the classical forum as a model.

The cells of the prison are arranged around a courtyard in a way that met Palladio's demand for healthy accommodation of prisoners by the standards of the day.[100] In the front part of the building, clearly divided from the cell section, were the offices of a kind of police, the Signori di Notte, and a chapel. While the rusticated façade designed by Antonio da Ponte, with its severe-looking Doric order, gives an idea of the building's function by the heavy gratings in front of the windows, its form is not governed by its function in the sense of *architecture parlante*. To be aware of this, it is enough to look at the side of the building or to enter the courtyard. Here, Cyclopean blocks of stone and tiny windows speak an unmistakable language.

With the prison, the remolding of the city's nucleus was concluded for more than two centuries. Later the proportions were changed by the demolition of the granaries next to the Zecca and the new buildings put up in the last century on the Riva degli Schiavoni, as well as a poorly designed hotel (1946) next door to the prisons.

In the Renaissance many buildings serving charitable purposes were built in Venice. These *ospedali,* (some of them also called *ospizi, alberghi,* and *case*), were maintained by the state, the church, private citizens, and the scuole. They admitted old people, widows and orphans, the destitute of all ages, and, of course, the sick. There were also *ospedali* like the Incurabili, which served the same purpose as our hospitals. Almost all the *ospedali* performed more than one task at the same time, the largest of them (Pietà, Incurabili, Ospedaletto, Mendicanti) becoming true centers of social welfare. Those in need not only had a right to care in Venice, but it often seems to have been forced on them. Financing and administration varied between institutions, so that generalizations are hardly possible.[101] A specially constituted authority, the Magistratura sopra Ospitali e Luoghi Pii, supervised their activities after 1561, while the Provveditori alla Sanità took care of the various *lazzaretti*.[102] In the case of the Cà di Dio[103] designed by Jacopo Sansovino in 1545, which gave shelter to respectable widows, the Procuratori de Supra were the responsible authorities, with the doge as the patron. A small church integrated into the building was part of the complex. The inconspicuous façade looks like two palaces with a central façade section that is not at first sight recognizable as a church frontage. Inside, the rooms are grouped in wings around a courtyard.

Architecturally more ambitious was the Ospedale degli Incurabili (fig. 34),[104] which was also begun from plans by Sansovino and completed by Antonio da Ponte (1572–91). Around an almost freestanding "oval" church (finished in 1567) were the four wings of a hospital built specially for syphilis victims. The building included separate wings for men and women, an apothecary open to the public, and rooms for orphan girls, whose singing in the choir of the church was renowned. The three aisled longitudinal halls on the ground floor recall similar rooms in the scuole grandi. They too seem to have had an altar at their front wall. The low façade on the Zattere with a rusticated socle and three entrances was probably built at the beginning of the seventeenth century.

There was no uniform plan for hospitals or welfare institutions in Venice in the sixteenth century.[105] It was only with the building of the Zitelle (fig. 87; ca. 1580) on Giudecca[106] that a solution was found that was satisfactory both architecturally and functionally and paved the way for the future. Attached to the side of the church were blocks intended to accommodate beautiful and thus (according to the foundation document) especially endangered virgins. The approximation to a convent pattern was complete, at least insofar as regards the façade.

Apart from these architecturally outstanding examples there were many smaller hospices mainly in the service of Venice's exemplary care for the poor. Many had their own oratory. Some of them were distinguished by reliefs on their facades, in a manner not unlike the scuole. Many of these buildings that gave shelter to the poor were no different in type from simple apartment buildings.

Fires played an important part in the history of Venetian architecture. After the Doge's Palace had been partially burned in 1574, a catastrophic fire of 1577 destroyed the Sala del Maggior Consiglio and adjoining rooms. The damage to the fabric was considerable but not irreparable, so that the advocates of restoration defeated those who supported complete rebuilding of the palace. The contradictory conclusions reached by the many experts are characteristic of debates on the conservation of historic buildings up to our own time.[107] Giovanni Antonio Rusconi, a very experienced architect, compared the damage to a mosquito sting on an elephant. Time has proved him right. Though the lower cost may also have carried a good deal of weight, the decision to restore the building was supported by a well-informed contem-

34 Jacopo Sansovino and others, Ospedale degli Incurabili, ground plan, as it was before the partial demolition in the nineteenth century. From a drawing in the Museo Correr

porary, Girolamo Bardi,[108] on grounds of its value as a historic monument. Among those who recommended rebuilding in view of the damage was Andrea Palladio, whose standpoint was supported in the senate, predictably by Marc'Antonio Barbaro.[109] While the exterior of the building was carefully restored at once, the burnt-out rooms inside were completely refurbished or rebuilt. In restoring the façade, however, the Gothic tracery was not replaced. Thus the preponderance of the upper floor, often criticized in recent times, can be explained by the windows that look far too large and empty, detracting, as modern single-pane windows generally do in historic buildings, from the balance of Filippo Calendario's masterpiece.

After the fires of 1574 and 1577 a number of magnificent molded ceilings were installed in the Doge's Palace.[110] These were part of a tradition going back to the star-strewn ceiling of the Maggior Consiglio (about 1400), burned in 1577. After the wooden ceilings from the turn of the century (Sala degli Scarlatti, Sala Grimani, Sala Erizzo, fig. 21) influenced by antecedents in Ravenna and Rome, and the wooden ceiling by Sebastiano Serlio, based on Roman models in the Sala dello Scrutinio (finished about 1538), came Alessandro Vittoria's stucco decorations of the Scala d'Oro (1557–60). In the latter

half of the century a number of decorative ceilings were produced that are among the most splendid in Italy. The Scuola Grande di S. Rocco had set the standard in 1574 with the ceiling of its Sala del Capitolo (fig. 95). The anonymous artist had broken up the network of connected frames introduced into Venice by Sansovino, but had retained their characteristic arrangement. Scrollwork now accompanies the frames, filling the irregular spaces between them, while a delicate tapestry of ornamental painting covers the carving. We find a very familiar combination of frames and scrollwork soon after in the flat ceiling of the Sala del Collegio in the Doge's Palace.

The decoration of the shallow barrel vault of the Sala delle Quattro Porte also consists of conventionally grouped frames and connecting scrollwork. An unusual feature is the statues of classical deities placed on the entablature at the top of the walls, perhaps an allusion to the "Corinthian atrium" of Andrea Palladio. In its function as a passageway and waiting room, this sala resembled an atrium, yet neither this nor other ceilings in the Doge's Palace was designed by Palladio.[111] His unconcealed dislike of cartouches and scrollwork was given lapidary formulation in his architectural treatise, where he denounced them as an eyesore for the educated per-

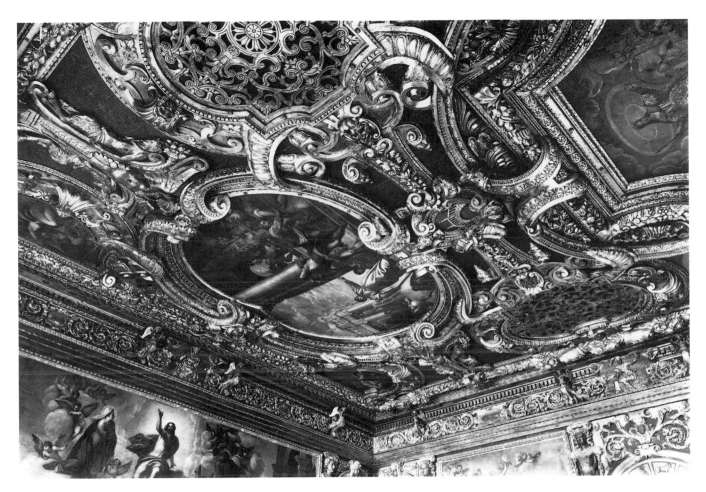

35 Cristoforo Sorte, ceiling, Doge's Palace, Sala del Senato, detail

36 Cristoforo Sorte, drawing for the ceiling of the Sala del Senato. London, Victoria and Albert Museum

son, confusing to the unlearned, and an unnecessary expenditure.[112] Palladio hereby set himself against a type of decoration that was very popular in Venice and that had been popularized if not introduced there by Paolo Veronese in his monumental frescoes for S. Sebastiano.

Scrollwork and cartouches are the characteristic elements of the splendid wooden ceiling of the Sala del Senato, designed by the painter, cartographer, and art critic Cristoforo Sorte soon after the fire of 1574 (figs. 35, 36).[113] The frames consist partly of volutes and scrollwork, or are embraced by scrolls as if by the tentacles of an octopus. There is a complete absence of classical motifs, the disinclination of those responsible for the building to follow Roman traditions being evident here too. Even well-informed contemporaries like Francesco Sansovino would not have considered a typical Venetian decorative ceiling like that of the Sala delle Quattro Porte to be *alla romana,* simply because it was of stucco. Clearly stucco as a medium, regardless of style, had a "Roman" quality attributed to it in Venice.

Signed drawings, like that of Cristoforo Sorte for the ceiling of the Sala del Senato, served as a starting point for the specialist who thought out the subjects of the canvas paintings for these ceilings. The number and sequence of the frames, orientated and often rising towards the center of the ceiling, were established first, and the subjects of the paintings had to be harmonized with them.

Sorte also designed the ceiling of the Sala del Maggior Consiglio, in which the linking of different-shaped compartments by almost zoomorphic scrollwork, and the combining of the frames into rows, reached perfection. The structure of such ceilings has a decisive influence on the way we perceive the rooms. An even sequence of uniform frames or systems of frames, as in the refectory of S. Salvatore or, before the fire, the Sala dello Scrutinio, reinforces the box shape of the room, giving it a firm structure. An arrangement of interconnected frames concentrated towards the center (as in S. Sebastiano, before 1555) makes square rooms seem centered.

Richly carved wood ceilings were not limited to the Doge's Palace. Further examples were or are to be found, apart from the Scuola Grande di S. Rocco already mentioned, in churches (e.g., S. Giuliano) and chapels (Cappella del Rosario of SS. Giovanni e Paolo, destroyed in the nineteenth century), but very seldom in private palaces.

The work of architects, painters, and sculptors included temporary architectural structures made of impermanent material for festive occasions, for example, state visits, military victories, or the ceremonial entry of the *dogaressa* to the Doge's Palace.[114] Some of them are recorded in prints or paintings. In 1574 Palladio designed a triumphal arch for the entry of the later Henri III of France to S. Niccolò on the Lido, while a loggia behind it was perhaps designed by a dilettante architect. For the entry of Dogaressa Zilia Dandolo Priuli (1557) the Guild of Butchers erected arches on the Piazza; in 1571 the victory of Lepanto was celebrated by the merchant drapers with triumphal arches on the Rialto, and in 1597 a triumphal arch bearing allegories of the republic turned the Piazza into a *via triumphalis.*

In 1582 another building site appeared on the Piazza. This time it was the procurators, who, starting at the Campanile, were building their private apartments on the south side of the square (fig. 75).[115] This project, more than any other statement, showed how much influence this small group of officials had gained. By 1556 (the Libreria was under construction at the time) it had been found necessary to make building works in the Piazza dependent on committee decisions in which the procurators did not have the majority. The commission to build the Procuratie Nuove was awarded to Vincenzo Scamozzi, who, as a response to the Procuratie Vecchie opposite and as a continuation of the Libreria, designed a unified façade behind which the traditional scansion of the Venetian palaces disappeared. By abandoning the Venetian palace façade and its rhythms, Scamozzi's solution obscured the individuality and the private character of these self-contained buildings.

The first section of the building, five window bays adjoining the Libreria and completed in 1599, contained the apartments of Federico Contarini and Andrea da Lezze; Contarini complained violently about the lining of the courtyards with columns, which was planned and partly executed, comparing them disparagingly to theater props. Scamozzi described the layout of the procurators' apartments in 1615:[116] at the front were the semipublic main room (*sala maggiore*) as well as the procurators' living rooms, while the women's chambers were on the other side of the courtyard facing the rio. The two apartments were joined by loggias reached by stairs. This separation, which was intended to leave the men undistracted by the women, followed Greek custom according to Scamozzi. The proximity to the official rooms in the Libreria with their art treasures led the passionate collector Contarini into temptation. A lawsuit refers to the unlawful appropriation of pictures that he had procured by stealth at night.[117]

The joining of the three-storied new building to the two-story Libreria was not treated by Scamozzi as a smooth transition in his first sketches. In two designs later rejected he tried to express the functional separation of the buildings architecturally. These designs emphasize and illustrate Scamozzi's criticism of the juxtaposition between the Libreria and the Zecca, a solution that had clearly been blamed on him. The decision in favor of a continuous wall between the Libreria and the Procuratie, which was taken after a good deal of controversy (one of the designs later rejected had already been

passed by the senate), may have been influenced by the project attributed to Sansovino and recorded by Manfredi (1602), whereby the Piazza was to be surrounded on all sides by uniform buildings.

One of the recurring themes of architectural discussion in Venice was the dilapidated wooden Rialto Bridge (fig. 25).[118] In the course of the sixteenth century a large number of prominent architects submitted designs and expressed their views, without the bridge being rebuilt. Michelangelo (1525), Vignola, Sanmicheli, and Sansovino

are mentioned in the sources along with numerous other experts, though without a design giving us any idea of their proposals. In 1551 the urgings of the Council of Ten led to the setting up of a new committee, the Provveditori sopra la Fabbrica di Rialto, to take the troublesome affair in hand. Technical questions to do with the foundations and the number of arches made the task extraordinarily complicated. The bridge was to link two quarters of the city and had to be easy to cross. It was to bring in the highest possible return by renting shops and

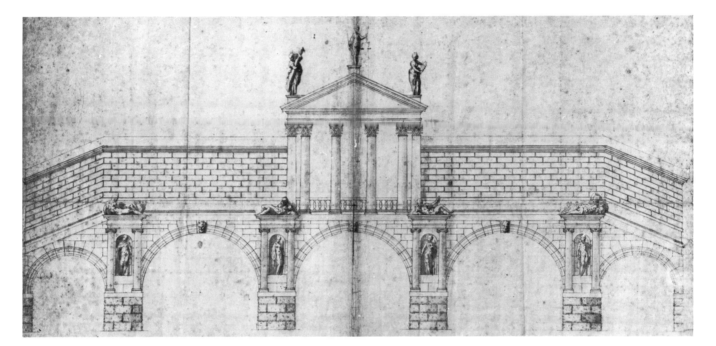

37 Andrea Palladio, first design for the Rialto Bridge, sideview. Vicenza, Museo Civico

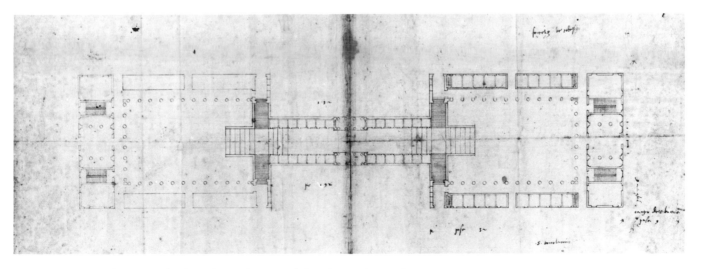

38 Andrea Palladio, first design for the Rialto Bridge, ground plan. Vicenza, Museo Civico

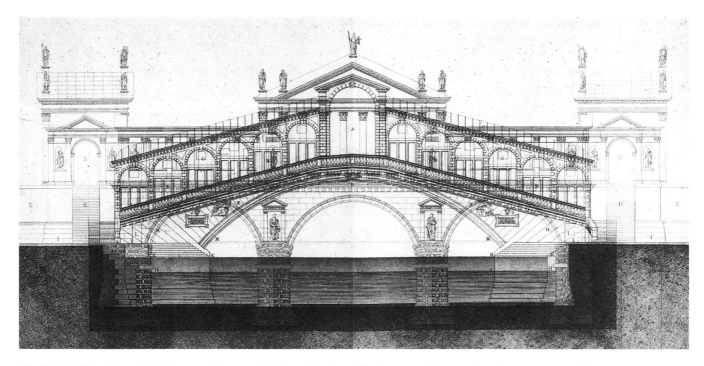

39 Rialto Bridge of Antonio da Ponte and the second design of Andrea Palladio projected one on the other. After A. Rondelet, *Saggio storico,* Mantua 1841

was at the same time to add special distinction to the Rialto district by its architectural features. Palladio appears to have been invited early on (in 1554?) to take part in a competition, and the surviving design in Vicenza (figs. 37, 38) may be his first attempt.

Palladio designed a bridge between two closed squares surrounded by colonnades. The entrances to these market squares are marked by two-story porticos with freestanding internal columns. As seen from the Grand Canal, the temple frontages of the middle loggias were predominant, opening between high rusticated walls. The bridge itself alluded to Roman edifices, especially to the bridge of Augustus at Rimini. Before the fire of 1514, a loggia intended as a meeting place for aristocrats was part of the Rialto area. Palladio's design—comparable in this to Fra Giocondo's Rialto project of 1514—required considerable intervention in the complex property relationships as well as extensive demolition of heavily used administrative buildings. This lack of consideration for local conditions must have been enough to rule out Palladio's proposal.

In his second project, in which he included even more (72!) shops (fig. 39), Palladio did away with the two market squares. In a manner similar to modern structures built over streets or railways, Palladio tried to erect the whole program on a horizontal plateau over the Grand Canal. Two expensive porticos at the end of wearyingly steep staircases mark the entrances to an area

reminiscent of modern malls, which combined intensive commercial use with prestigious effects. One broad and two narrow shopping streets are interrupted halfway by porticos which, after the bustle in the extremely narrow streets, give fresh air and a refreshing view of the Grand Canal. The loggia as a place of conversation—here commercial transactions—was a traditional feature of Venice. By choosing a pedimented front like those he used in palaces, villas, and church façades, Palladio was trying to impose ancient Roman motifs on Venetians, most of whom were more attached to local traditions.

The connection of the bridge to the street network and thus to the *fondamenta* that crossed its main axis, was provided by three staircases; nevertheless this bridge would have been a "gigantic obstacle" for pedestrians. Rondelet's sketch (fig. 39) also makes it clear that Palladio's bridge would have looked like a monumental barrier in the Grand Canal. It seems to be conceived less as a link between two parts of the town than as a self-contained market area erected over the canal, which, like certain temples, could only be reached by many stairs. The Rialto Bridge finally built in 1588–91 to designs by Antonio da Ponte is a moderate reply to Palladio's proposal by an experienced architect who accepted the local building tradition as an obligation. Instead of the "Roman" type with several piers, he constructed a single span similar to those of countless smaller bridges in Venice. The balustrade, like the horizontal middle section, is

part of the familiar silhouette. On this bridge da Ponte placed like an added furnishing the two rows of shops which, open on two sides, were broken by a transverse passage. A greater contrast to Palladio's loggias is hard to imagine; the motif of the opening, so portentously treated by Palladio, is preserved, yet reduced to a single narrow-looking arch. Da Ponte took advantage of the centuries-old experience of Venetian bridge builders in making bridges as comfortable as possible for their users. Rising gently with sloping steps, the Rialto Bridge spans the canal while its wide arch allows river traffic unimpeded passage.

After the completion of the works at the Rialto, public building activity was limited, essentially, to the often laborious completion of what had been begun and lesser measures, like the construction of a public gallery of antiquities (*statuario pubblico*) in the Libreria.[119] It was not until the votive church of S. Maria della Salute was begun in 1631 that new departures were apparent.

Jacopo Sansovino—Michele Sanmicheli—Andrea Palladio

In the second half of the 1530s, with the Zecca, the Libreria, and the Loggetta, Jacopo Sansovino had introduced new approaches to public building in Venice. This confronted all future patrons with the decision whether to side with these innovations or with the traditional forms. After the tradition-bound period between Codussi's death in 1504 and Sansovino's first public buildings, about the middle of the century a few highly individualized buildings were put up, like Sansovino's Palazzo Corner della Cà Grande (begun ca. 1545, fig. 42) and Sanmicheli's Palazzo Grimani at S. Luca (begun ca. 1558, fig. 48). By contrast, Palladio's attempts at about the same time to revise completely the façade and internal arrangement of the Venetian palace met with no success. Sansovino's and Sanmicheli's buildings have understandably been of special interest to art history, but the appearance of Venice

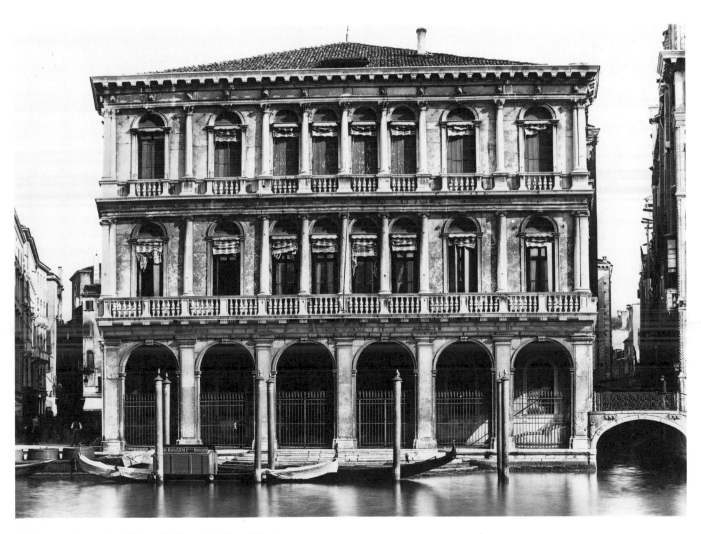

40 Jacopo Sansovino, Palazzo Dolfin on the Grand Canal

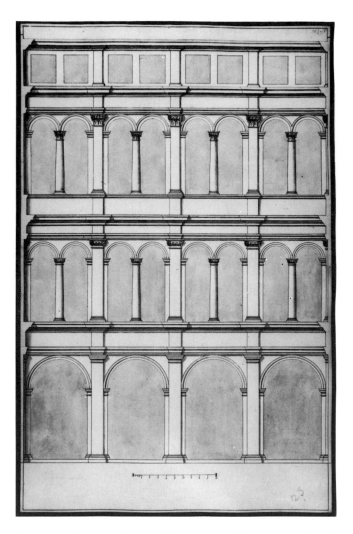

41 Jacopo Sansovino, Palazzo Dolfin, courtyard (original condition),
 after a drawing by Antonio Visentini. London, Royal Institute of
 British Architects

was characterized by the far larger number of palaces
built in the traditional manner. As Alvise Cornaro ob-
served, it is the large number of conventional houses that
makes a city. Insufficient knowledge of these buildings
and a lack of data on their dates of origin and their ar-
chitects make it difficult to write about them with as-
surance. There was also a tendency among Venetian
aristocrats to take Cornaro's advice and produce their
own designs. The design by Francesco Zen, as brilliant as
it was totally unorthodox, for his palace on the Campo
dei Gesuiti (1533, fig. 24)[120] and Daniele Barbaro's (?) de-
sign for the "Palazzo" Trevisan on Murano (fig. 110)[121] are
well-known examples. Fra Gabriele della Volta claimed
responsibility for the design of the cloister (1532, fig. 81)
and sacristy of S. Stefano.[122] Vincenzo Scamozzi records
the name of Valerio da Lendinara as a monk of S. Maria
delle Grazie and pupil of Serlio who designed a villa.[123]

Serlio himself named among the dilettante aristocrats,
apart from Francesco Zen, Gabriele Vendramin, Lodo-
vico Corner, and Marcantonio Michiel,[124] and there were
probably others. Alvise Cornaro, whose Odeo in Padua
played a crucial part in the history of the Venetian villa,
addressed himself explicitly to patrons and not to archi-
tects in his treatise of about 1550, arguing the beauty of
simple, practical buildings. All buildings ought to be
such, he wrote, that a comfortable, inexpensive edifice
earns more praise than an uncomfortable, expensive
one.[125] Rooms should be divided here and there by a
mezzanine, since these are dwellings for citizens (*cit-
tadini*) not princes (*principi*). Alvise Cornaro's refusal
to write about princely and "imperial" buildings is well
known. Enough was already to be found on them, he
contended, in the "divine" Vitruvius and the "great" Al-
berti. Nor did he wish to write about the orders of col-
umns, since the books of theoreticians like Vitruvius,
Alberti, and more recently Serlio were full of them, and a
building could be beautiful without orders, as the church
of S. Marco and S. Antonio in Padua showed. As far as
building technique was concerned, any simple mason
knew enough about that. A posteriori, Alvise Cornaro
provided a justification for a conception of building in
which moral and practical considerations were com-
bined with a clear repudiation of the excessive expense
incurred by a number of Venetian patrons. Possibly it
was the palace of Zorzi Corner (fig. 42), designed by
Sansovino and under construction at the time, which
prompted these pointed formulations.

Alvise Cornaro was no "anti-Vitruvian" (the epithet
"divine" applied to Vitruvius was certainly not intended
ironically), but he understood the realities of building in
a city that at that time had a living architectural tradition.
All the same, the study of Vitruvius and the deciphering
and interpretation of difficult passages were still popular
in certain Venetian circles. For example, Claudio Tolomei
had founded in Padua, before 1537, an academy devoted
to the study of Vitruvius[126] where the members could
consult a large number of editions published in Venice.
Studies of Vitruvius by the architect Giovanni Antonio
Rusconi were mentioned in a complimentary fashion by
a competent authority in 1553.[127] The very learned com-
mentary on Vitruvius by Daniele Barbaro (first published
in 1556) also set very high standards through Palladio's
collaboration on the illustrations. However, the results of
this philological activity in terms of building in Venice—
apart from Palladio's attempts—were slight.

After settling in Venice in 1527 Sansovino quickly
achieved success.[128] Soon after his arrival he produced a
model for the palace of a rich Venetian, perhaps Vettor
Grimani. This may be a surviving design that was sup-
posed to be realized instead of the Cà del Duca.[129] In
1529 Sansovino had become *proto* of the influential pro-

curators of S. Marco (de Supra) with a salary of eighty ducats and had moved into the uncomfortable apartment of his predecessor Bartolomeo Buon the Younger in the Procuratie Vecchie on the Piazza. Successful structural reinforcement in S. Marco and the reorganization of the buildings on the Piazza consolidated his reputation and influence, Vasari giving special emphasis to Sansovino's ability to increase the procurators' income by building measures. Additional factors were friendships with the writer Pietro Aretino and with Titian, which made it possible in his most difficult times—as after the collapse of

part of the vaulting in the Libreria—to limit the damage to his person.

With his Palazzo Dolfin (under construction in 1538), Sansovino did not break with Venetian tradition—on the contrary. The style of the façade (fig. 40) as of the courtyard (fig. 41) betrays his intention to follow local traditions, though not without making significant corrections. An unusual feature of the façade was the Doric ground-floor portico spanning a public path along the canal bank and leading to storerooms on the ground floor. Above the portico is the familiar picture of the tripartite front

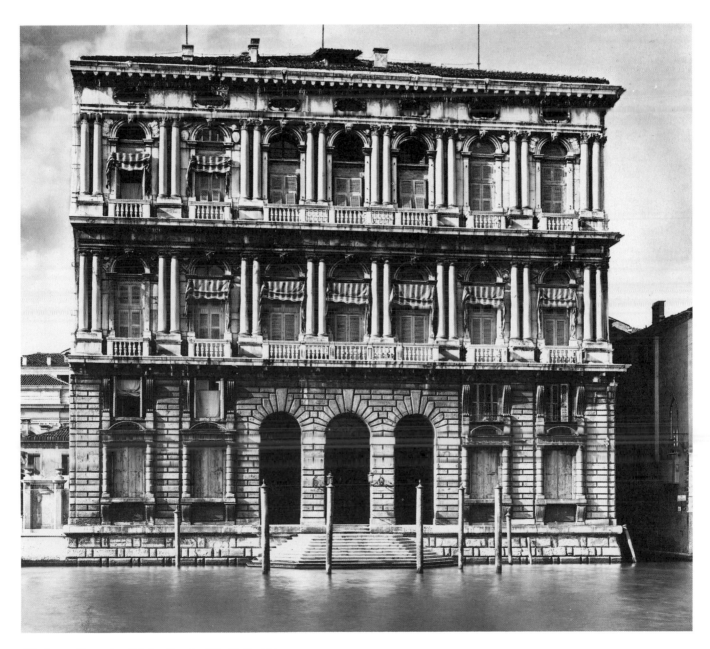

42 Jacopo Sansovino, Palazzo Corner della Cà Grande

43 Jacopo Sansovino, Palazzo Corner della Cà Grande, courtyard

framed by pilasters, in which Sansovino, like Mauro Codussi before him, placed the columns rhythmically, in harmony with the wall areas. Despite the use of classical orders—Doric, Ionic, Corinthian—the building is devoid of Roman character. With slender windows extending to floor level and deep balconies and framing pilasters, the result is a façade testifying both to the architect's adaptability and to the patron's attachment to tradition.

In contrast to the Zecca, Sansovino here chose alternate bifore and pilasters in the courtyard. The resulting diminutive effect reflected Venetian building convention as seen in the façade of the Procuratie Vecchie and the courtyard of the Fondaco dei Tedeschi. The choice of a courtyard enclosed on all sides is usually thought to show a deference to Roman models. This explanation seems too simple. In 1537 Serlio had assigned the courtyard to the aristocrat (*nobile*), while the portico *alla veneziana* was pronounced appropriate to someone living comfortably on the revenue from his property *privato gentiluomo*). The courtyard could therefore reflect the patron's self-image and social status.

It seems that Sansovino was the first to produce, for the Venetian palace, a unified courtyard that did not serve primarily as a source of lighting. Disregarding the anonymous design for the completion of the Cà del Duca produced in 1527, this kind of courtyard is found in the Palazzo Dolfin and the Palazzo Corner della Cà Grande (figs. 41, 43). The illustrations in Fra Giocondo's edition of Vitruvius of 1513 had no effect on Venetian architecture.

If in the Palazzo Dolfin Sansovino had been restricted by existing buildings, the awkward shape of the plot, and the need to plan long storerooms on the ground floor, in the Palazzo Corner (figs. 42–45) he was able to make use of apparently unlimited means without external restrictions. He divided up the long ground-floor portico, thus gaining an entrance loggia open towards the façade. Differing in form and probably in function from the loggias of pre-Gothic Venetian palaces and their successors, this opening of the façade on the ground floor represented a considerable innovation as compared to earlier palaces (with the exception of the plans for the Cà del Duca). The building and the public area (whether canals or streets) are open to each other as in the case of the Fondaco dei Tedeschi, a broad staircase bridging the separate spheres and inviting those outside to enter.

The effect when passing through the main portal into the interior of the palace must have been especially surprising for contemporaries. Instead of a long and usually very dark passageway (the traditional portico), Sansovino designed a large vaulted rectangular space open to the adjoining courtyard. The light from the courtyard unites the two areas, attracting those coming from the

44　Jacopo Sansovino, Palazzo Corner della Cà Grande, façade, detail

45　Jacopo Sansovino, Palazzo Corner della Cà Grande, ground-floor plan. From Cicognara, Diedo, and Selva, *Le fabbriche più cospicue . . .* , Venice 1815–20

Grand Canal or the upper rooms. A vault with lunettes instead of the exposed-beam ceiling usual in Venice gives this entrance area a spaciousness previously unknown. In contrast to Sanmicheli's rebuilding of the portico of the Palazzo Lando-Corner-Spinelli (1542, fig. 46), Sansovino made no use of orders to structure the walls. If the visitor was arriving from outside, the courtyard was the focal point. After the ground-floor loggia it opens expansively, surrounded by three towering floors. Scamozzi's criticism [130] that in some months of the year the sun never reached the ground floor, while true, was not regarded as a disadvantage by those exposed to the humid Venetian summer. The contrast between the rusticated ground floor and the smoothly stuccoed upper floors embellished with their Ionic and Corinthian orders has been heightened in the courtyard both by grime and by a change in the color of the stucco. Originally the white stone and the white *marmorino* harmonized in a way

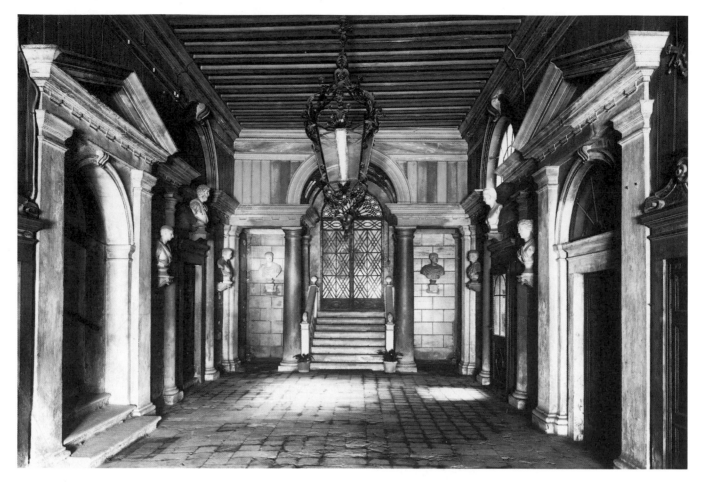

46 Michele Sanmicheli, Palazzo Lando-Corner-Spinelli, portico

comparable to the stone-clad courtyard of the Zecca.[131] The partial bricking up of the windows produces a desolate effect in the upper parts today. Rustication characterizes the ground-floor façade on the canal, the inner façade of the loggia, that of the portico facing the courtyard, and the four sides of the courtyard. To someone entering, the architecture unfolds a sequence of "pictures." Originally the courtyard appears to have been a multicolored pavement, "a kind of labyrinth."[132] Sansovino's courtyard of the Villa Garzoni at Pontecasale (fig. 103) and Sebastiano Serlio's versatile designs published in 1537[133] are called to mind. This was another way of distinguishing the courtyard from campi and calli.

Patience is called for in deciphering the architecture of the Grand Canal façade. Sansovino was seeking not to compose the facade by means of the orders but rather to create a many-layered disposition of elements one against another. Above the rusticated socle and the shallow dividing strip, rusticated pilasters are superimposed on a rusticated background in such a way that the horizontal joints link up. The longer blocks project further than the shorter ones, and only the corners of the pilasters break up the horizontal pattern. This is continued in the rusticated rings of the window columns, a dense network of forms extending over the ground floor. The layering is particularly prominent at the corners and in the portal, which is brought forward to the level of the pilasters.

The window groups cut across the rustication network. The Doric windows are supported on sturdy consoles and crowned by low segmental pediments, à la Codussi. Each of the mezzanine windows is flanked by a pair of very large volutes, which function as corbels. The linking of vertical pairs of ground-floor windows to form a composite figure was not new in Venice: in the Palazzo Contarini delle Figure (fig. 19) not long after 1504, a Codussi-inspired structure had been created from frames of different shapes, seamlessly filling the area between base and entablature. Sansovino went a step further. He not only unified the window group but, in the dynamic curves of the corbel scrolls, gave visual form to the weight of the parts and the strain borne by the structure. This composite formation is thereby distinguished from the somewhat prim framing of the loggetta niches and all

its Venetian predecessors, including the Palazzo Zen (fig. 24). But it is also linked to the upper floor of the Zecca and, above all, to the work of central-Italian architects, Roman as well as Florentine. Michelangelo was probably the point of contact, even though Sansovino did not imitate his buildings.

On the two upper floors, following Venetian custom, Sansovino opened the façade in front of the sala completely while unbroken wall surface is visible between the windows of the flanking living rooms. Both stories are divided by pairs of Ionic and Corinthian columns at equal intervals; the differences from Codussi's Palazzo Loredan (Vendramin-Calergi), which showed widely spaced pairs of columns on both upper floors as early as 1504, are considerable.

The Venetian palace often has a façade that is placed before the body of the building like a relief. Codussi's Palazzo Loredan (Vendramin-Calergi, plate 4) is an extreme example. There are also buildings like the Cà Dario in which one axis of the side wall is embellished like the façade and so connected to it. Factors to do with the prominent position of a building are likely to have been decisive here. In the Palazzo Corner, which stands out in front of the neighboring buildings, Sansovino fol-

lowed this tradition, designing a projecting structure (*avancorpo*) instead of a tableau, so that even the side view from the direction of S. Marco reveals the splendor of the façade. The other side was left unfinished, awaiting an adjoining building on the next plot. However, the completed side reveals how the stories, as was not uncommon in Venice, are clearly stepped back. These gradations of volume relieve the outline of any stereometric quality, giving the building a massive towerlike appearance.

Sansovino not only built magnificent palaces for very rich clients. His residence for Procurator Marc Antonio Morosini is an example of simpler building.[134] The apartment buildings erected at his own cost at S. Trovaso[135] have not yet been unequivocally identified.

While Sansovino's Palazzo Corner was an important stimulus to, and indeed set the standard for, Venetian baroque architecture and particularly for Baldassare Longhena, in about the same years Michele Sanmicheli built a palace for Giovanni Corner at S. Polo that was far more in keeping with tradition (fig. 47).[136] The irregular plot with access from the canal and from the Campo S. Polo, into which the palace juts diagonally, complicated the design. As compared to Serlio's designs "in the Vene-

47 Michele Sanmicheli, rio façade, Palazzo Corner. S. Polo

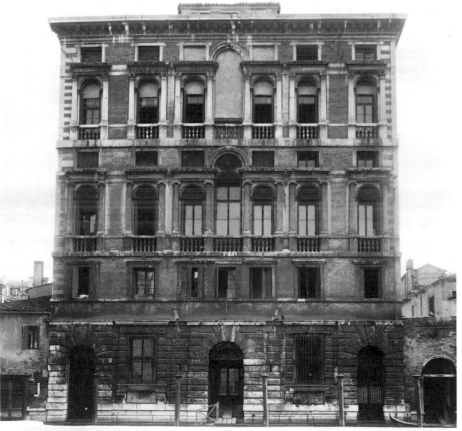

tian manner" (fig. 23, a, b) first published in his Fourth Book, one is most struck by the differences despite a number of common features, although it is not impossible that the patron's expectations were influenced by Serlio's book.

There is a striking contrast between the ornately rusticated entrance (in which the base and the ground floor are closely linked) and the steeply rising upper floors. Sanmicheli not only did without orders but reverted to bare brickwork, perhaps originally covered with a very thin layer of color. The irregular stone blocks at the corners recall Gothic palaces. The stories are separated by string courses, and the windows with their frames of Istrian stone provide vertical axes forming a framework linked by horizontal bands.

For the ground floor Sanmicheli chose a roughly marked rustication, making thematic use of the contrast between this "rustic" cladding and the delicately molded cornices and pilasters overgrown and trapped by the rustication, rather than juxtaposing them like Sansovino

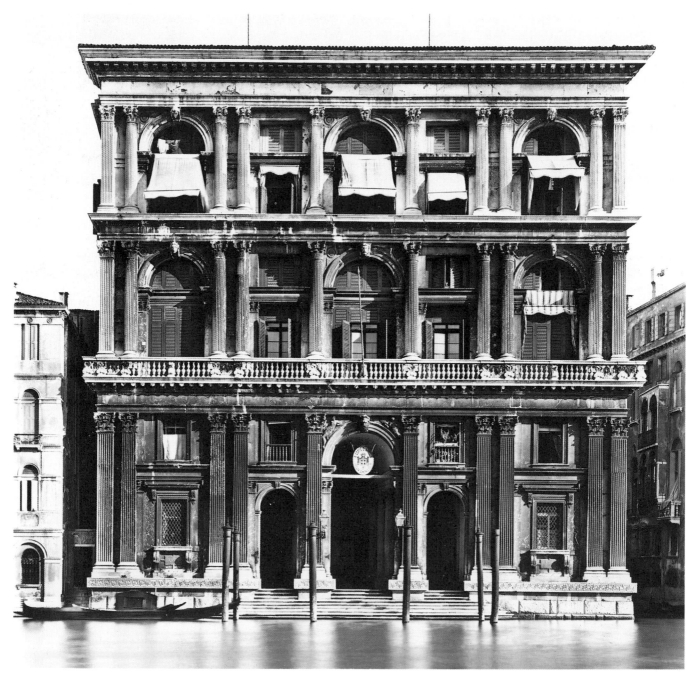

48 Michele Sanmicheli and Giangiacomo de' Grigi, Palazzo Grimani. S. Luca

and his Venetian predecessors. If there is any work in Venice that betrays a study of Serlio's Fourth Book, it is the Palazzo Corner.

Unlike Codussi, who created a highly condensed, multilayered relief of prominent frames in his palaces, and unlike Sansovino, who combined classical orders with rhythmical wall openings, in the Palazzo Corner Sanmicheli elaborated a flexible mesh of window frames and cornices while dispensing entirely with orders and entablatures. The pronounced vertical tendency is accentuated by the absence of the horizontal entablatures previously customary. Sanmicheli's treatment of the two upper floors pointed the way for numerous architects and patrons in the second half of the sixteenth century.

Shortly before his death, in 1559, Sanmicheli, then over seventy, was given the opportunity to design a palace that could hold its own in terms of prestige with Sansovino's Palazzo Corner della Cà Grande. The patron was Procurator Girolamo Grimani, who directed the work himself for two years (figs. 48, 49).[137] In 1561 Giangiacomo de' Grigi was put in charge as *proto;* his architectural competence, and its limits, are demonstrated by the Palazzo Coccina (begun ca. 1560, fig. 54). A year later it was decided to add an extra floor to Palazzo Grimani. Girolamo Grimani would later complain bitterly about the squandering of money during construction, though it is not clear with what justification.

The decision to raise the building seems to have gone hand in hand with a decision to change the proportions of the first floor, so that the rather squat, compressed appearance of the upper floors, originally planned to be taller, and their disproportion to the lofty ground floor cannot be blamed on Sanmicheli. Indeed, numerous departures from the original design gave rise to a dispute between the *proto* and the patron.

Here, as so often in Venice, the irregular boundaries of the plot made a symmetrical disposition of the rooms impossible. The imposing atrium three bays wide and the long, very narrow portico do not run perpendicular to the façade, and only two of the three bays of the atrium open onto the portico. The building's exposed position and great size allowed the architect to provide a façade at the back as well, in which he entirely followed traditional Venetian schema for palaces.

Sanmicheli also took issue with Venetian tradition in the Grand Canal façade. The central part is dominated by the serliana, which on the upper floor was combined with the colonnade. The placing and shape of the windows on these floors produces a rhythmical *a b a b a* sequence of openings, which integrates the serliana with the façade network. The doubling of columns (similar to that in Codussi's Palazzo Loredan [Vendramin-Calergi]) and the wider wall sections behind them recall the *alla veneziana* disposition of the sala and adjoining rooms, although Sanmicheli had abandoned it here. Thus on the

49 Michele Sanmicheli, Palazzo Grimani, ground plan. S. Luca From Ronzani and Luciolli, *Le fabbriche civili,* Genoa n.d.

two upper floors, behind the serliana and in front of the sala, there is a room connecting with the two side rooms. It seems possible to me that this divergence may have been connected with an unexecuted design by Palladio (fig. 50). Sanmicheli then designed an atrium with three aisles that eclipsed all previous solutions. This quotation from the Roman Palazzo Farnese doubtless met the patron's expectations. The Roman leanings of the Grimani family were well known in Venice, classical Roman art and Rome-oriented artists being favored by them. A characteristic example was the decoration of the residential and museum rooms of the Grimani of S. Maria Formosa by Giovanni da Udine (1537–40), who had previously worked chiefly in Rome, and Federico Zuccari (about 1562).[138] Copies of ancient decorations from the large baths in Hadrian's Villa at Tivoli, the grotesques in the vaulting—not to mention the world-famous collection of antiquities—made it clear to the visitor that the owner was convinced of the superiority of Roman art. There was no "Roman phase" in the Venetian architecture of the

sixteenth century, but there was a politically influential minority of aristocrats who, like the Grimani, preferred the Roman manner of decoration or Roman architectural features. Alongside these palaces countless traditional buildings continued to be erected.

50 Andrea Palladio, design for a palace on the Grand Canal. From Palladio, *I quattro libri dell'architettura,* Venice 1570

Whereas Sanmicheli and Sansovino succeeded in attracting commissions for Venetian palaces, Andrea Palladio failed to do so.[139] The reasons are likely to be found less in a lack of personal contacts than in Palladio's refusal to compromise with Venetian architectural tradition. His designs recently identified as for the Palazzi Grimani (S. Luca) and Corner (S. Maurizio) were competing with those of Sanmicheli and Sansovino, architects who had already proved their ability in this area, and are proof enough. In his design for the façade of the Palazzo Grimani (figs. 50, 52), Palladio had already broken with Venetian tradition. A slightly projecting block is clearly present at the center, and two bays stepped sharply back at the sides form wings; this meant the abandonment of the traditional façade line, which was undoubtedly regarded as obligatory by patrons and architects alike. Inside (fig. 52), instead of a portico continuing through the building, Palladio had designed a sequence of rooms rich in surprises and optical delights. A square atrium with four columns is followed by a narrow passage that widens into a T. A rear block is attached via a transverse (!) sala supported on columns, with a loggia opening onto the courtyard. A comparable subdivision of the ground plan had been realized only once in the vicinity of Venice, by Daniele Barbaro (?) in the "Palazzo" Trevisan on Murano (fig. 110); it was undoubtedly influenced by Palladio's palace designs and seems to have been a polemical reaction to local traditions. One should bear in mind that the "Palazzo" Trevisan was not built in the city but on an outlying island where strict conventions exerted little influence.

The complex ground plan is matched by the disposition of rooms on the two upper floors. Two state rooms extending from the first floor to the roof and surrounded by continuous balconies opened entirely new perspectives to patrons. Palladio followed a very similar course in his second Venetian project, produced for Zorzi Corner and thus in competition with Sansovino. Here he rejected as quite inadequate the elongated, single-story sala lit from its short sides. That Palladio was experimenting at the same time with more traditional Venetian ground plans is shown by a sketch that may be linked to the Palazzo Corner.[140] The later (1570) version published in his architectural treatise resembles, in its façade, his design for the Palazzo Grimani, even though the wings set back at the sides are absent. In the interior Palladio, as he had already done in the Palazzo Porto-Festa in Vicenza, had envisaged a very large oval staircase area about ten meters in diameter next to the central sala. Following the upgrading of the entrance area of Venetian palaces, the architectural improvement of the means of access to the sala on the piano nobile was only logical, yet costly staircases remained exceptions in private palaces. Two such exceptions were a design for the Cà del Duca (ca. 1528, attributed to Sansovino),[141] which was

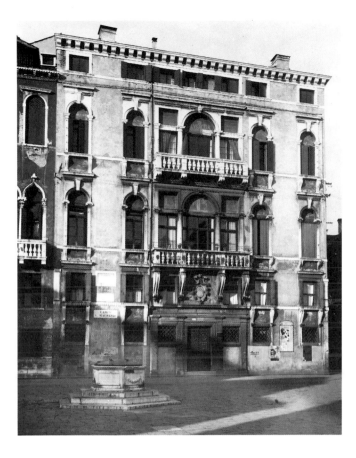

never realized, and the staircase of the Palazzo Loredan on the Campo S. Stefano (after 1536), comparable in type to the staircase of the Escorial near Madrid.[142]

In a statement in his *Quattro libri* (1570), Palladio distanced himself pointedly from Venetian architecture, which in his eyes entirely lacked "grazia" and "bellezza." In another pronouncement he deplored the compromises the architect often had to reach with his clients.[143] Palladio's designs make it clear that, at least in this sphere, he was not willing to set his convictions aside. But what would have become of Venetian secular architecture if, as in church building, he had found a patron prepared to break with hallowed tradition?

Buildings of the Second Half of the Sixteenth Century

No comparable palaces followed Sansovino's Palazzo Corner and Sanmicheli's Palazzo Grimani in the second half of the sixteenth century. No Venetian patron could or would now commit himself to such an individual and

51 Palazzo Bellavite on the Campo S. Maurizio

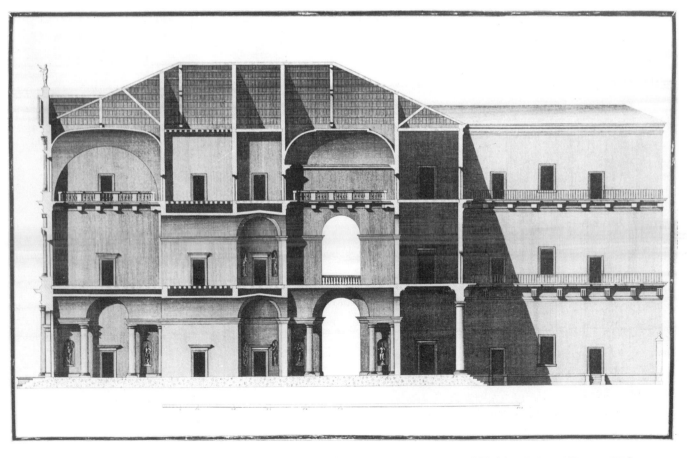

52 Reconstruction of Palladio's design for a palace on the Grand Canal. From Bertotti Scamozzi, *Le fabbriche e i disegni,* Vicenza 1776

architecturally ambitious project. Thus the history of the façade of the Venetian palace in the second half of the century is dominated by traditional designs.[144] Most of these buildings are anonymous today; it seems that some patrons must have followed Alvise Cornaro's advice and entrusted both the design and its implementation to experienced but today largely unknown practitioners. That prominent architects also designed unpretentious, inexpensive buildings is shown by Sansovino's palace for Procurator Marc Antonio Morosini on the Grand Canal.[145]

In the second half of the century large apartment blocks continued to be built, the accommodations being of a size comparable to those of the palaces.[146] The rent was usually very high, the occupants belonging to the wealthy *cittadini* or the aristocracy. The dates of building and the names and often even the professions of the residents can be obtained from the estimates of officials of the Dieci Savi sopra le Decime, which fixed the values of buildings and the revenues from them. Some of these housing blocks have recently been investigated in detail, but only the publication of the results of a large-scale study under the direction of Concina[147] will lay the foundation for research into the civil architecture of these decades. Some examples are the block at S. Basegio (begun before 1550, fig. 7), the houses in the Calle degli Avvocati, the row houses in the Calle Contarina (on the Rio Marin, first mentioned in 1566, figs. 8, 9), as well as the Castelforte block at S. Rocco (designed in 1549 by Scarpagnino). Residences of differing quality could be united in a single building. The general absence of decorative motifs is also found in many family palaces. A typical example is the palace of Daniele Barbarigo (Palazzo Barbarigo della Terrazza)[148] built in 1568 to plans by Bernardo di Francesco Contini. That there were many experienced builders and architects working in Venice in the second half of the sixteenth century is shown by the expert opinions, mainly on technical questions, following the fire at the Doge's Palace in 1577, as well as the technical comments and projects relating to the Rialto Bridge. It has not yet been demonstrated, however, that Giovanni Antonio Rusconi, the eternal second-place man in important competitions, Antonio da Ponte, Simone Sorella, Francesco Zamberlan, and Giovanni Girolamo Grapiglia were also involved in designing and advising on residential buildings.[149]

Apart from very numerous almost standardized buildings there were a few unconventional solutions like the Palazzo Contarini (S. Beneto), occupied on the piano nobile since 1561 by two brothers while the upper floor, as so often in Venice, was rented from the start.[150] In this building one is surprised by the combination of polychrome marble facing, which probably looked antiquated to some at the time and traditional to others, with figures of Roman rulers in the frieze, decorative motifs applied to the surface, and the serliana, never out of date

in Venice. There are also motifs like the blind windows that Codussi had used on the east wing (on the rio) of the Doge's Palace. These old-fashioned motifs and similarities with the Palazzo Malipiero (S. Maria Formosa) make an attribution to Sante Lombardo (died in 1560) seem arguable.

In about the same years (around 1555) the successful flour and oil merchant Dionisio Bellavite built himself a monumental palace on the Campo S. Maurizio (fig. 51).[151] This building, like so many others, makes it plain that in the sphere of architecture wealth levelled other differences of rank in Venice. In this building, apart from the almost obligatory serliana, the balconies with their large corbels were the dominant ornamentation. The pairs of windows structuring the façade at the sides, with their supporting corbels, are mounted on top of each other in a manner similar to Sanmicheli's Palazzo Corner (fig. 47), while horizontal bands at the height of the windowsills provide a loose horizontal articulation. The central part of the façade, like that of Giangiacomo de' Grigi's Palazzo Coccina (fig. 54) designed not long after (?), is treated like a *risalita* by compressing the structural elements, an effect that was further heightened by Paolo Veronese's façade paintings. Serlio compared the combination of brick and stone in a building with the flesh and bones of the human body,[152] an image that is especially apt for the Palazzo Bellavite. The interior is dominated by the sala much as in the nearby palace of Doge Niccolò da Ponte[153] (doge from 1578 to 1585) which, apart from the lost friezes, has a very similar elevation. It was the façade paintings that gave the buildings their individual character.

Veronese, Tintoretto, Zelotti, Giuseppe Salviati, and Pordenone (fig. 53), like less well known artists, decorated with their brushes many palaces built at that time or modernized older ones. Ridolfi (1648) briefly described these works, which had already faded in his day and of which only a few precarious remnants and a number of graphic reproductions survive today.[154] Thus simple façades like that of the Palazzo Marcello were transformed into magnificent historiated walls by Tintoretto's mythological paintings.[155]

In a report on art and artists in Venice by the imperial envoy in Venice, Veit von Dornberg, addressed to Maximilian II (1569), the writer draws a distinction between stonemasons ("praticanti") and those architects who have a theoretical knowledge of their profession.[156] His example of a practitioner's building is the palace of the cloth merchant Coccina, whose family came from Bergamo.[157] The building (fig. 54), completed about 1560, was erected on the Grand Canal diagonally opposite Michele Sanmicheli's Palazzo Grimani, which was just going up. Giangiacomo de' Grigi, son of the Bergamask Guglielmo de' Grigi who had long worked in Venice, was limited by the patron (a *cittadino*) to the

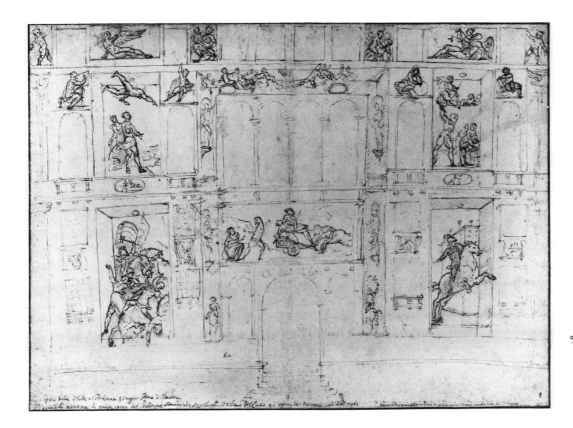

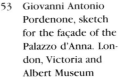

53 Giovanni Antonio Pordenone, sketch for the façade of the Palazzo d'Anna. London, Victoria and Albert Museum

traditional palace scheme. However, the façade of the Palazzo Coccina, unlike most buildings of the Venetian type, is faced with white Istrian limestone, the spaces between the windows being articulated by rectangular panels. This device, perhaps inspired by Serlio and taken up by Sansovino in S. Geminiano, created a fashion up to the eighteenth century. The windows of the upper mezzanine, shaped like cartouches and set into the frieze of the entablature, are inspired by Sansovino's Palazzo Corner (fig. 42). Very much in the Venetian tradition, the ground floor is not marked off by an entablature, but only by a flat strip. The orders *all'antica* are confined to the portal and window groups, which are thereby particularly emphasized, while the pilasters at the corners of the building have simple blocks instead of capitals. Much in this building that must have seemed like faux pas or mere incompetence to "learned" architects like Sansovino and Palladio was based on Venetian tradition; in Codussi's upper floor of the Scuola Grande di S. Marco, for example, the windows press against the pilasters in a similar way.

In his report of 1569, Veit von Dornberg attempted to give the emperor a comprehensive picture of Venetian architects, sculptors, and gardens. The outcome is revealing. Apart from Sansovino and Palladio he named only Giangiacomo de' Grigi and Giovanni Antonio Rusconi. His contemptuous judgment on the "stonemason-architect" ("tagliapietra architecto") de' Grigi, probably based on the comments of "educated" Venetian informants (architects?), still carries weight today. All he could find out about Rusconi was that he was said to have built in various parts of Italy. But who designed all the residential buildings constructed at the time?

Among the magnificent palaces on the Grand Canal is the splendidly situated palace of the aristocrat Niccolò Balbi (fig. 55).[158] From this building the great Venetian thoroughfare can be overlooked as far as the Rialto and the Accademia. Begun about 1582, the first floor was rented as early as 1590, while the patron had reserved the second floor for himself. It is clear from this that in such buildings the two upper floors were of equivalent value, so that one can speak legitimately of two piani nobili. The importance of such costly architecture for the patrons' image is indicated by their portraits in which recently erected buildings are shown. Niccolò Balbi had his portrait painted in front of his own palace,[159] just as the Coccina family had done in Veronese's group portrait (plate 29).

The traditional attribution of the Palazzo Balbi to Alessandro Vittoria is based on hearsay from the eighteenth century; however, the silence of Vittoria's extensive notes, in which he kept a record of the costs to himself arising from his works, is not in itself a sufficient argument against his authorship. The portals and the unconventional pediments exactly reflect the early-baroque formal repertory that he used, above all on altars.

As had become more common in Venice since the fifteenth century, a high rusticated frontage unites the ground floor with the first mezzanine. The façade rising from it, traditional in its placing of wall and openings, even recalls a pre-Gothic motif (Palazzo Dandolo-Farsetti) in reverting to the use of triforia with coupled columns. The façade of the Palazzo Balbi, quite unlike that of the Palazzo Coccina, is more assured in its detailing. Nevertheless, in it too the window pediments cut into the pilasters. On the piano nobile there are four Ionic pilasters which overlap recessed pairs of flanking pilasters. On the second floor we can see how reluctant

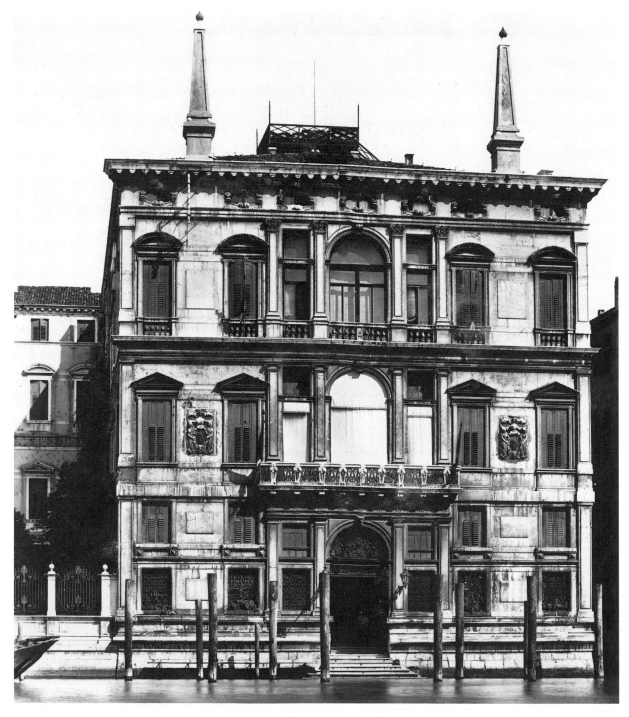

54 Giangiacomo de' Grigi, Palazzo Coccina on the Grand Canal

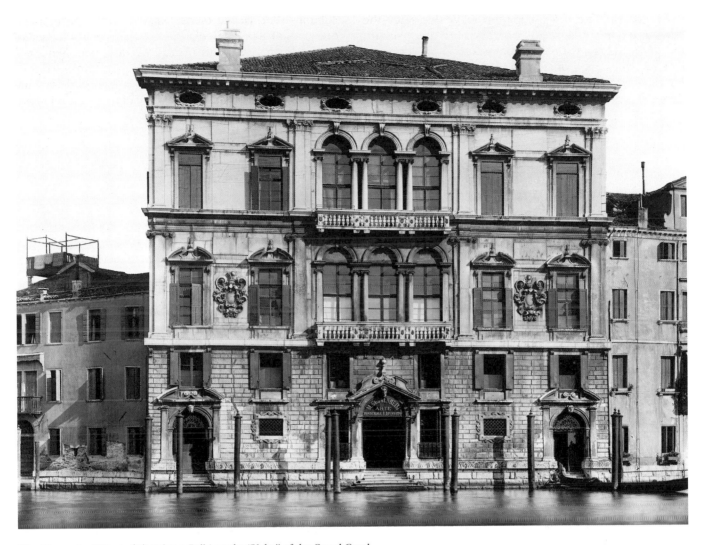

55 Alessandro Vittoria (?), Palazzo Balbi on the "Volta" of the Grand Canal

most Venetian architects were to use the orders as constituent elements of the facade. The overlapping pilasters are not strictly related to the movement of the entablature. Such treatment ignores constructive logic, being conceived in terms of sculpturally organized masses rather than of functional structure.

In 1581, one year before work began on the Palazzo Balbi, Sansovino's guidebook to the city was published. In it he made an observation that is still valid today: Venice's appearance is largely determined by Gothic buildings.[160] The fact that the Gothic Palazzo Foscari was next door to the Palazzo Balbi says much about how Gothic buildings were valued in the late sixteenth century. They could survive because they had the same sequence of rooms, often with similar dimensions and proportions, as the modern buildings, so that adaptation to the modern style of the time was not necessary. The age of a building, which could be read from its façade, was regarded by

many with good reason as a quality worth preserving, as is shown by the dispute over the rebuilding of the Doge's Palace after the fire of 1577.[161] The weaker party was the one that wanted a new building in place of Calendario's masterpiece of 1340, and even Palladio submitted a new project.

In these years aristocrats, against vehement resistance by the Jesuits, built the first permanent theaters in Venice.[162] They had been preceded by temporary conversions of existing rooms by Giorgio Vasari and Andrea Palladio. The theater at S. Cassiano financed by Alvise Michiel about 1580 seems to have been oval, the Trons' theater round. Neither building has survived, and their architects are not recorded.

In 1584, two years after work began on the Palazzo Balbi and four years after Palladio's death, the first complete edition of Serlio's architectural textbook appeared in Venice. The publisher, Francesco de Franceschi, dedi-

56 Giovanni da Udine, vault, Palazzo Grimani near S. Maria Formosa, Sala di Diana

cated the Seventh Book to Vincenzo Scamozzi, the architect of the Procuratie Nuove and the "Vitruvius of our time"[163] who had been living in Venice since 1572. With Scamozzi a phase began in Venice that led, uneluctably, to the baroque.

Hardly anything has been preserved of the interior decoration of the Venetian palaces of the sixteenth century. The splendid ceilings of the Palazzo Grimani at S. Maria Formosa are almost the only examples remaining today. Canvas paintings in wooden frames that were set into ceilings are very seldom found in their original contexts.[164] The frescoes in the porticos of Venetian palaces mentioned by Ridolfi as late as 1648 have, it seems, vanished without trace. The palace of the brothers Giovanni and Vittore Grimani, so opulently furnished within, was somewhat reserved in its exterior architecture. Inside, the Roman leanings of the patriarch of Aquileia were shown in the choice of Roman artists and the preference for *all'antica* decorations.[165] In 1537–40 Giovanni da Udine copied a vaulted ceiling of Hadrian's Villa at Tivoli (fig. 56), and the other decorations, executed by Federico Zuccari and Camillo Mantovano were also unusual for Venice. This *all'antica* decoration provided the framework for an important collection of classical works of art,[166] which, scattered about the courtyard and many rooms on the first floor, was one of the attractions of Venice for the educated traveller. Some of these antiques were integrated into complex wall schemes. A square room lit from above served exclusively for the presenta-

tion of smaller pieces. Built perhaps about 1568[167] and certainly before 1593, the date the collection was donated to the Venetian state, this room is one of the few surviving museum interiors of the time in Italy.

Also preserved is a sumptuous fireplace[168] partly molded in stucco and an integral part of an extensive sculptural wall decoration. This was not the rule in Venice. After the "Lombardesque" fireplaces adorned with classical-style entablatures (examples in the Doge's Palace), about the middle of the century people preferred stone frames, sometimes with caryatids or atlantes, as the fine examples in the Doge's Palace and Sansovino's fireplaces in the Villa Garzoni (Pontecasale) show. In the second half of the century stucco cartouches or scrolls with figures on the upper part were especially popular. Scamozzi (1615), who had himself designed an opulent fireplace for the Sala dell'Anticollegio in the Doge's Palace, tried to impose order on the multiplicity of Venetian fireplaces and published a Roman and a Venetian type as well as a fireplace with a richly stuccoed parapet, *a padiglione.*[169]

In the Palazzo Grimani, on the patriarch of Aquileia's floor, there is still today a small chapel with stucco decorations,[170] and records refer to another in Sansovino's Palazzo Dolfin.[171] Such private chapels in town palaces were very uncommon in the sixteenth century.

In that century Venice possessed a large number of gardens.[172] In 1946 there were only sixty. Since then, not only on the Giudecca, further gardens have been en-

closed, destroying precious open spaces. Little is known about the appearance of Venetian gardens in the Renaissance. Most were shielded from intrusive eyes by high walls. Contemporary paintings and prints showing gardens tell us little about what actually existed and at best something of the artist's idea of an especially beautiful garden.[173] In 1569 Veit von Dornberg mentioned—apart from the ornamental statues, which he thought unremarkable—a grotto, without naming the owner.[174] Perhaps he was thinking of the "palazzo" of Camillo Trevisan on Murano (fig. 110). But Venetian gardens stood no comparison with those of Rome and Naples. Garden works included several small buildings such as loggias and garden houses (*casini*) whose function is not very clear. They were probably connected with activities that made life in the country agreeable. Surviving examples are the *casinò* of the Palazzo Michiel of the early sixteenth century[175] and the so-called Casinò Mocenigo on the shore of Murano facing the lagoon.[176] The loggia of the Palazzo Coccina[177] has entirely disappeared.

4 SACRED BUILDINGS

Churches and Monasteries (1460–1530)

Despite the destruction that has taken place, particularly in the nineteenth century, the number of churches and monasteries built or partly reconstructed in the years between 1460 and 1590 is still high. With their towers and lead-covered domes they dominate the skyline of the city and the islands around it.[1] Among the churches, S. Marco had a special status as the state church and palace chapel. S. Pietro di Castello, see of the patriarch since 1451 and situated far from the center at the eastern end of the city, made the carefully nurtured distance between church and state visible in spatial terms. In addition, there were numerous monasteries and convents, the extensive buildings and grounds of which still cover large areas of the city and islands today. In 1581 Francesco Sansovino[2] counted seventy parish churches in all (attached to the seventy *contrade*) and fifty-nine monasteries (including twenty-eight convents), and for Vincenzo Scamozzi (1615)[3] Venice largely consisted of sacred buildings.

The many parish churches had a special status in Venice, since their priests (*pievani*) were chosen by the parish and only confirmed by the patriarch and the senate.[4] Several of these priests initiated or promoted building projects, with great energy and often with their own wealth. Matteo degli Eletti and Benedetto Manzini (the priest of S. Geminiano)—to mention only two—made their names in this way, alongside the usually better-known aristocratic patrons of architecture.

Before Mauro Codussi designed the façade of S. Michele in Isola (fig. 57), there had already been several attempts to break free of Gothic traditions. The parts of S. Zaccaria built by Antonio Gambello (begun in 1458, fig. 58)[5] and Buon's portal of SS. Giovanni e Paolo (from 1458, fig. 4) were the most important undertakings, thought they remained partly unrealized. Bartolomeo Buon, Antonio Gambello, and later Mauro Codussi distanced themselves from Gothic forms in their works, although some traditional motifs remain recognizable in new guises.

The church façades of the first half of the fifteenth century[6] are divided into three sections by piers or pilasters corresponding to the nave and aisles. For the façade of S. Maria della Carità Bartolomeo Buon designed three very steep, triangular, ornamented pediments with crab-like crocketing above round arches with framing friezes and the usual tabernacles surmounting the piers. Two splendid tall windows illuminate the aisles, as was common in Venice; an oculus lights the nave. In S. Maria dei Frari, S. Stefano, the Madonna dell'Orto, roof diagonals abut on the very high middle section of the façade, which is crowned by a pediment resembling a triangle without a base. Another group features quarter-circular tympana over the aisles and a semicircular tympanum crowning the nave (S. Andrea della Zirada). Sometimes the center of the façade is crowned by reverse-curve moldings (S. Giovanni in Bragora). S. Giobbe, before the baroque alterations, probably belonged to this group as well. In tripartite façades of hall churches, diagonals joining to form a pediment are dominant (S. Elena), while in five-bay façades a central section might be emphasized by diagonals (S. Alvise). Some of these Gothic brick façades showed their masonry, usually enhanced by painted joints in place of real mortar courses, while others were stuccoed. Thus a document of 1461 deals with the whitening of the façade of S. Gregorio. However, no uniform practice seems to have existed.

The façade of the Camaldolese church of S. Michele in Isola was erected under Abbot Pietro Donà from 1469, to a design by Mauro Codussi, in front of an existing structure (fig. 57). The flat rustication of Istrian stone that seamlessly incorporates the pilasters was to be found previously in Bartolomeo Buon's Cà del Duca. The quadrants and pediments were familiar to Venetians from Gothic façades like S. Giovanni in Bragora, but the compartmentalizing of the façade by entablatures and pilasters was new, although the short upper pilaster strips turn out on closer inspection to be piers. Porphyry roundels decorate the marble panels around the oculus, elongated shell moldings the quadrants, and radial fluting the semicircular pediment. The origins of the façade of S. Giovanni in Bragora and others related to it have not been securely dated as yet; what is certain is that this façade type

was chosen by the Venetian sculptors and architects Pierpaolo and Jacobello dalle Masegne for Mantua Cathedral as early as the end of the fourteenth century.[7] In a letter of 1477 the patron of S. Michele proudly emphasized what he took to be the classical character of the façade,[8] a claim that, though it does not seem stylistically justified, reveals the ideal of patrons and their conception of the classical. This reference to antiquity makes it clear how little the modern observer is in a position to discover the intentions of patrons and architects without written sources.

Mauro Codussi later used the "system" of this façade again, in 1497, for the cruciform domed church of S. Giovanni Crisostomo (fig. 66), though divested of all space-filling motifs. Other architects followed him for a long time afterwards. S. Felice, begun in 1531, is only one example.

The basilica of S. Michele (fig. 59), probably built on earlier foundations, recalls Gothic buildings in the proportions of its nave. A coffered ceiling covers the side aisles as well as the tall walls of the nave, which are devoid of architectural membering. The choir and choir chapel join abruptly, in what is clearly a deliberate contrast. A dome canopy is "inserted" into the choir on square columns, the entablature tying it to the semicircular apse. The variety of profiles and the costly marble facing of the triumphal arch are also found in the choir chapels, which, in their vaulting with its sequence of drum, dome, and flattened cupola, offer a varied picture dominated by round arches and curves. In the last third of the century the dome canopy was made the climax of several sacred buildings. The choir chapel of S. Giobbe (ca. 1471) and S. Maria dei Miracoli (1485, fig. 63), as well as less imposing chapels, should be mentioned here.

As we have seen, the façade of S. Michele was related by the church's patron to classical architecture. Can the claim be extended to the interior? None of the capitals of the main aisle,[9] probably the work of a certain Taddeo between 1474 and 1477, can be related directly to classical orders, as is the case with Brunelleschi. Nor are there

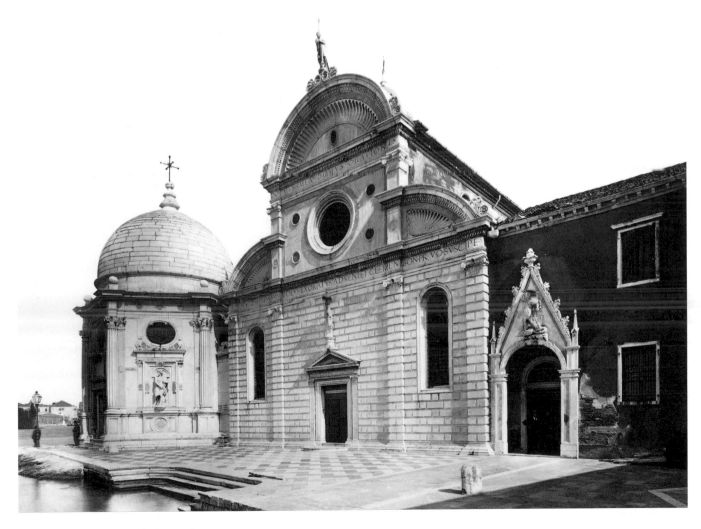

57 Mauro Codussi, S. Michele in Isola

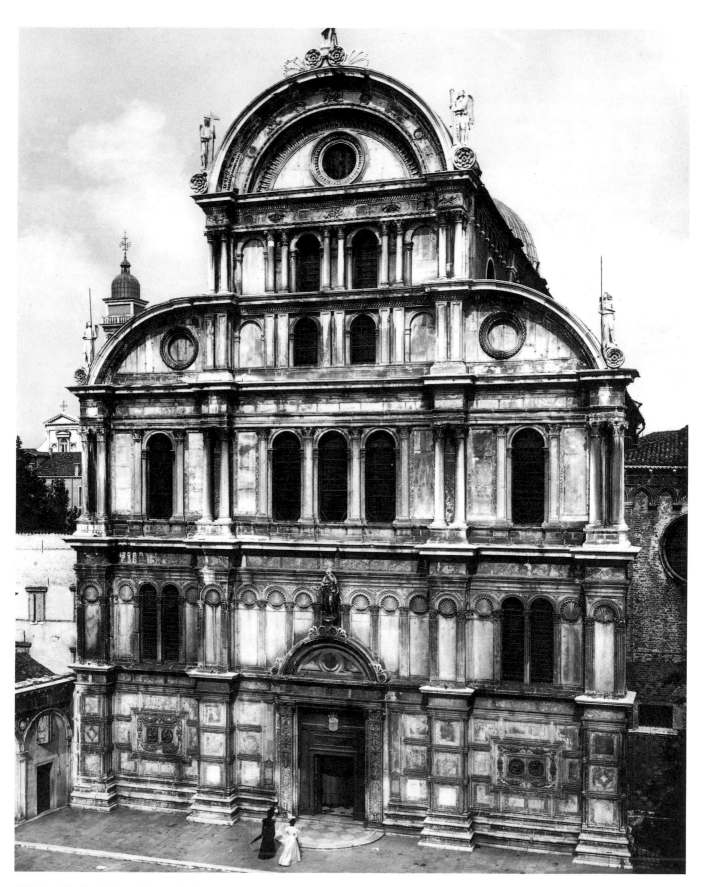

58 Antonio Gambello and Mauro Codussi, S. Zaccaria

allusions to the inexhaustible reservoir of patterns to be found in the capitals of S. Marco. However, it would be mistaken to regard as classical only those capitals that fit the orders that became canonical in the second half of the sixteenth century. Even Vitruvius, who may have been taken as an authority, referred to other orders designated by other names.[10] Early illustrations of Vitruvius (such as those by Cesare Cesariano of 1521, fig. 60) included among the classical orders capitals that in the eyes of later Vitruvians (Vignola, for example) may have been in the classical style but did not belong to the five main orders. The modern observer may relate the capitals in the main aisle of S. Michele to works by Tuscan architects[11] but possibly overlooks the fact that they were seen by contemporaries as a return to classical forms. This return can be seen more easily in the dolphin

capitals so popular in the lagoon city, or the arabesque decoration of pilasters, since they followed familiar classical models.[12] In his Vitruvius commentary, Cesare Cesariano included a capital with a fluted neck not unlike those of the façade of S. Michele in the Doric order, and recommended two other solutions, one of which, with its fascia above the shaft ring and its volutes, is comparable to the capitals in the main aisle of S. Michele.

Moreover, it is not even certain that details like capitals and profiles were executed according to the designs of the architect responsible for the overall plan. Thus, Tullio Lombardo was commissioned in 1507 to design the entablatures, cornices, moldings, bases, and capitals of S. Salvatore (fig. 69) without having been involved in formulating the general design, by Giorgio Spavento.[13] Even though the statutes of the stonemasons' guild ex-

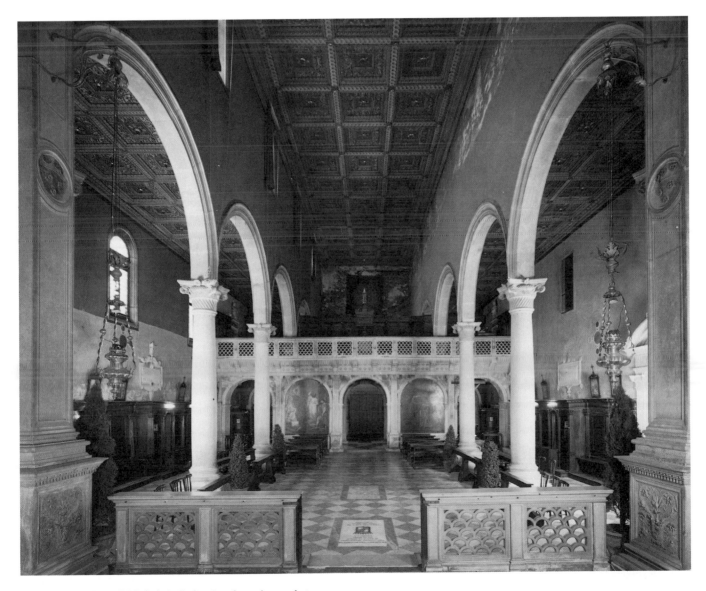

59 Mauro Codussi, S. Michele in Isola, view from the presbytery

60 Cesare Cesariano, orders of columns. From Cesariano, *Vitruvius Lucius Polio,* Como 1521

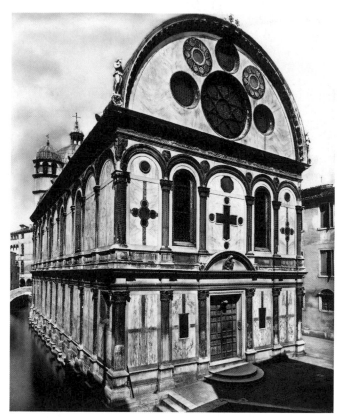

61 Pietro Lombardo, S. Maria dei Miracoli

pressly forbade members to complete a work begun by another if the original contractor had lost the contract without a compelling reason,[14] this clearly did not preclude the subcontracting of details to experienced and proven sculptors and architects. Giovanni Buora, for example, no doubt produced the splendid eagle capitals in S. Zaccaria (fig. 62) from his own designs and with reference to much older models. Lorenzo da Venezia probably created the portal of S. Michele in Isola to his own designs.[15] The often large differences between details in a single Venetian building also support the assumption that elements were often subcontracted to collaborators who designed independently.

When in 1483, after the death of Antonio Gambello (1481), Mauro Codussi was commissioned to complete the Benedictine convent church of S. Zaccaria (fig. 58),[16] Pietro Lombardo's S. Maria dei Miracoli (fig. 61) had been under construction for two years. Excellent personal contacts with influential aristocrats, some of whom had their tomb chapels in S. Michele in Isola, may have played a part in the award of the contract for S. Zaccaria, as in the later rebuilding of the Doge's Palace after the fire. The abbess was Lucia Donà, a relation of Abbot Pietro Donà, who had been responsible for starting the work on S. Michele in Isola.

Antonio Gambello had designed a rather low ground story. Codussi took up this idea and subdivided the façade quite independently from the interior into broad stories of different heights. The four dividing piers planned in Gambello's design were increasingly broken up by Codussi towards the top, the dividing and ornamental elements of the stories being integrated horizontally as well by corresponding motifs. Paired columns as in the portals of the Arsenal and SS. Giovanni e Paolo are predominantly featured and probably reminded the spectator of the facade of S. Marco. As in S. Michele in Isola and later in the Scuola Grande di S. Marco, the volume of relief increases towards the top; the low story below the semicircular pediment even combines a colonnade of double columns with an arcade, a motif anticipating the façade of the Palazzo Loredan (Vendramin-Calergi, plate 4). Codussi's unmistakable style is not to be found until the third level. In the two lower ones the effect is created by the contrast between a polychrome incrustation with Gothic moldings and the slender, extremely shallow fictive niches between pilasters. Because of its close ties through the abbess with the families of doges, S. Zaccaria

62 (*Opposite*) Antonio Gambello and Mauro Codussi, S. Zaccaria

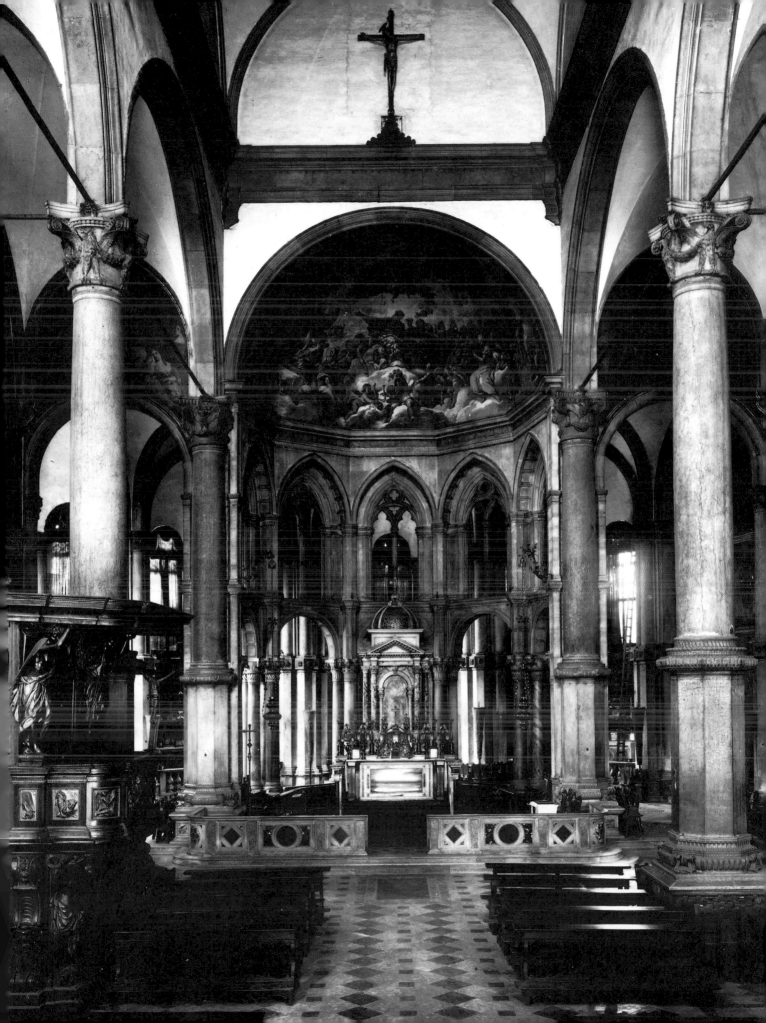

always had a special place among Venetian monastery churches. Perhaps the framing of colored marble areas by grey-green strips and above all the ample use of columns were supposed to make this relationship to the state church visible in the architecture.

The building history of S. Zaccaria is full of unsolved problems. Among the chief questions is whether Mauro Codussi modernized the choir (fig. 62) by introducing columns and whether the vaulting of the ambulatory reflects Gambello's original project. A number of inconsistencies, particularly in the vaulting, suggest changes of plan.

The splendid columns in the nave originated before Codussi's arrival; each of them on its own could adorn a public square as a monument and bear a lion of St. Mark. Like the columns of the Piazzetta, these columns stand on stepped octagonal pedestals, and one of the bases has what appear to be movable handles "riveted" to its diagonal sides, as if the sculptor had been inviting a Titan to test his strength on one of these monumental columns. Finally, the eagle capitals are a quotation from the "imperial" eagles of the earlier church, allegedly built by Byzantine craftsmen.[17]

The citations of elements from S. Marco, so striking in S. Zaccaria, are still more pronounced in S. Teodoro, a small church built in 1487 beside the sacristy of S. Marco,

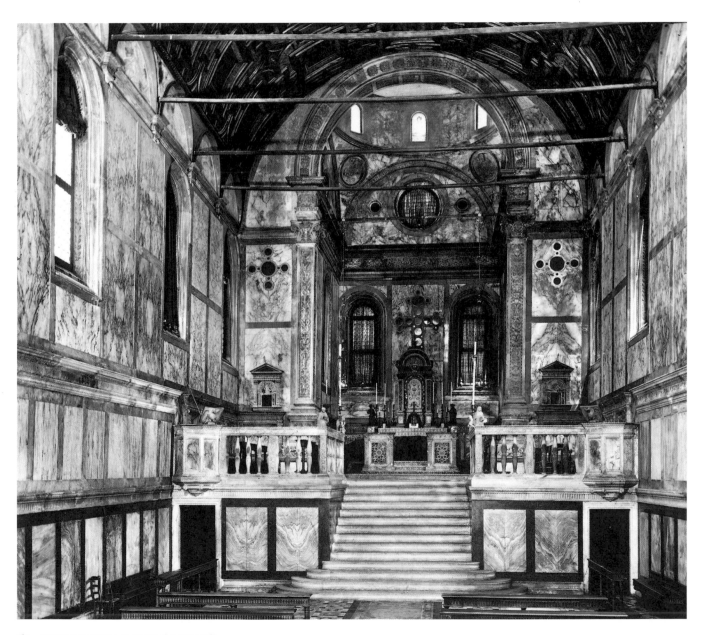

63 Pietro Lombardo, S. Maria dei Miracoli

in which the Inquisition court assembled during the summer months.[18] The semicircular apse is divided into two slender niches with three broader niches between them; the anonymous architect also symmetrically matched a further slender niche at the beginning of the nave wall to the first niche of the apse. It is possible that a previous Romanesque building on the site, which also served as the palace chapel, also had walls divided by niches.

In the year of Antonio Gambello's death (1481), two years before Codussi took over the building of S. Zaccaria, Pietro Lombardo was commissioned to construct S. Maria dei Miracoli (figs. 61, 63, 64, plates 5, 6).[19] In 1484 Felix Faber of Ulm disconcertedly noted that no German prince could have afforded such an edifice. Pietro Lombardo may have received the commission as the author of the tomb of Doge Pietro Mocenigo (died in 1476; fig. 124). His ability as a sculptor seems to have played a decisive part in getting the commission.

Unlike that of most Venetian churches, the exterior is ornamented on all sides like a precious reliquary. A pilaster order on the ground floor and the arcades on the upper floor enclose compartments in which colored marble slabs are inlaid, and these in turn are divided by cruciform red strips and framed by further grey-green strips. Pilasters and frieze make it clear that Pietro wanted to emulate classical buildings. The polychrome revetment recalls S. Marco but might have been associated by Venetian *litterati* with passages in Pliny[20] and Alberti[21] on the marble facing of ancient buildings.

Despite his Florentine experiences, Pietro Lombardo had not become the protagonist of the Tuscan version of the new style in Venice. He combined classical motifs like the frieze of the upper entablature with orders that no doubt met the demand for a style modelled on antiquity. Semicircular pediments were to be found at the time in S. Michele in Isola and, no less imposingly, in the façades of S. Marco. In its details, however, Pietro's architecture does not follow any of the buildings mentioned.

The single barrel-vaulted nave with the presbytery situated fifteen steps higher (having been added after a change of plan in 1485) is faced in marble like the exterior. Rather than by pilasters and entablatures, the wall is articulated by a structure of red marble frames, which incorporates the windows in its upper part. In deciding on a barrel-vaulted chamber Pietro Lombardo may have had in mind the Paduan Cappella degli Scrovegni as well as the very small, marble-faced (in 1430) Cappella dei Mascoli in S. Marco. The dome canopy with fenestrated drum has a thin-walled, delicate effect, compared to the fenestrated dome of S. Giobbe (after 1470).

Pietro Lombardo's flourishing workshop included his sons Tullio and Antonio, who had been praised as early as 1475 by the humanist Matteo Colacio as artists of high promise. Which of the many collaborators created the virtuoso ornamentation of the Miracoli church,[22] however, is not known. As compared to the frieze of the choir chapel of S. Giobbe, the forms are more sculptural, denser, so that the ground of the relief is often hardly visible. Foliated masks, putto heads, vases or wings are recurrent motifs. Similarly with the capitals: the calathus disappears almost entirely behind the proliferating foliage. Volutes entwined with leaves unfurl from a fine vase. The pedestals of the choir pilasters form the climax of this ornamentation. Across a ground of grey slate moves a procession of marble sea creatures which perhaps reminded collectors of graphic works by Andrea Mantegna. However, the motif dates from antiquity. Of a similar nature are the rather disturbing hybrid sphinxes flanking the

64 S. Maria dei Miracoli, choir, entablature

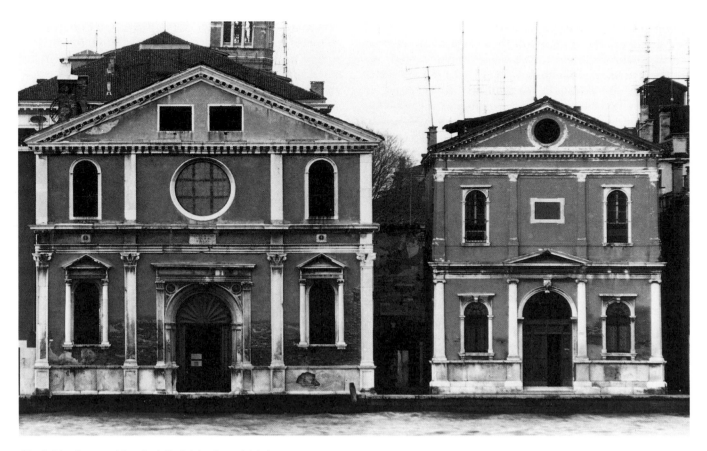

65 Spirito Santo and Scuola dello Spirito Santo (right)

altar of SS. Giovanni e Paolo (fig. 135), which once included Giovanni Bellini's *Sacra Conversazione.* Vasari (1568) may have had the marble carving of S. Maria dei Miracoli in mind when—talking about Venetian ornamentation—he praised the inventiveness of the sculptors and the unsurpassable execution of their works.[23]

On the choir pilasters of this church we find two exploding shells, a motif from the coat of arms of the duke of Urbino, Federigo da Montefeltre.[24] This poses the question whether these pilasters were designed by a sculptor who had previously worked in Urbino on the staircase of the ducal palace, or whether the martial motif had been chosen in ignorance of its meaning by one of the Lombardos (perhaps from a sketch). The pilasters in Urbino (pre-1474) resemble the Venetian examples not only in structure but in style, and those in the Miracoli are probably the work of a sculptor previously active in Urbino. The models for this heterogeneous ornamentation, therefore, are not to be sought in Lombardy, nor were Pietro, Tullio, and Antonio Lombardo alone responsible for its dissemination in Venice and Veneto.

The tabernacles for the sacrament and the two chancels (fig. 63)[25] and the altar rails are an original part of the Miracoli. Elaborately carved openwork panels divide the altar from the narrow presbytery, a solution that was doubtless chosen in consideration of the crowds of believers pressing around the miraculous image. Fifty years later, in 1535, Fra Francesco Zorzi recommended a similar solution ("balaustri ovvero quadri") for the altars in the chapels of S. Francesco della Vigna as if for a "sanctum sanctorum."[26] Both thus departed from the Venetian practice of having only short flanking stone barriers.[27]

Pietro Lombardo's exterior articulation of the Miracoli was highly influential. The orders placed one above the other were made flexible by the dimensions and proportions of the pilasters and the free choice of intervals, so that they could be applied without difficulty to any rectangular façade. Characteristic examples of this popular and long-lived type are the façades of Spirito Santo (Scarpagnino, 1506)[28] and the Scuola dello Spirito Santo (fig. 65) next door to it, and of S. Maria della Visitazione (1493).[29] In 1548[30] as the construction of S. Sebastiano came to an end, Scarpagnino placed freestanding columns close together at the ends of the façade and projected the entablature above them. The resulting possibility of forming groups of door and window openings was used by the architect of the Zitelle (fig. 87, begun in 1579), while the architect of the cathedral of Palmanova remained faithful to the traditional formula, though not

voluntarily. A decree of the senate (1599) had obliged him to follow the example of SS. Cosma e Damiano on the Giudecca.[31]

These churches are usually crowned by a triangular pediment, which can be embellished with figures or coats of arms. The pediment[32] used on S. Teodoro (begun in 1487) is also found on buildings with a raised central section: S. Rocco (begun in 1489), S. Maria Mater Domini (begun in 1504), and S. Maria Maggiore.[33]

It is unclear how the partly stuccoed church façades of today were originally painted. The surviving documents do not allow conclusions of wide scope, and investigations of the remnants existing here and there have not been published. In 1461 the Gothic church of S. Gregorio was stuccoed and painted white; in 1491 the painter Tommaso di Giorgio received two ducats for painting the façade of S. Teodoro, and a further five ducats in the same year for painting the no longer extant church of SS. Filippo e Giacomo.[34] Possibly the material used was *marmorino.* In the sixteenth century unstuccoed brick walls as used in Gothic churches seem to have gone completely out of fashion. The building contract for S. Martino (1553) even contains stipulations concerning the plaster.[35] The question of the use of color mainly concerns the relation of stone to plastered and painted wall surface, which often appears today as a contrast between different colors (e.g., white and red in S. Giovanni Crisostomo). In all probability the color of the stuccoed areas generally matched that of the dividing elements, that is, well-smoothed Istrian stone.

Architectural history has been especially concerned with the artistically outstanding buildings and so has neglected the many hall churches. S. Giobbe, Spirito Santo, S. Sebastiano, S. Giorgio dei Greci, S. Giuliano, S. Giuseppe di Castello are examples of such churches, the bare shape of which is compensated for by rich ornamentation. In many cases the impression given by the interior was dominated by flat wooden ceilings decorated with canvas paintings, S. Maria degli Angeli (Murano) and S. Maria della Visitazione being early examples. Pietro Lombardo's barrel vaulting for the Miracoli, reproduced in an engraving by Daniel Hopfer,[36] was an exception. These flat wooden ceilings, usually gilded,[37] made it possible to show extensive pictorial programs, which, leaving aside S. Marco, were rare in Venice. The painted decoration of S. Sebastiano by Paolo Veronese, which covered every inch including the walls, was an exception. Earlier, in 1518, one "Grisogono" had used a mosaic, no longer in existence, in the presbytery of S. Salvatore, and Pordenone had painted the choir of S. Rocco. Nothing remains of the painting of the ceilings of the Gothic Madonna dell'Orto by the Rosa brothers from Brescia (about 1556).

While Venetian churches have often been the objects of research, there is a lack of historical studies on monasteries and convents. Refectories and chapter houses, dormitories and cloisters have aroused little interest up to now. One might mention as representative examples of important enterprises a room as nobly proportioned as the twin-aisled refectory of S. Maria dei Frari,[38] entirely Gothic in style, as well as the atrium with four columns at the entrance of the monastery of S. Niccolò al Lido[39] and the chapter house of S. Giorgio[40] with its splendid portal.

In the fifteenth century there were still numerous buildings of a type originating in Byzantium and widely disseminated throughout Europe.[41] Of this group, the Byzantine models of which date from the eleventh and twelfth centuries, only S. Giacomo di Rialto is preserved, although it has undergone fundamental alterations. A dome canopy is contained in the central crossing bay of a square ground plan; this central bay is joined to four barrel-vaulted transepts, which describe a Greek cross. Between the "arms" of the cross are four lower domes, which fill the corners of the square. Today these structures are called *kreuzkuppel,* quincunx, or tetra-style churches, each of these recently coined terms emphasizing one element or another of these complex buildings. In 1581 Francesco Sansovino noted a close link between three Venetian churches of this group and S. Marco. S. Salvatore, he argued, was modelled after the central part of S. Marco, S. Maria Mater Domini had been restored on the example of the "central dome" of S. Marco, while the vaulting of S. Giacomo di Rialto might be said to be the prototype of S. Marco.[42] Sansovino seems to have been thinking primarily of the arrangement of a central dome with barrel vaulting above the cruciform arms, a form that, despite all the differences of type, links S. Marco with the Venetian Renaissance. He pointed to the common link with local pre-Gothic traditions and implicitly discounted formal differences between S. Marco and S. Giacomo di Rialto as irrelevant. What he took to be type-specific was the vault area, which in the case of S. Maria Mater Domini he saw as derived from the middle *cuba* of S. Marco. From this Hubala derived the term *cuba,* referring not to the dome alone, as in a literal translation of the dialect word *cuba,* but in Sansovino's sense, to the combination of "barrel, dome, and arcade structure."

The question arises whether the decision in favor of a traditional building type, which had strong ideological implications (S. Giacomo di Rialto as the oldest church at Rialto and the model for S. Marco), was justified a posteriori by Sansovino or should be understood as expressing the commitment of Renaissance architects and patrons to their own tradition. The supposition that it was a return to Venetian tradition and *not* a revival of the Byzantine style is supported by the Venetians' pride in their own history. Such a return to local traditions did not exclude the use of recent stylistic developments

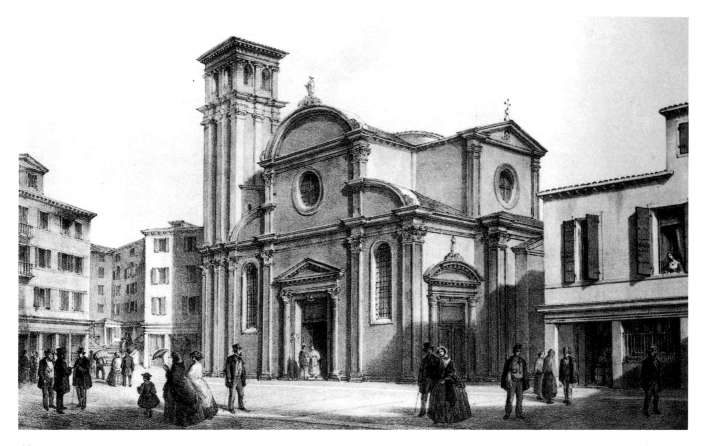

66 Mauro Codussi, S. Giovanni Crisostomo. From Moro, *Venezia monumentale pittoresca,* Venice 1859

by architects such as Codussi, who alluded to modern Tuscan architecture in his slender, round-headed windows, for example.

The earlier works in this group included, before its demolition in the nineteenth century, S. Andrea della Certosa.[43] The Carthusian monks' need for seclusion gave rise to a rather individual combination of a largely closed section of the building reserved to the monks, and a church built on the *kreuzkuppel* pattern. Only written documents will be able to answer the question whether this building was designed by Codussi.

Codussi's approach to traditional buildings is seen in S. Giovanni Crisostomo (under construction in 1494, figs. 66, 67).[44] The external proportions of the building are seriously impaired today by the raised street level, as the strongly sculpted socle was an important element of the building.[45] Frankl has aptly characterized the interior: "The crossing piers are so thin that the primary impression is of a single room with four piers added later, and the continuous hall below seems to be split up into isolated spaces only at the level of the vaulting. Following upon this the cruciform transepts have cross-vaulted ceilings."[46] The architectural features are restrained, almost meager—richly foliate ornamentation like that in

Pietro Lombardo's buildings is lacking—the beauty of the church lies in the grouping of domes and barrel and groined vaults, each being allocated to distinct parts of the building.

In every analysis, however, one should bear in mind that the parts made of Istrian stone were originally white with a slightly grey or yellow tinge. The separation so clear today between the grimy stone parts—the articulating ("load-bearing") elements—and the white stuccoed areas between them was never intended to be so sharp.

Considered as a type, S. Giovanni Crisostomo is a centralized building although, like most of its kind, it was given a direction by the lengthening of the choir chapel. The clear view of the interior that was no doubt particularly prized in Venice was developed still further by Codussi in S. Maria Formosa (decision to build in 1491, begun in 1492).[47] There the walls of the side chapels are opened by *bifore,* so that the visitor can see the altars immediately on entering.

The "severe" style adopted by Codussi for his churches also shaped the interior of S. Fantin (begun in 1507, vault 1538, fig. 68).[48] This happened despite the 1504 will of the founder, Cardinal Giovanni Battista Zen, which

expressed a desire for a polychrome decoration with marble columns, setting aside a substantial sum for them. The designer of S. Fantin is unknown; the fact that Scarpagnino directed the work does not mean that he designed the building. The starting point of the design was the *kreuzkuppel* church, although—unlike the usual arrangement—the pilaster sections in the chapels are broader and taller than the graceful orders set on oversize pedestals facing the nave. At the head of the choir are fluted freestanding columns bearing the dome, as in a tabernacle. Here at least the founder's wishes were met. Similar solutions are to be found in the Cappella Corner at SS. Apostoli (building permission 1483, completion 1499),[49] in S. Bernardino at Urbino and, in combination with a groined vault, in S. Salvatore at Spoleto.[50] Freestanding columns in the corner of the room are also found, however, in the medieval baptistry of S. Marco.

Externally, S. Fantin is faced almost entirely in Istrian stone, and the stucco areas in the upper part were doubtless of matching color. The heavily carved socle, so important to the effect of the building, has unfortunately disappeared beneath the pavement, as in the case of many Venetian buildings.[51]

The system of the pre-Gothic church, revised by Codussi, could be adapted to the spatial needs of a monastery church like S. Salvatore (fig. 69) by interlocking additions. The model of Giorgio Spavento chosen in 1506 seemed to the prior not only more dignified and beautiful but also more fitting to their needs.[52] As façade decoration, marble in various colors was envisaged.[53]

In 1507, while Spavento was still alive, the detailing of the design of S. Salvatore was entrusted to Tullio Lombardo, together with the management of the project.[54] This procedure, which may have been common in Venice, pulls the rug out from under any attempt to attribute the design of such buildings on grounds of particular features.

The multiplication of the "system" of the *kreuzkuppel* church by interlocking addition as in S. Salvatore is especially clear in the rhythmical sequence of the three domes. The low cells look like canopies placed against the walls. The use of these areas for chapels was convenient and was functionally in the tradition of the medieval baldachins (*cappelle*), freestanding or abutting on walls. The rhythm conferred on the building by the low, shaded canopies and the high, domed transepts bathed in

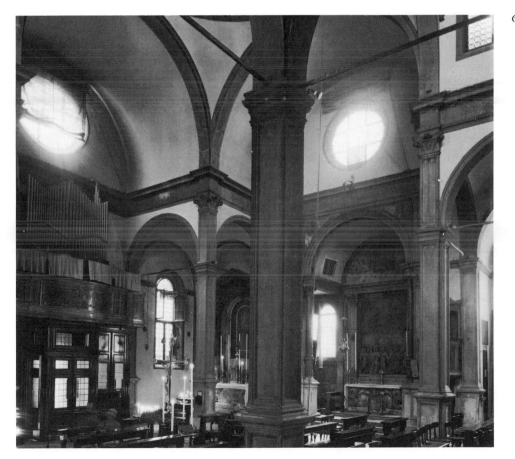

67 Mauro Codussi, S. Giovanni
Crisostomo

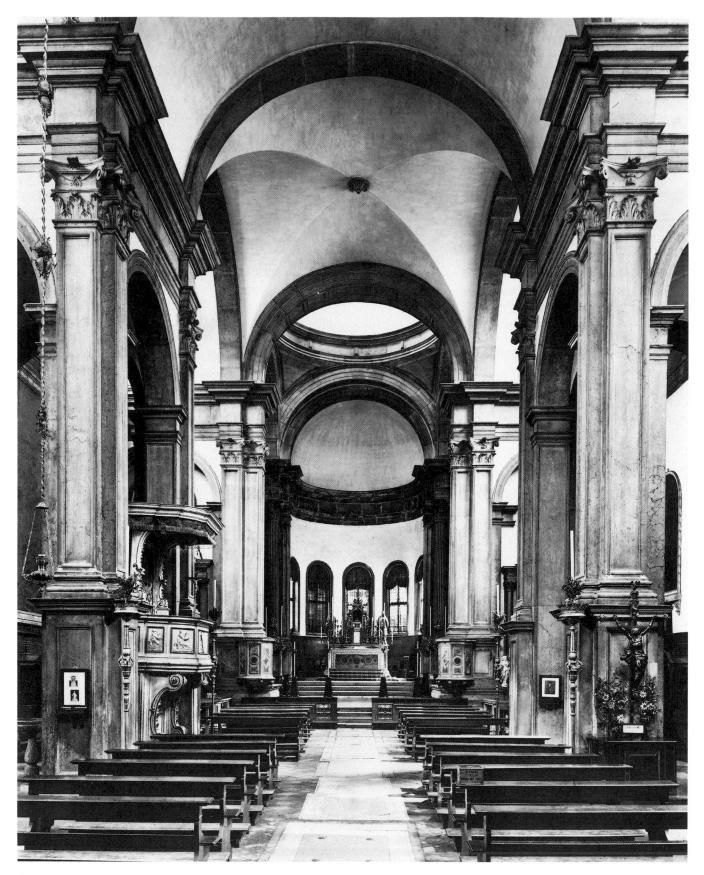

68 S. Fantin

light from the windows was obliterated in 1569 by the opening of the previously dark domes, so that the strong light from the fenestrated apse lost its predominance. In 1518 the choir chapel was embellished with mosaics, doubtless in imitation of the previous building described by Sanudo in 1493, and was thus clearly distinguished from the other parts of the church.[55]

Even in its strongly individual features, Spavento's design is explained by Venetian conditions. That similar aims were also pursued outside Venice is shown by the church of S. Sepolcro in Piacenza (begun in 1488) and the planning of S. Giustina in Padua. Fra Giocondo's plan for the new St. Peter's in Rome has been traced back to S. Salvatore.[56] New, and probably conceived by Spavento, was the supporting of the vault zone by an attic inserted above the entablature. This made the proportions of the bays more slender, even though the dividing pilasters look somewhat squat. This raising of the walls may have been suggested by S. Marco, where a comparable zone is found in the area of the crossing.

The top of the façade type created by Mauro Codussi was changed at the beginning of the sixteenth century, in a way perhaps not unrelated to buildings in central Italy. In the façade of S. Croce on the Giudecca (ca. 1508–11),[57] for example, triangular segments of pediments were added above the side compartments and a triangular pediment above the middle one. This and related façades therefore resemble, in essential features, a reconstruction of the ancient temple *in antis* by Cesare Cesariano (1521, fig. 70). Whether the anonymous architect was aware of the resemblance is not known; it seems likely that readers of Cesariano's commentary on Vitruvius would have interpreted the façade in this way. The reference to churches as temples (*templum*), widespread at the time, may have facilitated such associations. As the lateral pediments of S. Croce run parallel to the slope of the central pediment, they could be understood as part of a second pediment "overlapped" by the first. Because the ground plan of Cesare Cesariano's reconstruction of an ancient temple closely approximated that of the Venetian *kreuzkuppel* church, some learned contemporaries may have questioned Sansovino's assertion that the type was of Venetian origin.

The number of Venetian *kreuzkuppel* churches was great, and basic structural changes were few. The most striking of these was the replacement of Codussi's horizontally divided support of the dome canopy by a half or three-quarter column (e.g., S. Maria Mater Domini, from 1504; S. Geminiano, designed by Cristoforo da Legname, 1505). This made the central dome stand out from the rather rigid-looking framework, while recalling the columns of early *kreuzkuppel* churches like S. Giacomo di Rialto.

That the *kreuzkuppel* pattern was not from the outset the obvious choice for Venetian monastery churches is

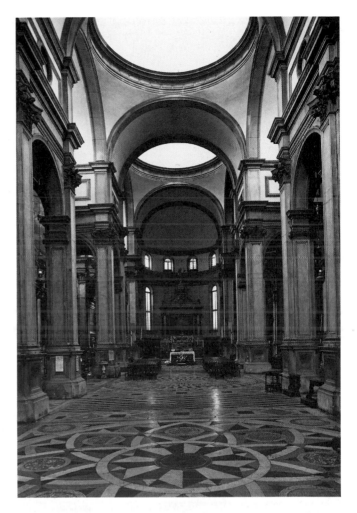

69　Giorgio Spavento and Tullio Lombardo, S. Salvatore

shown by a design produced by Tullio Lombardo in 1521/22 for the Benedictines of S. Giorgio. This plan envisaged three naves, the central one probably barrel vaulted, with semicircular chapels off the aisles and an atrium. The domes above the choir, crossing, and transept recall S. Giustina, the mother church of the congregation in Padua, while semicircular side chapels had been employed previously by Biagio Rossetti for S. Benedetto in Ferrara.

Venice's appearance is shaped not only by the façades of the churches but still more by their domes and bell towers (*campanili*). That contemporaries were aware of this is shown by the view of the city in the pilgrim's guide (*Peregrinatio in terram sanctam*) by Bernhard von Breydenbach (1486). Next to the square towers, in the sixteenth century, stood the hexagonal tower of S. Paternian and, as de' Barbari's view of 1500 reveals, on the island of S. Secondo there was even a round tower reminiscent of those in Ravenna. Among the artistically outstanding tower structures of the Renaissance were the campanile of S. Pietro di Castello (begun in 1482) and the

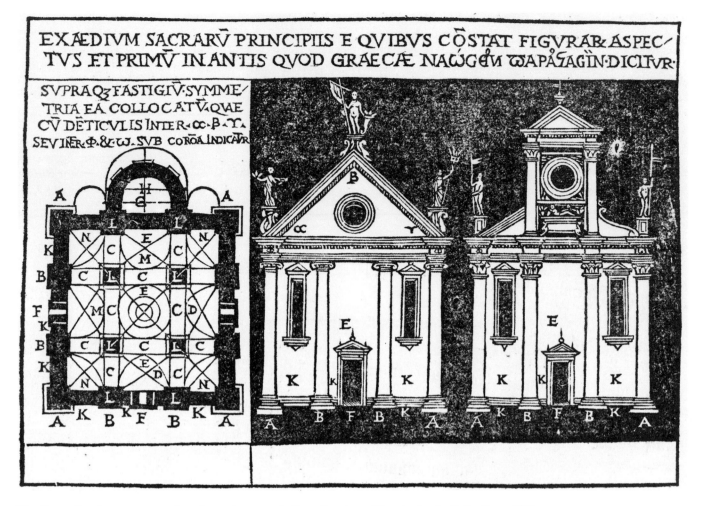

70 Cesare Cesariano, reconstruction of an antique temple. From Cesariano, *Vitruvius Lucius Polio,* Como 1521

especially fine tower of the Madonna dell'Orto (completed in 1503). While the campanile of S. Marco received its pyramidal, gilded pinnacle about 1514 at the instigation of Procurator Antonio Grimani, the anonymous architect of the campanile of the Madonna dell'Orto opted for a much more complex structure. Above the square belfry he erected a tall round drum with a balustraded gallery, placing on it a very skillfully constructed brick helmet resembling an onion dome in profile. In addition, there were segmental pediments on the four sides of the belfry. His attempt to transform a traditional type, with his lead-covered, slightly raised dome on an octagonal intermediate register above the belfry and the decorative tabernacles that often accompanied it, did not find imitators in Venice. Lead-covered, slightly raised "Venetian" domes on the belfry, or steep pyramids (like the tower of S. Francesco della Vigna, for example), as well as the cylindrical helmet, probably the oldest form of all, are also to be found in later periods.[58]

The effect produced by many interiors of Venetian churches is largely determined by the chapels[59] and their furnishings. S. Giobbe and S. Francesco della Vigna are prominent examples. In the chapels the owners could put into practice their ideas of the proper ornamentation of a sacred space. Churches like S. Giorgio and Il Redentore with their architecturally unified altars differ in this from most earlier buildings. By the kind of decoration used and the artist chosen the donors could remind the onlooker of their origins. The Martinis imported terracotta decoration by Luca della Robbia for the vaulting of their chapel in S. Giobbe, and Donatello's *John the Baptist* was displayed in a chapel of the Scuola dei Fiorentini in S. Maria dei Frari.

Among the architecturally outstanding chapels is the Capella Corner in SS. Apostoli (begun after 1483 and completed before 1499), usually attributed to Codussi. Its lead-covered dome distinguishes it from almost all the other chapels in Venetian churches.[60] Inside, the architect has placed four partly twisted and partly fluted columns on tall pedestals.[61] Together with voluminous

corbels they support an entablature strongly projecting over the columns, which conceals the bases of the arcaded arches.

In almost all Venetian churches we find to the right and left of the choir, in keeping with Venetian liturgy, two pulpits for the reading of epistles and gospels (*ambo, pergolo, pergoletto*).[62] The pulpits of S. Maria dei Miracoli (ca. 1480, fig. 63) and S. Fantin (1564, fig. 68) are characteristic examples. The freestanding pulpit in the shape of a chalice in S. Giacomo dell'Orio (fig. 71), included by Francesco Sansovino among the sights worth seeing in Venice, was unique.[63]

The rood screens (*barco, pontile*)[64] separating the areas of the laity from those reserved for the clergy, to be found earlier in large numbers in Venetian monastery churches, have almost all been lost. The congregation would see the high altar through one or more arches. Carpaccio has depicted a very fine Gothic screen in S. Antonio di Castello.[65] The documents lend evidence of many others. The choir of S. Maria dei Frari (ca. 1470)[66] and the *pontile* of S. Michele in Isola (fig. 59)[66] are still preserved. These structures were often also used as a raised tribune.[68] The screen of S. Maria dei Frari includes the magnificent late-Gothic choir pews. Almost all were

71 Chalice-shaped pulpit. S. Giacomo dell'Orio

72 Cappella Emiliani at S. Michele in Isola

removed following the decrees of the Council of Trent, but parts of such features have been preserved in S. Stefano and S. Giovanni in Bragora.[69]

Often in contrast to the sparsely decorated interiors of Venetian sacred buildings such as S. Giovanni Crisostomo, S. Salvatore, or S. Fantin are opulent altars and tombs. But in architecture itself, this rich style, which sometimes seems marked by a *horror vacui,* failed to establish itself. One exception is the chapel next to S. Michele in Isola founded by Margherita Miani and planned in 1527, but only completed in 1543 (figs. 57, 72).[70] Guglielmo de' Grigi (in Venice from 1506, died 1550) had distinguished himself previously as the architect of, among other works, a city gate at Padua, the Porta Venezia (1519), and as the designer of several altars including the one for Verde della Scala (SS. Giovanni e Paolo).[71]

From a distance the dominant feature is the dome of white stone above the hexagonal building. Fluted columns with added ribs and very pronounced entasis mark the corners. The niches between them and the horizontal oval windows are linked by ornamental motifs. The building can be entered from outside or from S. Michele. After passing through the antechamber, a low domed *tempietto* with fluted columns hardly over life-size, carved stone railings, and a richly inlaid floor, one enters the bright, colorful chapel. Not a centimeter of wall is without facing; only the shell of the dome is stuccoed. A complicated color pattern on the floor makes an awkward attempt to mediate between the hexagonal perimeter and the central circle. Coupled fluted columns support arches on which the dome rests. The columns are connected at the back to shallow moldings and accompanied by pilasters. Slabs of different-colored marble are mounted above the portals like pictures in frames and linked by ornamental motifs, in an encrusted style for which, at least today, Venice offers no models. Some of the decorative motifs, particularly the omnipresent scrolls, were highly esteemed by Serlio. His Fourth Book (1537) is full of them. Many people would have regarded this architecture as thoroughly modern at the time.

The altars by Giovanni Battista da Carona, another Bergamask artist, erected in 1539, fit into this solemnly ornate setting with no breach of style. The main role of sculptor-architects like Guglielmo de' Grigi or his colleagues from Lake Como was to provide Venetian churches with richly decorated altars and tombs. Few of them made their mark as architects.

Jacopo Sansovino and His Contemporaries

Jacopo Tatti, called Sansovino, did not receive a commission for a church until seven years after he had taken up residence in Venice.[72] His first design for S. Francesco della Vigna[73] (1534) has been recorded on a medal by Andrea Spinelli showing a profile of Doge Andrea Gritti on the back—a man who gave special support to both the building and the architect. From the start, influential families made a decisive contribution to the finances by acquiring chapels. The façade design, strongly influenced by tradition, resembles Venetian buildings like S. Maria Mater Domini and S. Maria Maggiore, though Sansovino might rather have had central Italian façades in mind.[74] The traditional elements included the tripartite division by pilasters and the oculi above the door and in the pediment, while the volutes linking the low side sections to the high middle one were common in central Italy (Rome, Tuscany).

The beauty of Jacopo Sansovino's design lay no doubt in the detailing and the proportions, and perhaps in the costly materials—features not recorded by the medal, which seems imprecise in some details. In 1542 the Grimani were granted permission to erect a façade monument (*sepultura*) to Doge Antonio Grimani in a design already in existence—an addition that made changes to Sansovino's project inevitable. A few months later the Grimani procured rights to the inner entrance wall as a burial site for Vettor Grimani and his family.

Sansovino's first project, as recorded on the medal and never convincingly reconstructed, seems to have been revised shortly after work started. The dome and with it the organization of the nave intersection, possibly recalling S. Spirito in Florence, were eliminated. This decision seems to have given rise to conflicts that were settled in a report by the highly respected Franciscan monk Francesco Zorzi in 1535. In it Zorzi stressed that nothing fundamental needed changing in Sansovino's project. Some well-founded suggestions he made for modifications of detail were not accepted. For acoustic reasons he recommended a flat, grey-painted coffered ceiling in the main nave instead of a vault and, as regards the proportions, a coordination of the façade with the interior. Long stretches of his text sound like a vindication of Sansovino's rather unexciting project. This applies not only to the symbolic proportions, to change which, in the words of Leone Battista Alberti, would ruin the "music" of an entire structure, but also to the argument that the simple Doric order suited St. Francis and the Franciscans. The bare, meager forms are therefore not to be explained by financial considerations, although Fra Zorzi's report does make it plain that even at that time Sansovino's design, determined by decorum, was in need of elucidation.

In the design of the interior (fig. 73) Sansovino very closely followed Cronaca's Franciscan church in Florence, S. Salvatore al Monte. The pilasters, mounted on high pedestals with elaborate panels, and capitals with fluted necks recall traditional Venetian buildings like

S. Fantin (fig. 68); breaks with local tradition like those in Sansovino's public buildings on the Piazza are nowhere to be found. After abandoning the central dome which, to judge from the medal, was to be mounted on a more spacious crossing, Sansovino used the elevation to hint at a centralization in front of the presbytery and below the vaulting. The arch of the choir and the transepts are of equal height and form a kind of crossing, though this is not reflected in the vaulting. A surprising feature is the choir, which almost equals the main nave in depth. Palladio chose a rather similar solution in S. Giorgio (1565).

That Jacopo Sansovino adapted local traditions is shown by his parish church of S. Martino near the Arsenal (designed about 1543), finished in the seventeenth century.[75] Despite extensive changes to the façade since 1897, the similarity to Venetian *kreuzkuppel* churches is obvious. The familiar shape no doubt reflected the ideas on the proper appearance of a church in an extremely modest parish.

In the interior Sansovino took over a number of tradi

tional elements of parish churches—the flat-ceilinged hall and the Greek-cross plan, though this was visible in the ground plan and not just in the ceiling, as in Venetian *kreuzkuppel* churches. The low chapels adjoining the higher arms of the cross on all four sides, with three steps leading up to them, recall the intersection of a *kreuzkuppel* church. The wall areas with their elongated Doric pilasters are the dominant element in the brightly lit nave. The increased lighting high up, as compared with older buildings, was in line with expectations. In the second half of the century the domes of several of the older, dimly lit churches were opened up by lanterns, as in S. Salvatore (1569) by Scamozzi, and in S. Giacomo di Rialto; in other churches more light was let in by new windows (S. Fantin) or by changes to the presbytery (S. Giovanni Crisostomo).[76]

In these years Sansovino tried out other solutions unconventional in Venice. The façade of S. Spirito in Isola (ca. 1542, fig. 74) with its three bays and three equal-sized windows in the upper story found imitators, characteris-

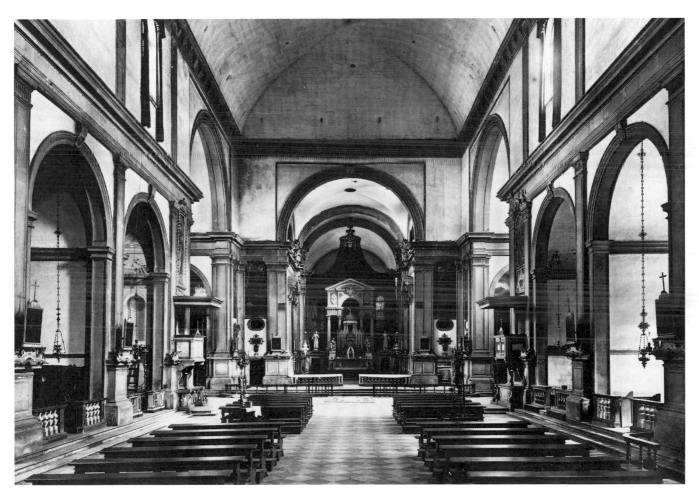

73 Jacopo Sansovino, S. Francesco della Vigna

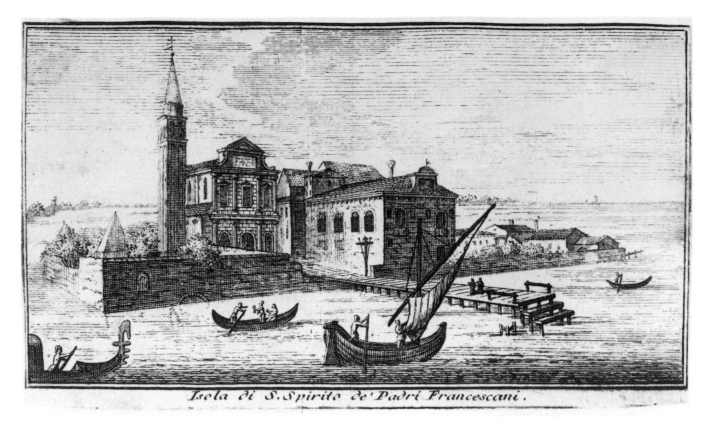

74 Jacopo Sansovino, S. Spirito in Isola. From *Forestiere illuminato intorno le cose più rare . . . della città di Venezia*, Venice 1765

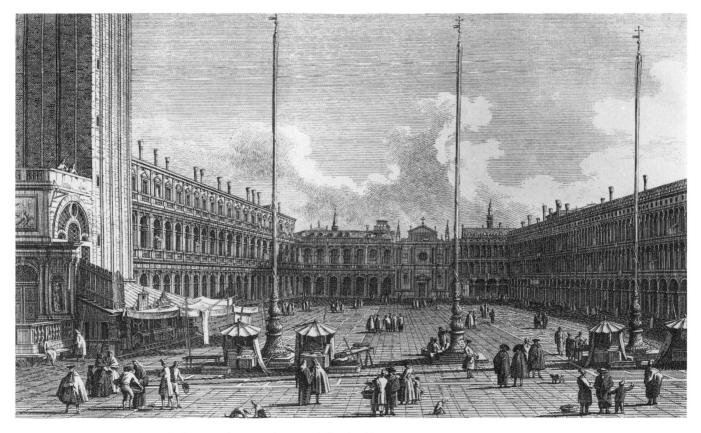

75 A. Visentini after Canaletto, the Piazza with Jacopo Sansovino's façade of S. Geminiano

tically, among the scuole and not in church architecture.[77] The surprisingly profane effect of this façade is clear from comparisons with later assembly halls of some of the scuole and the front of Sansovino's Fabbriche Nuove at the Rialto.

In completing the parish church of S. Geminiano opposite S. Marco (fig. 75), demolished in the nineteenth century, factors resulting from its conspicuous position had to be considered. For this reason the plan by the learned and egocentric physician Tommaso Rangone to have a portrait of himself mounted on the façade was doomed to failure from the start. S. Geminiano was squeezed between buildings several stories high on both sides. This is probably why Sansovino decided in 1552 on a two-story façade with a central attic surmounted by a pediment and flanked by volutes. He also chose coupled semicolumns, so setting up a visual relationship to the façade of S. Marco, though without literal quotation, a connection seen perhaps more clearly in the archaic-looking "Gothic" tabernacles above the lateral bays. Compared to the local tradition, the architectural relief looks condensed and animated, with the windows fitting tightly into the wall spaces, and residual spaces on the upper floor broken up by geometrical patterns surrounding tondi, as an adaptation of the local tradition of polychrome marble facing to a monochrome stone façade.

After his unsuccessful attempt to have his monument mounted on the façade of S. Geminiano, Tommaso Rangone succeeded in 1553 in getting the senate's agreement to a façade monument on S. Giuliano (figs. 76, 147).[78] The bronze figure by Jacopo Sansovino was completed by 1557 with the help of Alessandro Vittoria, but the construction of the façade was delayed; the contract for the present façade was accepted in 1566. As late as 1576, six years after Sansovino's death, Rangone mentioned in his will that he would build (complete?) the façade to designs by Sansovino and Alessandro Vittoria. Temanza's conjecture of 1778 that Vittoria changed only details of Sansovino's design seems to be correct. The epitaph does not look like an addition to the façade, like the statue of Vincenzo Cappello (1542) on S. Maria Formosa, but is fully integrated with it. The memorial and the large laudatory inscription are split between two levels clearly distinguished from the façade partly displaced "behind" them; yet at the same time they are linked to it by the continuous entablature. The contrast between the rather delicate elements of the façade and the robust epitaph is lessened higher up and disappears in the pediment, a decisive step towards the identification of façade and epitaph practiced by later sculptors and architects.

For the interior of S. Giuliano an almost square hall with rectangular groin-vaulted choir and choir chapel was chosen. The effect is governed by the sumptuous flat wooden ceiling[79] designed by the stucco-worker Ottaviano Ridolfi (?) in 1585, with its inset canvas paintings

76 Jacopo Sansovino and Alessandro Vittoria (?), S. Giuliano. (Giampiccoli)

and the horizontal cornices dividing the walls of the room. In keeping with taste and traditions the walls and ceiling carry pictures. The placing of the four side altars creates areas that are emphasized though not spatially cut off. Paintings and ensembles of sculpture articulate the available areas, as in the halls of the scuole or the Doge's Palace.

The oval as a shape for a ground plan is to be found only in a grotto of the "Palazzo" Trevisan (Murano, fig. 110) in Venice, yet in the field of decoration it was very popular after the middle of the century, as is shown by ceilings in churches (e.g., S. Sebastiano) and scuole (S. Rocco), as well as several rooms in the Doge's Palace. Even Sansovino's church for the Ospedale degli Incurabili (nearly complete in 1567, demolished in the nineteenth century)[80] was not a genuine oval but a combination of a rectangle and two semicircles (fig. 34).[81] The four simple, identical, diagonally arranged side altars and the slender round-topped windows contrasted with the magnificent ornamentation of the choir chapel. A flat wooden ceiling embellished by powerful cornices, together with the ovoid shape of the room, created especially good acoustics for the famous masses sung by orphan children. The singers stood in three separate galleries, which facilitated the performance of pieces for several choirs, such as were composed in Venice above all by Adriaan Willaert for S. Marco.

After two decades of success quieter times arrived for Sansovino. There were no important architectural commissions after the Palazzo Corner, and his designs for the

77 Jacopo Sansovino, tomb of Doge Francesco Venier. S. Salvatore

cathedral of Padua (1549) were promptly rejected.[82] Andrea Palladio's façade of S. Francesco della Vigna (ca. 1562) therefore takes on symbolic importance in Sansovino's biography. By that date Sanmicheli too had produced a model for the monastery of SS. Biagio e Cataldo on the Giudecca (before 1563) and so finally attained success in the ecclesiastical sphere. Sansovino's small commissions, like the restoration of the Cappella Emiliani (1560 and 1563)[83] or the design of an altar for S. Maria Maggiore (1558),[84] which was executed by Giangiacomo de' Grigi, must have been welcome. Sansovino had produced designs to be executed by less prominent masters earlier as well, as is shown by his altar for S. Maria Mater Domini (1536),[85] realized by Antonio Buora. The stylistic variation between these smaller works is very great.

Characteristic of Sansovino's readiness to express himself in local dialect if the need arose is his tomb for Doge Francesco Venier (died 1556) in S. Salvatore (fig. 77). Here Sansovino's concessions to Venetian tradition go much further than previously, although the question does arise whether he was bound to traditional elements by his contract. The antiquated elements can hardly be explained as an attempt to integrate the tomb into earlier architecture, as in the case of the tomb of Archbishop Livio Podacataro (died 1555) in S. Sebastiano.

The four large composite columns with much smaller Ionic columns placed above them, a combination that would have seemed positively anarchical to any architect trained in Rome, recalls much earlier altars, like that of S. Zaccaria and the high altar of S. Rocco (1517),[86] and Sansovino could also invoke Venetian tradition for the richly polychrome use of materials and the gilding. However, in the case of tombs it was certainly not questions of style but of decorum that were primarily discussed in Venice. In his commentary on Vitruvius of 1556 and 1567,[87] Daniele Barbaro took issue with the magnitude, the laudatory content of the inscriptions, and the sheer expenditure in erecting tombs. Gian Matteo Giberti, bishop of Verona, noted about the middle of the century that the tombs distracted the gaze of the faithful from the altar, an assertion that will be readily understood by a present-day visitor to S. Salvatore, for example.[88] But the opposite view was also held. In 1539 Giraldi recommended costly materials, above all porphyry and bronze, for the tombs of princes. Here too, therefore, there were controversial proposals and evaluations that provided the well-read observer with the means of forming a judgment of his own.

Sansovino's project for S. Francesco della Vigna was no more influential in Venice than his palaces. This was shown as early as 1539, when the Greek community commissioned Sante Lombardo to build S. Giorgio dei Greci (fig. 78). Like Pietro Lombardo in S. Maria dei Miracoli and like the anonymous architect of S. Fantin, Sante Lombardo covered all the exterior façades of the

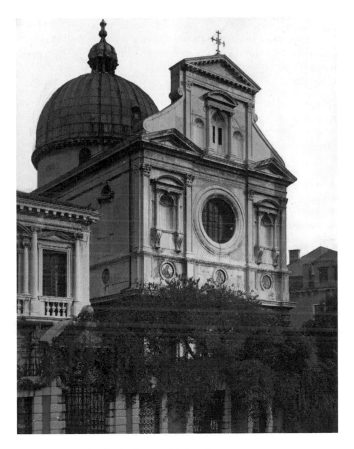

78 Sante Lombardo, S. Giorgio dei Greci

hall church with stone, so extending characteristic motifs of the façade to the sides—a very uncommon enrichment in Venice. The unconventional façade is reminiscent in its two upper stories of an earlier "Lombardesque" sacrament tabernacle in S. Martino, and the multiframed niches in the raised middle section are very similar to those in Alessandro Vittoria's altar in S. Francesco della Vigna (1561, fig. 149).

The deviation from both traditional and modern forms could be explained by the Greek community's desire to be distinct from the other Christian communities in Venice in the external appearance of its church. Sante Lombardo drew on his repertory of decorative niches, massive consoles, and frames-within-frames already tried out on the rear façade of the Scuola Grande di S. Rocco (fig. 94).

For the interior a hall form was chosen, which can be traced back to S. Andrea della Certosa and the choir chapels in Codussi's S. Michele in Isola. A long chamber with barrel vaulting is dominated by a cupola raised on a high drum. Comparable ceiling effects can be found in earlier, flat-ceilinged hall churches like S. Maria della Visitazione or S. Maria degli Angeli (Murano), where the coffers in the flat wooden ceilings are arranged around an emphasized center. An entablature supported on cor-

bels, as in Codussi, marks the transition from wall to vaulting in S. Giorgio dei Greci, and a cornice divides the wall horizontally. Horizontal and vertical moldings intersect on the walls to form a framework that does not, as in S. Francesco della Vigna, for example, simulate or represent structural functions but articulates surfaces in terms of framework. The large consoles treated as sculptures become features in their own right and parallel the proliferation of ornamental forms across the borders of decorative systems. The same phenomenon can be observed in ceiling decoration by Alessandro Vittoria after the middle of the century (e.g., the Scala d'Oro in the Doge's Palace).

Soon after work started on S. Giorgio dei Greci, S. Maria Formosa was given a new façade.[89] This was occasioned by the wish of the Cappelli to erect a façade monument to Admiral Vincenzo Cappello, who died in 1541. The arrangement of the pedimented façade was traditional, the details, above all the funnel-shaped windows and the clusters of pilasters, recall S. Giuliano (fig. 76). The sculptor Domenico di Pietro Grazioli da Salò signed the very stiff figure of the admiral; there is no record that he also designed buildings. Sansovino may well have had a hand in the work. When compared to the timid traditional façade of S. Sebastiano, Scarpagnino's late work (1548),[90] the qualities of the underrated façade of S. Maria Formosa are especially clear.

Andrea Palladio

With his Venetian churches Palladio set new standards not only for Venice and Veneto.[91] The Convent of S. Maria della Carità (1555/56), the façade of S. Francesco della Vigna (1562), the plans for S. Pietro di Castello (1558), S. Giorgio (1565), and Il Redentore (1576) show a radical break with local traditions that was impossible in palace design.

The considerations that induced the Lateran prebendaries of S. Maria della Carità to award the commission to Palladio are not recorded.[92] Their close ties to Rome may have fostered a wish to make the link visible in the new convent building (figs. 79, 80). As the author of the *Antichità di Roma* (1554) and a collaborator in Daniele Barbaro's commentary on Vitruvius (1556), Palladio was especially qualified for the task. In 1555 Anton Francesco Doni had recognized the importance of his theoretical knowledge and suggested the title *Norma di vera architettura* for Palladio's still unpublished treatise.[93] Additional evidence came from Palladio's buildings on the mainland.

Palladio's decision to design the convent along the lines of his idea of the ancient house ("casa degli antichi")[94] had implications for life within it. Beside the existing Gothic church he erected an atrium with four colossal composite columns on each side, supporting

79 Andrea Palladio, atrium, Convent of S. Maria della Carità. After Palladio, *I quattro libri dell'architettura*, Venice 1570

balconies onto which the well-lit and well-ventilated cells of the prebendaries opened. There had been no freestanding columns of similar dimensions in any previous Venetian courtyard.

A sacristy (Palladio equated it with an ancient *tablinum*) and a chapter house adjoined the atrium symmetrically. This sacristy differs clearly from its Venetian predecessors, which usually lacked architectural pretensions. Only the sacristy of S. Salvatore, probably built in the first half of the century, shows a design of comparable complexity, though quite different in form.

The cloister, which Palladio equated with the ancient peristyle, makes plain the links to modern Roman architecture, as in the courtyard of the Palazzo Farnese. The superimposition of the orders (Doric, Ionic, Corinthian) was without precedent in Venice. Earlier cloisters, like that of S. Giorgio (1516, Giovanni Buora) and S. Niccolò al Lido (1530), are quite different, and even that of S. Stefano (1529–32, fig. 81), despite its "modern" colonnade

with its entablature subtly projecting over the columns, had its place in Venetian tradition.

However, in details like the Doric frieze, which is not divided into triglyphs and metopes, and in the choice of brick, Palladio distanced himself from contemporary buildings influenced by Roman theaters, like the courtyard of the Roman Palazzo Farnese. In its shallow format the high-quality brick transported at great cost from Ferrara resembled the material of ancient buildings. Whether a *marmorino* coating blended with the white stone elements or Palladio intended the colorful contrast between the white stone and the yellowish brick in remembrance of Roman ruins is an open question.

Soon after, Palladio's project for the episcopal church of S. Pietro di Castello (1558) was formed. Vincenzo Diedo, the patriarch of Venice, thus aligned himself with the partisans of Palladio, among whom Daniele and Marc'Antonio Barbaro were the outstanding figures. Palladio's design has been lost, and the façade executed much later by Francesco Smeraldi deviates from it in im-

portant respects, as can be seen from the text of the contract for Palladio's façade. By and large Palladio's façade with its four monumental columns probably resembled his later designs. That this break with Venetian tradition was sanctioned by the patriarch is not without interest. Michelangelo had planned to adapt a temple front, a monumental arrangement of columns with a pediment, as part of the facade of St. Peter's in Rome. Palladio's façade, at least in its ambitions, is related to the same idea, if formally different. Other Venetian architects may have had in mind similarities with temples, or what they took to be temples, when designing their buildings. These include the façade of S. Maria Formosa (ca. 1542). Andrea Palladio made directly visible the affinities between church and temple, reflected in the traditional use of the word *templum* for the Christian place of worship.

Palladio's design seems to have convinced influential people with "Roman" leanings. Around 1562 Giovanni Grimani awarded him the commission for the façade of S. Francesco della Vigna (fig. 82), a decision that must

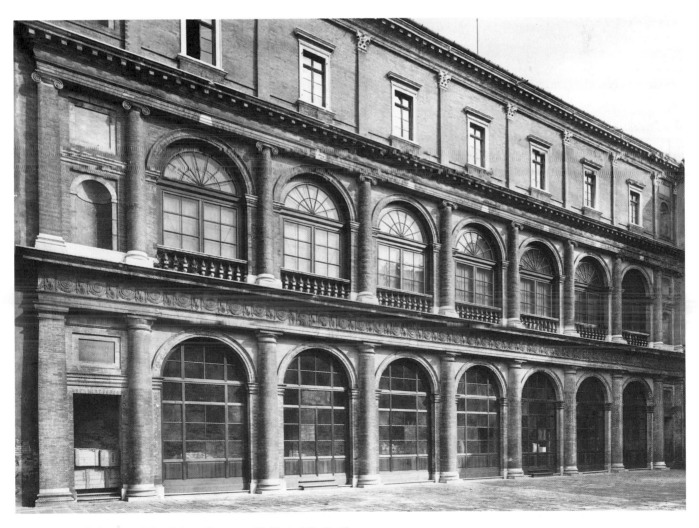

80 Andrea Palladio, part of the cloister, Convent of S. Maria della Carità

have deeply wounded the aging Sansovino as the architect of the church. Palladio placed a colossal temple front before the nave, and a small order with a segment of pediment before the lateral chapels. Through the extension of the entablature of the smaller order over the main portal and behind the flanking columns of the larger order, the façade appears to be comprised of two interlocking pedimented fronts. The effect of the façade, partly obstructed by the palace of Doge Andrea Gritti

81 S. Stefano, cloister with frescoes by Pordenone

(1525), is overpowering. Its mere scale dislocates all the standards of the surrounding buildings. The pedestals of the semicolumns are as high as the portal of the Palazzo Gritti, and Tiziano Aspetti's bronze figures of Moses and Paul appear like "giants." Then there is the white Istrian stone that dazzles the eye on sunny days—a provocative piece of planning that was put uncompromisingly into practice, as was Palladio's way.

Two years before, Palladio had completed to his own designs the refectory, begun much earlier, for the Benedictines of S. Giorgio.[95] From the vestibule a stairway leads to the atrium, which in turn gives access to the refectory, a sequence recalling ancient models in the proportions of its high-set vaulting. Vestibule, atrium, and refectory are stages in a sequence that casts its spell on even the inattentive visitor through an intense, carefully graduated experience of space. However, the once rich furnishings of the refectory, the wooden benches, a pulpit, and Veronese's *Marriage at Cana* (now in the Louvre) on the end wall—all this mitigated the atmosphere of antique revival. Here too, Palladio departed from Venetian tradition. The magnificent summer refectory of the Franciscans of S. Maria dei Frari with its twin aisles and its row of slender columns (ca. 1500)[96] and the squat-looking, vaulted refectory of S. Salvatore (ca. 1541) with its rich stucco decoration[97] are outstanding examples of building types decimated by later demolition.

Three years later, in 1565, Palladio furnished designs for a wooden model of S. Giorgio. The present façade was only built at the beginning of the seventeenth century under the direction of Simone Sorella, to revised plans. Originally Palladio had even planned a temple front freestanding and supported by columns in front of the nave. Unlike the façade of S. Francesco della Vigna and unlike a drawing that presumably records Palladio's definitive design,[98] the façade as executed has only the three-quarter columns mounted on tall pedestals, probably reflecting the piers of the nave. This gave rise not only to new proportions alien to Palladio's style—the separateness of the two pedimented fronts being emphasized—but to solutions such as the pilasters of the small order, which are overlapped by the three-quarter columns.

As with S. Francesco della Vigna, the façade of S. Giorgio could not originally be viewed from a distance. Only the intervention of Doge Leonardo Donà in 1609 could induce the general chapter of the congregation to have the houses in front of it demolished so that—this was the reasoning—the façade could be seen from the Piazza and the Doge's Palace. The much-praised urbanistic configuration that resulted was not anticipated by the order and was at best only hoped for by the architect. In 1570 Palladio had demanded that temple fronts should overlook large areas of the city to make it clear that religion

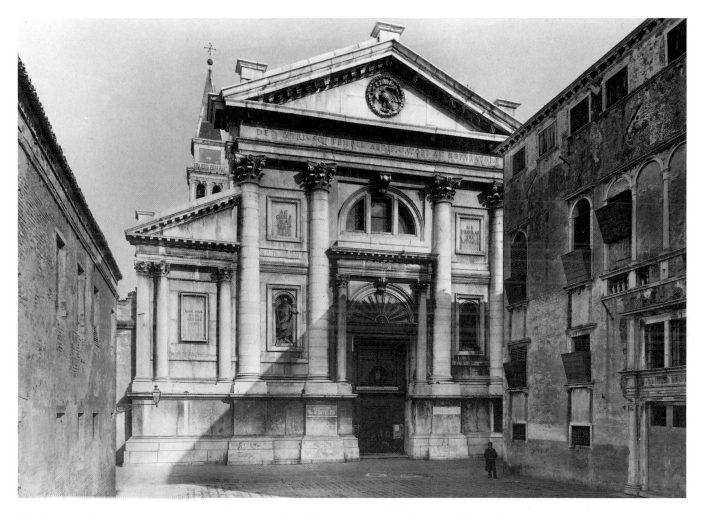

82 Andrea Palladio, façade, S. Francesco della Vigna; on the right the palace of Doge Andrea Gritti

watched over and protected the citizens,[99] a view that was certainly endorsed in Venice as far as its own interests went.

At that time the ties of the Benedictines of S. Giorgio to their mother institution of S. Giustina in Padua were close. In 1565 the construction of S. Giustina was nearing completion; in 1549 Sansovino had submitted a design for the cathedral at Padua,[100] and in 1551 even Michelangelo was asked for a design for its choir.[101] Palladio's design for S. Giorgio was probably measured against these projects.

Palladio planned the building as a cruciform basilica with a cupola raised on a drum, barrel-vaulted arms, and a monks' choir behind the presbytery (fig. 83). Even though, in the nave, columns similar to those in the basilica of Constantine in Rome are mounted on high pedestals before the walls, the motif is so naturally integrated into its new context that it ceases to appear a quotation. The freestanding columns in the presbytery are similarly treated, something that is paralleled in ear-

lier Venetian church architecture (Cappella Corner in SS. Apostoli, and S. Fantin). Palladio decorated the walls of the monks' choir with a series of niches and pediments, much like those he illustrated in his reconstruction of the Roman temple of Jupiter in 1570. However, such reminiscences pale before the inner logic of his design, which still inspires awe in the spectator today, just as Palladio required that temples should.[102]

Overwhelming as the first impression of the interior may be, the architecture demands close scrutiny if it is to be understood. This is especially true of the articulation of the walls. The entasis of the monumental columns, for example, matches that of each of the four square piers that Palladio fused into a massive pylon. These supports dividing the nave from the aisles and bearing the walls look so strong that they seem effortlessly to bear the weight of the vaulting. Palladio had tried a similar effect in the basilica of Vicenza, perhaps referring to the supports in the courtyard of the Doge's Palace. By comparison with Venetian sacred architecture and its

strict regard for the autonomy of supports and wall surface (S. Salvatore, S. Francesco della Vigna), this was a fundamental innovation. The connection of the large order mounted on pedestals and the pilasters rising from ground level is indicated by a few continuous moldings holding the elements of the structure together like the hoops of a barrel. The articulation of the nave walls is concentrated towards the entrance, the relief being enriched and animated by figures by Alessandro Vittoria. The nave, when looking towards the inner entrance wall, appears like a space surrounded on all sides by columns. Palladio used the same concentration of columns before the chancel and before the apses of the transepts, so grouping together the orders of the nave, the transepts, and the presbytery around the crossing.

Even though the original coloring of the interior was altered in detail during the latest restoration, the "sacral" white demanded by Palladio for temples still predominates today. Whether Palladio intended the stone and the adjoining stuccoed areas to be distinguished by color and not only by the texture of the surfaces is an open question in S. Giorgio as in many other Venetian churches. In his report of 1567 on Brescia Cathedral,[103] he expressly recommended the use of stone only up to the height that could be reached with the hand, while further up stucco obliterated from sight the differences of material. The white areas are textured in the ceiling of S. Giorgio by the varying play of light, and the dome and chancel are distinguished from the neighboring bays by greater brightness to match their importance. The light-flooded building, wholly composed of refractions of white, rests on a red, white, and black patterned floor, a solemn color contrast traditional in Venice.

The monks' choir is set behind the chancel and—comparable in this respect to some Roman thermal baths—is separated from it by a columnar screen. This solution for a retro-choir may have been imposed on the architect, as the Benedictines' Congregation of Monte-

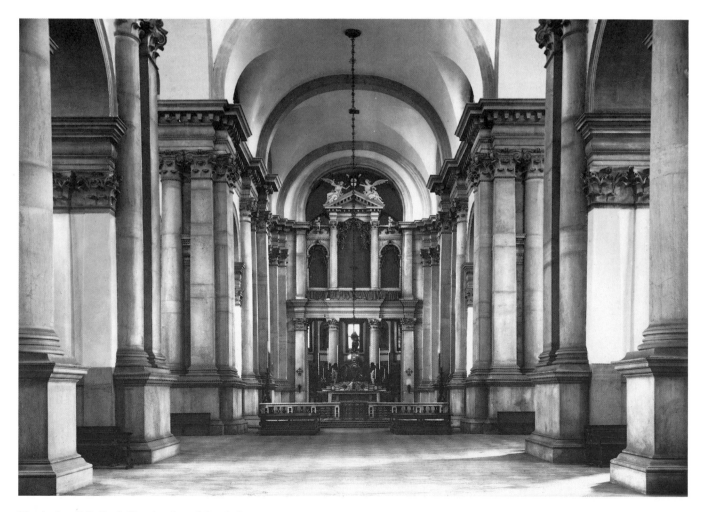

83 Andrea Palladio, S. Giorgio, view of the choir

cassino had, since the 1540s, made them remove the monks' choir from all their buildings, because it obstructed the lay congregation's view of the altar. Jacopo Sansovino had adopted a similar layout as early as 1534 in S. Francesco della Vigna (fig. 73). The solution chosen by Palladio was later codified by Catholic reformers following the Council of Trent, and St. Charles Borromeo described it in 1577 in his instructions for the building and furnishing of churches (*Instructiones fabricae et supellectilis ecclesiasticae*). Thus Girolamo Campagna's bronze group on the high altar (1591) is visible from all sides including that of the monks' choir. The "transparency" of the group, designed by the painter Antonio Vassilacchi, called Aliense, shows great understanding of the special character of the building.

In the autumn of 1576, at the end of the terrible plague that carried off 50,000 Venetians, the state pledged itself to build a votive church: Il Redentore (figs. 84–86).[104] The search for a suitable site posed considerable difficul-

ties. Political considerations inclined the senate against the Campo S. Vitale in the heart of the city opposite S. Maria della Carità, since that would have given undesirable influence to the unpopular Jesuits through their college for young aristocrats situated there. Marc'Antonio Barbaro not only represented the losing party in the senate that wanted the building erected within the city and not on an island some way off, but also demanded a central edifice worthy—as he saw it—of the dignity of the republic. This desire of a dilettante pledged to classical ideals and a friend of Palladio's found few supporters. In the same year the senate, urged by the later Doge Leonardo Donà, decided in favor of a site near a small Capuchin church on the Giudecca, and at the beginning of the following year they also rejected a centralized building. Functional considerations must have played a decisive part here, since there was a need to provide space for large numbers of people at the time of the procession.

There are several drawings that, presumably, show

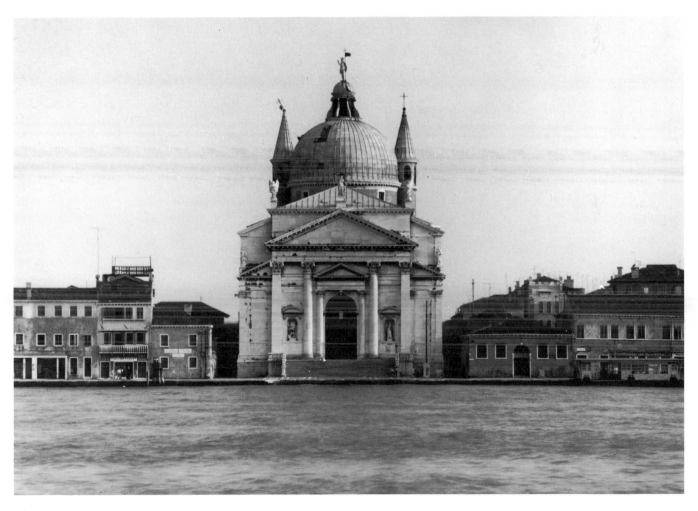

84 Andrea Palladio, Il Redentore

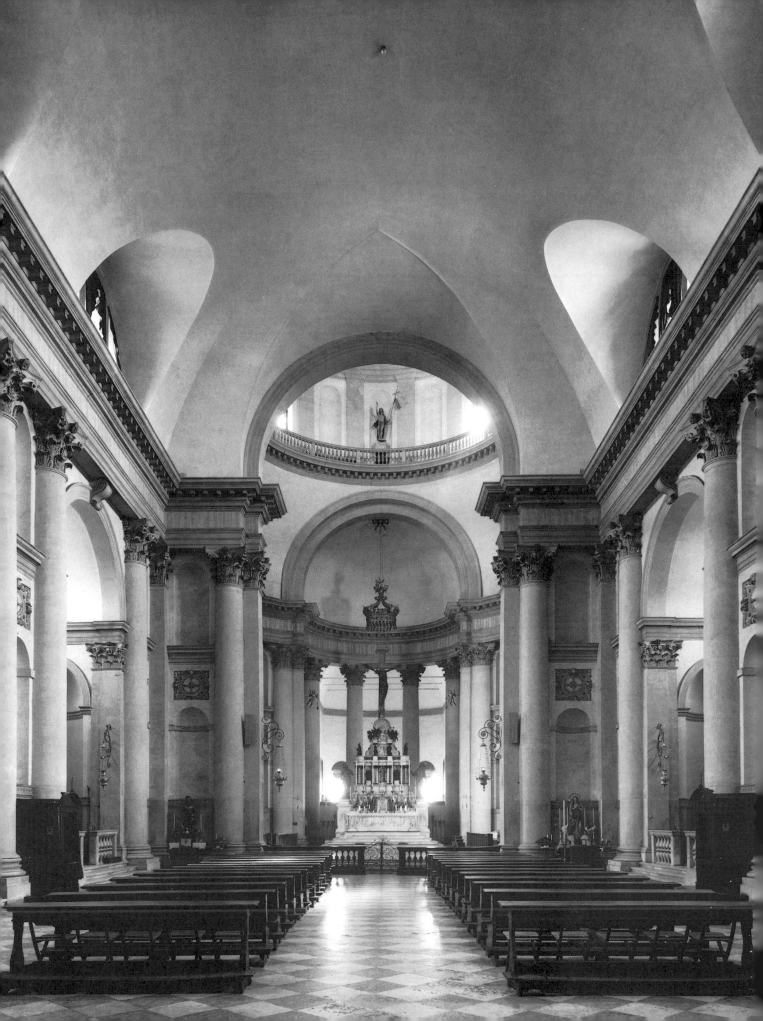

Palladio's ideas on a centralized building. Three of them show a projecting front six columns wide and four deep. A second design does away with this, placing monumental semicolumns (with pediment) in front of a wall articulated by niches flanked by columns. The design finally put into effect in 1577, three years before the architect's death, is a "summa" of Palladio's reflections on the purpose of the church façade (fig. 84). By the double pediment in conjunction with a high attic, Palladio alluded to the Pantheon, which he studied and drew with such zeal, expressly calling it "republican" in his architectural treatise. Was the Republic of Venice, in commissioning Il Redentore, to receive a building matching its constitution? The owners of his treatise published several years before (1570) were able to study other classical temples, the pediments of which, interlocking and surmounting each other, make Palladio's church façade seem a rebirth of the ancient temple front.[105] In comparison, earlier Venetian efforts in this direction look like clumsy attempts to spell out, letter by letter, a difficult text.

The half columns and the piers with columnlike entasis at the middle of the temple front form by their strong relief a clear contrast to the slender-looking pilasters set back in front of the side chapels. In their sequence these correspond to the pilaster strips of the side walls.

The building's effect is largely determined by the broad front steps, which the participants in the procession ascend after a long walk across an unsteady bridge formed of boats. Here too Palladio recalled ancient temples similarly raised on high socles. To a strictly frontal view from the opposite shore, the Zattere, Il Redentore gives an effect of incomparable concentration. The triangles of the roofline and pediment, one above the other, and the related pediment sections at the sides, the high "Venetian" drum dome with its traditional lead covering and the flanking bell towers recalling Romanesque buildings (like S. Antonio in Padua) or minarets, are evidence of Palladio's masterly use of architectural heritage.

The interior of the building (fig. 85) reveals itself step by step as one enters. Palladio combined a nave, which served mainly for the lay congregation when solemn processions were held, with a triple conch; in its two side apses, which were without altars, dignitaries sat on special pews. Owing to a narrowing before the crossing and the matching shape of the entrance wall as well as the elliptical vaulting, the nave resembles a large hall. The sequence of spaces, separated by three steps, is felt as an intensification. In the nave monumental composite col-

85 (*Opposite*) Andrea Palladio, Il Redentore, view of the choir

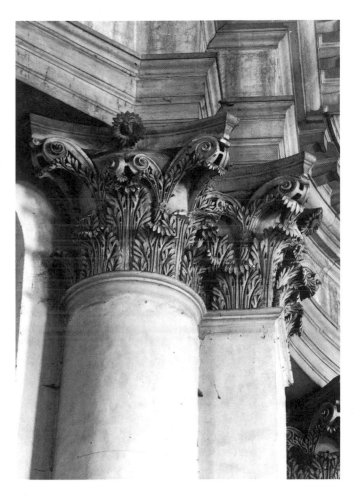

86 Andrea Palladio, Il Redentore, presbytery, capital

umns, arranged in pairs around niches, support a continuous entablature. They frame three chapels with broad, high openings. On the façade wall and at the narrowing before the conches there are additional piers, a solution that Palladio also chose at the crossing. Behind the high altar, freely visible from all sides, freestanding columns support the semidome. Columns and the continuous entablature bind the parts of the building together.

The effect produced by the interior of Il Redentore has been impaired by heavy grime. That the color of the Istrian stone should match that of the painted areas is clear because the lower parts of the columns are made of stone while stuccoed brick is used higher up. A change of color at such a point is highly improbable. The wall surfaces and the elements articulating them were originally closely related in their light color, so that the plastic effect of the light was more fully developed, as it still is in the ceiling area.

If Palladio failed to realize his design for a centralized building for Il Redentore, during his lifetime (in 1579) such a building was erected in the church of S. Maria della

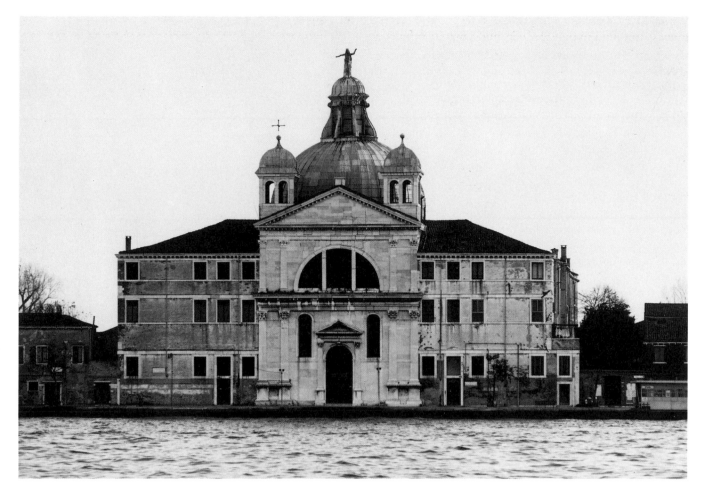

87 S. Maria della Presentazione ("Le Zitelle")

Presentazione, the *Zitelle* (fig. 87) on the Giudecca.[106] The institution for beautiful and therefore—according to the founder—especially endangered girls from poor families, was founded in 1558 and presented the same requirements as monastic or hospital buildings. The anonymous architect placed the church between symmetrically arranged, flanking residential wings, a solution that was imitated in later Venetian hospitals (S. Lazzaro dei Mendicanti near SS. Giovanni e Paolo).

The octagonal interior is dominated by the drumless dome that starts low down. The observer associates the pendentives with the angled pilasters in the corners, while the other pilasters carry pediments. The space is thus surrounded by pilasters of equal size, while the wall seems thin, as if made of folded pieces of paper.

The traditional attribution of this building to Palladio is hardly tenable in face of its style and quality. The façade resembles the Venetian façade pattern of the first half of the sixteenth century, and one "thermal bath" window does not make a Palladio. The interior lacks strength, the articulation of the walls and the projection of the en-

tablature being timidly executed. The inventive power of the architect of Il Redentore cannot have deserted him to quite this extent.

Shortly afterwards in 1582, Vincenzo Scamozzi tried his hand at a centralized building in the church of S. Maria della Celestia.[107] In 1571 Andrea Palladio, who died in 1580, had directed the building of the cloister,[108] probably designing details of it. Perhaps the nuns had hoped to entrust Palladio with building the church as well. In his building—Stringa tells us in 1604—Scamozzi had followed the example of the Roman Pantheon, which gave rise to an extremely violent controversy in the convent, the immediate suspension of building, and finally in 1605 the destruction of the half-finished church. Scamozzi, said one of his opponents in 1595, regarded his building as the eighth wonder of the world, while everyone else saw it as a monster, a body without a head. According to Stringa, to whom we owe a detailed but unfortunately not very professional description of the unfinished building still standing at the time, a centralized building had been chosen as appropriate to the patrocinium of the

Virgin Mary and also because—a very revealing argument—this kind of building was unknown in Venice, despite its many churches, the opposite being the case in Rome.

In the course of this controversy towards the end of the sixteenth century the well-known arguments for and against the centralized building were rehearsed once more. At the same time, in Stringa (and certainly not only in him) we can detect an awareness of a special Venetian tradition. The demolition of the building, seemingly out of place in Venice because it was so obviously "Roman," put an end once and for all to the argument between the exponents of an architecture based on Roman ideals and the advocates of local traditions.

5 SCUOLE

The term *scuola* signified in Venice an association of citizens with common charitable interests or hopes, of the same nationality (for example, Dalmatians or *Schiavoni*), and relating to the same infirmities (the scuola of the blind, the *orbi*).[1] In addition to the very numerous small scuole, the *scuole piccole*—one hundred and twenty of them appeared at the funeral of the doge in 1521—there were in 1500 five, and later six, large scuole enjoying especially high esteem, the *scuole grandi,* in which a small minority of wealthy *cittadini* had the say. Each of these scuole had between five and six hundred members; aristocrats could obtain honorary membership, but clerics were excluded.

Sansovino gave the six scuole grandi a separate chapter in his guide to the city of 1581, without convincingly explaining why he had isolated them from the mass of other scuole. On the other hand Antonio Milledonne, a Venetian citizen of long standing, allocated the different scuole in the same year to the classes making up the community.[2] The government of the six scuole grandi to which a large number of Venetians belonged, he wrote, was in the hands of the *cittadini,* so that they resembled small republics. They chose their officials (*ministri*), namely the *guardiano grande*, the chaplain, the *guardian da matino*, the *scrivani* and *degani* and *massari*, from the circles of the *cittadini* and lower officials from the common people (*popolo*); they paid priests to read the masses, allocated (*per grazia*) apartments, married off girls, and distributed alms, so earning the respect of the poorest people (*plebe*). The lower classes, the *popolo,* Milledonne wrote, had formed associations (*fraglie, scuole, confraternite*) in which they too elected functionaries (*officiali*) whom they called *gastaldi* or *massari.* Francesco Sansovino offered a brief, well-informed description of their political role: the scuole grandi were, he said, a kind of government ("*governo civile*") in which the *cittadini,* almost as in a republic of their own, received offices and honors according to their merits and rank (*qualità*).[3]

The building activity of the Venetian scuole was not confined to their own assembly houses or the provision of their own altars and chapels in churches. As the executors of wills the scuole grandi, like the procurators, administered property and engaged in extensive building activities.[4] The buildings they owned bore the sign of the scuole on their façades. Depending on their position, size, and furnishings, apartments were either granted to poor members of the scuola "for the love of God" or, as in the case of the *Castelforte* development begun by the Scuola Grande di S. Rocco in 1547, rented to rich merchants. Alongside numerous private people, often represented by procurators, the scuole thus played their part in the flourishing construction of the row houses so urgently needed.

According to Francesco Sansovino, the Scuola Grande della Carità, founded in 1260, was the model for all others both in its organization and as a building. Despite drastic changes in the eighteenth and nineteenth centuries, the layout of the rooms built after 1461 in the Gothic style, and important parts of their interior decoration, have been preserved.[5] They confirm Sansovino's statement.

The indispensable parts of the scuole grandi from a functional point of view were a spacious hall on the ground floor with three aisles and a flat ceiling, a flat-ceilinged assembly room of similar size above it, and beside this *sala del capitolo*, the smaller *sala dell'albergo* reserved for the governing officials (the *banca*).[6] The function of the ground-floor room was never quite clearly defined. It served as a common room and possibly for the burial of members of the confraternity. In 1519 tombs for members were mentioned in a ground-floor room of the Scuola Grande di S. Rocco, as are graves in the ground before the façade of the Scuola dei Fiorentini on the Campo dei Frari (1436) and in the portico of the Scuola Grande della Carità.[7] An altar opposite the entrance gave an opportunity for celebrating masses for the dead and for devotion.[8] Rooms of this kind from the Gothic period have been partly preserved, or can be surmised from evidence, in the scuole grandi of S. Giovanni Evangelista and of the Misericordia. The many functions arising from the scuola's needs demanded a form of building that could not be adapted from ecclesiastical or secular models without an inevitable distortion. The flat wooden ceil-

ings are reminiscent of the porticos of Venetian palaces, whereas the rows of columns indispensable for structural reasons are to be found in church building (though in conjunction with vaulting) and in the chapter houses of Venetian convents (such as S. Maria dei Frari and S. Stefano). There might also be, as in the Scuola Grande di S. Marco, a colorful and vigorously patterned floor.[9]

The chapter room (*sala del capitolo*), the large assembly hall on the first floor of the scuole grandi, also had an altar and apparently—like the refectories—a pulpit for sermons and the reading out of documents (*ordini*), as is recorded in 1476 for the Scuola Grande di S. Marco. The walls of these rooms were adorned with large-format picture cycles on Christian themes, and a richly carved, colorfully framed, and richly gilded wooden ceiling recalled the Sala del Maggior Consiglio in the Doge's Palace. The *sala dell'albergo* reserved for the governing board of the scuola, next to the chapter room and usually quite small, was as a rule similarly em-

bellished though without an altar. As in the council chambers in the Doge's Palace, there was on the main wall a wide bench for dignitaries, the *tribunale*. The picture cycles, in which numerous portraits of members of the confraternities are to be found, had from the first been created in competition with the aristocratic government of the republic. The assembly rooms of the scuole grandi and the great council chamber in the Doge's Palace give evidence of the self-image of the two classes.[10] The senate was aware of the role of the scuole in the general image of the republic. When the Scuola Grande di S. Marco was rebuilt in 1485, the senate granted a state subsidy, since the scuola, it pronounced, was an ornament and an honor not only to its members but to the whole community.

The façades of Venetian scuole were not, like those of the Venetian palaces, formed by a long tradition according to a given type. When the first buildings were designed, the patrons and their architects were confronted

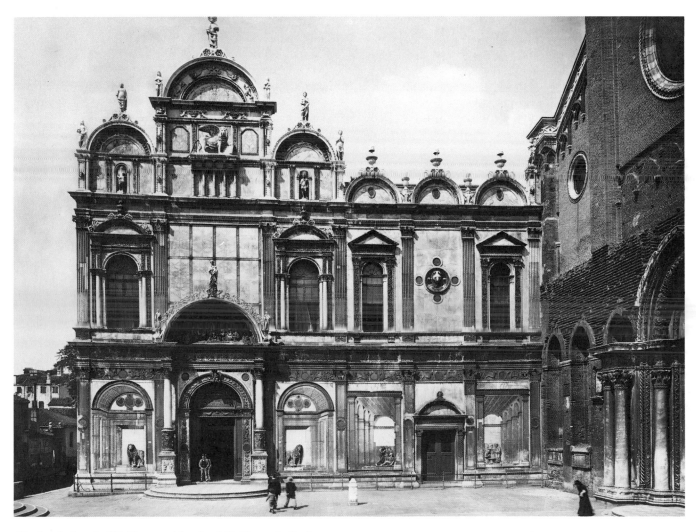

88 Scuola Grande di S. Marco and façade of SS. Giovanni e Paolo

with the question whether the façade was to recall secular or sacred buildings. The solutions were not uniform. The Gothic Scuola Grande della Carità (begun in 1461) and the Scuola Vecchia della Misericordia built after 1441 were reminiscent of churches, through their characteristic façade decoration, the arrangement of the windows, and, in the case of the Scuola Vecchia della Misericordia, the relief surmounting its portal. By mounting a group votive image on the façade, the function of a building otherwise almost indistinguishable from a church could be defined as that of an assembly hall. In the campo there was also the base for the banner (*stendardo* or *penello*) and often a wellhead with the sign of the scuola as its eloquent adornment. The appearance of the façade of the Scuola Grande di S. Marco, built in 1435, is not known; there are not enough records of other Gothic buildings to allow us to form general conclusions. What is certain is that in the Renaissance the façades of a number of scuole closely resembled the churches often situated be-

side them (scuola and church dello Spirito Santo, fig. 65), while other scuole followed more "profane" models.

How strongly felt was the need to give architectural shape to the space in front of the assembly halls, as well as to the buildings themselves, is shown by the square in front of the Scuola Grande di S. Giovanni Evangelista (fig. 90, plate 7), segregated from a street in 1481 according to plans by Pietro Lombardo. This was an intelligent solution from an urbanistic point of view, since the architect did not encroach on the street network while enhancing the entrance area of the fundamentally Gothic scuola by the use of modern architecture.

Probably the first scuola to be rebuilt in the Venetian Renaissance style was the Scuola Grande di S. Marco (figs. 88, 89). The cause was the fire of 1485, which had destroyed the Gothic building with the exception of parts of the façade and the outer walls. Even before this, however, there had been modernization not only of the pictorial decoration but of the buildings of various scuole.

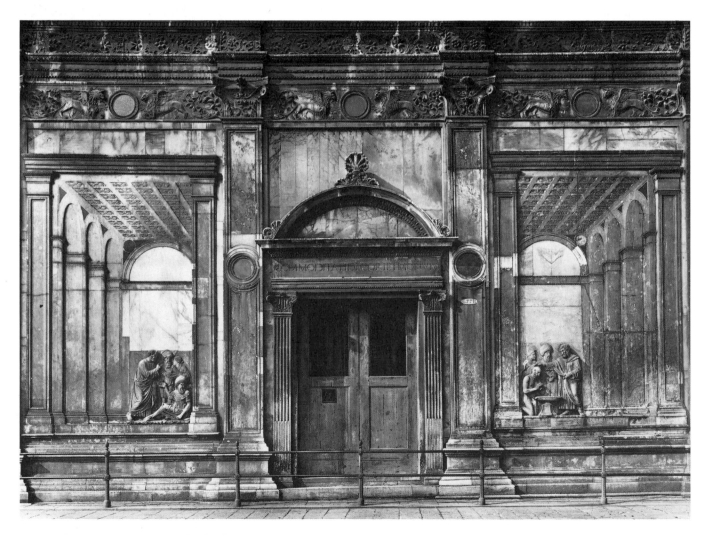

89 Scuola Grande di S. Marco, façade, detail

In 1476, for example, Antonio Rizzo had constructed a spiral staircase and a new pulpit for the Scuola Grande di S. Marco from designs by Gentile Bellini, and Pietro Lombardo had redesigned the square in front of the Scuola Grande di S. Giovanni Evangelista.

How far the surviving parts of the Scuola Grande di S. Marco were a constraint on the architect designing the new building cannot now be discovered; but it will be clear to any observer that the portal erected for the adjacent church of SS. Giovanni e Paolo by Bartolomeo Buon in 1458 influenced the proportions of its façade. Pietro Lombardo distinguished the façade of the *albergo* and a chapel on the ground floor (Cappella della Pace)[11] from the rest of the building by varying the intervals between pilasters, by a different treatment of the portals and—especially effectively—by the different vanishing points of the perspective reliefs (*prospettive*) that he added on the ground floor. While the pilasters articulating the façade and the side of the building towards the *rio* resemble the elevation of S. Maria dei Miracoli (1481, fig. 61), the reliefs are unique in Venice.

In the upper part of the façade Mauro Codussi, who took over the building work in 1490, made the connections with the façade of S. Marco, established in the picture program, visible in architectural terms as well. Perhaps Pietro Lombardo in the reliefs, executed probably by his son Tullio, wanted to bring to mind the deep, column-flanked niches in the façade of S. Marco? All the same, Bramante's illusionistic choir in S. Maria presso S. Satir (Milan) is the closest of all the models mentioned so far. About 1500 Tullio Lombardo designed similar *prospettive* for the Cappella dell'Arca in S. Antonio (Padua).[12] The authorities of the scuola decided to have a narrative relief carved for the upper story of the façade in 1489.[13] The subject matter is not known; perhaps it was events in the life of the city's patron that were later depicted in the reliefs in front of the Capella della Pace.

Codussi's alterations to Pietro Lombardo's design concerned the shape of the windows and the top of the building, while the pilaster articulation and the grey strips framing the wall areas probably go back to Pietro's design. Codussi's windows partly overlap the framing pilasters and entablatures, his predilection for composing a dense relief from interlocking forms showing itself here. The upper section of the façade of the building recalls the fluted segmented pediments of S. Zaccaria (fig. 58) and probably derived from Venetian church façades like S. Giovanni in Bragora. The contour of the façade is reminiscent of that of S. Marco. Three pediments of the same shape and height, like those of the *sala dell'albergo,* are later to be found on the façade of the dormitory of S. Giorgio.

The effect of the scuola's façade was largely contributed by the colorful juxtaposition of the marble and Istrian stone and by a rich polychromy that has been partly

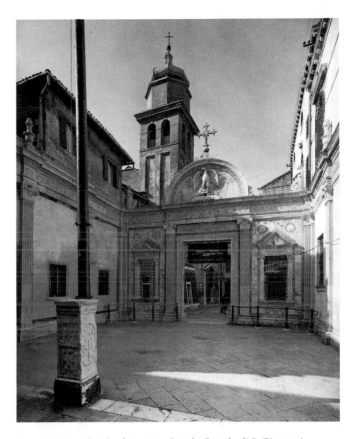

90 Pietro Lombardo, forecourt, Scuola Grande di S. Giovanni Evangelista

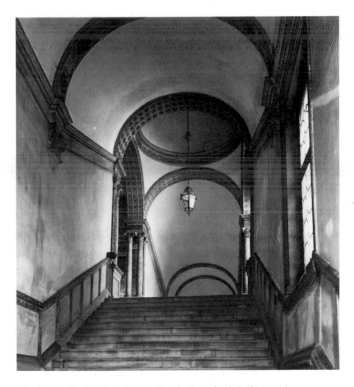

91 Mauro Codussi, staircase, Scuola Grande di S. Giovanni Evangelista

preserved.[14] The use of marble slabs had already been tried out in the façades of churches and palaces, but hardly any traces of their polychrome decoration have survived. The ornamentation of the entablatures and friezes of the scuola was set off in gold and red from the background, and the flat surfaces of Istrian stone in the *prospettive* were marked off in red from the grey marble background of the lions.

Unfortunately the splendid double staircase of the Scuola Grande di S. Marco has been destroyed, and the modern reconstruction is unreliable.[15] This type had been decided on by 1486, before Codussi's change of plan, one stairway being used for ascending to and the other for descending from the upper-floor rooms, a necessary precaution in view of the large number of members. Whether the double flight of stairs was inspired by an external staircase of the Palazzo dei Trecento in Treviso (ca. 1300) or of the Palazzo della Ragione in Padua or—more probably—an outside staircase at the Rialto shown by Jacopo de' Barbari (destroyed by the fire of 1514, fig. 25) is not known. Its architectural form also has links with the covered Scala Foscari in the courtyard of the Doge's Palace (destroyed). One would also like to know what was the form of the outside staircase of the Scuola dei Fiorentini leading to the Campo dei Frari, mentioned in a document of 1436.[16] However, Codussi's magnificent staircase of the Scuola Grande di S. Giovanni has been preserved, and it is certainly one of the finest staircases of the Renaissance (fig. 91). Broader and more agreeably proportioned than the staircase of the Scuola Grande di S. Marco, it is also distinguished from it by domes over the first and last landings, there being a discernible heightening of the ornamentation towards the top, culminating in the upper landing with its dome. There is also a distinct "perspective" widening of the two flights of stairs towards the top. A document of the Scuola Grande di S. Rocco of 1544 states that the staircase of a building is its most important part.[17] In the Scuola Grande di S. Giovanni Evangelista, Codussi provided a festive setting for the passage of the members

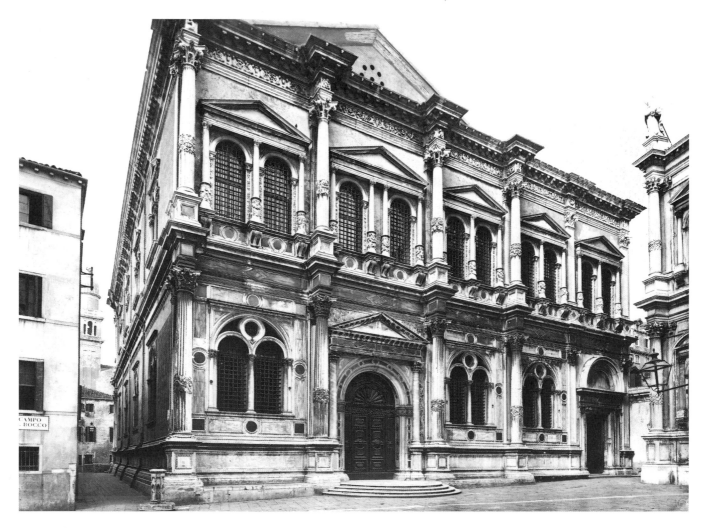

92 Scuola Grande di S. Rocco

through a new portal and up the lavishly constructed staircase, a decision probably influenced by the staircases in the Doge's Palace.

The rebuilding of the Scuola Grande di S. Marco and the alterations to the Scuola Grande di S. Giovanni Evangelista had set new architectural standards. When Bartolomeo Buon was commissioned in 1517 to erect the new building for the rapidly growing Scuola Grande di S. Rocco,[18] a resolution had already laid down that the chapter room and *albergo* were to be treated as in the other scuole grandi. It is probable that the resolution had Leopardi's plans of 1505 for the Scuola Grande della Misericordia, later rejected, in mind. Bartolomeo Buon the younger (in charge of building for the Procurati di Supra since 1505), was appointed in 1517 as *proto* of the building of the Scuola Grande di S. Rocco, a parallel to institutions that had their own directors of building. For the scuole as for the procurators there seems often to have been a single post for the architect designing a building and the manager of the work, and the resulting

conflicts attended the new building of the Scuola Grande di S. Rocco from the first.[19] During his period of office, Bartolomeo found a certain Giovanni Celestro appointed over his head on a high salary; in 1524 Celestro produced a first model for the staircase but left the project in the same year. When Bartolomeo was dismissed in 1524, after seven years, because he had been carrying on the building in his own way according to his own designs, the decision was influenced by the desire of the patrons to decide all the details themselves. Bartolomeo's successor, Sante Lombardo, was forced to accept extensive contractual restrictions. He was not allowed to decide anything on his own initiative but had to discuss everything with the *guardiano grande,* the *banca,* and the *procuratori.* However, after the first difficulties Tullio Lombardo, Sante's father, obtained a legal order that the scuola should not further curtail the rights of the architect in charge.

Three years later Sante was dismissed and the highly respected and experienced Scarpagnino appointed; he

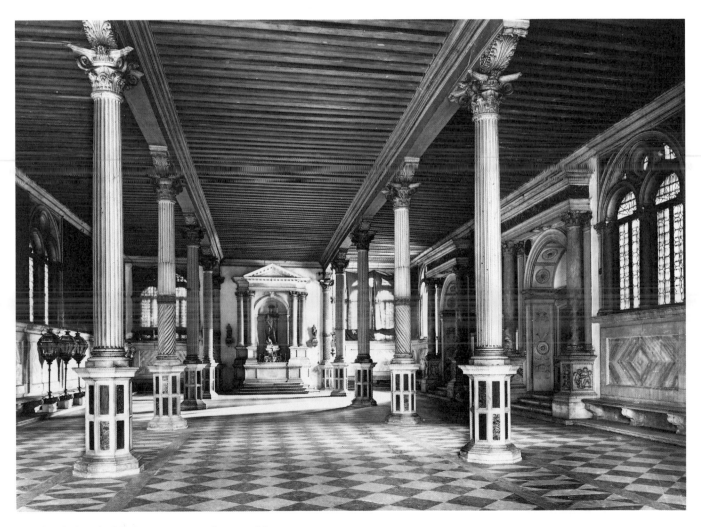

93 Scuola Grande di S. Rocco, room on the ground floor

was clearly better able to deal with the self-assured committees and guided the work responsibly until his death in 1549. He had probably learned his lesson from bad experiences in building the Scuola dello Spirito Santo (1523).[20] These frequent changes, the interference by patrons, and our inadequate knowledge of the individual styles of the people involved make it difficult to reconstruct the history of the building process. Bartolomeo Buon the younger was able to complete the structure as far as the ground-floor entablature (figs. 92, 93), although the clear division into two wings was probably prescribed by the patrons. The columns in front of the façade and the main portal belong to a later phase. Characteristic of the times is the use of encrusted window frames divided into fields, together with the adoption of Codussi's bifore. As Cesare Cesariano's reconstruction of the basilica of Fano (1521)[21] shows bifore surmounted by triangular pediments, learned contemporaries could interpret the

windows of the scuola as *all'antica.* To support the three-aisled structure on the ground floor (fig. 93), Bartolomeo chose fluted columns on octagonal, polychrome pedestals. Sante Lombardo's contribution seems to have been primarily the elaboration of the unusually rich rear façade (fig. 94), even though plans for it had already been drawn up by Buon, with alterations by Antonio Celestro. Similarities with S. Giorgio dei Greci (fig. 78), the only building securely ascribable to Sante (design 1536), consist primarily in the use of the empty niche as a decorative motif. The combination of columns with pilasters is reminiscent of Codussi, though the marble inlays in the pilasters are more in keeping with interior decoration. Splendid consoles, quite unorthodox capitals, and projecting heads, leafy rosettes, and the deep niche make up an animated façade of great variety. Even though individual motifs can be traced back to works by Codussi, a fundamental change is nevertheless evident in this fa-

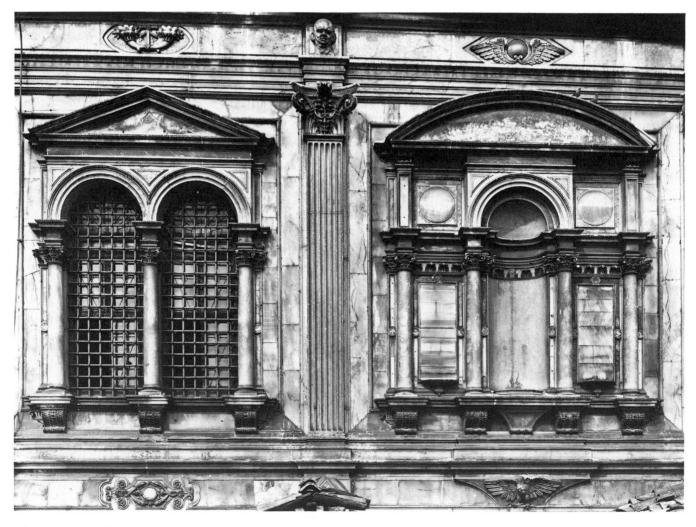

94 Scuola Grande di S. Rocco, rear façade, detail

çade, in the composition of sculpturally conceived architectural elements into a powerful relief. From this design Sansovino, on his arrival in Venice, could recognize what was modern in architecture at that time.

Those responsible for the building of S. Rocco declared themselves dissatisfied with the proposed plans. In 1532 the Scuola Grande della Misericordia had invited designs from several architects including Giovanni Maria Falconetto, Guglielmo de' Grigi, Pietro Vido, and Jacopo Sansovino, with a view to adapting their new building, planned since 1505 and advanced as far as the foundations, to their current needs.[22] Sansovino won the competition, was appointed *proto,* and joined the confraternity. His first project, soon rejected, appears to have featured freestanding columns that rapidly became a bone of contention, so that Sansovino promised to eliminate them. In the Scuola Grande di S. Rocco, however, this hint from a competitor was seized upon avidly. In

1536 a project was approved to rebuild the façade with freestanding columns in front of pilasters. The craving for opulent ornamentation, not the desire for an architecturally outstanding design, was the driving force of these patrons, who would scarcely otherwise have demanded "as much embellishment as possible." These may not have been universally binding demands in Venice, but they might also explain Sansovino's extremely rich ornamentation for the Loggetta and Libreria.

Freestanding columns before pilasters are to be found not only in prominent buildings of antiquity such as the Forum Transitorium and the arches of Septimius Severus and Constantine. Guglielmo de' Grigi, to whom the columns of the Scuola Grande di S. Rocco are attributed, used them previously (the resemblance extending to details of the entablature) on a city gateway, the Porta S. Tomaso in Treviso (1518).[23]

There were also arguments over the staircase. A first

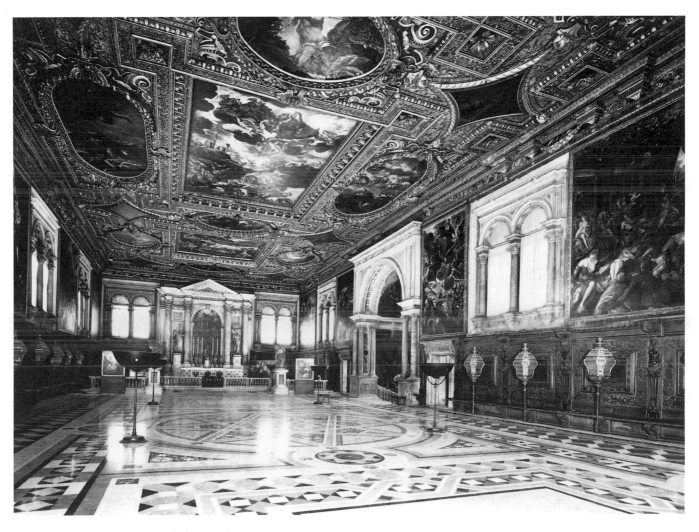

95 Scuola Grande di S. Rocco, Sala da Capitolo

staircase for S. Rocco soon fell into disfavor with the patrons and was demolished. The present stairway was built in 1544, with parallel flights joining halfway up to form a broad vaulted staircase. This created a new staircase type for Venice.

The enormous expenditure of the scuole grandi on building found its critics. Caravia,[24] who had to answer for his polemics before the Inquisition, pilloried the blatant competition of the builders in his *Sogno* of 1541,

claiming that the funds of the scuole were so drained by it that hardly anything was left for alms for the poor. Between 1516 and 1564 the Scuola Grande di S. Rocco spent 47,000 ducats on the building and 2,500 on the furnishings. This sum equals the expenditure for welfare purposes between 1551 and 1572. In 1597 an altar was planned, and by 1602, 4,825 ducats had been collected for it, a sum equalling the annual spending of the scuola on charity.[25] Moreover, the competition was not confined

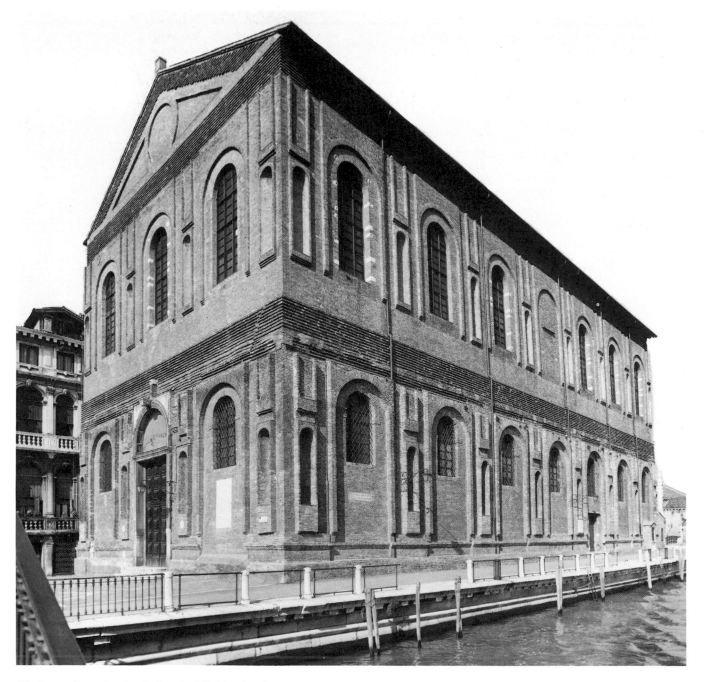

96 Jacopo Sansovino, Scuola Grande della Misericordia

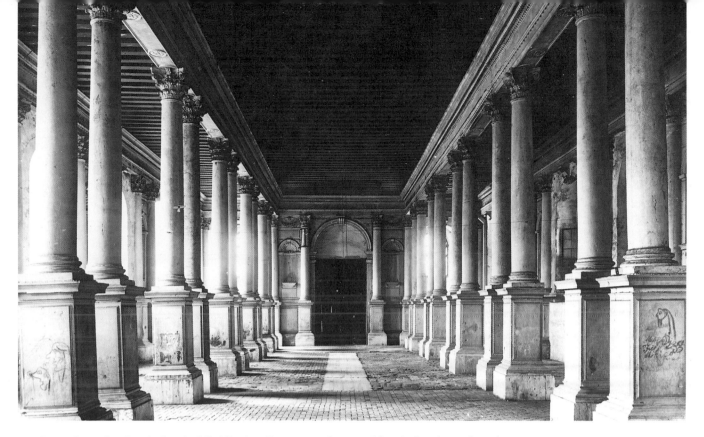

97 Jacopo Sansovino, Scuola Grande della Misericordia, room on the ground floor before the modern changes

to buildings; the scuole tried to outdo the rooms of the Doge's Palace, particularly the Sala del Maggior Consiglio, in the use of decorative paintings, the artistic rank of the paintings appearing to be an important criterion (fig. 95).

While most of the scuole grandi kept their building costs within their financial capabilities, even if on occasions they neglected their statutory duties, the plans of the Scuola Grande della Misericordia were far beyond its means (figs. 96–98). It managed to finish only the rough brick shell, with enormous efforts and sacrifices, by the end of the century. A drawing attributed to Palladio gives an idea of Sansovino's design (1532). Unlike the other scuole, the building, freestanding on all four sides, was to be embellished uniformly all round, comparable to Palladio's basilica in Vicenza.[26] In the very large ground-floor hall, despite the rhythm imparted by the sequence of columns and repeated in the wall articulation, Sansovino stayed within the accustomed bounds. Unfortunately, the extensive program of figures for the façade cannot be reconstructed on the basis of the drawing. It would certainly have come into competition with public buildings like the official residence of the procurators (the Libreria), built a few years later—a further indication of the intentions of the patrons. The financial troubles that had accompanied the building of the Scuola Grande della Misericordia gave the patrons of the Scuola Grande di S. Teodoro (a scuola grande since 1552) the revolutionary idea of installing shops on the ground floor, as

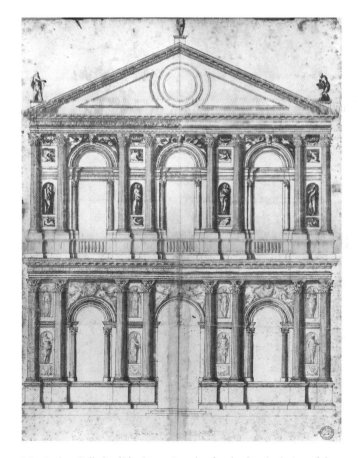

98 Andrea Palladio (?), alternative plan for the façade design of the Scuola Grande della Misericordia

was done by public buildings on the Piazza and the Rialto, to secure the financing of the building.[27]

The internal division into two stories is reflected, in the case of most of the less influential scuole as well, in the façade. But a differentiation between the chapter

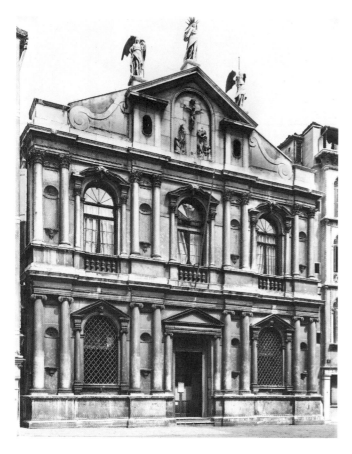

99 Scuola di S. Maria della Giustizia e di S. Girolamo

room and the *sala dell'albergo* did not appear in the façade. Like that of the Gothic Scuola Grande della Carità, the façades often resemble the fronts of churches. This is particularly clear in the case of the almost indistinguishable façades of the Scuola dello Spirito Santo and the church of the same name next to it, both probably designed by Scarpagnino.[29] The façades of the Scuola di S. Giorgio degli Schiavoni (1551), the church of S. Geminiano (1557, fig. 75), and the Scuola di S. Girolamo (fig. 99) show formal similarities that lead us to suppose that the assembly building was to be given a visibly sacral character. This effect is underlined by the raised middle section, which might suggest a three-naved church. Similarly, the façade of the Scuola della Passione opposite the Frari (1593) calls to mind, in the arrangement of its upper-floor windows, a building like Sansovino's S. Spirito in Isola. The fact that, with the exception of Sansovino's Scuola Grande della Misericordia, the type of the church façade was followed shows how much importance was attached to making such a connection visible.

In the smaller scuole there is often a contrast between the unassuming building and the high quality of the paintings embellishing it. Usually this magnificence, as in the case of the Scuola di S. Orsola with paintings by Vittore Carpaccio, is turned entirely inwards. Carpaccio's picture cyles often adorned the simplest, outwardly insignificant buildings. This also applies to assembly rooms, built like chapels onto churches. The Scuola del Rosario attached to SS. Giovanni e Paolo,[29] built for the merchants by Alessandro Vittoria after the victory of Lepanto (1571), showed pictorial decoration that rivalled the pictures in the Doge's Palace. The decoration was comparable not only on the strength of the artistic value of the works by Domenico Tintoretto but above all by the choice of a program alluding to recent political events.

6 VILLAS FOR VENETIANS

The term *villa* was used in the Renaissance for buildings and groups of buildings with different functions. The narrower use of the term current today, to designate a mansion used as a country residence, gives rise to misconceptions. It overlooks buildings on the outskirts of Venice used primarily for leisure—not surprisingly, as they were absorbed into the city as early as the sixteenth century by the increasing density of building, losing their often famous gardens. Jacopo de' Barbari depicted such villas on Giudecca; Pietro Bembo's villa at S. Maria di Non (an authentic *refugium* according to old descriptions) seems to have been demolished,[1] whereas Alvise Cornaro's "Casinò" in Padua (ca. 1530) gave new directions for the Venetian villas of the sixteenth century.[2]

Some aspects of life in these country houses can be reconstructed from contemporary letters, like those of Pietro Aretino. Conversation, banqueting, music, conviviality in all its aspects, and the possibility of retreating for a short time from the bustle of the metropolis into a private, protected realm were the central features of this life. One may possibly have exchanged some words on agricultural questions, but these buildings had no connections with large areas of land used for agriculture. Most of the extant buildings used as villas at that time date from the second half of the sixteenth century. Their original use, however, is not always easy to establish.

Far more villas were built on the mainland, as the administrative centers of extensive estates from which the landowner derived a substantial part of his income. The Villa Giustiniani at Roncade, Sansovino's Villa Garzoni at Pontecasale, and numerous villas designed by Andrea Palladio belong to this group. Others seem to have been used mainly for display. The enormous villa-palaces built by Vincenzo Scamozzi among others towards the end of the sixteenth century, with suites of rooms often unused from the first, anticipate the castles of the baroque period.[3]

At an early stage villas were built on the periphery of the city, on the island of Giudecca (fig. 100) and above all on Murano.[4] Murano, which had as many as thirty-two thousand inhabitants by the beginning of the sixteenth century, had, like Torcello, Burano, Mazzorbo, and Pel-

lestrina, a relatively autonomous status relative to the metropolis nearby.[5] No trace remains of the "house" of the Venetian Francesco Amadi on Murano, mentioned with its "exquisite" garden in 1411. Gothic villas on the lagoon islands must certainly have existed but have not been identified. An essential aspect of the villa was its garden, which enabled the owner and his or her friends to flee the turmoil of the city to enjoy the pleasures of a sometimes solitary but free life close to nature, devoted to the arts and sciences. Petrarch celebrated this ideal life in literature.

The acquisition of land by wealthy Venetians in the newly won territories had in the fifteenth century taken on dimensions that were viewed with concern by the mainland towns dependent on Venice. In 1446 the Paduans complained eloquently that Venetians had already acquired a third of their land; laws attempted to protect the interests of the Venetian state viv-à-vis the special interests of Venetian landowners.[6] Considerable tensions resulted between the local aristocracy, who often lived from agriculture, and the Venetian families. The latter, supported by laws and decrees, had opened up a new source of wealth to supplement their state offices and their income from trade.[7] Of the buildings that came into being in the course of this peaceful takeover of land at the expense of the subject cities, few dating from the fifteenth century have survived.

Alongside the Venetian annexation of territory there developed a controversy over the use of revenues from landowning. That the Venetian did not plow, sow, or harvest ("non arat, non seminat, non vindemiat") was asserted about the end of the fourteenth century; similar statements, formulated as recommendations or demands, occur later.[8] There is a famous dictum by Chancellor Rafaino Caresini (1314–90) that it was the Venetian's affair to cultivate the sea, not the land, since the sea promised riches and honor in superabundance, while landowning brought with it dire consequences not further explained.[9] At the beginning of the sixteenth century Gerolamo Priuli, in his vehement criticism of the Venetian aristocracy, also addressed this theme. Every Venetian, he claimed, whether aristocrat, *cittadino*, or *populare*, who

had the opportunity would have acquired land and a house in the region of Padua or Treviso, since these places were close to Venice and one could enjoy oneself there for a day or two without making a long journey.[10]

By then, however, the trend had become established, and above all peaceful conditions like those promised by the Peace of Bologna (1529) were needed to foster renewed investment in land on the mainland and in agriculture. In these decades injunctions to turn back to the sea and trade took on a nostalgic, private timbre.[11] The importance of the Venetian *latifundia* for the supply of the metropolis with provisions and the prosperity of the landowners was no longer disputed. These are the years in which an ideology for the rural activity of the landowners was formulated that went beyond the ideal of country life as described by Petrarch ("De vita solitaria") and a large number of humanists. Alvise Cornaro, living in Paduan "exile," coined the expression "*Santa agricoltura,*" which soon caught on.[12]

To enlarge the area of arable land the Venetians drained large tracts of marshland. In this Alvise Cornaro was prominent both as organizer and as theoretician. To solve the technical and legal problems of the annexation better than had previously been the case, the Magistrato dei Beni Inculti was established in 1545.

Most Venetian patrons were familiar with the notion of harmonizing the status of a property with the external appearance of its villa. Sebastiano Serlio in his then unpublished Sixth Book (ca. 1547), Anton Francesco Doni in his work *Le ville* (1556), Andrea Palladio (1570), and Vincenzo Scamozzi (1615) expressed views on this question as architects. Serlio went further than all the others in establishing very fine gradations and illustrating them by designs. This awareness put patrons under considerable pressure to build according to their status. At the same time, such a catalogue provided an ambitious patron with the opportunity to signal his aspirations without infringing the rules of social convention that were applied strictly in all other areas of communal life. When the *cittadino* Luigi Garzoni had a villa of gigantic dimen-

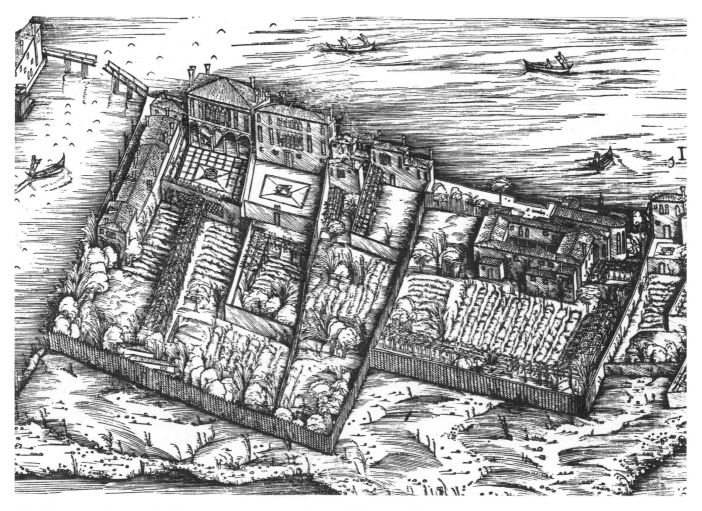

100 Villas on the Giudecca, detail from the view of the city of Jacopo de' Barbari (1500)

sions built for himself near Pontecasale by Jacopo Sansovino (ca. 1540), it was an indication of the power of money in this area to blur the class frontiers that were otherwise insurmountable in Venice.

Serlio[13] distinguished the following types: the house of the poor, the mediocre, and the rich farmer,[14] of the poor artisan outside the city, of the simple merchant ("basso mercante") or the *cittadino*, of the *gentiluomo*, of the aristocrat ("gentiluomo nobile"), the prince ("principe illustrissimo"), and finally of the king. The higher the status, the broader the spectrum of solutions recommended.

Doni, on the other hand, distinguished five types: the *villa civile* ("da re, da duca e da signore"), the residence of the *gentiluomo* ("podere di spasso da gentiluomo"), the merchant's holiday home ("possessione di ricreatione de mercatanti"), a "casa de risparmio," and a hut ("capanna de l'utile").[15] Doni was the only writer to discuss the interior decorations of the buildings—though he did so too briefly and too generally. A more extensive treatment would have given a better insight into the pretensions of patrons than did the architecture. The status terms chosen by Serlio and Doni (*gentiluomo, gentiluomo nobile, signore*), not readily applicable to Venetian conditions, further impede a precise classification. In the history of the Venetian villa the residence of Caterina Cornaro, ex-queen of Cyprus, not far from Asolo, has a special place.[16] Caterina lived there throughout the year with her retinue of more than eighty people. The edifice was not a villa, at least not in architectural terms, but rather a princely residence. The complex begun in 1491 and perhaps designed by Francesco Graziolo (1460–1536) consisted of a mansion situated within an area surrounded by high walls protected by towers. Further living quarters and farm buildings were built next to each other against the wall on one side, and a chapel, the loggia, and a few other buildings not clearly defined survive today. But the high walls, all the towers, the possible divisions of the large grounds, and unfortunately the residence of the ex-queen have been lost.

Caterina Cornaro's life in gilded exile had much in common with *villeggiatura,* or the rural life. Pietro Bembo's *Asolani* gives an idea of the intellectual climate at this court. Bembo derived the contemporary term for the estate—*barco*—from the Greek for *paradiso,* an interpretation that may have carried weight for the visitor but does not stand up to philological scrutiny.[17] Several buildings with different functions and Cornaro's residence were designed by the architect in an unpretentious villa style. A clumsy sketch from the early eighteenth century probably comes closest to the original state of the buildings; later copyists added misleading extensions to the residence, long since demolished. According to the sketch, the rather modestly proportioned, two-story main house seems to have followed the type of the Venetian palace, complete with a mezzanine.

The defeat of the Venetian army at Agnadello in 1509 brought with it the loss of large areas of territory on the mainland. Although the army commander, the later Doge Andrea Gritti, succeeded in recapturing Padua in the same year, Venetian control of the mainland was reestablished only gradually in the years that followed. Most of the unprotected Venetian villas fell victim to the turmoils of war. However, the uncertain political situation did not prevent influential Venetians from acquiring land and building villas on it quite soon after 1509. This building activity is connected to efforts fostered by the state to curtail the influence of the local aristocracy, in which the Venetians made use of a wide range of laws and measures (particularly with the help of their local governors or *rettori*). When Agnesina and Gerolamo Badoer commissioned Tullio Lombardo (?) in 1511 to build them a magnificent country residence, the Villa Giustiniani (plate 8),[18] this testified to a high degree of confidence in the ability of Venetian politicians to achieve a lasting pacification of the area. The Peace of Bologna (1529) finally vindicated the judgment of these patrons.

The well-preserved Villa Giustiniani in Roncade is surrounded by a high wall with round towers. It awakens memories of fortified towns and castles and of other villas, although the thin walls would have been quite unsuitable for defense purposes. In contrast to the martial exterior is the urban-looking residence. Similar crenellated but militarily useless walls are still to be found around the Villa da Porto near Thiene (north of Vicenza), three decades older and the residence of a Vicentine family. Walls, towers, and battlements gave the Villa Giustiniani the character of a feudal mansion (*castello, rocca*). Caterina Cornaro (Asolo), the Veniers (Sanguinetto), and the Trevisans (S. Donà di Piave), to mention only three examples, were feudal rulers vested with civil and, in some cases, judicial authority.[19] What was more natural than to make this visible in the external aspect of the buildings?

The question whether this architectural language was understood and by whom can be answered in part by reference to old terms such as *castello*. Also noteworthy is the use of towers as part of the residence in some villa designs by Andrea Palladio. Possibly this was not merely a revival of traditional elements of the Venetian villa (such as that of the humanist Gian Giorgio Trissino at Vicenza), but an allusion to feudal residences like the *castelli* with four towers. Serlio (ca. 1546) produced several designs for country residences "a modo di fortezza."[29]

The crenellated walls of the Villa da Porto at Thiene were complemented by rich paintings of knights and horses on the side façade facing the street, a nostalgic evocation of chivalry that has a parallel in the literature

of the time. In his diary of his travels through the *terra-ferma* of 1483, Marin Sanudo drew and noted a large number of small fortified estates with towers.[21] Villa complexes with towers could be associated by the observer with such settlements.

At the center of the Villa Giustiniani estate stands the residence of the patron. The disposition of the rooms (though not their proportions) largely follows that of the Venetian palace, but the façade shows elements uncommon in Venice, such as the projecting loggia in front of both stories and the pediments at the top. Palladio listed the advantages of loggias for life in a villa, although in older buildings the loggias were not freestanding but flush with the ground floor or the piano nobile. By projecting from the main building the loggia of the Villa Giustiniani could be opened on three sides; flooded with light and air, it was an ideal place to be in suitable weather. A triangular pediment is to be found not only on ancient temples but on numerous Venetian churches and surmounting the windows of a Venetian palace, the Palazzo Contarini delle Figure (1504, fig. 19). How the architect

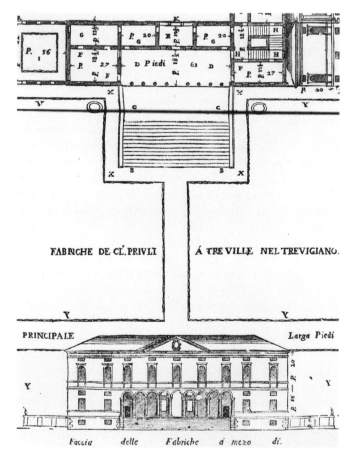

101 Villa Priuli. Treville. After Vincenzo Scamozzi, *Idea della architettura universale* 1615, ed. S. Du Ry, 1713, detail

of the Villa Giustiniani justified his use of it can no longer be determined. What is clear, however, is the chronological coincidence with the first illustrated edition of Vitruvius by Fra Giocondo (Venice 1511), in which triangular pediments are shown in conjunction with temple fronts that are anything but correct from an archeological point of view. It was the architect of the Villa Giustiniani and not Andrea Palladio who first introduced this motif into Venetian villa architecture.

The Villa Giustiniani was the administrative center of a considerable estate. The Villa Corner at Oriago,[22] built not long before and no longer extant, was situated directly on the bank of the Brenta and is likely to have been primarily intended, like most of the Brenta villas, to allow a carefree life. The characteristic bifore and the sham colonnade of half columns recall works by Mauro Codussi but may be by a follower (such as Bartolomeo Buon the younger). One is strongly reminded of palace façades such as that of Codussi's Palazzo Loredan (Vendramin-Calergi).

The Villa Priuli in Treville (ca. 1528–33) has also been demolished; its appearance is recorded by a woodcut (fig. 101).[23] The transverse building on a *basamento* was opened on the ground floor by an arcade nine axes wide. The unidentified architect gave the side parts the rhythm of a Venetian palace façade, resulting in an irregular sequence of windows on the first floor. Three windows were embraced by a triangular pediment, making them stand out from the middle group. The opening of the ground floor is in the tradition of Venetian villa architecture. Through the opening of the rear façade into a loggia the visitor, approaching nearer, looked out onto the landscape through the windows and door of a "diaphanous" dividing wall. This opening of the building on both sides reminds us of buildings by Biagio Rossetti in Ferrara, like the Palazzo Ludovico il Moro; later, Jacopo Sansovino adopted this motif in his Villa Garzoni at Pontecasale. The regularized ground plan shows that Palladio's early villas followed local tradition in this respect.

In the fourth decade of the century a number of villas, built on Venetian territories, reflected their owners' interest in antiquity and the Roman sympathies of their architects. None of these buildings was erected for a patron living in Venice. Alvise Cornaro in Padua built a casino (*intra muros*) next to his residence and probably to his own design (Serlio called it an *odeo*), with a ground plan that quoted the Roman villa of Marcus Terentius Varro in Cassino and with rich interior decorations, which, probably for the first time in Veneto, made use of Roman decorative customs as a program for a villa.[24] Villa designs based on the buildings of antiquity occupied Andrea Palladio throughout his life, and the paintings in the Odeo Cornaro, with landscapes and Christian themes above the doors and grotesques, triumphal processions, and

classical *exempla* of virtuous action, found many imitators in the succeeding decades.

A similarly programmatic departure from traditional Venetian villa architecture is seen in the façade, designed by the humanist Gian Giorgio Trissino about 1530, of his quattrocento villa outside the gates of Vicenza. An unexecuted design for the garden façade of Raphael's Villa Madama in Rome, edited and simplified in Serlio's Fourth Book (1537), was this amateur architect's model.[25]

This group of patrons (Alvise Cornaro, Gian Giorgio Trissino) and architects (Giovanni Mario Falconetto and Sebastiano Serlio) with classical learning made a substantial contribution to a reorientation of villa design, yet in their buildings they created no models. As precursors of Palladio, but not as his models, they played an important part in the history of the Venetian villa.

After the Peace of Bologna, which promised extensive guarantees of territorial integrity, more and more Venetians and numerous landowners from the cities allied to Venice decided to construct expensive villas. Even Tullio Lombardo laid down in his will that his property should be sold and much land bought with the proceeds.[26] Sanmicheli and Sansovino must have recognized by the early 1540s that in Andrea Palladio they had a rival whose villa designs enjoyed far greater popularity among patrons than their own, even if the approval was not unanimous. Soon after his trip to Rome in 1541, Palladio built his first villa for a Venetian patron, Giovanni Pisano, at Bagnolo. Shortly before, Sansovino (for the Garzoni) and Sanmicheli (for Alvise Soranzo) had already built imposing villas for Venetians. Palladio had worked also for a Vicentine patron, on the Villa Godi at Lonedo (1537).

In the Villa Garzoni (figs. 102, 103)[27] as in his Venetian palaces, Sansovino integrated traditional elements into an unconventional design. The tripartite façade, built over a tall socle, may arouse memories of Venetian buildings going back to the pre-Gothic palace façade (as in the Fondaco dei Turchi). In 1457 Bartolomeo Buon had chosen this type as the model for his Palazzo Corner (Cà del Duca), he found no imitators in Venice itself, whereas his influence is detectable in a number of villas. The loggia opens on the ground floor onto an inner courtyard situated far above ground level, with Doric porticos on three sides, and on the first floor onto wide balconies running round the three wings. A comparable opening of the ground floor onto the surrounding countryside is found in the Villa Priuli (Treville); in Revere, not far from Mantua, Luca Fancelli created a similar three-winged structure in his castle (*castello*) for Ludovico II Gonzaga about the middle of the fifteenth century.

In his Venetian palaces, Dolfin and Corner, Sansovino made the courtyard, which had the same stylistic treatment on all sides, into an essential part of the palace. Serlio recommended the courtyard as an appropriate architectural solution for aristocrats as distinct from the elongated portico *alla veneziana* in the town palace of the *privato gentiluomo*. In a further design in his unpublished Sixth Book (ca. 1546), and perhaps under the impression of the Villa Garzoni, Serlio recommended a courtyard surrounded by balconies and loggias for the villa of a *gentiluomo* or other rich patrons.[28] Finally, G. D. Scamozzi, in his analytical index to Serlio's treatise (1584), connected the courtyard accompanied on three sides by porticos with Vitruvius's description of the Greek house.[29] About 1555/56 Palladio designed the Convent of S. Maria della Carità in Venice, with its balconies above the columns of the atrium, as an approximation to the residence of antiquity, the *casa degli antichi*. One supposes that in his Villa Garzoni Sansovino was pursuing a similar objective. It is the same with architecture as with sculptures and paintings. The observer will be able to form associations according to his or her expectations and knowledge but in so doing will only touch on a spectrum of possible interpretations, and may seldom be able to recognize the intentions of those involved in the building.

In the Villa Garzoni, Sansovino made the center of the façade stand out from the lateral sections by a *tabularium* motif copied from the Roman theater, while continuing the Doric and Ionic entablature around the corners of the building, the front of which was thereby pulled together and defined as a kind of projection. Memories of Roman buildings as well as of Sansovino's Libreria (1537), probably just begun, are aroused, the Libreria, still richer in its treatment, being the first building in Venice to show the superimposition of Doric and Ionic orders in combination with the *tabularium* motif. For the barrel vaulting of the portico of the Villa Garzoni, Sansovino chose the decorative system of the Libreria, a decision that might be understood by the visitor as a quotation from a public building.

It is a mystery why Sansovino, so successful in Venice at the time, was unable to commend himself as a villa designer with this subtle and monumental work. Possibly the cost, which must have been very high, was not judged favorably in relation to the size of the accommodation; perhaps the dimensions of the living rooms were unsuited to life in the country. Goethe's observation on the Rotonda is particularly applicable here: "Habitable, but not comfortable." It is unlikely that there were functional problems as regards agriculture. Sansovino had built extensive farm buildings (*barchesse*), which were separated from the mansion by walls on the eastern side and which offered space for the products and implements of a flourishing farm, and he provided ample storage space in the high socle area of the main house.

If Sansovino's Villa Garzoni defied comparison with the traditional Venetian villa, Sanmicheli's villa for Alvise

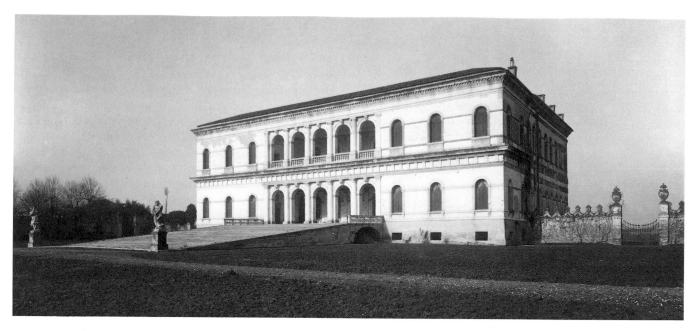

102 Jacopo Sansovino, Villa Garzoni at Pontecasale

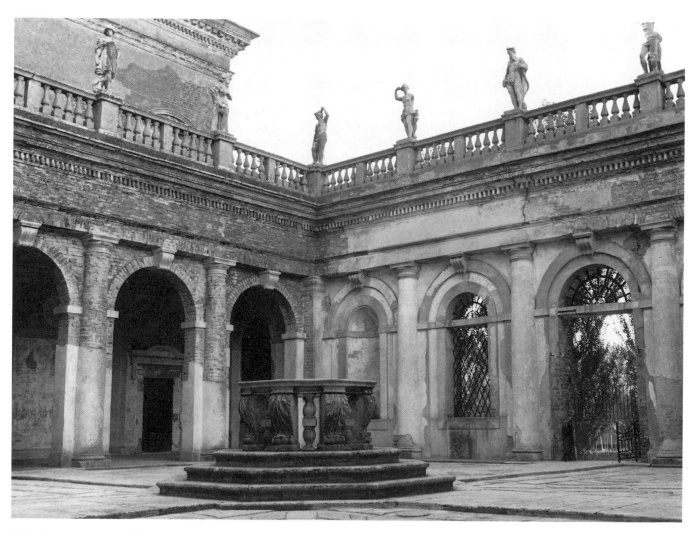

103 Jacopo Sansovino, Villa Garzoni at Pontecasale, courtyard

Soranzo (1540) can be understood as an antithesis to Palladio's Villa Godi (1537).[30] Palladio had deformed the transverse cube traditional in the Veneto by recessing the middle section, only three axes wide, which accordingly projected at the rear. The resulting projecting wings are only remotely reminiscent of the characteristic towers of older structures, for example, those of the Villa Trissino near Vicenza (Cricoli). Each of them contains four rooms of equal size, the windows, in keeping with Venetian tradition, being placed close to the walls dividing the rooms. The design is characterized by the regular grouping of the rooms and the harmony of internal proportions. This almost unadorned building gives a cool, stereometric effect, an uncompromising artistic manifesto that Palladio was soon to revise, after his visit to Rome in 1541.

In dividing the projecting lateral sections from the open loggia between them, Sanmicheli too followed a tradition that appears to have still been felt as binding by many. Perhaps influenced by Palladio, he designed projecting blocks (not towers), but the sequence of his windows, independent of the arrangement of rooms, is related to the five-bay loggia. The form of the loggia and its relation to the projecting blocks seem like a quotation from Serlio's woodcut of Poggioreale. The harmony of the parts attained by the almost regular sequence of openings is further emphasized by a fine network of rustication cut into the stucco.

The name of Andrea Palladio has become synonymous with the Venetian villa of the second half of the sixteenth century. This does not correspond to historical reality. While Palladio clearly surpassed his rivals Sanmicheli (died 1559) and Sansovino (died 1570) in the favor of Venetian patrons, and although his buildings tower in artistic rank above most contemporary architecture, there were nevertheless few who decided in his favor. Giovanni

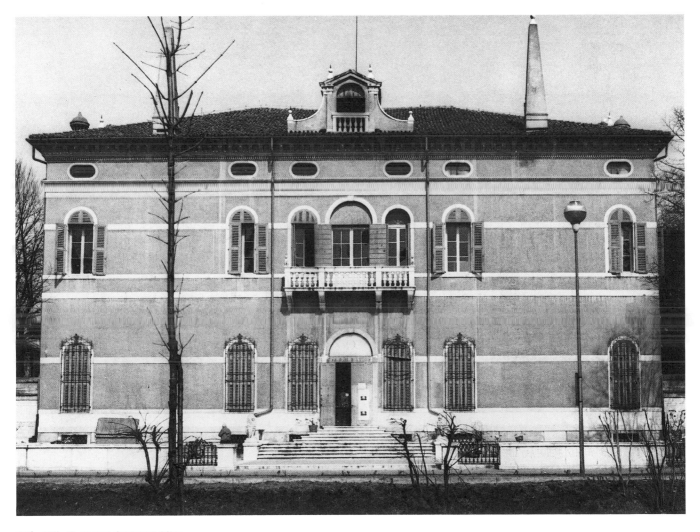

104 Villa Contarini dei Leoni. Mira

Pisano (Bagnolo), Francesco Badoer (Fratta Polesine), Marco Zeno (Cessalto), Francesco Pisani (Montagnana), Giorgio Cornaro (Piombino Dese), Marc'Antonio and Daniele Barbaro (Masèr), Niccolò and Alvise Foscari (Malcontenta) and Leonardo Emo (Fanzolo) were his chief Venetian patrons. A gigantic project for Leonardo Mocenigo seems to have stayed on the drawing board. Other prominent Venetian families remained loyal to traditional forms of living and of architecture. These buildings have been so little studied, however, that they are hardly known. This is also true of the many villas on the Brenta, including the Villas Gradenigo (Oriago), Con-

tarini dei Leoni (Mira) (ca. 1558, fig. 104), Soranza (Strà) with its T-shaped "old-fashioned" sala ("in crocciola"), or Grimani Morosini, known as Cà della Nave, at Martellago.[31] A building as unusual both architecturally and functionally as the Villa Grompo di Concadirame at Rovigo,[32] erected amid the large estates of the Grimani, passed largely unnoticed and was abandoned to decay. Several of these villas were richly frescoed on the exterior, an enrichment popular with the "simple" Venetian town palaces which allowed the owners to make statements concerning their ideals. The painters, however, did not feel obliged to follow Palladio's example on the

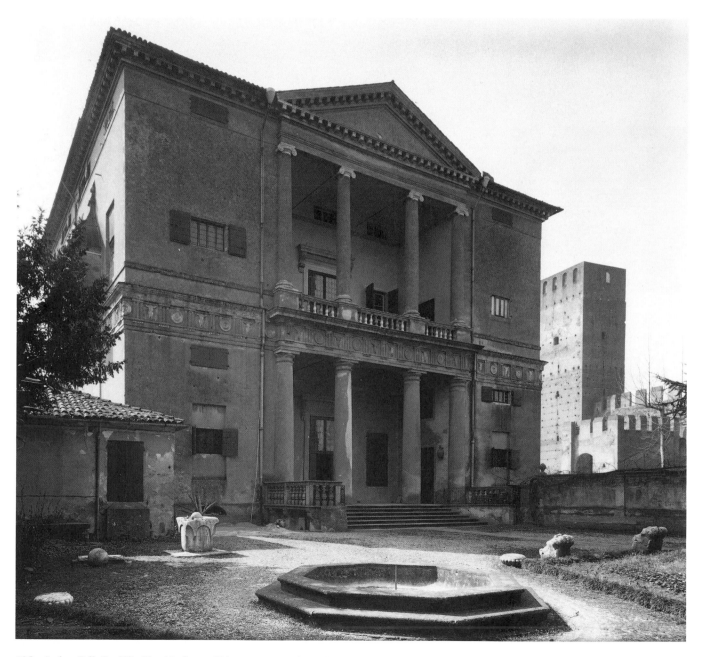

105 Andrea Palladio, Villa Pisani in front of Montagnana, garden side

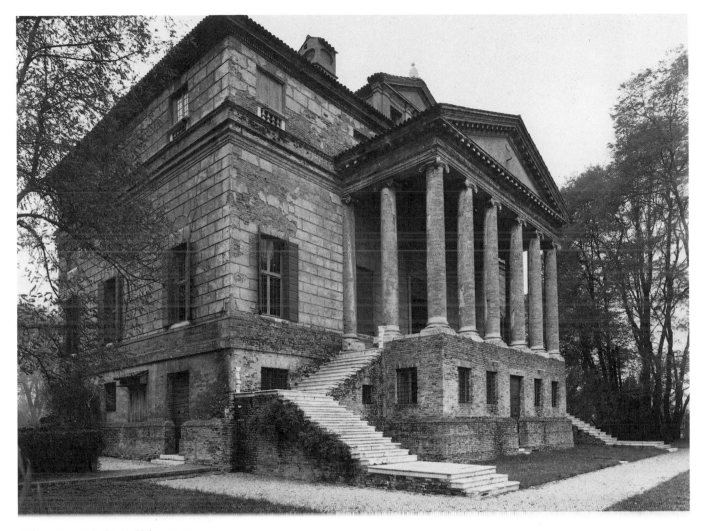

106 Andrea Palladio, La Malcontenta

façades or in their fictive architecture inside the villas. Thus in the Villa Piacentini Corner a S. Andrea (Castelfranco Veneto), the painter applied columns to the walls, just as Zelotti and his contemporaries were wont to do on interior walls.

Palladio remained the architect of an elite who accepted the changed living conditions imposed by his architecture. In general town and country life took place in fundamentally different rooms and suites of rooms. Palladio's projects extend from very small houses limited to a few rooms (the *villini*) to gigantic complexes designed for Vicentine patrons and never completed. Presumably it was sufficient in Vicenza, where building was a prerequisite of the individual's position in political life,[33] to be able to show evidence of a grand project. The publication of these projects in Palladio's *Quattro libri* served the prestige of the patron, as it was doubtless intended to do.

Palladio's numerous designs for the villa of Giovanni

Pisano (Bagnolo, completed in 1544) reveal an attempt to combine traditional elements like towers (*risalite*) with new sequences of rooms based on Roman models, which he had recently (1541) studied at first hand. The starting point was, above all, the middle part of the façade and the *sala veneziana,* which he obviously regarded as obsolete and later eliminated from his palace designs. In his highly original façade designs, later rejected (as too extravagant?), a niche is the central feature, in combination with a staircase running in both directions and made up of semicircular steps. Bramante's staircase and niche in the Belvedere courtyard in the Vatican had already been adapted by Alvise Cornaro, in pocket size, so to speak, for his Odeo, and Serlio had introduced both motifs to a wider public through his Third Book (1540). In his designs for the Villa Pisani Palladio shaped the traditional portico into a colonnade that surrounds the entering visitor. Behind it, a narrow passage opens onto a wide central room for which Palladio de-

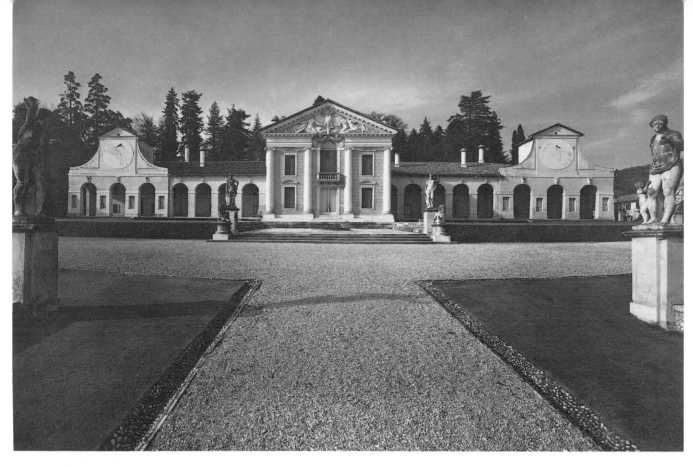

107 Daniele Barbaro and Andrea Palladio, Villa Barbaro at Masèr

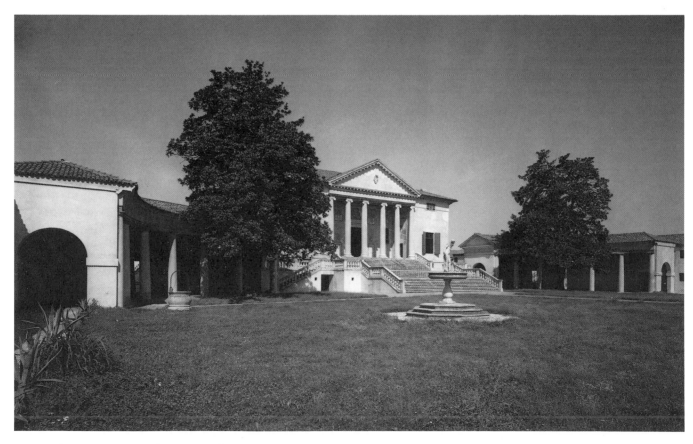

108 Andrea Palladio, Villa Badoer. Fratta Polesine

124

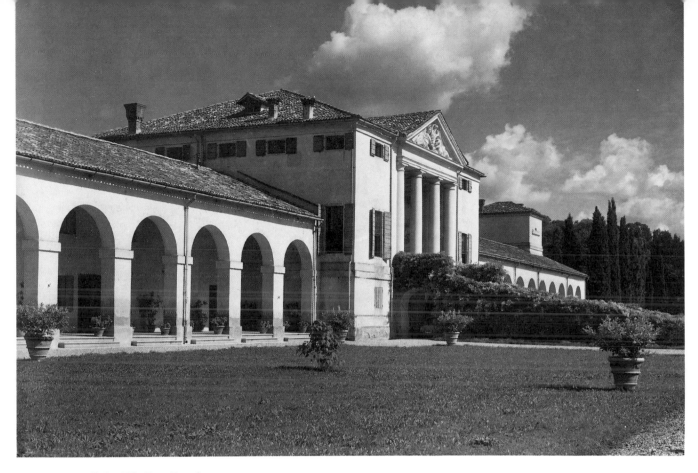

109 Andrea Palladio, Villa Emo. Fanzolo

veloped various solutions. In two designs we already find cross vaulting, and rooms with short transverse arms inspired by Roman baths.

In the version actually built, which Palladio later revised for the *Quattro libri* as was often the case for his youthful transgressions, a low, barrel-vaulted room leads to the high cross-vaulted sala, while a transverse loggia opens on the rusticated garden front. A break with Venetian tradition is already accomplished here, even though the allusion to a *castello* fortified by towers can be explained as a concession to familiar dignifying formulae to which Venetian patrons seem to have become attached.

That Palladio planned from the first a regular courtyard surrounded on its two long sides by porticos is shown by at least one design. The access via a rectangular, loggia-like portico at one design stage remained an isolated episode in his oeuvre. In the first Rialto design a similar solution gives access to the market squares. Palladio was already grappling here with the difficult task of arranging the very extensive outbuildings in relation to the patron's house in such a way that "the necessary appeared as a luxury." [34] In Pontecasale Sansovino had arranged the *barchesse* at the side of the villa as a rectangular self-contained courtyard, using a wall to provide both a caesura and a link to the main house. In such diverse solutions we can discern the clash of the idealistic notion of rural life shaped by literary records of antiquity, with the reality of the cohabitation of different classes with

noisy, often smelly and dirty agriculture. Palladio made clear through architecture the close link between the practice and the ideals of agriculture, without offending decorum. The outstretched arms of the colonnade of his Villa Badoer (Fratta Polesine) (fig. 100), which enclose the approaching visitor in the manner of ancient buildings such as the Forum of Augustus and of Baroque architecture, were the definitive solution to the problem. That such gestures were understood by experienced observers is shown by the venomous criticism by some contemporaries of Bernini's colonnade in front of St. Peter's in Rome. Palladio's acute sense of the manipulation of movement within a building to provide changing views is as much in evidence here as his awareness of practicalities: the visitor, he declared, should be able to reach all parts of the building with dry feet. [35]

Not all Palladio's villas stood at the center of agricultural land. The suburban villa built in 1552 for Francesco Pisani at Montagnana, a few meters from the town gates, belongs to a different type (fig. 105). [36] Into a cube with a roof hipped on all sides Palladio inserted two loggias opening onto the garden and surmounted by a pediment, while on the street front semicolumns covering the same width as the loggias articulate the two stories. As in the façades of the Villa Godi, the manipulation of cubes and blocks seems to reveal a principle of composition. The loggia, the *andito* with its side rooms, and the four-column atrium are grasped as parts of a central block that

the interconnected rooms adjoin—a distant recollection of the continuous sala of earlier times. In the Villa Giustiniani (Roncade) Tullio Lombardo (?) had placed two loggias, one above the other, under a classical-style triangular pediment in front of the main block. Palladio's double row of columns, comparable to the columns on the street façade, is conceived as an applied element, as is shown by the join in the entablature. The connection of a temple front to the wall by continuing elements of the entablature that encircle the block, in Palladio's words, "like a crown" is also to be found in Palladio's Villa Cornaro at Piombino Dese.

The Villa Foscari (the so-called Malcontenta) at Gambarare di Mira (1559/60, fig. 106) was also not related to agricultural land. Situated close to the lagoon and facing the city, it is elevated above the damp ground on an unusually high socle, presenting itself freely to the approaching visitor. Henri III, in 1574, was one of the most prominent visitors to this building, which today, cut off from the lagoon by foul-smelling industrial installations, symbolizes the threat both to our life and to our architectural heritage by negative environmental influences.

In the main façade the Ionic temple front, two bays deep before a shallowly rusticated block, is predominant. Palladio had chosen a temple front for the reconstruction of the classical house in Daniele Barbaro's commentary on Vitruvius (1556), justifying it in his buildings as follows: "Pediments give the edifice grandeur and magnificence. The ancients used pediments on temples and public buildings, and it is probable that this was suggested by their houses."[37] Narrow, steep stairs lead to the loggia, the main entrance to the building. On the garden side, by the projecting bay, Palladio recalled the cruciform central room, which received its abundant light through a middle group of windows consisting of three vertical rectangular windows and one thermal window. This group has essential qualities (optimal admission of light, flexibility) in common with the serliana. The shal-

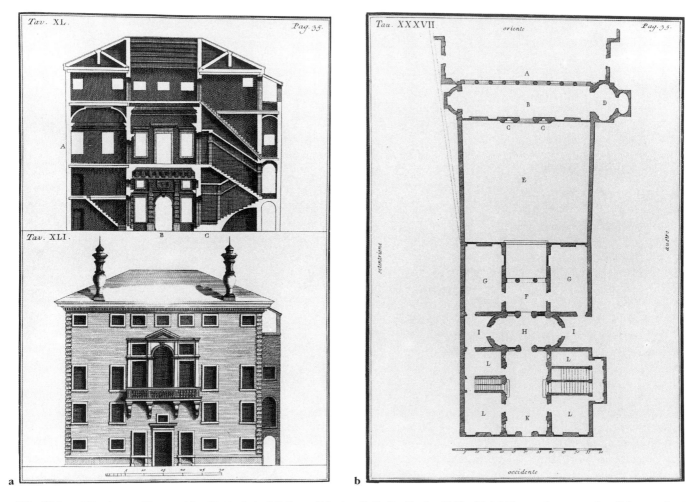

110 "Palazzo" Trevisan on Murano. After Muttoni, *Architettura di Andrea Palladio,* Venice 1740–47. (a) View and cross-section; (b) ground plan of the entire complex; (c) the grotto (portal and ground plan), and view of the back of the palace; (d) the loggia in the garden

low pediment with its broken lower line, like the semicircular window, recalls Roman baths. The network of rustication cut shallowly into the stucco is of unsurpassed richness yet entirely different from the rusticated façades of Sanmicheli, only a few years earlier. Ashlar is simulated, as is particularly clear at the corners of the building or of the central block. As so often, Palladio used inexpensive materials that fascinate the onlooker regardless of their intrinsic value. The quality of materials took second place to the qualities of the design. The "slabs" of this rustication compose themselves around the windows like frames.

For a long time the Villa Barbaro at Masèr (fig. 107) was considered the outstanding example of Palladio's art. His contribution to the basic design, however, was less than that of the owners, the "dilettanti" Daniele and his brother Marc'Antonio, who were attempting in their mansion to recreate an ancient building, Pliny's Triclinium in the Laurentine Villa.[38] In this they were part of

a tradition that was especially well represented by the amateur architect Alvise Cornaro and his Odeo in Padua. Inconsistencies in the elevation that Palladio never perpetrated in his own works suggest that the builders sought the advice of their protégé mainly on details and structural questions.

The weaknesses in the design of the Villa Barbaro are especially clear if it is compared to a masterpiece like the Villa Emo in Fanzolo (ca. 1561–64, fig. 109). The strictly cubic residence with its temple front forms a unified entity with the farm wings, which are lower and stepped back from the line of the main façade. In its formal harmony, the Villa Emo powerfully idealizes the living pattern of the *villeggiatura* without blurring hierarchical distinctions.

Palladio exerted no influence on the paintings used to ornament his villas.[39] The simulated architectural features concocted by the painters transform Palladio's rooms in a fundamental way and even in their details are

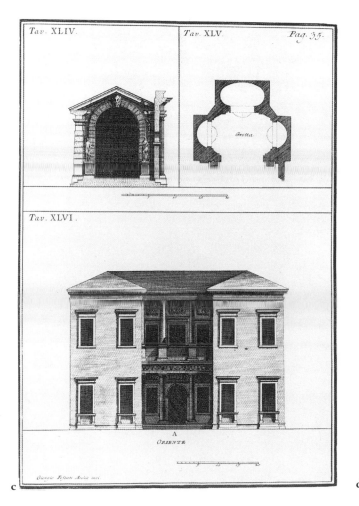

c

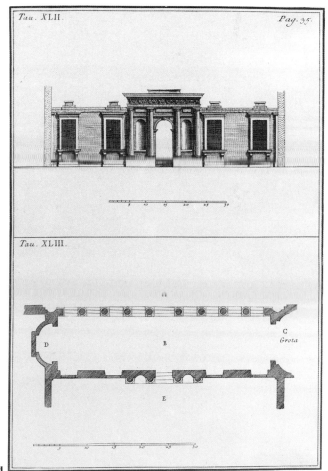

d

not based on his "system." Unity of architecture and decoration to form a *gesamtkunstwerk* was neither expected by the patrons nor within the influence of the architect. Sebastiano Serlio testified to this very clearly in his Fourth Book of 1537. Thus, the entire stucco decoration, including the richly stuccoed fireplaces of the Villa Barbaro, appears to have been designed by Paolo Veronese.

There is a similar state of affairs with the residence of the Venetian city commandant, the Loggia del Capitano in Vicenza. In it Palladio had designed a building in which the façade facing the piazza was to be dominated by mighty semicolumns, weighty balconies, and windows cut high into the entablature. When the news of the Venetian naval victory at Lepanto reached Vicenza in 1571, the façade, in a departure from the original plan and to the design of an anonymous decorator, was covered with a triumphal stucco decoration. If one mentally disentangles the loggia from this uniform embellishment, one has a glimpse of Palladio's design, in which the splendid composite capitals stand out against their background like sculpture, and the contrast of the monumental semicolumns to the wall area is effective. The *horror vacui* characterizing the loggia today reflects neither Palladio's style nor his conception of appropriate decoration for his buildings.

The often very rich pictorial cycles of Venetian villas, hardly investigated up to now, gave the patrons an opportunity to celebrate their family history and ideals, usually through allegorical or mythological cycles.[40] As compared to the rather discrete pictures in a Venetian palace, here celebratory programs are prevalent. In the pictures decorating the villas the self-glorification of the patrons, kept within strict limits in Venice itself, is given free rein. Palladio provided the architectural framework for such statements.

Palladio's success with villas for Venetian families was confined to buildings on the *terraferma*. In Venice itself and the surrounding islands he obtained no commissions. There, at the same time, numerous buildings anonymous today and in part the work of amateur architects were put up; they combined elements from the Venetian city palace with those of the villa. They include the "Palazzo" Trevisan on Murano (fig. 110),[41] designed about 1556/57 perhaps by Daniele Barbaro, with its rich paintings by Paolo Veronese and the Casinò Mocenigo (Murano) (ca. 1560)[42] with no less opulent paintings. The same group includes the "Palazzi" Vendramin (demolished), Dandolo, and Mocenigo on the Giudecca.[43] In 1581 Sansovino gave a long list of buildings of this type and of their extensive gardens.

From the fifteenth century loggias were often found on the rear of a villa, opening onto a garden. Jacopo de'

Barbari's view of the city (1500, fig. 100) records a number of buildings, of which the demolished "Palazzo" Vendramin on the Giudecca (early sixteenth century) was an especially prominent example. Later buildings show, on the garden side, the projecting lateral wings familiar from villa architecture developing into a U-shaped configuration. The façade conformed as a rule to the conventions of Venetian palace architecture, while the garden façade made the building's villa aspect clear by means of an open loggia. There were also exceptions: the one-story Casinò Mocenigo recalls early villa designs by Palladio, while the regular sequence of windows in the rusticated façade of the "Palazzo" Mocenigo on the Giudecca (ca. 1580?) was highly unusual in Venice.

Palladio took advantage of the opportunity to design villas and city palaces without major stylistic differences, as a comparison of the street façades of the suburban Villa Pisani near Montagnana with the Palazzo Antonini in Udine shows. Before Palladio, Sebastiano Serlio had designed a palace "in the Venetian manner" (fig. 23c) which, according to his explanation, could also serve as a villa.[44] The loggias opening one above the other in Serlio's design were chosen soon after the middle of the century by Daniele Barbaro (?) for the garden façade of the "Palazzo" Trevisan (Murano) (fig. 110). The reasons that led to a combination of characteristic elements of the town palace and of the villa are probably to be sought in the self-imposed constraints of the site, on the periphery of Venice, which made the conventions of city architecture seem obligatory at least for the façade on a canal or a street.

The program of some villas included a loggia separate from the main building, often adjoining the garden wall, that probably had a variety of functions. Of these the loggia of the *barco* of Caterina Cornaro (Altivole) (ca. 1490) and the loggia next to the Odeo Cornaro in Padua (signed by Giovanni Maria Falconetto in 1524) have been preserved; the loggia of the "Palazzo" Trevisan on Murano and a project by Palladio for the Villa Pisani at Bagnolo are recorded only in drawings. Alvise Cornaro used his loggia in Padua and another in his no-longer-extant country house at Este as a background (*scenae frons*) for theater performances, quoting the example of antiquity.[45] Adjoining the loggia of the "palazzo" for Camillo Trevisan was a grotto built on an oval ground plan, comparable to the nymphaeum still preserved at the Villa Barbaro (Masèr). The whole complex was surrounded by high crenellated walls. The almost total loss of these buildings, which were also to be found in the gardens of some palaces, has given rise to a somewhat restricted view of the range of buildings permissible in Venetian villas.

7 SCULPTURE

The Sculptor's Workshop

A large number of surviving documents and an analysis of the works enable us to make some general comments on the operation of the Venetian workshop.[1] These documents include the statutes of the guild of stonemasons (the *tagliapietra*), which contain information on the rights and duties of individuals, questions to do with competition, and references to the practice of different epochs, as well as numerous contracts, and payments. A study of the Venetian sculptor's workshop is an important prerequisite for an assessment of attributions.

It was decided by the Council of Ten in 1460 that foreign stonemasons could be given immediate Venetian citizenship and so receive all the privileges of native Venetians.[2] The reason is likely to have been a sharp increase in the demand for qualified stonemasons, which would also explain the relatively high wages in Venice.[3] The effects of the decision did not take long to show themselves. Only six years later the guild complained of the grave effects that a regular invasion of foreign stonemasons and the many imports had on the local craftsmen, and urged restrictive measures. No such decree appears to have been issued, however, as is shown by the large number of stonemasons still recorded in the documents today, mainly (but not only) from the duchy of Milan. Finally, a document of 1491[4] speaks of 126 foreign master stonemasons and their 50 apprentices (usually referred to as *garzoni* but here called *fanti*) who, adding insult to injury, obstinately refused to pass on their knowledge to Venetian apprentices, which was said to be damaging to the whole city. The motion, which was accepted by the responsible authorities, the Giustizieri Vecchi and the Provveditori di Commun, demanded primarily that these troublesome competitors should not be allowed to occupy any influential offices. An exception was made, of course, for stonemasons from the mainland territories under Venetian rule. These documents reflect changes that took place after 1460, resulting in an influx of foreign stonemasons. Many of the immigrants succeeded in obtaining civic rights, and the great success of a Pietro Lombardo from Lake Como makes it clear who had the whip hand in these decades. Pietro not only had numerous important commissions in Venice itself but was in demand outside the metropolis, as contracts in Mantua, Bergamo, Padua, Treviso, and Belluno (?) show. In addition, he was a member of the Scuola Grande della Misericordia, from 1499 *proto* of the Doge's Palace, from 1514 a *gastaldo* of the guild, and at all times sought after as an expert—one could hardly be more successful than that.

As in the fourteenth century, there were a large number of family businesses. The Lombardos (Pietro, Tullio, and Antonio) and the Bregnos (Giambattista and Lorenzo) were especially successful. The members of these family firms usually signed contracts jointly, which in 1485 was described as a normal procedure in Venice by a Treviso client of Lombardo.[5] This practice gave the sculptors bigger advantages than the patrons, since the distribution of the labor was not as a rule contractually enforced, giving the workshop considerable flexibility. This did not prevent the patron, in the course of work that not uncommonly lasted for several years and sometimes even decades, from confirming the content of an agreement with one member of the family, a sign that within a workshop the tasks could be divided up. Examples of this practice can be found in the firm of Pietro Lombardo and Sons. There were also associations of experienced masters who could often cope with large-scale contracts better as partners (*soci*). The patrons seem to have been inclined, with especially big contracts, to commission several small concerns together,[6] so that it was probably a special case when Pietro Lombardo wrote in 1496 from Venice to Francesco Gonzaga, duke of Mantua—perhaps exaggerating somewhat—that he was hastening with twenty-five men to complete the commission for a chapel for the Mantuan *castello*.[7]

In all this one should not forget that the tasks of the stonemason included not only the production of statues but the supply of decorative or structural parts of a building or its interior decoration. The capital on the ground-floor portico of the Doge's Palace depicting the patrons of the guild (the four crowned saints) shows this diversity of tasks. We may suppose that within the firms there

was a hierarchy of responsibilities, in which the day-laborers (*lavoranti*), trained like independent masters, could execute a work on their own, whereas the apprentices would seldom be allowed to put the finishing touches to important statues.

Even a superficial examination of large ensembles indicates that within a workshop the tasks must have been distributed primarily with punctual completion and the desired profit in mind, the qualitative discrepancies between individual elements being often dismayingly large. But it also becomes clear how such ensembles (chapels, tombs, altars, etc.) were evaluated by the great majority of patrons. There is hardly any record of a demand for a price reduction or the replacement of substandard work (as in the Tron monument, in which rather clumsy figures stand side by side with Antonio Rizzo's masterpieces).[8] It appears that the few highly qualified sculptors could take any liberty they chose. It was not until 1548 that there is any mention of disputes between Venetian patrons (aristocrats and *cittadini*) and inexperienced and ill-trained masters over poor work, which was seen as damaging to the guild.[9] Perhaps the demands and discrimination of some patrons had changed.

That clients refused on several occasions to pay for works emerges from a document of 1465, in which the members of the guild are placed under obligation not to finish any work begun by others, unless the member originally commissioned agreed.[10] That such breaches of contract were justified or explained by defective quality of execution is unlikely. In such cases there would have been arbitration, as is recorded from the beginning of the century in the case of the altar of the brothers Pierpaolo and Jacobello dalle Masegne for S. Francesco in Bologna. The date of 1465 suggests, on the contrary, that after foreign stonemasons had been successfully attracted to Venice, some patrons knew how to take advantage of the resulting intense competition.

One result of the concentration of sculptors' workshops in Venice was that in many dependent cities masters residing in the metropolis were given preferential treatment, to the grave detriment of the local craftsmen. But this was nothing new. Even in the fourteenth century Venetian workshops like those of the de Santi and the dalle Masegne largely controlled the market beyond the boundaries of Venice. If this was true above all for cities like Treviso, Belluno, and Udine, there were others that were able, at least for a time, to support competitive workshops and, as in the case of the commissions awarded to Donatello in Padua, to set their own standards and found their own traditions.

If the commission was awarded from outside to a Venetian workshop, as a rule the work was completed down to its last detail in Venice, carefully packed, and finally sent, if possible by water, to its destination. It was assembled on the spot, usually under the supervision of the workshop head.[11] Many stonemasons also engaged alongside their craft, as had long been the tradition in Venice, in trading in stone, the quality of which they were able to judge better than anyone else. Here, too, the details were regulated by the guild. These traders also had customers outside Venice. For example, in 1497 the sculptor Gian Cristoforo Romano bought Carrara marble from Antonio Rizzo in Venice.[12]

More important is the question of the personnel of these workshops. Did the members come and go, or did they form, over long periods, a team that could become deeply versed in the idiom of the workshop's head? Seldom are the documents as explicit as in the case of Guglielmo de' Grigi from Bergamo, who, constructing an altar in 1523, had surrounded himself with five other craftsmen from Bergamo, three stonemasons, a gilder, and a carpenter, obtaining the stone from his colleague Zaccaria in Istria (Rovini).[13] At the same time Guglielmo was contracted to incorporate into the altar two figures received as presents and executed more than a decade earlier.

Numerous documents give a clear picture of the production process of the works up to their assembly. The contracts frequently refer to drawings that were to be binding even in their details. They were a part of the contract and could be annotated and signed accordingly. These visual parts of the contract usually made detailed verbal specifications of the dimensions and material superfluous. To be sure that the artist did not depart from the contract drawing, one copy could be retained by the designer and another by the client, as in the case of Paolo Veronese's design for the high altar of S. Sebastiano.[14] Unfortunately, few of these contract drawings have been preserved.[15] Also lost are the bundles of drawings making up the pattern books, often referred to in the sources when the books changed hands in legacies. Jacopo Sansovino left his gesso molds and his *modelli* to Danese Cattaneo, and his drawings, still lost today, to a stonemason named Salvatore.[16]

The fine drawing used by Antonio Lombardo to prepare a relief in the Cappella dell'Arca in the Santo (fig. 111) has only recently come to light.[17] If this drawing, showing the miracle of the miser's heart discovered in the treasure chest, is an autograph contract drawing (1501) for a relief that was never begun, it would have far-reaching implications. The important part played by the strong light from the left and the deep shadow in molding the figures and clarifying the spatial relationships is obvious. The details are reproduced so precisely that collaborators could get all the necessary information from this quite small drawing. The drawings after ancient statues and reliefs used by Venetian sculptors for inspiration or as models might have been made in the same way.

It was also customary to produce three-dimensional models. This was true both of sculptures and architec-

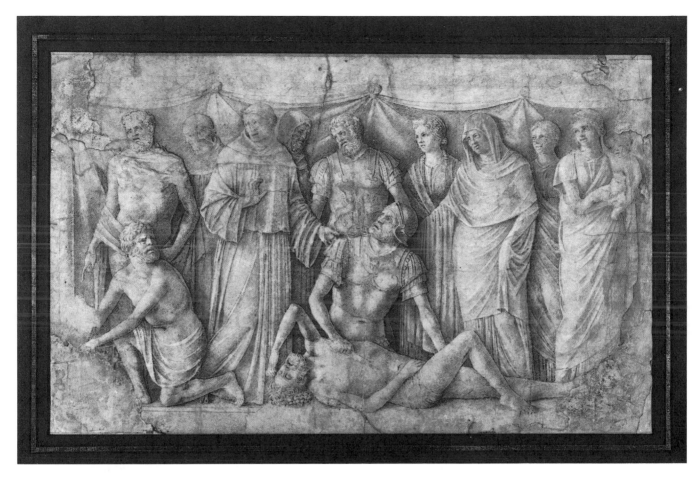

111 Antonio Lombardo (?), drawing for a relief of the Cappella dell'Arca in the Santo at Padua. England, private collection

tural details. A full-size model for Antonio Lombardo's relief in the Cappella dell'Arca in the Santo (Padua) seems to have been preserved up to the seventeenth century, and a life-size terracotta model of Mosca's relief for the same chapel (1520) found its way into the possession of Sansovino's pupil Tiziano Minio.[18] Both models were part of the contract.[19] In 1536 a stone model by Antonio Buora for the altar of the Scuola della Beata Vergine in S. Maria Mater Domini is mentioned,[20] although it is open to question whether the description of the material is to be taken literally. In addition, in 1524 Bartolomeo di Francesco submitted a wax model for his *Magdalena* for the altar of the Verde della Scala. For the altar itself a wood model was made in 1523 by Biagio da Faenza from the design by Guglielmo de' Grigi.[21] An architectural model for the Cappella del Santissimo in the cathedral of Treviso has been lost, like all the other models mentioned in contracts or payments.

We may suppose that these three-dimensional models had an important function in the training of artists. Successful workshops attracted many visitors, as we know from a letter of Pietro Lombardo of 1497, in which, not without pride, he compares his workshop to a church

consecration, since everyone wanted to see the pieces prepared for Mantua.[22] In several contracts the imitation of another work is prescribed. This may have been a window, the top of a façade, or the form of a sarcophagus, as in the case of the tomb for Giambattista Zen, which was to be copied from that of Orsato Giustiani, or just the imitation of the capitals of the Doge's throne in S. Marco for an altar in S. Maria Mater Domini (1536).[23]

Drawings for sculptures and sculptural elements for the interior of buildings could also be supplied by painters. This was an exception, but it opens far-reaching perspectives. In 1476, for example, Antonio Rizzo, at that time the most important sculptor in Venice, followed drawings by Gentile Bellini in his work on the fittings of the Scuola Grande di S. Marco. They even prescribed the choice of materials and the resulting color effects.[24] Antonio Rizzo had already shown great interest in the work of contemporary painters, and some essential traits of his work are the result of an intensive study of Andrea Mantegna's pictures. It is possible that sensitive contemporaries were aware of these affinities.

Painters not only designed reliefs with human figures. It is recorded that in S. Sebastiano, Paolo Veronese de-

signed everything from the floor to the windows, the altar, the pews, and the organ case. His contribution to the sculptural decorations of the Villa Barbaro (Masèr) has only recently been recognized.[25] Drawings done by painters for fireplaces in Venetian villas lead us to suppose that the employment of painters for such tasks was widespread. Towards the end of the century Antonio Vassilacchi, called Aliense, designed the high altar of S. Giorgio, which the sculptor Girolamo Campagna was commissioned to execute.[26] Girolamo Campagna's sculpture of Federigo da Montefeltre (Urbino) goes back to a design by Federico Barocci.[27] The judgment of painters also carried weight in the assessment of sculptures. The negative verdicts of the jurors Gentile and Giovanni Bellini on the altar begun for the Scuola Grande di S. Marco by Giovanni Dalmata was decisive in terminating the contract.[28]

Many Renaissance sculptures and buildings preserved in Venice show some partial gilding and less frequently polychromy (plate 9).[29] In this they do not differ from those of the preceding decades or centuries. This use of polychromy, however, has never been systematically studied, so that it is not possible to comment on possible changes of style. Documents also refer to gilded and painted sculptures, the execution being in most cases left to painters. In 1505, for example, Giovanni Matteo, the son of a Gaspare "teutonico," contracted to paint the tomb of Ludovico Marcello (S. Gaetano, Treviso) in gold and blue.[30] Both the loss of the contract drawings and the meager information found in the text of the contracts make it impossible to comment on contemporary ideas of appropriate polychromy for sculpture. The contracts with painters and gilders, agreed to following the completion of the sculptor's work, are usually very brief, suggesting that these painters had to be guided by notes on the drawings, even if this was not mentioned in the contracts. The contract with Donato of Bergamo (1524) for the gilding of the altar of the Verde della Scala (now in SS. Giovanni e Paolo)[31] contained minute specifications regarding the parts of the altar to be embellished. Because of their high cost, blue and gold were usually mentioned specifically in contracts and seem to have had a major influence on the effect of many works. The façade of the Scuola Grande di S. Marco, for example, was painted in blue, gold, and red. On looking closely one can still discover considerable residues today. But here too generalizations would obscure the diversity of the possible solutions. Besides gold-outlined or "colored" architectural details and sculptures, there were unpainted ones like Pietro Lombardo's figures for the altar of the Cappella Colleoni in Bergamo (1491) produced in Venice, one of which was "embellished" by a bookseller named Paolo di Acquate soon after it was installed; this earned the unfortunate individual a heavy punishment.[32] One thing seems clear: painting or gilding could mask poor workmanship in a sculpture and considerably modify the effect of a good sculpture. No doubt more than one sculptor counted on this cloak of mercy as he prepared his figures.

If we consider that in 1490 126 Lombard stonemasons were established in Venice, clearly providing stiff competition for the 40 or so local masters, it is clear that the widespread practice of attributing the very numerous works surviving from these years to some ten sculptors cannot fit the facts. On the other hand, the sculptors active in Venice (not counting the *garzoni* still undergoing training) would not all have developed a distinct individual style, so that the surviving works are more often distinguished by differences of quality than of style. These qualitative differences are far too often neglected when attributions are made. The sculptors naturally took some contracts more seriously than others, although one would like to know how far this was the result of the incompetence or parsimony of the patron or the disinterest or "business acumen" of the artist. Thus—as in the Gothic period—it was quite uncommon to oblige a sculptor to supply work produced by him alone. If one looks closely at, for example, the figures on the tomb of Giovanni Battista Bonzio (SS. Giovanni e Paolo) and compares them to Mosca's relief for the Cappella dell'Arca in the Santo (Padua), so carefully and ambitiously worked, apart from a great difference of quality an almost unbelievable shoddiness in the execution by his assistants is apparent. Such substandard figures are to be found in considerable numbers not only in the first decades of the sixteenth century, particularly on tombs, but also on altars, rood screens, and portals. As in the Gothic age mediocrity preponderated—to judge by the surviving works—in the Venetian Renaissance. This makes it all the more important to separate the wheat from the chaff.

Even if this problem is perhaps less evident after 1530 and the death of Tullio Lombardo (1532), the quality of many works was still censured by contemporaries. Jacopo Sansovino, Alessandro Vittoria, Girolamo Campagna, and Danese Cattaneo are unlikely to have been criticized. But who were the "inexperienced, ill-trained" masters? Many names are mentioned in the record book kept by Alessandro Vittoria, but independent works completed by these craftsmen are generally lacking. Moreover, a not inconsiderable number of sculptures in Venice cannot be convincingly attributed by our methods to a particular workshop. Neither the term "collaborators" nor "school" is very helpful, unless it refers merely to the social relationships within a workshop. Working for one of the leading sculptors did not as a rule mean a renunciation of artistic identity, for example, when Vittoria worked for Sansovino; minor craftsmen simply brought to the task at hand their acquired skills and artistic vocabulary. Stylistic similarities were a necessary result neither of joint work on a project nor of training by a particular sculptor. In the countless qualitatively modest

sculptures populating the Venetian tombs, altars, and rood screens, reflections of works by the leading sculptors such as Antonio Rizzo and Pietro, Tullio, and Antonio Lombardo are discernible in all imaginable combinations. The "mix" of motifs was no doubt individual, yet hardly a consequence of affiliation to a particular workshop, which is usually a matter of conjecture in any case. In the hands of imitators, the traits of their models were often simplified to formulae. If this is the case, however, attributions of the often eclectic works of these imitators to the "workshop" of one of the "great" (such as Pietro Lombardo, Antonio, Rizzo, or Tullio Lombardo) are hardly sustainable. The collaborators based their works on those of the main master, favoring elements that, we may suppose, seemed characteristic not only to them but to patrons and experienced critics. Antonio Rizzo's collaborators on the tomb of Doge Niccolò Tron (fig. 115) gave their works so much of the style of the head of the workshop that these qualitatively undistinguished products were misunderstood as the result of a collaboration with Rizzo. Slender hands placed conspicuously in view, "inspired" gazes, the dancing posture of slender feet, and a few fold configurations are not enough, in the case mentioned, to prove that Rizzo was involved. Despite all the imitation, one detects different habits in the collaborators in the molding of drapery folds, a varying interest in elaborating the body beneath the garment. There is no element in these and similar figures that necessarily points back to a design by the master. This design might have consisted only of a drawing or a sufficiently detailed model. But then it would be necessary to prove that the design and the execution are by different people. No one will seriously imagine that the workshop head blocked out the figures, which were then completed by assistants. Similar questions arise in the case of the Venetian painting of our period.

It is revealing that the Venetian sculptors who preceded Sansovino were reluctant to sign their works. Donatello's *Baptist,* Antonio Rizzo's *Eve* on the Arco Foscari, Tullio Lombardo's *Coronation of the Virgin* in the Cappella Bernabò (S. Giovanni Crisostomo), sculptures by Giovanni Antonio Lascaris (Pyrgoteles) and Simone Bianco are rare exceptions. The signatures on the reliefs of the Padua Cappella dell'Arca, partly made in Venice, are a special case. On them, prominent sculptors such as Jacopo Sansovino and Danese Cattaneo as well as the lesser-known Grandi brothers were obliged by contract to sign, without being required to produce the works single-handed.[33] The reluctance to sign changed after about 1530 with Jacopo Sansovino, who proudly called himself "Florentinus" on a number of occasions, by which he no doubt intended to demonstrate his origins as well as the superiority of the school of sculptors from which he came. Alessandro Vittoria, Girolamo Campagna, and Giulio Angolo dal Moro signed as a rule.

Often, especially with state contracts, several sculptors independent of each other worked at the same time on a large project. The refurbishing of the Sala delle Quattro Porte in the Doge's Palace after the fire of 1574 is only one example. It has been demonstrated that even in the case of smaller contracts, like the altar for the Cappella del SS. Sacramento in S. Giuliano (1578–80), three well-known artists—the architect Giovanni Antonio Rusconi and the sculptors Alessandro Vittoria and Girolamo Campagna—were involved.[34] However, this was probably a special case.

In deciding the results of competitions, too, there was no uniform practice. How many stages there might be in a competition is shown by one held in 1583 by the Scuola Grande di S. Rocco for the altar of the Sala del Capitol.[35] Apart from signed drawings (five have been preserved) and a sculptural model, a life-size perspective is also mentioned.

It is particularly difficult to define the contributions of more than one sculptor in bronze casting. Here the chasing of the cast or the fashioning of a clay or wax model for the cast might be left to assistants. For example, in May 1546 Jacopo Sansovino paid Alessandro Vittoria and another colleague a sum of money for the "cleaning," that is, the final preparation before casting, of the surface of his wax model for the sacristy door of S. Marco (fig. 148).[36] The activity gave Alessandro the opportunity not only to study each detail but doubtless to put in accents of his own. The ability to imitate the style of contemporaries, as we see from examples in painting as well, was held in high esteem.

Few written sources give us an insight into the workshop of the sculptor Sansovino,[37] but a letter written by the master himself has particular significance. In 1550 Sansovino wrote to the duke of Ferrara that he had intended to have a figure of Hercules destined for Ferrara made by his young assistants, guided and corrected by himself, without touching the work himself with a chisel. This, he wrote, was how he was accustomed to work on many other figures in Venice, since other contracts for which he was obliged to carry out the work himself left him no time. Now, however, he was after all taking up the chisel he had laid aside for so long. Despite these promises Sansovino had several assistants working on the block in the following years, without finishing the figure. After Alessandro Vittoria had tried to steal the commission, an unnamed Ferrarese sculptor is mentioned as a rival candidate for carving the figure in 1554. Sansovino had obviously realized that his figure was unsuccessful, which is why in 1552 he steadfastly refused to show it to the Ferrarese agent, to whose ears damning reports had come in the meantime. Having at first adjudged Vittoria's *modello* better than Sansovino's work, in 1553 the agent changed his mind, though without good reason, as is shown by the clumsy colossus on the piazza at Brescello.

That Sansovino was not afraid to describe this practice, clearly accepted in Venice, to a "foreign" patron is somewhat surprising. He had "for years" been producing sculptures in his workshop without touching them. That this was not an isolated case in Venice is clear from the careful notes of his pupil Alessandro Vittoria.[38] Here are a few examples: in 1553 Vittoria first paid a certain Giovanni, then a Giacomo (for five days), and finally Lorenzo Rubini for a total of seventy working days for their work on one of the two over-life-size figures, signed by Vittoria, at the entrance to the Libreria. In the same year, for work on the second figure, he paid a Giovanni da Sasso (two days), a Giovanantonio Vicentino (thirteen days), and his apprentice Battista (fourteen days). The varying degrees of involvement by assistants that emerge from these notes are to be found in many other commissions, so that the question of Vittoria's own contribution to any work has to be posed again. In 1557/58 he had his assistants work on figures on the tomb of Doge Francesco Venier; in 1584/85 the two under-life-size saints in the Cappella Bernardo in S. Maria dei Frari were executed consecutively by Andrea Gazino, Cesare Milanese, Matio Milanese, and Marcantonio Palladio. In these figures it becomes clear that Vittoria's designs, whatever they may have looked like, lost so much in being translated by less gifted stonemasons that they cannot, on the basis of their style, be termed works by Vittoria. This was despite the fact that Vittoria had developed a repertory of formulae for drapery which was easy to imitate, as can be seen from the works of Giulio Angolo dal Moro, for example. Nor is it usually possible in the second half of the sixteenth century to trace back a figure of conventional design to an "original" by a more gifted artist. The two figures in the Cappella Bernardo that were produced in Vittoria's workshop contain nothing that the mediocre sculptors who produced them could not have invented themselves. Thus a study of the workshop yields no patent solution to the problem of attribution but takes us back to the old conclusion that only a thorough analysis taking workshop practice into account can lead to well-founded attributions.

Antonio Rizzo

Antonio Rizzo's status as a sculptor has been distorted by the attribution of second- and third-rate works. However, if securely attributed works such as his *Adam* and *Eve* are taken as a yardstick, he is among the great sculptors of his time.[39]

When Bartolomeo Buon died circa 1464 in Venice, Rizzo was already a famous man. His rival Pietro Lombardo, later to be so successful, was still working *ante portas* in Padua. Rizzo's name is surprisingly absent from the Venetian art histories of the sixteenth and seventeenth centuries, doubtless a *damnatio memoriae* that

can be explained, if not justified, by the inglorious end of his Venetian career—in 1498 he fled the city, accused of embezzling public money.[40] In 1581 Sansovino attributed Rizzo's tomb of Doge Tron, his Scala dei Giganti, and Mauro Codussi's courtyard façade of the Doge's Palace, which had been erected with Rizzo as *proto,* to Antonio Bregno. This controversial record of events makes it necessary to make a further excursion before considering Rizzo's works.

An engraving of 1777 named Antonio Bregno and his brother Paolo from Lake Como as the authors of the monument to Doge Francesco Foscari (died 1457, S. Maria dei Frari). Only at the end of the last century were documentary references to the two Bregnos discovered, so that the conjecture that the old attribution of the Foscari monument is based on written sources becomes almost a certainty. In 1460, in the discussions about the completion of the Cà del Duca, a certain Paolo is mentioned several times as *proto* of the procurators, together with Bartolomeo Buon.[41] The great similarity between the Arco Foscari (fig. 15) and the Foscari tomb might speak in favor of attributing the Arco Foscari, work on the figures of which was in progress in 1463, to Paolo and Antonio Bregno.[42] The garments of the four Virtues of the Foscari tomb cling to their limbs and form oval patterns and fillets; they find their closest correspondence in Andrea Mantegna's frescoes in the Cappella Ovetari (Padua), for example in the fresco *St. James Being Brought to Trial before King Herod.* In Antonio Bregno, too, the often very close relationship of Venetian Renaissance sculptors to painting is evident.

Francesco Sansovino also names another sculptor active in the 1460s, Antonio Dentone. He claims that the tomb of Orsato Giustiniani (died 1464) from the little church of S. Eufemia in the monastery of S. Andrea della Certosa (demolished) and the façade monument for Vittore Cappello (died 1467) on S. Elena (fig. 112), were Dentone's work. These works are often attributed to Antonio Rizzo, with, as it seems to me, insufficient reason.

Vittore Cappello died in 1467 as a military commander on a galley at Negroponte, from grief—as the chroniclers report—over a lost battle. The artist shows the deceased wearing armor, but not as a military hero. His attitude expresses modesty, and no spurious bodily strength is attributed to him; even the armor does not conceal the stiff back bent by age. Cappello seems to have grown together with his armor; as a translucent garment shows the body's form, the armor reveals the age and posture of its bearer. The swellings on the withered neck and the crooked hands are not hidden. A similarly comprehensive characterization that includes the armor is to be seen only in Donatello's portrait of Gattamelata, which must have been our sculptor's yardstick.

The figures of St. Helena and of the commander are grouped in masterly fashion. Cappello's right arm and

Helena's left obscure to the eye the dividing vertical of the cross, now lost; the gazes meet, and the urgency of the attitude and gaze of the worshipper is met by the bent head of the saint. Her arm placed across her breast ensures the proper distance between them. These close links speak in favor of a unified conception but cannot conceal the considerable differences of style and quality between the two figures. Worlds separate the moving portrait of Cappello from the two saints on the altar in the transept of S. Marco (1465, fig. 113), the first figures securely attributed by document to Rizzo.

The similarities of St. Helena to the allegorical figures on the tomb of Orsato Giustiniani are so obvious that Francesco Sansovino's attribution of this figure to the same master is convincing. Her drapery hanging in dough-like folds recalls figures on the tomb of Doge Foscari.

Sansovino was hardly interested in artistic questions. He never expressed attributions without a document or an oral record, so that the notion that Antonio Dentone was the creator of these figures is better founded than all the more recent attributions. I can only explain Sansovino's attributions of works by Antonio Rizzo to Antonio Bregno at the same time by believing that he associated the name Antonio recorded in the documents with Antonio Bregno, who seems to have been better known at the time.

With the depiction of Vittore Cappello kneeling before a sarcophagus a new era in the history of the Venetian façade memorial begins; after the mid-sixteenth century its most magnificent examples were to transform whole façades into memorials to the dead. While in earlier centuries sarcophagi were often mounted on façades

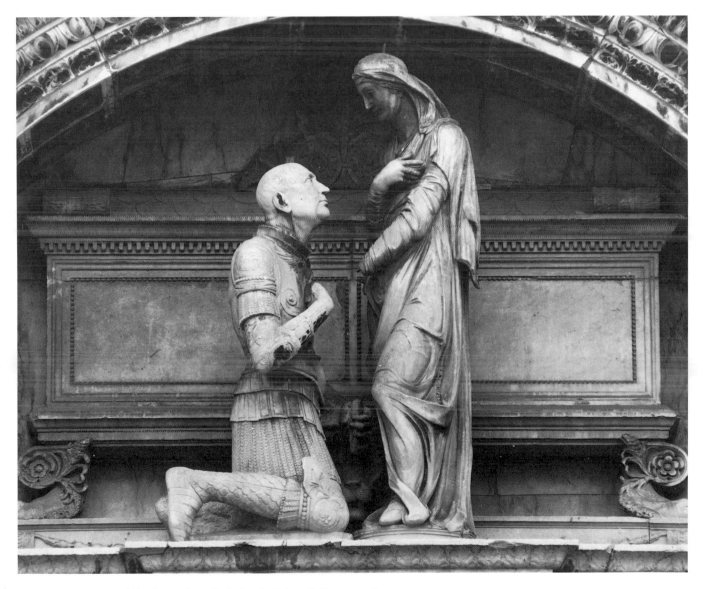

112 Antonio Dentone (?), *Vittore Cappello before St. Helena.* S. Elena, portal

113 Antonio Rizzo, altar of St. Paul, detail. S. Marco

(as is still the case today with SS. Giovanni e Paolo), Dentone chose a type familiar to Venetians from investiture portraits on coins and medals. Whether portraits of patrons were earlier to be found in connection with Venetian façade monuments is an open question. An unbroken tradition of such portraits in churches, above all on the mainland, makes this seem possible.

The seventh decade of the fifteenth century in Venice was marked by disputes between native and immigrant sculptors. After the city had been opened to foreign masters in 1460, it was decreed in 1466 that no one could import works to Venice. This means that the competition from sculptors working outside Venice, for example in Padua and perhaps farther westwards, was putting heavy and successful pressure on local craftsmen. One wonders whether works that, like the Cappello monument, show such clearly Donatellesque features might not have been produced in Padua. A further passage in the statutes of the guild refers to the practice of importing works that had been started or were unfinished, although it is not known who completed them in Venice. Not even the transit of works that had been begun was allowed.[43] At the time foreign artisans meant the *forestieri,* all masters not resident in Venice, while in 1491, when the situation regarding commissions had deteriorated further for the

114 Antonio Rizzo, *Conversion of Saul,* altar of St Paul. S. Marco

136

native craftsmen, the foreigners coming from the Lake Como area were designated more precisely as Milanese.[44]

Antonio Rizzo, probably born in Verona, was among the immigrants who took the best commissions from the native sculptors. About 1464 he was commissioned by Doge Cristoforo Moro to create three altars for S. Marco (completed in 1469), two of which are still preserved almost unchanged (figs. 113, 114).

Even after the enormous losses of Venetian sculpted altars (whether of wood or stone), the novelty constituted by these aedicules with their inset niches surmounted by shell motifs is plain. The type of ancona with niches traditional in Venice and common in painting as well (a roughly contemporary example is preserved in the Cappella Miani in S. Maria dei Frari) was abandoned in favor of the frame customary in Florence for tombs and tabernacles. In another case Cristoforo Moro had an exact idea of the quality of the works that he wanted, as is shown by provisions of his will (1470); there he insisted that a stonemason, Antonio, from the diocese of S. Zaccaria, together with an unnamed sculptor from the diocese of S. Severo should execute the church and chapels of S. Giobbe.[45] Although Pietro Lombardo is generally credited with introducing a style based on Tuscan models into Venice, Antonio Rizzo's altars were produced before Lombardo's arrival there. Rizzo's beautiful pilasters with their scrolls emerging from vases and floral forms were created before the portal of S. Michele in Isola (1470) and all the Venetian works by Pietro Lombardo.

The figures of James and Paul (fig. 113), compared to Rizzo's later Virtues on the Tron monument, look slightly rough hewn; their models were Mantegna's figures. In the Cappella Ovetari, built up from large forms, and his manner of draping garments, which eschewed all beauty of line. Unlike Bregno and Dentone, Rizzo did without geometrical or ornamental fold configurations, interrupting the flow with breaks in the folds. The intention to break free of formulae by deforming them and so to draw nearer to natural forms seems clear. Rizzo may still have been looking at nature at the time through the eyes of Mantegna.

The conversion of Saul to Paul, which adorns the altar of St. Paul with its low relief suggesting perspective effects (fig. 114), is part of a different tradition. Indeed, one is tempted to attribute this masterly relief to another artist. However, the similarities to the best pilasters in Rizzo's Scala dei Giganti (fig. 121) are so great that one supposes that Rizzo used different styles at the same time. After all, Donatello's relief beneath his *St. George* on Or S. Michele shows a similar stylistic divergence.

Ten years later, in 1476, Antonio Rizzo was to execute, after designs by Gentile Bellini, a spiral staircase and a pulpit ornamented with figure reliefs for the Scuola Grande di S. Marco, works that were destroyed in 1485 by the fire at the scuola.[46] The white figures on the pulpit

were to appear against a black background; additional polychrome effects were not envisaged. The patrons clearly hoped to find elements of Bellini's style in the reliefs. This means—leaving aside all the affinities between painters and sculptors—that the style of a work could be influenced by the patron in binding contractual prescriptions.

Also in 1476 Antonio appears to have received the commission for the tomb of Doge Niccolò Tron (died 1473, figs. 115–117).[47] The additive nature of the architecture, wholly lacking in strict organization, was probably created under the impression of Pietro Lombardo's tomb for Doge Pietro Mocenigo (SS. Giovanni e Paolo) on which work was already in progress. The piers hollowed into niches on both tombs recall Renaissance Roman tombs (Pope Eugene IV, Cardinal Martinez de Chiavez), but the sarcophagus is an exact copy, probably

115 Antonio Rizzo, tomb of Doge Niccolò Tron. S. Maria dei Frari

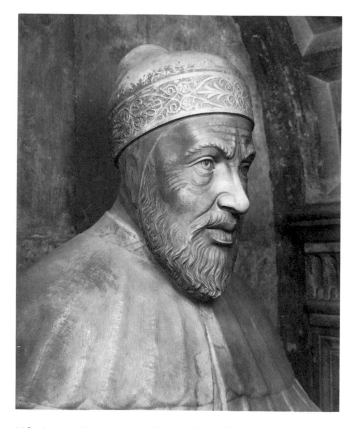

116 Antonio Rizzo, portrait of Doge Niccolò Tron. S. Maria dei Frari

directly derived from works of antiquity, and like a well-concealed quotation, her torso is so well linked to the other parts of the body that recently this figure was attributed, incorrectly, to Tullio Lombardo. Rizzo's self-assured use of available forms that might equally come from classical or "Gothic" traditions complicates attributions to this versatile and perceptive artist.

Rizzo's Virtues set a high standard for all attributions. One misunderstands the practice of Venetian workshops if one attributes to him all the "wooden" and awkward figures on the tomb, among which only the recumbent figure of the doge can pass muster.

Antonio Rizzo's figures of *Adam* (fig. 118) and *Eve* (fig. 119, plate 10) on the façade of the Arco Foscari were greeted enthusiastically by learned contempo-

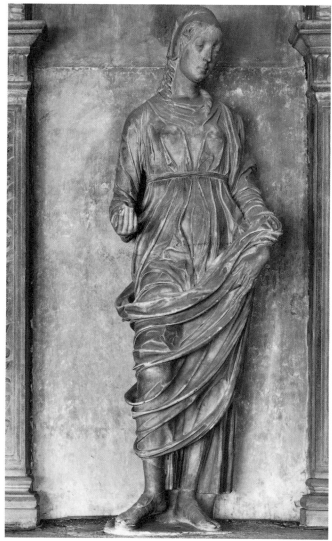

117 Antonio Rizzo, Virtue on the tomb of Doge Niccolò Tron. S. Maria dei Frari

as required by the patron, of the (now destroyed) tomb of Orsato Giustiniani.

The few original sculptures by Rizzo on the tomb register a change from the altars in S. Marco. The attitudes of the two Virtues beside the doge (fig. 117) are freer, Rizzo having rediscovered the beauty of the unbroken line; there is virtuosity in the treatment of the body beneath the garments, which reveal as they conceal. The two Virtues were conceived for a frontal viewpoint, however, while the doge is intended to be seen in profile from the nave. The realistic effect of the doge's portrait was heightened by a rich polychromy, and the very summary carving of his robes is compensated by the painted brocade.

It appears that Rizzo drew at second hand upon antique models. The similarities with Andrea Mantegna's figures on the altar of S. Giustina in Padua have often been stressed. But even when Rizzo clothes his allegorical figures in garments that recall ancient works in their modelling, his conception of the body departs entirely from that of antiquity. Here we find a number of nuances characteristic of Rizzo's selective appropriation of ready-made forms. In Charity on the left one finds a clothed version of Eve from the Arco Foscari: the build, proportions, and posture are the same. Her pendant, however, shows a broad, indeed ample, torso. She seems

raries. Rizzo portrayed the psychological situation of the first human couple after the discovery of sin. Adam holds his right hand to his breast as if fighting for breath; his frightened eyes and downcast mouth inspire the viewer. Eve, by contrast, seems untouched, indeed uninvolved, her gesture of shame being rather coquettish.

Rizzo apparently worked from nude models and adhered to nature. Neither the knotty muscular Adam nor the narrow-shouldered, broad-hipped Eve match the ideal conception of the proportions and form of the human body that Rizzo knew from ancient models. Classical sculptures were collected, and even Gentile Bellini owned an ancient Venus.[48] Despite an obvious reference to the type of the Medici Venus, the contrast between the Eve and the classical-style nudes of Tullio Lombardo

on the Vendramin tomb (figs. 127, 129) could not be greater.[49] Filippo Calendario had chosen a similarly psychological manner of depicting the first human couple on the southwest corner of the Doge's Palace. But the decisive factor for Rizzo must have been an encounter with Andrea Mantegna's work. Adam's pathos, coupled with the unclassical treatment of the nude, has a parallel in Mantegna's *St. Sebastian* (Kunsthistorisches Museum, Vienna) and Mantegna's figures for the high altar in S. Zeno (Verona). These similarities, and a possible reference in the writings of Sabellico, favor a dating for our figures of about 1470.

In 1483 the east wing of the Doge's Palace burned down. In 1484 Antonio Rizzo was put in charge of reconstruction.[50] The acceptance of this office was conditional

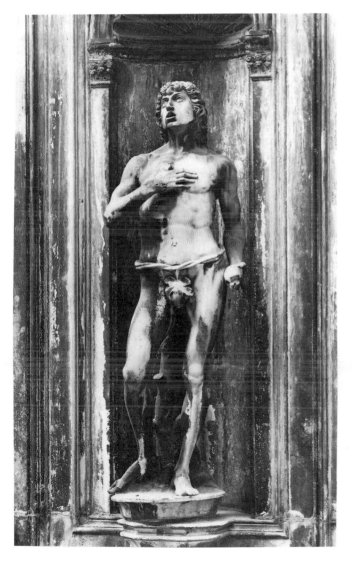

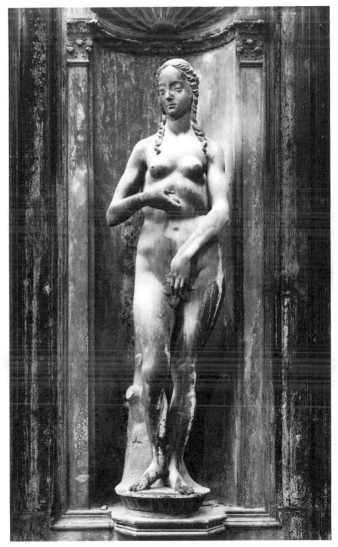

118 Antonio Rizzo, *Adam*. Doge's Palace, courtyard, Arco Foscari (original setting)

119 Antonio Rizzo, *Eve*. Doge's Palace, courtyard, Arco Foscari (original setting)

on giving up his workshop; a regular salary was supposed to compensate him. Rizzo later complained bitterly at what in his eyes was a poor salary, contending that he had earned double as an independent artist. This meant that, between the acceptance of this office in 1484 and his flight from Venice in 1498, Rizzo did not execute any more works under his own control but had to concentrate entirely on directing the work on the Doge's Palace.

Rizzo's duties included the organization and supervision of the work as well as the design and execution. While the east façade of the Doge's Palace was built under his direction to a design by Mauro Codussi with the collaboration of numerous Lombard stonemasons, Rizzo designed the Scala dei Giganti, probably in 1485, and himself executed parts of its sculptural ornamentation (figs. 15, 120, 121). The work on the staircase dragged on until after 1497, as we learn from a note by Arnold von Harff on an Italian journey.

The building of the staircase had its origin in a decree of the Great Council of 1485, to the effect that the doge should henceforth receive the doge's cap publicly and

121 Antonio Rizzo, pilaster spandrel in the Scala dei Giganti. Doge's Palace, courtyard

120 (*Left*) Antonio Rizzo, Victory in the Scala dei Giganti. Doge's Palace, courtyard

ceremonially on it.[51] It was thought that the practice of bestowing these "most noble" insignia within the palace, out of public view, detracted from the dignity of the office. Thus future doges, after the solemn investiture in S. Marco and after making their way through the rejoicing populace across the Piazza, were to be conducted back into the palace. There on the staircase they took the oath on a document setting out the rights and duties of the doge (the *promissio*) and received from the youngest member of the council the *rensa* and from the oldest the doge's cap, placed on his head with the words, "Accipe coronam ducatus venetiarum." Up to now it has not been possible to explain all the motifs depicted in the staircase as parts of a "program." Prominently in view is the inscription Astrea Duce ("With Astraea as leader") which offers a key to the iconographic program. Astraea, the goddess of justice, could be equated with the constellation of Virgo, which would place her in the heavens between the constellations of Leo and Libra, signs that would have been familiar to Venetians. Venetia (the virgin republic because she had never been conquered by

other powers), the lion of St. Mark, and the symbol of Justice often linked with Venetia suggest an interpretation of the figure as Venetia-Astraea. The doge, but certainly not he alone, was called to embark upon a golden age with Venetia-Astraea as leader.

In the remaining spandrels winged Victories process with the doge's cap, olive branches, and symbols of the virtues, which could be related both to the person of the doge and to the republic. Next to them are other items that have caused many learned headaches. However, it is not difficult to identify figures of Justice and St. Theodore on the lower pilasters of the balustrade. The trophies, musical instruments, heads, and combinations of letters adorning the pilasters do not yield a message in the sense of a literal program. Inspired by recent book illustrations, like those of the Master of the Putti,[52] Antonio Rizzo and his collaborators chose motifs from the almost inexhaustible repertory of ancient and contemporary decorations, combining them with great virtuosity into a festive ensemble rich in associations and fascinating to the eye and the imagination.

122 Master of S. Trovaso, *Angel Concert.* S. Trovaso

The eight Victories with their windblown garments and fluttering ribbons bear a resemblance to three reliefs by the Master of S. Trovaso (S. Trovaso, fig. 122).[53] These reliefs, apparently famous in their time and copied (two such panels are in Berlin), have counterparts in their depiction of spiritual impulses, in the vividness and the modelling of tense or relaxed limbs, only in the work of Antonio Rizzo, and it would not surprise me if documents should one day confirm the attribution to Antonio Rizzo and a dating about 1480.

In 1484 Rizzo had agreed to dissolve his workshop and devote himself entirely to directing the works at the Doge's Palace. That he was able in exceptional cases to work for private patrons, however, seems to me to be proved by his portrait of Doge Agostino Barbarigo, which came originally from the tomb of the two Barbarigo doges, Marco (died 1486) and Agostino (died in 1501), in S. Maria della Carità (today S. Maria della Salute; plate 11).[54]. Originally the two doges knelt within a splendid architectural framework in "perpetual adoration" about an altar, a positioning that is reminiscent of chapels.

The figure of the kneeling Agostino Barbarigo is intended solely for a profile view. A similar concentration on the characteristic elements of a physiognomy and, at the same time, an economy of detail are found previously only in Rizzo's Statue of The Doge Niccolò Tron (fig. 116), which it resembles in style. Only Rizzo himself can have created it, years before Agostino's death. Soon after this portrait was completed in 1498, Rizzo fled from Venice. Pietro Lombardo, his most intense rival, became *proto* of the Doge's Palace.

The Lombardo Family and Their Contemporaries

For half a century (from 1470 to about 1530), Pietro Lombardo and his two sons, Tullio and Antonio, had a profound influence on Venetian sculpture.[55] Pietro, son of Martino of Carona (on Lake Como), had contact with important centers of art before his arrival in Venice. The style of his early works makes it almost certain that he spent an extensive period at a sculptor's workshop in Florence. It has been demonstrated that in 1462/63 he was in Bologna,[56] and from 1464 to 1468 in Padua. His first securely attributed work, the tomb of the scholar Antonio Rosselli (Padua, S. Antonio), imitates Desiderio da Settignano's tomb for Carlo Marsuppini (Florence, S. Croce).[57] Pietro's first Venetian work, the presbytery of S. Giobbe, was built following a bequest of Doge Cristoforo Moro (died 1471), though he had proposed different sculptors in his will.[58] Pietro and his collaborators decorated the piers and entablatures with the most delicate foliage based on classical models, which became the trademark of his workshop (fig. 123). The stylistic differences between the foliage on the front and rear pilasters

show that even then highly gifted sculptors were working alongside Pietro. Perhaps they included the author of the main portal of S. Michele in Isola. In 1475 Tullio and Antonio, Pietro's sons, were mentioned by Matteo Colacio as sculptors following in their father's art. Whether this praise was based on their work in S. Giobbe is not known.

The presbytery of S. Giobbe had confirmed Pietro as a sculptor who, in both figures and ornamentation, could hold his own with Antonio Rizzo, already well established in Venice and clearly held in high esteem. From now on there was an abundance of prestigious commissions, which meant that Pietro Lombardo had to engage a large number of less qualified collaborators. He immediately became an entrepreneur who, according to one document, employed twenty-five assistants on one commission. Thus the question of Pietro's style presents itself anew with each product of his indefatigably active workshop and can usually be given only a qualified answer. Apart from his sons Antonio and Tullio, the experienced Giovanni Buora[59] seems to have played a special part as collaborator.

The tomb of Doge Pietro Mocenigo (died 1476, fig. 124), begun in 1476 and completed probably in 1481, aroused surprise, criticism, and every kind of misunderstanding by its unusual iconographic program, whose author is unknown to us. However, it also brought Pietro the commission for the church of S. Maria dei Miracoli.[60]

How strongly classical themes could affect an attentive observer is shown by the unusually long and sometimes indignant description of this tomb, among other items in Venice, penned by the pilgrim Felix Faber from Ulm about 1490.[61] If this text did not exist, it would have had to be invented.

In the Dominican church in Venice are the tombs of several Venetian doges. Never have I seen more costly and extravagant tombs. Even the graves of the popes in Rome cannot compare with these. They are tombs above ground, let into the wall, the surface of the wall being embellished to an unfitting degree with various marbles and sculptures, and with gold and silver. In these tombs we find images of Christ, of the Virgin Mary, the apostles, and martyrs, according to the wish of the client. The images of the saints are in the middle, as if they were the principal figures, and around them are arranged with their attributes the images of pagan gods, Saturn, Janus and Jupiter, Juno and Minerva, Mars and Hercules. In our church [SS. Giovanni e Paolo] I also saw, to the right of the door, on the costly tomb of a doge [Pietro Mocenigo], a sculpted image of Hercules. He was seen as usual in battle, yet clad in the pelt of a lion he had slain instead of a pallium, as in his fight with the hydra, a hideous monster with seven heads who grows seven new ones each time one head is severed. There are also [he was probably recalling the tomb of Andrea Vendramin] pugilists with naked bodies and with swords and spears in their hands, with shields hanging from their necks and no breastplates, true images of idols. Then

there are naked winged boys bearing signs of triumph in their hands, or grieving, and there are many such images to be found among those that tell of redemption. Simple minds believe them to be depictions of saints, and worship Hercules, whom they take to be Samson, and Venus, whom they mistake for Magdalen. We also find sea creatures and the arms of the deceased, with inscriptions telling of their deeds.

The iconographic program of these tombs probably reflects the change in the content of the funeral orations on the doges, which increasingly stressed the virtues and deeds of the deceased, relating them to virtues of antiquity.

The innovations include not only statues of Hercules but the depiction of the dead man as a standing figure. The model might have been the tomb of Vettor Pisani (now also in SS. Giovanni e Paolo), one of the heroes of

Venetian history who in 1380 had defeated the Genoese at Chioggia. Pietro Mocenigo is celebrated as a Christian hero, a *miles cristianus,* reliefs on his sarcophagus recalling his successes as a military leader. Eulogies of the person of the doge have moved into the foreground, as the proud inscription Ex Hostium Manubiis (from the spoils taken from the enemy) shows.

According to Francesco Sansovino (1581), Pietro Lombardo and his sons created the tomb jointly. If one tries to allocate sculptures to the different sculptors, one gets into difficulties. It is generally assumed that the relief with the three Marys at the tomb of Christ is not by Pietro; but it also has little in common with Tullio's or Antonio's later works. The ornamentation of the main entablature (plate 9) cannot compare in quality with the magnificent embellishment of the presbytery of S.

123 S. Giobbe, details of various choir pilasters

Giobbe or the decoration of S. Maria dei Miracoli. One must conclude that although Pietro Lombardo guaranteed by contract that he and his sons would be responsible for the execution, parts were nevertheless passed on to unknown assistants, who were able to follow their own ideas.

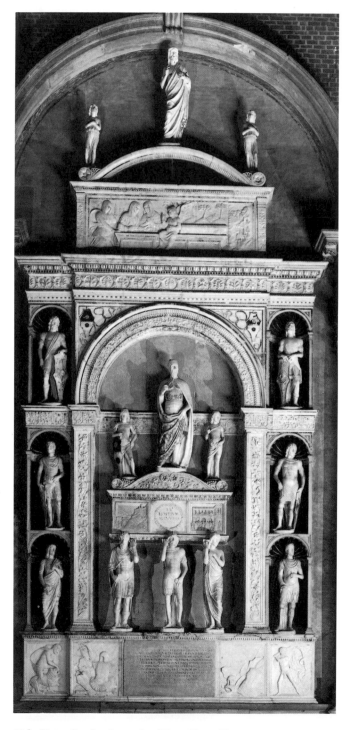

124 Pietro Lombardo, tomb of Doge Pietro Mocenigo. SS. Giovanni e Paolo

In the pallbearers, the shield bearers, and the portrait of the doge, virtuoso elements are mingled with peculiarly inept ones. Enamored of details, Pietro faithfully reproduced material and ornamentation, a suit of armor, for example, yet the figures look stiff-jointed, wooden. In the style of the garments they may resemble works by Antonio Rizzo—compare the right pallbearer with Rizzo's Charity on the Tron monument—but without attaining their rich, living quality.

The portrait of the doge seems to be made of soft material and modelled in a rather perfunctory way by indenting, stretching, and scratching. Bartolomeo Buon's mercilessly realistic portrait of Francesco Foscari on the Porta della Carta was no doubt the model. Similar in conception and texture is the frequently overrated statue (formerly in S. Maria dei Servi, now in the Museo Civico, Vicenza) of the Venetian aristocrat Giovanni Emo (died 1483), attributed to Antonio Rizzo. The *eques auratus* and *senator gravissimus* or his heirs had decided on a treatment that up to then had been granted to very few generals and had recently been claimed by two doges or their executors. This triumphal mode of presentation contrasts strikingly with the depiction of the dead that was traditional in Venice, kneeling in adoration before the Madonna and accompanied by attendants.

The tomb for Pietro Mocenigo is mentioned in the contract for the construction of S. Maria dei Miracoli (begun in 1481) in support of the choice of Pietro Lombardo. This is not surprising with an architecture so refined in its ornamentation and sculptures. In furnishing the Miracoli Pietro engaged his workshop to the full. The many reliefs with figures, the pilasters and friezes (figs. 63, 64, plate 6) were produced in a relatively short period, many of them, especially the figure reliefs on the exterior, being of a mass-produced nature. The choir chapel, begun in 1484, was treated quite differently. Here Pietro continued the tradition begun in S. Giobbe, the illusionistic tondi in the pendentives being attributed to his sons. The movement towards a style of parallel folds, as well as the pathos of the faces, recall the façade reliefs of the Scuola Grande di S. Marco and the tomb of Doge Andrea Vendramin created by Tullio.

While Pietro was directing the work on S. Maria dei Miracoli, further prestigious commissions came his way. In 1482 he was engaged by the Venetian governor (*podestà*), Bernardo Bembo, to produce a relief for Dante's tomb in Ravenna and two columns for the piazza in that city;[62] in 1485 he signed a contract for the tomb of the bishop of Treviso, Antonio Zanetti. At the same time, Zanetti entrusted him with extensive architectural commissions in the cathedral. This gave an immense boost to Pietro's workshop, for few patrons expected original execution. In 1484 Antonio Rizzo made the mistake of entering relatively low-paid state service as head of building at the Doge's Palace and disbanding his workshop.

Pietro now had hardly any serious competition. And he was certainly not alone in realizing that at least one of his sons, Tullio, had long since surpassed him. Tullio, like Antonio, stayed in his father's workshop as a highly respected and sought-after sculptor, which did not prevent him from concluding agreements on his own account. The custom in Venetian family firms whereby the father signed agreements also on behalf of his sons[63] seriously impedes a definition of individual styles.

In the agreement over the tomb of Bishop Zanetti, the model for the framing oval was the tomb for the procurator Ludovico Foscarini (now destroyed, formerly in S. Maria dei Frari); by this means Pietro's authorship of the Foscarini tomb has been deduced. The solution, probably invented by Pietro, had great success in Venice and Treviso.

In all these works a frame holds together a variety of forms; frequently there were paintings as well. Thus, painted trophies and a triumphal procession heighten the martial effect of the tomb for Jacopo Marcello (S. Maria dei Frari). The wall painting on the tomb of Melchiore Trevisan (S. Maria dei Frari, fig. 125) adds some important accents with the lion of St. Mark, while being a foil and framework for the tomb architecture. Presumably many of the tombs that now look "lost" on the bare wall were once completed, in content and formally, by pictorial effects. These might have been fictive drapery (as on the tombs of doges Francesco Foscari and Niccolò Tron), in the tradition of Gothic tapestries, or simulated reliefs. Noteworthy here is a contract signed in 1483 by Giovanni Minelli for the tomb of Cristoforo da Recanati in Padua. This referred to a drawing with the observation that a part of the tomb should not be carved from stone, as originally envisaged, but painted. There are also records of painted frameworks for altars, like that of the Verde della Scala (now SS. Giovanni e Paolo), which in 1523 was given a frame showing trophies in chiaroscuro and animals on a blue ground.[64] In his view of the interior of S. Antonio di Castello (Gallerie dell'Accademia) Carpaccio shows a painted altar frame.

Most Venetian wall tombs originally had polychromy. An accumulation of grime and the absence of systematic studies prevent general conclusions at present. Gold was predominant on architecture and ornamentation (plate 9), while the garments of the deceased were usually painted naturalistically. In this way crudities in the sculpture were hidden; indeed, the practice of coloring made fine detail in the surface treatment unnecessary and also obviated a precise definition of form. The painting reduced the contrast to the painted wall decorations, without cancelling it entirely.

Pietro worked not only for Venetian patrons. In 1490 he sent the altar of the Cappella Colleoni to Bergamo, where it finally arrived after intervention by the doge. In 1495 Pietro was working in his Venice workshop on a

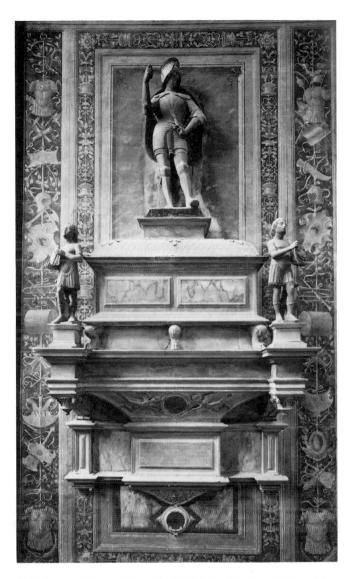

125 Lorenzo Bregno (?), tomb of Melchiore Trevisan. S. Maria dei Frari

chapel for the cathedral at Mantua, and in the 1490s he seems to have devoted himself primarily to architecture and to running his flourishing workshop.

In the architectural sphere he had a very successful rival in Mauro Codussi, who in 1490, following the inexplicable dismissal of Pietro, took over the work on the Scuola Grande di S. Marco, changing Pietro's conception in fundamental ways. The specialization of Pietro's workshop in small-scale architecture and ornamentation continued to attract large numbers of clients, however, and its productivity was undiminished. About this time, in 1491, came the attempt by Venetian stonemasons to resist, by legislation, Lombard superiority, which was obviously not only numerical. Pietro was the Lombards' most prominent representative.

Despite all his successes, Pietro took over the prestigious but far from lucrative post of *proto* of the Doge's

Palace after Antonio Rizzo's flight in 1499. Unlike Rizzo, however, he did not close his workshop, which from now on was run by Tullio. By then Tullio was much sought-after as a sculptor. In his own work, as far as it can be isolated from the collective output of the workshop, there are frequent allusions to classical forms. To explain this change of orientation we need to broaden the discussion.

Venice, officially founded in 421 A.D., had no tradition going back to classical antiquity. From the beginning of the fifteenth century the Venetians conquered the cities of Padua, Verona, and Brescia and cities in Friuli and Istria such as Pula, cities that had a far longer Roman history embodied in their buildings and works of art. This lack of a Roman era was not considered a deficiency in Venice but a distinction, a positive influence on the city's fortunes, so that the equation of cities with Rome prevalent everywhere in the fifteenth and sixteenth centuries did not make headway in Venice, even though it might be apostrophized as *alter Roma.*[65] The traditional tensions with the papacy contributed further to the reluctance of Venetian authors to share in the glorification of the achievements of ancient Rome. The attempts by popes (in 1483–85 and again in 1509) to bend Venice to their will by interdict came to nothing when Venice refused to publish the fact in the city's dominion.

From early on in Venice, ancient sculptures were set up as trophies in public places, as symbols of civic consciousness. Trophies like the horses of S. Moro, the porphyry head of Justinianus II Rhinometos on the balustrade of the basilica of S. Marco (referred to in the fifteenth century as a portrait of the beheaded traitor Carmagnola), the lion and the "Todaro" on the columns in the Piazzetta should all be mentioned. In the eyes of educated Venetians in the late fifteenth and the sixteenth centuries, it made a big difference whether these trophies were works of art of high quality matching the ideals of their own time, like the horses of S. Marco or the numerous Byzantine reliefs on its façades, which were not rated highly in the Renaissance but had been imitated in the thirteenth century. In 1329, *St. Theodore* (the "Todaro"), a counterpart to the lion of St. Mark, was set in place on the Venetian "Forum"; these ancient pieces of sculpture gave an aura of antiquity to the patron saint. Reference to the age of a work of art as evidence of the genuineness of a literary tradition plays an important part in Renaissance scholarly discussions as well. The artwork was a document, if only one among many.

The case was similar with a clothed figure from antiquity that, about 1440–50, was completed as a figure of St. Paul by a gifted imitator of Donatello and set up in the Gothic tympanum of the main portal of the church of S. Polo.[66] Here too, the style of the artwork was made to bear a message that was only secondarily related to aesthetic ideals. Similar concerns must have led in the fourteenth and fifteenth centuries to the adaptation of an antique bust as St. George on the façade of the Palazzo Zorzi-Bon,[67] while the ancient busts erected in the mid-sixteenth century a few yards away on the portal of the Palazzo Grimani were doubtless intended to point to the Grimani's collection of antiquities, world-famous at the time.

Even these few examples make clear the different motives of patrons in choosing ancient spoils as parts of a larger frame of reference. In no case was it primarily aesthetic concerns that lay behind these choices.

Original works of antiquity were collected in Venice, as everywhere. The private collections—some, like the Grimani's,[68] very important—and later the collection of the procurators contributed to the fame not only of individuals but of the republic, as an informative chapter of Francesco Sansovino's guide to the city makes clear. Revealingly, Sansovino included in the public domain the collections that the Venetian aristocrats assembled in their palaces.

In the fabric of the city itself, by contrast, fragments from antiquity did not play a significant part, if we disregard the spoils and trophies on the Piazza and a pair of putti formerly found near the church of S. Maria dei Miracoli. Often imitated, this pair of putti originated from Ravenna and were mentioned as early as 1337. At that time a citizen of Treviso, Oliviero Forzetta, had tried unsuccessfully to acquire them for his collection. The collecting zeal of Venetian families[69] led to ancient sculptures being "completed," partly for aesthetic reasons, and an inevitable result of the shortage of such sculptures on the art market was that there were many imitations and forgeries. In both areas, imitation as well as forgery, well-known Venetian sculptors showed much prowess, although the extent of their activities can only be conjectured at present.[70] Many such pieces are sure to be found in the stores of museums of antiquities. Expressly mentioned by contemporaries as specialists in the completion and, no doubt, the forgery of antiquities are the Florentine Simone Bianco, proved to have worked in Venice after 1512, Agostino Zoppo[71] about 1545, and towards the end of the century Tiziano Aspetti.[72] Many of the Venetian sculptors would have carried out such commissions. How skillfully they worked was painfully discovered by the Bavarian duke Albrecht V on buying the Loredan collection, even though his friend Fugger wrote confidently, and rather over-optimistically, that one could easily distinguish an ancient original from a modern work by the material and execution (*fattura*).[73] Nowadays, pieces from this collection are passed endlessly back and forth between archeologists and art historians.

Up to now, very few restorations of ancient sculptures have been successfully linked to the name of a Venetian

artist. A famous completion is that of the lost "Red Mar-syas" in Florence by Verrocchio, but similar instances are lacking in Venice. An attribution that seems convincing to me is that of the completed parts, including the head, hands, and feet, of one of the Muses by Philiskos in a "Cleopatra" ensemble to Tullio Lombardo, a work now in the Museo Archeologico in Venice.[74] Such completions demanded a thorough study of ancient sculpture that went far beyond the slavish copying of drapery or contrapposto. In his restorations Tullio Lombardo retained the expressive style characteristic of the physiognomies of his original sculptures of the 1480s. This probably reflected not only his own idea of the classical style but the expectations of an educated client. Tullio's interest in clarifying the moods and impulses of his figures is evident in these faces, pain, tension, or grief being

visible around the bridge of the nose and serenity, alertness, and strong emotions being conveyed by an open mouth. The iris and pupil, drawn as if with a compass, give the gaze direction and intensity. However, Tullio's faces have nothing stereotyped about them, even though, like Andrea Mantegna in Padua before him, he used formulae to convey pathos. The mouth of Adam, open but communicating an elegiac calm, (fig. 129), is similar to those of the two young pages in armor on the Vendramin tomb and is copied from works of antiquity. For comparison, take the head of Guidarello Guidarelli in Ravenna (fig. 140), which reminds one of Schlüter's "masks" of the dying soldiers at the Berlin Zeughaus. The heightened expressions of these faces should be seen against the background of the monumental contemporary sculptures which, though quite different in nature, are in

126 Tullio Lombardo, *Healing of Anianus.* Scuola Grande di S. Marco, facade

tended to evoke empathy by intense expressions in tune
with a popular piety that expressed itself in powerful,
even violent forms. The *Lamentation* by Giulio Mazzoni
(1485) from S. Pietro di Castello (fragments in the Mu-
seo Civico in Padua)[75] was an impressive example.

It is rarely possible to explain the style of a work of art
by reference to the intellectual currents of the time or
the personal views of a patron. This is especially true of
the various forms of "classicist" style adopted by many
Venetian sculptors active between 1480 and 1520. Among
the Venetian sculptors who were guided by works of an-
tiquity, Tullio Lombardo has a preeminent place. Tullio's
contribution to the countless projects issuing from his fa-
ther's workshop, in which, as was usual in Venice, he had
for a long time a legally dependent position, is difficult to
disentangle. Indeed, one must ask whether, given the
mode of organization of Venetian workshops, such a de-
marcation is at all feasible. This is true also of two reliefs
on the Scuola Grande di S. Marco (figs. 89, 126), which
are unanimously attributed to Tullio by scholars without
unquestionable documentary or stylistic evidence.

One relief depicts the healing by St. Mark of the cob-
bler Anianus, who had injured his hand with his awl in
Alexandria, and a second the baptism of Anianus. The
drapery of the bulky figure of the city's patron saint is
built up of parallel folds on the surface planes, and the
body of the cobbler—who, it seems, could not bear the
sight of blood—is also composed of facets. However,
the sculptor seems to have encountered problems in the
transition from the surface to deeper layers of the relief,
making it difficult to construe details. The figures of the
saint and the cobbler in the foreground are comple-
mented by a middle figure parallel to the picture plane,
forming a threefold group. Although the intention is far
too evident, this should not count against the relief, since
programmatic features of a work that were intended to
be understood can be part of the artistic achievement. In
a third plane of the baptism relief the sculptor shows
people running past, two of them completely uninvolved
and the third touching the Oriental on the arm, although
the story does not require this. One is reminded of street
scenes with people hurrying by. In 1504 the Paduan hu-
manist Pomponio Gaurico described this kind of relief in
his treatise *De sculptura,* and I suspect he was guided, as
an admirer of Tullio, by the latter's works if not by his
"theory," which was never set down in writing.[76] In a sec-
tion on perspective in sculpture ("sculptoria perspec-
tiva") Gaurico distinguished three levels, so that with an
assumed viewpoint of the observer at the height of the
heads of the figures, a view of the figures on the second
and third levels (Gaurico does not go further) is only pos-
sible in the spaces between the major figures.[77] Whereas
the foreground figures should show slightly more than
half their volume, those on the second level should be
compressed, as should those on the third, to the extent

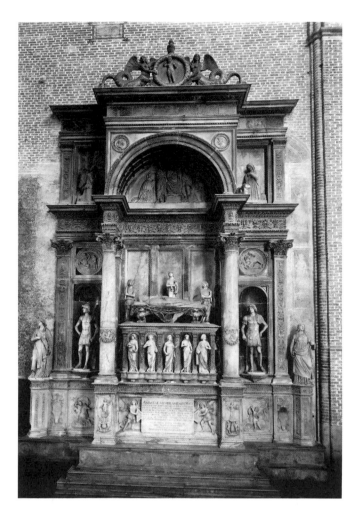

127 Tullio Lombardo, tomb of Doge Andrea Vendramin. SS. Giovanni
e Paolo

that they are scarcely in relief at all. Gaurico legitimized
this procedure by models from antiquity. Leaving aside
the concept of "compression," which Vasari took over in
his concept of *rilievo schiacciato,* or flattened relief, the
clean, apparently seamless transition between layers is
noteworthy and can be demonstrated in several of Tul-
lio's works, sometimes enriched by a fourth layer. Tullio
used a further artifice by favoring heads in profile as the
distance from the viewer increased, looking in opposed
directions. This practice,[78] based on ancient models, is
found in exemplary form not only in the reliefs of the
Scuola Grande di S. Marco but later in Antonio Lombar-
do's relief in the Cappella dell'Arca in the Santo in Padua.

However, it was not Tullio Lombardo who introduced
rilievo schiacciato or, in Gaurico's term, "compressed
relief" to Venice. In the decades before he began work-
ing there, and at least since Donatello's arrival from
Padua in 1455, there were reliefs of high quality that
used this style very naturally without such pointed refer-
ence to ancient models. The relief on the altar of St. Paul
in S. Marco (a work by Antonio Rizzo of ca. 1465, fig.

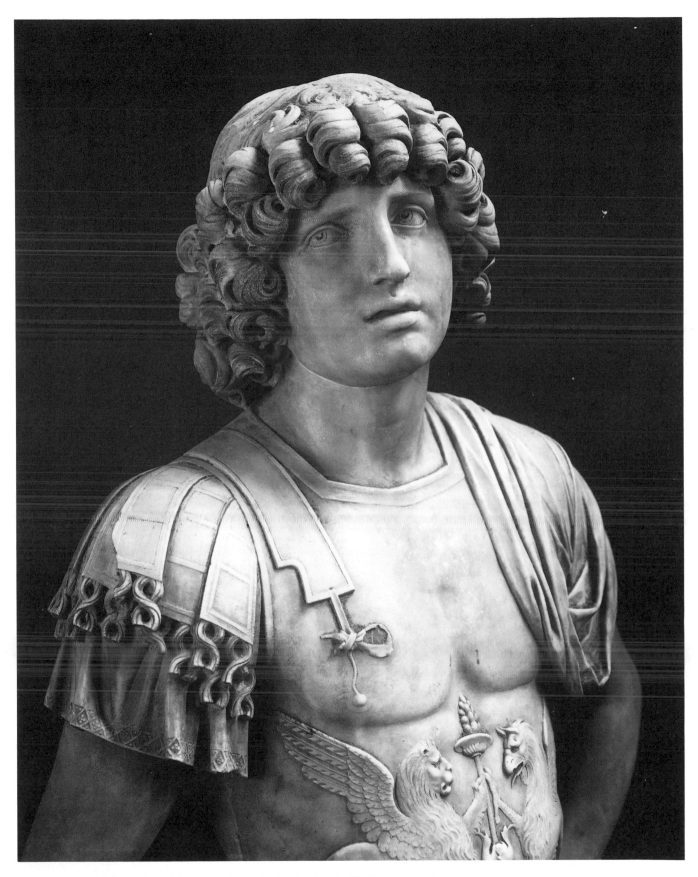

128 Tullio Lombardo, soldier on the tomb of Doge Andrea Vendramin. SS. Giovanni e Paolo

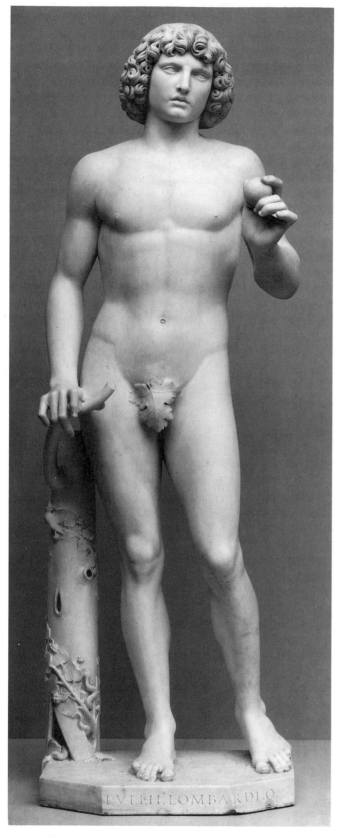

129 Tullio Lombardo, *Adam.* New York, The Metropolitan Museum
of Art, Fletcher Fund (1936)

114), the reliefs by the Master of S. Trovaso (Antonio Rizzo?, ca. 1480, fig. 122), and, above all, some very beautiful reliefs on the Scala dei Giganti in the courtyard of the Doge's Palace (fig. 120) should be mentioned in this context. Against the background of these works, the didactic, programmatic quality of the two reliefs on the Scuola Grande di S. Marco becomes fully clear.

In 1493 work was in progress on the tomb of the Venetian doge Andrea Vendramin (figs. 127–29). Vendramin, enormously rich though not a man of humanistic education, stated briefly in his will that the tomb should be very ornate—"asa adorna" in his native dialect. Who acted as executor, who made contact with the sculptor, whether conditions were attached to the commission, why initial designs by Verrocchio were rejected—none of this is known. The tomb is now incomplete. The *Adam,* perhaps the finest figure, is in the Metropolitan Museum, New York; two young shield bearers, badly damaged in the Second World War, are stored at the Bodemuseum in East Berlin.

In connection with the figure of Adam one might point with some justice to Michelangelo's visit to Venice of 1494 and draw connections with his *David* in the Piazza della Signoria in Florence (1504). The profound knowledge of human anatomy, the breathtaking life of the surfaces, find their counterparts in such works of antiquity as the "Apollo of Mantua," yet Tullio can hardly have been concerned merely with an antiquarian resurrection of classical art. The hairstyle follows the Venetian fashion; the elegiac mood of the idealized face finds a parallel in a number of portraits by Venetian painters of the time, including Giovanni Bellini and Giorgione. The physical "presence" of Adam and Eve (the *Eve* has not yet been traced) and their neighbors, the two warriors, must have been very striking, a quality that is difficult to appreciate today. From written sources, the historian can form an idea of the judgments formulated on such a figure by educated contemporaries among their friends. A letter written as a formal exercise in Rome between 1411 and 1413 by the Byzantine scholar Manuel Chrysoloras enumerates all the points of view that carried weight in the fifteenth century.[79] A masterful working of brittle stone to produce an imitation of nature that deceives the eye, and the ability to make emotional and spiritual states visible in stone were, according to our author, the causes of the admiration of ancient works. The classical literary sources of these formulations are well known. However, Byzantine writers of the tenth century expressed themselves in very similar terms when describing works produced by their contemporaries, works that to the modern observer would seem characterized by a lack of fidelity to nature.[80] One thing seems clear: among educated people there was in the fifteenth century no recent theoretical consideration that could have caused a sculptor

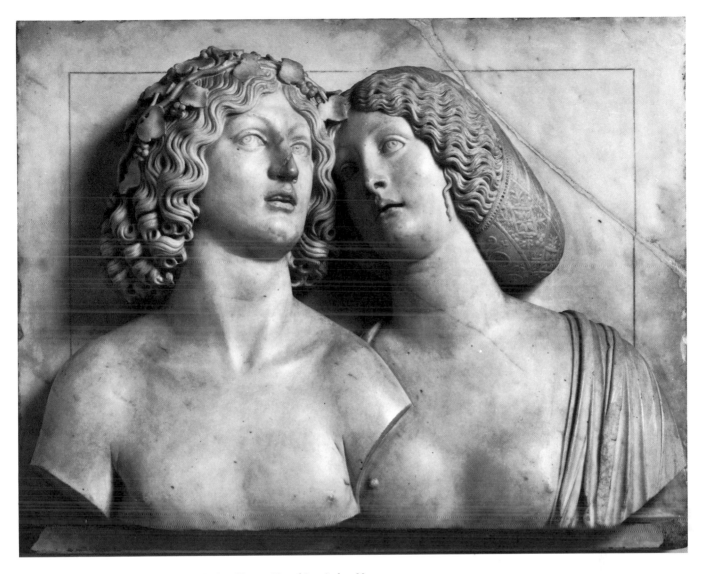

130 Tullio Lombardo, *Bacchus and Ariadne*. Vienna, Kunsthistorisches Museum

like Tullio to turn to antiquity. On the contrary: it is only when applied to Tullio's works that the literary commonplaces could take on a palpable meaning. It is not enough to refer to the cursory requirement found in a number of artists' contracts that they should base themselves generally on ancient works (which does not mean that they should take an abstract interest in their qualities)—a demand designed to accommodate the artists but which Tullio Lombardo, unlike most of his contemporaries, seems to have taken seriously.[81] Even though Pomponio Gaurico, as a friend of Tullio, may have exaggerated somewhat, his description of an entablature carved by Tullio and adorned with tendrils being carried in triumph through the streets of Treviso testifies to the enthusiasm aroused by the rediscovery of skills thought to be lost.[82]

It is interesting to consider Tullio's signed *Double Portrait* in the Cà d'Oro against the background of the literary sources just mentioned. Tullio carved two busts in the classical style and placed them close together as a relief. The male head is placed slightly higher than the female and behind it, as is particularly clear from the only correct viewing angle, with the eyes at the height of the signature. Tullio has given this composition so much life that the heads seem to move and turn towards each other. In a very similar way, painters like Lorenzo Lotto endowed the sculptures in portraits of Venetian collectors with life, so that they seem to move under their owner's gaze. In the Vienna relief probably produced later (fig. 130), the figures turn towards each other in a gesture of mutual attraction, their longing upward gaze also taking hold of the viewer. There were models of such reliefs in antiquity. In his *Paris Sketchbook* Jacopo Bellini records a comparable ancient relief from S. Salva-

tore in Brescia.[83] In a letter to Marco Casalini of Rovigo,[84] Tullio, defending his medium against the strong competition from painting, rests his case solely on the greater durability of sculpture, proving that argument was not his forte.

The standards set by Tullio in the assimilation of antiquity must have opened the eyes of many patrons, with the result that an army of less gifted stonemasons now began to work *all'antica,* though the results were often satisfactory only in the ornamental work.[85]

The two soldiers on the Vendramin tomb (figs. 127, 128) are, as far as their armor is concerned, copies of ancient statues like that of Trajan (now in Leyden) or another in Copenhagen.[86] For all the exactitude of detail, however, Tullio has evidently misunderstood the incense burner at the center of the cuirass, as is clear from its indefinite form, which is reminiscent of fruit.

Tullio's interest in reproducing human emotions appears above all in the faces of the soldiers, naturally, but also in their wholly unmartial attitudes. They seem to grieve for the deceased doge. In this preoccupation with works of antiquity, Tullio's figures mark a turning away from Venetian tradition. Filippo Calendario and Antonio Rizzo (figs. 118, 119) had placed a profound study of nature entirely in the service of the depiction of complex human emotions, which caused them to neglect idealization in the classical sense. In his *Adam* Rizzo had reproduced all the imperfections of the male model, while the *Eve* probably conforms to a contemporary ideal of beauty as much as to the form of his model. In this Antonio Rizzo is much closer[87] to Tilman Riemenschneider than to Tullio Lombardo. Yet the same interest in complex, usually conflicting emotions in his subjects is to be found in both Tullio and his Venetian predecessors, and seems to be a characteristic of Venetian art.

Not long after the Vendramin tomb, Tullio signed the relief of the *Coronation of the Virgin* in the Cappella Bernabò of S. Giovanni Crisostomo (1499–1502, fig. 131). It is difficult to recognize these immobile figures, which seem cast in metal, as works of the sculptor who a few years before had carved the *Adam* of the Vendramin tomb. A hypothesis recently advanced that the models for these figures are not ancient reliefs but Byzantine ones deserves careful examination.[88] The similarities with the thirteenth century (?) relief of the *Traditio Legis* in the treasury (*tesoro*) in the basilica of S. Marco, a work important for Venetian ideology, might be understood as representing a programmatic rejection of Roman antiquity in favor of early Christian traditions. (About thirty years later this relief was to be given a prominent place by Doge Gritti when the *tesoro* was reorganized.) Today this *Traditio Legis* is classified by many medievalists as early Christian and by archeologists as medieval, and is probably a copy made in Venice in the thirteenth century of an early Christian model. Early Christian art played an important part in the development of Venetian sculpture in the Middle Ages, an influence explained by Demus in the context of a "renovatio imperii christiani."[89] The idea that Tullio's reversion to works like the *Traditio Legis* should be seen in the context of a study of Byzantine codices would carry more conviction if it could be proved that such works were regarded about 1500 as examples of the Eastern style. It is more likely that the *Traditio Legis* was taken in 1500 to be a work of Venice's own early period. The allusion to such a work gave an opportunity to formulate a Venetian style distinct from classicist works orientated towards Roman models of the kind particularly valued by the collectors with their classical education. In this connection one should call to mind the Grimani of S. Maria Formosa, with their Roman interests, who some years later supported artists trained in Rome and had copies made of ancient decorations like those of the thermal baths in Hadrian's villa at Tivoli, so demonstrating Roman and papal sympathies which were not the rule in Venice.

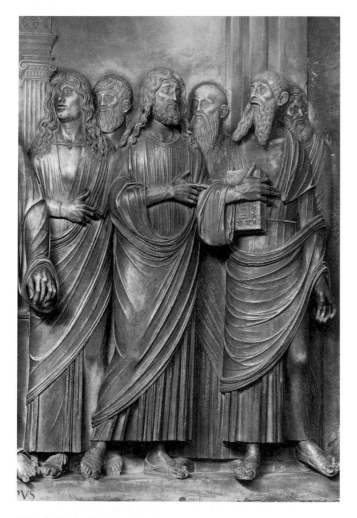

131 Tullio Lombardo, *Coronation of the Virgin,* detail. S. Giovanni Crisostomo, Cappella Bernabò

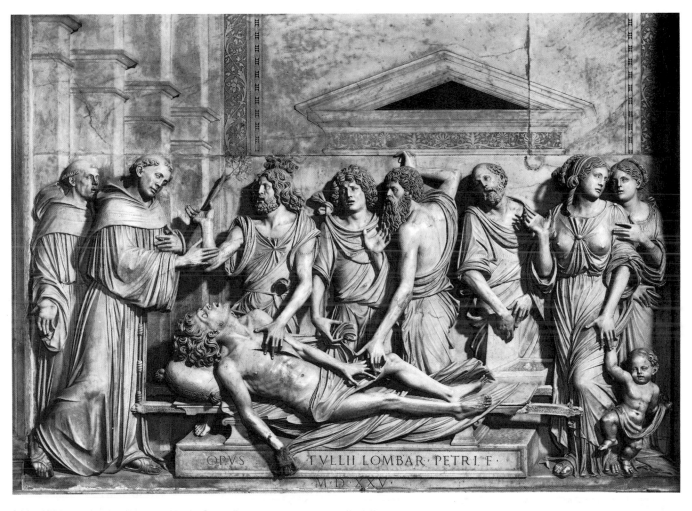

132 Tullio Lombardo, *Miracle of St. Anthony* Padua, S. Antonio, Cappella dell'Arca

The divergence between the *Coronation of the Virgin* and Tullio's figures on the Vendramin tomb imply a deliberate turning away from previously accepted models. For Tullio the decision seems to have had more to do with his technical capabilities than with the style he had adopted hitherto. Thus his change of style was not primarily motivated by artistic considerations. It was probably preceded by a demand to follow an exactly specified model conforming to the patron's ideas, a limitation found in several Venetian contracts. Since in the case of sculpture no account of the Venetian sculptors' (or their patrons') understanding of their own Venetian tradition can be extracted from written sources, we have to refer to analogous tendencies in architecture, for example the reversion to the cruciform church.

The fact that works like the *Coronation of the Virgin* can be traced back in terms of style, and Venetian *Kreuzkuppel Kirchen* in terms of spatial disposition, to Byzantine models should not mislead us into seeing the Byzantine component as the agent or legitimation of such citations. Venice versus Byzantium—how easy it would

be to oversimplify, particularly as after the fall of Constantinople (1453), Venice became a center of Eastern culture among others. It seems more sensible to interpret the few Venetian works based on Byzantine models as a return to a tradition that the Venetians believed to be their own. Similar tendencies can be seen in the work of Mauro Codussi. Unlike the Florentines, who traced the Baptistry back to a Roman temple of Mars, making it, with other buildings, a model for the architects of the Renaissance, Venetian architecture (and perhaps some sculpture) was governed by programmatic directives from a number of patrons, with the object of making visible the unique, unmistakable aspects of Venice so important for the self-image of the city. There does not appear to have been a generally binding style, nor does everything we call a classical style today seem to have been always regarded as such at the time.

In its style too, the "open" character of a work of art manifests itself. The style can be the starting point of reflections on the part of observers whose knowledge and expectations must lead frequently to divergent conclu-

sions.[90] To note that "in this work there are forms dating from antiquity or recalling classical works" presupposes training or experience in interpreting art. Art was not taught in the schools. Only in Mantua, in the school of Vittorino da Feltre, were there painters who taught.[91] We must suppose that only a few people engaged in such reflections, primarily learned collectors and dealers in antiquities, whose antiquarian interests were often bound up with an allegiance to papal Rome.

Neither the patron nor the artist had a uniform conception of what was characteristic of the antique or worthy of imitation. Dürer,[92] in a letter of 1506 to Pirckheimer, after expressing a high regard for Venetian artists, stressed the intolerant views of what was for him a troublesome minority of painters. They were hostile to his work when they came across it in churches and elsewhere, he wrote. "They criticize it, saying it is not in the antique manner, and therefore not good." After all that has been said one must wonder whether Dürer's critics knew what they were talking about.

While Tullio was still working on the *Coronation,* he accepted a commission to produce a relief on the miracle of the severed foot for the Cappella dell'Arca in the Santo (Padua).[93] Here virtuoso craftsmanship in the imitation of nature is allied to a highly developed personal style. Sweeping contours attract the eye, forming a melodious play of lines quite independent of the story. As compared to the façade reliefs of the Scuola Grande di S. Marco (fig. 126; badly damaged not only on the surface), Tullio gave greater emphasis to linear elements, while clearly distancing himself from the metallically rigid style of the *Coronation.*

In his second relief for the Cappella dell'Arca (begun in 1520, dated 1525, fig. 132), Tullio adopted a highly colorful narrative mode. Gesticulating arms and eloquent hands are composed into a "still life," though this animation is not reflected in the stereotyped faces. Presumably it was the influence of contemporary painting that caused this change. Tullio here distanced himself from the classical models chosen for the Vendramin tomb, following a direction that found its extreme expression in the lamentation groups but also in the school

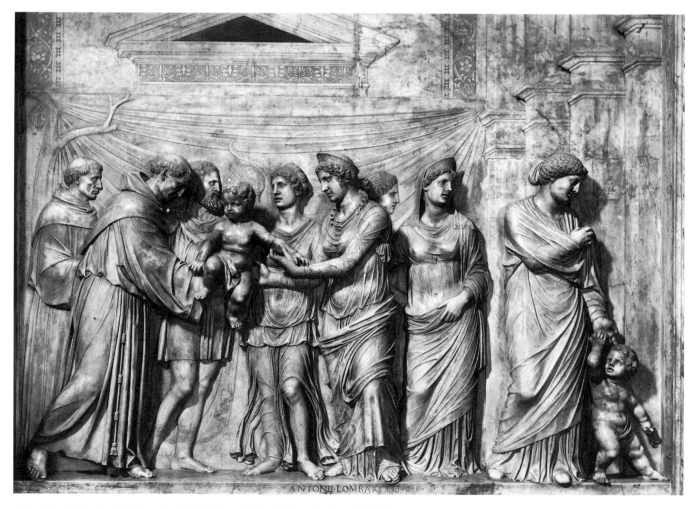

133 Antonio Lombardo, *Miracle of St. Anthony.* Padua, S. Antonio, Cappella dell'Arca

of Donatello, as in the magnificent relief in Trogir (Dalmatia),[94] There is a revealing document that throws light on this connection. In 1528 in a contract for a relief depicting the miracle of the mule, unfortunately never carried out, Tullio and the authorities responsible for the Arca del Santo agreed that the sculptor would receive a plaster cast and a drawing of Donatello's relief on the high altar showing figures that the authorities thought important for the presentation of the theme.[95] Clearly underlying this clause is the distinction between the elements essential to the story (*storia*) and the primarily ornamental parts (*poesia*) of a work, a distinction that was applied equally to art and to historiography. It would have occurred to no observer to link Tullio's style to that of Donatello, yet does not such a connection emerge from the document as a whole? The heightened pathos of his earlier reliefs might also have resulted from a study of Donatello's dramatic narrative manner.

There are very few drawings by Venetian sculptors from the period about 1500. The design by Antonio Lombardo (1501) executed with utmost care for the Cappella dell'Arca (fig. 111)[96] differs in some fundamentals from the relief later produced by Tullio (fig. 132). Tullio chose the moment when someone opens the miser's body to look for his heart, which to everyone's horror is found not in the body but in the treasure chest. Only the strict isocephaly and the sustained and calculated symmetry of the composition recall his relief of the *Coronation of the Virgin* in S. Giovanni Crisostomo.

Antonio, on the other hand, was guided in his relief for the Santo (fig. 133) by a closer adherence to classical figures, some of them veritable matrons, an entourage that makes St. Anthony and his companion look out of place. His figures are informed by a Roman *gravitas,* expressed particularly in the earnest, stereotyped faces. Antonio's sense of the antique was different from that of his brother Tullio.

In 1501, while working on the relief for Padua, Antonio, with Alessandro Leopardi, was awarded the important commission for the tomb of Bishop Giambattista Zen in the atrium of the S. Marco (plate 12).[97] The deceased's presumptuous wish to be buried in the transept of the basilica was not granted. Alessandro Leopardi, who was probably hired as a specialist in bronze casting, was immediately dismissed, no doubt a grave disappointment since the project for bronze doors for the Doge's Palace (1496)[98] had also come to nothing.

Before his definitive move to Ferrara in 1506, Antonio Lombardo created the *Madonna of the Shoe* for the Cappella Zen but was then replaced by Paolo Savin, who completed the altar and produced important parts of the tomb. A happy invention of Antonio's is the contrast between the child, almost hovering on the Madonna's lap, while she opens her hands solicitously to protect him.

Antonio's Venetian successors favored voluminous,

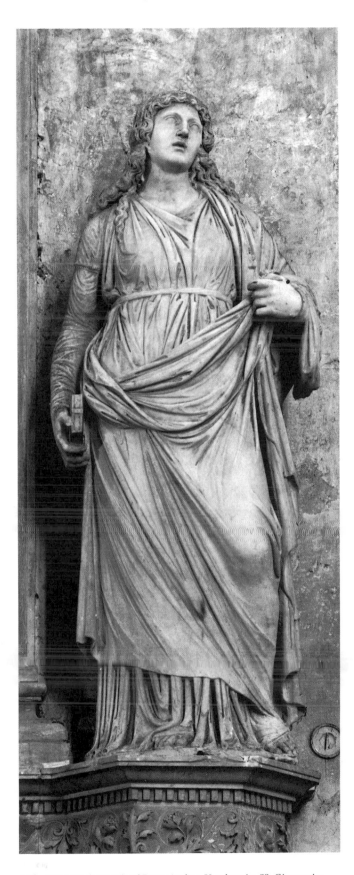

134 Saint on the tomb of Doge Andrea Vendramin. SS. Giovanni e Paolo

often stately figures and "quotations" from classical authors to delight the learned observer. The requirement that Bartolomeo di Francesco should clothe his Magdalen for the altar of the Verde della Scala (1524) in capacious, classical-style garments[99] was no doubt typical of the taste predominant at the time. Thus Thomas Aquinas, on the tomb of Alvise Trevisan (now in SS. Giovanni e Paolo),[100] was given the head of Vitellius, copied by the sculptor, perhaps Paolo Stella, from a specimen to be found in Venice at the time, which is also thought to be a Venetian "classical" forgery produced in the early sixteenth century.[101]

"Antiquity" as a frame of reference continued to exert its influence in these years. As compared to the very heterogeneous sculptures by Tullio and Antonio, however, we now find sculptors turning to other works of antiquity that had so far received little attention. Now ample figures swathed in flowing garments served as models.

Apart from the *Magdalen* by Bartolomeo di Francesco, prime examples of the new trend are the figures from S. Marina, usually attributed to Lorenzo Bregno, now on the tomb of Doge Vendramin (fig. 134), whose faces are closely related to Simone Bianco's female busts.

While Antonio Lombardo was still working in Venice, the versatile Alessandro Leopardi was commissioned by the procurators to replace the stone socles for the three flags in front of S. Marco with bronze ones (plate 13).[102] Ancient reliefs, the pedestals of the choir pillars of S. Maria dei Miracoli (plate 6), and decorative sculptures of antiquity, particularly Roman candelabras, are called to mind by these bases. The themes of the picture program praising Venice, indecipherable without written sources, were explained by Pietro Contarini in his *Argo Volgar* of 1542. There are also signatures of the three procurators and the current doge Leonardo Loredan, although the portrait of Loredan in the unfamiliar form of a plaque

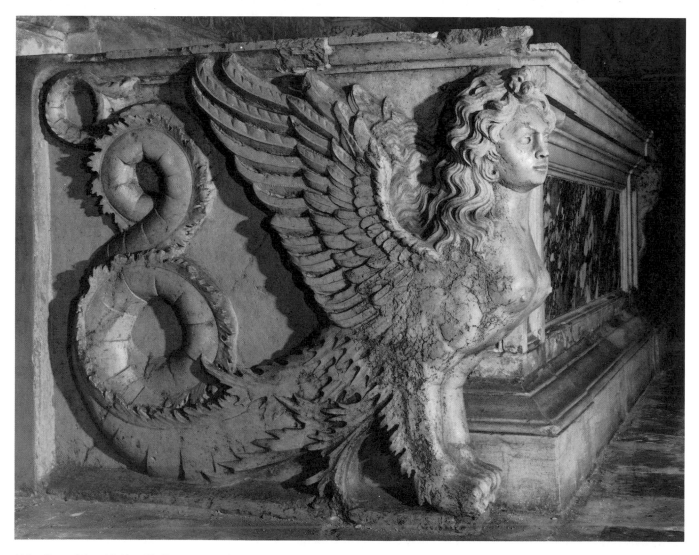

135 Altar rail (ca. 1470) in SS. Giovanni e Paolo

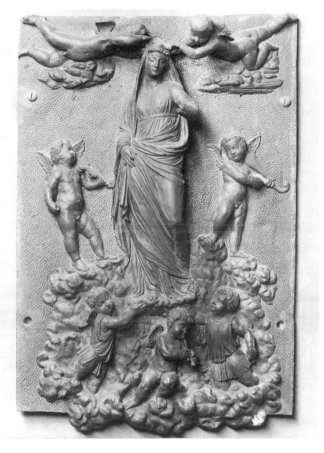

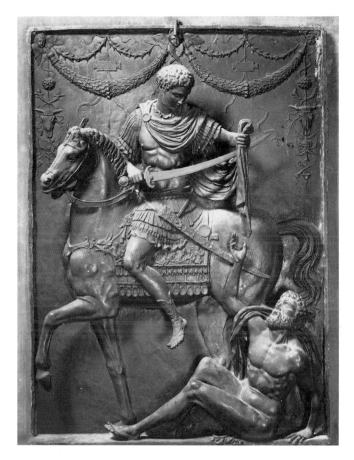

136 Master of the Barbarigo Reliefs, *Ascension of Mary.* Cà d'Oro

137 Andrea Riccio, *St. Martin.* Cà d'Oro

must have raised some eyebrows, since images of the doge were forbidden outside the Doge's Palace.

In the first third of the sixteenth century bronze seems to have been especially popular even outside the private collections, as is shown by the still enigmatic reliefs on the tomb of the two Barbarigo doges in S. Maria della Carità (1515, fig. 136), by several works by Andrea Riccio (fig. 137) for the Servite church, and the beautiful reliefs of Vittore Gambello, originally on his brother's tomb in S. Maria della Carità.[103]

Like Pietro Lombardo and his sons, the family firm run by Giambattista and Lorenzo Bregno seems to have enjoyed great success. In 1502 Giambattista was commissioned, after Antonio and Tullio Lombardo, to make a relief for the Cappella dell'Arca in the Santo, but never carried it out. His close adherence to Tullio's style, so clear in later years, may have influenced the award. He was evidently already known outside Venice's borders by then.

In his Cappella del SS. Sacramento in the cathedral at Treviso (under construction about 1504) the interplay of color in the materials—red and green tondi, the black inlay of the frieze—and the marble and stone slabs set off the sparse, rather dry moldings. There was a similar rejection of floral ornamentation in Tullio's Cappella Ber-

nabò in S. Giovanni Crisostomo, and this trend became more and more frequent after the turn of the century. All the same, for a long time patrons like Alvise Malipiero in his altar for S. Maria Maggiore of 1537 (now in S Maria Mater Domini)[104] decided in favor of rich floral ornamentation. In this way conservative workshops were to have opportunities for a long time yet.

The fine-limbed, athletic *Christ* of Giambattista Bregno (fig. 138)[105] in the Cappella del SS. Sacramento in the cathedral at Treviso reminds one both of the figures on the sarcophagus of Tullio's Vendramin tomb and, by its type, of ancient statues of Aesculapius, through its clinging drapery and intricate folds. The broadly built, Herculean *Peter* in the same chapel by contrast is rather in the tradition of the façade reliefs of the Scuola Grande di S. Marco. Tullio's interpretation of sculptures of antiquity was always the guiding influence in Giambattista's work.

After Giambattista's death in 1513, Lorenzo took over the workshop single-handed, bringing the joint commissions to completion. Later, in addition to tombs for military commanders, for which his services seem to have been particularly valued, he executed in 1514−17 a commission for Cesena.[106] In the same region (Forlì) from 1515 to 1536, there are records of a Jacopo Bianchi from

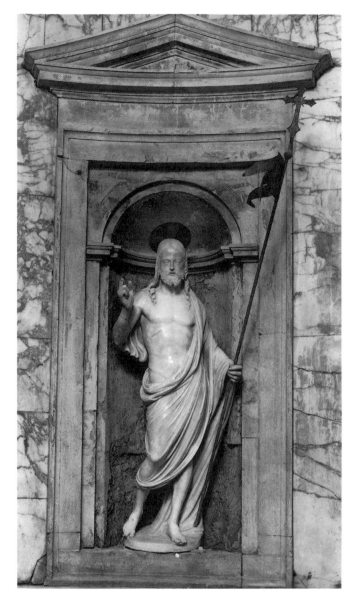

138 Giambattista Bregno, *Salvator Mundi.* Treviso, cathedral, Cappella del SS. Sacramento

here would cause us to become inextricably involved in controversial questions of attribution. Instead, two principal tasks of the sculptor will be discussed in terms of selected examples: the portrait bust and the tomb of the military leader.

Portrait busts seem to have been very rare in the second half of the fifteenth century and the first decade of the sixteenth. The autonomous portrait was among the leading tasks of painters. Popular in Venice, as in Florence, were small-format reliefs in profile resembling enlarged plaques, probably intended to be displayed in houses. The origins of the marble bust of Carlo Zeno (?) (Museo Correr),[109] attributed to Giovanni Dalmata, and of the still engimatic bronze bust of Andrea Loredan (?) (Museo Correr), probably made from a modified life cast, are unknown. The portrait of Benedetto Brugnolo da Legnago, probably based on a death mask, on his tomb in S. Maria dei Frari is a precursor of the busts that were later to be so numerous on memorials. Many such sculptures have been lost.

Of the sculptors active in Venice, the Florentine Simone Bianco (documented from 1512)[110] became a specialist in busts *all'antica,* some of which he signed with his name transposed in Greek letters. Pyrgoteles (Giovanni Antonio Lascaris), the author of the Madonna on the main portal of S. Maria dei Miracoli, preceded him in

Venice, whose portal for the Cappella Ferri in S. Mercuriale shows him to be a sculptor highly gifted in ornamentation and influenced by Tullio's works.[107] Jacopo Bianchi had certainly been active in Venice for some time before this, although no work there has yet been attributed to him. Like Jacopo Bianchi, many another gifted sculptor would have sought and found success outside Venice at that time.

Apart from the Lombardo workshop, Alessandro Leopardi, and the two Bregno brothers, the most successful sculptors were Venturino Fantoni from Bergamo, Gianmaria Mosca, the Milanese Paolo Stella, and the Bergamask Bartolomeo di Francesco, who was highly regarded by some clients.[108] To present their work extensively

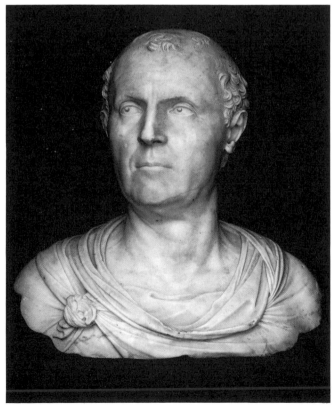

139 Simone Bianco, portrait. Stockholm, Nationalmuseum

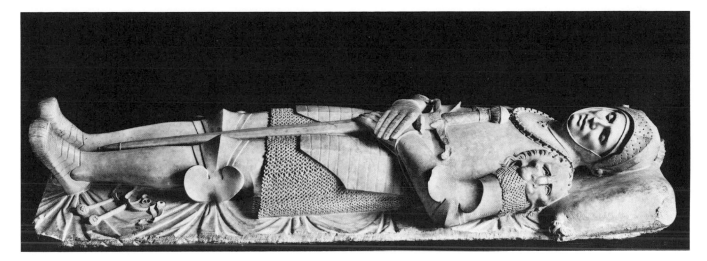

140 Tullio Lombardo, *Guidarello Guidarelli.* Ravenna, Museo Nazionale

this. Simone's works—of which only busts have been identified so far—were also sought outside Venice; Pietro Aretino conferred literary fame on him, and Christoph Fugger seems to have held him in high esteem.

Characteristic of his way of interpreting subjects is an anonymous portrait in Stockholm (fig. 139), the classical make-up of which reflects the sculptor's study of antiquity as well as the client's expectations. The collecting of ancient sculptures was an indication of status, and identification with classical ideals was widespread. As in so many contemporary pictures, however, it is often difficult to decide whether or not Simone's busts were specific portraits. The Roman custom of setting up busts of ancestors in the atrium was revived, using busts in a classical style. In 1525 a bust of the priest of S. Geminiano by Bartolomeo di Francesco is mentioned as being mounted in the presbytery of the church.

The portraitists working in Venice seem to have enjoyed a good reputation. In 1526 the marquis of Mantua instructed his Venetian agent to commission bronze portraits of outstanding army leaders, mentioning explicitly Gattamelata, the count of Carmagnola, Colleoni, Bartolomeo d'Alviano, Nicolò Piccinino, and Roberto da Sanseverino.[111] The reply from Venice refers to discussions with various sculptors, one of whom was said to be especially good, having shown the agent his recently completed portraits of members of the Grimani family. In the same year Sanudo listed in his diary items exhibited during a public procession by Doge Andrea Gritti in S. Maria Formosa.[112] Apart from pictures said to be by Michelangelo, there were bronze portraits of Doge Antonio Grimani and his son, Cardinal Domenico, both lent from the Palazzo Grimani near S. Maria Formosa. Presumably the Mantuan agent had seen these very portraits.

The rather low esteem in which portrait busts seem to have been held by most patrons changed when Jacopo Sansovino, Danese Cattaneo, and Alessandro Vittoria took up portraiture. The reasons for the change are still obscure.

While it was an honor for Venetian aristocrats to serve as *capitano general al mar*—some of them later became doges—the land army was largely led by hired soldiers. Two kinds of representation of the army leader on a tomb were favored in Venice: the equestrian monument and the standing figure.[113] The recumbent figure frequently chosen before 1450 had probably ceased to match the status of the subject or the intentions of the state, which also had a say in the matter. The Roman Paolo Savelli (died in 1405) had already been honored in this way by a wooden equestrian statue on his tomb in S. Maria dei Frari; on his tomb Vettor Pisani, victor over the Genoese at Chioggia (1380), stood in full armor under a canopy.

However, there were limits to the honor accorded to an individual in Venice. When the Bergamask Bartolomeo Colleoni (died 1475) expressed the wish to have his statue erected on the Piazza S. Marco, the senate placed it instead on the square in front of SS. Giovanni e Paolo, near the Scuola Grande di S. Marco.[114] The position on the Piazza S. Marco would have contravened a time-honored custom, which enjoyed status similar to law, prohibiting the commemoration of a person by a statue in this square. Tommaso Rangone later suffered a similar rebuff. The equestrian statue commissioned from Verrocchio in 1479 and cast and signed by Alessandro Leopardi in 1488 was elevated above the bustle of the Campo SS. Giovanni e Paolo on a very high socle embellished with columns. Leopardi seems, with good reason, to have been especially proud of the design of the socle, since he would not otherwise have alluded to this work in the inscription on his tomb.[115] In 1492, however, before its erection (1496), there were serious discussions

about the most appropriate position on the campo, in which the doge, his closest advisers, and many aristocrats were involved. Whether artistic considerations concerning the siting of the statue or simply questions of property rights on the campo were involved remains unclear.

In Venetian churches there are still many equestrian and military monuments today. In S. Maria dei Frari we find Jacopo Marcello (died 1484), Melchiore Trevisan (died 1500, fig. 125), and Benedetto Pesaro (died 1503) in full armor on their tombs. That those responsible were aware of the propaganda aspect of these tombs of army commanders is shown by the concentration of such works around the crossing of SS. Giovanni e Paolo.[116] Niccolò Orsini (died (1509), Leonardo da Prato (died 1512), both on horseback, and Dionigi Naldo da Brisighella (died 1510) had been prominent in the war against the League of Cambrai. By erecting conspicuous monuments to them in the same place, the saving of the republic from great danger was commemorated. That some church visitors were confused by these martial statues is shown by the mounted statue of Taddeo Volpi (formerly in S. Marina); it was considered by many of the faithful to be a St. George or a St. Martin, so that they genuflected before him.[117] Standing out from the ranks of these, for the most part, artistically insignificant portraits is that of the deceased Guidarello Guidarelli, produced in Venice for S. Francesco in Ravenna and convincingly attributed by Ravenna chroniclers to Tullio Lombardo (fig. 140). This reclining figure was part of a (still extant) ancient sarcophagus. Tullio made the suffering of a very young soldier his theme, treating it in the manner of ancient idealized portraits of dying soldiers. The contrast between the armor and the face of the dead man that it encloses heightens the moving effect of the face. Pity and perhaps even mourning over the death of this man are aroused in the viewer. Schlüter sought similar effects with his "masks" in the Berlin Zeughaus.

The relatively tranquil decades after the Peace of Bologna (1529) led to a recession in portraits of army leaders in Venice. Only in the picture cycles in the Doge's Palace produced after the fires of 1574 and 1577 were army leaders again honored in public places.[118]

Jacopo Sansovino

In 1527, shortly before the imperial armies sacked Rome, the Florentine Jacopo Sansovino fled to Venice. His skill as an architect, which he first demonstrated in structural repairs to the domes of S. Marco, led in 1529 to his appointment as *proto* and architect to the procurators. That is probably when he decided to stay in Venice. In sculpture Sansovino's Venetian oeuvre is not very large, and it is heterogeneous. One reason is probably that up

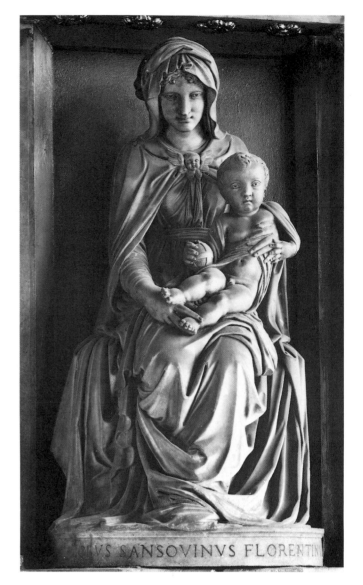

141 Jacopo Sansovino, *Madonna.* Arsenal

to at least 1550 he was fully taxed with architectural commissions.[119]

Shortly after Sansovino's arrival in Venice Pietro Aretino, an influential writer, took him under his wing. In a letter to Federigo Gonzaga, marquis of Mantua, Aretino schemed to procure the commission of a Venus for the marquis's private rooms, a figure that would inspire lustful thoughts in anyone who saw it. Whether anything came of this is not known, and the figure has been lost.[121] That Sansovino was not unknown in Mantua is shown by a letter of Isabella d'Este to Francesco Gonzaga, in which she credits Sansovino with a sure judgment on classical statues and contemporary forgeries.[122] In this ticklish area sculptors no doubt had the greatest expertise. Later,

in 1603, people in Mantua turned to Alessandro Vittoria for the same reason.[123]

About the same time the painter Lorenzo Lotto wrote to the governors of S. Maria della Misericordia in Bergamo, recommending that the commission for the *modelli* of figures for a silver altar be awarded to Sansovino,[124] who, as said Lotto in his letter, was ranked second only to Michelangelo in Rome and Florence. At the same time Lotto pronounced a harsh judgment on the sculptor Bartolomeo di Francesco, whose talent was indeed modest and who had submitted designs. This linking with the divine Michelangelo, in terms of the value of his art if not its style, was in line with Sansovino's own thinking. One cannot escape the impression that Sansovino was using Lorenzo Lotto as his mouthpiece. At any rate one detects his intention to establish himself in Venice with the aid of like-minded supporters. In the same breath Lotto recommended another gifted young man who claimed to be a pupil of Michelangelo and was also residing in Venice, maybe Giovanni Angelo Montor-

soli. Presumably he had come to Venice with Sansovino and possibly Ammanati. However, neither stayed long.

Sansovino's earliest surviving sculpture in Venice, the *Madonna* at the entrance to the Arsenal, commissioned by three officials (1534, fig. 141),[125] diverges clearly from his Roman and Florentine works. Designed to be seen only from below, the Madonna inclines towards the viewer. Her flowing cloak spreads over her seat, the artistically draped material being at once a foil to and a part of the delicate figure. Seen from the entrance of the hall, which Sansovino conceived as the main viewpoint, the attention is absorbed by the virtuoso draping of the cloth. This virtuosity is lacking in his preceding works. It seems as if he sought a confrontation with local tradition, as embodied by Tullio Lombardo and the two Bregnos. As in so many Florentine Madonnas of the fifteenth century, the tender play of hands moves the observer. The seriousness of the young mother, perhaps slightly inert, and the fierce gaze of the child are, however, somewhat disturbing.

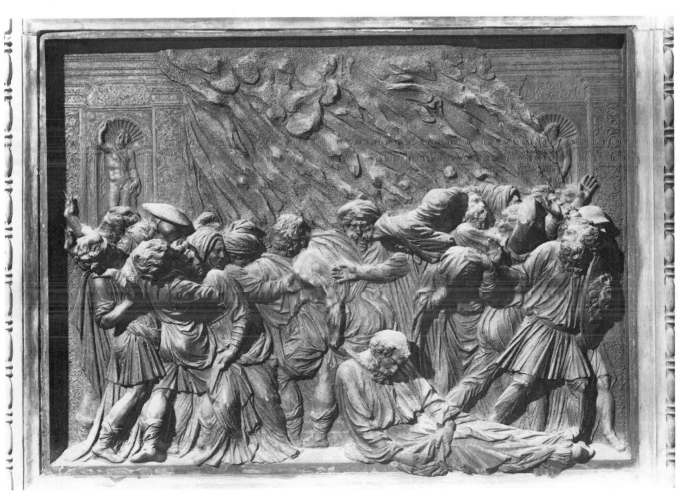

142 Jacopo Sansovino, *Dragging of St. Mark*. S. Marco

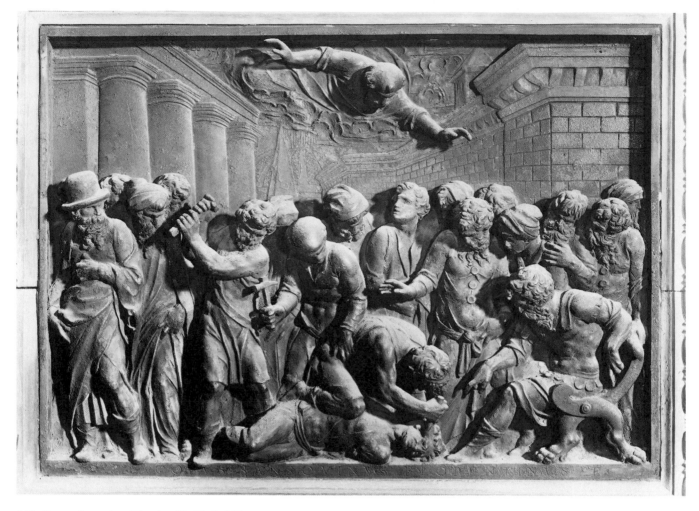

143 Jacopo Sansovino, *Miracle of St. Mark.* S. Marco

In 1536 Sansovino accepted the commission for a re-
lief of the miracle of the drowned girl for the Cappella
dell'Arca in S. Antonio (Padua).[126] The almost unbeliev-
ably delayed delivery (1563) indicates his lack of interest
in the task. He had more than enough to do in Venice.

With his first series of reliefs for the tribunes in S.
Marco (under construction since 1537, the year of Vit-
tore Gambello's death, fig. 142),[127] Sansovino set new
standards in Venice for the treatment of groups and the
emotions. His message was taken up in the same year by
the painters Jacopo Bassano and Bonifazio de' Pitati, in
pictures full of hectic drama, something that proved a
temporary aberration for both painters. Sansovino thus
triggered a brief "mannerist crisis" (Coletti) in some Ve-
netian painters. His role as one of its promoters is per-
ceptible only by reflection but was eagerly championed
by Pietro Aretino.

The scenes from the life of the city's patron saint take
place in the open air with many people involved. When a
demon is exorcized, dense clusters of curious spectators
gather around. When the saint is dragged along, his tor-
mentors' arms link to form a coherent pattern, while on
the right of the picture shock, even panic, crush into a
knot the people fleeing the avenging hail of stones. The
mood of the event is shown less by the attitudes of indi-
viduals than by the behavior of groups. The generalized
faces contribute little to the narration. In a letter Aretino
stressed the wonderful coherence of the groups of fig-
ures in the reliefs, pinpointing a major achievement of
Sansovino's art.[128] Soon afterwards, in the reliefs for the
second tribune (about 1541, fig. 143), Sansovino changed
his style. Perhaps his earlier reliefs had been subjected to
criticisms similar to those levelled later at Tintoretto's
Miracle of St. Mark for the Scuola Grande di S. Marco
(1548) and his picture for the Sala del Maggior Consiglio.
Now each figure stands more on its own and is more dis-
tinct from the background, and almost all the heads are
at the same height. The emotions seem more temperate,

and some effects seem forced; there is a complete lack of clustering. Psychological impulses are conveyed by attitudes rather than by facial expressions. The composition of these "pictures" looks calculated; as in the works of Tullio Lombardo earlier, the symmetrical arrangement of figures creates a pattern that is easily assimilated.

In the same years the Loggetta at the foot of the Campanile was being completed. Sansovino left the reliefs of the attic to Gerolamo Lombardo, Danese Cattaneo, and Tiziano Minio but kept the four bronze figures for himself (figs. 144, 145). His son Francesco later passed on their meaning in relation to the state, no doubt basing his

precise explanations, not evident from the figures themselves, on written sources, paraphrasing the text where he did not reproduce it verbatim.[129]

Jacopo Sansovino was much too experienced not to know that a subtle deeper meaning of this kind could not be communicated by the sculptor but needed explanatory words. He therefore made no attempt to signal further meanings by adding numerous attributes. That other approaches were possible is shown by the example of the allegories on the four doors of the Sala dell'Antipregadi of the Doge's Palace, produced after the fire of 1574.[130]

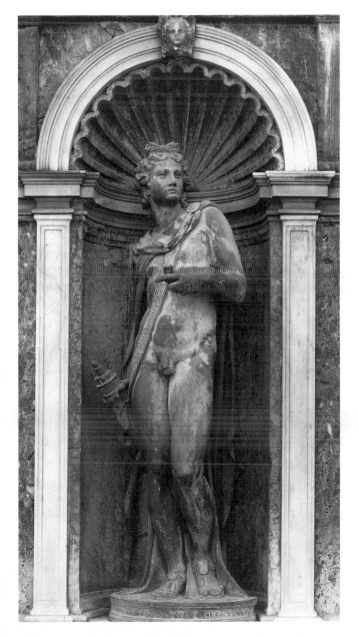

144 Jacopo Sansovino, *Apollo*. Loggetta

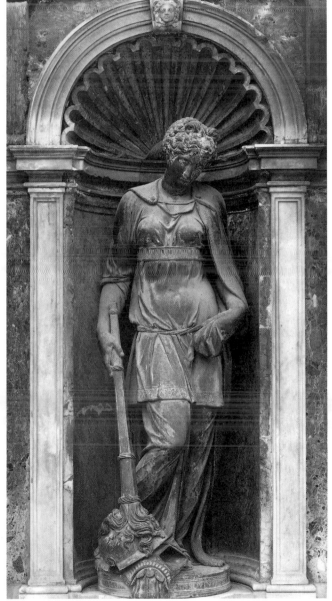

145 Jacopo Sansovino, *Peace*. Loggetta

Apollo gazes into the distance with an intensity that Sansovino heightens by the proud, even challenging turn of the shoulders. Apollo takes an arrow from his quiver and shows it, while he once held a lyre in his left hand. His garment falls softly, clinging to his body.

In a fictitious dialogue ("L'Aretino") published in 1557, Lodovico Dolce described various possible ways of shaping the human body, a topic that was clearly much discussed at the time.[131] He distinguished fleshy from lean, muscular from delicate (*delicato*), giving preference to the latter quality, which painters would have called tenderness (*dolcezza*). To the objection that tenderness was better suited to women than to men, he replied that while this was true, there were nevertheless many fine-limbed men, particularly among the *gentiluomini,* who did not on that account resemble women or Ganymede. Here, as so often, Michelangelo and Raphael are cited as antagonists, Dolce preferring the *grazia* of Raphael. It is against the background of such discussions that Sansovino's muscular but lithe figures, with their restrained movements, should be seen. Raphael's fictive statue of Apollo in his *School of Athens* (Vatican, Rome) is related to Sansovino's *Apollo.* Sansovino seems to have been impressed by some works of antiquity and by Raphael, but not by Michelangelo's figures.

Peace, perhaps the most beautiful figure on the Loggetta (fig. 145), is a deeply impressive symbol. Self-absorbed, as if absent-mindedly, she lights with a glowing torch, symbolizing love between peoples,[132] the implements of war lying on the ground. Sansovino has made not the lighting but the mood of the goddess his theme. Seriousness, weariness, perhaps even mourning are conveyed by her posture and her lowered eyes. In this psychological manner of depiction we can recognize a constant of Venetian sculpture that was essential to the work of the Master of the Labors of the Months on the main portal of S. Marco, to the figures of Filippo Calendario on the façade of the Doge's Palace, and to the work of Bartolomeo Buon.

Studied arrangements of drapery similar to those of the early Madonna at the Arsenal are found later in the John the Baptist, carved entirely by Sansovino, on the font of S. Maria dei Frari (before 1550, plate 14). The saint's restless attitude and the torsion of the body culminate in the rapt gaze which strikes the observer. Here, in the depiction of emotions, Sansovino distanced himself from the style embodied by Tullio Lombardo. The delicate figure, emaciated by fasting, reminds us of the *Baptist* by Donatello only a few yards away; the divergence from the Herculean *St. John* by Paolo Savin in the Cappella Zen (S. Marco) is unbridgeable. With this figure Sansovino reworked a Florentine tradition of the second half of the fifteenth century, setting new standards for Venetian sculptors. Shortly afterwards the young Ales-

sandro Vittoria was to surpass himself by fashioning his own *Baptist* under the influence of Sansovino's.

Since the early 1540s some of Sansovino's collaborators begin to produce works independent of the architecture directed by the *proto* of S. Marco. Ammanati,[133] Danese Cattaneo,[134] Tiziano Minio, and Tommaso Lombardo had given sufficient proof of their ability. While Ammanati found in Padua a new field of activity and in Marco Mantova Benavides an educated and prodigal Maecenas, Danese Cattaneo stayed in Venice. Not only his sculptures but his poetic works were well received, and he became a friend of Torquato Tasso. Vasari used him as his informant on Venetian art and artists. For the well in the courtyard of the Zecca (now in the courtyard of the Cà Pesaro, fig. 28) he created an *Apollo* and, unusually, devised an iconographic program. His proposal to carve figures representing silver and bronze as well as the gold worked in the mint, which Apollo symbolizes, was not accepted by his clients. In the fleshy youthful *Apollo,* Cattaneo followed Sansovino's *Apollo* of the Loggetta.

Vasari was also well informed about Cattaneo's portraits. The impressive portraits of Pietro Bembo (died 1547, Padua, Santo) and of Lazzaro Bonamico (died 1552, Bassano, Museo Civico) are certainly by him. The fact that Cattaneo owned a portrait of a member of the Dolfin family by Titian[135] may have influenced his treatment of portraiture.

Danese Cattaneo's late style and his freer artistic relationship to Sansovino can be illustrated by his *Peace* on the tomb of Doge Leonardo Loredan (1501–21), which the sculptor created shortly before his death in 1572.[136] *Peace* holds the torch negligently, the sculptor being more interested in shaping the body and drapery than the theme. The idealized face with small mouth and smooth, stereometric forehead recalls Ammanati's allegories. Unlike Alessandro Vittoria, in whose robed figures of the 1560s large, simple shapes predominate, Cattaneo draped his figures in minutely folded garments.

Whether Cattaneo with his literary expertise thought out the unusual theme of this tomb is not known. Venetia, a drawn sword in her right hand and the olive branch of peace on her breastplate, confronts an allegory of the League of Cambrai. Between them is enthroned the doge in whose rule occurred the republic's traumatic defeat at Agnadello (1509) and the laborious reconstruction of Venetian rule on the mainland. The figure of the doge is by Cattaneo's pupil Girolamo Campagna. He was probably working to a design by Cattaneo.

Tiziano Minio (1551/12–52), to whom the middle and left reliefs on the attic of Sansovino's Loggetta have been attributed and who had previously collaborated in his first tribune, also worked for Venetian and Paduan patrons.[137] Still heavily dependent on Sansovino in his stucco decorations for the Odeo of Alvise Cornaro in

Padua (ca. 1540), he broke free of this influence with his fine bronze relief on the cover of the font in S. Marco (1545, fig. 146), in which Desiderio da Firenze collaborated.

Vasari[138] tells us that Tommaso Lombardo produced countless very beautiful stucco figures for Venetian houses, none of which, however, has yet been identified. His portrait of Charles V also seems to have been lost. A signed *Madonna with the Child John* in S. Sebastiano shows him following in the wake of Sansovino. In 1567–69, with Sansovino, Alessandro Vittoria, Tintoretto, and Orazio Vecellio, he produced an inventory of the important art collection of Gabriele Vendramin.[139] His specific area of competence in this illustrious circle is not known.

In the 1540s Ammanati had produced a *Hercules* much over life-size and famous at the time for the palace of the professor of law and connoisseur Marco Mantova Benavides in Padua.[140] Possibly it was this figure that gave rise, in 1554, to the desire of the Provveditori del Palazzo Ducale to commission Sansovino to produce from two large marble blocks, said to be "accidentally" present, two giants[141] to adorn the Doge's Palace. Over-life-size figures or groups were popular in Florence in the first half of the century as a sign of communal self-celebration, and some people seem to have pursued the same goals in Venice. The contract did not make it quite clear where these two figures were supposed to stand.

Sansovino executed *Mars* and *Neptune* with the help of several collaborators, basing their physique so closely on antique sculptures that a man as experienced as Schinkel considered them classical works. The contrast to Rizzo's delicate architecture made their placing on the coronation staircase in the courtyard (fig. 15), which thus became the Scala dei Giganti, an unsatisfactory solution for both sculptures and architecture. This happened in 1567. The Grimani, more sensitive in aesthetic questions, had found a more appropriate solution in the courtyard of their palace at S. Maria Formosa, when erecting the monumental *Marcus Valerius Agrippa*.

146 Tiziano Minio, relief from the baptismal font. S. Marco

Shortly afterwards in 1553, Sansovino was commissioned to erect the façade of S. Giuliano and with it the façade monument for Tommaso Rangone (figs. 76, 147). There was a strong tradition of scholars' tombs in Venice,[142] even if they could not match those of the university town of Padua. The knowledge or profession of the deceased was usually indicated by still lifes of books and an inscription. The physician Jacopo Surian (his tomb in S. Stefano was erected before 1493) seems to have preferred Aristotle and Galen, and other books, without titles, are stacked beneath his feet and under his pillow. Noteworthy in Venice is the absence of a portrayal of the *magister in cathedra;* the reference to teaching was confined to inscriptions. Jacopo Bellini's design for a tomb depicting a teacher and his pupils[143] probably did not conform to Venetian sensibilities in the veristic rendering of the gisant. Outstanding examples of Venetian scholars' tombs are the one for the historian Antonio Cocci, called Sabellico (died 1506), from S. Maria delle Grazie (Museo Correr) and the one, adorned with a bust,

for the humanist Benedetto Brugnolo da Legnago (died in 1505, S. Maria dei Frari).

Against this background Rangone's excessive self-esteem becomes comprehensible.[144] Up to then portals had shown only enthroned saints or kneeling mortals.[145] Rangone was not content with just a portrait on the façade of S. Giuliano. Alessandro Vittoria later produced another bust, a few steps from the Piazza, next to the sacristy of S. Geminiano, and a statue (disguised as St. Thomas) for the façade of S. Sepolcro on the Riva degli Schiavoni (now in the Seminario Patriarcale).

The doctor and scientist, as erudite as he was eccentric, had himself immortalized on S. Giuliano surrounded by his beloved books, globes, and other implements, when his presumptuous plan to have his portrait put up over the entrance to S. Geminiano was frustrated by the state. He seems to have given the sculptor exact instructions on details of the furniture of his "study," amongst which his own figure appears somewhat incongruous.

Juxtaposed to the very large, laudatory inscription,

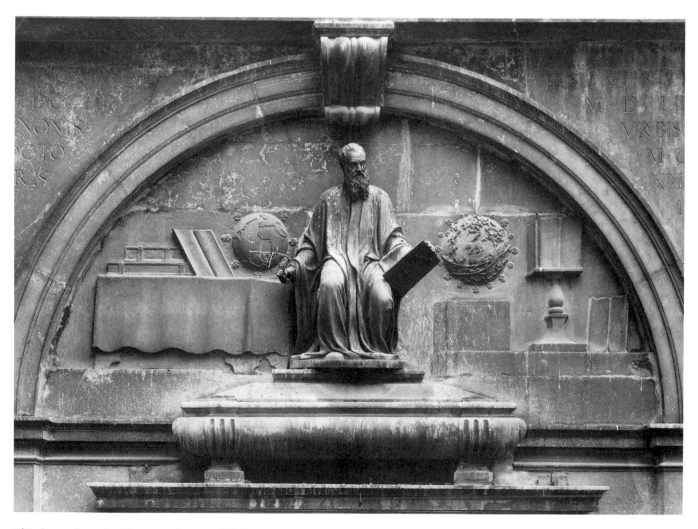

147 Jacopo Sansovino, *Tommaso Rangone.* S. Giuliano

the coat of arms, and the framing architecture of S. Giuliano, Rangone looks rather vulnerable. The heavy, clinging garment that falls softly over the body is, however, a firm base for the expressive portrait. The placid hems and folds of the garment, which hold the gaze, underline the commanding quality of the portrait; Rangone's eyes and bearing indicate an alert, energetic personality. Alessandro Vittoria repaired the clay model before casting and—as at other moments of his collaboration with Sansovino—it must have given him food for thought. Vittoria's conception of the portrait as a genre is influenced by Sansovino's portrait of Rangone, as his own portraits of this eccentric man show.

Sansovino made a fundamental contribution to the modernization of the presbytery of S. Marco.[146] After the two tribunes and the designs for the pews (which were removed in 1955, some being lost), he was commissioned, probably in 1545, to produce the bronze door of the sacristy (fig. 148).[147] As an allusion to Ghiberti's *Gate of Paradise* for the Florence baptistry, Sansovino placed

heads in the small square fields, filling the horizontal rectangular ones with lying figures. The two standing evangelists in the upper niches appear moved by the miracle of the Resurrection.

In the two scenic reliefs Sansovino shows a new style. Heads and upper parts of bodies detach themselves here and there from the shallow relief; some parts of the figures are in low relief while others stand out plastically. There is no stage on which the figures perform. Sansovino detaches the heads of figures standing further back from the background, a device no doubt intended to condense and clarify the story rather than to show natural relationships by foreshortening. In the relief of the *Entombment,* which can only be "read" correctly from a kneeling position, Sansovino peopled the mountainous landscape with numerous figures, including horsemen and lance bearers in very low relief. Sansovino's son Francesco compared these backgrounds with paintings,[148] probably indicating the sculptor's intentions as well as offering a criterion for the observer. The

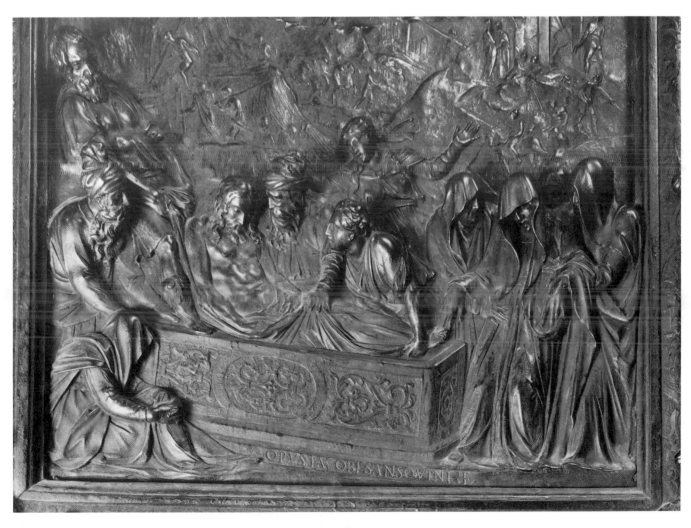

148 Jacopo Sansovino, *Entombment of Christ.* S. Marco, sacristy door, detail

figures on higher ground on the left recall Tintoretto's treatment of the *Golden Calf* (Madonna dell'Orto); on the right is the hill of Golgotha with Christ's empty cross.

It remains uncertain to what extent details of the sculpting were executed by Sansovino's assistants, particularly Alessandro Vittoria, who in 1545 were paid for preparing the wax model. The great similarity of the putti to Vittoria's works might be explained in this way. In these years Sansovino admitted openly that he had many of his sculptures made by young collaborators, confining himself to guidance and correction.[149]

This does not mean that Sansovino had all his works executed by assistants. In the tomb of Doge Francesco Venier (died 1556, S. Salvatore, fig. 77),[150] he entrusted the high-mounted lying figure of the doge and the devotional picture to Alessandro Vittoria, who performed the task, evidently without much commitment, with Antonio di Piccio and Tommaso de Zara. He himself signed both his figures (Iacobus Sansovinus Sculptor et Architectus Florentinus Fecit).

In the symbol of *Hope* the consonance of the body posture with the lines of the hems and folds of the garment is used as an artistic device. The figure's timid, retiring attitude and yearning gaze fixed on the high altar show how Sansovino embodied allegorical themes. In the *Peace* of the Loggetta he had conveyed his interpretation of the allegory just as vividly by the attitude of the figure. However, even with *Hope* he did not dispense with bravura effects such as the contrast between different kinds of folds on the sculpted lower body, superficial touches that were probably meant to satisfy the demands of art connoisseurs. Contrasts between elements important in conveying the theme, and peripheral embellishments showing the virtuosity of the artist were employed by painters, too, at that time.

Compared to *Hope, Charity* looks hesitant, molded like a relief. The serenity of the young mother with her two children who, though struck by the outside world, still cling to their mother almost fearfully is a no less convincing symbol of love and concern for one's neighbor. A letter of the publisher Marcolini[151] gives us an idea of how the deep, intimate relationship of mother and child in such a piece was received by contemporaries. The letter refers to a relief by Sansovino that Pietro Aretino gave to the duchess of Urbino. Mother and child, Marcolini writes, "absorb each other [*santissimamente*] with their eyes." The differences between the two figures on the tomb show how little Sansovino worked within the categories of a binding style.

Despite all his allusions to works of antiquity and central Italy, Sansovino did not overlook the sculptures of Venice. In composing his reliefs, however, he did not look for models or inspiration for body outlines or garment motifs in his elective homeland. On the contrary, what impressed him in the best Venetian works was a subtle but unmistakable rendition of human feelings, even contradictory ones. Thus there is no "development" in his oeuvre, but constant attempts to find an appropriate, perhaps new, form for the task he has been set—not an easy legacy for his successors and imitators.

In 1562 there is the first mention of an illness that forced Sansovino to take on an assistant in performing his duties as *proto*. In 1566 there is another such decision. These are the years in which less gifted sculptors, such as the Paduan Francesco Segala, whose cause was espoused by Danese Cattaneo, were able to secure highly attractive commissions—at S. Marco and the Doge's Palace, for example. At the beginning of the 1560s, Alessandro Vittoria became the leading sculptor in Venice. But as late as 1569 Veit von Dornberg, the imperial agent, still ranked the aged Sansovino higher.[152]

Alessandro Vittoria

In 1543, at the age of eighteen, Alessandro Vittoria arrived in Venice from Trento.[153] Sansovino took him on as an apprentice and soon entrusted him with chasing[154] the bronze reliefs of his second tribune (fig. 143) and in 1546 with cleaning the wax model for the sacristy door for S. Marco (fig. 148). In this way Vittoria was able to familiarize himself with the works of the leading sculptor in Venice at the time. He also participated, like many other experienced sculptors before him, in the decoration of the Libreria façade.

Before 1550 he was involved in a dispute with Sansovino that induced Vittoria to leave Venice for Vicenza. Sansovino was undoubtedly a difficult man, but hardly a madman,[155] as he was described by an exasperated critic in 1552. Vittoria's stucco ceilings and a fine fireplace for Palazzo Thiene in Vicenza,[156] produced shortly after the breach, show him to be an inventive and surprisingly independent-minded stucco worker.

At the same time he modelled numerous medallions that Pietro Aretino immediately praised in his much-read letters. The conflict with Sansovino came to a head in 1552 with the spectacular challenge that Vittoria should carve a Hercules for Ercole d'Este in competition with Sansovino.[157] In a self-assured letter to the duke's agent, Vittoria complained that Sansovino criticized his work mainly out of envy. If one looks at Vittoria's early Venetian works, Sansovino's less than enthusiastic judgment is not so difficult to understand. The controversy brought Pietro Aretino onto the scene; he was able to effect a reconciliation. Vittoria returned to Venice and at once obtained good commissions, without always living up to them. This was not helped by the traditional Venetian practice, which he took over from Sansovino, of delegating even important contracts wholly or partly to less gifted assistants. The two over-life-size caryatids on the Libreria portal (executed in 1553 in collaboration with

Lorenzo Rubini[158] and others) are an example. Compared to Sansovino's fine atlantes on the fireplace of the Villa Garzoni (Pontecasale) or the much smaller atlantes on the fireplaces of the Doge's Palace (works by Danese Cattaneo and Pietro Grazioli da Salò), these lifeless figures are hardly a proof of supreme ability, Sansovino's *Giganti* on the coronation staircase of the Doge's Palace, begun in 1554, put the matter promptly and clearly into perspective.

Vittoria was much more successful with smaller formats—indeed, it was here that his main gift lay. His *John the Baptist* on the font of S. Zaccaria (about 1550) shows also how profound Sansovino's influence was. Vittoria was particularly attached to this successful figure, reacquiring it in 1565 for his own collection, which also included paintings and drawings by Parmigianino. In his various wills he gave detailed instructions, still valid today, on how to protect his "Giovannino" from incompetent treatment.

The procurators and Sansovino seem to have been satisfied with Vittoria's work and in 1556 entrusted him with the stucco decoration of the staircase of the Libreria. In decorating the barrel vaulting Vittoria followed Sansovino's system in the portico, while in the domes above the landings he chose the scrollwork and cartouches peopled with putti that he had already tried out in Vicenza. In a very similar manner, again indebted to Sansovino, he decorated, from 1557, the vaulting of the Scala d'Oro in the Doge's Palace. At that time he achieved new social status, being recognized in 1557 as head of a workshop (*padron*) by the guild. A year later he acquired a sketchbook by Parmigianino, which seems to have fascinated him both as a sculptor and as a collector. In 1560 Parmigianino's famous *Self-portrait in a Mirror* (Vienna, Kunsthistorisches Museum) was added, Vittoria acquiring it through the offices of Andrea Palladio and later bequeathing it in his will to Emperor Rudolf II.

The collaboration with his mentor Sansovino ended with his figures for the tomb of Doge Francesco Venier (S. Salvatore, fig. 77), on which he worked from 1557. Sansovino handed over to him the high-mounted and poorly visible recumbent figure as well as the lunette with the kneeling doge before the Pietà. In his treatment of the Pietà Vittoria distanced himself from the Venetian tradition as it had been formed by the Lombardo generation, not without German influence (examples are the beautiful altar of the Cappella Gussoni in S. Lio, an altar panel in the Seminario Patriarcale and Tullio Lombardo's late *Pietà* in Este). Instead, Vittoria was guided in some respects by a print showing Michelangelo's *Pietà* in St. Peter's (Rome). The result was a clear artistic program in a very superficial formulation, although Vittoria might be partly exonerated by ignorance of the original and—as usual—by the involvement of several collaborators. The art of Michelangelo, whose works in Rome and Florence Vittoria seems never to have seen, was to remain a model in the future, though not the only one. But what would Vittoria have become if he had at least once made the journey to Rome and Florence? Parts of the figures in the Medici Chapel, for example, the left foot of the *modello* of *Day,* which he acquired in 1563,[159] could not make up for the lack of firsthand experience. On the contrary, the exclusive study of details and body movements was bound to make it even more difficult for him to understand Michelangelo's artistic achievement.

With the altar of S. Francesco della Vigna (1561, fig. 149) begins the series of works that carried his influence far beyond the frontiers of Venice.[160] In terms of its type, however, this altar must have seemed rather old-fashioned. Figures in niches are often to be found in altars of the Gothic period. In the first half of the century sculptors and patrons favored narrative reliefs.

In his altar in S. Francesco della Vigna, Vittoria has enriched the architectural vocabulary familiar to us from older works with powerful consoles elaborated like pieces of sculpture, which lightly carry the figures in front of tall, slender niches. The architecture is largely separated from the figures. This autonomy of the frame has a parallel in Venice in the development of the cartouche in relation to the framed picture. The ceiling decorations in the Doge's Palace are evidence of this. The separation of figure and frame gave rise later, as a logical step, to the emancipation of figures, which came to stand freely in front of the aedicule of the altar.

Characteristic of Vittoria's unorthodox architecture are the upper parts of his altars. In the altar of S. Giuliano he not only opens the segmental pediment at the bottom but deforms it to become a kind of console at the apex with lateral elements resembling ogee arches. In the later altar of the Luganegheri in S. Salvatore (about 1600) we find, instead, two staggered aedicules, in which the overlapping columns, rather as in some especially elaborate altars of the first half of the sixteenth century, cause a heightening of attention towards Palma's picture at the center. This exhibiting of a picture in the framework of an altar has a parallel, and perhaps its model, in Sansovino's isolated frame on the altar bearing Titian's *Annunciation* (S. Salvatore). Vittoria's "early baroque" altars were studied with profit by architects and sculptors up to the eighteenth century, not only in Venice but north of the Alps as well.

It was probably soon after 1520 that memorials to the dead with a bust of the deceased came into fashion in Venice. The bust of Matteo degli Eletti (died 1523), priest of S. Geminiano, executed by Bartolomeo di Francesco[161] and originally mounted in the presbytery of S. Geminiano, was probably part of a memorial. Sansovino may have played a part in the history of these memorials. In his will of 1568 he mentioned a memorial begun in

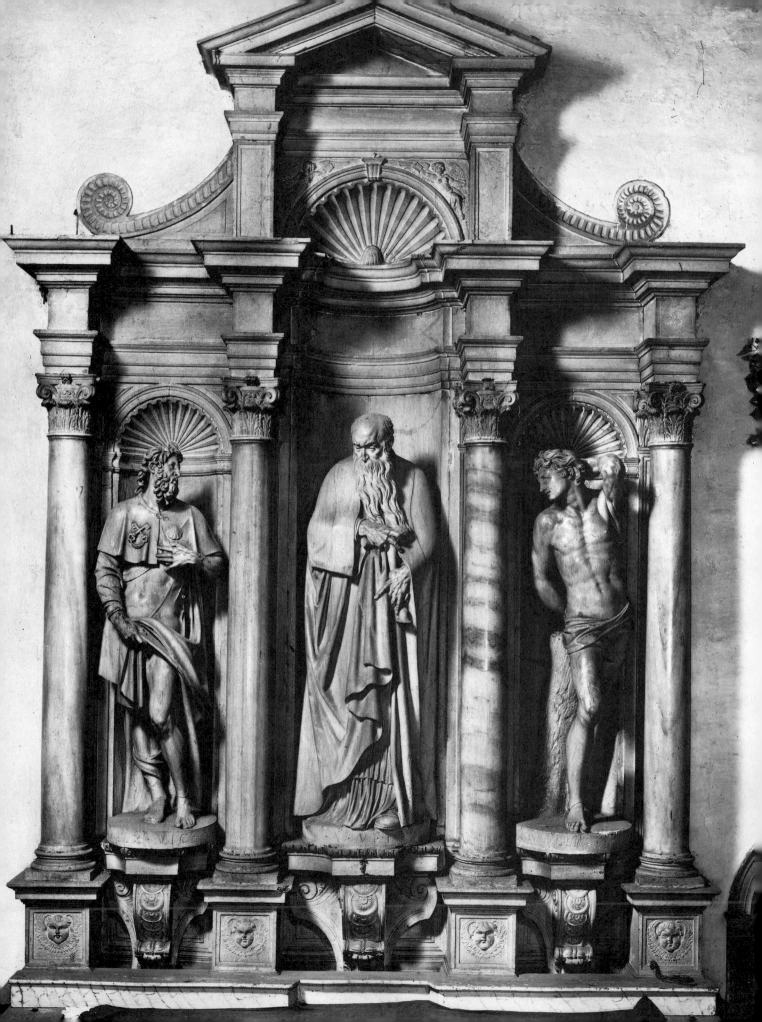

1533 that he now wanted completed and mounted on the wall together with his bust.[162]

The bust of the deceased, framed or mounted before a shell, became, with the laudatory inscription, a frequent commission, and Vittoria one of its busy specialists. In this genre he could demonstrate not only his skill as a portraitist but also his inventiveness in designing frames. Scrollwork, broken pediments, and accompanying caryatids were his preferred motifs. The busts, usually mounted high above the memorials, are designed to be seen from a few viewpoints determined by the position on the wall. This is perceptible in figures removed from their original contexts. Seen frontally, the shoulders and extended arm of the bust of Benedetto Manzini (Cà d'Oro), originally mounted in the presbytery of S. Geminiano,[163] look unnatural, the posture unstable. Only when viewed diagonally from the right does the bull neck with pulsing carotid artery, the impatient, forward-bending attitude of this energetic man become visible.

In the Venetian memorials of these decades Christian themes are absent, the image of the deceased man and his services to the community being placed center stage. That this secularization (which has a parallel in the façade monuments) was not accepted by everyone without contradiction is shown by the negative judgment pronounced by Fra Paolo Sarpi on an inscription on the tomb of Doge Leonardo Donà (1606–12). Sarpi thought it necessary to insert at least a few Christian formulations in the exclusively eulogistic text.[164]

Alessandro Vittoria produced a particularly fine memorial for himself in S. Zaccaria. It is not only the lapidary inscription that explains the program: ALEXANDER VICTORIA QUI VIVENS VIVOS DUXIT E MARMORE VULTUS (Alessandro Vittoria, who, when alive, drew living countenances from marble). It is accompanied by personifications of architecture, sculpture, and painting. In the floor of the church, on Vittoria's tombstone, the visitor then deciphers a Latin inscription speaking of hope and redemption.

Compared to the memorials already mentioned, the family tomb of the Contarinis in the Madonna dell'Orto brings to mind an ancient necropolis. The regular arrangement of aedicules side by side, each with an inscription panel on a high socle and a bust, is of great formal strictness. The individual is subordinated to the linking and unifying element of the family.

Vittoria's busts were destined not only for tombs but also for villas and, not least, private palaces. Marble was the preferred material, and clay was often employed, but bronze busts were rare. Reminiscences of the custom of the upper classes in ancient Rome, who erected wax images of their ancestors in the atrium, probably influenced a number of commissions.

In his portraits Vittoria shaped the drapery with particular care. The bust of Doge Niccolò da Ponte

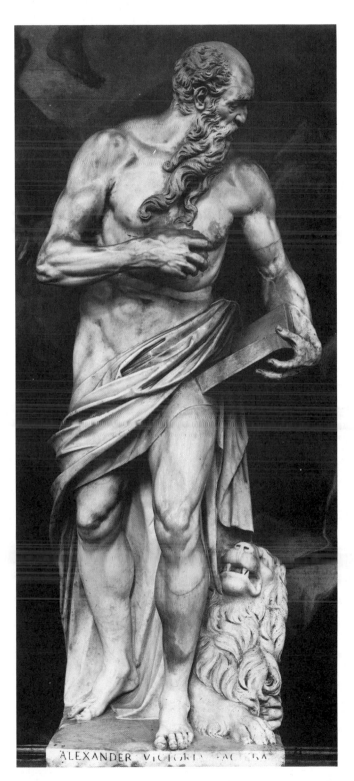

149 (*Opposite*) Alessandro Vittoria, altar of S. Francesco della Vigna

150 Alessandro Vittoria, *St. Jerome*. S. Maria dei Frari

151 Alessandro Vittoria, *St. Daniel.* S. Giuliano

(1578–85), originally mounted high on his tomb, is an especially fine example (plate 15).[165] The doge's mantle, open at the center and as if inflated from within, gives the commanding head a dignified base. How far the portrait resembled its subject is no longer easy to determine. Jacopo Tintoretto painted the doge during his lifetime, looking older and frailer, in his votive picture in the Doge's Palace (Sala del Collegio; fig. 271). Presumably Vittoria wanted to harmonize the face with the high state office indicated by the mantle and the doge's cap, glossing over the debility of the old man.

The same might be true of Vittoria's portrait of Procurator Ottaviano Grimani (procurator from 1571 to 1576; Berlin, Stiftung Preussischer Kulturbesitz). The procuratorial dignity celebrated in many occasional writings of the time is evident in the confident turn of the torso and the intense gaze. Vittoria's portraits of Venetian statesmen no doubt largely reflected both the image they had of themselves and the image of offices and their holders that the republic promoted. One supposes that in these and numerous other portraits individual features were faithfully reproduced, but the characteristics of the sitter were heightened, insofar as they could be communicated by posture and gaze and by the beard and the usually sturdy socle of the neck. Coupled with this was Vittoria's ability to communicate the presence of an individual through his treatment of drapery or armor.

Some subjects, including Saints Sebastian and Jerome, were treated more than once by Vittoria. In his *St. Sebastian* on the altar of S. Francesco della Vigna (1561–63, fig. 149), Vittoria used a model, probably Hellenistic, for the face[166] and a little later in 1566 in the small-format bronze, cast with special care because of its size (New York, Metropolitan Museum). The pain evident in the face is amplified by the wind-blown hair. In the *St. Sebastian* collapsing lifelessly on the late altar of the grocers (*luganegheri*), Vittoria compassionately turned the agonized face from our view, as Veronese had done before him on the high altar of S. Sebastiano. While in the figures from the early 1560s Vittoria's interest was concentrated on the male nude artistically turned in on itself, his later figure shows a greater mastery of this theme.

Vittoria's early *St. Jerome* in the Frari (1565, fig. 150; today mounted too low), is done entirely in the spirit of Tintoretto. Compared with the St. Jerome in Tintoretto's votive painting for Doge Girolamo Priuli in the Doge's Palace (on the ceiling of the Atrio Quadrato) and in the painting from the Palazzo dei Camerlenghi (now in the Accademia), Vittoria's saint is Herculean and, despite unmistakable features, his age is dissimulated. In some portraits of old men he idealized his subjects in a similar way—not surprisingly for someone living in a gerontocracy. His complete mastery of anatomy is demonstrated, and the saint's attitude is more complex than the

152 Alessandro Vittoria, *Annunciation* ("Pala Fugger"). Chicago, The Art Institute, Edward E. Ayer Fund

theme of penitence required. One detects the intention at least to equal the divine Michelangelo. At the same time, in the head with its mighty beard twisted in shaggy tufts the influence of Sansovino's *Neptune* on the Scala dei Giganti is all too apparent.

About ten years later, around 1576, Vittoria created his second *St. Jerome* (now in SS. Giovanni e Paolo, plate 16) for the Scuola di S. Maria della Giustizia e. S. Girolamo near S. Fantin; one of the duties of this scuola was to accompany those condemned to death on their way to the scaffold. In this figure Vittoria clearly distanced himself from his earlier conception. Penitence and meditation are convincingly shown. St. Jerome kneels on the sharp rock, his attitude humble, a peacefully sleeping lion underlining the effect of inner composure. Vittoria prized his late *St. Jerome* as highly as his earlier *Baptist,* stipulating in one of his very numerous wills (1576) that no one should dare to complete the figure, which was unfinished at that time. He was evidently aware how much faith was to be placed in the assistants he so often used.

Vittoria depicted emotional states with similar power in the beautiful, black-patinated bronze group of *Mary and St. John under the Cross* (originally in the same scuola and now, with the altar, in SS. Giovanni e Paolo). Wringing her hands in despair Mary is turned lamenting towards the cross, while her feet move away from it. The urge to leave the place of crucifixion but not to turn her eyes from her dead son is reflected in the movement of the body. The helpless gesture of John, as he looks up and opens himself entirely to pain, contrasts with the closed posture of Mary; the outline of his figure is appropriately broken in several places. These two black figures are part of an altar in black marble which fitted the black and gold decoration of the room in the scuola, a room that still feels oppressive today with its flat ceiling showing drastic scenes of the pains of purgatory by Jacopo Palma the Younger.

Throughout his life Vittoria favored recherché poses not required by the theme. His two figures on the altar of S. Giuliano (1584, fig. 151) are characteristic of this approach. Opposed movements, the twisting of powerful bodies, and the taut lines of hems and drapery folds yield a richness of forms culminating in the standardized, "rapt" faces. In 1581 Vittoria had acquired further drawings by Parmigianino. His enthusiasm for Parmigianino's art, as his figures show, had not abated.

Vittoria had a deep interest in works of Venetian painting, as was shown by his friendship with Jacopo Palma the Younger. It is not surprising, therefore, that in a very fine bronze relief for Hans Fugger (fig. 152, ca. 1580) he elaborated on a model by Titian now only known in a woodcut. The nervous, flaring garments and the fervent gestures not only show the consummate craftsmanship of this master, inundated with commissions, but also convey to the viewer something of the surprise and excitement of the moment.

The contrast in style and, it seems to me, in quality between the Fugger relief and the contemporaneous figures on the altar of S. Giuliano is evident, and one wonders whether Vittoria's experienced assistant Andrea dall'Aquila, who received payment for the *Daniel* and *Catherine* in 1584, did not take a greater part in their execution than is generally supposed. Tintoretto's hectically productive workshop confronts the historian with similar questions. There too the assistants worked as a rule with easily grasped, time-saving simplifications.

Although Vittoria had given outstanding proof of his skill as a stucco worker in Venice, after the fire at the Doge's Palace (1574) Giovanni Cambi, called Bombarda, who had previously worked in Lombardy, was commissioned to decorate the vaulting of the Sala delle Quattro Porte. The figures over the four doors were assigned to four sculptors, Giulio Angolo dal Moro, Francesco Castelli,[167] Girolamo Campagna,[168] and Vittoria. This was in keeping with the practice in state contracts of engaging as many artists as possible at once, so giving opportunities to some not deserving it. The figures in the Gritti window on the west façade of the Doge's Palace were also distributed among several sculptors, of whom Pietro Grazioli de Salò (for *Mars*) and Alessandro Vittoria (for *Mercury*) were especially mentioned by Vasari.[169]

Giulio Angolo dal Moro, a native of Verona who described himself in his signatures as a sculptor, a painter, and an architect (died probably in 1618), and Girolamo Campagna (died 1625) were at the beginnings of their careers in the 1570s, while Castelli was soon lost from view. With Tiziano Aspetti (died 1607), Campagna and dal Moro represent the Venetian sculpture of the late Renaissance, which is not the subject of this chapter.

At that time, about the end of the sixteenth century, the sculpture of Venice was already ranked a good deal lower than the painting. A fictional dialogue published in Venice in 1583 between a Venetian and a foreigner puts it in a nutshell. Foreigner: "Tell me something about sculptures." Venetian: "There are a lot of them in Venice, but not so many as there are paintings, since sculptures give less pleasure than paintings."

If it is only recently that systematic attempts have been made to protect Venetian sculptures from further environmental damage, this is another result of the higher value traditionally attached to painting in Venice.

PLATES

1 Row houses on the Calle Riello

2 Vittore Carpaccio, buildings on the Rialto, detail from the *Miracle of the True Cross.* Venice, Gallerie dell'Accademia

3 Gentile Bellini, buildings near S. Lorenzo, detail from the *Discovery of the Relic of the True Cross.* Venice, Gallerie dell'Accademia

4 Mauro Codussi, Palazzo Loredan (now Vendramin-Calergi)

5 Pietro Lombardo, S. Maria dei Miracoli, side frontage

6 S. Maria dei Miracoli, choir pillar, detail

7 Pietro Lombardo, forecourt, Scuola Grande di S. Giovanni Evangelista

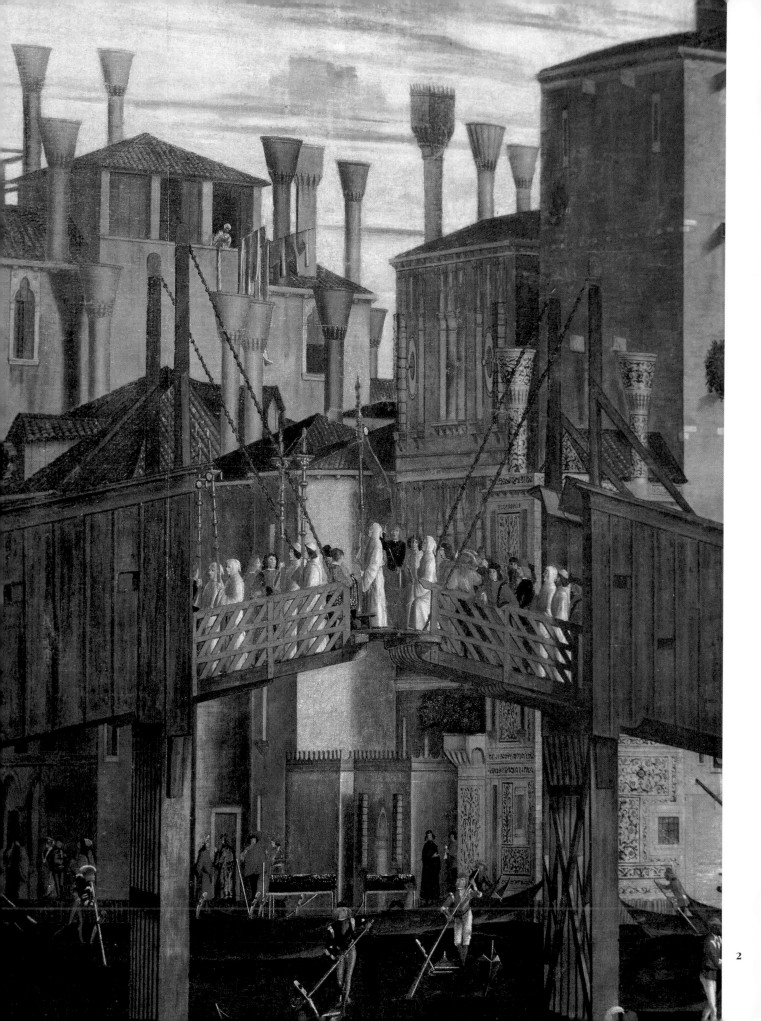

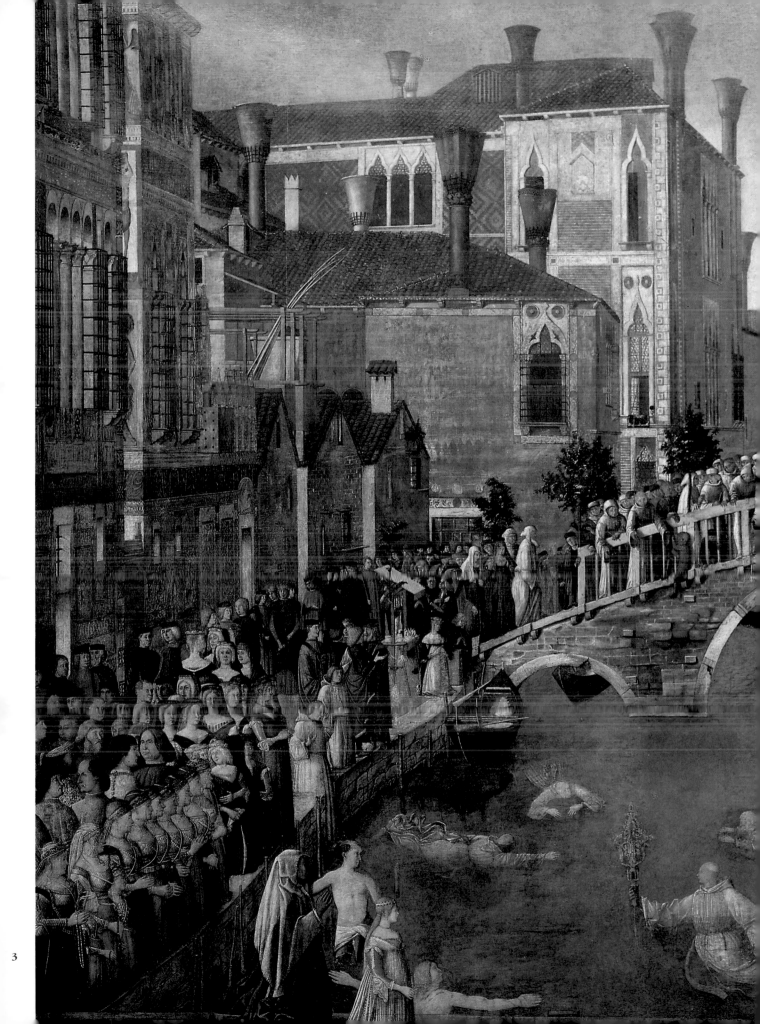

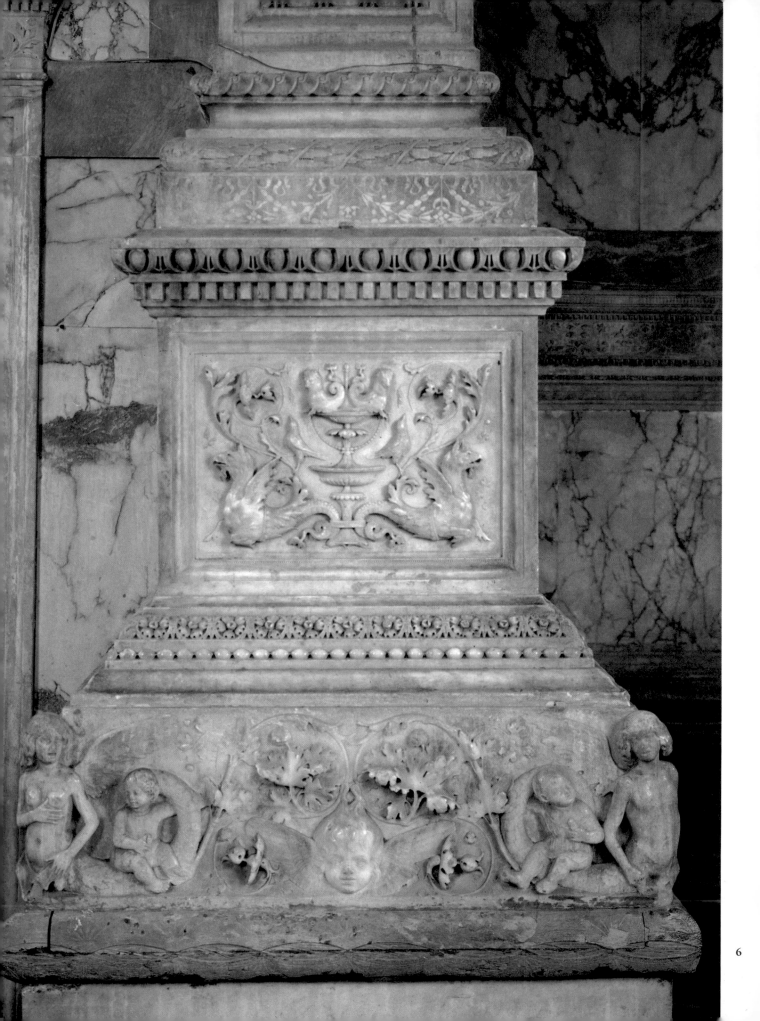

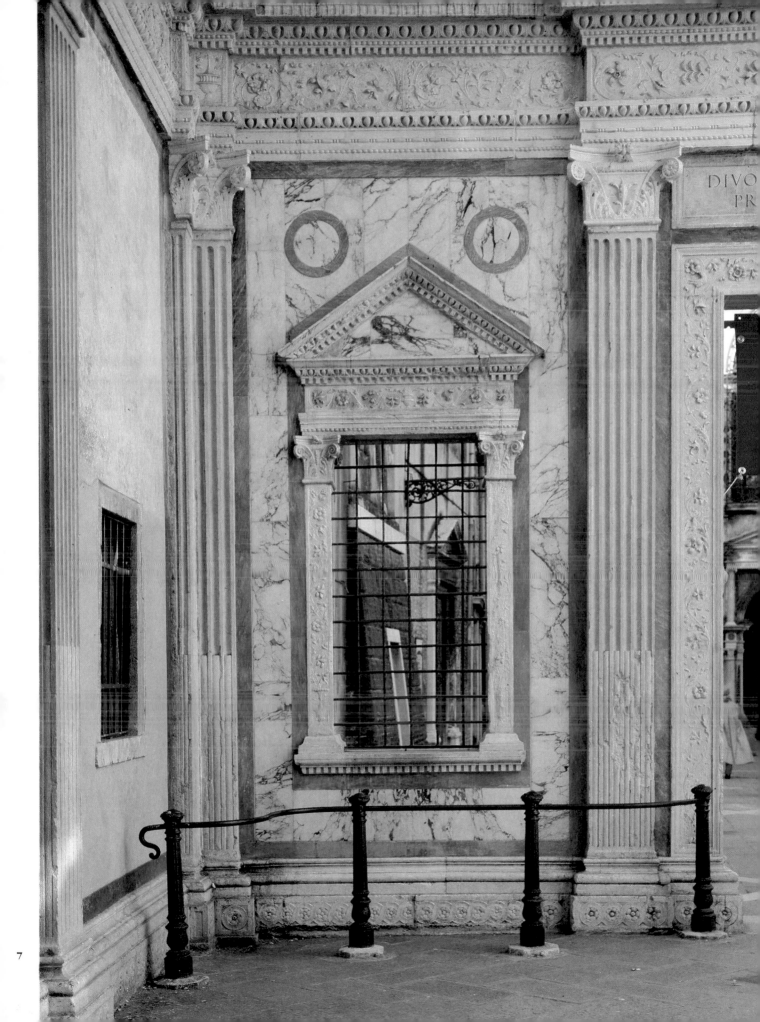

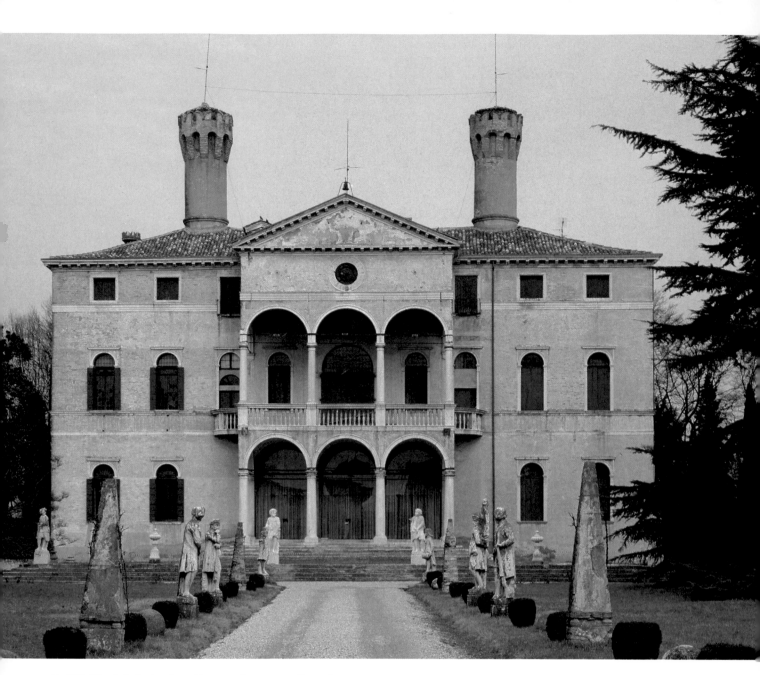

8 Villa Giustiniani, view from the grounds entrance. Roncade

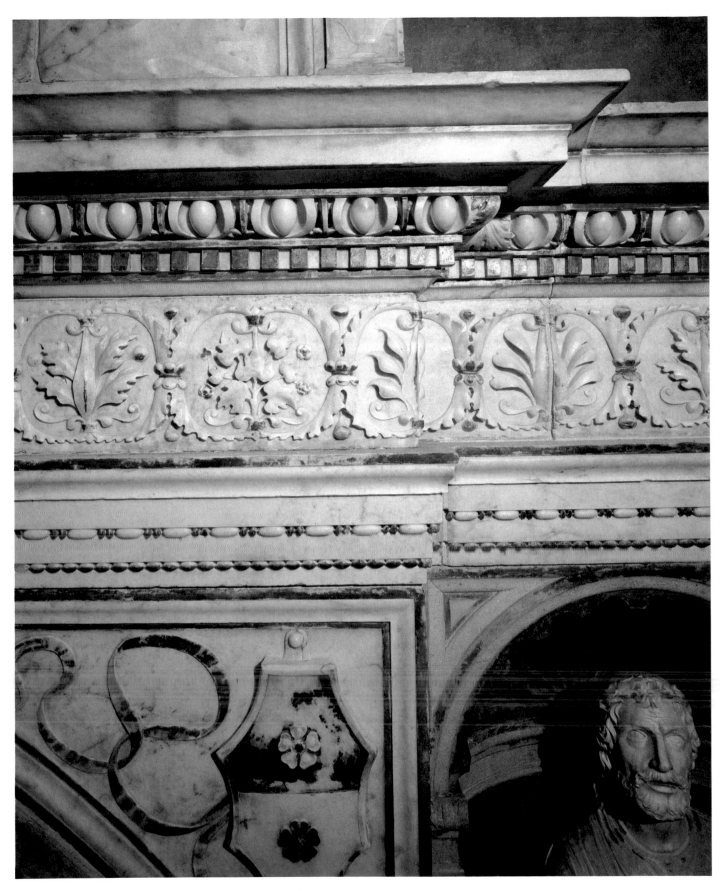

9 Tomb of Doge Pietro Mocenigo, detail. SS. Giovanni e Paolo

10 Antonio Rizzo, *Eve,* from the Arco Foscari. Museum of the Doge's Palace

11 (*Opposite*) Antonio Rizzo, portrait of Doge Agostino Barbarigo. S. Maria della Salute, sacristy

12 Antonio Lombardo, *Madonna of the Shoe*. S. Marco, Cappella Zen

13 (*Opposite*) Alessandro Leopardi, socle of the middle flagstaff. Piazza S. Marco

14 Jacopo Sansovino, *John the Baptist*. S. Maria dei Frari, baptismal font

15 Alessandro Vittoria, bust of Doge Niccolò da Ponte. Seminario Patriarcale

ALEXANDER · VICTORIA · F ·

16 Alessandro Vittoria, *St. Jerome*. SS. Giovanni e Paolo

17 Jacopo Bellini, *Iris.* Paris, Louvre, Cabinet des dessins

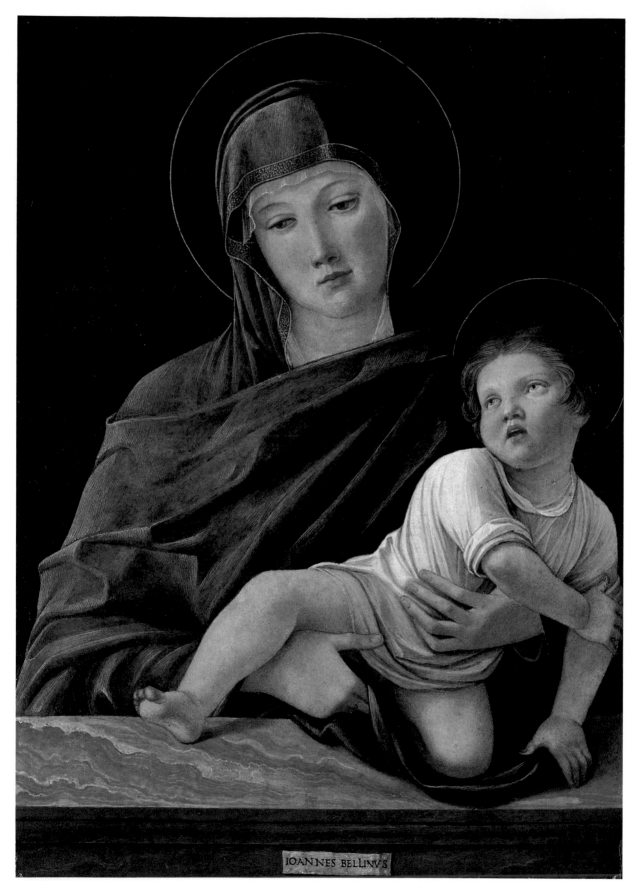

18 Giovanni Bellini, *Madonna Lochis*. Bergamo, Accademia Carrara

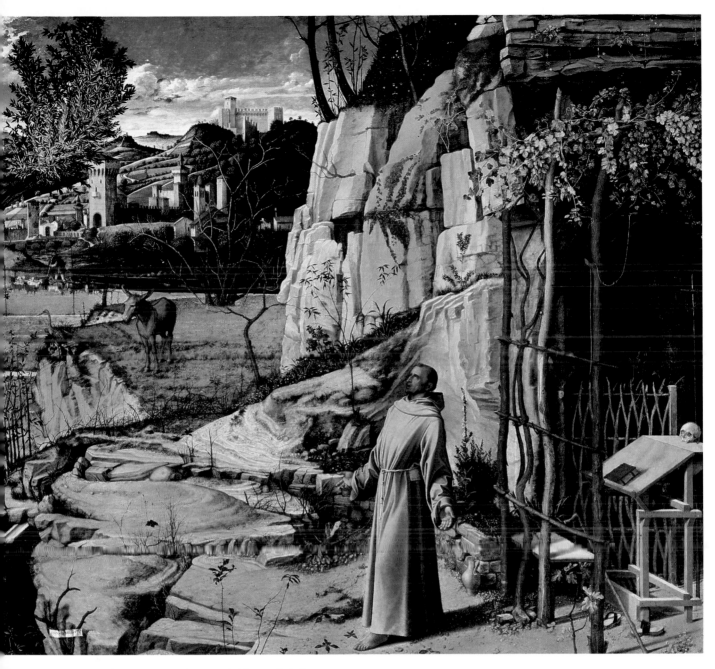

19 Giovanni Bellini, *St. Francis*. New York, The Frick Collection

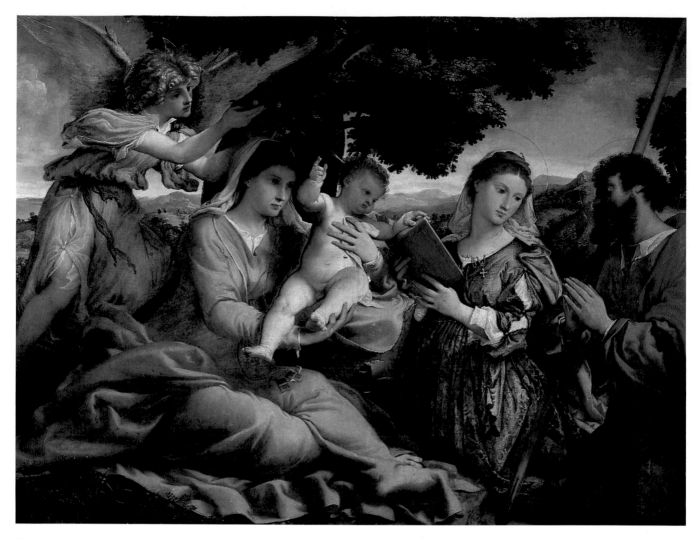

20 Lorenzo Lotto, *Sacra Conversazione.* Vienna, Kunsthistorisches Museum

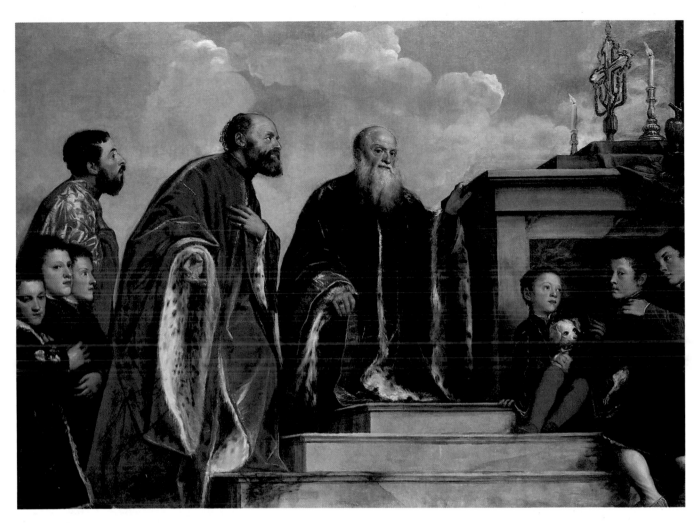

21 Titian, *The Vendramin Family.* London, The National Gallery

22 Titian, *Clarissa Strozzi*. Berlin, Staatliche Museen Preussischer Kulturbesitz, Gemäldegalerie

23　Titian, *Paul III and His Nephews.* Naples, Museo di Capodimonte

24 Titian, *Presentation of the Virgin,* detail. Venice, Gallerie dell'Accademia

25 Jacopo Tintoretto, *Jesus among the Scribes.* Milan, Cathedral Museum

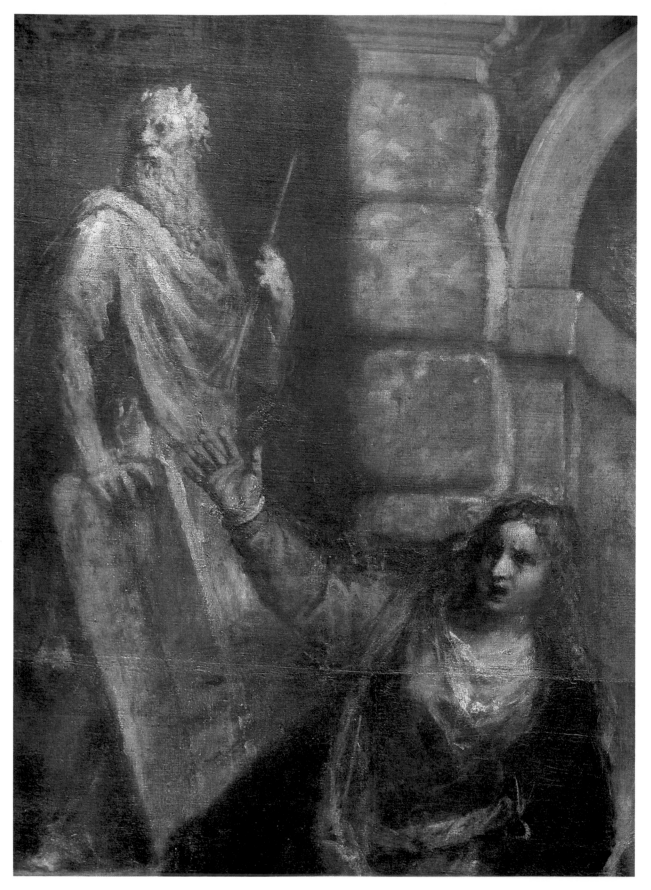

26 Titian, *Pietà*, detail. Venice, Gallerie dell'Accademia

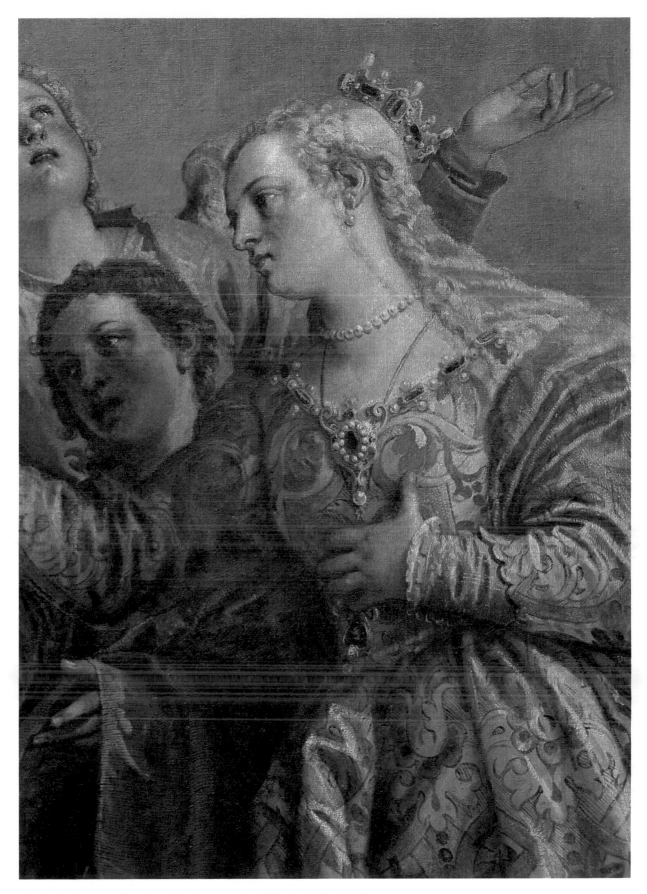

27 Paolo Veronese, *Marriage of St. Catherine,* detail. Venice, Gallerie dell'Accademia

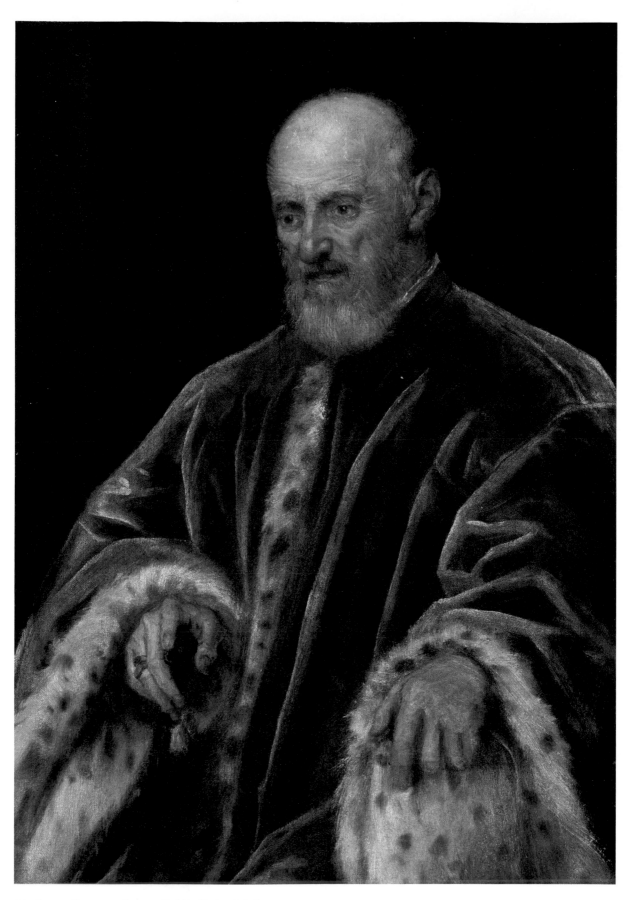

28 Jacopo Tintoretto, *Senator.* Dublin, National Gallery

29 Paolo Veronese, *The Coccina Family before the Madonna.* Dresden, Staatliche Kunstsammlungen

30 Paolo Vero-
nese, *The
Coccina
Family
before the
Madonna,*
detail

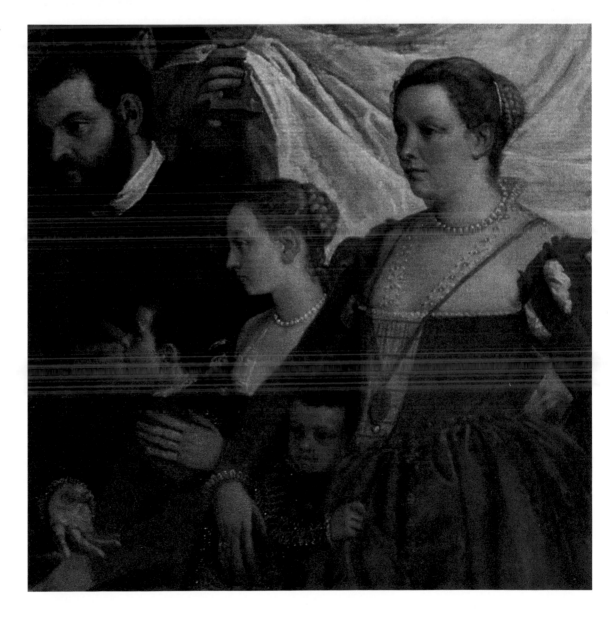

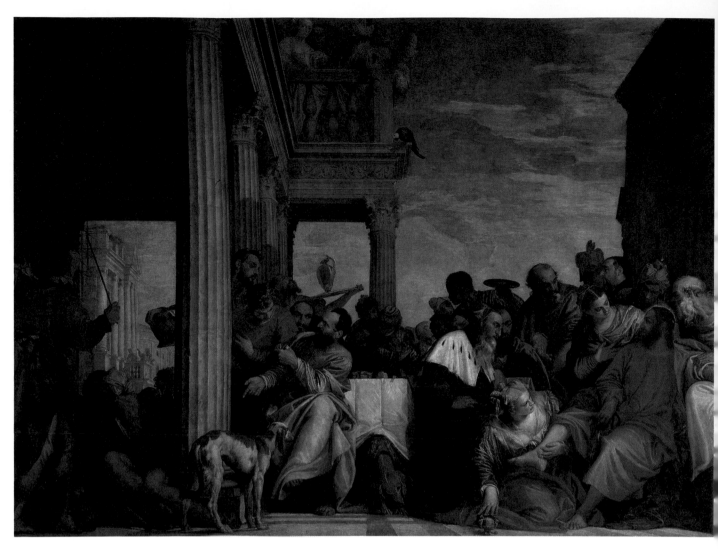

31 Paolo Veronese, *The Feast in the House of Simeon*. Turin, Galleria Sabauda

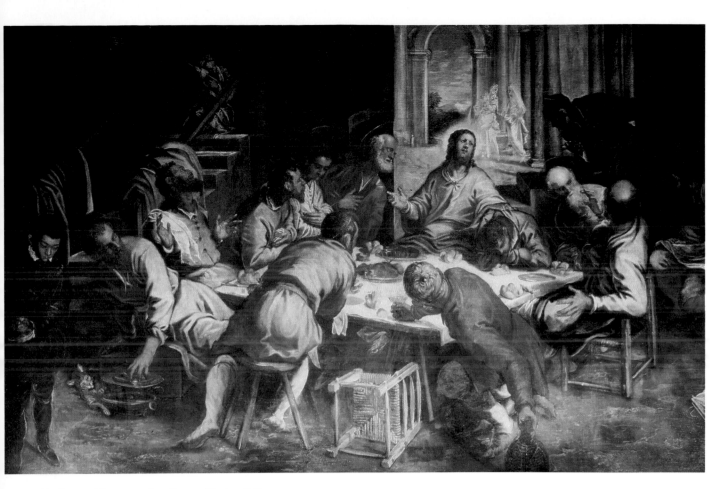

32 Jacopo Tintoretto, *Last Supper.* Venice, S. Trovaso

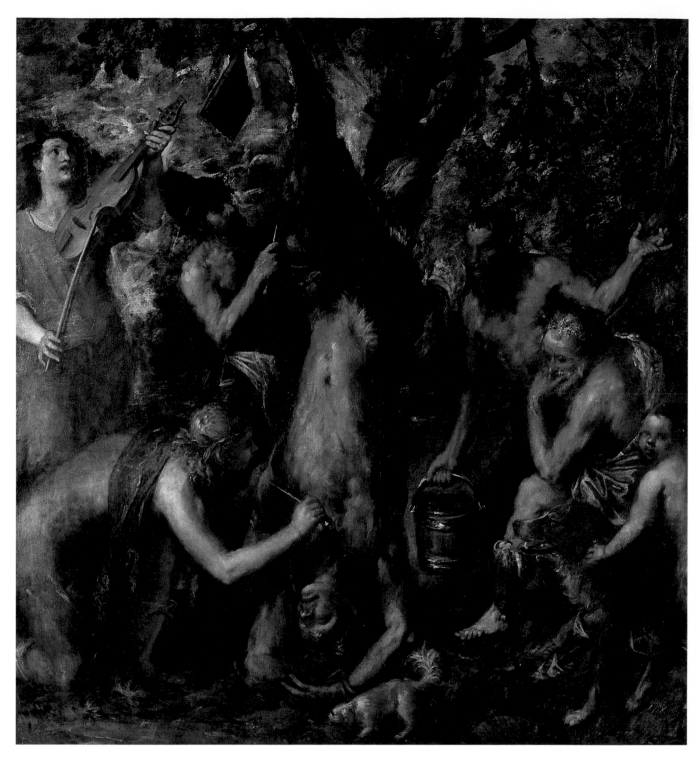

33 Titian, *Flaying of Marsyas.* Kremsier, Archiepiscopal Palace

PAINTING

Norbert Huse

Artisans or Artists?

When Paolo Veronese was brought before the Inquisition in 1573 for taking too many artistic liberties in his *Last Supper* (fig. 278), he was asked to state his profession. "I am a painter," he replied and then added, "and do figures." The qualification was necessary, for Veronese might otherwise have been classed with the many others who also practiced the craft of painting. In the guild, to which everyone who wished to work in Venice had to belong, the *figureri* were only one of eight groups of artists. The *figureri* found it more and more humiliating to be equated with gilders and textile painters, painters of leather and mask makers, as well as book painters and makers of playing cards. But when in 1511, led by Cima da Conegliano, they tried to elect two representatives instead of the usual one to the governing body of the guild, they were put in their place by the government. Affairs continued to be conducted according to ancient custom and order ("modo et ordene antiquo"), which meant a governing body of one figure painter, one casket painter, one curtain painter, and one gilder.[1]

The artists' new sense of their calling, the belief that they were not pursuing an *ars mechanica* like the gilders or curtain painters, but an *ars liberalis* like musicians, poets, and philosophers, could no longer be reconciled with the world of craft guilds. But it was not until 1754 that Venice acquired an academy like the one founded by Giorgio Vasari in Florence in 1563, in which artists represented their own ambitions and interests. For this reason, Titian, Tintoretto, and Veronese, together with Palladio, sought admission to the Florence academy in 1566.[2]

The pictures of the Venetian Renaissance came almost without exception from family firms. Those of the Vivarini and the Bellini were the best known in the fifteenth century but by no means the only ones, and they were followed in the sixteenth by the Vecellios around Titian, Tintoretto's Robusti, and the Caliari, who after Paolo Veronese's death set themselves up as "haeredes Paoli."[3] Most painters probably took up their profession less from inner vocation than because their father, brother, or uncle was a painter. Keeping up a family workshop was an important objective when art was organized on guild lines. These workshops gave the next generation the chance of working in an established firm and access to potential clients as well as to the pattern books, drawings, copies, and objets d'art that constituted a major asset of the workshops. Control of these assets was therefore an important item in all artists' wills. In 1625, for example, Jacopo (Giacomo) Palma the Younger, who could look back on one of the most successful careers any Venetian artist ever had, made a will. Seven years earlier he had a monument to himself erected over the sacristy door of SS. Giovanni e Paolo. It shows a bust of himself on the right and one of his great-uncle Palma the Elder on the left. Between them, at a higher level, the bust of Titian is presented by two painted putti, over whom embodiments of Fama proclaim the fame of the three artists. The inscription reads, AERE PALEMO COMUNI GLORIA (At Palma's expense for the common glory). Palma had therefore wanted to remind the viewer of two things, the continuity of the family (hence the palm branches held by the putti) and their pursuit of the free art of painting, represented by Titian. Palma's will shows the same coexistence of traditional and modern ideas. The master first provided for his daughters: Giulia, obviously well-married and wealthy, received only one hundred ducats. The ailing Lucretia, a widow with an unsupported ten-year-old son, was bequeathed three thousand ducats, as well as "everything pertaining to the profession of a painter—like finished paintings and rough sketches, drawings, reliefs—and all the implements of the profession. I leave them to my grandson Giacomo, the son of my daughter Crezia, who is to practice the profession of painting and to style himself 'from the house of Palma' in memory of the famous Giacomo—and in memory of me."[4]

Jacopo Tintoretto also showed concern for the continuation of his workshop in his will. "I wish my son Domenico to finish by his own hand the paintings that I leave unfinished and to show the same manner and care as in many other works of mine. I ask my son Marco to live in peace with his brother and not to falter in devot-

ing himself to his and my craft." [5] In 1645, more than fifty years after her father's death, Ottavia Robusti dictated her will: "I am bound in marriage to Mr. Sebastiano Casser, at the command and instruction of my brothers Domenico and Marco, to whom I was obliged to promise before their deaths that I should take the said Mr. Sebastiano as my spouse if he seemed to me to prove himself a good artist, so that the name of the house of Tintoretto should be preserved. For several years I was undecided, but then I saw that in painting he was the equal of every good painter and was surpassed by few in portraits. Then I made up my mind and took him as my spouse." [6]

Of the books of drawings that feature so prominently in the wills hardly any have survived, for the more art changed the more quickly they lost their practical value. The two surviving volumes by Jacopo Bellini were not kept as models to work from, but as works of art. But they became that only later. We can assume that originally it was their first function to store knowledge and experience for future use. The books of drawings that Jacopo's widow left in 1471, together with reliefs, pictures, "and everything pertaining to painting," to Gentile,

her eldest son, show figures and landscapes, studies of antiquity, and devotional pictures; but there are also designs for statues of gods, tombs, and cutlery among the narrative pictures that make up the core. [7]

What Jacopo Bellini was able to realize, what he set aside for future use, and what he merely dreamed of remain uncertain. From their character, however, the sketchbooks do not seem to have served merely as a practical record of solutions once found; they were also a field of experimentation. Admittedly, it can no longer be clarified how the signed drawing of *Christ bearing the Cross* (fig. 153) is related to Jacopo's paintings on the same theme, which are recorded in documents but not preserved. Among the narrative pictures painted by Gentile Bellini, Carpaccio, and many others about 1500, there is no real pendant to Jacopo's sketch, as none of the pictures has a comparable structure. For all the differences, the young painters always have a series of figures in the foreground, like those in the old mosaics on the façade of S. Marco. But none of them gave so much space to "secondary" motifs like the building site on the left, the sculptor, or the soldier falling from his horse, and in

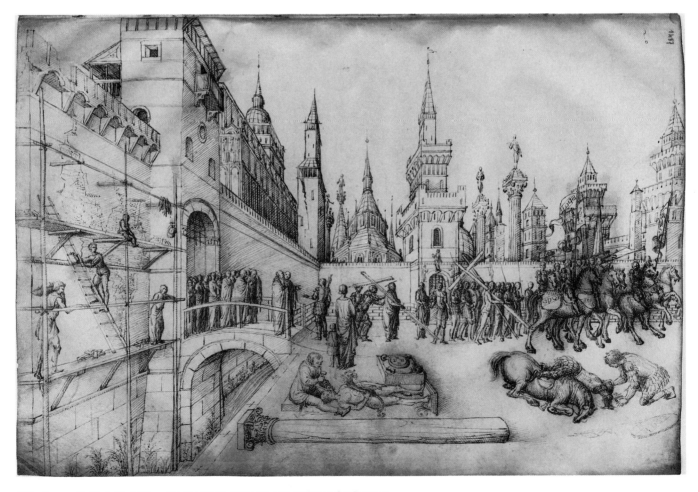

153 Jacopo Bellini, *Christ Bearing the Cross.* Paris, Louvre, Cabinet des Dessins

none of them are such motifs so independent of the main action. Perhaps the motifs are only like this in Jacopo's work because they are a later elaboration of the original sketch. If the masons, sculptor, and horseman are covered up, there remains to the right of the city gate and above the bridge a nucleus made up of city architecture and a procession of figures that might very well have been a model for Gentile or Carpaccio.

The additions, in depicting everyday life, introduce a range of themes that are not required by the subject and that, in the mid-fifteenth century, had no place or public of their own in Venice. But Jacopo did not merely discover, he invented. However precise the observations, the connections usually came just as clearly from his imagination. The individual observations are part of a world depicted in consistent perspective; but it is a world that does not derive its logic from within itself, but from the viewpoint of a fictitious ideal observer, presupposed by the central perspective of the Italian Renaissance. The rigorous construction of his pictorial worlds did not cause Jacopo to forget their fictitiousness. Occasionally he even seems to play with such ambiguities: is the arch surrounding John the Baptist as he preaches (fig. 154) a gate or a frame? Has a craftsman—as on other pages of the Paris codex—signed a plan for a picture and not an imagined reality? Or has an artist begun to play with the problems of the new methods of depiction, for himself and the few who were shown his drawings? If the drawing was intended for a painting, where in the Venice of the time could it have hung? For an altar of St. John the accessories are too extensive and the title saint too small: John stands on a socle as if he were a statue of himself. He is not, however, in the middle of the pedestal, but right at the front, like a preacher who wants to be close to his congregation.

The requirements of rationality in perspective and proportion led necessarily to small figures and a detailed depiction of the scene of an action; thus open-air scenes gave rise to landscapes more extensive than any previously known. If the main characters were not to be lost in these landscapes, conflicts were hard to avoid. Traces of them are present in the structure of drawings such as *St. Francis Receiving the Stigmata* (fig. 155). One sees at once that landscape was an important theme for Jacopo Bellini, while the crucifix was an iconographic necessity. St. Francis was so important for the artist that he is shown much larger than he ought to be by the laws of perspective, so large, indeed, that Jacopo was unable to find any convincing connection between the saint and the mountain behind him.

But the investigative eye of the artist was directed not only at the broad sweep of the landscape but at details of nature. There is a page, the same size as *Christ Bearing the Cross* and *John,* on which there is nothing except the bloom of an iris (plate 17). It is perhaps awaiting a sec-

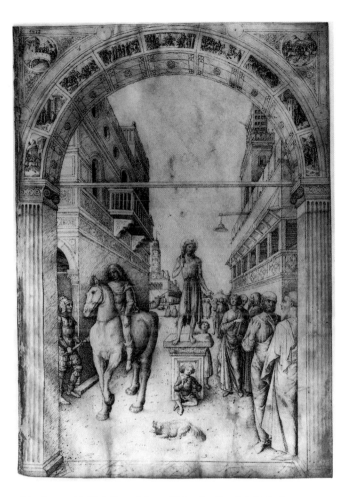

154 Jacopo Bellini, *Preaching of John the Baptist.* Paris, Louvre, Cabinet des Dessins

ond flower but does not otherwise point to any wider connections. Originally probably a preliminary study for a flower arrangement, the watercolor turned into a portrait of an individual moment when the bloom is nearing its end, a portrait that became a work of art in the modern sense not later than the moment it left the artist's workshop.

As the drawings were not seen by the public, Jacopo could ignore its expectations and leave in place contradictory or ambiguous elements. Conflicts between the tasks entrusted to the leading workshop in the city and the artistic interests of its director did not need to be hidden or resolved in the drawing. This gave rise in a part of his sketchbook—apparently for the first time in Venice—to an artistic oeuvre that, even in its subject matter, owes its special nature less to the commissions than to the artist.

After the artistic upheavals of the second half of the century, Jacopo Bellini's drawings had finished their useful life as a collection of patterns, but not as collector's items. If the pages were kept legible by retracing of

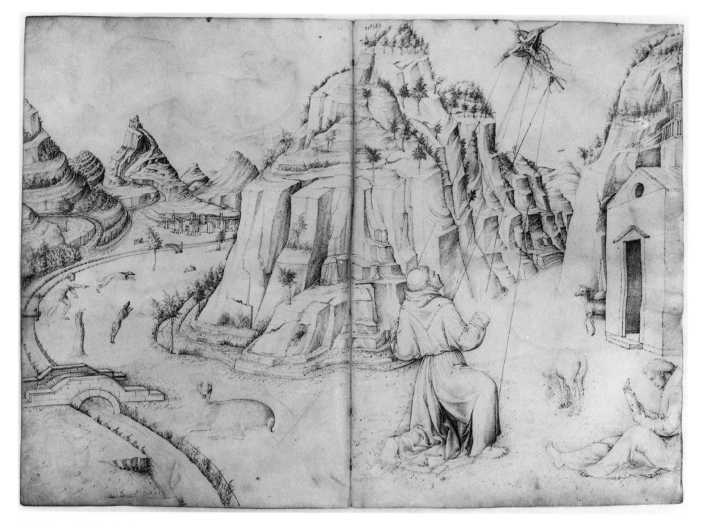

155 Jacopo Bellini, *St. Francis Receiving the Stigmata.* Paris, Louvre, Cabinet des Dessins

the lines, this may have been done initially for the sake of use, but certainly later to conserve a collector's piece. When the marchioness of Mantua wished to acquire a view of Venice by the long-dead Jacopo in 1493, her envoy wrote to her that, while Gentile Bellini was willing to sell, he wanted to go over the drawing first with a pen, since hardly anything could be made out.

Of the two surviving sketchbooks by Jacopo, Gentile Bellini seems to have taken the one now in Paris with him to Constantinople, where he went in 1479 on the instructions of the state. In 1507 he bequeathed the volume now kept in London to his brother Giovanni. By 1532 it was no longer in the possession of the family but in the famous art collection of Gabriele Vendramin. An artisan's book of samples had become, partly through its treatment by the artist but finally through its inclusion in this collection, an autonomous work of art.

No sketchbooks of Gentile and Giovanni Bellini have survived. But written sources indicate that Jacopo's sons sought as painters, and not only—like their father—as draftsmen, to enlarge the scope that the craft-formed tradition allowed to an artist. In 1483 Giovanni took over for the Scuola Grande di S. Marco two pictures originally ordered from the deceased Bartolomeo Montagna. The fee was to be two hundred ducats, "provided that he [Bellini] paints the Flood with appropriate accompaniment, as well as the creation of the world or some other suitable and elevated theme, which will be dictated to him." Bellini was not to take on any other commissions, to use good pigments, and to execute the whole work himself. Experts would evaluate the finished work and determine the final fee.[8]

By 1492 the Bellini brothers no longer waited for commissions from the scuola but took the initiative. Impelled "more by divine than by human inspiration," they offered to undertake the painting of the *albergo*. In memory of their father, who had painted in the same place, but also to give a proof of their art, they wanted to work without profit. For the façade side a single large

painting was envisaged that would show "the stories chosen by the scuola, although with the advice and judgment of the two brothers." The brothers pledged themselves to take over all the other pictures in the sala when this one was completed—in reverence for their father, as they claimed, but no doubt also to keep other artists away from this prestigious site. The scuola was to agree "that no other artist will be allowed to paint the Albergo, even in part." If this program had been realized, the Scuola Grande di S. Marco would perhaps be a museum to the Bellini today, as the Scuola Grande di S. Rocco is to Tintoretto and the church of S. Sebastiano is to Paolo Veronese.[9]

Other obligations prevented the brothers from putting their plan fully into practice. Giovanni completed for the façade wall the picture that Gentile had almost finished on his death in 1507, and in 1515, in extreme old age and one year before his death, he even took on a large-scale commission from the scuola for a history painting. But by 1515—after the emergence of Giorgione and Titian—Gentile's art was outdated. Giovanni therefore had to give an explicit pledge that his own work would surpass his brother's. Gentile's original contract of 1504 had contained a competition clause. It did not refer, however, to a competition between artists, but between patrons. In 1504 Gentile had to agree that the pictures to be painted in the Scuola Grande di S. Marco would be better than those that he and others had just completed for the Scuola Grande di S. Giovanni Evangelista. Not only the size and colorfulness of the paintings were the subject of competition between the scuole grandi, but the artistic quality. This artistic, not directly functional aspect of a painting was seen as a separate and important value but was at once placed in the service of the patron's self-display.

From a number of points of view, Giovanni Bellini had a special position in his time. As early as 1483 he was allowed to leave the guild because of his services to the state and was released from all obligations towards it. He was to devote himself without restriction to decorating the Sala del Maggior Consiglio in the Doge's Palace and to place his outstanding artistic talent ("egregium ingenium suum in arte picture") entirely at the service of the signoria.[10]

That Bellini's outward independence was matched by an inner one is seen in his dealings with Isabella d'Este.[11] The marchioness wanted a picture by Giovanni for her famous *studiolo,* a kind of study and art room. After Giovanni had failed to honor a pledge given in 1496, contacts were renewed in 1501. Again the old artist proved difficult. The obligation to follow a precise picture program not yet revealed but already announced seems to have particularly displeased him. The marchioness regarded her *studiolo* as, among other things, the site of a

kind of tournament in which the leading painters of the day entered the lists against each other. She stubbornly, if unsuccessfully, sought to enlist Fra Bartolommeo and Leonardo da Vinci. Bellini was willing in principle to take up the challenge, but he would not hear of the proposed theme. He knew the marchioness's judgment, he argued, and was aware that his picture would compete with that of Andrea Mantegna. He therefore wanted to achieve the best result possible. But with the set theme he could produce nothing of value. Isabella's Venetian agent therefore urged her to allow Bellini "the freedom to paint what he pleases."[12]

Isabella, who saw herself as a Maecenas of the liberal arts but in reality did not act differently than someone tying a craftsman to a contract, finally gave way. She let Bellini decide the subject, provided it was from antiquity or something resembling antiquity and "of beautiful meaning" ("bello significato"). Bellini continued to be obstructive, and after much ado the marchioness finally lost patience with "so much villainy." She mobilized her Venetian relations and threatened an intervention by the doge. In July 1504 Bellini was ready at last. His picture, Vianello reported to Mantua, "is better than I expected. . . . For his own honor and out of respect for Master Andrea Mantegna, he has taken great pains. However, I do not believe he equals the excellent Master Andrea in invention." Vianello recommended acceptance of the picture but also knew of another interested party who would have been glad to buy it. Apart from those who commissioned paintings there were, then, other connoisseurs who tried to buy paintings commissioned by others. The marchioness took the work but tried to save face by putting the painter in his place: "Master Giovanni Bellini, if the picture you have painted in my name is equal—as we hope—to your reputation, we shall be satisfied with you and forgive the insults we have suffered through your tardiness."[13]

The marchioness owed her acquisition of a painting by Bellini entirely to the mediation of the poet and humanist Pietro Bembo. Bembo had the task of finding a theme that would meet with both the applause of the marchioness and the agreement of the artist. The program, he wrote to Isabella, should kindle the imagination of the person who had to paint it. Bellini did not like to have fixed limits set to his imagination, being used to giving his fantasy free rein in his pictures ("di sempre vagare a sua voglia nelle pitture"), so that, as far as was in his power, they would satisfy the viewer.[14] Thus Bellini did not see the highest authority in the patron's wishes but in his own artistic freedom and his relationship to a public that was not necessarily identical to the patron. How large this public was we do not know, but it was certainly much smaller than the clientele of the firm of artisans of "Ioannes Bellinus," which provided the artist Bellini with his economic basis.

Altar Panels

Between 1460 and 1464 Jacopo Bellini, with his two sons, painted four triptychs for the church of S. Maria della Carità, now in the Accademia.[15] They probably adorned the wall below the upper choir stalls, side by side. Although paid for by four different families, they were designed not as separate pictures but as an ensemble, the parts being coordinated in terms of their measurements and arrangement. The triptych of S. Lorenzo (fig. 156) was paid for by Lorenzo Dolfin, whose patron saint therefore takes up the central panel. That this cannot have been painted by the same artist as its neighbors is evident to the eye. Nor can the panels of *St. John the Baptist* and *St. Anthony of Padua* be by the same hand. The head of the workshop must therefore have allowed his assistants unusual freedom in developing their individual styles, even within the framework of a conventional series of pictures.

That the artist designing the work was not satisfied with the traditional juxtaposing of saints in a triptych is clear from the relations he tries to establish between them through look and posture and the matching of the bases. How large a frame separated these bottom areas is very uncertain. In the fifteenth century the painter was only one of many people who were involved in producing an altar panel. Cima da Conegliano's *Baptism of Christ* (fig. 165), for example, provided a livelihood between 1492 and 1495 for more than seven artisans. A sculptor provided the frame, a mason installed it, and a gilder embellished it. A carpenter prepared the picture panel for the painter, another painter executed the frieze around the picture frame, and finally a glazier altered the windows to improve the lighting. The curtain in front of the picture and considerable transportation by land and water accounted for much further work. Whether the sculptors and wood carvers themselves designed the frames they executed is not revealed by the documents. Painters occasionally specified the frames for their pictures in sketches, but not infrequently the frames had already been ordered when the painter started work.[16]

This may have been the case with the triptych of SS. Giovanni e Paolo (fig. 158), today attributed with good

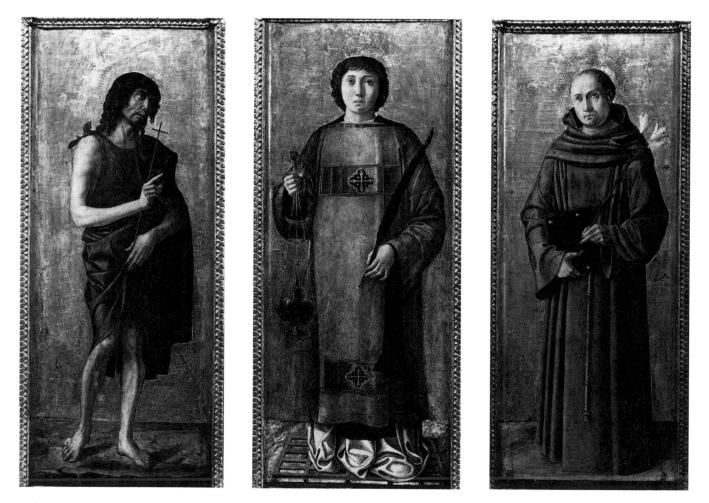

156 Jacopo Gentile and Giovanni Bellini (?), triptych. Venice, Gallerie dell'Accademia

reason to Lauro Padovano.[17] The framing architecture was under construction in 1464, and the pictures were produced in parallel to it or shortly afterwards. The altar, donated by the Scuola di S. Vincenzo Ferrer, follows the traditional type, yet the frame is dominated by the figures. The lack of ornate structures and the clear organization of the work are modern, as is the mastery of contrapposto in the figures, the composition of the landscapes, and the narrative style in the predellas. What is traditional is the combination of a devotional picture on one hand and panels showing saints and narrative pictures on the other—a combination of very disparate genres which, although quite adequate to its function, was soon to be left behind by artistic developments. Compared to the triptychs of the previous generation, the figures have gained a new size. Life-size, they conspicuously solicit attention for the saints they represent, for the altar they adorn, and thus for its donor. From close to one can also in the predellas follow the narrative of the events that made Vincenzo Ferrer a saint and admire a brilliant art of composition derived from Mantegna. An observer well informed about art, who might well have been the same person as the one who came to pray, could also appreciate the glowing color, the modernity of the contrapposto, and the vivid tautness of the surfaces.

How many such observers there were and how they actually experienced the paintings, we naturally do not know. Altarpieces were probably taken so much for granted as a part of church furnishings and as a task of painting that they were not usually given much thought. Nor is much precise information available on the intentions and interests of the donors, and it would be futile to try to reconstruct the exact balance between ostentation, piety, and artistic pretensions in each individual case. The reasons for the donation are seldom clear from the paintings. A panel like the one delivered to S. Pietro on Murano (fig. 157) by Andrea da Murano towards the end of the 1460s[18] is exceptional in the intensity with which it makes us feel the distress of people afflicted by the plague, in the sick youth before the plague saint St. Sebastian, and in the woman who has been saved before St. Roch.

Altarpieces had no indispensable liturgical function, since an altar could fulfill its purpose in a mass without them. They had been taken so much for granted in Italy since the Middle Ages, however, that their existence could be seen as a problem only by iconoclasts. But their form did become problematical whenever art underwent a fundamental change.[19] Thus the inconostasis-like arrangement of the panels came increasingly into conflict, in the fifteenth century, with tendencies in painting that demanded a "natural" placement of the kind that had long become accepted for the most influential genre, history painting. Ways out of the dilemma were sought from an early stage. The young Bartolomeo Vivarini was

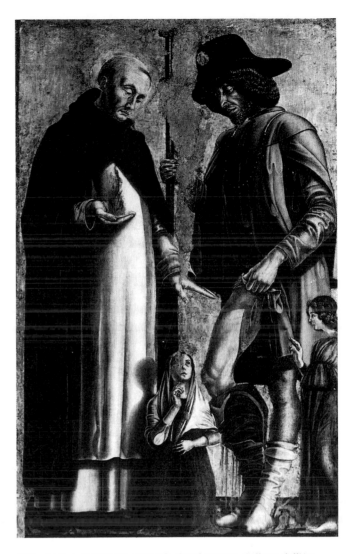

157 Andrea da Murano, triptych, detail. Venice, Gallerie dell'Accademia

particularly willing to experiment in this respect (fig. 159),[20] being one of the first in Venice to assemble the saints of an altarpiece in a unified place around the Madonna.

Vivarini served his large clientele with solid competence but avoided irritating them with excessive audacities. While advancing only hesitantly beyond the state reached in the 1460s in terms of structure and the stylization of figures, he was open to innovation in details; the copious signatures and dates show that he did not see himself as an anonymous artisan and was well able to look after his personal fame. Over the years, however, his painting, which had been only peripherally disturbed by the development instigated by Giovanni Bellini, grew more and more conservative, even the areas of exactly observed everyday reality that he inserted into his pictures making little difference. He was most flexible in his center panels, in which we find not only individual saints

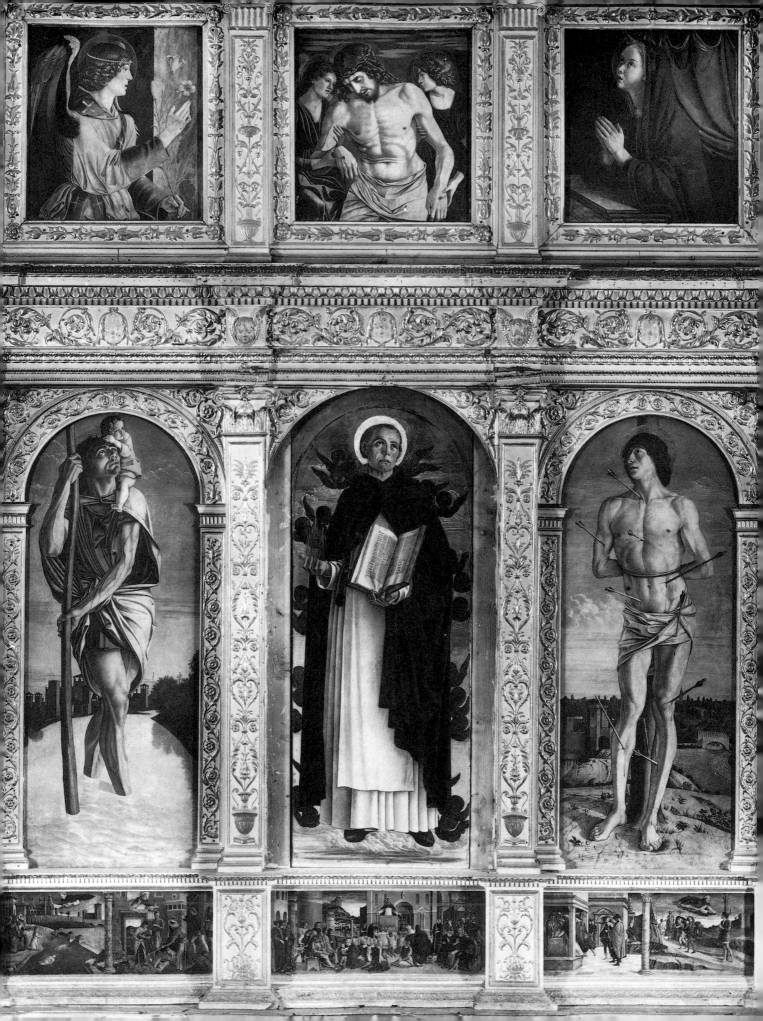

but devotional pictures and narrative scenes, although this flexibility may have been due to the differing wishes of his clients rather than to the artist himself.

The triumph of the unified *pala* (altarpiece) made important parts of the old altars, as such the upper devotional pictures and the narrative predellas, homeless. The purposes served by the multipart pictures and the responses they evoked had either to disappear from the altar or to be transferred to the center panels. Once the dividing inner frames had gone, the previously isolated

saints came together. This required new means of distinguishing the main figures. The result was a gathering of saints in a place that was usually architecturally defined, around a central, raised person, usually the Virgin. At first the arrangement was always symmetrical; this preordained the number of saints, and so not all had the same theological importance. In contracts often only the most important saints were specified.

The artistic form that was to hold good for many years was discovered in the 1470s. Whether the discovery was due to the Venetian Giovanni Bellini or to Antonello da Messina, who arrived in Venice from Sicily in 1475[21] is the subject of heated controversy.

158 (*Opposite*) Lauro Padovano (?), triptych. Venice, SS. Giovanni e Paolo

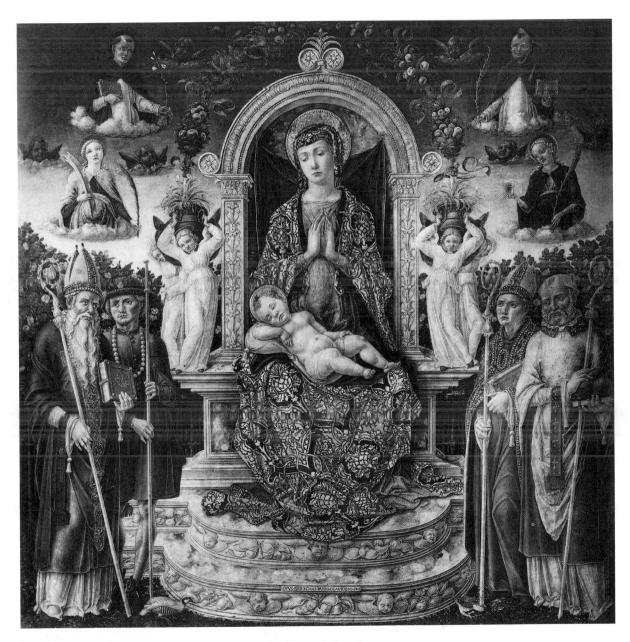

159 Bartolomeo Vivarini, *Sacra Conversazione.* Naples, Museo di Capodimonte

Bellini's first great altarpiece (fig. 160) was done in tempera. Burnt in 1867, it is known only from copies and engravings. Only the frame has been preserved in SS. Giovanni e Paolo. The saints, five on each side, gathered around the throne of the Virgin but instead of looking at the Mother of God looked at each other or straight ahead. The men and women formed groups, each of which had two spokespersons. Their relation to the viewer was only apparently a simple one. Eye contact was possible with very few, and only the martyr at the very front was turned clearly towards the outside. She looked towards the person who had entered the church by the main door, but

160 Giovanni Bellini, *Sacra Conversazione* from SS. Giovanni e Paolo, engraving

she was not understood as being present in the church: while the painted pilasters had the same form as the carved ones, the cross-vaulted space, open at the back, was more like a loggia or a gallery than a chapel. Unquestionably the gathering of saints in this picture was far closer to the worshippers than in earlier altarpieces, but they were not yet in the same room. Although Bellini allowed for the observer's viewing angle in the slight foreshortening of the figures (the bottom of the painting was somewhat above eye level), the dividing altar was still between the picture and the worshippers. The closeness of the saintly and divine personages did not result from an illusory continuation of the profane sphere, but from a view into a different, higher world, though it was one with similar architectural forms to the viewer's. From that world the martyr bent towards the viewer, and from it Christ blessed those who followed St. Catherine's invitation and stood directly in front of the altar.

The first of Giovanni Bellini's *sacre conversazioni* that has survived is the one that was removed from S. Giobbe (fig. 161), where the frame is still in existence, to the Accademia.[22] The term *sacra conversazione* suggests an exchange of words, which does not take place in the pictures. It is a misunderstanding from the nineteenth century. Five hundred years ago one spoke more matter of factly of "madonnas with saints." If elements of dialogue are involved, it is less in the picture itself than in the relation of the viewer to the people depicted. The inscription of the *pala* of S. Giobbe takes the form of an invocation: "Hail to thee, unplucked flower of maidenly chasteness" (AVE VIRGINEI FLOS INTEMERATAE PUDORIS). The contents of this invocation, above all the virginity of Mary, were not shown directly but only symbolically or metaphorically, as in the flowers beside *flos*. The greeting suggested to the viewer, however, finds an answer in Mary's gesture. There is thus, again, a direct relationship between the divine person above the saints and the believer. However, Mary's gaze, refusing all intimacy, passes far above the viewer.

Bellini's painting is seen not infrequently as an imitation of the altar painted in 1475 by Antonello da Messina for the church of S. Cassiano (fig. 162), the second altar commission for Antonello, who also produced a triptych with plague saints from which the *St. Sebastian* in Dresden might originally have come (fig. 163).[23] Although this panel was in all probability donated on the occasion of a plague, its theme is primarily an artistic one. The perspective, the partial inclusion of contemporary life, the heroic nude, and, not least, the mastery of oil painting as well as the management of light were not only means of portraying St. Sebastian, but also a challenge to the painters of the Venetian avant-garde. The most spectacular Sebastian up to then had been in SS. Giovanni e Paolo (fig. 158), but now it looked almost old fashioned. The

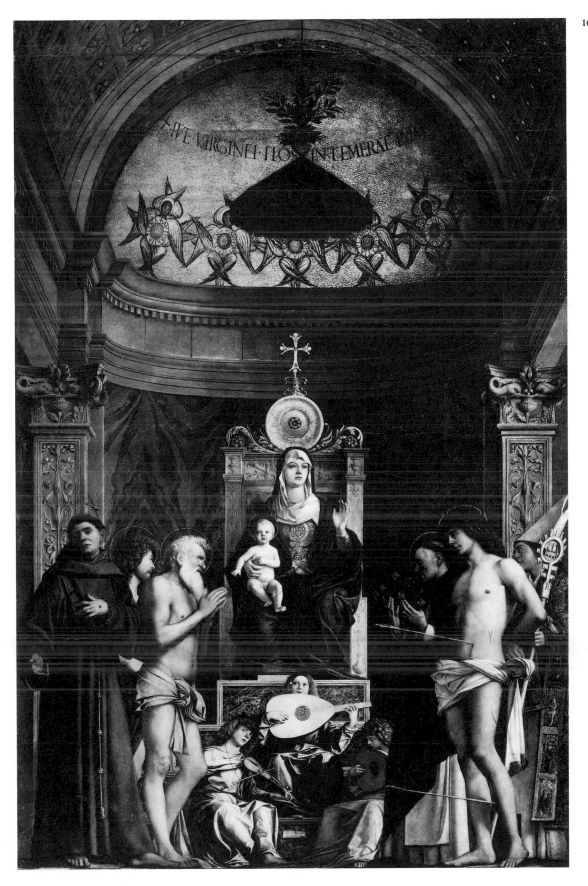

Sicilian was not only totally sure of himself in the treatment of the model but of perspective as well, so much so that he could even playfully call his own system into question with the fallen column. The artificiality of the total constellation was not a problem for Antonello. He had no compunction in placing the dead tree of martyrdom in the middle of a very well kept town or in giving the saint larger proportions than he should have in relation to the buildings, making him as large as was needed to have the maximum effect. The problem that Jacopo Bellini (fig. 154), with his insistence on logic and plausibility, was unable to solve is simply ignored by Antonello.

Of course, if Bellini's altarpiece in S. Giobbe already existed in 1475, Antonello's *Sebastian* would have been a reply to the Venetian's. At any rate, the relation between his altar for S. Cassiano and that of S. Giobbe is a close one, no matter how the question of priority is answered. Even so, a comparison is not simple, as only fragments of Antonello's picture have been preserved. All reconstructions of the picture's architecture are uncertain and extremely hypothetical. But in the figures the two pictures are so similar that the later one, no matter which, can only be understood as a critical response to the earlier. Whatever the sequence may have been, the differences remain the same: Antonello's people are more monumental in their deportment and more solemn in their gestures; Bellini's are more natural but are also imbued with greater significance. Compare the madonnas' heads and their surroundings, the children, or the manner of reading in both pictures.

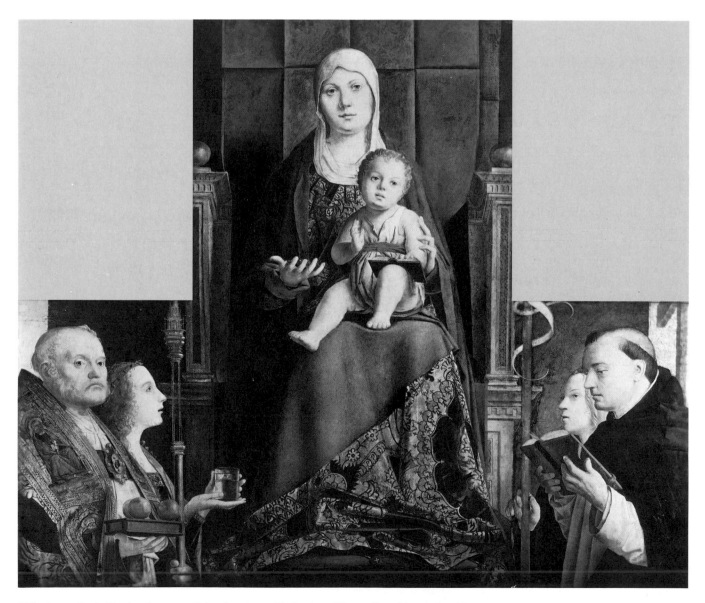

162 Antonello da Messina, fragment of the altarpiece of S. Cassiano. Vienna, Kunsthistorisches Museum

Bellini's picture hung on the right side wall of the church, about two meters above the ground.[24] Mary therefore appeared to those entering the church to be raised above the other visitors, while St. Francis, the patron saint of the order, turned towards those approaching the picture from the other side, the monks coming from the adjoining monastery. The turning in each case is not violent but undoubtedly effective, particularly as both, Mary like St. Francis, have architectural structures behind them that have pronounced axes and look more impressive and more antique than anything, whether built or painted, that had been previously seen in Venice.

At the sides the building is open. One understands that the saints have come onto the scene but does not see from where. For Bellini, however, this was enough to make us aware that their coming together in this place was neither fortuitous nor self-evident. As compared to the altarpiece in SS. Giovanni e Paolo the number of saints is less, so that Bellini had more room for them. All the people are calmer, more serene than in the earlier painting. In the nude figures, for the first time in Venetian painting, human corporeality becomes the subject of great art. They stand together but are linked not by activity but by deportment and mood.

Despite audacities like the two nudes, the painter's complete technical mastery is not an end in itself; for him, beauty and artistic perfection were not the antithesis or even a threat to religious feeling, but its precondition. In their pensive self-containment the saints display a form of behavior that Bellini may have wanted to arouse in the viewer of his altar panels. At the same time, with pictures like the one for S. Giobbe, he laid the foundation for the "existence painting" of the great Venetian painters of the sixteenth century.

In the 1490s Bellini seems to have painted hardly any altarpieces, probably because his work every morning at the Doge's Palace[26] took most of his energy. One of the few exceptions is the *Baptism of Christ* in Vicenza (fig. 164). Produced shortly after the turn of the century,[27] it shows the septuagenarian artist at a new peak of his skill as a painter of altarpieces. The Vicenza work is closely related to a picture by Cima da Conegliano in S. Giovanni in Bragora (fig. 165), which must have been finished in 1495.[28] They may both follow a lost older work, but it is much more likely that Bellini was contracted to follow Cima's example. The only entirely new element is God the Father, who is only indirectly present in Cima, in the light on a bank of clouds. He is a somewhat old-fashioned motif that might have been a request from the patron.

No matter how closely Bellini might have been bound to his model by contract, however, he never copied it. Everywhere his changes define and qualify not only the course of the events depicted but their significance, whether by clarifying the shape of the rocks, changing

the position of the baptizing bowl, or transforming the rather indifferent background into the remote landscape of a hermit. The angels standing by and looking on are filled with wonder, bend their knees, and fall into prayer heedless of the garments entrusted to them. In terms of composition, they bridge the height difference between the foreground and the mountain landscape, and at the same time they are linked, through the yellow robe in the foreground, to a triad of basic colors that sends its glow far into the church.

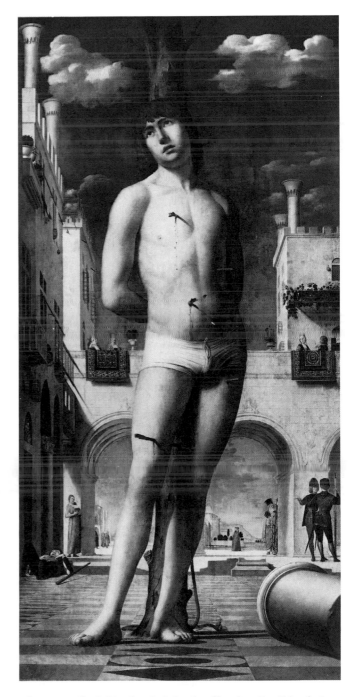

163 Antonello da Messina, *St. Sebastian.* Dresden, Gemäldegalerie

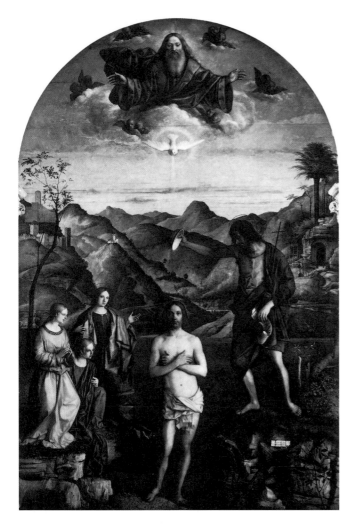

164 Giovanni Bellini, *Baptism of Christ.* Vicenza, S. Corona

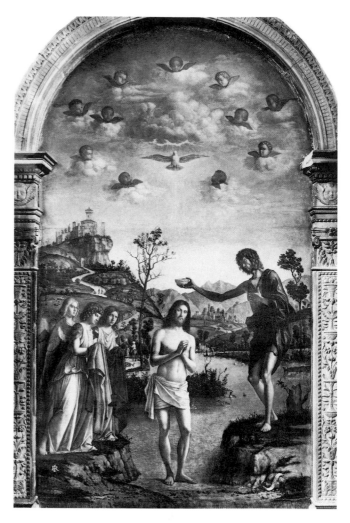

165 Cima da Conegliano, *Baptism of Christ.* Venice, S. Giovanni in Bragora

The most important changes are to the act of baptism itself: John has already emptied the bowl, and at this moment God the Father, who has appeared in the heavens, sends down the dove, so confirming the baptism of water by one of spirit. That John is only acting as a proxy is seen by his posture. Christ is not turned towards him, but to the person praying before the altar.

Christ and the Virgin "in Forma Pietatis"

On 17 February 1499, a few days before his death, the lawyer Rainario di Lodovico Migliorati of Rimini gave orders for the construction of his burial chapel. For its altar he donated from his own property "a panel painted by the hand of Giovanni Bellini [fig. 166] on which the image of our Redeemer Jesus Christ is painted, dead and being taken from the cross, in the form of a devotion" ("in qua est depicta imago . . . in forma pietatis").[29] Migliorati thus characterized not only the content—Christ taken from the cross—but the manner of depiction. But

what is meant by "in forma pietatis"? Who is the subject and what is the object of this devotion? In the sources the term can mean a pious attitude in the viewer or a manner of portrayal that arouses and fosters this attitude. We find references to "pictures painted for the purpose of devotion"; Lorenzo Lotto is said to have painted a picture for his devotion, "per sua divotione," but at the same time the pictures themselves are called *divotione* or *devocion.*[30] They therefore form part of the large area of private devotional exercises, the stimuli for which might be rosaries or writings—but also pictures. Above all, the memory of the Passion was to be constantly rekindled in the pious contemplation of the individual, to whom many ways were open, from the perusal of written texts to free meditation. The goal was always a direct, personal immersion, not mediated by liturgy, in the facts and secrets of faith.

We know very little about the way devotional pictures were commissioned. Not one contract seems to have survived; perhaps, with the small sums involved, verbal

agreements were thought enough, or the picture was chosen from what a workshop had in stock, and paid for in cash. A few hints are given by a letter of 1473, in which the jeweler Antonio Choradi from abroad gave a list of orders to Venetian relations: he needed tools, he wrote, and pieces of jewelry, and bibles as well, "to read when I have nothing to do." Finally, they should go to Lazzaro Bastiani on the Campo S. Polo and order a small picture, as big as half a sheet of paper, with a figure of Christ, which Choradi would himself describe in writing to Bastiani. But if Bastiani were already dead or did not want to accept the order, "then go to Giovanni Bellini, show him my letter, and tell him that I want it as it is described there, with the fine, clean gold molding." However, Lazzaro Bastiani did accept the order and was paid six ducats the following year.[31]

Up to the middle of the fifteenth century, most Venetian devotional pictures seem to have been parts of polyptychs. It is not certain when they began to detach themselves, but it seems to have already happened in principle in Jacopo Bellini's sketchbooks. As they became separate from the assemblage of the old altar, the context of devotional pictures moved more and more into the private sphere of the house and the family chapel. In houses, particularly, they served not only for pious contemplation but as ornaments, and there might be small bronzes and other collector's items in the same room. Contemporary interiors often show the pictures in bedrooms, usually with a candle and incense holder in front of them, but they are also found in living rooms.[32] In all cases the pictures are hung much higher than in museums today. Very seldom was the lower edge of the picture below eye level. One did not look Christ and Mary in the eye as equals, still less from above; one looked up to them.

In altar painting, too, Giovanni Bellini was the artist to whom Venice owed its most outstanding works. While we do not know whether Dürer's note in a letter to the effect that Bellini was a "pious man"[33] was also true of his youth, his earliest works show an artist of great seriousness who did not put his extraordinary talent on display, but placed it in the service of his theme. He was an artist, moreover, who constantly rethought his work, neither

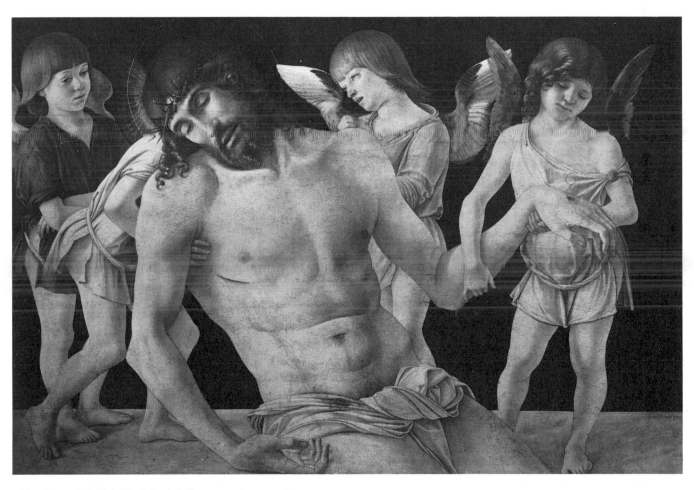

166 Giovanni Bellini, *Pietà*. Rimini, Pinacoteca Communale

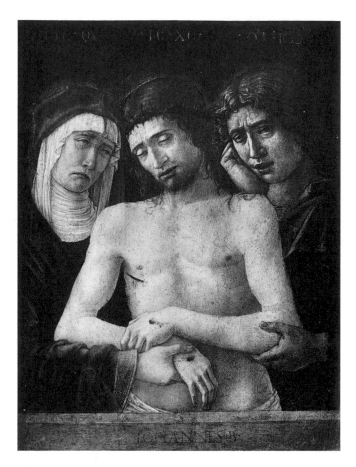

167 Giovanni Bellini, *Pietà*. Bergamo, Accademia Carrara

taking over accepted types and traditions untested nor rejecting them without reason. With a kind of severity he preferred to accept formal inadequacies rather than tolerate a superficial treatment: one of his earliest works, the *Pietà* in Bergamo (fig. 167), follows the traditional Venetian type, yet Bellini was clearly dissatisfied with it, for he attempted to make some of the elements of faith, the contemplation of which the pietà was supposed to arouse, visible in the persons themselves and not only by means of attributes or other signs. This meant showing Christ not only as a lamented corpse but also, as the mystery of faith requires, as even in real death a living being. Hence the eyes, which still "look" even when closed, and the bending of the head towards the grieving Mary and the hands, which Christ himself seems to be showing. Beside such details, extraordinary in conception and execution, are some amazingly inept foreshortening, weaknesses in surface modelling, and a face of Mary that Bellini lifted almost unchanged from Flemish paintings.

Bellini seems soon to have left this stage, in which he invested all his powers of invention in a single figure, behind him. In the *Pietà* in Milan (fig. 168),[34] which he is likely to have painted at about thirty, the figures no longer stand simply behind a wall but inside a tomb,

which placed quite new demands on the plausibility of their arrangement. Everything is attuned to Christ, even the color of the landscape relating to the pallor of his body. The presence of Mary and John seems rather to heighten Christ's solitude than to relieve it. And this despite the poignant identification of the mother with her son's suffering, which is seen even in physiognomic terms, and despite a composition that draws them together in a way that derives its extreme—and cathartically unresolved—tension from the fact that their faces finally do not touch. Such significant inventions did not happen as a matter of course in Bellini. Although artistic achievements of the highest order, they are not an end in themselves but serve the presentation of the theme and so, if in an entirely new way, the purpose of devotion.

In its general character the Milan picture has a solemnity and monumentality that, at least for the modern observer, do not necessarily elicit the tears of which the inscription speaks: "As soon as the eyes swollen (with weeping) let forth their lament, Giovanni Bellini's work was able to weep."[35] It is very unlikely, however, that these are Bellini's words, for his composition refuses precisely such direct contacts. None of the figures looks outwards, all seem under a spell that stifles any loud lament, and the composition centers not on the faces but on the *corpus* displayed like a monstrance, with the wounds on the center axis. Later works like the *Pietà* in Rimini (fig. 166) soften the severity and demands of the death spell, portraying a noble body that speaks of sleep, but not death. The wounds are again signs, not real injuries, and the attitude of the angels is less of reverence, grief, or mourning than of childlike curiosity. Adding to this effect are the beauty of locks and limbs, the noble coloring, and the harmony of outline—all features that do not meet the modern expectations of a picture *in forma pietatis*, as its owner saw it and explicitly described it. Here, too, appearance and function do not necessarily coincide.

The most common domestic devotional picture, and the one still most popular today, was the half-length madonna with child, sometimes accompanied by angels or saints. These pictures clearly achieved wide circulation, and the most popular of Bellini's madonnas are still to be found in many copies and variants today.

The madonna and child: to begin with it was a motif, not an artistic theme. In such commissions many painters, above all in Florence, placed domestic happiness and intimate mother-child relationships at the center, experiences of human life that there was little other opportunity to portray. At the opposite pole are pictures that not only present the whole panoply of *arma Christi* (fig. 169) but in addition offer a veritable encyclopedia of the fauna and flora capable of having symbolic meanings.[36] But by and large, in the Venetian madonna picture the elements that demanded a religious interpretation were

put in the background. Obvious attributes of the Passion, for example, disappeared more and more, and worshipping donors like those in Gentile Bellini's Berlin painting (fig. 170) become increasingly rare. It is therefore often difficult to decide how particular postures or situations were meant. They may be interpreted religiously, but need not be. A child sleeping on its mother's lap, for example, is a far too general motif for us to know without further indications whether it can or should be understood as prefiguring the dead Christ in a pietà. And whether the Madonna's earnest face is supposed to express only her personality or her foreknowledge of her son's sufferings can often only be decided if attributes are present. In Bastiani's *Madonna,* for example, putti with the implements of torment are to be seen on the frame, with all three on the left looking towards the Virgin. Without such explanations one is usually thrown

back on conjecture. Thus it is quite conceivable that the Madonna in Bartolomeo Vivarini's altarpiece in Naples (fig. 159) is intended as a prefiguration of the pietà, but a stubborn doubter could not be convinced by the composition alone, for Vivarini never had at his disposal the kind of imagination that allowed Giovanni Bellini, in the earlier center panel of a polyptych (fig. 171),[37] to find an attitude for the child Jesus that anticipates that of the dead Christ. As compared to Vivarini, Bellini has reduced the cushions and the throne ornamentation and divested the child's body of all puttolike qualities. But he has enlarged the Madonna's hands and related them formally, through the folds of her garment, to her head and to the child. The importance of the people depicted in the story of salvation is no longer shown by additional attributes, but within and by means of the composition.

Bellini's skill in composition could also be demon-

168 Giovanni Bellini, *Pietà.* Milan, Brera

169 Lazzaro Bastiani (?), *Madonna.* Berlin, Staatliche Museen Preussischer Kulturbesitz, Gemäldegalerie

strated by the *Madonna Lochis* (plate 18): the heavy folds emphasizing the inclination of Mary's head, the robe across her breast that sets up a wall between her and the child, the heavy loading of her arm that seems to press the elbow far down. Here Mary does not hold the child as her possession, as almost every mother would do, but as a precious thing entrusted to her.

How much this kind of logic was understood by Bellini's contemporaries is, of course, an open question. In most, the understanding cannot have been very great, for there would otherwise have been loud protests at the many imitations, which lacked these very features. The *Madonna* in Berlin (fig. 173), for example, clearly has her model in the one in S. Maria dell'Orto (fig. 172). Most scholars take it to be an original variant done somewhat later, yet the changes are so serious and so affect the meaning that it is difficult to attribute the work to Bellini himself. For example, the child is lifted up rather than held, the narrow curtain that in Venice holds them together in Berlin stretches right to the frame; the standing posture is confused by the swathe of garment at the bottom of the picture, the Madonna is displaced from the axis of the picture, and the attitude of the child is trivialized by the fingers in his mouth. Which is not to speak of the loosening of the tight composition, seen in the connections and contrasts in the juxtaposed hands, the relationship of hood to shawl, the interaction of eye, nose, forehead, and cheek, or the way Mary's arm emerges from its sleeve and the child's foot disappears behind a fold of garment.

No matter how similar the two pictures may seem at first glance, as works of Bellini they belong in two separate categories. Clearly Bellini drew a sharp distinction—even if he was the only one to perceive it—between pictures conceived and executed only by him and those he left to his workshop from the outset, to which he seems seldom or never to have set his hand, despite the often profuse signatures.[38] Apparently it was not the same thing for him whether he sent a picture out into the world as a piece of goods or took personal responsibility for it as a work of art. The conflict between the general public's traditional notion of art as a matter of craftsmanship and the modern conception held by the artist was fought out in the inner structure of his oeuvre. In addition, to speed up production of the popular half-length paintings with several figures, Bellini developed a number of easily reproduced character heads that he never used himself in his own pictures but that gave his workshop a stock of motifs that enabled it to cope with the many commissions it received. There was a pattern for a young woman that would do for Magdalen as well as for any other young saint, a dignified bald-headed figure for older saints, and a young bearded man particularly suitable for John the Baptist.

The modern observer sees the paintings of the late decades of the fifteenth century far less as instruments of piety than as works of art.[39] In reality, these two functions seem to have been far more intimately intertwined than modern ideas would suggest. Simple deductions of the function of a picture from its appearance—or vice versa—would be questionable for that reason alone, and they become still more dubious if one realizes that devo-

171 Giovanni Bellini, *Madonna.* Venice, Gallerie dell'Accademia

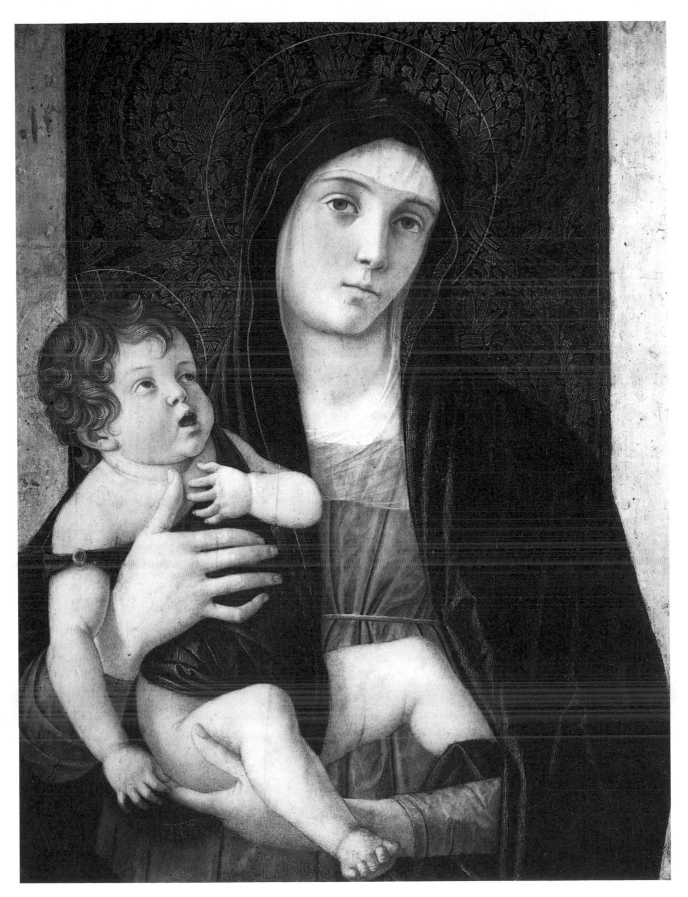

172 Giovanni Bellini, *Madonna*. Venice, S. Maria dell'Orto

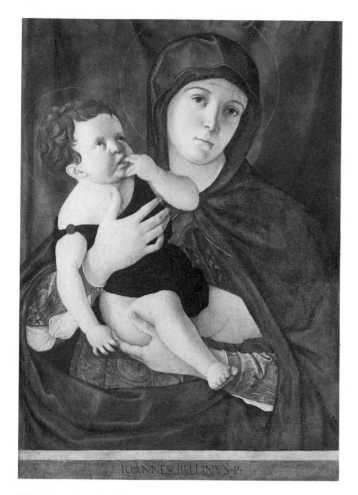

173 Giovanni Bellini (workshop), *Madonna*. Berlin, Staatliche
Museen Preussischer Kulturbesitz, Gemäldegalerie

no longer extant chapel of the Holy Cross of the church
of S. Rocco, which was to receive for one hundred ducats
benches, paintings, a magnificent floor, and other orna-
ments. The coats of arms envisaged for the walls by the
donor were not approved, however, and for pictorial em-
bellishment he had to make do with a single altarpiece.
In keeping with the dedication of the chapel, it shows
Christ with the cross in a half-length picture of seventy
by one hundred centimeters. In 1550 Vasari recorded the
miracles it worked and the veneration it received. He
thought the picture a work by Giorgione and described
it as "a picture of Christ bearing the Cross and a Jew
dragging him along."[42] This description is far more con-
ventional than the painting, for in reality the old man is
not pulling at all, and his Jewishness is a matter of conjec-
ture. So what is really meant? An act of turning round,
perhaps the conversion of someone who had actually
come to drag Christ along and to whom the indifferent
profile on the left is intended to be a contrast? The com-
position seems to be based on an antithesis rather than
the straightforward narration of an action. To that extent
it invited the kind of contemplation specific to devo-
tional pictures. Or was it intended to show someone
who takes a last look at a Christ resigned to his fate, be-
fore this man's hands, which look as if they are ready for
action, start pulling the rope? That would be to take the
interpretation psychologically and temporally beyond
the point that would serve the purposes of devotion.

In the woodcuts that popularized the work, problems
of this kind do not arise. Above the picture they show a
lunette with the instruments of Christ's torment and
guide reflections into conventional channels with added
mottoes and texts: "O holy, glorious Jesus / What hast
thou suffered beneath these thongs / Humbly as a lamb
thou goest" says the title page of one of the many prints,
and beside the picture is written, "That Jesus bears the
Cross / To purge our sins / Dragged by a rope / Cruelly
by a Jew, wicked and criminal / With cruelty and rage in
his face"—which is just what is not seen in the painting.

Histories and Legends

On 1 September 1474 the deliberations of the Venetian
senate concerned painting. The frescoes in the Sala del
Maggior Consiglio were no longer pleasing to the eye
and had partly flaked off. "For the honor of the signoria"
they had to be repaired. Gentile Bellini had offered to un-
dertake the work and to keep the paintings in good con-
dition in future, without further payment. A few weeks
later the Great Council approved the senate's proposal
by 943 votes to 29 to commission Bellini "to put the fig-
ures and paintings of the said room in order, repairing
and, where necessary, repainting." As Gentile Bellini was
then working, at the signoria's request, at the court of the
sultan of Constantinople, the commission was trans-

tional pictures could find their way from the workshop
not only to the chapel but to the art collection. In 1532
an early *Madonna* by Giovanni Bellini mentioned in a
collection was certainly painted for a less profane place:
"The half-length Madonna, much below life-size, painted
on wood, holding the child on her arm, was by the hand
of Giovanni Bellini. It was revised by Vincenzo Catena,
who replaced a curtain spread in the background with a
blue sky." The highlights had not been successfully linked
to the half tones. Nevertheless, this picture painted many
years before was praised for its drapery and other parts.[40]
Here, therefore, it was not the devotional aspect that was
of interest, but the work of art by Giovanni Bellini, seen
from a historical and critical perspective.

At the same time, the conditions of the time allowed
as artful a work as the *Christ Bearing the Cross* from
Giorgione's circle (fig. 174) to become an extremely
popular cult picture, although it is likely to have owed its
dissemination more to simplified reproduction in a wood-
cut than to the aesthetic qualities of the original.[41] The
painting, now displayed in museum fashion in the Scuola
Grande di S. Rocco, was commissioned in 1508 for the

ferred to his brother Giovanni.[43] The gigantic work seems to have made slow progress, for again and again there are complaints about the dilatory painters. Only about the middle of the following century does the work seem to have been more or less finished.[44] By 1577 the room had burned down. The main work of Venetian history painting in the fifteenth and early sixteenth century was destroyed. Giovanni Bellini had worked there every morning for years,[45] not as a restorer but as an artist, for in the end the old frescoes had been not repaired but replaced one by one by new canvas paintings. The number of extras included suggest that they must have contained whole portrait galleries, and the backgrounds must have shown much of the contemporary city.[46]

There are hardly any records of these paintings; possible traces of the main groups exist in a few other works.[47] A drawing by Carpaccio (fig. 175) probably shows the center group of a painting by Giovanni Bellini, or at least a sketch for it. It depicts the handing of the parasol to Doge Ziani. By Venetian tradition, originally only the emperor and the pope had a claim to this distinction derived from Byzantine court ceremony. After Venice had brought peace between emperor and pope in 1177, so rising in its own view to the position of the third great power in Europe, the doge too was granted the privilege of the parasol by the pope. Narratively Bellini's depiction of this scene must have been as exact as it was rich: the courtiers stand back behind the rulers to left and right, but the protagonists, pope, emperor, and doge, do not detach themselves equally from their entourages: the defeated emperor stays further back and gives precedence to pope and doge. But he remains formally linked to the pope by the latter's robe. Between the pope and the doge a page appears as a linking element with the parasol, the transfer of which is the theme of the painting. This transfer is not solicited by Venice but claimed.

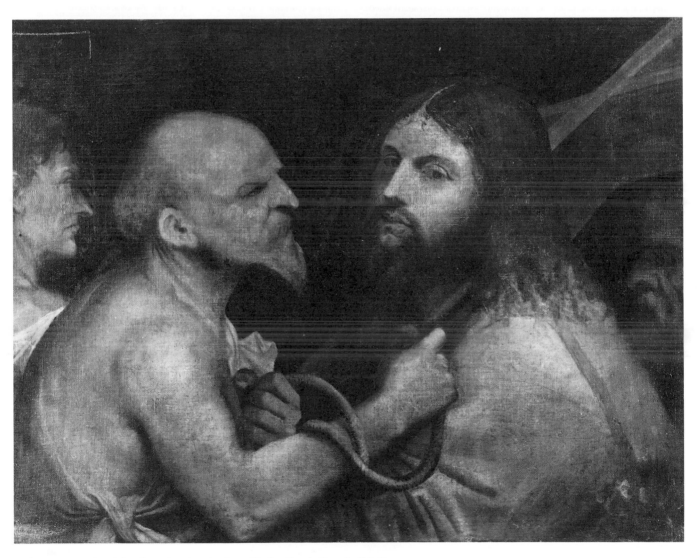

174 Giorgione (circle), *Christ Bearing the Cross.* Venice, Scuola Grande di S. Rocco

The doge does not abase himself: he merely receives what is due to him. Accordingly he does not kneel like the two clerics, but ceremonially bends his knee. All the same, protocol forbids him to stand about as nonchalantly as his attendants.

The Doge's Palace was the university of Venetian history painting. To paint a picture independently there brought fame and respect, so that young painters were ready to prove their ability on disadvantageous terms. Alvise Vivarini made the following petition to the signoria in 1488: "For some time I have wanted to produce a work showing my activity as a painter, so that your lordships can see with your own eyes that my enduring study and the care I have taken were not in vain, but do honor to this illustrious city [of Venice]. As an obedient citizen I therefore offer to paint a canvas in the Sala del Maggior Consiglio without reward or payment for my work, as the Bellini brothers also do."[48] He wished to be paid only

for the paint, the canvas, and two apprentices. The actual fee was to be determined by the signoria when the work was finished. The application was successful, and Alvise was soon working on the same conditions as the Bellinis.

Pasqualino Veneto, by contrast, had to sign a very inferio contract when he came to an agreement with the Scuola Grande di S. Maria della Carità in 1502: "As we have not yet seen any original work by Master Pasqualino that resembles the one we desire, but as the invention of his work pleases us far more than those of other painters who have submitted themselves to trial, Pasqualino offers to paint the picture at his own expense, should he not produce a perfect work that pleases our chapter."[49] In case of dissatisfaction, only the cost of canvas and frame would have been refunded to Pasqualino, and he would even have had to pay for the expensive paints himself.

Pasqualino died not long afterwards. Had he successfully completed the assignment and strengthened his po-

175 Vittore Carpaccio, after Giovanni Bellini (?), *Transfer of the Parasol.* Sacramento, California, Crocker Art Gallery

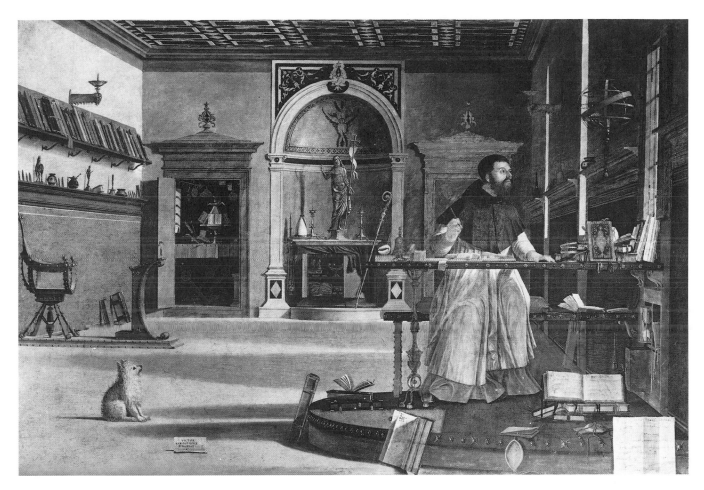

176 Vittore Carpaccio, *Vision of St. Augustine*. Venice, Scuola di S. Giorgio degli Schiavoni

sition thereby, he too would certainly have profited from the rivalry for status among the scuole grandi, which was expressed not only in a succession of building projects but in the increasing dimensions of their picture cycles.

Since pictures were cheaper than buildings, even the smaller scuole could keep up to some extent.[50] In the scuole too, frequent fires took their toll. Their victims included the large cycles painted by Jacopo Bellini in the scuole grandi of S. Marco and S. Giovanni Evangelista, which is why Venetian history painting has come down to us only in the form usual about 1500, and even then not in the works that held first place earlier. The position occupied in the modern mind by Vittore Carpaccio, for example, would scarcely have been understood by his contemporaries; in the fifteenth century Carpaccio was not one of Venice's leading painters. Mentions of him are rare, and independent commissions seem to have come only from the smaller scuole, while Carpaccio was overshadowed by the Bellini at the Doge's Palace and the Scuola Grande di S. Giovanni Evangelista.

Not only Carpaccio's themes were dictated to him by the works' destinations, but the choice of low, horizontal rectangular formats. The protagonists had difficulty in filling these areas, and the artist's imagination was spurred far more by the accessories than by them. Venetian history painting at the time was limited to a narrow spectrum of emotional registers—a psychological andante, largo, and adagio. Carpaccio shared this limitation to such an extent that even scenes as dramatic as the martyrdom of St. Ursula or St. George's fight with the dragon were reduced in his hands to ceremony. Only rarely are the people individualized in physiognomic terms. Their deportment, expressions, and gestures are those of roles: the serious mature man, the sweet young lady from a socially elevated home, the graceful young prince. The actions are performed like rituals, being neither dramatically developed nor explained by the way the characters are depicted. Carpaccio's people exist passively. No matter what is happening, their gestures and faces are muted, often as if they were under a spell. However colorful Carpaccio's painting may sometimes be, carefree, joyful, or blithe, as it is sometimes called, it is not.

The decoration of a scuola usually began in the so-called *albergo,* the assembly room of the governing committees, with paintings showing the most important stages in the life of the titular saint. This was the case

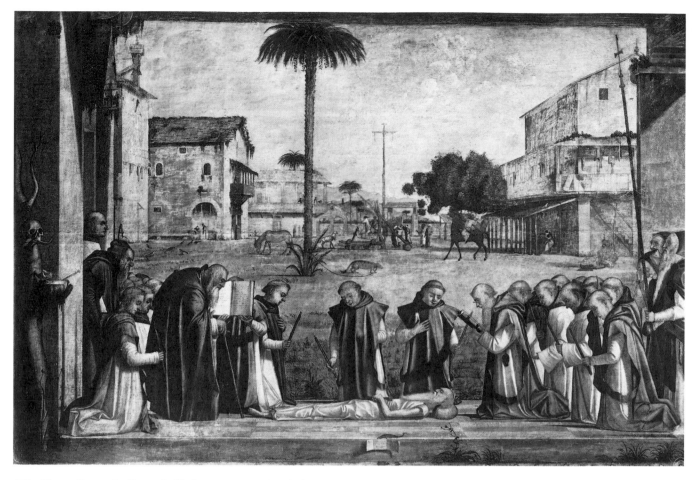

177 Vittore Carpaccio, *Funeral of St. Jerome.* Venice, Scuola di S. Giorgio degli Schiavoni

with Carpaccio's first cycle for the Scuola di S. Orsola. First came the arrival in Cologne that made Ursula a martyr; it was followed by the martyrdom and burial, and then by secondary events like the dream of the saint, the greeting by the pope, the departure of the betrothed, the return of the envoys from the English court, and the reception of the English envoys, and finally, years later, the glory of the saints.[51] The painter's scope must have grown with every stage, since the clients' expectations and instructions would have been less precise for the less common scenes than for the better known. In the later paintings of the legend of St. Ursula one feels that topics were chosen on the basis of whether they gave Carpaccio the opportunity to unfold his increasing powers.

Carpaccio's theatrical imagination put almost everything he painted on a stage. There the buildings and costumes, while resembling Venetian reality, were not identical to it. In his stage settings he proceeded very selectively: the vulgar populace, for example, is seen only at the edges. What is shown is a world far closer to the aristocratic sphere than the middle-class world from which the members of the Scuola di S. Orsola or the Albanians and Slovenes came, for whom the luxury of the buildings and dress displayed must have been unattainable and even alien. The social exoticism of these fantasy worlds was often coupled to a geographical one, based on the imaginative reconstruction of travel-book illustrations of the time. As a rule the fictive character of the scene is combined with great exactitude of detail. Costumes, hairstyles, ships and implements, architectural features, and particular situations—all these motifs were to be seen in the city, and never before had so many of them been considered suitable material for art. In the early paintings such details were packed close together, but from the 1490s the spaces between them grew.

Between the formal arrangement and the content of the scenes depicted is a discrepancy that favors the arrangement, just as, conversely, the presentation of details does not exactly blend into the narrative context. But it is not least this fact that gives the pictures their extraordinary decorative value. The mode of contemplation that Carpaccio's pictures favor is the somewhat distracted one of the member of the scuola, directed primarily either at the room as a whole or at interesting details that catch the wandering eye.

A particular claim to distinction are Carpaccio's inte-

riors. They too are shaped more by the things that completely fill them than by the people that inhabit them. The study in which St. Augustine has his vision (fig. 176) is dominated by implements and utensils and their arrangement. The room becomes a place for the exhibition of what on close inspection is a highly artificial arrangement of costly and interesting objects. The lack of overall relationships that isolates the objects shown to the point of alienating them is, however, probably involuntary, for in preliminary sketches Carpaccio had not only attempted but succeeded in supplying such relationships by light and atmosphere.[52] As a painter, Carpaccio sought to make up for the lack of relationships by a multiplication of the objects. So many theatrical properties are accumulated around St. Augustine that they tend to distract attention from the vision of the saint, which is the real subject, particularly as they owe their existence and even their positions to Carpaccio the stage designer rather than to the church father, who would have had to perform the most unlikely contortions to put them in these places. They are there for the viewer, not their owner. He too was presented more convincingly in the drawing, which showed him pausing in concentrated work, than in the finished picture, which is supposed to show his vision but finds no proper object for his gaze. But it was not only with the treasures in the richly equipped study that Carpaccio delighted the Slovenes and Dalmatians of the Scuola di S. Giorgio, but with a farmyard on a contemporary estate. The occasion was the funeral rites of St. Jerome (fig. 177), which are performed on the proscenium.

The everyday world, which Jacopo Bellini had formerly made a subject of art only in drawings and there only in the margins, became for a brief period at the end of the fifteenth century the center of large-scale history paintings. In Carpaccio's picture of the Rialto (plate 2) only the initiated could have discerned the main action. Anyone without prior knowledge would even at that time have taken the healing of a possessed person—at the top left on a balcony—to be one of the many scenes from Venetian daily life that makes up the painting. It was painted about 1494 as part of the decoration of the *albergo,* with which the Scuola Grande di S. Giovanni Evangelista wanted to outdo all its rivals. The scuola had overstretched itself financially, for in 1501 it had to get a special dispensation from the government to enroll fifty new members whose subscriptions were urgently needed. The times were difficult, they pleaded, and donations so meager "that it will not be possible to continue painting the canvases that have been begun to adorn the *albergo* and to venerate the relic of the cross."[53]

In the paintings, however, the legends of the relic play a very subordinate part and not only in Carpaccio. Far more important to the clients as to the artists seem to

have been the many portraits and the Venetian setting. Thus a sequence of city portraits was produced in the Scuola Grande di S. Giovanni Evangelista that was not equalled for a long time in European painting.[54]

For Mansueti's *Miracle in the Campo S. Lio* a sketch has been preserved that is with good reason attributed to Gentile Bellini. The legend that gave rise to the picture tells of the burial of a member of the Scuola Grande di S. Giovanni Evangelista who, dying in 1474, had spared little thought for religion during his lifetime.[55] Shortly before reaching S. Lio, the goal of the funeral procession, the relic of the cross that was being carried grew so heavy that it could no longer be lifted. It had to be given to the priest of S. Rocco, as the picture shows, and a new cross had to be fixed to the bier. To tell his story, the painter changed the scene of the action fundamentally, as compared to the topographically far more accurate drawing. Just as the grouping of the figures in the drawing is abandoned for a comparatively simple alignment, so too the complex plan of the Campo di S. Lio is reduced to a rectangular stage, the walls of which are very richly embellished. The tapestries hanging on them compete with the marble encrustations and with the beauty of the sumptuously dressed women at the windows—as was usual at state festivities.[56]

Smaller corrections to the urban configuration were also to be found in the gigantic pictures that Gentile Bellini painted in the Scuola Grande di S. Giovanni Evangelista. In the *Discovery of the Relic of the True Cross* (fig. 178), for example, he somewhat straightened the Rio di S. Lorenzo.[57] Otherwise, however, he showed it correctly in all the details that can be verified today, an impressive portrait of this area at the end of the fifteenth century. The large building on the right with the prisonlike barred windows is part of the complex of the monastery of S. Lorenzo, probably a remnant of a palace of the Orseoli, mentioned by Francesco Sansovino, that was incorporated in the monastery. On the opposite side one sees, almost in the manner of a textbook, the three basic forms of Venetian residential architecture, which must have been a common sight in the city. At the back is the noble's palace that has a door to the *fondamenta,* then comes a presumably older building of modest pretensions, and on the far left the upper parts of a social welfare building also shown in the town plans of the time.

It may be that in this painting the city and portraits were more important from the outset than the miracle that a monk from the Vendramin family had managed to rescue the cross relic, the scuola's precious possession, which had been lost in the canal. Apart from the swimmers, there was room for figures only on the bridge and the bank on the left. Gentile Bellini needed the bridge for the procession that, according to tradition, had let the relic fall into the canal, and the bank for Caterina Cornaro and her entourage. For the governors of the scuola, there-

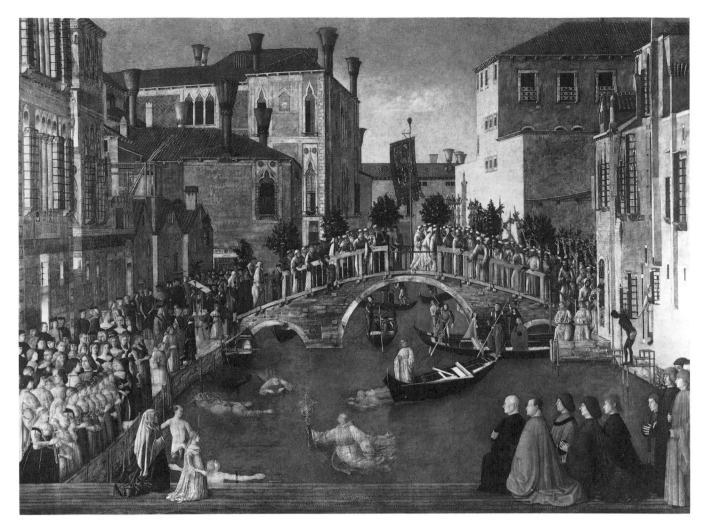

178 Gentile Bellini, *Discovery of the Relic of the True Cross near the Ponte S. Lorenzo.* Venice, Gallerie dell'Accademia

fore, the painter had to fashion a special imaginary stage, since this was the only way to meet their demand for representation. All in all, Gentile was able to include a surprising number of portraits and to flatter an equivalent number of vanities. In artistic terms, however, he only knew how to show rows of people or a diffuse crowd: in front Caterina Cornaro with her ladies in waiting, behind her an accumulation of figures in which the main consideration seems to have been to include as many members of the scuola as visibly as possible. The status-proud painter placed himself and his brother in an especially prominent position: the figure kneeling directly behind the governors of the scuola is probably Gentile, and the second kneeling man from the right can be taken to be his brother Giovanni.[58]

Faces and Landscapes

"Freed from the countless bonds which elsewhere in Europe checked progress, having reached a high degree of individual development and been schooled by the teachings of antiquity, the Italian mind now turned to the discovery of the outward universe, and to the representation of it in speech and form"—so begins Jacob Burckhardt's chapter on the discovery of man and the world in *The Civilization of the Renaissance in Italy.* In Italian painting a new task presented itself in the course of this discovery, the portrait, and a new subject, landscape.

According to the written sources, there must have been many portraits, and important ones, in Venice in the fifteenth century. But most of them do not seem to have been independent works but parts of history paintings. Altarpieces and devotional pictures also contained many portraits, overtly or covertly. The self-sufficient private portrait, however, seems only to have been brought into fashion by Giovanni Bellini. Bellini, Giorgio Vasari wrote in 1568, introduced to Venice "a practice . . . that every man of any note should have his portrait painted either by Giovanni or by some other. Hence all the houses of Venice contain numerous portraits, and several nobles

have those of their ancestors to the fourth generation. . . . Who does not experience the utmost satisfaction in seeing the likeness of his ancestors, especially of those who have been distinguished in politics, for worthy deeds in war and peace, in letters or other honorable employments."[59] The ancients had had portraits of their great men painted in public places, to inspire those who strove for virtue and fame.

What was new for Venice, however, was not the public portrait, but the private one. Doges, for example, had already been portrayed in the Sala del Maggior Consiglio with the sole object of demonstrating by the continuous chain of their effigies the republic's independence unbroken by foreign rule. That Giovanni Bellini painted Doge Loredan in the Doge's Palace was therefore far less surprising than that he also painted a family portrait for the Loredans' private palace, showing the doge with relations at table.[60] Unlike the public portraits, the private ones usually had neither inscriptions nor family insignia, only the name of the painter. After all, the family knew the father, nephew, or son-in-law who had been painted far better than it knew the artist.

The pleasure suddenly taken in portraits in Venice was not due only to Giovanni Bellini, but also to the example of the Flemish painters, at that time admired by all lovers of art. Jan van Eyck, Rogier van der Weyden, and somewhat later Hans Memling—these were evocative names in Venice, and in the early sixteenth century their works were among the display pieces in any art collection of rank. How long this had been so is not known, but what is certain is that in 1475/76, in the person of Antonello da Messina, there lived in Venice the Italian artist who had worked hardest to acquire the transalpine technique of portrait painting.[61] Antonello's portraits had an important influence even on the oeuvre of Giovanni Bellini. In 1474, a year before Antonello's arrival in Venice, both of them painted a young man. The one by Bellini (fig. 180) may be the earliest surviving portrait by that painter, though probably not his first, since otherwise the young Jörg Fugger is unlikely to have commissioned him. Bellini used a narrow format, about half of it for the head, and put the emphasis not on the skull but the face. The neck and especially the torso are accessories, not the main theme. In Antonello (fig. 179) the format is broader, making room for the shoulders. His portrait is not composed around the face, but from below to above.

Pictures like Antonello's probably impressed Bellini less by their comparatively superficial psychology than by their form: the structure modelled after the three-dimensional bust, the clarification of the spatial relation to the viewer, and the importance given to the torso in depicting and characterizing the person. From Antonello Bellini also learned details like the tauter treatment of clothes and hair, although he never shows Antonello's succinctness. Not least, he learned from Antonello how

to manage light effects that did not simply illuminate the face and leave the rest in darkness, but placed accents and emphasized the head as a volume in space.

The differences between the heads in Bellini's altarpieces and in the portraits are fundamental. Unlike many Florentines, who seem to have included an abundance of portraits in their altarpieces, Bellini always gave his saints an ideal character, which required significant, mature heads. The young Fugger, by contrast, is quite immature in character and face. The cheeks and chin show this as much as the forehead. Thanks to his fundamental distinction between the two tasks, Bellini's portraits are free of the need to idealize. However, the individual imperfection that now comes into view and becomes the theme of the work is not seen as a fault. Although the painter observed the subject objectively and exactly—how much more one learns about the personality of Fugger than of Antonello's youth—he is not concerned with exposure. Bellini always tactfully respected the dignity of the sitter.

Probably because the portraits were originally mounted quite high, Bellini normally showed his people slightly from below, from a perspective of respect. His investigation was not of the surface of the faces, but of the

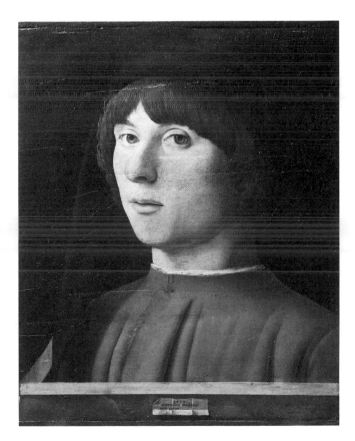

179 Antonello da Messina, portrait. Berlin, Staatliche Museen Preussischer Kulturbesitz, Gemäldegalerie

180 Giovanni Bellini, *Jörg Fugger.* Florence, Contini-Bonacossi Collection

181 Giovanni Bellini, portrait. Washington, National Gallery of Art, Samuel H. Kress Collection

person's essential nature. Even the open sky against which he soon began to place them helped almost imperceptibly, but effectively, in the characterization. The differences between the portraits in Washington and in the Capitoline museum (figs. 181, 182) are not large at first sight.[62] Both men follow the norms of their rank in dress and posture. The functional demands of a portrait were thus satisfied, and not many viewers in the fifteenth century would have looked so closely as to become fully conscious of the very different characterizations of the two young men. In the figure in the Rome portrait everything is—relatively speaking—indecisive, hesitant. The chest is not expanded under the garment, the right eye and the head contour are not joined, shoulders, neck, and head are not shaped by a single posture. Eyebrow, eyeball, lock of hair, and forehead are relatively unconnected. The attributes of rank are worn quite differently: in one case the cap is still as round as it came from the hatter, and the hair is as the hairdresser set it; in the other the hair is looser, taking on an individual style that suggests the living, active character of its wearer.

The heights that Bellini's art of portraiture was able to reach—perhaps through his experiences in the Doge's Palace, where his history paintings, according to the sources, were portrait galleries in themselves—are shown by the *Portrait of Doge Loredan* in London (fig. 183). A contemporary characterized Leonardo Loredan as "emaciated, wholly spiritualized" [tutto spirito] and tall of stature; of little wealth, he led a very regulated existence; he was choleric but shrewd and wise in governing the republic." A personality full of tensions and contradictions, therefore, seemingly held together by extraordinary self-discipline. Thus, at any rate, must Bellini have seen the doge. Another contemporary portrait, attributed to Vittore Carpaccio,[63] shows only an exterior stiffened to a mask and the costume, assembled piece by piece, whereas Bellini saw all the details as parts of a single entity. Even the coloring of the background and shoulders is attuned to the doge's eyes, and in them it is not the eyeball and iris that are important but the expression of spirituality and inner animation. The physical frailty is not concealed in the brief glimpse of wrinkled neck, but this is shown as a contrast to the costliness and splendor of the doge's habit. Its brocade and the gold of the buttons are recorded but not emphasized. They are in half-shadow. It is not the official dress or the social and political status of a doge that is highlighted, but the face of the unique person who holds this office and exercises its functions with a dignity peculiar to him. The cap too,

182 Giovanni Bellini, portrait. Rome, Gallerie Capitoline

183 Giovanni Bellini, *Doge Loredan.* London, The National Gallery

the most unmistakable of the insignia of office, is brought into play with discretion. Bellini's portrait has its true center in the face and eyes of Loredan. The person, who has been moved slightly but effectively from the picture axis, was more to Bellini than the office, even if it was the highest office the republic could bestow.

Towards the end of the fifteenth century portraiture had become established as an independent genre. Landscape, however, although its importance had increased, particularly in the paintings of Giovanni Bellini, was only a setting even in his work. Bellini did not paint landscapes for their own sake. Although in the early sixteenth century many "landscapes" are listed in Venetian collections,[64] these *paesi* were usually pictures of saints in which it was not the tiny figures but their surroundings that mattered to the collectors.

The basis and objective of Bellini's landscape painting was not a feeling for nature that was seeking expression, but the representation of an event. *Christ in Gethsemane* (fig. 184; 81 by 127 centimeters) might have been part of the predella of a large altar or a separate devotional picture.[65] The work is closely related to a picture on the same subject by Bellini's brother-in-law Andrea

Mantegna (fig. 185).[66] In both pictures the landscape is not only a setting but a subject, and for both, signed landscapes by Jacopo Bellini were the starting point. Jacopo had depicted on the right a mountain peak the shape of which was repeated in the distance as part of a chain of mountains. The peak, built up in undulating strata, had space for Christ; the left half of the picture had space for Jerusalem in the distance and for the bailiffs approaching on a loop of road.

Mantegna made Jacopo's broad stage narrower, bringing the background forward so that a good half of the picture area was left for the distant view. The figures are larger, the sleeping disciples at the front of the stage take up almost the whole width of the picture, and the mountain peak has become an altarlike rock, above which putti show the praying Christ the instruments of torture. Of the garden in which the Bible describes this prayer as taking place nothing is to be seen. Few plants have survived in the rocky landscape. There are more on the slopes of the city hill, and in the far background there are even green hills. The meaning is stated pictorially by the vulture on the branch of the near-dead tree: the landscape expresses the significance of the moment in which Christ resolved to endure the Passion.

184 Giovanni Bellini, *Christ in Gethsemane*. London, The National Gallery

In Mantegna's painting a crystalline clarity extends to the farthest corner of the frame, bearing witness to a gaze that embraced all parts of the scenery with the same attention—whether near or far, large or small, bright or dark. In Bellini, by contrast, light is used to place accents. And even what it emphasizes is not always painted in the same way. Connections are formed by the many paths. In keeping with the late hour and the situation, they are all deserted—except for one on which Judas is bringing the soldiers. The bare landscape of the picture, very different from an Arcadia, is not simply nature but to a large extent the work of men, even if those who have shaped it and use it have long since withdrawn to the distant settlements. How a stream is bridged and a pasture fenced is shown in exact detail. One sees how the bridge is built of rough-hewn stones and how the fence is woven. Between them are parts that are consciously kept much more indefinite, to ensure a greater effect for the others.

This landscape could not have been painted without the most concentrated observation of nature, for the light of the setting sun that lights up the clouds from below while the darkness has already reached the mountain slopes cannot be observed in the studio. It describes the time of day when the putto with the chalice appears to the praying Christ in a shining vision, but for the believer it can also become a symbol of Christ's departure from the world.

The landscape of a picture is not discovered somewhere in reality but must be invented and composed in exactly the same way as a group of figures in a history. Even as "natural" a landscape as that in Giovanni Bellini's *Transfiguration* (fig. 187) is a bravura exercise in the art of composition. The distribution and concentration of land formations and the insertion of the figures at their exact points of intersection shows not only the figures to best

185 Andrea Mantegna, *Christ in Gethsemane*. London, The National Gallery

advantage but also the different spheres of nature, while opening them to the apparition of divine light.[67] In Bellini there is no contradiction in this, nature being for him not a profane world opposed to religion but a different manifestation of Creation. Natural being and religious meaning are thus not antithetical for him, but intensify each other. The felled tree that puts out unhoped-for shoots was a familiar symbol of the Resurrection of Christ, always seen as prefigured in the Transfiguration. But at the same time this symbol is a natural formation studied with deep seriousness. The longer and more closely one looks at Bellini's landscapes, the more of the study of nature one discovers in them—and the more meaning. The manner of representation still has something of the freshness and the joy of the first-time discovery. Bellini the botanist was also a theologian. To combine both while giving each its due was one of the great achievements of his art.

Both the particular forms and the connections within nature are taken incomparably more seriously in Bellini's paintings than in Carpaccio's meditation—inducing pictures that were based on them (in New York and Berlin, fig. 186), even though at first sight the opulence of Carpaccio's motifs and meanings makes a far stronger impression. Even the inscriptions demand erudition. Unlike Bellini, Carpaccio rejects a simple vision that confines itself to the visible—in these paintings meanings are suspected even where they cannot be allegorically deciphered but only grasped associatively by intuition. Motifs and meanings are multiplied as in a magic lantern display. But the connections, like the structure and stratification of rocks, the way plants grow out of the ground, or the linking of foreground, middle ground, and distance, that Bellini used to show not only the variety of *natura naturata* but the inner coherence of *natura naturans*—all this is lacking in Carpaccio's paintings.

186 Vittore Carpaccio, *Christ*. Berlin, Staatliche Museen Preussischer Kulturbesitz, Gemäldegalerie

187 Giovanni Bellini, *Transfiguration*. Naples, Museo di Capodimonte

The interweaving of nature and theology is deepest and most concentrated in Bellini's *St. Francis* (plate 19).[68] Bellini depicts the daily surroundings of the saint with great exactitude: the roughly made lectern, the canopy of growing foliage propped up by sticks driven into the ground, the sandals, and the plants, the crag, the trees and bushes. The pastoral landscape before the town, with paths crossing it, provides a contrasting background to the pathless country where the saint has made his home. Bellini may have had the signed picture of St. Francis in his father's sketchbook (fig. 155) in front of him as he worked; in it there were trees but no vegetation, crags but no stones, and above all no connections between things, since Jacopo had not been able to represent the ground convincingly. Only his son was able to combine optically the very different surfaces of the rocks near St. Francis, the cliff near the ass, and the ground near

the shepherd, while drawing attention to the characteristic differences between the areas thus connected. The hills behind the town are characterized by the hedge-enclosed fields, modern at that time; the valley in front of the town is pasture, but enough grows on this high plateau for the contented ass, and around the saint's retreat there is just enough water in the rock crevices to support a few flowers, making understandable the saint's love of each one of them. St. Francis has closed his book and turned his back on his studies. Not in reading or meditation on the skull on his desk does he encounter the God he worships, but in praising his Creation.

Bellini may have studied the interpenetration of intense observation, symbolic interpretation, and a laudatory style of painting in the works of the great Flemish painters. But none of them shows an invention so bold, so unsupported by tradition, as the top of the laurel tree

bending towards St. Francis. It expresses the real, not just the symbolic, presence of God in a manner that is almost that of antiquity, for only there was the divine conceived as working within nature, not above it. There is no book in which the viewer could find out that the rustling tree-top has this meaning; but there is Bellini's composition, which relates this tree not only to the one St. Francis has incorporated into his cell but also to the dead branches behind the ass. Whether St. Francis is at this moment receiving the stigmata, or is already stigmatized and conversing through nature with the crucified Christ, is left open. The fact that for the initiated the plants can also be symbols of Christ is not a contradiction but an intensification. In 1525 the picture, whose original destination is unknown, was part of the collection of Taddeo Contarini: "The oil painting of St. Francis in the wilderness was a work by Zuan Bellini. The landscape in the foreground is done with an art both wonderful and select [ricercato]."[69] The pride of this collection, however, were the paintings of the next generation, especially the three works by Giorgione that Contarini called his own. They owe their origin and their peculiarity to very different conditions than those that produced the works of Giovanni Bellini.

BETWEEN 1505 AND 1550

Autonomy and Competition

At the end of 1505 Albrecht Dürer visited Venice for the second time. Although it was his graphic work that had earned him a good name in Italy, he was soon able to sell the paintings he had brought. Dürer was to paint an altarpiece for the German merchants of Venice in the church of S. Bartolomeo near the Rialto, a lucrative contract that gave him the chance to test his ability against the Venetian painters. In his letters he wrote of much ill-will. He said he had even been warned of attempted poisonings. Although the Venetians copied him wherever they could, he wrote, they complained that his art lacked the "antique style" and so was not good. Only the finished rosary painting silenced the critics: "As an engraver I was good, they said, but I did not know how to use paint. Now everyone says they have never seen more beautiful colors." [1]

Only Giovanni Bellini gave the German a friendly welcome, visiting him, praising him in the presence of nobles, and even ordering a painting from him: "He is very old, and is still the best painter." [2] Whether "still" meant that Dürer saw this position as already endangered or that he thought his earlier works better is uncertain. In favor of the second reading is the fact that Dürer the painter studied only the works of the 1480s, while Bellini's late works, finished since Dürer's previous visit to Venice, had no impact on the Nuremberg artist. But perhaps not only he but the whole of Venetian painting would have taken a different direction if he had accepted a long-term commission from the signoria and stayed in Venice. Circumstantial evidence suggests this might have involved the painting of the Fondaco dei Tedeschi, which after Dürer's departure was entrusted to Giorgione and Titian. [3]

Only fragments have been preserved. Reproduction engravings of the eighteenth century show some of the figures painted by Giorgione (fig. 188) between the windows on the canal front and by Titian (fig. 189) on the side wall, but hardly anything of the decorative friezes that appear to have embellished the lower part of the palace. Over the land entrance there was a lion of St. Mark in marble relief and above it, doubtless as a symbol of republican justice and virtue, a painted *Judith.* An allegory

of peace was also to be seen. As a whole, however, the decoration, which included "trophies, nudes and heads in chiaroscuro; at the corners geometers measuring the globe; perspective views of columns with horsemen between them, and other inventions," does not seem to have followed a strict program. Some individual figures are identifiable, such as a youth from the Compagnia

Giorgione dipinse . *2*

188 After Giorgione, fresco. Venice, Fondaco dei Tedeschi

189 After Titian, fresco. Venice, Fondaco dei Tedeschi

della Scalza, and a smuggler known throughout the city and just then in prison was portrayed. Perhaps he was there to remind the Germans to obey the laws.[4]

When Giorgio Vasari saw the Fondaco, however, such possible meanings seem to have been forgotten. Giorgione's only intention, he stated, had been to create fantasy figures in order to demonstrate his art ("per mostrar l'arte"). Vasari emphasizes the lack of history paintings with an internal order and showing the deeds of a particular person from antiquity or the past. It was not only he who failed to understand the paintings; so did all those he asked about them—although they must have included Titian, whom Vasari knew and visited at that time.

Other famous façades, like those painted by Sante Zago, are also described as freely invented.[5] But such freedom only existed because house painting was not highly regarded. Even Giorgione and Titian, the artists commissioned by the senate to paint the Fondaco dei

Tedeschi, were not yet the world-famous masters they had become by Vasari's time, but two young painters from the provinces about whom not much can have been known in Venice as they still had the major tests of their ability ahead of them. This would not have troubled the government, who had set tight limits to the ostentation allowed to the Germans, specifying that the steps of the trading house should not extend to the Grand Canal and that "no marble fixtures should be attached to the Fondaco, or any stone openwork."[6] Instead of the forbidden marble incrustation the Germans were allowed only frescoes, and everyone knew that they would not stand up to the Venetian climate for long. The lack of a program further reduced the pretensions of this decoration. However, the work gave the painters the golden opportunity to demonstrate their skill and their powers of invention at the center of the city and without major restrictions. Nowhere else could they have attracted the

190 After Tintoretto, fresco. Venice, Palazzo Gussoni

owners had had them painted for their own enjoyment—"per volere goder de loro." The correspondence says not a word about what the pictures actually represented. Their subject matter was obviously secondary.

Though Giorgione had not entirely detached painting from its prescribed, traditional themes and tasks, he had demonstrated that the link between picture and subject matter could be far looser than had been previously supposed. One example is the music pictures from his immediate circle. Their models are the music-making angels of the *sacre conversazioni,* and their typological framework was supplied by the half-length devotional pictures showing several saints.[9] The free relationship with the subject altered the traditional themes and created new ones like the pastoral, genre, or the landscape almost as a form in its own right. Borderlines strictly observed up to then in Venice now became fluid, and older picture types also

interest of such a large circle of potential clients. In his somewhat fanciful biography of Andrea Schiavone, Carlo Ridolfi tells how the artist even made friends with masons, so that they would leave him walls to paint without a fee.[7] Even Giorgione is said to have painted frescoes on his own house to advertise himself, and Tintoretto, on his façades, put on show not only his imagination and mastery of color but also his knowledge of Michelangelo.

> In his youth he painted, by the Grand Canal, . . . two figures copied from Michelangelo, *Twilight* [fig. 190] and *Dawn,* and in two niches above them he painted two inventions of his own, Adam and Eve and Cain slaying Abel. At the Campo S. Stefano he painted St. Vitalis on horseback on the outside of a chimney, the figure being shown in an extremely difficult foreshortened manner which the experts declared unique. Out of *capriccio* he took as his model the statue of Bartolomeo Colleoni. In the window spandrels he placed a number of nude figures painted in so free and polished a manner that they could not have looked fresher or better as oil paintings. In this way he demonstrated his own value in comparison to the inventions of others.[8]

When Giorgione died suddenly in 1510, at the beginning of what would undoubtedly have been a brilliant career, Isabella d'Este wrote at once to her Venetian agent, having heard about a "nocte" by the painter that she was determined to acquire. The reply referred to two night scenes by Giorgione that were not available, since their

191 Cima da Conegliano, *Adoration of the Shepherds.* Venice, S. Maria dei Carmini

opened themselves to new content. Half-length paintings, for example, were no longer confined to saints and the Virgin and could even make room for concerts.[10]

With a sure mastery of effects, new motifs and new attractions were introduced into painting. The older manner lived on, not least in the oeuvre of Cima da Conegliano. His *Adoration* in S. Maria del Carmini (fig. 191) builds up before the viewer a stage-set landscape in which is placed a group of figures that, in terms of the history of types, represents a mixture of a *Madonna con santi* and a narrative picture.[11] It therefore meets the two requirements of the picture—to be both an altarpiece and a depiction of an event. In the execution, everything is equally illuminated and elaborated, figure by figure, plant by plant, and fold by fold. The bold innovations of Giovanni Bellini a generation earlier had become the basis of competent craftsmanship of the highest quality.

The new direction is represented by the *Adoration* in Washington (fig. 192), which might well be a work by Giorgione, perhaps even the *nocte* so eagerly sought by Isabella d'Este.[12] One of its characteristics is the emergence of closely observed and painted landscape details, each of which, like the details of the heads, the wall, and the drapery, draws attention to itself. But rather than combining into the evenly dense and intensely worked structures of Bellini (cf. plate 19) or drawing their strength from the human or narrative context, they are arranged as individual motifs. A process of seeing that passes with aesthetic enjoyment from motif to motif without concern for structures seems inherent in the painting.

The sfumato, which conveys the veiled appearance of distant objects but also, applied to things close at hand, creates a mysterious veiling of its own, becomes a central artistic device. The nature and degree of Giorgione's

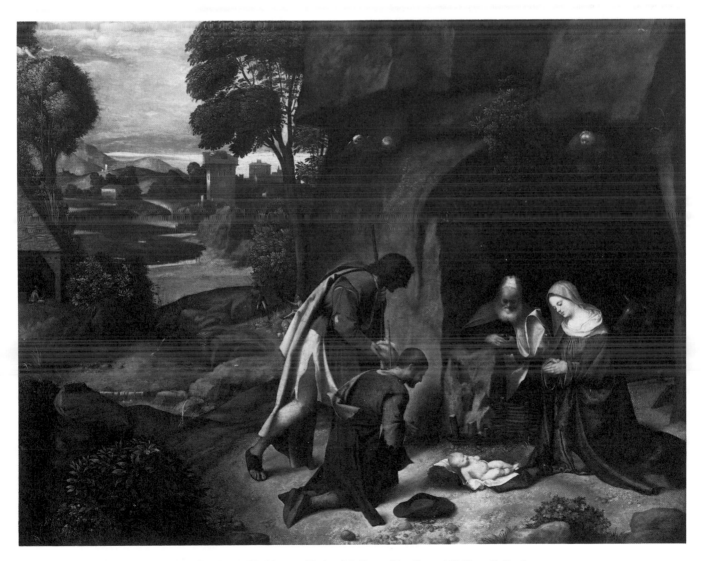

192 Giorgione (?), *Adoration of the Shepherds.* Washington, National Gallery of Art, Samuel H. Kress Collection

sfumato do not follow objective criteria, such as the fictive observer's distance from the object, being far too varied within one and the same spatial zone. Not only objects appearing in a particular manner are the theme of these paintings, but the changing attitude of the observer towards the observed. Not only the specific organic forms of tree and trunk, branch and leaf, can be experienced, but still more the gaze passing over their surfaces in a state of aesthetic contemplation. Everything, whether earth, plant, human being, or building, is seen and painted from the outside, articulated only at that level. Thus in the rocks it is not the structure of the stones that is stressed, but the magic effect of light that makes their surfaces seem no less alive than the leaves and grass.

A theme as traditional as the adoration of the shepherds, despite its interesting treatment, was an exception in Giorgione's work. The few works securely attributed to him show formally and thematically a juxtaposing of persons that, while devoid of structural relationships, is pregnant with meaning, fascinating and confusing, enchanting and disturbing. In the *Three Philosophers* (fig. 193)[13] in Vienna, for example, even the attributes announce that something unusual is intended. But no key is provided. This was not the result of inadequacy but of a plan, since X rays show a first version in which the three men clearly represented the Three Kings. However, Giorgione did not retain this straightforwardness. Whether he also wanted to change the theme of the painting is uncertain. A tension arises between the apparent simplicity of the motifs and their suggestive significance.

The visible, conscious intention in the use of artistic

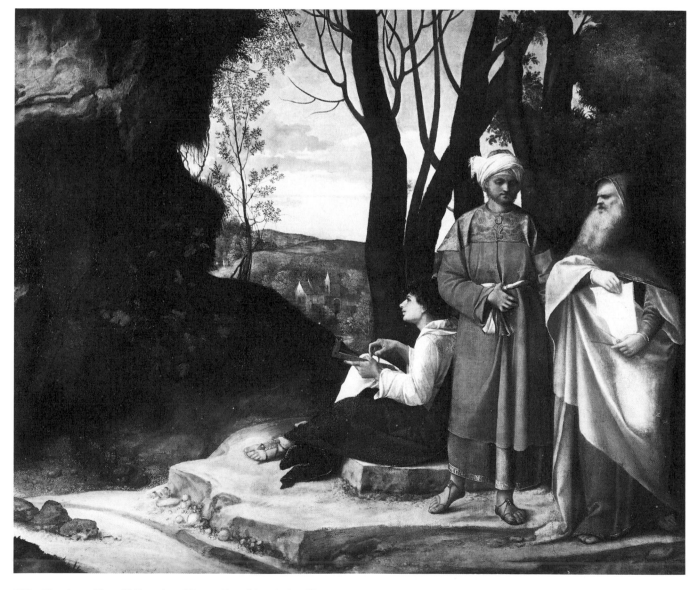

193 Giorgione, *Three Philosophers.* Vienna, Kunsthistorisches Museum

means combines with the calculated obscurity of the meanings to produce an interplay in which ambivalence and association count for more than unmistakable clarity. The pictures speak of people, states, and events while keeping the viewer deliberately in the dark about their causes, location, or time. How they were seen by those who first commissioned or bought them is difficult to reconstruct. Their social sphere was the collections in some noble palaces. Almost all the undisputed paintings of Giorgione are first mentioned there. In the notes kept by Marcantonio Michiel, himself a collector, often only the general theme is stated, not the specific subject of the picture.[14] We read of naked figures without being told who they were; landscapes, for example in the Netherlands, are mentioned, but not what was taking place in them. Did this happen because the initiated knew in any case, or was there a tendency towards *l'art pour l'art* here, not only in the forms but also in the meanings? According to his will, the aim of Gabriele Vendramin, one of the most important collectors, was to find relaxation and inner peace in the pictures that he had brought together "per adornamento" in several rooms of his house. His goddesses were called "eccellentia et rarità." The paintings were to be outstanding, but they were also to be rare.[15]

The freedom to decide not only forms but subjects was an important step in the emancipation of the artist. This path led not to the realm of freedom, however, but to the market. The very features that made up the partial autonomy of pictures were the most potent weapons in the struggle with competitors. Artistic originality became a commodity. Even freely created pictures were not only an end in themselves but also the means of obtaining contracts that may have brought money and honor but certainly not freedom. This competition made the rules of craftmanship as upheld by the guilds more and more obsolete.

The dissolution of the guild system gave more scope to the strong, but for the others it meant the end of a guaranteed livelihood that may have been modest but at least was secure. Poverty and bitterness were the results. Paolo Pino, one of the many painters who spent their lives in the shadow of others, complained of the new situation in a dialogue of 1548. The clients were too ignorant to appreciate good work, he asserted, and moreover they were tight-fisted. Meager earnings and low status prevented the painter from progressing in his art. Thorough preparation and repeated correction, which alone would have advanced him, were prohibited, for what should he live on meanwhile? The poverty was murderous. Often one was reduced to painting chairs, for commissions for panel paintings were as rare as comets. The artist was at the mercy of the judgment of an uninformed public. A single figure that displeased, and no

work would find favor again. Even the great Girolamo Savoldo, Pino's teacher, had not escaped this fate, having to live at times on a pension from the duke of Milan.[16]

Lorenzo Lotto was just over forty when he settled in Venice shortly before Christmas 1525; he had a varied but on the whole successful career behind him. Born about 1480 in Venice, he achieved his first successes in Treviso. In 1506 he moved to the Marches and from there to Rome, where he worked for Raphael at the Vatican in 1509. Back in the Marches, Lotto competed for the altarpiece of SS. Stefano e Domenico in Bergamo in 1513. Then began the most successful and artistically significant period of his life, at the center of which are the great Bergamo altarpieces. Fresco cycles and portraits brought further employment.

Why Lorenzo Lotto left Bergamo is not known. But he must have hoped for something from Venice other than the bitter disappointments that awaited him. His circle of acquaintances was modest. While he knew Jacopo Sansovino and had close contacts with the Dominicans of SS. Giovanni e Paolo, by and large he moved among craftsmen and small merchants. We hear of tailors, masons, perfume traders, gilders, dyers, notaries, and druggists. Lotto could hardly make a living from their commissions, and so was dependent on orders from the provinces. Most of them came from the hinterlands of Bergamo and the Marches, where clients were more interested in solid, ready-made items than the bold innovations of the Bergamo altars or the psychological explorations of Lotto's portraits.[17]

Lotto had brought the most important commission of his Venetian years with him from Bergamo. He had to design twelve scenes for the intarsias of the choir stalls in the cathedral of that city. For each scene there was a covering panel, and the only directive was that the meaning of its decoration should bear some relation to the scene beneath it. In the surrealistic brilliance of their invention and form, these *capricci* are, from a present-day standpoint, among the major works by Lotto. A Renaissance author called them "symbolic hieroglyphs." They are coded commentaries on the scenes they cover. To lift them to see the actual picture was also to reveal their secret. Some were difficult to decipher, but there are also simple ones like the cover of the scene of *Delilah's Betrayal* (fig. 194), where scissors and tufts of hair, hung up symmetrically—yet as if to dry—make the identification of the shorn head easy. The cistern behind which the head can be seen is more difficult, but a biblical passage solves the riddle: Proverbs 5:15–23 warns against adulteresses: "Drink waters out of thine own cistern, and running waters out of thine own well . . . Let thy fountain be blessed: and rejoice with the wife of thy youth."[18]

One hieroglyph likely to be controversial is the *Crossing of the Red Sea*. That the mask stands for falsehood

and the ass for folly, the cage around the head for narrow-mindedness, the mirror for vanity, and the squinting eyes for a lack of clearsightedness—all that was easy enough to make out in a picture where only the corpse of the wise snake is shown. But what makes the horseman into Pharaoh, when the helmet and cardinal's hat suggest far more topical connections? The artist's reply was as cryp-tic as it was disgruntled: "Know that these are not things that are written down. Imagination must bring them to light." [19]

Criticism of his *coperti* (covers) was only one of the many stages on the doleful path that the completion of this work represented for Lotto. Seen from his viewpoint, the Bergamasks lacked both understanding and com-

194 Lorenzo Lotto, intarsia, *Delilah's Betrayal.* Bergamo, S. Maria Maggiore

mitment. Promises were not kept, fees were willfully changed, and even firm agreements could not be relied on. Information on the desired themes was incomplete, and technical data such as dimensions and lighting conditions often came late, causing loss of time and belated corrections. On the other hand, the patrons' inefficiency and lack of a plan gave the artist scope that he used for initiatives of his own. Thus he began the *Downfall of Pharaoh* without direct instructions,[20] and a smaller scene "that no one asked for but which has a theme that pleases me, *The Five Cities of Sodom,* and because my surname, Loto, appears in it". At the same time he requested additional themes. Sometimes he made suggestions, for example, a depiction of Joshua holding back the sun.[21] The more drawings Lotto sent to Bergamo, the more agitated he became. Again and again he begged the *compagnia* to take good care of his designs and, above all, to conceal them from his competitors. There was clearly uncertainty on both sides. The painter felt a lack of appreciation for his art: he was, he said, being fed with hopeful words as at court.[22] The Confraternità della Misericordia in its turn was overtaxed as a patron, and the letters they received from the Venetian studio did not necessarily reassure them regarding Lotto. In March 1529, for example, he was unable to promise to design anything: "If a fantasia comes into my head, I shall do it; but I think this will be hard for me, as my mind is affected by various alien perturbations."[23] In February the arguments had so agitated him that he had difficulty in finding the inner peace he needed to work.[24] The theological doubts coming from Bergamo had particularly confused him. The freedom he had been allowed had come to an end. The peculiarities of the text and the many meanings ("sensi") of the Scripture were not what mattered to him, he wrote, and in any case he had sought advice from respected theologians and preachers.[25] He had probably found them in the monastery of SS. Giovanni e Paolo, where he was living at the time. The monastery was a theater for theological discussions that were very free even by Venetian standards, and not a few of its monks were regarded as clandestine Lutherans.[26] Lotto himself had theological interests, and even in bad years he saved money for books that were well thought of by reform-minded Christians. In 1540 he gave his nephew a small picture of Luther and, still more scandalously, one of Luther's wife, for the reformer's marriage to a nun incensed many of even Luther's friends.[27]

We owe this information to Lotto's account books, which give us an insight into his daily life in the years between 1538 and 1556; successes were rare and poverty was a frequent guest. Often there was no money for materials, and models, particularly naked women, were seldom affordable for Lotto.[28] We see how little he was able to sell in Venice, apart from small portraits, and we see his dependence on clients who either did not pay at all or tried to push down the price. We see how Lotto again and again, under humiliating conditions, assembled whole collections of paintings that others, usually unsuccessfully, put on sale for him at fairs and markets. In 1552, for example, he sent five paintings, with some ornamental pieces, to Rome, including "a John the Baptist; an Apollo surrounded by muses, asleep in paradise with a fame; a small painting of the child Jesus surrounded by the implements of the Passion; a Magdalen lifted up to Heaven by angels." Six months later not one of these pictures had been sold.[29] In 1550, having retired to Loreto a year previously, Lotto even had to part with the sketches for his Bergamo intarsias.[30]

When tradition and guild laws ceased to count, the individual integrity of the painter took on a new practical importance. The code of honor sketched by Paolo Pino in 1548 included, apart from suitable dress, education, the correct perfume, sexual abstinence, and riding to combat melancholia, a conduct in commercial affairs that Pino wanted to subject to the rules of aristocratic duelling. It was wrong, he maintained, to incite people to award commissions with drawings and grand promises.[31] These were the weapons of him who understood little of his art. The true artist was one who induced people to come to him. If another sought to better him, a duel in the form of a competition was in order, like the one that Palma the Elder wished to fight with Titian for the altarpiece of St. Peter Martyr in the church of SS. Giovanni e Paolo. If it was agreed that the more perfect work would be chosen, the artist could always preserve his honor in this way.

Only paintings could make an artist known, but the commissions for them often came only after his ability had been demonstrated. The difficulties experienced by a young painter in breaking out of this circle are described by Tintoretto's biographer. The only works to meet with approval in Venice were those of Palma the Elder, Pordenone, Bonifazio, and above all Titian, who had attracted all the most important commissions, so that it was difficult for Tintoretto to prove his skill with public pictures on important themes, which demanded much study.[32]

The most famous and successful of Venetian painters was Titian. From 1516, when he took Bellini's place at Ferrara, Titian had conquered a clientele and a public, first at the courts of northern Italy and finally in the whole of Europe, that absorbed a larger and larger part of his output. The link with the court of Mantua began in 1523, with the Emperor Charles V in 1530, and with the dukes of Urbino in 1532. In 1533 Titian was ennobled, in 1545 the papal court received him with honor, and finally, in 1548 and 1550 he spent many months at the Augsburg Imperial Diet, where the contact with Philip II of Spain, so important for his late work, was made.

This did not cause Titian to neglect his Venetian base. During longer absences like the trip to Augsburg in 1548, Pietro Aretino, as Titian's representative, reminded his competitors of their proper place in a series of letters well calculated in their content and timing. For each artist praise and blame were so mixed that the distance separating him from Titian was made clear even when Titian was not directly mentioned. In April a letter was sent to Lorenzo Lotto, containing compliments that could only be understood as mockery by the recipient.[33] Aretino sent greetings from Titian, whose successes he listed. But there should be no envy in Lotto's breast, he wrote, for even if Lotto was surpassed as a painter he had no equal in piety, so that Heaven would reward him more richly than this world. The letter to Schiavone[34] was also not lacking in references to the superiority of Titian, who had always praised Schiavone's *prestezza,* admiring the skill with which he sketched his histories, so that it was only necessary to turn the haste of the sketch into the care of execution and perfection. Next month it was the turn of Giuseppe Porta, called Salviati.[35] He too was praised, but only for his achievements in façade painting—a field Titian had long since left behind. Tintoretto, who had become especially dangerous through the sensational success of his *Miracle of St. Mark,* was conceded good draftmanship, powerful settings, and effective coloring, but these did not yet constitute the highest level of artistic perfection, and above all an over-hasty manner of work would have to be overcome.[36]

The most dangerous of Titian's rivals had been dead for ten years when these letters were written. Titian had met Giovanni Antonio de' Sacchis, called after his birthplace Pordenone, at the latest in 1520, when Titian was painting an *Annunciation* for the Cappella di Malchiostro Broccardi in the cathedral at Treviso, while Pordenone painted frescoes on the walls and the dome. In them the figure of God the Father draws behind him a throng of putti, in a vortex of movement not previously seen in Venetian painting, its dynamics only contained with difficulty within the circle of the dome. The painted critique of Titian's "Assunta" is unmistakable. Thus the place and rules of the coming duels were laid down. It was not a question of content but of forms, and in them it was not tranquillity and harmony that were at issue, but complex perspectives and breathtaking foreshortenings. The terms of comparison did not originate in Venice but in central Italy, most of them—by whatever detours—from Michelangelo. Both men, Titian like Pordenone, seem to have sought the confrontation.[37] Pordenone, the challenger almost forgotten today, had started the contest from an almost hopeless position, but by his death in 1539 had seriously threatened Titian's supremacy. In 1538 the Scuola Grande di S. Maria della Carità had turned to Pordenone for the further decoration of their *albergo,* not

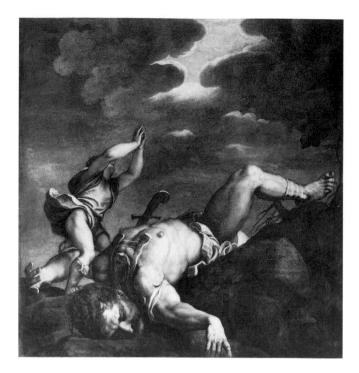

195 Titian, *David and Goliath.* Venice, S. Maria della Salute

Titian, although he had just finished his *Presentation of the Virgin* there. A year before Titian had to give up his place at the Doge's Palace to Pordenone for a time, and even the court of Ferrara was making serious advances to the challenger in these years. In 1536 Ludovico Dolce, later one of the missionaries of Titian's fame, named not him but Pordenone as the only painter comparable to Michelangelo—though he corrected this by 1538.[38] Finally, in 1537 the nuns of S. Maria degli Angeli returned an *Annunciation* to Titian as too expensive and ordered one from Pordenone.[39] In the courtyard of the monastery of S. Stefano where, according to a later legend, Pordenone always painted with a sword within reach for fear of Titian, he had another great success.[40] The remains and the reproductions of these frescoes, whether an *Entombment,* an *Adam and Eve,* or a *Descent from the Cross,* show flamboyant pictures that do not shun coarse effects. A small number of figures that seek to impress by violent affects and movements, further heightened by the view from below, fill the picture space to bursting point. Even the burial is dramatized, as if the body were not being laid in the tomb but thrown.[41]

This kind of foreshortened figure was praised by later art theory. As a particularly brilliant example, Dolce cites a façade decoration on the Grand Canal (fig. 53), praising above all a foreshortened Mercury, a battle, and a horse.[42] After the countless foreshortenings that were to follow in the next centuries, the *scorci* that so preoccupied artists and public at that time have become commonplace.

But in sixteenth-century Venice it was precisely in them and their mastery that the new autonomy of art was embodied. Pino therefore advised the young artist to include at least one heavily foreshortened, and therefore difficult and enigmatic, figure in each painting, so that connoisseurs could judge his ability.[43]

In retrospect the contest between Titian and Pordenone seems a very unequal one, not quite worthy of a Titian because of its exclusive concentration on somewhat superficial formal problems. However, Titian took it very seriously, and its traces are seen not only in his business conduct but in his art. Perhaps they are clearest in the ceiling paintings he produced for the church of the island monastery of S. Spirito (fig. 195) shortly after Pordenone's death, in which he sought to defeat the dead man with his own weapons (fig. 196).

Moreover, Titian had been only the second choice of the monks of S. Spirito. The first was the thirty-year-old Tuscan Giorgio Vasari, who can have had little more in his favor than a familiarity with the latest central Italian fashion.[44] Only the altarpiece was ordered from a Venetian painter, Bonifazio de' Pitati, while the refectory ceiling and the wall paintings were entrusted to Giuseppe Salviati, who also had Roman experience. Admittedly, the Venetians had no experience of ceiling painting and the associated problems of foreshortening, since Venetian ceilings up to then had almost always been without pictures. However, Giuseppe Salviati showed himself to be open to Venetian experiences and soon developed a tasteful, solidly eclectic, if rather uninspired, style of painting. From composition to color and foreshortening it offered everything that was prized at the time, but all in moderation, never quite seriously. His whole art has the same quality as the movements of Salviati's people: everything it touches loses its individuality and its sting.[45]

Salviati and Vasari were only two of a number of central Italian artists who tried their luck in Venice about 1540. Their appearance is interpreted by many scholars as the beginning of a "mannerist crisis" in Venetian painting. The forms taken by this "crisis," however, are as different as the works and the artists by which these painters oriented themselves and the manner in which they did so. There was never really a common set of methods and forms used to seek a way forward. The older painters, like Titian and Pordenone, seem to have paid most attention to Giulio Romano, with whom they were linked by a common origin in the painting of the High Renaissance, while the younger ones looked rather to the contemporary Tuscans: Veronese to the cool elegance of Francesco Salviati and the young Vasari, and Tintoretto to the figures of Michelangelo. From a Venetian viewpoint that may have looked like mannerism. But judging by the art of Florence, Rome, or Parma it appears at once that in the case of Venice, unlike those cities, one cannot speak of a mannerist style, but only of mannerist ferments.[46] And on closer inspection—even from a Venetian viewpoint—many of the "mannerist" phenomena become far more plausible if they are considered not as an expression of some general crisis, but within their own specific context. For example, Jacopo da Ponte in Bassano attempted to attach himself to what he thought to be a general Italian development, by adapting the most modern graphic methods. His attempts were unlike the preceding contest between Titian and Pordenone and unlike the claim of the young Tintoretto not only to equal Michelangelo's drawing and Titian's color, but to bring them together in a higher unity. Finally, the arrival of so many Tuscan painters certainly has less to do with the inner state of Venetian art than with a policy towards art and culture backed by powerful groups. Their goal was not mannerism but the systematic renovation of Venice on the model of Rome, and found its urban and architectural expression in the buildings of Jacopo Sansovino and Michele Sanmicheli.

196 Giovanni Antonio Pordenone, title page from Lodovico Dolce, *Il primo libro di Sacripante,* 1536

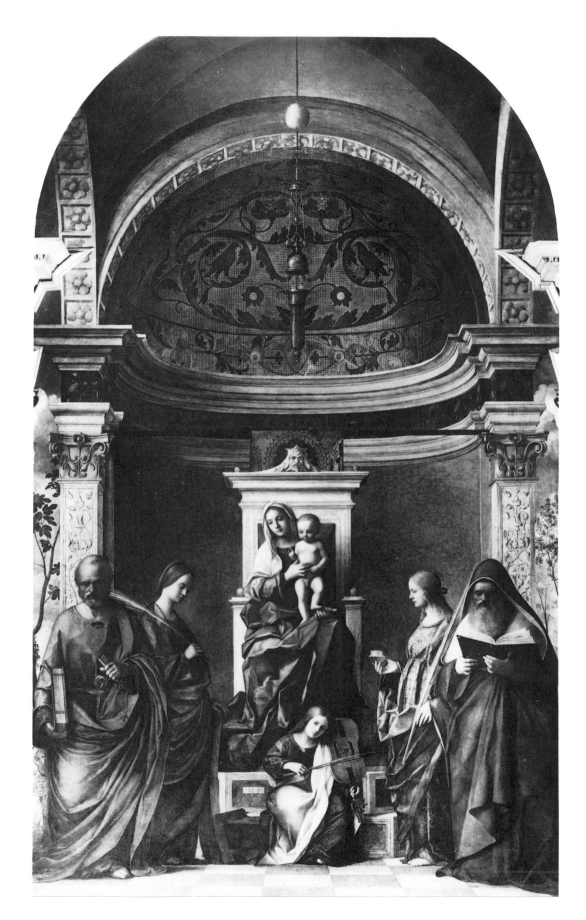

197 Giovanni Bellini, *Sacra Conversazione.* Venice, S. Zaccaria

Altarpieces and Devotional Paintings

In 1505 Giovanni Bellini completed his altarpiece for the convent of S. Zaccaria (fig. 197). Badly damaged today, at that time it represented the outcome of a preoccupation with this task that had lasted decades.[47] About ten years after it was finished, the painting was put, not without violence, into a frame matching those of the neighboring altars. To make it fit, it was extended at top and bottom by about a sixth and may have been cut somewhat at the sides. Whether the original frame continued the painted architecture is doubtful, and not very probable. The outdoor view in the painting must, however, have made it clear at that early stage that the saints were in a different location from that of the viewer. These glimpses of landscape, however, do not imply a profane treatment, as the laurel on the right and the fig tree on the left were familiar symbols of Christ.

The picture is most impressive from the left, as seen by someone entering the church by the main portal. When it had its original low frame, the contrapuntal relation between the broad, expansive architecture and the inwardly turned saints would have been more obvious than it is today. Of the three angels of the altarpiece of S. Giobbe (fig. 161), only one is left, and instead of the six saints there are only four. But as in the earlier picture the visual explanation of their presence is a central artistic problem. Most space is taken up by the diametrically opposed saints, Peter and Jerome. But as a counterweight, Bellini has given special importance to the two women's heads against the grey areas of the niche and in relation to the Virgin.

The saints illustrate different stages of inner meditation. In St. Peter, the first figure who confronts the approaching observer, something of the effort of inner concentration is still discernible in his face and hands. The folds of his garment running up to his arm also are energetic and concentrated in character. They are answered by the much looser folds of the garment of St. Catherine, which also establish a formal link to the center of the picture. The distinction in the folds corresponds to one of bearing; Peter's severely erect posture is answered by a gentle bending on the part of St. Catherine. With a characterization and linking of figures the painter creates relationships that prepare in an attentive viewer, while not enforcing it, an inner attitude matching that of the saints.

Giorgione, probably not long afterwards, produced an altarpiece (fig. 198) for his native city that, although it does not follow Bellini, takes him as a precondition.[48] He clearly felt the architectural framing of the figures to be constricting, and discarded it. The Madonna is placed on a kind of stage, between views of two small landscapes. As elsewhere, the accessories—coats of arms, floor, carpet, armor, marble plinths, folds of drapery—are given a good deal of space and attention. Everything is of the most precious kind, to which the lighting adds further interest, the dark shadows making the light effects prominent. The connections between the people are formal, being constructed in terms of symmetries and axes rather than arising from the actions or attitudes depicted. A second unifying element, which also does not come from the people, is the mood. It is surprising in an altarpiece, for even the child Jesus seems overcome by a melancholy that is seen both in the isolation of the people and in their eyes and bearing. The inner peace and composure of Bellini's altarpieces have given way to resignation. Even Mary is sitting as if she has to seek support from her throne. If Giorgione's St. Francis is compared to the one in the altarpiece of S. Giobbe (fig. 161), only differences are apparent, from the way of standing to the clothes, from the hands to the lighting. Even St. Liberalis appears a curiously sensitive knight. Giorgione has introduced mystery and secrets even into the altarpiece.

Giorgione's name was mentioned earlier in connection with the high-altar painting in S. Giovanni Crisostomo (fig. 199), painted between 1509 and 1511, in all proba-

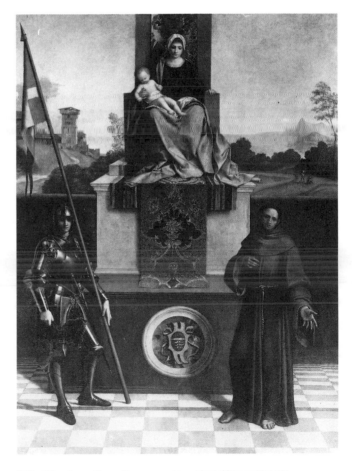

198 Giorgione, *Sacra Conversazione.* Castelfranco Veneto, Cathedral

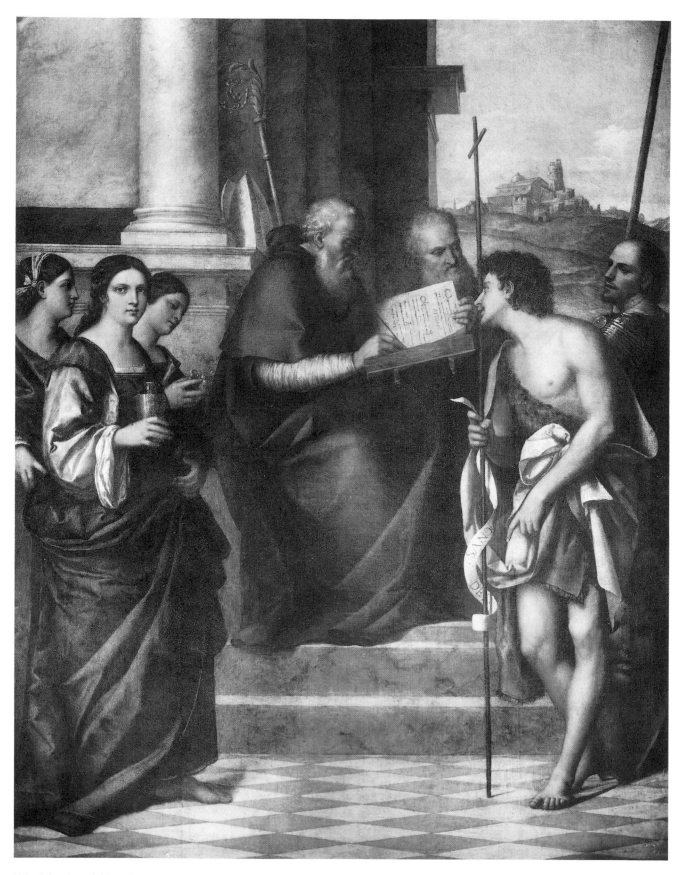

199 Sebastiano del Piombo, *Sacra Conversazione.* Venice, S. Giovanni Crisostomo

200 Giovanni Bellini, *Sacra Conversazione*. Venice, S. Giovanni Crisostomo

201 Titian, *Sacra Conversazione.* Venice, S. Maria della Salute

S. Giovanni Crisostomo (fig. 200), that had been ordered almost twenty years before. He appears to have designed and executed all its important features himself. In this painting the central saint is also seen from the side and from a considerable distance in a landscape. He is therefore smaller than the two other saints but at the same time is brought very close to us from this distance: a devotional picture has been inserted into a *sacra conversazione.* Breastwork and rocks contrast the two spheres yet hold them visually at once together and apart. In a similar way in the two young saints, analogies and points of comparison serve to emphasize differences: in the heads and attitudes, in the crosier and the walking staff, and in the openness or closedness of outlines. The inscriptions[50] in the mosaic of the vault belong spatially to the front zone, but their themes, death and resurrection, to which the fig tree distorted into a lectern also refers, relate primarily to St. Jerome. Extreme terseness and concentration of presentation force the observer too into a state of inwardness. The only distracting motif, the clouds behind St. Jerome, which deprive the sky and the saint's head of much of their solemn effect, are probably an addition by a contemporary who found the picture too severe.

The art with which Bellini manipulates distances and relationships is immaculate, as in the relations between the staffs and between staff and tree, which do not merely form a line but, despite their closeness, preserve distance and difference. The distinction in the lighting adds to this effect. Most light comes from the right, from the church entrance, from where the visitor sees Bellini's picture for the first time. But in the back zone of the painting there is a quite different light, so intensified and concentrated in the upper part of the sky and about the saint's head that it becomes an aura.

The saint at the center is sometimes identified as St. John Chrysostom. In that case the same person would be portrayed here as on the high-altar painting by Sebastiano del Piombo. But what a difference in conception and invention! Where it only occurred to Sebastiano to have the saint write in a book, Bellini has imagined a situation between reading and thinking, a pause for reflection, which conveys a sense of distance and solitude far more powerfully than busy book entries could ever do. And in the most restricted space Bellini includes closeness and distance, landscape and architecture, youth and age, wealth and poverty, high and low status—and all without visible exertion.

Young artists were able to offer something different and new, but never something deeper than this work of Bellini. Even Titian, in his early altarpiece in S. Maria della Salute (fig. 201), had difficulty infusing content and meaning into his assembled saints.[51] However, he probably understood his task merely as executing a pic-

bility by Sebastiano del Piombo.[49] The decisive innovation is the placing of the principal saint, who is seen not from the front but from the side. Paying attention neither to the other saints nor to the viewer or the church congregation, he is absorbed in writing. This set aside one of the unwritten rules that had limited the scope of Venetian altar painting up to then. In addition, the pictorial architecture no longer obliged the artist to present a complete structure but gave him a free hand to select architectural elements and compose them according to the dictates of meaning and form. Sebastiano's way of justifying and motivating the innovations is not, however, always convincing. Pleasing as the three saints on the left may have been to the churchgoer of the time, and novel as the yearning, almost languishing gaze of John the Baptist may appear, the industrious church teacher is hardly a fitting object for such yearning, and the three women are without motivation.

Bellini responded to the challenge by the young Sebastiano in 1513, when he delivered a painting, also to

ture type, to the meaning of which no one apart from Giovanni Bellini seems to have given much thought. However bold the idea to put all the emphasis on the figures and to reduce the architecture to three columns, however audacious the decision to place St. Mark freely in front of the sky, however interesting the presentation of St. Mark's face in a half shade pregnant with meaning, however concise the placement of the two pairs—the comparatively superficial deportment of these figures is worlds apart from the wisdom of the old Bellini. At what is St. Mark gazing, and to whom is he showing the book placed so significantly on his knee? Undoubtedly one of the two saintly doctors Cosmas and Damian is looking up to him for advice, but the advice seems to be of a more professional than spiritual kind, for as he is presented, he is involved in a medical consultation with his neighbor on the plague wound being shown by St. Roch. The choice of these saints, four of whom were invoked against the plague, makes it almost certain that the painting was produced at a time of pestilence, probably that of 1509/10. In Sebastian, however, there is no hint either of the distress of the client (as seen in the altar by Andrea da Murano, fig. 157) or of the solace that such a picture ought to dispense. Skillfully as Sebastian's body is conceived, with its almost juvenile softness, and brilliant as the painting is of the white loincloth, the picture conveys little beyond the narcissistic complacency of the youth who acted as model.

A few years later in 1516, Titian started work on an altarpiece that was to be epoch-making not only for his work but for the whole of European altar painting in the following centuries. For the Franciscans who unveiled Titian's "Assunta" (fig. 202) in 1519 on the feast of St. Bernardino, the picture had two primary purposes: to adorn church and altar and to act as a pictorial sermon giving powerful expression to the theologically very contentious doctrine of the Virgin's assumption into Heaven. As was usual, the frame, dated 1516, seems to have preceded the painting, not vice versa. But according to tradition the artistic conclusions that Titian drew from the subject, size, and location of the picture shocked the prior who had placed the commission. Titian is said to have painted the picture in the Franciscans' monastery and to have been constantly disturbed by visits and criticism: "Fra Germano, who ordered the work, complained again and again that the apostles were of excessive size, so that [Titian] had no little trouble in correcting the friars' judgment and explaining to them that the figures had to be proportional to the enormous space in which they would be seen." Titian's arguments had little success in the monastery, and soon an imperial envoy came on the scene, wishing to buy the painting and send it to Vienna. This alerted the monks to the work's

true value, and they realized that the evaluation of pictures "was not their true calling and that saying one's breviary and understanding paintings were two very different things."[52]

It is easy to understand the monks, for never before had such gigantic figures been conceived for a Venetian altar. Perhaps they also sensed that the painting was intended not only for their choir but for the less privileged people, the simple believers who had access only to the part of the church in front of the rood screen.

Titian gave his main figures dimensions that dominate the choir and command the more distant parts of the church. The most important themes can be clearly made out from a distance and understood by anybody: Mary

202 Titian, *Assumption of the Virgin* ("Assunta"). Venice, S. Maria dei Frari

entering Heaven, God the Father floating down to meet her—the figure in a red garment on the right of the picture who is so near to her optically yet never reaches her. This basic theme, orchestrated essentially in the primary colors red, blue, and yellow, is then—for those who look at the painting more closely and intensely—developed and paraphrased very richly in terms of color, composition, and theme. One sees the diversity of character and reaction among the apostles, who are left behind, the inexhaustible vitality of the putti, and the precise way in which Titian is able to distinguish the natural light below the cloud from the heavenly light around the Virgin, a reflection of which falls on to the apostles as a proof of grace.

203 Titian, *Ascension of Christ.* Brescia, SS. Nazaro e Celso

The painting's composition is also virtuoso. For example, the figure of God the Father, unlike Bellini's treatment (fig. 164), is shown as approaching and not as simply present. His appearance had to be made credible no less than his presence here, which Titian—very paradoxically—understood not as a fleeting moment but as something permanent. Similarly in the case of Mary he did not, as the logic of the scene might have suggested, put her departure from the earth in the foreground, but her abiding presence, which would have been comforting to the community. By expressing the movement almost entirely through her garment, he was able to show Mary's body as calm. The stupendous skill shown by Titian here is wholly at the service of what is being depicted. But although it never seeks to be admired for its own sake, it must have seemed breathtaking to all the experts present, artists and connoisseurs alike, when the "Assunta" was ceremonially unveiled in 1519.

This did not, however, dissuade the papal legate in Venice the following year from ordering from Titian a wholly conventional triptych (fig. 203)[53] that was as unsuited as could be to the dramatic theme of the Ascension of Christ. The individual panels may have been cut somewhat when being fitted to the present frame, but even in its original form the conflict between the type and the theme can have been hardly less apparent. Even the angel of the Annunciation seems to burst the frame. Christ himself at the center has barely enough room to escape his grave, and above him there is no room to show anything of the Heaven to which he is ascending. On the contrary, the flag cut off by the frame optically presses its bearer downwards. Titian might have avoided these difficulties if he had made the figures smaller. But by 1520, unlike 1500, that was no longer possible for an artist committed to modernity. Only large figures could be considered, even if they became as autonomous as the St. Sebastian, which is signed separately. Its artistic brilliance would have caused a furore in any princely collection, for which reason the duke of Ferrara tried by every means to lay hands on this part of the triptych.[54]

Friction between the format and the subject of a painting led painters in the second and third decades to a new type of picture, which was practiced by Bonifazio de' Pitati, Lorenzo Lotto, and Titian, but especially by Jacopo Palma the Elder.[55] The pictures are usually a good meter wide and about a third broader than tall. To judge by the format, most of them must have hung in houses rather than standing on altars. To an extent the "Madonna dell'umilta" was a typological model, in which Mary sits on the ground so that her whole figure could be seen even in a low-format picture. This sitting posture was now divested of its earlier connotation of humility, so that, kneeling or sitting, saints and patrons could keep the Madonna company. Veneration, whether by shepherds or kings, was especially suited to the format and

therefore popular. Probably for the sake of large figures, the pictures were usually filled to the edges, which could give rise to unusually intense confrontations with the viewer, particularly when donors were shown. The individual definitions and interpretations of the subjects by the artists were very diverse. For Palma such pictures were normally a welcome opportunity to develop his "existence painting." But in the picture in Lugano the juxtaposition of figures gives rise to what is by Palma's standards a violent dispute over the salvation of the donor. In Lorenzo Lotto's Vienna painting, too, the proximity is heightened into a concrete event (plate 20): James the Less has come, praying, to Mary, Catherine, and the child. The child, turning from St. Catherine and the book with which he had been engrossed, blesses him with so earnest and penetrating a look that one can under-

204 Titian, altarpiece of the Pesaro family. Venice, S. Maria dei Frari

205 After Titian, altar of St. Peter Martyr. Formerly in Venice,
 SS. Giovanni e Paolo

stand in the case of this picture, as with few of its time, that it not only gave artistic enjoyment but religious comfort. Even the movement of the rose-strewing angel, primarily directed towards the child, also seems to answer James's prayer. A masterful use of light in the manipulation of half shade and darkness and the intense coloring built up on light blue and white transfigure the scene with a fairy-tale radiance.

Titian's second epoch-making altarpiece, of 1526, was also delivered to S. Maria del Frari (fig. 204). The client was Jacopo Pesaro, for whom Titian had worked at the very beginning of his career.[56] The family members are placed under the protection of St. Francis, but the donor presents himself alone. With the attributes of his military triumph, the laural-adorned flag with his coat of arms and that of the pope of the time, he steps before the throne together with a captive Turk, who is led by a knight (or saint?). However ceremonially he bends his knee, he is one who can claim a fitting reception, not a supplicant or even someone seriously at prayer. At him, and at the saint

or the Mother of God, the family's gaze is directed. They too demonstrate status, not piety. This is particularly notable through the comparison with St. Francis, whose veneration of the Savior includes even the child's playfully extended leg.

St. Peter has a central position. As he is neither the name patron nor the church patron of this altar, there must be other reasons for his prominent position. From what we see, the reasons have to do with Jacopo Pesaro, for Peter mediates between him and the divine personages. He has his place two steps above ground level before the throne, where he has been reading before Pesaro's arrival. He pauses in his reading, turning to the newcomer. As in the other figures, the scenic elements are pronounced, yet they do not serve the narration of an event but the characterization of the people and their situation. The folds of Peter's cloak, artistically contrived and largely independent of the turning of his body, are so arranged as to form a contact with the knight, the flag, and the hands, and then, through Peter's forearm, a compositional link with the Virgin.

That the central role falls to St. Peter rather than to St. James is explained by the life story of the donor. Peter represents the church of the pope for whom Jacopo, many years before under Pope Alexander VI, a Borgia whose coat of arms is displayed on the flag next to the Pesaro arms, had won a decisive victory over the Turks. If St. Peter—that is, the church—from now on represents Pesaro, in his eyes that is the paying of a debt, not the bestowal of grace. An additional factor is that Jacopo's contribution to the long-past victory had been publicly exposed to serious doubt in Venice and was now being confirmed at least pictorially.

In terms of its function and its typological characteristics this work, although donated as an altarpiece for a scuola, belonged to the category of private devotional pictures, of the kind that Doge Barbarigo, for example, had painted for his private palace.[57] The translation of this type from the horizontal to the vertical format posed extraordinary difficulties for Titian. The Madonna is moved far up and to one side, and while this made room for other figures, it made it difficult to give her the position that befitted her. She could not be placed too high if the link to Pesaro were not to be lost. To begin with Titian seems to have planned an oblique view into a hall-like architectural structure. Only by a second step did he arrive at the spectacular columns that owe their origin to the necessities of composition rather than to a deep theological meaning. Like the whole arrangement of the painting they made a powerful impression on Titian's fellow painters, for the number of double columns in Venetian altarpieces immediately increased sharply.

On closer inspection, which perhaps was not the habit of the client, we note a large number of features

206 Titian, *Salome*. Rome, Galleria Doria-Pamphili

207 Giorgione, *Madonna.* Oxford, Ashmolean Museum

that tend to relativize the importance of the family. This is not done directly, however, but by an intensification of the saints. Not only is their realm, already cut off by the steps, distinguished by the columns, but they are marked out further by the concentration of the most intense light on them and by the fact that they alone are given harmonious color effects.

The next high point in Titian's altar painting was the picture he began in 1528 for the altar of the confraternity of St. Peter Martyr in SS. Giovanni e Paolo (fig. 205). The confraternity had apparently awarded the commission to a less important painter when Palma the Elder, who was a member of the confraternity, sent a petition to the chiefs of the Council of Ten, the supervisory body of the scuole. Some members of the scuola, Palma complained, wanted to entrust the painting to people who were not equal to the task. He and like-minded members, however, wanted a painting of a beauty and perfection that matched the rank of the confraternity and its church. Palma believed

he was acting as the chiefs of the Council of Ten would themselves wish if he offered to commission the painting from one of the leading artists, if necessary at his own expense, in order to avert a scandal. Artistic quality was for him, therefore, a means of ostentation.[58]

Palma's petition was rejected by the authority, but he seems to have got his way with the confraternity. Later sources tell of a competition among him, Titian, and Pordenone that Titian won. That Titian displayed an unusual degree of ambition with regard to this painting is amply demonstrated by copies of the picture, which burnt in the nineteenth century. After the countless martyrdoms that appeared on Italian altars from the end of the sixteenth century, Titian's design no longer looks so unusual. At the time of its conception, however, it exploded all the standards and norms. Even the sketch by Pordenone, who was famed for excessively dramatic treatments, seems reserved by comparison. A concentration of this kind, a reduction to so few gigantic figures or so

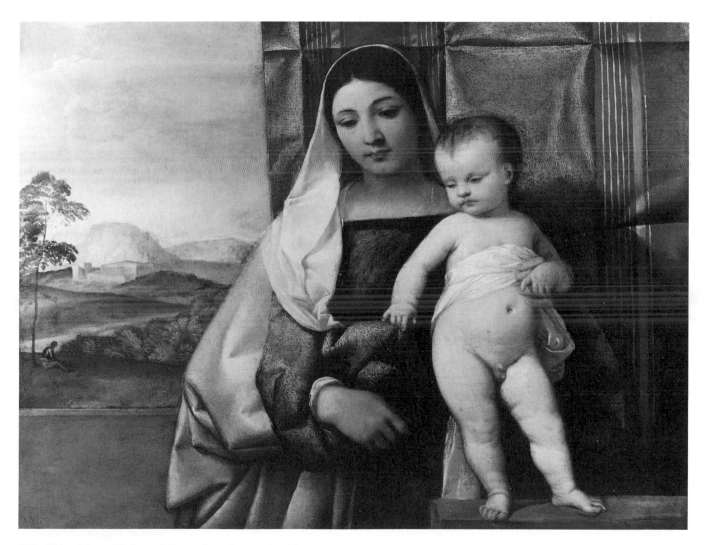

208 Titian, "Gypsy Madonna." Vienna, Kunsthistorisches Museum

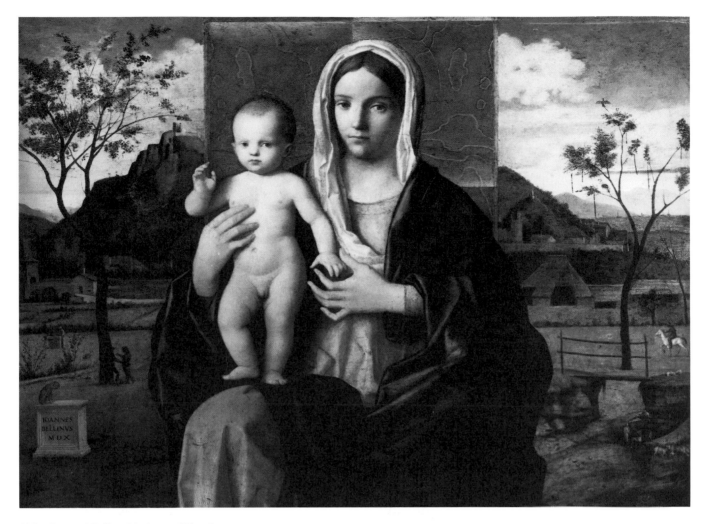

209 Giovanni Bellini, *Madonna.* Milan, Brera

breathtaking a counterpoint between the event and its staging as Titian presented here in the saint and the trees, had never been seen before 1530.

Such paintings were hardly suited to be the object of pious contemplation—worlds separate them from the altarpieces of a Giovanni Bellini. The secularization seen here,[59] however, was not confined to altarpieces but from an early stage affected devotional pictures as well. While the large-scale production of madonnas by Bellini's successors continued, the *Magdalen,* who was to be "as lacrimose as possible," ordered from Titian by Federigo Gonzaga,[60] was to have many sisters (fig. 251)[61] in whom the charms of the beautiful sinner were more in evidence than her contrition. This would not have displeased the clients, many of whom must have thought as Federigo did, who once, ordering a picture from Sebastiano del Piombo, left the artist free to choose the subject, as long as there were "no nails or other Franciscan hypocrisies."[62] Not infrequently the religious subject was simply an alibi. Lorenzo Lotto's account books list a

number of pictures of saints that were concealed portraits of the client. Dominicans, for example, who could hardly hang their own portraits in their cells, had themselves painted as a half-length St. Peter Martyr.[63] Of Titian's *Salome* (fig. 206) it has been convincingly shown that she probably served to portray a very private and extremely profane subject matter. Though suggested by the putto, the subject was only fully comprehensible to someone who was familiar with the apocryphal tradition of a love relationship between John the Baptist and Salome and who also knew that the St. John on the platter had the features of Titian.[64]

Even in the devotional pictures that do not contain coded amorous messages, the religious function—as far as it still existed—was increasingly undercut by profane themes. For example, Giovanni Bellini, in madonnas like the one in Bergamo (plate 18), shows the child so large and so important that it controls the entire picture. Giorgione, by contrast, showed an everyday scene (fig. 207), not unlike the rooms that such pictures adorned.[65] The dimensions of the reading mother and the child lying

beside her are much closer to those of reality. Simply from its appearance, the picture might be called "Venetian woman with child at the window."

About 1510 Venetian devotional paintings became considerably larger, and at the same time the previously vertical rectangular panels became mostly horizontal rectangles. The new format—particularly when the Virgin and Child were alone—left far more room for other motifs. There was a temptation to be diffuse rather than concentrated, and the gradual drawing aside of the curtain created on the left the space for a large, self-contained landscape. Titian's "Gypsy Madonna" (fig. 208) is one of the earliest and most significant examples.[66] Its landscape lacks any motifs that would have pointed to a meaning other than the literal one, mother and child. The abundance of exactly depicted but religiously significant forms was disap-

pearing, connections were created more and more by moods and less and less by a symbolism anchored in tradition and so capable of objective presentation. As compared to Bellini, formal relations, like the iconographic ones, also become looser in the young Titian. On the other hand, individual elements, whether the Virgin's face or the landscape, gained space and freedom to take on significance for their own sake rather than as part of a superordinate whole. For this reason a mode of viewing directed solely at natural and feminine beauty meets far less resistance in Titian than in Bellini. That Mary in the "Gypsy Madonna" has become, in her posture, her appearance, her strong hands and dark complexion, a simpler woman than in Bellini, can be interpreted theologically, but there is no compulsion to do so. Even Bellini's late work (fig. 209) was affected by this general development. But in Bellini, and only in him, this devel-

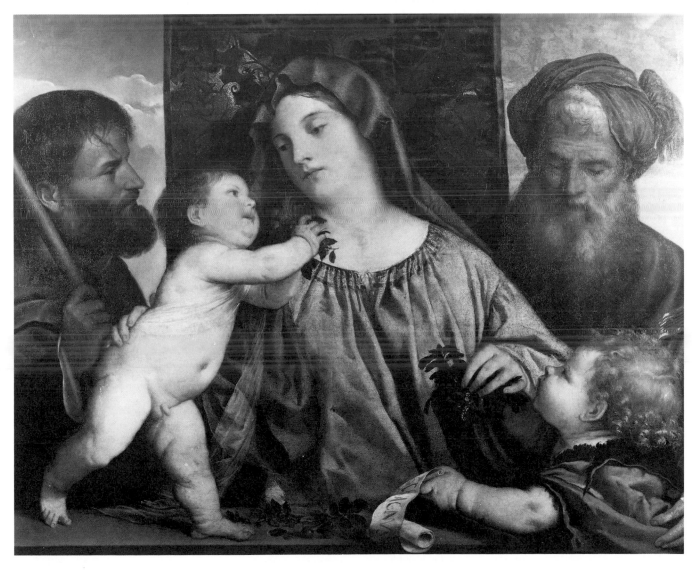

210 Titian, *Madonna with Cherries*. Vienna, Kunsthistorisches Museum

opment was the occasion for a significant invention: with childlike unsteadiness Jesus stands on his mother's knee, seeking room and support, still a child, yet nearly ready to take up the attitude of the world ruler who gives blessing.

In Titian's *Madonna with Cherries* (fig. 210), the half-length picture is conceived as a section from a scene.[67] There is no continuous breastwork. All the movements and postures have their cause and their goal within this scene. With the traditional frontality, the direct relation to the viewer has been abandoned. In later pictures[68] the structure became still looser. Titian's paintings were shaped more and more by features taken from narrative painting. The half-length painting lost its identity. A scene is presented that demands an effort of imagination from viewers but also limits them. The composition of a painting no longer enjoins an ever-renewed, pious meditation but admits other modes of contemplation. Thus while one may know that cherries are a symbol of the Passion, one does not need to know it, and the picture does not suggest any "deeper" meaning. One can equally well simply take pleasure in the colors, the light, the character and manliness of James, or the free movement of the child's body.

Of the important painters of his time, Lorenzo Lotto possibly painted the most devotional pictures. On one hand this painter, who could not choose what he painted, appears to have supplied the very large market for artistically insignificant Madonna-with-child pictures, of which, according to inventories, even poor Venetians usually owned more than one.[69] But on the other, as a quite young artist Lotto tried to equal Giovanni Bellini, if

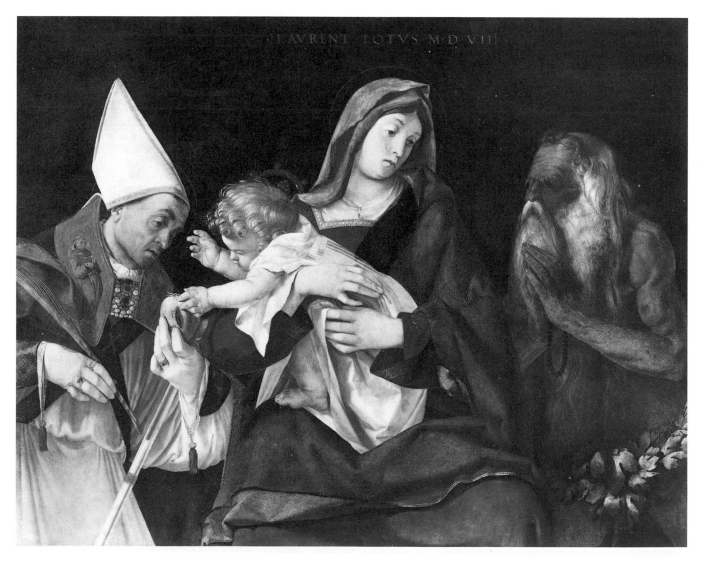

211 Lorenzo Lotto, *Sacra Conversazione.* Rome, Galleria Borghese

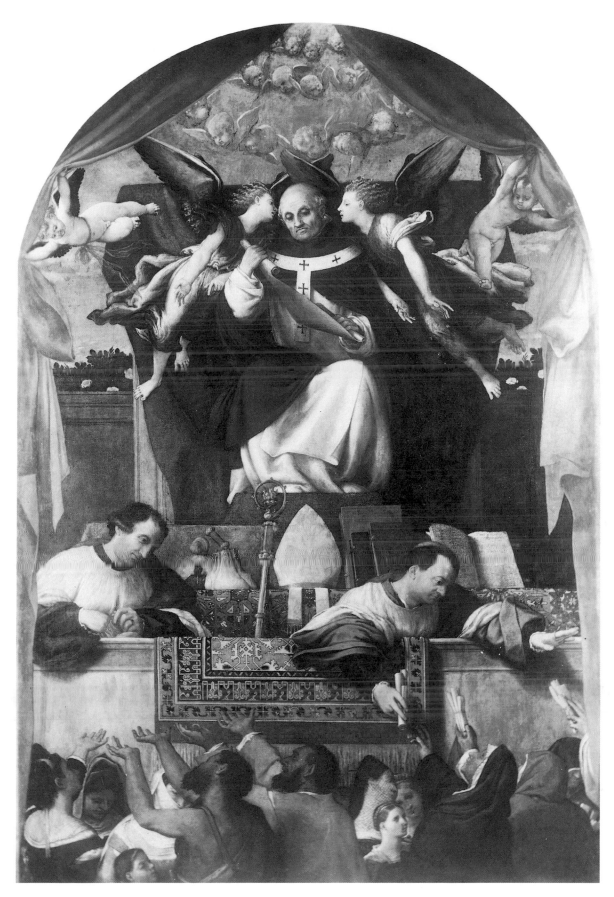

212 Lorenzo Lotto, altar of St. Anthony. Venice, SS. Giovanni e Paolo

not to surpass him. Moreover, for this artist, who once during Holy Week painted a Christ on the cross surrounded by the instruments of the Passion[70] for his own edification, the religious function of devotional pictures was undoubtedly still obligatory. One of the earliest of these pictures (fig. 211) shows within a confined space (53 by 67 centimeters) almost too much meaning and invention. The faces in Lotto's youthful works mostly come from the standard types of the Bellini workshop. They were not simply taken over by Lotto, however, but were developed and accentuated, so that the gentle became still more gentle, the dignified more dignified, and the earnest more earnest. In elaborating the compositions, the artist often created wide differences. Thus the part between the Christ child and the saint on the left, densely packed in terms of form and meaning, is opposed on the right by a section relatively devoid of tension. Facial expressions and gestures are nearly always treated very deliberately by Lotto. The naturalness and serenity of Titian's beings remained foreign to Lotto throughout his life, and not uncommonly he verges on the exalted. Equally, as regards the religious significance of the pomegranate—unlike that of Titian's cherries—there can be no shadow of a doubt.

About 1535 the era of innovative upheavals in Venetian altar painting was over. Even quite conventional solutions found an audience. In S. Maria del Frari Bernardino Licinio was able to erect an altar in 1535 that, though imitating the style of Pordenone's figures, was in fact a document of utter perplexity. Pordenone himself had shown more ambition three years earlier when he painted an altar for the Madonna dell'Orto. At the center he placed Beato Lorenzo Giustiniani, who is beckoning the faithful to the altar. In each figure one detects the strenuous attempt to achieve a new, impressive invention. St. Francis is obliged to fall to his knees in veneration of the lamb, but Pordenone failed to discover a matching motif for John the Baptist, who is holding the lamb, and he finds no better occupation for St. Louis than to involve him in a theological disputation.[71]

The most important altarpiece of these years is the one of St. Anthony, delivered by Lotto in 1542 to the Dominicans of SS. Giovanni e Paolo (fig. 212). The monks paid little but promised Lotto a free funeral in appropriate dress. For this altarpiece, the most important of his Venetian commissions, Lotto had made intensive preparations. On several occasions he had to spend money to do portraits of "poor people for the painting of St. Anthony."[72] Poverty and ways of dealing with it are the theme of the painting.[73] Even at first glance, the panel shows no selfless Franciscan generosity. Two putti draw aside the curtain on a situation depicted on three levels. In the bottom, narrowest zone the poor are seen, followed by two ecclesiastical secretaries and finally, at the top, St. Anthony of Florence. Almost exactly in the middle of the painting are seen the insignia of a bishopric and some money bags, which are well filled but closed. The area into which the poor are crowded is adorned with a sumptuous carpet. Access to the alms is sought in vain. Of the two secretaries, the one on the left jangles his purse while the other receives or rejects petitions.

As bishop of Florence, St. Anthony concerned himself theologically with the problem of the right treatment of the poor. The highest goal, he concluded, was to combat begging, so that alms were not to be distributed spontaneously or directly, but only after careful examination and only through the parishes. Above all one should make sure that those seeking help were not merely indigent but deserving. People of rank who were ashamed to make their need public, for example, were to be given precedence. There had been legislation based on the Florentine bishop's maxims since the beginning of the sixteenth century in Venice. Since the Dominican order upheld the views of its deceased member, there can hardly be doubt that the picture painted by Lotto was to help the propagation of his ideas. What Lotto's own views on them may have been we do not know; perhaps he even shared them. But, in a way of which the artist was possibly unaware, his picture became a critique of the official treatment of the poor that could only come from someone who knew poverty from his own experience. On close inspection we see that most of the petitions are refused, that so far not a single coin has been distributed, and that no one shows any sign of acting otherwise. Someone who had often sought help in vain would be as familiar with the indifferent objectivity of the secretaries as with the distasteful expression of the saint as he studies a petition, ignoring even the attempts of the angels to draw his attention to the poor.

Portraits

Even in the sixteenth century the esteem enjoyed by a portraitist could not match that of a history painter. It was said of the Bergamask Giovanni Battista Moroni, who was reputed to have been recommended by Titian himself, that he produced only a few *opere d'invenzione,* since he concentrated on portraits, for which he had more talent. However, even if portraits could not take first place in painting, since the painter was obliged to imitate and could not demonstrate the liveliness of his mind, nevertheless portraits were to be praised provided they were well painted and good likenesses.[74]

The forms of the Venetian portrait were as diverse as its locations and its functions. Concealed portraits continued to be produced, and crowds of portraits continued to populate the history paintings in the Doge's Palace and the scuole grandi (figs. 178, 245). The majority of por-

traits as such were painted for the private sphere. If the painter or the sitter was a prominent person, the pictures could take on considerable mobility. Aretino presented his portrait signed by Titian to Federigo Gonzaga, who also received a portrait of his court architect Giulio Romano from Titian himself.[75] Titian also painted portraits to earn the favor of his business partners,[76] and Lorenzo Lotto used them on occasion to pay the rent he owed. Titian painted portraits for exchange as well, trading his *Alessandro Trasontino* for a harpsichord,[77] for example, and when on one occasion Titian was unsure whether the subject of a portrait was still in favor when it was delivered, he assured the recipient that any painter could transform it with two brushstrokes into a likeness of someone else.[78]

The portraits of the sixteenth century were usually at least twice as large as their predecessors. They all replace the profile by a three-quarter view, and practically always the hands were included in the picture. But not only the form of portraits became more complex, so too did their psychology. Possibly as a consequence of the grave political and moral crisis that Venice and its ruling class passed through at the beginning of the century, the portraits from those years reveal a far more restless group of people than those of the preceding generation. We meet with nervousness, melancholy, and resignation, in the women as well as the men. Entirely new provinces of the psyche came into view for painting. People like these had certainly existed before, but now, for the first time, they found artists who had an eye for them, and only now do such states of mind seem to have become socially acceptable enough for the pictures to be hung and their subjects content to be remembered like this by posterity. The closed, uniform way in which up to about 1500 the ruling class had presented a calm, serious front, thanks to an obligatory portrait type and an obligatory bearing, was for some decades eclipsed by the multiplicity of individual temperaments and characters.

If Palma's *Ariosto* (fig. 213), Giorgione's Berlin *Young Man* (fig. 214), or Lotto's *Young Man before a White Curtain* (fig. 215) are compared to the young men by Giovanni Bellini, even the section of the person shown in the portrait shows the younger men's dissatisfaction with the way their fathers had had themselves painted.[79] In addition, the new paintings give away more about how they were produced. The attentive observer, at least, is kept aware of the situation that one person is sitting for another, presenting himself or herself to be painted. Unusual sections, new poses, a surprising attribute, or an especially interesting light effect remind observers that the portrait in front of them is the result of the artistic interpretation of one person by another, and so does not show the sitter "objectively," not "as he or she really is," but as Palma, Giorgione, or Lotto saw the sitter. The manage-

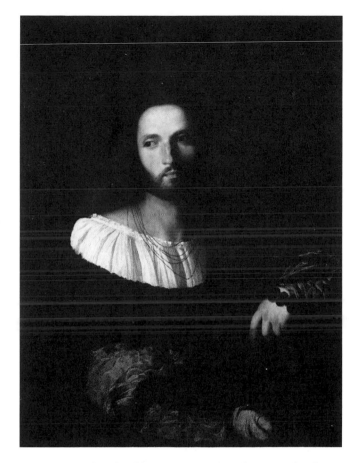

213 Jacopo Palma the Elder, *Ariosto*. London, The National Gallery

ment of light, with which painters now liked to arouse admiration, made use of an element that the artist manipulates. With light the artist can reveal or conceal, divide or join, what is not divided or joined in itself, but only from the artist's viewpoint.

By means of light, too, art could now portray moods in an entirely new way. The master of moods was Lorenzo Lotto. Even in his early works his attention was drawn to the flawed or ambivalent aspects of his models. In the portrait of a youth (fig. 215), for example, the light brings out the unformed, uncertain qualities. The curtain borrowed from Madonna paintings does not mitigate this impression, but rather heightens it: neither calmly spread nor cast into noble folds, it looks agitated and petty. The single large fold looks almost like a cut, while the hesitant outline of the edging on the right seems to paraphrase the character of the young man. The painter has inclined the curtain somewhat inwards, to show the small oil lamp, one of the commonest symbols of transience. The viewer's gaze is met by that of the youth, who looks as if he wants not only to be seen but in his turn to examine the viewer. He makes the alert observer aware not only of the painter's art but of the observer's position as a voyeur.

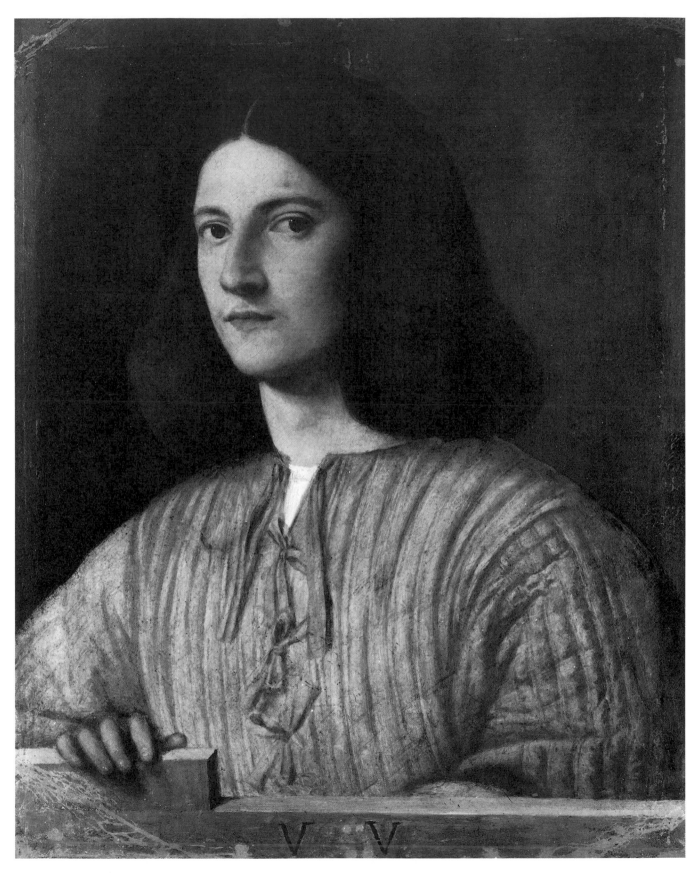

214 Giorgione, *Young Man.* Berlin, Staatliche Museen Preussischer Kulturbesitz, Gemäldegalerie

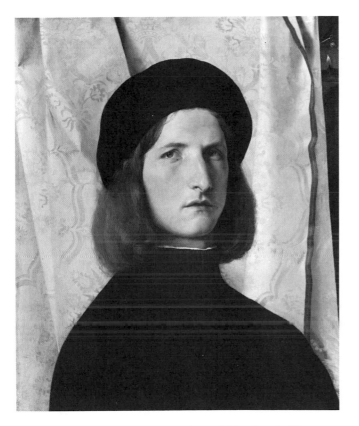

215 Lorenzo Lotto, *Young Man against a White Curtain*. Vienna, Kunsthistorisches Museum

In no small number of Lotto's portraits the question arises whether he was really concerned with the "essence" of the sitter at all, that is, whether he wanted to show what lastingly characterized the sitter, or whether he was exploring what the sitter might also be. In the totality of his portraits, which prior to modern photographic collections could only have been present to the mind of the artist (and then only in memory), one finds a quite different psychological spectrum than in Titian, for example. What in the individual portrait seems a character trait turns out in retrospect to be a part of Lotto's anthropology. Many other elements, on the other hand, could only have been understood by the sitter's immediate circle, owing to their ambivalence and ambiguity. The allegorical accessories, for example, admittedly make use of the usual attributes, but probably only someone who knew the sitter could have known which of several possible interpretations fitted the actual case. In particular, the pale, unknown figure in the Accademia (fig. 216) has elicited whole novellas from later commentators.[80] The puzzles begin with the place depicted and the posture of the sitter. Is he bending down towards the table, or in the act of standing up? Is he looking up from reading, or only absent-mindedly fingering the parchment pages of a book he is not really aware of? This book is probably the ledger of a trading firm, but the table it lies

on is certainly not that of a countinghouse. On the wall hunting implements and flutes evoke favorite occupations of aristocratic youth. They are to be seen behind the young man's back, but has he therefore mentally turned his back on them too? And if so, does that mean that he is now to devote himself to business?[81] The rose petals point to unhappy love and tempt us to interpret the letter as a love letter. But what of the unopened letters on the right—has the young man written them or received them, do they even contain the reply to what the opened letter says?

Even the portrait of an art collector (fig. 217) became, under Lotto's restlessly penetrating gaze, a psychological frontier expedition. Painted in 1527, the picture is mentioned five years later in the collection of Andrea Odoni, and it had probably not been anywhere else. Whether it depicts the sitter's collection as well as the collector himself is not known, for many of the figures have not been identified. Perhaps Lotto is showing Odoni in the midst of an ideal collection, an interpretation favored by the fact that only ancient sculpture is shown and no pictures.[82] The portrait was hung in Odoni's bedroom, where bronze statuettes, devotional pictures, and "a large nude" by Girolamo Savoldo were also to be seen. Surprisingly, Lotto's Odoni does not give his treasures a single glance. He holds a statuette resembling the Diana of Ephesus in his hand, but he does not hold her in such a way that he or the viewer can see her particularly well, but as if he wanted to argue about her and defend his collection. Whether he had himself read Petrarch's attacks on this vice, or whether the painter was alluding to them, is highly uncertain. A certain bluntness of face and body make Odoni appear a somewhat ponderous, narrow-minded person, a fetishist rather than a humanistic, cultured art lover. But what is almost alarming is the way the marble sculptures change in Lotto's painting. The head of Trajan under the tablecloth looks hardly less alive than its owner, and is so placed that it seems to be just emerging from under the cloth.

Among Lotto's contemporaries, such ambiguities are uncommon. When Bernardino Licinio signed his portrait of Ottaviano Grimani (fig. 219) in 1541, he had completed an ambitious work of which he and Grimani could rightly be proud. Neither was untouched by the art of portraiture that Titian had developed in the preceding years. The empty background and the section of the figure are evidence of this. However, their understanding did not go very deep. Perhaps only Licinio's limits are revealed when he paints Grimani without further transformation in the probably status-conscious pose he has struck. Whether the painter was simply letting him have his way or advised him on the choice of posture is a workshop secret. What is striking, however, is the artist's way of looking, which sees his subject not as a person but as a thing. With uniform, unflagging care he regis-

tered what he saw in front of him. Or was it indifference, if the tailor's work was given the same attention as the features, and the eyes were not more important than the buttons?

Titian's portraits never confined themselves to fixing what was unquestionably present. In the *Aretino* in Florence (fig. 218), for example, Titian transformed the massiveness of his friend's body into a psychological power that seems to form and unfold before the observer's eyes.[83] As Titian only loosely sketched the edges of the painting, Aretino gains more and more volume and presence from below to above and from outside towards the center. The picture culminates in the face, which makes the fullness of body appear as an expression of Aretino's

vitality. The change in technique from the simplifying sketching to the highlights put in finally, reminds us constantly that the picture has been painted and at the same time characterizes this painting as a process of exploration, discovery, and celebration. Titian can only have been disappointed, therefore, when he read what his friend had printed about this, his freest and most personal portrait up to then: "To be sure, it breathes, its pulse beats, and its spirit moves just as I am in life. And if I had paid more scudi, the materials would indeed have become glowing, soft, or stiff like silk and brocade."[84] However, Aretino used the painting as a present for the duke of Florence. He must have feared that there would be little appreciation of Titian's specific qualities in that

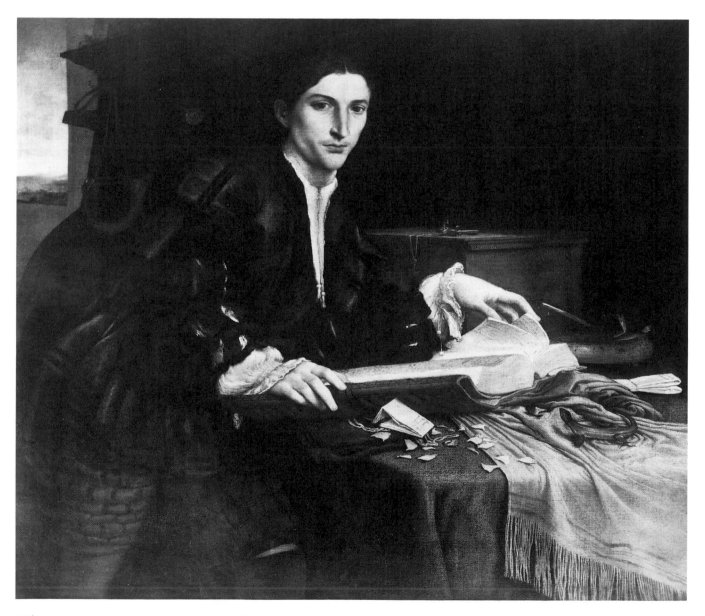

216 Lorenzo Lotto, portrait. Venice, Gallerie dell'Accademia

quarter, and wondered whether the gift might miscarry in its purpose of securing him the ruler's favor. It had been only in 1537 that Aretino had declared precisely the freedom of Titian's style his stylistic model.[85]

There is a second portrait of Aretino by Titian (fig. 220), but its dating is disputed.[86] If, as is likely, it was later than the portrait in Florence, it would be a response to Aretino's letter, for it avoids everything that was criticized there. However, this cost Aretino dear. In a conventional sense he appears a thoroughly important person, sumptuously dressed and adorned with the chain presented to him by the king of France. The fur on the mantle gleams, everything is clearly recognizable and, in a banal sense, excellently painted. But of the vitality and fire of the first portrait nothing is left, and instead of the brow and the eyes, the thinning hair and fleshy neck are prominent. We are no longer informed about Aretino's nature—which Titian saw in a positive light—but about the contents of his wardrobe and his jewel box, as well as the stoutness that went with such prosperity. Had the Aretino of this picture been a merchant, no one would have doubted his solvency.

The most artful quality of Titian's portraits is the natural way his subjects present themselves. Lotto, in his Vienna nobleman (fig. 223), for example, shows a far more interesting posture, a far more unusual attribute, and a background much more charged with significance than does Titian (fig. 221). Lotto's picture depicts a man who

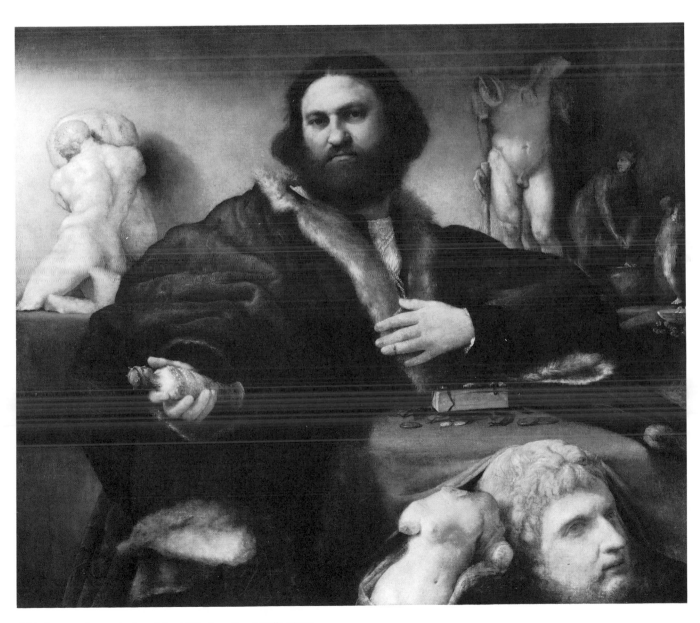

217 Lorenzo Lotto, *Andrea Odoni.* Windsor, Royal Collections

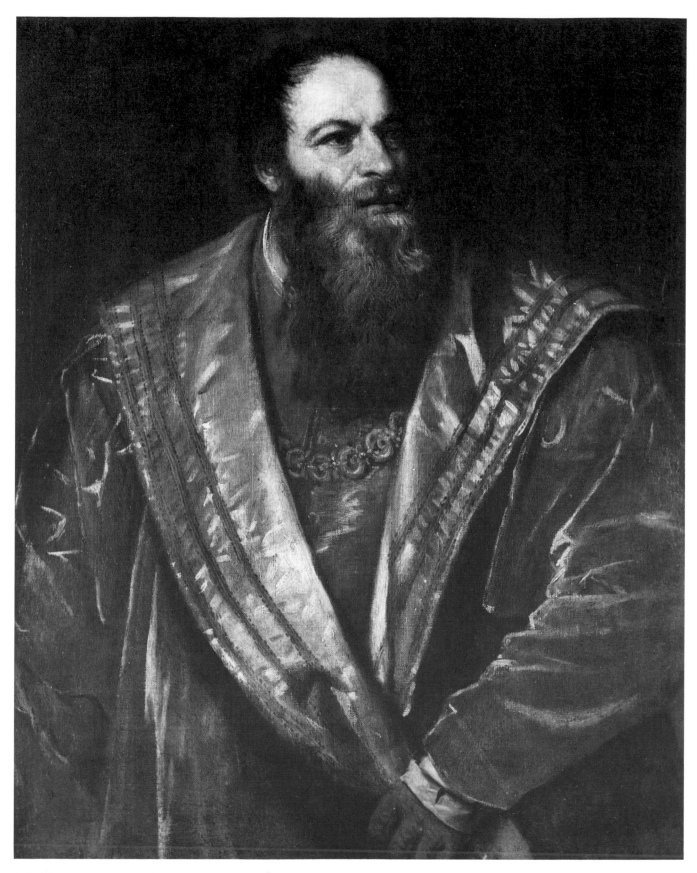

218 Titian, *Pietro Aretino.* Florence, Palazzo Pitti

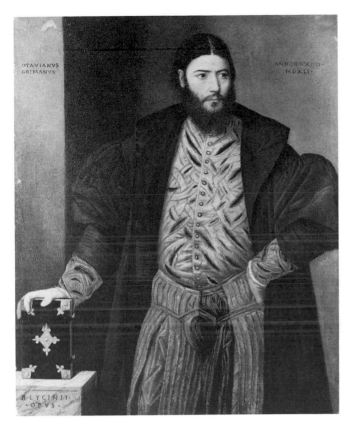

219 Bernardino Licinio, *Ottaviano Grimani.* Vienna,
Kunsthistorisches Museum

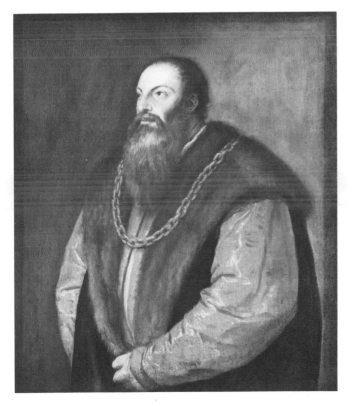

220 Titian, *Pietro Aretino.* New York, The Frick Collection

is posing, painted by an artist who, while, acknowledging the pose, reveals it at the same time as "put on," and so as a sign of a split identity. Both painters—as was usual in the sixteenth century—show their subjects slightly from below, from a viewpoint of respect. In Lotto one feels, and is no doubt supposed to feel, that this viewpoint has been chosen by the artist, whereas in Titian the slightly upward view, imperceptible to the viewer, merely adds a certain dignity to the subject. In both portraits the way the attributes are treated is important. Titian shows by it that his noble embodies the class ideal of *sprezzatura* (B. Castiglione), while Lotto was concerned with the sitter's problematic relation to himself.[87]

The prerequisites of great portraiture included, with artistic ability, the experience the painter had had in his life. Titian, from his years of dealing with the mighty, must have had a different horizon than Lotto, who only knew the rulers from a distance or by hearsay. On the other hand, the precarious psychological make-up that caused Lotto in a business letter to refer to "strange perturbations" that oppressed his mind undoubtedly made him alert to psychological fissures and insecurities in other people, which would have escaped most of his colleagues or seemed irrelevant to them.[88]

A oneness with the social role manifested by posture and costume is by no means common to all Titian's portrait subjects. Such an identification is not an expression of an affirmative attitude in the painter, but is a characteristic of the person depicted. The "Englishman" (fig. 221) in the Palazzo Pitti is a counterpart to the *Aretino* there: the gaze turned to the right, upward, and outward in *Aretino* and to the left, forward, and inward in the "Englishman." In the latter, body position and direction of gaze are opposed to each other, indicating a personality marked by hesitation and uncertainty, quite different from the vitality of Aretino, which self-confidently urges body, head, and eyes in the same direction. Compare the portrait of the young man in the Louvre (fig. 222), in which everything—from the erect throat to the beard and hairline—not only goes back to a different model but to a kind of characterization that emphasizes the whole head, whereas in the case of the "Englishman" only a part of the head, the face, is important. It is only such features, which have their origin not in the model but in the painter, that create—together with the section, costume, illumination, and the varying degree of detailing and therefore of observation within a picture—the hitherto unknown power of characterization peculiar to Titian's portraits.

They meet us so individually and they give us a conception of spiritual vitality unlike what a face actually confronting us gives. This is like what happens with a description of great deeds and events provided by a truly artistic historian who sketches for us a picture that is far higher and truer than any

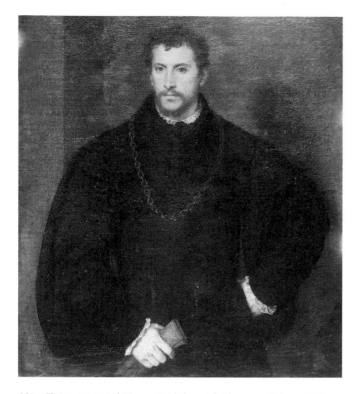

221 Titian, portrait ("Young Englishman"). Florence, Palazzo Pitti

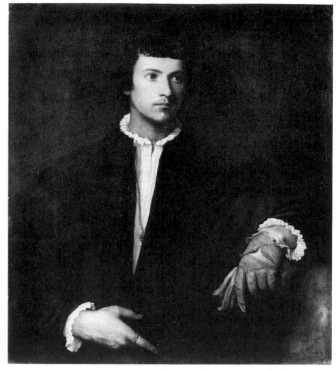

222 Titian, portrait. Paris, Musée du Louvre

we could gain by ourselves as eye-witnesses. . . . It is their indwelling sense and spirit which alone makes events into great actions, and these are given to us by a genuinely historical portrayal which does not accept what is purely external and reveals only that in which the inner spirit is vividly unfolded. In this way too the painter must set before us by means of his art the spiritual sense and character of his subject. If this is done with perfect success, then we can say that such a portrait hits the mark better as it were, is more like the individual than the actual individual himself.[89]

In 1536 Titian was working on two portraits of women for the court of Urbino. One of them, called "La Bella" (fig. 225), shows a woman in a blue dress, the other (fig. 226) Duchess Eleonora Gonzaga. The physical resemblance between the two women is considerable, and their dresses too are comparable. The differences are thus all the more striking. In the case of "La Bella" everything is calm, harmonious, sculpturally formed, alive, and vigorous, the contour no less than the section and the hair. In Eleonora Gonzaga, who had been celebrated throughout Italy for her beauty, not only are the face and hands marked by age and resignation, but the lace and puffed sleeves seem limp, and even the view of the lovely landscape free of all human traces only emphasizes the impression of confinement, which also characterizes the relation of clothes to body. That Titian used clothing to characterize rather than to describe emerges from the correspondence about a portrait he painted later for Urbino, when Titian ordered a dress of a particular color

and material that seemed appropriate to him. He thereby caused some confusion in Urbino, for although the duchess possessed a dress of this color, it was in a different material and unsuited to public display.[90] The lifeless quality of the duchess has caused some commentators on this painting to doubt Titian's authorship.[91] They saw incapacity where Titian had put characterization, showing a person at a distance from her role, without reproaching her for this distance. Women who are no longer young can take on a special dignity in his paintings through this very distance. If the portraits take sides at all, it is with the person and not the social norm.

The relation of the individual to the social norm is also a theme of the large group portrait (plate 21) that Titian painted of the men of the Vendramin family in the mid-1540s.[92] No doubt destined from the outset for the family palace, the picture served not only to express piety but to represent the family publicly. Informed Venetians knew how much the reliquary on the altar owed to the Vendramins; originating in Constantinople, it had been donated in 1369 by the king of Cyprus to the Scuola Grande di S. Giovanni Evangelista, headed at that time by one Andrea Vendramin. He it was who rescued the reliquary when it was lost in a canal—a legend that Gentile Bellini had resurrected not long before (fig. 178). The painting's donor, called Andrea like his famous forbear, is kneeling on the left, but his attitude is more expressive of pride than of humility. He is not one zealously immersed in prayer, but the self-confident performer of a

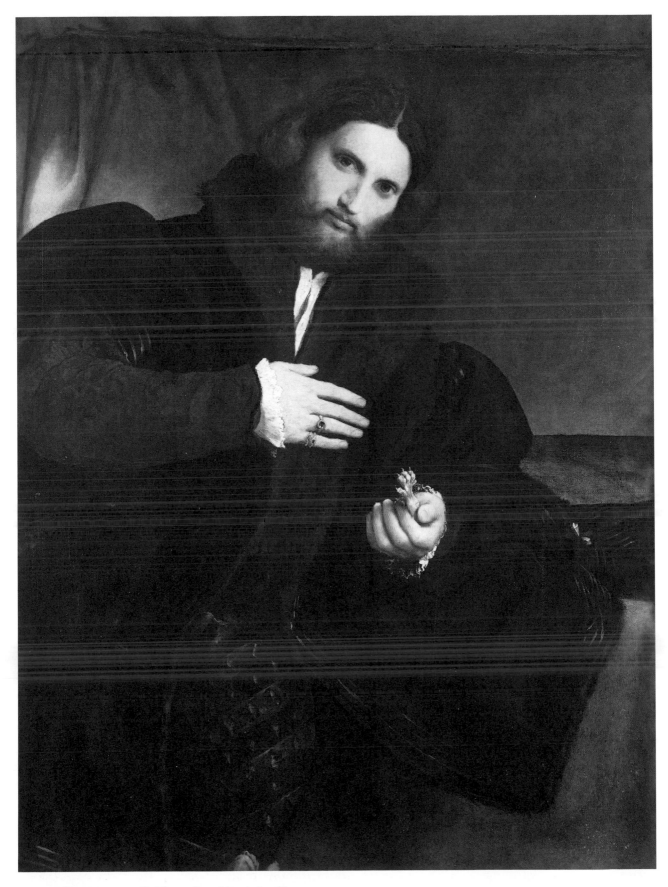

223 Lorenzo Lotto, portrait. Vienna, Kunsthistorisches Museum

ritual. The stages of life, understood as an increasing removal from the childlike naïveté of the youngest member of the group to the weariness of the oldest to whom the sumptuous attire of his estate is burdensome, are carefully illustrated. On the far left stands the elder son, who has not yet attained his father's freedom and assurance in handling the attributes of his class.

Titian as a rule probably wanted neither to glorify nor to criticize the people in his portraits, but he observed them exactly. He seems to have shown unmixed admiration only for the children. Clarissa Strozzi (plate 22) was only two years old when, in exile in Venice, she stood model for a full-length portrait by Titian.[93] She is dressed as a grand lady and also poses as one. But she is not frozen by the pose. She looks tall and important, because Titian does not look down on her from above, but takes her seriously from her own level. He shows her as a child who is undoubtedly posing, not with a sign of rule or

status, but with her pretzel. The very way she stands playfully neutralizes the orthogonal order built up by the accessories around her, and the putti, performing Bacchanalian dances as in Donatello, that the drapery exposes to view suggest a very different possibility of childish existence outside all social norms. Whatever awaited Clarissa in the form of education and socialization, it could only bring confinement and constriction.

In 1548, summoned by Emperor Charles V, Titian spent eight months at the Augsburg Imperial Diet. The most important outcome was the painted horseback monument in the Prado (fig. 224). A year before, Charles V had decisively defeated the Protestants at Mühlberg, and he now had his portrait painted in the armor he had worn.[94] The learned Aretino, proud of his competence in advising his artist friends, had suggested in a letter to Titian that he should show the emperor in the same armor and

224 Titian, *Charles V.* Madrid, Prado

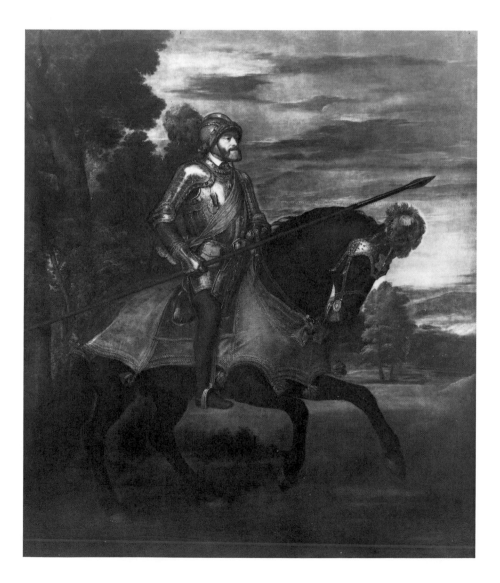

on the same horse that had served him at Mühlberg: "On the opposite side I should like to see Religion and Fame rising up and setting themselves in motion. One, with cross and chalice in her hand, shall show him Heaven, while the other, adorned with wings and trumpets, shall offer him the world.[95] Titian painted none of this, and of war and victory nothing is directly to be seen in the picture, even in the background. Once again Titian's art of omission proved its worth, and once again he painted a person who is not entirely at one with an event or a function. It is possible, however, that Titian wanted to make use of a metaphor relating to state theory, which linked the art of riding with that of guiding the state. Charles V seems to have grown together with his horse, and by means of formal connections Titian creates a relationship of reciprocal intensification between the characterization of the horse and that of its rider. For example, the form of the horse's red plume is echoed in the helmet decoration of the rider, forming with the point of the firmly held lance one of the focal points of the composition. Something of the strength of the effortlessly mastered horse passes into the rider. Both are backed up in terms of composition by the trees on the left, while the horse has additional support from the tree in the background. The whole sky, by contrast, is a space in which the face of the emperor resonates, a face not touched by the light of the rising—or setting (?)—sun; in the upper part of the sky the pale colors of the face predominate.

A few years before portraying the emperor, Titian had painted the Farnese pope then in office, Paul III. Papal portraits "leave little scope in the selection of colors. The cap, . . . cloak, . . . throne, and *portiera* are all of glowing crimson with few nuances, interrupted but also heightened by the snow-white surplice. Amid this sumptuous color, which was quantitatively overwhelming and further inflamed by reflections, the task was to give the face its due for the sensuous eye."[96] Throughout the painting, Titian did not show the crimson as sumptuous and luminous, but muted with brown and grey. Even in the strongly lit places it seems rather to glimmer or glow darkly, never to gleam. The garments are everywhere heavy and burdensome, and the clothes are cut so opulently that the body seems buried in them. Only the tensed hand and the face are free of them. The hand is set against the purple sash, the head against the collar. He is an old man seemingly overwhelmed by the sumptuous robes, but one full of willpower, watchful, mistrustfully appraising, full of an inner tension that comes from the person, not the office.

Titian would surely have been incapable of such an unsparingly objective analysis, though one free of either agitation or denunciation, without the deepened understanding of the psychology of power that resulted from his years of traffic with those in high office; nor could he

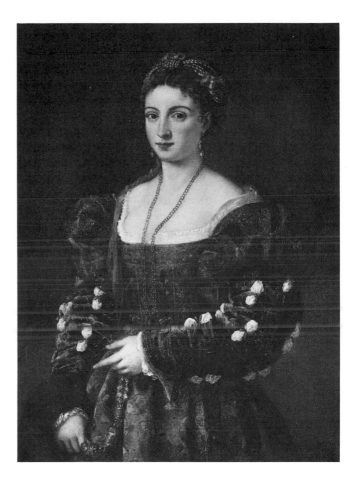

225 Titian, "La Bella." Florence, Palazzo Pitti

have created the psychogram that the never-completed family portrait of the Farnese pope (plate 23) became in the painter's hands. What is painted here is not merely a family gathering based on a shared interest in art and family feeling—like Raphael's painting of Leo X with his nephews—but the living lie of a family.[97] The pope, reminded of his mortality by the clock, sits in isolation between his two nephews, Cardinal Alessandro, cold and indifferent, who takes no notice of him, and Ottavio Farnese, who could have played the part of the villain in any play by Shakespeare, so thoroughly false is his bow, though it does not allay the cunning mistrust of the old man. The painting is unfinished in most areas, so that definitive judgments are hardly possible; but simply the way the pope's hand is set against the ermine lining of his cloak shows this to be the most pitilessly revealing of Titian's portraits known to us. Undoubtedly one finds out more from it about the papal family than they would ever have disclosed themselves. If the Farnese had really understood the painting they would have had to destroy it. Although that did not happen, it would not have been by accident that this work by the always famous Titian

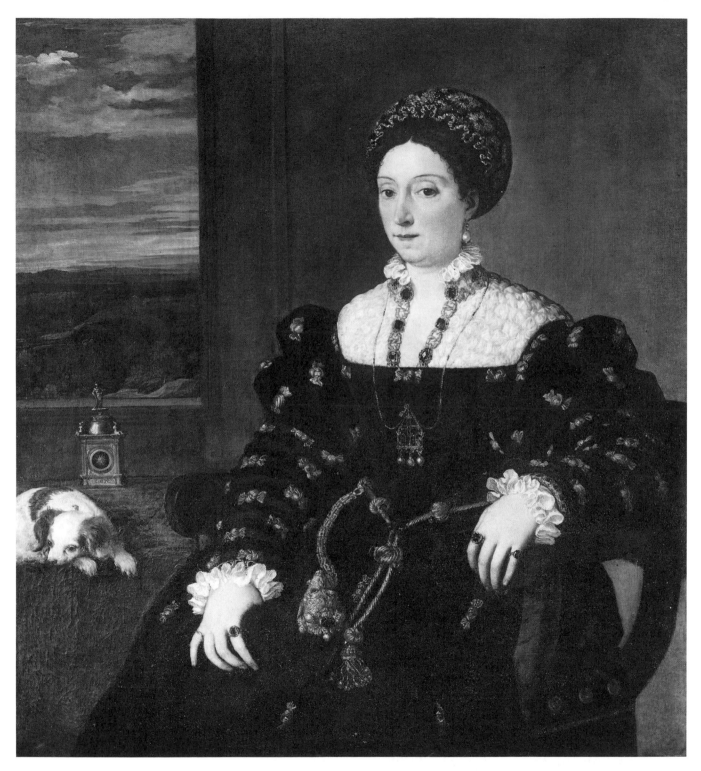

226 Titian, *Eleonora Gonzaga.* Florence, Uffizi

disappeared into the provincial oblivion of their family palace at Piacenza.

Mythology or Genre?

In 1530 the *notizie* kept by the noble art connoisseur Marcantonio Michiel listed among the paintings in the collection of Gabriele Vendramin a "small landscape with a thunderstorm, a gypsy woman, and a soldier" by Giorgione (fig. 227), one of the few works incontestably by the painter.[98] In the early sixteenth century there were a large number of collections like Vendramin's. They were not museums in the modern sense but contained far more paintings, figures, utensils, and ornaments than normally made up the furnishings of an aristocratic house.[99] The essential parts of a collection were concentrated in relatively few rooms in a palace, but these rooms were also lived in, and important items of the collection could be found in rooms used almost exclusively by the master of the house, such as the bedrooms.

Giorgione's picture was probably ordered and painted for the collection, for only there did a work of this kind find a place and a public, not in the churches, not in the state offices, and not in the scuole. Giorgione appears to have been the first—and for a long time the only—artist who fully appreciated this situation and adapted his art to it. The rooms in which such paintings hung were small, and open only to a select public. The pictures were therefore seen from close to and probably only by connoisseurs or people who considered themselves such. Almost all the authentic pictures by Giorgione were to be found from an early stage—and probably from the outset—in the collections of a small group of young nobles who were closely bound together by common interests and studies.[100] It is likely that many of the riddles surrounding Giorgione arose because we know practically nothing about the inner workings of this small group. Much that has to be laboriously and speculatively reconstructed today was taken for granted there, and knowledge and taste were probably so refined that the

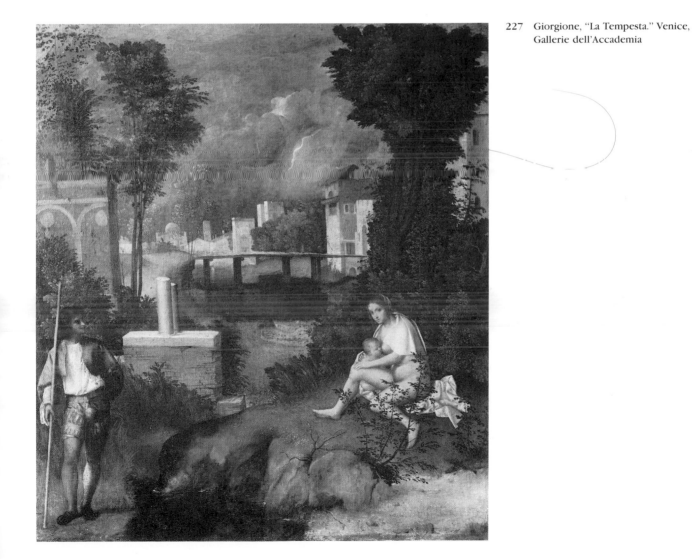

227 Giorgione, "La Tempesta." Venice, Gallerie dell'Accademia

landscape was considered more important than the saints not only in old Flemish pictures of saints, but in contemporary works as well. Thus the use of a gypsy rather than a goddess or an allegorical figure as an accessory in "La Tempesta"—a theme that according to Pliny had been mastered only by Apelles—may have been a special attraction to Vendramin's friends. That Michiel's description of the painting as a "small landscape with thunderstorm, gypsy woman, and soldier" was not the result of ignorance or negligence is shown by his observations on other paintings by Giorgione, as when he effortlessly recognized a *Birth of Paris* as such and was able without hesitation to identify Aeneas and Anchises. However, modern scholarship has been given no peace by Michiel's note on "La Tempesta," and attempts to interpret this painting would now fill a small library.[101] That none of them has so far proved convincing may be explained not solely by the insufficient insight of the interpreters, but by the picture itself, for although it appears so pregnant

with meaning as positively to provoke complicated analyses, every analysis attempting an unambiguous interpretation has proved ultimately futile.

If the painting had any firm meaning when Giorgione began it, it must have changed fundamentally, for a bathing female nude originally sat in the place now filled by the soldier. But perhaps the question that asks for a single indubitable meaning is wrongly posed. Possibly the functional and formal emancipation of painting is accompanied by an iconographic one. And if the meaning of this painting, in which Charity and Fortitude, Adam and Eve, and secret messages of the freemasons have all been discovered, was so exclusive that even Michiel was unaware of it, do we not find here a meeting of the extremes, is not the intellectual charm of deciphering the meanings perhaps the equivalent of the aesthetic enchantment created by painting itself?

An enumeration of all the interpretations of the painting that became famous as the "Concert champêtre" (fig.

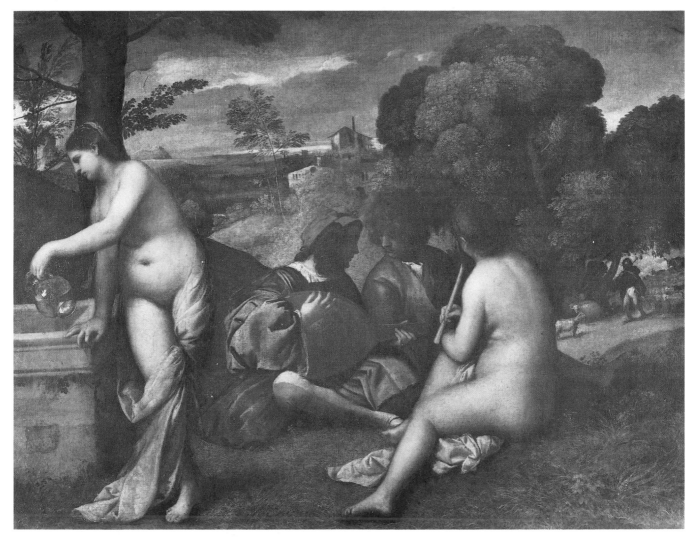

228 Giorgione and Titian (?), "Concert champêtre." Paris, Musée du Louvre

229 Jacopo Palma the Elder, *Rustic Concert.* Private collection

228) would also fill many pages, and there would be further pages of speculation on its authorship.[102] Someone who values invention will incline towards Giorgione, while those who find execution more important will favor Titian. As we know for certain in at least one case that Titian completed one of Giorgione's paintings, a similar situation might be suspected here.

The presence of naked women in company with fully clothed men must have been at least as provocative to the public of Giorgione and Titian as the *Déjeuner sur l'herbe* was later to Manet's. Among the motifs, the only unambiguous ones are the costumes indicating the present. Unequivocal in a different way is the elegiac, even melancholy mood. And a final unambiguous fact is that the more genteel of the two young men is not at home in the countryside shown but in the town and—as his clothing shows—a contemporary town at that. The picture, therefore, is not about Arcadia. On the other hand the women possess no clothes, not even discarded ones, so that they belong, like the shepherd, permanently to this place. For this reason, the most convincing interpretations of the picture are those that seek its sources in the literature of Giorgione's time.[103] The source could have been Sannazaro's *Arcadia* of 1502, for example, a poem that, although it does not contain the exact scene depicted in the painting, addresses themes such as the lost unity of man and nature. The women in the picture

would therefore be understood as nymphs. The relationship between the two men, overshadowed by a rather gloomy mood, admits at least two interpretations without entirely fitting either of them. It might signify the return of the townsman to Arcadia, or equally the shepherd's attempt to relearn his own music, which has been lost in Arcadia and has survived only in the art songs of the town.

In almost all the pictures of Giorgione and his circle we encounter situations that are seemingly naive, but in reality are treated sentimentally. In each painting the mood is unique, individual. But it is never serene, cheerful, or joyous. Instead, emotive states are almost always shown that would have been criticized if not condemned by the doctrines setting out the moral temper of the time. We enter a realm of melancholy. Palma the Elder, for example (fig. 229), shows three townspeople on an excursion to the country. The pleasant spot where they are resting and the rural river settlement shown—perhaps as a contrast—in the background, are in clear antithesis to the mood of the visitors. The young man lets his instrument drop as if he can hardly continue to play. No sheet of music is to be seen, so that it is left open whether the melancholy that almost reaches the pitch of mourning is the theme of the music and arises from an identification with it, or whether it comes from the people; favoring the latter interpretation is the fact that it affects only the youth and the girl on the right.

Mythological paintings, extremely rare in Venice in the fifteenth century, became in the sixteenth one of the most important tasks of painters. They are found in very diverse places and in very disparate forms. In upper-class rooms they replace or supplement the religious devotional pictures: from Judith to Lucretia was not such a big step.[104] In political iconography, mythology became closely allied to allegory, and not uncommonly it took its place entirely. Gods offered a wider field of associations than allegories, yielded more impressive figures, and had familiar and eventful biographies, which filled out large programs more easily and vividly than embodiments of abstract concepts.

To paint a Diana or a Mars in the sixteenth century was something other than to depict a Christ, a saint, or even a Venetia. Whereas these involved real people, institutions, and events, or at least what were believed such by most people, mythology was concerned either with documents of superstition, of *falsa religione,* or with the poetic inventions of distant times. The reunification of classical themes with classical forms, which had been completed everywhere by the end of the fifteenth century, was the precondition for the fact of "the double significance of the old gods to the men of the Renaissance. On the one hand, they replace abstract terms in poetry, and render allegorical figures superfluous; and on

the other, they serve as free and independent elements in art, as forms of beauty which can be turned to some account in any and every poem."[105]

Open to many interpretations, the mythological paintings could also accommodate themes that found no other place in the painting of the time. One of them was the depiction of a natural, amoral existence outside the social norms.

In 1514 Giovanni Bellini, who ten years before had so stubbornly refused Isabella d'Este a *fabula antiqua,* delivered to her brother in Ferrara a *Feast of the Gods* (fig. 230), the theme and spirit of which would actually have better suited Isabella's *studiolo* than the *camerino* for

which it was destined.[106] Bellini's painting presupposes at least some basic mythological knowledge if its point is to be understood: at a feast of the gods waited on by nymphs and satyrs, Priapus tried to lift the dress of the slumbering Lotis. But at this moment Silenus's ass gave vent to such clamorous braying that the sleeper awoke. The contrast between the chaste nymphs and the lascivious drunken gods is the picture's theme, and even Apollo and Jupiter have drunk so much that they might be expected to attempt the same exploit as Priapus. Apollo has to misuse his lyre to support himself and is even unable to drink unaided. Moral admonitions of this kind were soon felt to be old-fashioned in Ferrara, it seems, for after

230 Giovanni Bellini, *Feast of the Gods.* Washington, National Gallery of Art, Widener Collection

231 Titian, landscape. Berlin, Staatliches Museen Preussischer Kulturbesitz, Kupferstichkabinett

Bellini's death Titian several times revised the picture. He exposed some breasts and made Neptune and Cybele into a newly married couple. Above all, however, Titian altered Bellini's bright glade, which—with the nymphs between the trees—stood in such eloquent contrast to the gods on the ground. Titian painted towering mountains and rushing streams and contrasted the sparse copse to a thicket, so that today the scene of the action conveys no moralizing effect.[107]

Titian's landscapes presuppose those of Giovanni Bellini, but they are also from the outset independent. As in his painted architecture, in his landscapes Titian follows the principle of the *pars pro toto.* The great panoramas are lacking, and just as in an altarpiece a pair of columns can stand for an entire hall, a few tree trunks here represent a whole wood. Titian devoted intense study to faults in the soil structure and the realm of roots. The ever-recurring complexes of earth, roots, and trunks is symbolic of his conception of nature.[108] In his woodcuts Titian gave much space to such parts (fig. 231).

When he made his first alterations to Bellini's *Feast of the Gods,* Titian must have had in mind his own depiction of drunkenness (fig. 232), which now hung next to it. Wine and desire, for Bellini enemies of virtue, are celebrated by Titian: "He who drinks and does not drink again, knows not what drinking is," the inscription announces, and instead of a nymph imperilled in her virtue Titian shows as his framing figure a nymph sleeping off her intoxication. The natural living shown in the *Andrians* is no longer measured by moral norms but celebrated, like the passion of Bacchus in the neighboring picture, as part of a Dionysian nature that includes human desires.

In 1510 a painter was mentioned for the first time in Venice who today stands in undeservedly low regard, Palma the Elder, who had arrived from Bergamo: "Not a pupil of Giorgione, but an artist who developed and extended what he had sought to achieve . . . in whom existence painting seems to reach the apex of its perfection. He is

the principal creator of those female characters, some-what amply but nobly formed and inspiring particular trust, who are especially beloved by the later Venetian school.[109] Not a few pictures show such women half-length, it being very uncertain whether they are god-desses or mortals.

The people in Palma's paintings are always passive rather than active, most reposing in themselves and some, particularly in portraits, depressively self-absorbed. This general temper is matched by a manner of composition that gives rise to pictures easily understood, counting on a viewer more interested in beauty of surface than in complex attitudes, and valuing calm enjoyment more

than arcane refinement. This cast of mind is also peculiar to the half-length paintings of beautiful women that seem to have been a speciality of Palma's. Some of them appear in a role, as Flora, for example (fig. 233), or as Judith, but most are only themselves. The first viewers would have been less interested in the attributes than in the beauty of the faces, the charm of the undone ribbons, and the lace chemises slipping from white bosoms. Even these motifs, however, do not outweigh the almost vegetal naturalness of Palma's women. One need only take the at first sight similar "Flora" by Titian (fig. 234) as a com-parison, to see how negligently the pleated lace chemise is worn, how loosely the slipping undergarment fits.[110] In

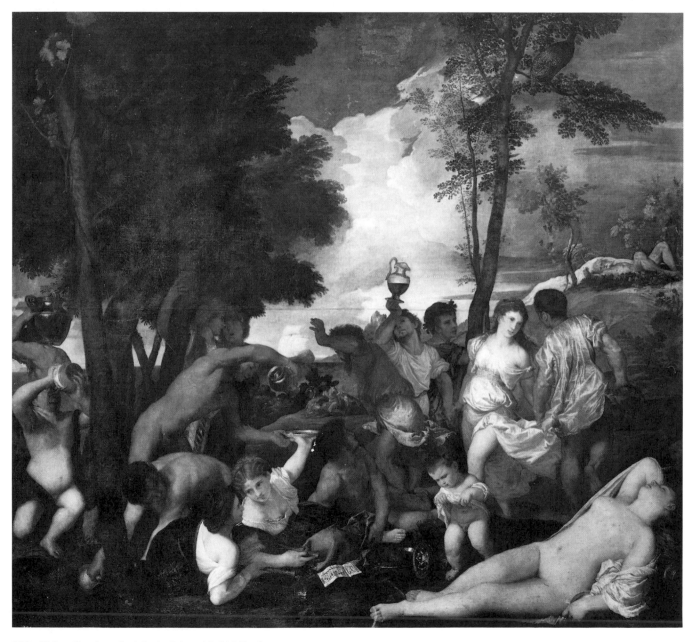

232 Titian, *Bacchanal of the Andrians.* Madrid, Prado

Titian everything—whether contour or volume, hand positions or shape of head—is calmer and firmer, more definite and so more charged with tension. The roses lie securely in her hand, her dress is pulled high. Where Titian draws together, as in the left hand, or characterizes by contrast, as he does about Flora's breast, Palma loosely juxtaposes. Titian's gentle but effective countermovements are as alien to Palma as the densely filled picture space.

Whether the young women who were Titian's and Palma's models for such paintings were chambermaids, courtesans, or ladies of rank cannot now be established. In the inventories the subject is usually given as a *donna*. The depiction of a woman's beauty, therefore, was clearly more important than her name. This theme found its fulfillment in the female nudes that were one of the most important inventions and discoveries of Venetian painting in the sixteenth century. The place for such nudes was naturally a private one. They were to be found in collections or in bedrooms. The collector Odoni had a nude by Savoldo hanging behind a curtain over his bed. It was only later literature that baptized all the known pictures of this kind as "Venus," even those where any attributive reference to the goddess of love is absent.[111]

The first in the series was Giorgione's *Venus* in Dresden (fig. 235). Unfinished at the artist's early death, it was completed by Titian, to whom it owes the landscape and a Cupid removed during later restoration.[112] In the uninhabited and uncultivated landscape, only the village on the hill reminds us of human beings. The goddess slumbers on her couch, not undressed but in a natural state of nakedness, unaware that she is looked at. She fills the entire picture area, monumental as an antique statue by the Venetian standards of 1510. What is shown is a state, not an identifiable event from the life history of the goddess. Were not the putto, armed with arrows, at her feet, she might have been any other woman. The theme of slumbering is paraphrased in the gentle rising and falling of the outlines and forms of her body, which stand out against the folds of the bed but find many echoes in the landscape. The colors, with their halftones and refractions, imbue the scene with an elegiac mood. Near as the composition brings the goddess to the viewer, she remains, by virtue of the mood, remote.

The next *ignuda* that has been preserved, painted by Palma the Elder (fig. 236), has opened her eyes. She is not only seen but shows herself; she is not always naked but has temporarily taken off her clothes. No attribute shows her to be a goddess, nor is she a being from an idealized Arcadian nature, but from contemporary society. Her hair elaborately arranged, her gaze meets the viewer's. She would hardly look different if she were receiving her lover in her bedroom. The modest pose adopted by Giorgione's Venus while asleep has been abandoned. The woman who, fully aware of her naked-

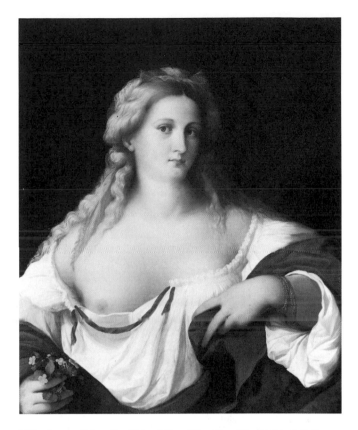

233 Jacopo Palma the Elder, "Flora." London, The National Gallery

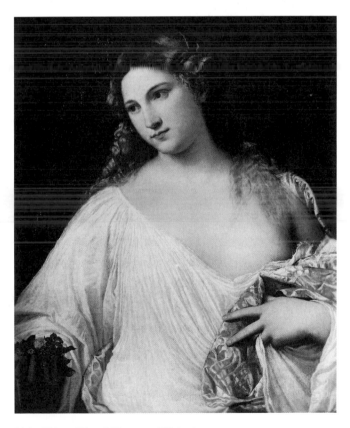

234 Titian, "Flora." Florence, Uffizi

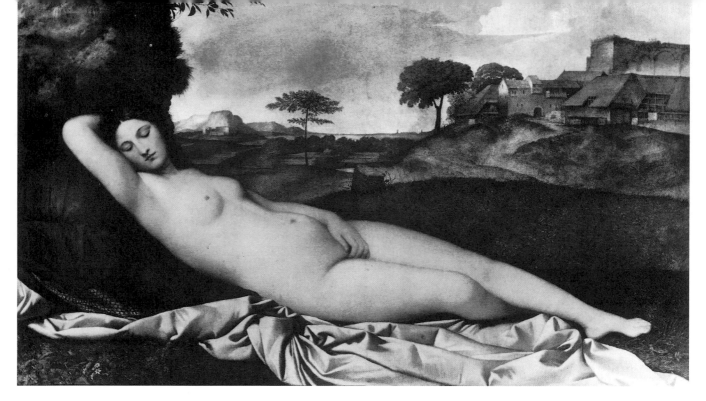

235 Giorgione, *Venus.* Dresden, Gemäldegalerie

ness and of the presence of an onlooker, presents her body does so without shame, though not shamelessly.

In 1538 the court of Urbino urged Titian to deliver the "donna ignuda" (fig. 237) ordered long before. The painting, which was dispatched soon after, has become known as "Venus."[113] The baptism, however, took place decades later and not in Urbino. Titian omitted anything that might have enforced or even suggested such a designation. Undoubtedly, however, this picture was his reply to the work of Giorgione's he had once completed. All the more eloquent are the differences: instead of the landscape, the contemporary alcove. Instead of the Cupid, the maidservants and the dog of a fine lady, and instead of the sleeping, the waiting for the morning toilet. The description in Wilhelm Heinse's *Ardinghello* is doubtless taken to extremes, but it could never have been provoked by a painting like Giorgione's.[114]

However much one is impressed today, after the travesty in Manet's *Olympia,* by the calm and serenity of Titian's celebration of feminine beauty, no less must the people of the sixteenth century been struck by the lack of any mythological alibi and the freedom with which the naked woman shows herself. The picture was hung in the duke's summer residence near Pesaro, where Alessandro Farnese must have viewed it. In 1544 Alessandro, now a cardinal, was reminded of this visit. A letter from Venice reported on the progress of the *Danaë* (fig. 238) that he had ordered from Titian. The correspondent was full of praise: compared to the new nude the one in Pesaro was a nun, and even a friendly bishop who saw her would have the Devil to contend with. To oblige the

cardinal, Titian would give the Danaë the features of Donna Olimpia—a famous courtesan with whom the cardinal was reputed to have a liaison.[115]

According to this letter, for the cardinal and his entourage the function and content of the painting were unambiguously ambiguous. Their attitude is not entirely inappropriate to Titian's painting, for features like the Cupid stealing away, his work done, and the invocation of a tradition that saw Danaë as a harlot rather than a heroine of virtue tend in the same direction. Titian evoked the tradition in a not altogether subtle way by mixing some coins with the gold rain.

Painter colleagues of Titian's, however, paid heed to quite different aspects of the painting.

> One day, when Michelagnolo and Vasari visited Titian at Belvedere, they saw a naked Danae with Jupiter in her lap, transformed into a shower of gold, and praised it greatly as was polite. After they had gone Buonarrotti criticised Titian's methods, praising him a good deal, and saying he liked his colouring and style, but that it was a pity good design was not taught at Venice from the first, and that her painters did not have a better method of study. If this man, said he, were aided by art and design as he is by Nature, especially in copying from life, he would not be surpassed, for he has ability and a charming and vivacious style. This is very true, for without design and a study of selected ancient and modern works, skill is useless, and it is impossible by mere drawing from life to impart the grace and perfection of Nature, so that certain parts frequently lack beauty.[116]

For Titian himself the picture certainly served very prosaic purposes too. He doubtless saw it as a well-tried

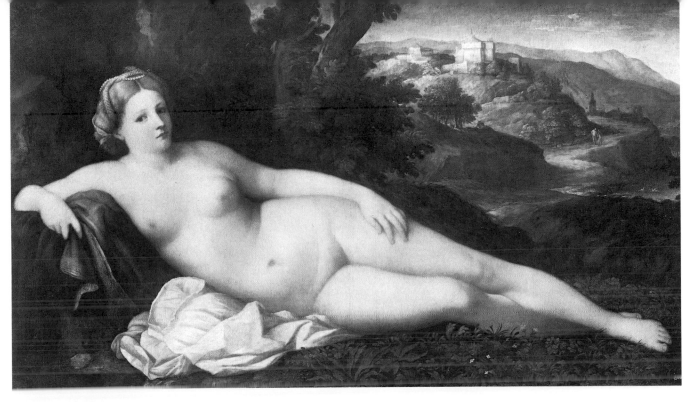

236 Jacopo Palma the Elder, *Venus* (?). Dresden, Gemäldegalerie

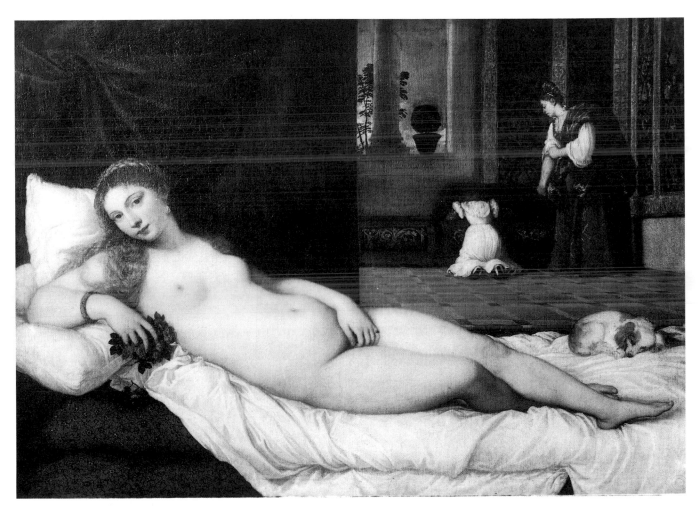

237 Titian, "Venus of Urbino." Florence, Uffizi

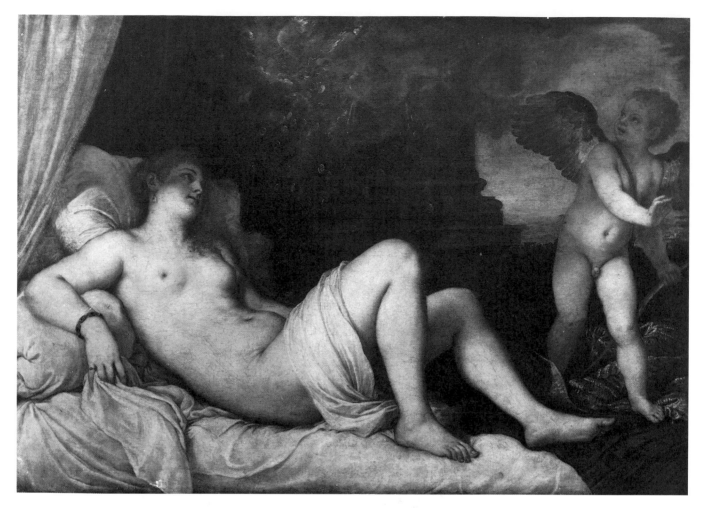

238 Titian, *Danaë*. Naples, Museo di Capodimonte

method of earning the cardinal's favor, hoping for his support in obtaining a living for his son. If we proceed not from its public but from the essential nature of the picture, however, other traits move into the foreground. Observers who did not project their own expectations but fixed their attention on what was depicted would probably have admired, even in 1546, the inner vivacity and the freedom with which Titian was able to celebrate the dignity and grandeur of Danaë's surrender without any allegorical or other amplification. Thus the way of looking that is indicated, though not enforced, for the viewer by the coloring and lighting is not one that exposes. The places that interest the voyeur are, quite deliberately, left in shadow.

History Painting

In the great fires that devastated the Doge's Palace in 1574 and 1577, a major part of Venetian Renaissance painting was destroyed. To grasp the scale of the losses, one should picture the situation if the Vatican had burned in 1577, and not only Raphael's *Stanza* but the Sistine Chapel had been lost. Of the majority of the lost paintings we only know that they existed; in some cases the theme at least has been recorded, but in very few have we an idea what they looked like.[117]

The losses include a large battle scene by Titian. Young and ambitious, Titian had been unwilling to await the death of the aged Giovanni Bellini and in 1513 had applied for his post as state painter. Titian offered to paint the *Battle of Cadore* on the south wall of the Sala del Maggior Consiglio, a place that all previous artists had avoided. At the same time, he reminded the signoria that he had received offers from the pope and other princes but that he first wanted to serve his native state. A year and a half later his work had come to a standstill through the intrigues of those who "do not want to see me as a rival." When, after Bellini's death, he had finally obtained the position he coveted, Titian did little more in the Doge's Palace. His battle picture progressed so slowly that he was reproached in 1537 with not having properly started, and the fee already paid was reclaimed. That progress was faster after that probably has to do with the presence of Pordenone at Titian's heels. The former had

just produced a painting in the Sala dello Scrutinio to the great satsifaction of the patrons, impressing not least by his punctuality. In 1538 Pordenone was even allocated the wall next to his rival, which had probably been first intended for him. It can be supposed that Titian composed and executed the main features of his battle only at that time. Preparatory sketches are mentioned as early as 1516, but the painting, completed in 1538, with its topical references to Michelangelo, was certainly a composition of 1537, which tried in its use of foreshortening and movement to defeat the challenger Pordenone with his own weapons.[118]

Titian's triumphantly self-confident skill was placed in the service of a battle the identity and outcome of which have not been clearly established even today. Possibly the name has been changed. The sources speak only of a "battle," and perhaps its precise course was less important than the Venetian victory.[119] What is shown is not the main battle but, as a *pars pro toto,* a preparatory skirmish (fig. 239). The girl scrambling out of the river has been surprised at her morning bath. The commander is only just putting on his armor, while a groom tries to restrain the horse. In the drawing he had already given orders. Like Michelangelo and Leonardo in their car-

toons for the Great Council Hall in the Palazzo Vecchio in Florence, Titian did not give an overview of the battle but showed it through a characteristic minor incident. In the sketch (fig. 240) the accent was on the surging back and forth of the battle, which was expressed not only in details but in the total composition. In the execution Titian adopted a more polarized structure, by heightening the suffering and death on the left while emphasizing the Venetians' confidence of victory in the commander's serenity and the orderly advance on the right.

When Titian first made his entry to the Sala del Maggior Consiglio in 1513, he was still very far from such unconventional concepts. His experience was in inverse proportion to his self-confidence, for as a narrator he could at that stage point only to the frescoes in the Scuola del Santo in Padua.[120] In Padua he had in 1511 painted three large frescoes showing scenes from the life of St. Anthony. The young artist had sought guidance for these paintings neither from Carpaccio nor from Giorgione, but from the Paduan frescoes by Giotto,[121] two hundred years old, in which he discovered a pictorial language that, in concentrating economically on its theme, combined precision with monumentality. Com-

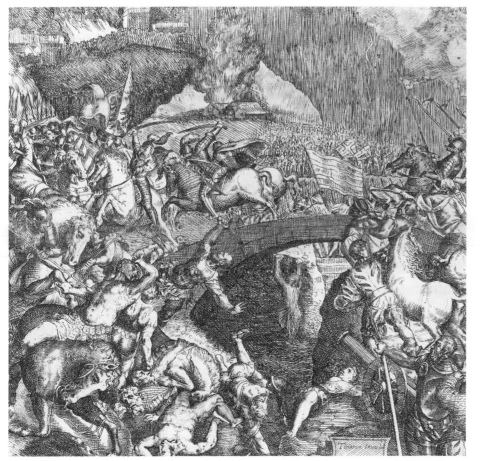

239 After Titian, *Battle of Cadore.* Formerly in Venice, Doge's Palace, Sala del Maggior Consiglio

pared to the often loquacious manner of the late fifteenth century and Giorgione's narrative style, which aimed almost exclusively at artistic effects, that of Giotto came close to the most up-to-date Roman art, that on the ceiling of the Sistine Chapel.[122]

An idea of Giorgione's history paintings can be derived from a picture by Sebastiano del Piombo, to whom Giorgione was very close in his youth. Sebastiano's unfinished *Judgment of Solomon* (fig. 241) was for a long time attributed to Giorgione himself.[123] The courtroom, probably intended as a reconstruction of an ancient basilica, is composed in an extremely modern architectural style, although it is the background rather than the real theater of the action. The symmetrical composition of figures, a kind of *sacra conversazione* enlarged at the sides, despite numerous modern motifs is still in the spirit of the fifteenth century. The people form a row, the narrative is in the enumerating manner of a chronicle ("here stood a man who . . . ; next to him a young man with . . . ; finally, in the middle"), the eye is led from figure to figure and from one step in the action to the next, lingering indulgently on beautiful particulars on the way: a bared arm, an absorbed profile, a choice color com-

bination, an interesting pose, a languishing gaze, or an elegantly cut, opulent sleeve. Giorgione's influence is everywhere apparent. His own history paintings, for example the *Judgment of Solomon* in the Doge's Palace ordered in 1508, would have looked much like this, only subtler and more refined.

Titian, by contrast, showed in Padua a few large figures. He kept the groups small but used linking figures to relate them to each other and to the main theme. The accessories are sparse. Buildings are shown not complete but in bold fragments. A single arch with a statue stands for a large hall, and a few young and not particularly pleasing trees for whole landscapes. The legend—a jealous man suspects his wife of infidelity, and by allowing the child to speak the saint saves the mother's honor—is told in a composition that has friezelike extent but is full of tension, showing many characters with different reactions in the series of heads but accentuating only a few large figures (fig. 242): the saint, the couple with the child, and the young man dressed in the latest fashion, who, by the logic of the composition, must be the alleged lover.

Titian's art centered on the individual characters who,

240 Titian, sketch for the *Battle of Cadore.* Paris, Louvre, Cabinet des Dessins

241 Sebastiano del Piombo, *Judgment of Solomon.* London, Royal Academy of Arts, National Trust, Kingston Lacey

although defined in connection with the action narrated, do not fundamentally change. In terms of composition, this means postures rather than rapid movements, gravity in the demeanor of the figures, and a use of form that tends to generalize rather than lingering on the individual. In this respect, however, the young man is clearly inferior to the mother or the monk. The motif of the cloak flung hastily over the shoulder is in contradiction to the monumental formal character of this same cloak. And in other places, particularly in the arrangement of figures and in eye relationships, the beginner is apparent. No matter how accurately the psychology of suspicion is caught in the father, its effect is reduced because the mother takes up so much space and is placed so that someone not familiar with the legend would believe the child to be talking to her, not about her. To a striking degree Titian has done without explanatory gestures. Much as he understood about faces in his early pictures, he has very few ideas about hands. Usually he left them out altogether, and the few that had to be visible seem to have been an embarrassment to him.

Titian designed the most ambitious of his early histories not for the concrete public of a particular place but for the broader and more diffuse use of the print. This does not mean that he abandoned the large-scale form, however, for the dimensions of the woodcuts are also considerable; in the *Destruction of Pharoah* (fig. 243) they exceed two meters, which made no fewer than twelve printing blocks necessary. Too large for a collector's cabinet, such graphic works probably served as wall decoration, a substitute for history paintings that were not—or could not be—painted.[124] Perhaps the idea of producing them came not from the public but from painters who wanted to draw attention to themselves and their art. As graphic artists they needed neither to await a commission nor to pay heed to the wishes of clients, and in addition the effect of the works was not confined to a single place.

The most ambitious and impressive of these prints is Titian's *Destruction of Pharoah.* The oldest of the copies still extant goes back to a print of 1549, but the composition was probably developed thirty-five years earlier, in the same period as the "Assunta," in a period of Titian's life when his artistic development was positively explosive, but when he still had to fight hard for positions like that of state painter. It was possibly for this reason

that he chose a theme that, after the years of what had at times seemed the hopeless struggle of the republic against all the European powers, must have had special importance for Venetians. For just as the Jews had been saved from an overwhelming foe at the last moment by water, in the wars against the League of Cambrai the Venetians had found themselves similarly delivered: when Padua had fallen and the enemy was established even in Chioggia, only the lagoon had saved the city. The contemporary dress of the Egyptians, contrasting with the idealized costumes of the Jews, actually demanded such associations.[125]

The brooding darkness of the city and clouds on the Egyptian side is opposed by the light on the Jewish side. Although only a narrow strip of the land that will save them can be seen, so that the threat that has just been survived can still be felt, this strip is in its form and motifs so alive, free, and lofty that the deliverance is rendered visually. The enemy have come close, the outline of their formation can still be discerned, but inwardly they no longer hold together: everywhere, at the head, on the flanks, and at the center, chaos is breaking out. The perdition of the Egyptians is the salvation of the Jews, as can be seen and felt in the very different reactions of Moses and his followers.

One of the protagonists in the picture is the water. Whether in the parts framed by the weapons, the town, and the stormy sky, or in the vortices embroiling the Egyptians, or in the wave forms on the right that correspond to the patterns of the land, everywhere natural phenomena and human fate are intertwined. The interests and experiences of the landscape painter are allied

242 Titian, *Miracle of the Speaking Infant.* Padua, Scuola di S. Antonio

243 Titian, *Destruction of Pharaoh,* woodcut

to a graphic imagination and a virtuosity that Titian can only have learned from Dürer. The relation of form to object is even freer than in the work of the German, however, so that in places the lines are not used for descriptive delineation but only for characterization.

Even in the sixteenth century, the most important clients of a history painter, apart from the state institutions, were the scuole grandi. Commissions like the Vienna *Christ before Pilate* that Titian painted for the private palace of a Dutch merchant were exceptions.[126] The decoration of the scuole usually began with the *albergo* and normally proceeded in stages. Many plans were very old before the means for their realization had been assembled. The *Presentation of the Virgin* (fig. 245 and plate 24), for example, painted by Titian in 1534–38, had been ordered by the Scuola Grande di S. Maria della Carità from Pasqualino Veneto in 1504. After his premature death the money seems to have been used for other purposes, and thirty years passed before enough had been brought together again.

Titian's painting is one of the few major works by Venetian painters that are still in their original places. This place, however, much to the detriment of the picture, has undergone massive changes. It no longer serves for assemblies, but as a thoroughfare. The staircase incorporated for this reason allows a proper view from only a few angles. Not least, the picture itself has suffered: although Titian was able to incorporate the door on the

right into his painting, a strip of canvas has probably been sacrificed to the one on the left. All the same, the height and extent of the *albergo* have been preserved, as, above all, have the Gothic triptych and the old ornate ceiling, the main colors of which, blue and gold, Titian used as the basis of his color composition and even its center, in the part around the Virgin.[127]

For a painting almost eight meters wide the *albergo* is a relatively small, low room. A dramatic scene like the one on the walls of the Doge's Palace, where Titian was completing his battle picture (fig. 239) at the same time, would therefore have been hardly appropriate, nor was it required by the theme. But as the Presentation always involved an ascent, two levels were indispensable, and given the extreme horizontal format this gave rise to figures that were, by Titian's standards, rather small. The contract, which has not survived, may have contained a reference to earlier representations such as the *Presentation* by Cima da Conegliano in Dresden, where the tripartite arrangement, the placing of the Virgin, and the market woman are prefigured.

The use of extras unavoidable with a format of this kind made room for a large number of more or less hidden portraits of prominent members of the Scuola Grande di S. Maria della Carità. At least ten of them have mingled with the crowd. Before the doorway on the left was made, they would have been more in evidence than today, and at that time the glances and gestures addressed to their fellow members in the *albergo* would have been

244 Paris Bordone, *Presentation of the Ring to the Doge*. Venice, Gallerie dell'Accademia

245 Titian, *Presentation of the Virgin.* Venice, Gallerie dell'Accademia

far more effective. Perhaps just as an alibi, but possibly as a reminder of the scuola's real task of caring for the poor, an act of charity is shown. It remains strikingly peripheral, however, as it did also in the practice of the scuole, which often gave beneficence a lower priority than ostentation in the sixteenth century. Thus the begging of the poor appears as an irritant amid the stately advance of the notables. The four most important of these ignore not only the beggar woman but Mary as well. Logically, Titian has separated them from Mary's following to form a line of their own, clearly distinguished by posture and demeanor from the rest. Through the rich colors and forms and the spontaneous vivacity of Mary's followers, the conventional dignity of the governors of the scuola is not directly criticized but is deprived of its impact. They are all looking either into the *albergo* or at the market woman, who is included among the traders that Christ was later to eject from the temple.

The Scuola Grande di S. Maria della Carità does not seem to have been especially pleased with Titian, for as early as 1538 they were negotiating with his archrival Pordenone regarding a painting for the neighboring wall.[128] The scuola knew how much money they wished to spend and which artist they wanted. It was also clear that the picture was to do honor to the scuola and be appropriate to it. How this was to be achieved was the subject of the negotiations with the painter, who died before he was able even to start the work. Pordenone, the records of a session state, had visited the scuola and enquired about the theme that the *signori* had in mind. They had no firm idea, but Pordenone elicited that one of the gentlemen would have liked to see an Assumption of the Virgin. After long deliberation he concluded that this theme was unsuitable, the report noted. The picture area was not appropriate, the Assumption did not temporally follow the Presentation, and it was in any case to be seen in the sala of the scuola. Pordenone suggested the betrothal of the Virgin, which followed the Presentation and would fit well into a wide format.

The scuola stuck to this theme even after Pordenone's death. The execution went to the mediocre Gian Pietro Silvio (fig. 246), who in a vote had outdistanced such distinguished painters as Bonifazio de' Pitati and Paris Bordone.[129] In a superficial sense his paintings were, admittedly, very modern, particularly in their stagelike architecture. That the main theme, Mary's betrothal, is not exactly prominent does not seem to have troubled the scuola, since it left much space for portraits. This picture is quite certainly free of critical undertones, and right at the front a beggar and a Charity in a beggar woman's costume remind us of the name and official function of the scuola. Today, utility art like Silvio's painting has either disappeared into museum storerooms or has been consigned to remote churches. Only in exceptional cases

246 Gian Pietro Silvio, *Betrothal of the Virgin*. Mason Vicentino, Parish Church

has it been collected and looked after for its own sake. But such pictures are probably more representative of the breadth of Venetian output than the works in which posterity is exclusively interested. On the expectations of the Scuola Grande di S. Maria della Carità, at any rate, Silvio's picture no doubt gives more exact information than the masterpiece by Titian.

In the vote of 1539 Silvio had received nineteen votes, only six of those present being against him. With Bonifazio de' Pitati the result was much closer, thirteen voting for and twelve against. And Bonifazio was one of the most competent painters of his time, who had proved himself in all areas. Bold advances and risky experiments were not for him, but he did try successfully to integrate the discoveries of the early sixteenth century with the praxis shaped by tradition. From the late 1520s, the depiction of the everyday world had found sanctuary in his narrative paintings. The *Finding of Moses* in Milan, for example, was quite clearly a pretext for him to portray an upper-class picnic, and he left out neither fools nor dogs, hunting scenes nor portraits, nor amorous couples of all kinds. Later Bonifazio enriched his paintings with movement motifs derived from Pordenone. This was usually done cautiously and in moderation, radicalism being foreign to this artist whose main consideration seems to have been for the needs of a moderately progressive public.

More demanding, but also more strenuous and not always free of a sense of strain, was the painting of Paris Bordone from Treviso. His most famous work, the *Presentation of the Ring to the Doge* (fig. 244) for the Scuola Grande di S. Marco, was completed perhaps in 1535.[130] In this case Titian's *Presentation* would have been a reply to it. Bordone had to portray a scene from the legend of St. Mark in which a fisherman whom St. Mark had rescued brings the saint's ring to the doge. The figures are fairly small, leaving much room for painted architecture in the latest Serlian fashion. There was also room for portraits of members of the scuola, and finally honor could be paid to the ruling doge. To this extent Bordone solved the problems posed by the vertical format in a masterly fashion, from the point of view of his patrons and the broad public. Unlike Titian—and closer in this to Carpaccio and Cima—he did not evolve his composition from the figures but first built his stage and then fitted the people into it.

The unfinished picture *Jesus among the Scribes,* now in the cathedral museum in Milan (plate 25), must have been finished a few years later. The painter responsible for this work chose a much simpler stage than Paris Bordone: two rows of columns and a throne in the middle were enough for him, all being regular and severe, cut off at the sides but open at the top.[131] Christ is in the distance but also at the vanishing point, directly opposite

the viewer, the others leaving open a path for the eye despite all their exaltation. To the right and left there are pulpits as in a church. All the seats are filled. Only the Virgin, the maid on the far right, is not involved in the general excitement. Her joy at finding her son was less important to the painter than her low class, which contrasts so conspicuously to that of the disputing scribes. A noisy, fanatical discussion is shown, with dignified men kneeling on the ground to find the correct passage, urged on by supporting choirs behind them. If the painting is measured against Paris Bordone, Bonifazio, or Titian, most of it is not successful; the size relationships are incorrect, there are unexplained changes of scale, and the accompanying groups lack differentiation. But the ambitions are all the greater. The work attempts to surpass all the successful Venetian painting of the time by quotation: Bonifazio in the Virgin, Paris Bordone in the centerpiece, Pordenone in the two old men at the front, and finally, at the very front on the right, even Michelangelo's prophets on the ceiling of the Sistine Chapel. A picture, therefore, that no handbook on art could find satisfactory, but bearing witness to a tempestuous genius who was not sure of his way but did not fear to take issue with everyone. Perhaps this painted manifesto, the original destination of which we do not know, remained unfinished for internal as well as external reasons. It bears no signature, but the attribution to the young Tintoretto, once voiced, was never again doubted.

Pictures and Their Audience

The relation of progressive painting to its audience in the second half of the sixteenth century was a complicated one. Painters complained more and more frequently about the incomprehension of an audience that for its part charged artists like Tintoretto with failing to show the necessary care and being more interested in giving free rein to their ideas than in pleasing the viewer with delicate brushwork.[1]

The modalities of ordering and buying—and consequently of artistic work itself—began to change fundamentally. Although the idea that art owed its origin and its rights to the artist's expressive needs existed, it was by no means general. The guild form of organization still survived but was not everywhere a decisive influence. New structures—like free competition in the market and a factory-like organization of workshops—gained importance, but they too were not always decisive. Although the general trend was very clear, individual situations differed widely. Even the idea of a simple antithesis between artist and patron, for example, though it was the foundation of contemporary artistic doctrines, no longer corresponded to reality in the sixteenth century. Almost always the relationship was not limited to a single point in time but could extend over weeks, months, or even years. The roles did not remain constant. The painter was not only someone who accepted a commission but also someone who indirectly, through earlier works, or directly, through sketches and models, offered, suggested, proposed. The buyer in turn had usually chosen a theme and formed some ideas about the artist and so had made a large number of decisions before setting foot in the workshop, decisions in which—consciously or unconsciously—the buyer took account of many factors: what was well thought of in the buyer's circle, what was affordable, and which painters were available, for not everyone had access to a Titian. In the dealings between artist and client, therefore, neither was either purely active or purely passive. Both not only accepted or rejected, but compromised, gave way, accommodated.

Artistic freedom was most likely to be achieved by the artist who succeeded in turning a market always governed, finally, by demand into a market that, at least for him, was dominated by supply. No Venetian painter pursued this goal as stubbornly as Jacopo Tintoretto. Even his contemporaries looked on with amazement and indignation as he secured one contract after another. Vasari offered the comment that Tintoretto worked so fast that he had usually finished while the others were just thinking about starting. Whether he secured a contract through connections, by low prices, as a present, or by violence, Vasari went on, Tintoretto took it, come what may. In Venice Tintoretto's business style was the talk of the city. The first detailed guidebook of the sixteenth century said in 1561 that Tintoretto, then only forty-one, had painted more than all the others together. Quickness of mind and hand were united in him. Overflowing with ideas, he had little patience, the guidebook concluded, and at all events he started far too much.[2]

Tintoretto was most successful with the Scuola Grande di S. Rocco, where he used determination and adroitness to secure a monopoly. Not everyone in the scuola was enthusiastic about his tactics or his pictures, and one donation was made on the condition that the commission would not go to Tintoretto.[3] But by and large Tintoretto got his way. He knew like no other how to exploit the weaknesses of his clients. For there was not only competition between artists but between patrons, particularly where the scuole were concerned, and they were of special interest to history painters. Although the painting of a scuola usually began with single works, as a rule the individual donations of the members were combined into cycles that—as in the Doge's Palace—covered the walls. From the mid-sixteenth century on—again in competition with the Doge's Palace—the ceilings were also decorated with pictures. But competition was waged not only between the scuole grandi on one side and the Doge's Palace on the other, but among the different scuole and among the members of each scuola. So that as many as possible could satisfy their ambitions, the signoria legislated short periods of office at the scuole. Some-

one who wished to leave behind a trace of his activity had little time, and a painter who guaranteed prompt delivery could expect to do well. On the other hand, prestige demanded well-known artists. The Scuola Grande di S. Rocco first made contact with Venice's most famous painter in 1553. The negotiations over the price seem, however, to have come to nothing, for the painting earmarked for Titian in the *albergo* above the tribunal was taken over by Tintoretto and finished in 1565. In 1564 the scuola had set up a committee that was to invite the three or four outstanding painters in Venice to take part in a competition. Those asked were Giuseppe Salviati, Federico Zuccari, Paolo Veronese, and Jacopo Tintoretto. While the others carefully produced models, Tintoretto is said to have mounted a full-size sketch onto the ceiling. To the objection that he had been asked for a proposal and not awarded a commission, he replied that that was how he worked, and if the scuola did not want to pay him he would make it a present of the picture.[4] As Tintoretto well knew, the scuola was not allowed to refuse such a gift. This ruse, no doubt embellished in the retelling, marked the beginning of a cycle of paintings that was doubtless unique not only in Venice, that took on ever-increasing proportions over the next fifteen years, and in which the painter seems more and more to have taken the lead (cf. fig. 95).

When the *albergo* of the scuola was finished, Tintoretto suggested in 1575 that he would now decorate the center of the great room on the first floor with "a history that I will explain, or with a different theme." The first proposal therefore came from the artist. Whether he already envisaged a whole hall full of Tintorettos is not certain. The scuola, at any rate, had no such plan, for it was decided the same day that the walls were to have the old canvases removed and be freshly whitewashed. The next year but one, on 13 January 1577, Tintoretto offered, with success, to paint the rest of the ceiling. In November 1577 there followed a still more ambitious proposal. Tintoretto, then fifty-eight, offered to work at the scuola for the rest of his life, not only on the ceiling, the ten wall paintings, and the altar of the sala, but in the church. To start with, on every St. Roch's day he would deliver three paintings. The plague was then at its height, so that the scuola of the plague's saint was the recipient of many donations. Its members would not have been free of the prevailing fear. Tintoretto explained his proposal not only by his love of the scuola, but for the first time by his "devocion" to St. Roch and his desire to see the scuola perfected and adorned with pictures wherever they were needed.

As a commercial arrangement the work at the scuola was less than lucrative. Although the competition was excluded, that was not a sufficient explanation for such a long-term commitment. Perhaps Tintoretto was influenced by the example of Veronese, who, even as a successful painter, had not turned his back on the small, remote church of S. Sebastiano, where a fellow countryman had first given him the opportunity to "show the Venetians his hand." We know nothing of Veronese's motives, but the course taken by the decoration of S. Sebastiano was not unlike that of the Scuola Grande di S. Rocco. First, starting with the ceiling, a small room (the sacristy) was decorated, the ceiling of the church followed, then its walls, then the high altar and the organ, and finally the paintings in the choir.[5] A complex of pictures was produced that, in its frescoes and oil paintings, ceiling paintings, altarpieces, and histories, gave the painter the opportunity to unfold his art without too much interference. He could also change the given room structure by painted architecture, and in the galleries there was even room for illusionist games: the arrows destined for the saint in the martyrdom seem to fly across the church, and a negro monk is seen leaving the gallery through a painted door. When Veronese was buried in S. Sebastiano in 1588, the church had become a museum in which his art had been allowed to develop in unusual freedom.

The old Titian, too, had attempted to make himself independent of single orders. In the *poesie* for Philip II he succeeded, but other proposals for cycles of histories found no echo in Madrid. Titian then applied to paint a cycle on the life of St. Lawrence, and before this he had made an unsolicited suggestion to the Habsburg monarch: "Your Majesty would be well advised to give out commissions for paintings commemorating for posterity the glorious and immortal victories of the emperor [Charles V]." He, Titian, in gratitude for the many favors he had received from the emperor, wished to be the first to deliver some paintings and begged to be informed on the lighting of the rooms and halls in which the pictures would hang.[6]

An artist who did not paint for a single client but for the public had to keep the public informed about his activities. This applied especially to Titian, whose admirers often lived far from Venice. For them were intended the reproduction prints that exist of many paintings by the master. Anyone who knew the paintings only from the engravings missed a great deal, however, above all the color that more and more became the basis of Titian's painting. One would also have had to look at many of the laterally inverted works in a mirror to get a proper idea of the composition. Moreover, the prints were to begin with of mediocre execution, even containing errors of reproduction. From 1566, concerned for his reputation, Titian had them made only under his direct supervision. In the same year he persuaded the signoria to issue a decree that gave him the monopoly of the distribution of

all the prints that "he had had engraved in copper for the convenience of friends of art and at great trouble and expense."[7] Otherwise mercenary people could have snatched the trade, sullying the painter's honor and deceiving the people with counterfeits of low value.

The majority of the works that Titian had reproduced were those destined for Spain, for while supplying the imperial family brought the highest fame to the painter, the pictures were inaccessible to the Italian audience. Occasionally Titian also used prints for subjects that he lacked the opportunity to paint himself. Lampsonius, secretary of the bishop of Liège, had in 1567 obtained six such prints from the art dealer Niccolò Stoppio. He wrote enthusiastically to his friend Titian that the invention in the pictures was as divine as in earlier years and the graphic quality far better, for the hand of the new engraver, Cornelis Cort, was incomparably more vigorous and quick, especially in drapery folds and thickets in landscapes. Lampsonius found wholly unique "the small, deserted hermit's landscape in the *St. Jerome*, and I imagine with great pleasure how it has been put into color by your so felicitous hand, with the figure of Jerome lifesize, as I am convinced you have made it." His bishop, the secretary reported, was so enthusiastic about the six engravings that he had to part with them and was hoping for the next consignment, already announced. Lampsonius had also been overjoyed to hear that Cort was to engrave further paintings, and he goes on at once to list his own wishes: the old prints of *Venus and Adonis* were so inadequate, he wrote, that they damaged Titian's reputation and honor. They had to be replaced. But above all, he would like to see prints of some pictures that he knew only by hearsay: a *Christ Triumphant*, the *Conversion of Saul*, the *Birth of Christ*, the *Imprisonment of Samson*, and a *Madonna with St. Ann, St. Joseph, Another Saint, the Child Jesus and Two Angels*. The distant admirer also wished for a new version of the *Annunciation* once inadequately reproduced by Caraglio. He had seen prints of some parts of the *Martyrdom of St. Lawrence* that had obviously made him curious. He almost entreats the aged painter to have as many of his inventions as possible engraved before his death.[8] According to contemporary art theory the "invention" or main idea, which was amenable to reproduction, was the most important part of a work of art.

Engravings like those admired by Lampsonius usually contain no information on the place, client, or date of origin of the picture reproduced. They thereby sever it from the context in which it was produced and in relation to which its effect was originally planned. Today, in the age of unlimited reproduction, this is taken for granted, but in the sixteenth century this step marked some fundamental changes in the reception and understanding of art, for now the work was placed definitively—and deliberately by its author—in a quite different context

to the one originally intended. If a painting changed its place, not infrequently its effect and meaning also changed. Vasari tells of an Emmaus picture that Titian had painted for a noble from the house of Contarini. It had seemed to the client that such a fine painting deserved to be shown in public. He had therefore, out of love of his country and the public, presented it to the signoria, who kept it for a long time in the private rooms of the doge but now, in 1568, hung it over the door of the Council of Ten where everyone could see it.[9] Paintings, particularly votive pictures and portraits, were also present in astonishingly large numbers in the houses of the *popolani,* who made up about 90 percent of the population. Inventories from about 1600 do not mention paintings in only one-tenth of the houses.[10] The *popolani* had access to a place like the Doge's Palace only on exceptional occasions, and when they did they must have reacted to the number, size, and splendor of the paintings there with no less amazement than the masses of visitors today; but they too would probably not have understood the works. Not even the names of the painters would have been familiar to them, for in their own circles, generally confined to their parishes, pictures by Bellini, Titian, or even Tintoretto were seldom seen. As a rule, this only happened when an ambitious neighbor from a higher class donated a new altar to their parish church and decorated it with a painting that in its modernity seemed alien to the old furnishings. To the Arsenal worker the landscape in the new style shown by Carpaccio on the first altar of S. Antonio di Castello[11] is sure to have been much more problematic than the familiar polyptych next to it. The person who commissioned the modern picture, however, perhaps a *cittadino,* had a much broader horizon. He knew other churches, had knowledge of the paintings in the scuole grandi, and had probably travelled outside Venice. He therefore knew that there was a development in painting, could distinguish modern from traditional work, and knew many more forms of painting than the *popolano,* whose experience was essentially confined to the religious painting in the churches and the secular painting on the façades of houses. The *cittadino* was also familiar with the history paintings in the Doge's Palace and the scuole, as well as portraits and probably some of the paintings in the private rooms and collections with their mythological or freely invented subjects. If he was especially interested, he could turn himself into a connoisseur by reading the literature on art that flourished after the middle of the sixteenth century.

A further differentiation within the audience, far more difficult to reconstruct than the class difference, is the one that resulted from the horizons governed by different professions and experiences of life. For example, a legate who saw the Palazzo Vecchio of Cosimo I in Florence and the new frescoes of the popes in Rome, considering their political content as well as their artistic

character with a knowledgeable eye, saw a new state painting differently from his brother, who as a merchant was at home in the eastern Mediterranean but in his experience of art was limited to Venice; and the experienced diplomat studied ceremonial pictures with different eyes than his nephew who had never had to concern himself with protocol and saw only festive pomp where the initiated saw claims, subtleties, and innuendoes. Tintoretto's depiction of the Last Supper would have irritated the traditionalist by precisely those features in which a sympathizer with Luther saw a new depth of faith; and the connoisseur who read Vasari may have perceived in the same features only the brilliance of the *invenzioni.*

The artist did not necessarily prejudge the section of the public for which he was working, and the different points of view did not have to exclude each other. There could be large differences between the implicit, ideal audience of a work and its actual audience, and often the painter would not have regarded the client as the ideal viewer of his work. There was as little preestablished harmony between the paintings and their audience in Renaissance Venice as anywhere else. The deciphering of simple programs often went astray, and where they were needed, especially in the Doge's Palace, guides were printed for which, despite their many errors, there were clearly enough buyers.[12] Even the few who could read in the sixteenth century did not, therefore, understand the content of paintings without any explanation.

On one hand the new audience helped art gain independence from the constraints of the guild system, but on the other this audience soon became, in the artists' eyes, too self-confident. More and more, people who had never used a paintbrush believed themselves competent to judge art. Of course, clients had always done this unconsciously, as when they refused to accept a picture that had been ordered. But in such cases contracts and tradition called for adjudication by qualified guild members— as would happen with a disputed piece of furniture. The contracts had therefore concentrated on materials, delivery dates, methods of payment, iconography, and dimensions, and for the rest people relied on the binding principles of a serious craft. But now contracts became possible in which the client, a lay person, tried to prescribe to the artist even the effects the painting was to produce.

Titian, for example, had in 1565–68 to paint three ceiling pictures for the city palace of Brescia. The order was accompanied by very detailed *avvertimenti* concerned not only with the content of the pictures but with the desired effect. The clients had very precise ideas on the figures, for example. Ceres was to be a "woman of matronly majesty, beautiful in features but not really mellow; delicate, as if browned by the sun and somewhat emaciated by her toil." Bacchus was con-

ceived as "a beautiful, delicate youth, beardless, with long spreading hair, two small horns at his temples, and a merry, festive, jocular face; in short, somewhat nonchalant, in every movement somewhat effeminate and lascivious, plump like an epicurean, but not bloated as some depict him."[13] The actual size of the figures was to be decided by the artist, but they should seem more than life-size. It should also be noted that the entrance was to the west and the painting was intended above all for the eye of someone entering the palace. The figures should therefore point towards the west, for if they were viewed from below with head back and face lifted they should appear to observers as if they were lying on their back with their head towards the west. Apart from that, the contract did not wish to anticipate the artist's judgment, particularly as regards the foreshortening of the figures in the air.

The *Vulcan and the Cyclopes* (fig. 247) was also exactly visualized in Brescia. Dark and smoke-blackened, it should display many weapons. For an animal, a lion seemed appropriate. Vulcan was envisaged as an ugly, emaciated old man covered in soot. His only piece of clothing was to be an old-fashioned hat, and he was supposed to be fashioning a middle-sized knife. At least three cyclopes of gigantic stature were to fill the space, and if there was enough room an apprentice could be tending the fire. "The raking of ore and pouring of iron should be omitted, for so much cannot be understood at a distance without confusing the eye." Titian's reply no doubt contains a good measure of irony; he finds the instructions "bellissimi" and feels considerably enlightened on the subject of *poesia.* So amply instructed on the wishes and ideas of his clients, "I shall make every effort to achieve everything that the demands of art and the peculiarity of the work require for my honor and the service of this magnificent city."

When the ceiling paintings, of which Titian also had engravings made, were delivered, the clients refused to pay an adequate fee. They complained that the paintings were not by his own hand. In 1559 Titian asked his friend the archbishop of Brescia to mediate. On completion, he wrote, the paintings had been accompanied by his son Orazio to Brescia, where their authorship had been called into doubt. Despite this, an offer to pay more than had first been offered had been turned down by Orazio out of regard for his father's honor. He, Titian now sought an honorable compromise, but he had to insist that the value of his paintings could not be judged by laymen, but by painters, and only by excellent ones: "For even if Aristotle were called upon, he could judge neither the differences of style nor the difficulties peculiar to art."

In 1561 Francesco Sansovino, the son of the sculptor and architect and one of the most successful polyhistors of his time, published his guide to the city in dialogue form. One of the many things the Venetian was to explain

to his Tuscan visitor was art. Like the situation, constitution, or history of the town, its art had now become an area that deserved attention and explanation for its own sake. This in its turn was in part a precondition and in part a result of a new kind of art literature that no longer addressed its instruction, advice, and warnings to the artists, but to an audience of interested laymen and amateurs.[14]

Francesco Sansovino's little book also contains the first continuous sketch of a history of Venetian painting. Its models and sources were the passages devoted to Venice that Giorgio Vasari had published in the first edi-

247 After Titian, *Vulcan and the Cyclopes.* Formerly in Brescia, City Palace

tion of his *Lives of the Artists* in 1550, and the dialogue by Lodovico Dolce that appeared in 1557.[15] Following in the footsteps of the model developed by Vasari for Florence, Sansovino outlined an early phase in Venice, now surpassed but deserving respect as a prerequisite for the present, the most important painters of which were the Bellini brothers, who had painted as delicately and carefully as miniaturists, although they had lacked softness and modelling. Among Giovanni Bellini's works, apart from the histories and the altarpieces in S. Giobbe and S. Zaccaria, the madonnas are given special praise. After that, according to Sansovino, came a golden age whose protagonists were Giorgione and Titian. For the next decades Bonifazio de' Pitati and Paris Bordone are mentioned, but above all Pordenone. He is said to have painted more powerfully than the others and shown more lifelike postures. But he shone above all in fore-shortened effects like that of the horse on the Palazzo d'Anna (fig. 53). All, however, Pordenone included, were surpassed by Titian, whose histories and portraits were not equalled even by Apelles. At the center of the whole Venetian scene Sansovino saw Tintoretto, then forty-three.[16] Perceptively, he also pointed to the young Veronese, who had just distinguished himself at the Doge's Palace. In his canvas paintings he was ahead of everyone, his color and drawing lacked nothing, and his style was soft and beautiful.

Although the home audience saw only a small part of his works, Titian remained even in old age, for Venetians and foreigners alike, the Venetian painter par excellence. His fame was undimmed by the condescending remarks with which Vasari informed the readers of the second edition of the *Lives of the Artists* (1568) about Titian's late works. Like the other Venetians, he wrote, Titian dispensed with preparatory drawings, firmly convinced that to paint with colors alone was the right way. Vasari had little understanding of this and encouraged his readers to believe that Titian wished to conceal his shortcomings in drawing with the beauties of his color. For the late works Vasari had at best pity: it would have been better for Titian to paint only for his own amusement and not to fritter away with bad paintings the reputation won in earlier years.[17] Vasari's polemic was a counterattack intended to parry Venetian attempts to place Titian beside or even above Michelangelo. The controversy over Michelangelo's supremacy was for the Venetians a struggle over their own artistic identity. In the seventeenth century the free brushwork of the Venetian painters was even praised by Marco Boschini as an expression of the political freedom existing in the republic. In 1548 Paolo Pino had ranked Michelangelo and Titian equally, adding somewhat naively that perfection would be attained by that artist who could combine Michelangelo's drawing with Titian's color. Legend has it that the young

Tintoretto wrote this program as a motto over his studio door. An open attack on Michelangelo by Lodovico Dolce followed in 1557.[18]

Even the Venetian audience had difficulty, however, with a painting style that departed so far from the traditional craft virtues. Such pictures were held to be unfinished, speaking of negligence or undue haste. Tintoretto, for example, was pursued throughout his life by the charge that he worked too fast. In 1548 Aretino coupled to his praise of the *Miracle of St. Mark,* which marked Tintoretto's breakthrough, the admonition that Tintoretto would only attain perfection when the "prestezza del fatto" had given way to the "pazienza del fare." [19] Schiavone too, and on occasions even Titian, was taxed with undue *prestezza.* Here, *presto* and *prestezza* seem to have had a double meaning. On one hand it meant the time actually spent (or not spent) by the artist, but on the other a kind of painting that looked as if it had been produced quickly, merely sketched—regardless of how long the artist had actually needed. Titian, unlike Tintoretto, worked very slowly, far more slowly than Veronese, who was so much more faithful to detail. The great difficulties experienced by the broad audience and later the attacks by Vasari forced Venetian art theory to come to terms with the problem of *prestezza.* Pino distinguishes in 1548 between expeditious and over-precipitate work (*ispedizione* and *prestezza*), the latter being a fault.[20] But a never-ending polishing was not a good way either. Rather, the artist should, like the poet, tread the path of medium care. For the rest, it was not a matter of how much time was invested but of the perfection and value of the result; these distinguished the true master from the fool. Lodovico Dolce argued more elegantly eight years later. He too was not in favor of mere sketching, but he criticized excessive care that could only do harm. "Una certa convenevole sprezzatura" was the right way, a seemly nonchalance, as the "Cortigiano" had advised the courtier.[21]

For many non-Venetians *prestezza* became the trademark of the painting practiced in Venice. More and more, we read in the treatise by Armenini of Faenza in 1587, Venetian painters were in the habit of painting nudes in mere material (probably meaning *alla prima*) and of no longer modelling drapery folds in dark areas, so that they lacked all relief. None of them worked as carefully as the Flemish, and even paintings for important sites—meaning the Doge's Palace and the scuole—were often only sketched and half-finished. Some works were good, but many were not even properly laid out.[22]

The decoration of the Scuola Grande di S. Rocco, which was by no means Tintoretto's only occupation between 1564 and 1589, was not least a feat of organization. Without a rather large workshop and a very efficient working procedure such an undertaking would have

been doomed to failure from the start. The pictures are marked by the conditions in which they were produced, in conception no less than in execution. Judging by eye, the role of assistants must have varied greatly in the different paintings. The sources reveal little, since officially everything was done by the master. But in practice, one has to examine each painting separately in order to say what is really meant by the designation "Tintoretto." Does it refer to the merchant, the head of the firm, or the artist? And if the artist, does it mean the one who conceived, or the one who executed? Word got around that as a rule the master was only partially involved in the execution, but it is less well known that he was also only partly responsible for the conception of many paintings. A clear allocation of tasks and definition of competence, as has been proved to exist in the case of Veronese's workshop,[23] seems to have been absent in Tintoretto's. Since the invention and elaboration of a composition claimed his time and the delivery times were very short, it is hardly conceivable that Tintoretto could have taken

over even all the preparatory stages himself. On occasions he seems to have delegated entire paintings from first to last to Domenico and others. Normally, however, more than one pair of hands—and more than one head—was at work on any one painting. In one and the same painting, therefore, one not uncommonly finds the most original ideas beside the most trivial, and the quality of execution ranges from the virtuoso to sheer incompetence. Measured against the exceptional capabilities of Tintoretto, there is a shoddiness of work that no other workshop would have permitted itself. Paintings as replete with stereotyped and often inappropriate motifs as *The Pool of Bethesda* are matched by others as entirely original and as intensely relevant to their themes as the *Adoration of the Shepherds* or the *Annunciation.* The painter who did not apply so much as a brushstroke to such important conceptions as the *Scene in Gethsemane* or the *Assumption* elsewhere conjured the most extraordinary individual motifs from meager workshop inventions. Nor is it the case that the most important figures in

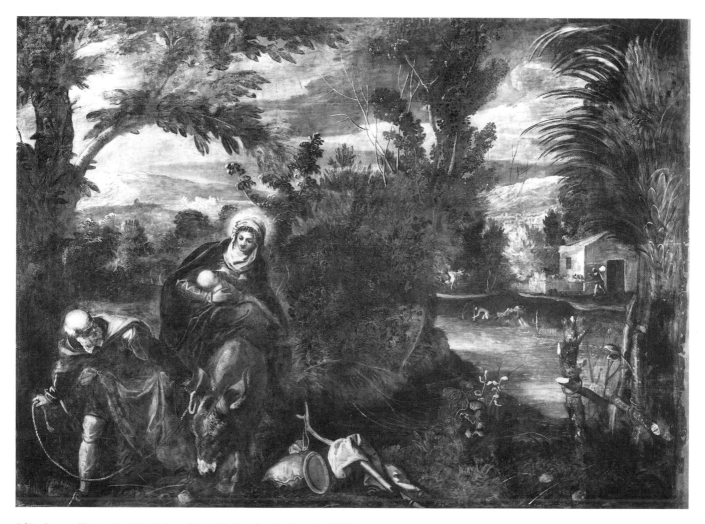

248 Jacopo Tintoretto, *Flight from Egypt.* Venice, Scuola Grande di S. Rocco

an event depicted are always by Tintoretto. In the *Annunciation* it is the instrument rather than the Virgin, in the *Flight into Egypt* (fig. 248) the luggage rather than the infant Jesus. A catalogue raisonné of the original parts could show only fragments of many pictures, often not even a whole figure. It would have to detach passages of consummate art from an often desolate environment of painted canvas.

The independence and need for self-realization that had impelled Tintoretto to commit himself so completely to the Scuola Grande di S. Rocco became fragmented and threadbare in the realization. The standards of craftsmanship fell accordingly, and up to his death Tintoretto failed to build up a standard of workshop practice that would have counteracted this and guaranteed uniform quality. Was it that he lacked the organizational gifts of a Raphael, a Rubens, or a Veronese, or that he saw a danger of losing his spontaneity?

The time by which he was faster in delivering than his competitors was lost to the work of composition and, above all, elaboration. Even his contemporaries praised the vigor of mind and brushwork of this artist driven by an almost compulsive urge to invent and realize. These qualities still arouse enthusiasm for his works today, although almost every one of them bears witness to Tintoretto's permanent overestimation of his capabilities, his constant taking on of more than he could achieve, so that in the years he worked for the Scuola Grande di S. Rocco he hardly painted a single picture in which all his potential was entirely realized.

Altarpieces

At the end of the sixteenth century there was hardly a Venetian home that did not contain several devotional pictures, new and old. Giovanni Battista Armenini, a rather unsuccessful painter from Faenza, complained in 1587 in his treatise on painting that he knew of many richly furnished houses that had brocade wallpaper and objets d'art in even the most private chambers. Only the devotional pictures did not fit: many were *alla greca* (Byzantine) in style, clumsy and repellent, and covered in soot. They served no other purpose than to inspire devout thoughts and certainly not to embellish such genteel rooms. It was a shame, he concluded, that good Christians and Catholics who spared no other expense should not hang a single fitting and well-executed painting in the rooms in which they spent most time. For how was one to turn to God daily in prayer, if not by contemplating beautiful pictures?[24]

The function of the devotional painting could come into conflict with the demands of art. In his fictional discussion among Vittoria Colonna, Michelangelo, and himself, Francisco de Holanda has Michelangelo express an opinion on the merits of Flemish devotional pictures. He declares that in general they appeal more to women than any Italian painting, which could not draw a single tear from anyone. However, the effect of the Flemish paintings was to be attributed not to their artistic value, but to the faith of the viewer: "They will appeal to women, especially very young and very old ones, as well as to monks and nuns and a few noblemen who have no sense of true harmony."[25]

When Titian travelled to visit Charles V in Augsburg in 1548, he had in his luggage, apart from a *Venus* now in the Uffizi, an *Ecce Homo*. A second, somewhat altered version had been given to his friend Aretino for Christmas.[26] Aretino attested that it had changed his bedroom from a room of worldly state to a temple of God.[27] Pleasure had been turned to prayer and lasciviousness to uprightness. Identification with the Christ depicted, according to Aretino's letter of thanks, showed the viewer the way: "The pain wrenching the figure of Christ moves all to penitence who in a Christian spirit contemplate the arms constrained by the rope that binds the hands." He who pays heed to the rod will learn humility, he continues, and he who sees the peaceful devotion of the face can henceforth feel neither hatred nor ill-will.

That Aretino hung Titian's gift in his notorious bedroom bears witness to an immunity to embarrassment almost unimaginable today, but even the emperor, famous for his piety, was given a *Venus* as well as the *Christ*. On the other hand, despite its rhetoric, Aretino's text may testify to the uncommon power of this painting, badly damaged today, which is almost programmatically free of artistic ambition. The small part of the figure shown by the painting brings the viewer close to Christ, but this only heightens the inner distance. The captive Christ is shown almost but not entirely frontally, an image of resignation to a fate the weight of which is more intensely conveyed, in that all allusions to redemption are avoided. As a pendant Titian later sent the emperor a "Mater Dolorosa" (fig. 250). Correctly hung, she would not have looked into a void but at Christ. This painting too, which with its pendant accompanied the emperor to the monastery after his abdication, has suffered badly. But even in the state in which Titian presented it, it disregarded any purely aesthetic expectations concerned primarily with beauty of posture, hands, materials, or even of color. We see features disfigured by grief and eyes inflamed by weeping, not the luxuriant hair and blooming flesh tints of the Magdalen (fig. 251). Even the gesture is not cathartic: no praying in pious abandon or woeful wringing of hands, but a petrified intermediate state.

Looking at the *Christ on the Cross* in the Escorial (fig. 252), too, it is easy to believe that Titian painted it primarily for the emperor's eyes. Produced perhaps about 1555, the picture is mentioned for the first time only years after Charles's death.[28] More than two meters high, the painting is too large for frequent transportation, yet

we do not know which site Titian envisaged for it. Perhaps he had in mind the main altar of a small chapel, where one would be directly confronted by the picture. In a first hilly and then mountainous landscape with soldiers, and with Jerusalem already sunk in darkness, the cross is placed at the front in the center. Wooden stakes forcibly driven into the ground remind us of its raising, and a skull on the right alludes to Golgotha, the place of

skulls. Painted as if alive, this skull looks up at Christ. The empty part of the cross upright bisects the landscape, with the part of the sky colored by the sunset low down behind it. The upper half of the picture belongs entirely to Christ, who has withdrawn far into solitude. A heavy sky, partly stormy and partly a threatening darkness, is split in only two places: on the left by the traditional half moon, and on the right not by the corresponding sign of

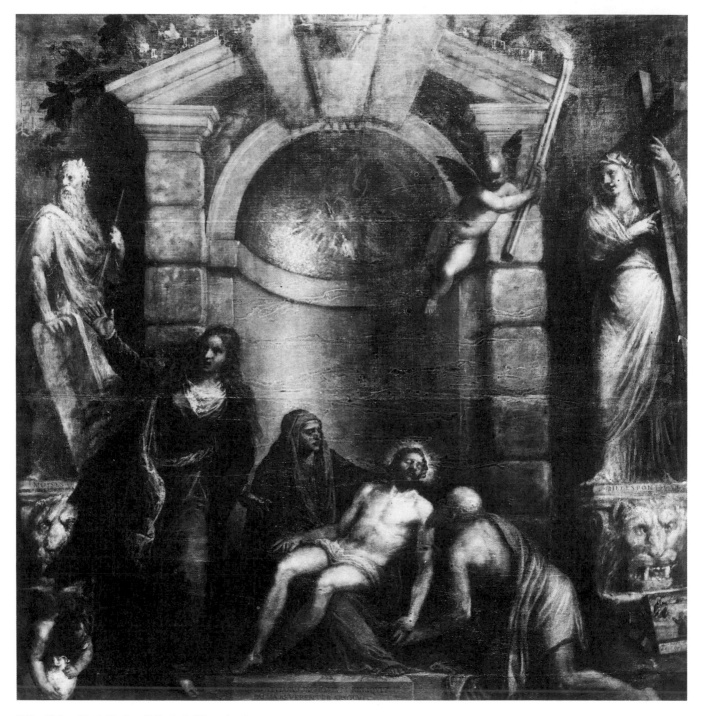

249 Titian, *Pietà*. Venice, Gallerie dell'Accademia

the sun but by a flash of lightning. A light not explained by what is shown in the scene illuminates Christ's body from the left, transfiguring the sacrifice that is recalled by the Eucharist. It is not the events of the crucifixion that are presented, but its meaning. Hence the omission of psychology and a description of the nailed body, and hence the laconic upper section, where the crossbeam, nails, crown of thorns, and inscription are joined in a strict order more symbolic than narrative.

As in his middle years, in old age Titian produced

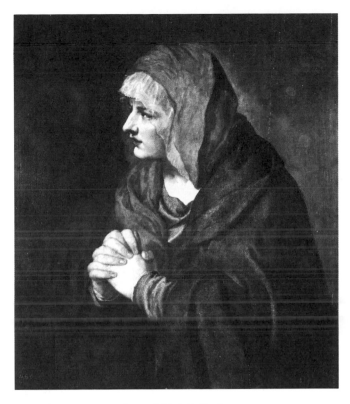

250 Titian, "Mater Dolorosa." Madrid, Prado

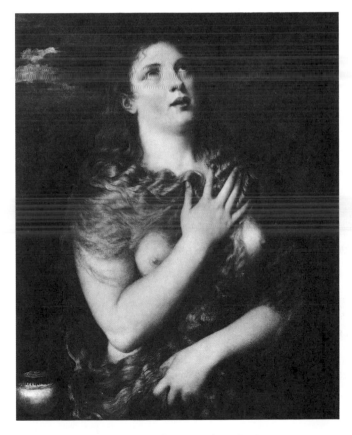

251 Titian, *Mary Magdalen.* Florence, Palazzo Pitti

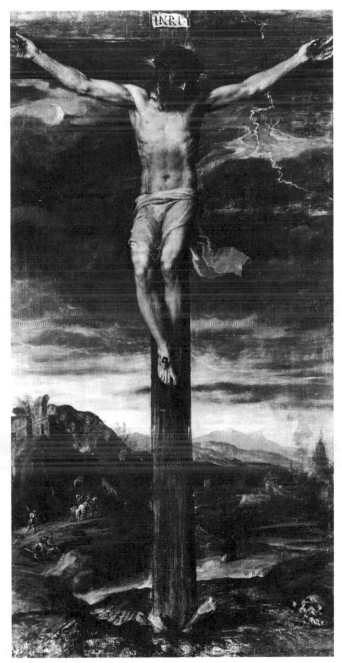

252 Titian, *Christ on the Cross.* Escorial

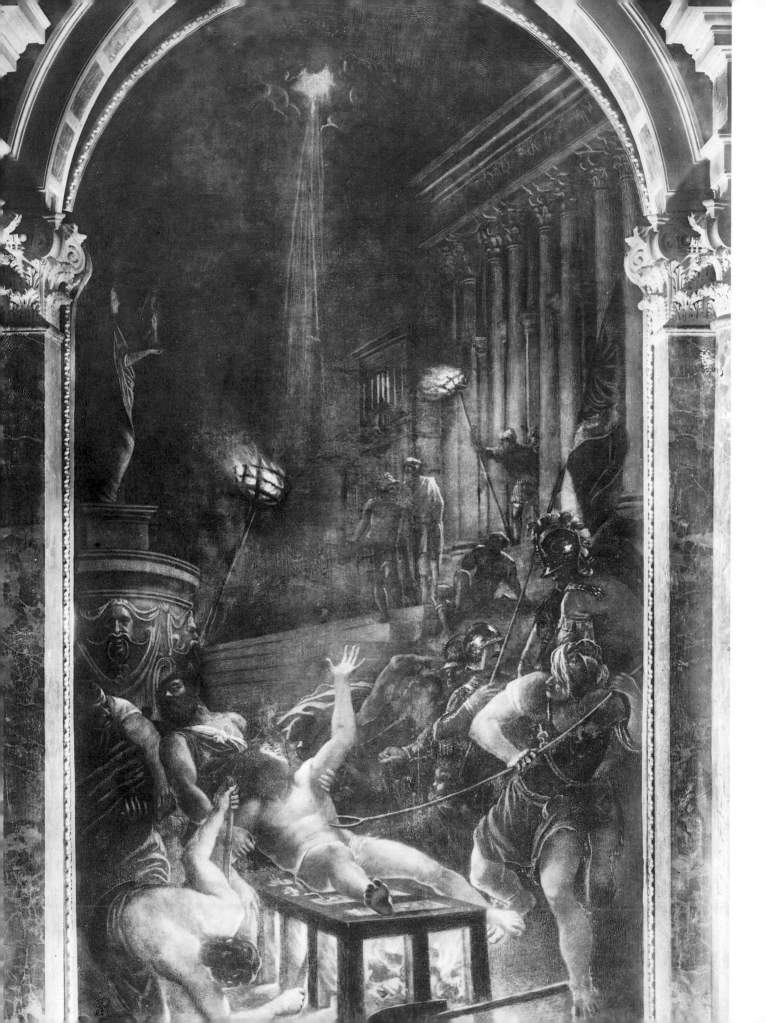

examples of the narrative altarpiece without which the altar art of the seventeenth and eighteenth centuries would certainly have taken a different direction. The one that had the greatest effect was the *Martyrdom of St. Lawrence* (fig. 253). Already in progress in 1548, it appears to have been finished soon after 1557. Descriptions and engravings quickly spread its fame, and in 1564 Philip II is even said to have been content with a copy painted under Titian's direction for the Escorial.[29]

Whereas Veronese in his famous altarpieces for Padua and Verona (fig. 254) expends much effort in showing the preparations for the martyrdom, Titian makes the act itself his subject. His fire is hot, the flames, painted with heavy impasto, are painful, and the fork with which the victim is pushed down onto the grid bends under the pressure exerted by the enormous torturer. While Veronese assembled whole colleges of saints above his martyrs, to whom they could raise pious eyes, the gaze of Titian's Lawrence meets either his towering persecutors or the indifferent bystanders looking on from the temple steps. Although the black sky has slightly opened, the light breaking through has not nearly reached the tormented saint.

Titian did not wish to inflict so much despair on his royal client in Madrid. In the version sent to Spain the steep stairs with the columns of the temple and the spectators, which cause the saint's abandonment to be felt in all its keenness, are missing, and instead of the pitifully small light in the sky a stately moon had risen. If not the martyr, the viewer sees two angels floating down with a victor's laurels. In this, Titian approaches paintings by Veronese, in which the saints are brought garlands and palms, sometimes even before the martyrdom has taken place. Veronese places the rewards and the salvation of the martyr before the eyes of the faithful, whereas Titian shows his abandonment and torment. Veronese's audience is spared the martyrdom itself. Titian, by contrast, takes literally the text of the legend, which does not speak of a future transfiguration and takes the night of torture that the Roman Imperator prescribes for St. Lawrence as its main subject.

In its original place, the second side chapel in the right aisle of the building that preceded the present church of I Gesuiti and was demolished in the baroque period, one could probably have escaped this effect far less easily than today. Coming from the main door, one would have looked directly at the saint. The shovel that had heaped up the coals and the glow of the fire would have been at eye level. The minion poking the fire and the force the torturer on the right is exerting on the fork are threatening to the viewer also, particularly as the evil

in them is not shown as moral depravity but as a demonic power.

Ten years' work on a picture like this was not a long time by Titian's standards. Anyone who ordered from him had to practice patience. The artist was seldom impressed by agreed deadlines, and pleading or threatening usually had little effect. As he did not work from cartoons, which, once fixed, could in case of need have been transferred by others, he performed almost the entire creative process on the canvas itself. The boundaries between sketch and execution became more and more fluid, until for the last works there are hardly any objective criteria for deciding when a painting is finished and when it is not.[30] Even with Titian's method of work, however, the basic elements must have been decided at least in outline at a relatively early stage. The position of the martyr and his tormentors and—following logically—the figure on the plinth at the left must be among the early parts of the painting, if not necessarily in their present form. Other elements, like the stupendous night pieces around the torches, the windows, the men on the steps lit from behind, and the statue on the left, would have been painted only in the last stages.

Among the great works that still stood unfinished in his workshop on Titian's death in 1577 was a painting that he had intended for an altar near his grave (fig. 249, plate 26). By type it is a pietà, a devotional picture, but by its dimensions (3.53 by 3.48 meters) an altarpiece. It was to adorn the altar of the Holy Cross in one of the most important Venetian churches, and at the same time it was to express the private devotion of the artist, who for this painting at least was finally his own client.[31]

In 1573, shortly before Titian's death, another Venetian painter, Parrhasio Michiel, had painted a *Pietà* (fig. 257).[32] It decorates an altar donated by him, before which he later had himself buried. Parrhasio, Ridolfi recounts, "painted himself there, standing absorbed in adoration, with two angels 'in gloria'; he took the idea from a drawing by Veronese that we have seen ourselves." The body of Christ is laid out as if lying in state on an altar before the viewer. Angels hold the chalice as a sign of the second element of the Last Supper. Accompanied by cherubim, one of them has descended to show Parrhasio the stigmata. Great pretensions, therefore—a portrait of himself as the chief motif of an altarpiece and the painter himself as a pious model—but perhaps only the expression of a naive faith. Inscriptions explain the meaning. At the bottom we read, QUI MORTEM NOSTRAM MORIENDO DESTRUXIT, and at the top, EST PANIS QUI DE COELO DESCENDIT.

The inscription on Titian's painting does not relate to its meaning but to its history. This work, it says, that Titian left behind unfinished was completed with reverence—"reverenter"—and dedicated to God by Palma the Elder. How large was Palma's contribution to the

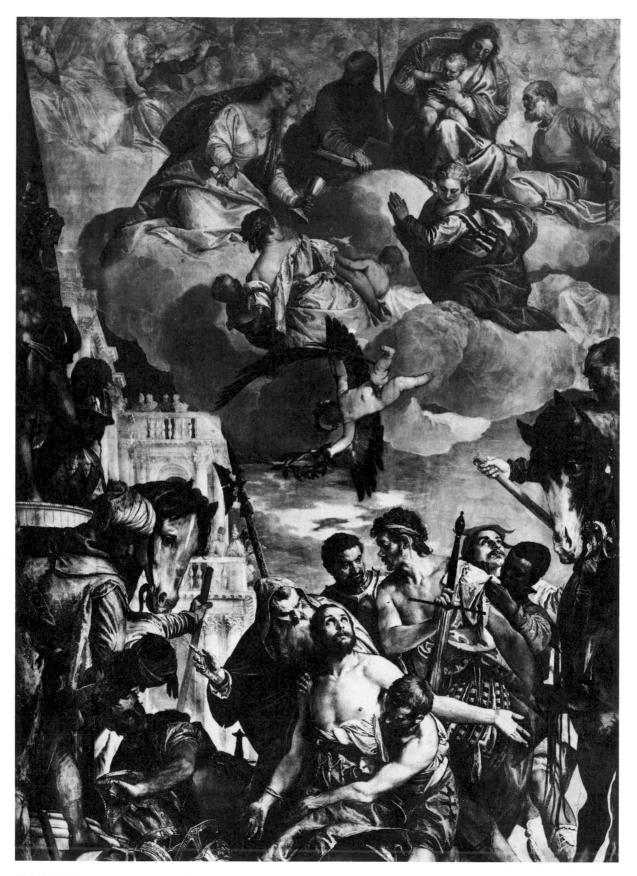

254 Paolo Veronese, *Martyrdom of St. George.* Verona, S. Giorgio in Velabro

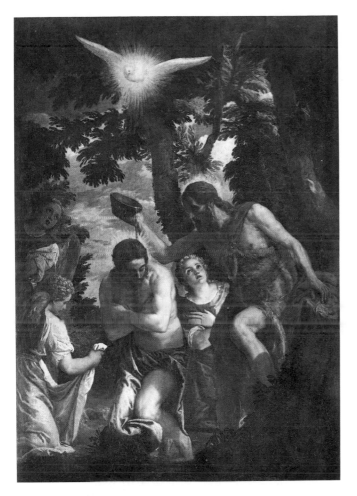

255 Paolo Veronese, *Baptism of Christ*, Florence, Palazzo Pitti

execution cannot be exactly assessed today. The old tradition that he left only the two statues untouched has something in its favor. From the only unfinished painting by Titian that does not seem to have been retouched later, the *Crowning with Thorns* in Munich,[33] we learn that individual parts could be in very different states. While Titian was putting the highlights on some widely scattered points, he had not even decided the exact posture of some other figures. All that is clear is that the most "picturesque," least definitely objectified parts are the earliest, for Titian worked not "impressionistically," dissolving objects in color and light, but rather like Cézanne, from relatively free configurations of color and form to the definite objects. The final appearance of a garment or expression of a face was often decided only at the last stages of work. Or not at all, for in not a few cases Titian broke off and let his workshop "complete" what was missing. Whether this happened because only the process of painting mattered to him or because he simply gave up, Palma for all his reverence had to finalize many things, including expressions and gestures, of which Titian himself probably did not know how they were finally

to look. But the large relations would probably not have been changed by Titian. The gap formally bridged by Mary Magdalen between the niche with its surround and the actual pietà with St. Jerome has often been explained by the argument that Titian had first begun a smaller pietà and then decided to enlarge it into an altarpiece. But in the two groups and the work's dual function as altarpiece and devotional picture reflected in them, might there be two divergent forms of piety? One seems manifest in the great architectural form, the prestigious statues, and the public appeal; the other leaves the wide niche empty because it seems to find expression less in the pompous altarpiece than in the small votive tablet that Titian has placed low down on the right, before the coat of arms bestowed on him by the emperor.[34] St. Jerome, kneeling in reverence before Christ, is probably a self-portrait.[35]

The Madonna holds the dead Christ in such a way that Jerome/Titian can approach him. Magdalen and the two statues, by contrast, are turned outward and to the left. If these movements were not to issue into a void, the most important access must have been from the left. The light that makes these movements visible comes from the right and so has a retarding effect. How strong the discrepancy becomes depends on the angle of view. It is greatest from the right. Seen from the left, Magdalen arouses the viewer's attention and directs it at the pietà. In this she harmonizes with the statues beside the niche. From the right, however, the side of Titian with the votive tablet, coat of arms, and self-portrait, Magdalen is first of all someone who turns away and, in contrast to St. Jerome but entirely in unison with Moses and the Hellespontica, takes no notice either of the Virgin or of Christ. From the left, too, the emptiness of the niche is far more noticeable. The putto flying nearby for no clear reason is an attempt to counteract this formally.[36]

Might there be in this painting, hidden to a superficial, conventional view, two levels and two messages? An unproblematic one for the broad audience and a second one revealed only to those who look with concentration at the motifs and forms and are guided by them, not by tradition and visual habits?

Even in his late period Titian's altarpieces were the most important produced in Venice, but they were not typical. The typical ones were the routine products of the various workshops. Pupils of the pupils of Giovanni Bellini in the Santacroce workshop found an audience until the 1550s, but the most powerful presence in the market was the firm of Tintoretto.[37] Its output reflects the whole range of contemporary altar painting: saints alone, saints with the Madonna, saints with donors or with both together. Narrative altarpieces like the *Birth of St. John* or the *Assumption of the Virgin* are also well represented. Only masterpieces are rare.

The *Baptism of Christ* in S. Silvestro (fig. 256) is one

of them.[38] The over-life-size figures of this painting almost three meters in height are brought right to the front. John baptizes with water, but the actual baptism is performed by the Holy Spirit present in the light. The divine light is so intense that it over-illuminates John, leaving part of his face in shadow. In other parts, divine and earthly light can so mingle that it is impossible to say which is responsible for the lighting of a given spot. The artistic use of light also sets off the brilliant nudes, working in conjunction with the arches of shadow, partly vibrant and partly rigid, formed by the outlines. But not only in the execution did Tintoretto forget his much-criticized haste. In this painting he also found motifs for the spaces he often simply left empty: as a setting for John the Baptist a stream flowing into the Jordan, and

next to his foot a small laurel, a symbol of redemption which—as if by accident—touches Christ's hand. Christ's right hand expresses attention and reverence, but also points forward, resuming the direction that had brought him to John the Baptist. For Christ, Tintoretto states in this painting, the baptism was only a stage on his long journey.

The Christ in Veronese's much smaller baptism picture in the Palazzo Pitti (fig. 255) is not walking light-footedly forward but kneeling, almost shivering, on a stone in the water.[39] If Tintoretto had opened a view of loosely sketched distances, so providing a stage and a path for the dove, Veronese chose a forest interior—as if the baptism were taking place at a spring and not at a river. Veronese did not even try to provide a motivation

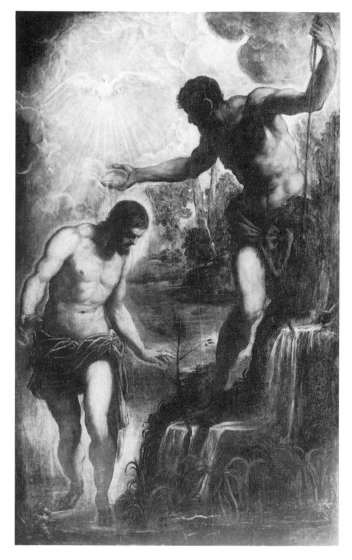

256 Jacopo Tintoretto, *Baptism of Christ.* Venice, S. Silvestro

257 (*Right*) Parrhasio Michiel, *Pietà.* Venice, S. Giuseppe di Castello

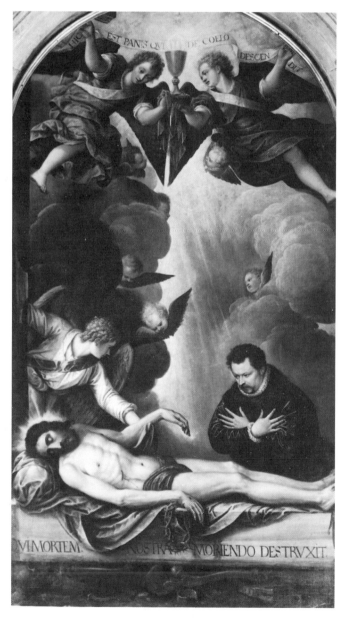

for the dove's appearance. It remains a symbol but is related to the action by two of the angels who look up from the bowl, that is, from the baptism of water to the spiritual baptism, from the visible process to its sacramental meaning. The impact of Tintoretto's painting spreads, attracting and comforting the viewer, far into the church. On coming closer it can appear as if Christ is bending in benediction towards the visitor. With Veronese's painting it is different. In this much smaller work, probably painted for a private chapel, everything is concentrated around Christ who, although near, is separated from the viewer by the dark zone at the front. The group of three angels, who traditionally hold Christ's discarded garments, has been broken up by Veronese. Two are moved to the very edge as a counterweight to John, and the third angel—in a quite new invention—is placed between John and Christ. The angel's delicate, inward emotion sets the tone for the whole painting, including St. John, who so cautiously pours his water on to the Redeemer's head.

When Veronese was working on this picture he already had a long career as an altar painter behind him. One of his first attempts after arriving in Venice was the altarpiece for the Cappella Giustiniani in S. Francesco della Vigna.[40] In this work, voluntarily or involuntarily, he had come into competition and incurred comparisons with Titian's "Pesaro Madonna," which was recalled above all by its arrangement. There was the same extensive use of architecture. But the difficulties encountered by the inexperienced artist in giving a meaning of its own to an arrangement predetermined by its model were considerable. The young Veronese even had problems explaining the postures. He had to make Joseph squat, while Anthony was posted on a piece of column introduced for this very purpose. Areas of transition, connection, or mediation are everywhere weak, the relationships external, formal—in sharp contrast to the conception and execution of some of the individual figures, like St. Catherine sunk in admiring contemplation of the infant Jesus.

The more the altarpiece lost its identity, in the course of the sixteenth century, as an autonomous artistic entity with its own specific themes, the more pronounced became Veronese's special position, not only in his celebrated martyrdoms but also in his miraculous images, like the one on the high altar of S. Sebastiano (fig. 258).[41] Around the titular saint of the church, whose column has been doubled to indicate an arena, five other saints are gathered. They are not calmly assembled, but deeply moved: looking up, starting from their reading, falling to their knees before something appearing above them, without being able to tell who or what it is. Even Sebastian is overshadowed by the cloud on which the Virgin is enthroned. Although one of the accompanying angels looks down towards the saints, the other directs the eyes

of the congregation in the church, who can see all the figures, towards the Madonna appearing before them above the saints, who is related more strongly to the church and those present in it than to the saints. But the saints' reaction shows the unusual, even terrifying aspect of the apparition. With deep seriousness Paolo Veronese restores to prominence functions of the altarpiece that had largely fallen into disuse, particularly that of acting as a focus and inspiration of meditative contemplation.

The high-altar painting for S. Caterina (fig. 259, plate 27) was painted for one of the most aristocratic convents in Venice.[42] The nuns, who came from the first houses in the city, would have had no difficulty in identifying with

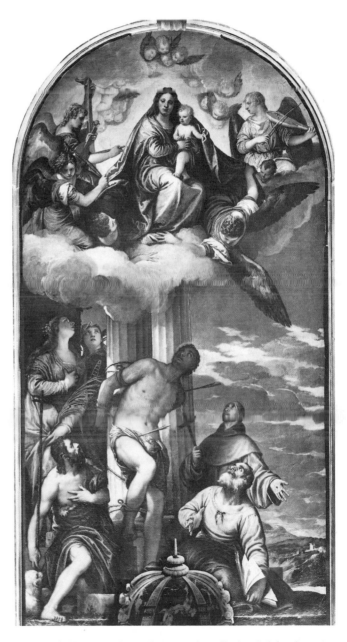

258 Paolo Veronese, *Sacra Conversazione.* Venice, S. Sebastiano

Mark are closely linked by composition and color. St. Jerome is their counterpart. Christ appears again higher up, *in forma pietatis,* held by angels, rigid in death. Here the rules of the history painting are as inapplicable as the tradition of the altarpiece. Both Christ's modes of appearance, as a corpse and after the Resurrection, complement each other in the meaning of the work but do not constitute the context of a history. Only a meditative

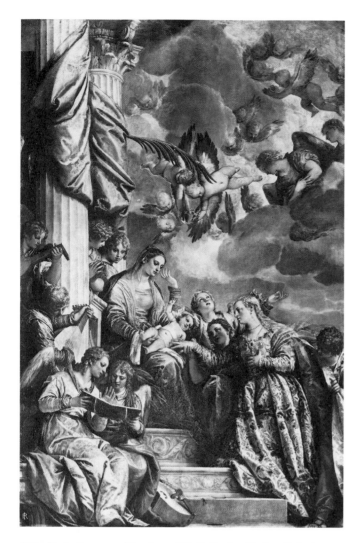

259 Paolo Veronese, *Marriage of St. Catherine.* Venice, Gallerie dell'Accademia

the martyr who is betrothed to Christ in a rich wedding dress and with loosened hair. A careful preliminary drawing, perhaps the one that earned Veronese the commission, shows the groups sharply isolated. Veronese discovered the close links between all the angels on the right only at a later stage, and the figure between St. Catherine and Christ, whose raised arms not only link the two protagonists but also, as if naturally, receive the putti bringing the palm and crown to the martyr, was also a later idea. But it was only these inventions that made a picture that was in danger of becoming a costume piece into one that culminates, not in the brilliant entry of the royal daughter before the throne of a Madonna in deliberately simple clothes, but in the betrothal of a saint beneath the symbols of martyrdom.

The altarpiece in S. Giuliano (fig. 260), one of Veronese's last works, was a private donation.[43] The donor's patron saint, the kneeling St. Jerome, turns from his reading to Christ, who appears as a pilgrim. Christ and St.

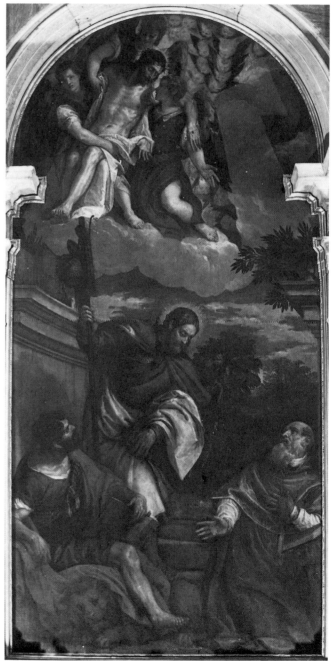

260 Paolo Veronese, *Pietà with Risen Christ Appearing to St. Jerome and St. Mark.* Venice, S. Giuliano

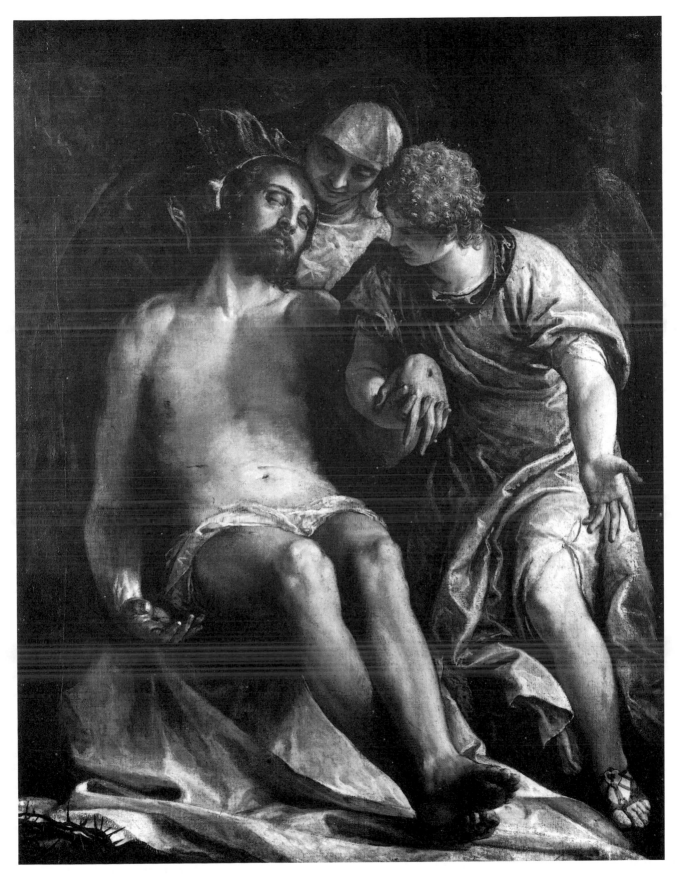

261 Paolo Veronese, *Pietà*. Leningrad, Hermitage

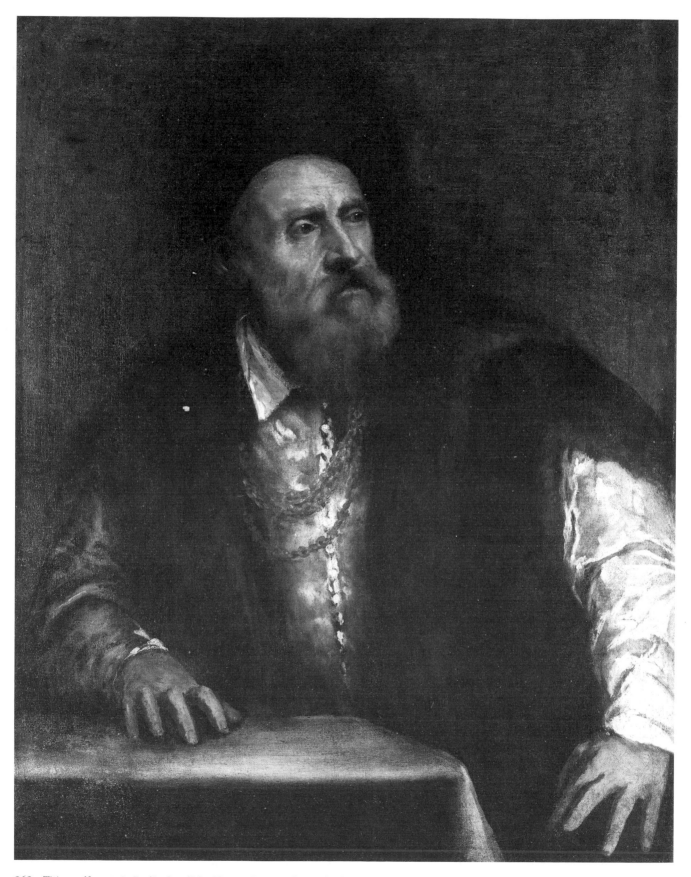

262 Titian, self-portrait. Berlin, Staatliche Museen Preussischer Kulturbesitz, Gemäldegalerie

contemplation that includes this meaning can create a connection between them.

It is not surprising, therefore, that it was Paolo Veronese who also produced one of the last great works of sixteenth-century Venetian devotional painting (fig. 261).[44] As usual, it is painted to be viewed slightly from below, and it was probably intended for an altar. There one would have first seen the crown of thorns, which has been removed, and then Christ, who, supported by Mary, seems to be almost sitting on the shroud, and then the angel who has come from the right, from where the light also falls. The angel's attitude towards Christ is the most important theme of the painting. Christ is not depicted as a corpse, but as if he were asleep, leaning back (and returning?) to his mother's breast. His crossed legs and right hand remind us of the Crucifixion, but this memory is not forced, even though the angel's left hand is held out as if it were reenacting Christ's posture. It is a picture without solemnity. The gentle, attentive, considerate, and almost delicate quality of the attitudes shown characterizes the painter's own approach to his theme.

Portrait Painting

When the artists of the Venetian Renaissance painted themselves, they liked to adopt roles. Titian, for example, played the part of the great lord: his gold chain is a sign of the knightly estate to which Charles V had elevated him in 1533 (fig. 262). But the stately man in the fur coat is more than the bearer of the chain. In turning aside, away from the table, he is distancing himself both from the viewer and from his imaginary interlocutor. The sleeves and hands are unfinished, so that the final definition of the character is lacking. Perhaps Titian had not yet decided whether the lordly pride of the posture was to appear as an expression of tension or of class-conscious *grandezza*. The self-portrait in the Prado from the last decade of his life shows a very different person: by the pencil in his hand he reveals himself as an artist. Titian has painted himself from the side, in the simplest imaginable posture, upright and almost in profile, with his eyes, which dominate the face, turned towards an indefinite distance.[45]

Leaning back with his eyes fixed on the observer, Palma the Younger made sure of his public's attention (fig. 263). He presents himself as a painter—not a craftsman but an artist performing in his studio. For this reason, Palma has not just any work on his easel, but one of the highest category, a history painting, to which he is putting the finishing touches. And he is not doing so just anywhere, but at an outline: the artist does not merely paint, he draws, which contemporary theory regarded as the nobler, because supposedly the more intellectual, part of painting. Those with an understanding of art—and only they will be interested in a self-portrayal by an

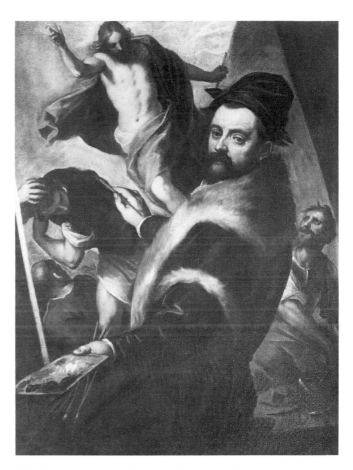

263 Jacopo Palma the Younger, self-portrait. Milan, Brera

artist—could hardly fail to notice the effortlessly mastered foreshortening. That of the painter is complicated enough but is surpassed by those in the Ascension, which happens to be placed so that Christ seems to be rising just above the artist—as if with the intention of blessing him.

The requirement of verisimilitude central to all portrait painting can easily cause us to overlook the fact that, no less than history paintings, portraits demand a capacity for invention. Whenever the painter is not content merely to give a descriptive inventory of the subject's features, the portrayal of real people is one of the most difficult tasks of all. A historically adequate understanding of early portrait painting is difficult. Recourse to physiognomics or contemporary psychology only appears to bring greater objectivity, for its schematic doctrines of types and affects are far too coarse to be applied to Lotto or Titian. Moreover, its reductive procedure that goes back to known concepts is opposed in principle to the subtle and complex interest of the good portraitist, which is concerned with individual qualities. In Italy, the political literature based on observation would be much more relevant, as would the works of Shakespeare in the north. Only there has the anthropology of the great por-

traits of the sixteenth and seventeenth centuries a true counterpart. Dilthey mentions Machiavelli, Guicciardini, and Cellini.

> In this whole literature, the relation of man to the web of purposes in which he is enmeshed is moved into the background, and incomparable weight is given to the art of showing people and depicting passions. This is a consequence of a scientific attitude not yet able to master the deeper problem of the laws of spiritual life, but unequalled in outward and inward description, particularly of affects and characters. The manner of seeing at this time is naive, sensuous, embracing the whole of the physical-spiritual person and with a genius for detail. For at that time political and social action was founded more on the observation of human beings, on reckoning with the ruling personalities and their means, than on a study of the relationships of economic and social life.

The basis of this situation Dilthey saw "in the changed valuation of the human senses in perception and the affects." This "secularizes the whole wealth of experience conquered by Christian mysticism."

Even towards the end of the century, theorizing artists like Lomazzo held steadfastly to the principle of decorum, which, if a conflict arose, gave priority to propriety over reality. Thus the depiction of an emperor required a noble, majestic aura even if nature had denied the subject such a characteristic.[47] In general, the painter was supposed to heighten the dignity and significance of faces and gloss over natural defects. In addition, the depiction of the individual person was to reveal general realities: the artists of antiquity had depicted wisdom in Socrates, pride and cruelty in Nero, and, in Octavian, the epitome of mildness and nobility of mind. In a similar way, Titian was believed to have shown "fertility and pleasing appearance in Ariosto, and in Pietro Bembo majesty and exactitude."

The harshest criticism of such ideas came from the theologians of the Counter-Reformation. Paleotti's "Discorso intorno alle immagini sacre e profane" of 1582, though it did not entirely condemn portrait painting, was not sparing with criticism of current practice. It all depended on who was portrayed and why, he affirmed, but anyone who painted himself manifested a striving after fame that betrayed no slight infirmity of mind ("debolezza di mente"). The theologian took it as self-evident that only honorable and exemplary people deserved a portrait, but in depicting them truth, not celebration, should be the guiding principle: "One should take care that the face or other parts of the body are not painted more beautifully, with more dignity, or in any way differently to that which nature has granted [the sitter]." Even defects, whether inborn or acquired, cannot be ignored. The painter's exemplar should be the historian, who tells

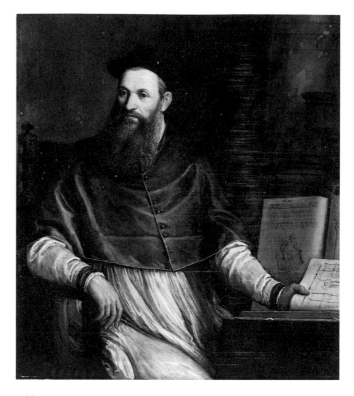

264 Paolo Veronese, *Daniele Barbaro*. Amsterdam, Rijksmuseum

the facts as they are, and not the orator, who embellishes and beautifies.[48]

If we do not look at the supreme works but at the average output of the Venetian portrait painters, which the museum storerooms now conceal from view, we find a bland utility art whose producers and consumers were fully satisfied provided it was possible to recognize who was depicted and there were no objections to posture, costume, or insignia. The common starting point was the portraits of Titian. The sitter is seen, usually in three-quarter profile or en face, somewhat from below, from a perspective of respect that also suited the original position in which the pictures were hung, usually much higher than today. The background, if it is not entirely dark, shows little. There were differences of lighting. Whereas Tintoretto emphasized details but left much in the dark, Veronese usually illuminated evenly. By Paleotti's criteria, Tintoretto was the orator and Veronese the historian of Venetian portraiture.

Daniele Barbaro (fig. 264) does not present himself in one of his high ecclesiastic functions. Although the columns and posture recall his status, he is shown not performing official duties but engaged in his hobby, architectural theory.[49] This too, for all his seriousness, is done in moderation; the consuming passion with which Odoni collected his pieces (fig. 217) is foreign to the scholar in this portrait. As he appears here in his leisure

hours, he could equally well receive visitors. Majesty is no more conveyed by the figure than familiarity; rather he shows seriousness and distinction. If Veronese was aware of rifts, depths, or abysses in Barbaro's nature, he passed over them here.

For Tintoretto portrait commissions were far more frequent than for Veronese. Sometimes he attended to them personally, but the bulk of the contracts were fulfilled by the workshop. Even prominent clients were not uncommonly fobbed off with stereotyped works that, by the routine application of a number of devices, could turn out as involuntary caricatures of the master's portraits. Pictures in which he was as heavily involved as the senator's portrait in Dublin (plate 28) are an exception in the later years. Among these portraits, those of old men are the most affecting. Their real theme was not the rank of the sitters, though it was often high, but their aging. With an intensity that had become uncommon by this stage, the old painter immersed himself in such faces as if they revealed his own aging, and the burning eyes he gave them were his own. Age, these pictures proclaim, brings not only an increase of dignity and experience but, far more, it brings decrepitude, petrifaction, loneliness. The old man in the Dublin portrait stares into space, blind to his surroundings. Head and hands are far apart. The folds in his robe, mostly straight like the contour of his back, do not join but divide. The body seems extinguished under the official costume. Although here and there highlights attract the eye to the red of the brocade and the white of the ermine, the patterns this creates are rigid, full of harsh jolts, far from the beauty of flowing drapery.

Separate portraits of women were rare in the second half of the sixteenth century. Once the freedom of the second and third decades with their slightly lascivious pictures was over—pictures in which one is unsure, and is perhaps supposed to be unsure, whether the subject is a lady, a courtesan, or simply feminine beauty—there were once again clear boundaries between portrait and "genre." Only Titian kept up the old tradition in a series of paintings in which his daughter appeared sometimes as herself and sometimes as a model for Pomona or Salome.[50]

That women had their portraits painted much less often then men is not surprising in view of their social position. What is remarkable is how often, in Venetian portraits of women, conflicts between the sexual role and the person became the main theme. It has even been asserted that the "Bella Nani" (fig. 265) in the Louvre could not be by her painter, Paolo Veronese, because she fails to meet the expectations of a Venetian female portrait that had long degenerated to a cliché.[51] Her posture, conventional in itself, has a slight nuance of stepping back, and the hands and the eyes convey a shyness, even

timidity, that assorts ill with her festive attire. Her head seems almost lost above the bare shoulders, even the pearl necklace contributing to its isolation. The young woman stands by the table as if in resignation, her eyes shadowed, gazing into emptiness, more burdened than adorned by her dress and her social role.

In a pair of paintings the young Paolo Veronese placed Lucia Thiene beside her husband, Count Giuseppe da Porto (figs. 266, 267). As was common, the son is included in the portrait of the father and the daughter in that of the mother. The paintings would originally have been hung so that the wife looked at her husband and the children stood between their parents.[52] The wife's beauty, the brilliance of her wardrobe, and the elegance of her appearance are given due weight by the painter, but the real theme, despite the tact and reserve with which it is stated, is the melancholy veiling the wife's attitude, a melancholy that causes her even to forget her daughter, who already is inwardly beginning to resemble her mother.

The count has stepped to one side to make room for his son. He turns his body outwards, his head inwards, and his eyes, again, outwards. This back-and-forth movement is reinforced by the uncertain position of his legs and is even paraphrased in the folds of his cloak. Da Porto's left hand with the glove—held passively rather than loosely—becomes the center of a still life the pictorial brilliance of which might have been by Titian, while the right hand is given to his son. Only the child, however, not the observer, can believe he will really find protection there. As with all his children, Veronese has painted the little da Porto from a viewpoint that corresponds neither to the condescendingly prettifying view of the grown-ups nor to the idea that children are simply incomplete adults. The son of Count da Porto, himself unsure, embarrassed in his role, has sought protection under his father's arm. But the way he looks out curiously from his refuge unmasks the conventionality of his father's pose, particularly as the physiognomic similarity between the two invites the comparison.

In portraits uniting a whole family, the stance, position, and interpretation of the wife differed widely, for a fixed type of family portrait never crystallized in Venice. From Tintoretto's workshop, which received most commissions, came pictures in which the sitters were simply lined up and reproduced. There were also conceits, however, such as a son holding his mother's train before an altar on which God the Father dispenses blessing, while she presents a second son to her husband as if making an offering in a temple.[53] In another picture (4.52 by 2.01 meters) a scene from the *villeggiatura* is shown: "A large painting, six ells wide, with eight full-length life-size portraits of a noble family. Three of the older members, two nobles and a woman, sit at a table covered with

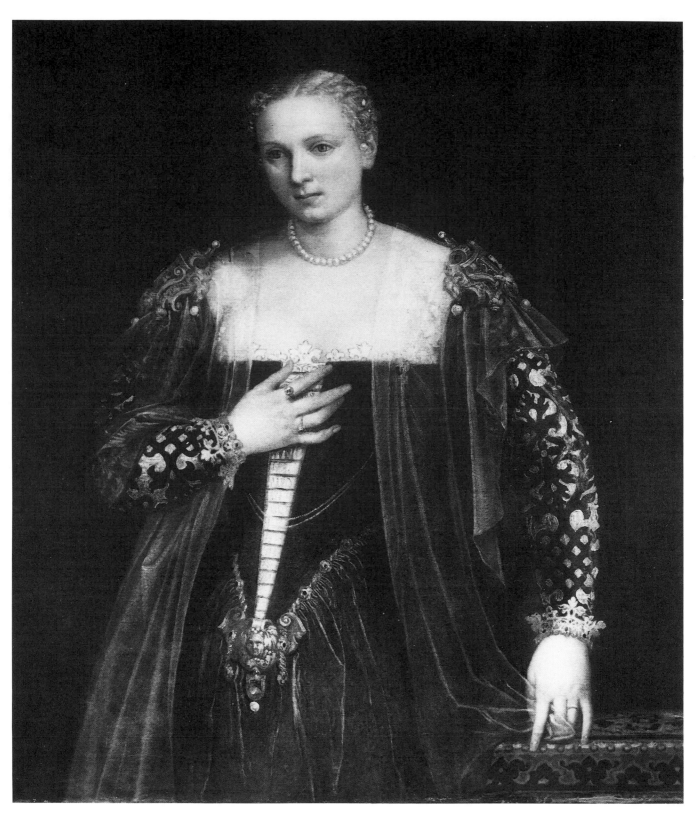

265 Paolo Veronese, "Bella Nani." Paris, Musée du Louvre

a Persian carpet. Beside them stand two young noble-women looking at three noblemen who are returning from the hunt with their dogs, carrying rabbits and other game."[54] Doge Alvise Mocenigo had his family arranged like a *sacra conversazione* around the Madonna, contenting himself with the role of donor while his sons took the places of the saints and his grandchildren the part of the music-making angels. The absence of the lion of St. Mark and all other allegorical heightening shows the enormous painting, over four meters wide, to be part of the private sphere, in which status pretensions could be expressed far more openly than in the Doge's Palace.[55]

In private palaces, too, there were frequently paintings that embedded the family portrait in a biblical scene. Veronese's work *Christ at Emmaus* in the Louvre[56] even

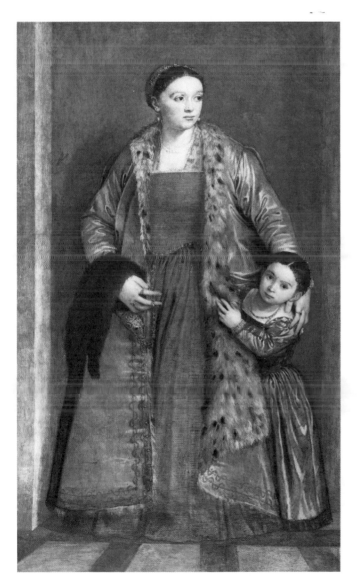

266 Paolo Veronese, *Lucia Thiene and Daughter.* Baltimore, Walters Art Gallery

depicts a conflict between the family portrait and the event. This is not the case in the votive picture of the Coccina family (plates 29, 30).

Judging from its provenance, theme, and format, the original location of this painting must have been the family palace, where it not only displayed the devotion and intercession of the family on behalf of the deceased Giovanni Coccina,[57] but showed, despite its formality, a tender, loving group. The family, accompanied and protected by the three cardinal spiritual virtues, Faith, Charity, and Hope, appears before the Madonna, John the Baptist, and St. Jerome. The realm of the saints is demarcated by two columns. Contrasting to it on the right is the newly built family palace on the Grand Canal.

At the center of the family—surprisingly—is a woman. Turned towards Christ, she commends to him her brother-in-law who, supported by Hope and taken by the hand by Faith, bends his knee before Christ in an attitude of hope, while Christ, through the intercession of John the Baptist, seems to approach him in an attitude of greeting. The interlocking of the figures is unusually tight even for Veronese, and the Virtues and the portraits are linked in a very singular way. The posture normally used as an attribute of hope is transferred to Giovanni Coccina, and Charity even appears on the right in the guise of a maid. Had not a clearly allegorical figure, Faith, appeared as the patron of the lady of strong faith at the center, one might have taken the other two Virtues to be members of the family or their household. Moreover, Hope and Faith are not linked by attributes, but by what Hope is doing. This, and the contrast to the animation of the well-behaved children and the more conventional behavior of the other grown-ups, imparts to Giovanni Coccina's attitude a significance that relates him to Christ across the whole distance of the painting.

About 1550 a large part of the Venetian demand for portraits had been satisfied by the history paintings in the Doge's Palace and the scuole grandi, which must in many cases have been veritable portrait galleries. But the dramatic scenes with large figures that became the norm in the sixteenth century left no room to include as many equally ranked portraits as the corporate constitution of the scuole and the *magistrati* demanded.

Since the late fifteenth century there had been officials who—much like the doges—had themselves painted before Christ or the Madonna. Still more common were more or less hidden portraits in biblical scenes from the New Testament or in the pictures of saints that, in rapid succession, filled the Palazzo dei Camerlenghi after 1529. These paintings were done at the end of each period of office, thus serving as a commemoration but not as a promise or obligation. Two or three of the departing officers would donate a picture of their patron saints, adorned at the edge by the arms and initials of the donors.

267 Paolo Veronese, *Giuseppe da Porto and Son*. Florence, Contini-Bonacossi Collection

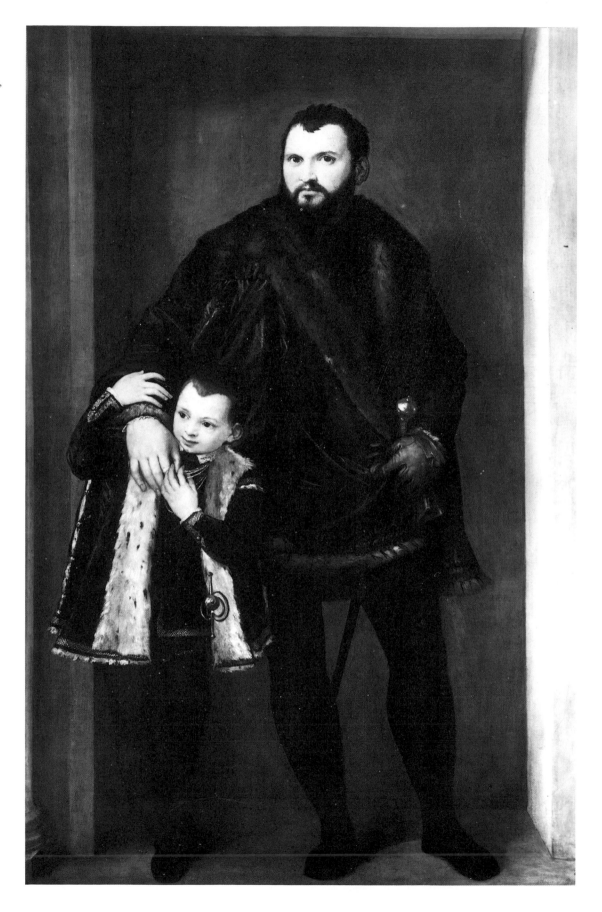

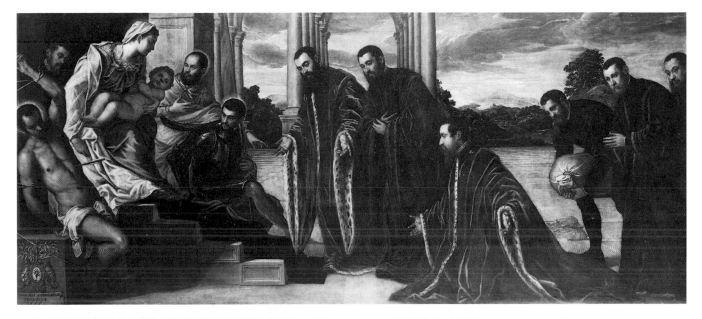

268 Jacopo Tintoretto, *Madonna with the Treasurers*. Venice, Gallerie dell'Accademia

The loose link between the subject of the picture and its purpose tempted Tintoretto in 1552 to produce a study that was as bold formally as psychologically.[58] Having to paint a St. George for a Giorgio, he placed in the foreground not the knight but his "attribute," the princess he had saved. Not satisfied with this, he made her lead the dragon with a nonchalance that makes the saint's deed seem somewhat less than heroic. The attitude of St. George, who points to heaven, without whose help the monster would still be alive, takes on a quality of helpless pleading, and St. Louis of Toulouse, not very advantageously placed, averts his eyes from the provocative scene with a troubled and slightly bigoted air.

In the Palazzo dei Camerlenghi the pictures of saints alternated with scenes from the Bible. Among finance officials the scenes in which treasure was handed over enjoyed understandable popularity. Thus in various fiscal offices we find the adoration of the kings and the queen of Sheba before Solomon, peopled by numerous financiers' portraits.[59]

In Jacopo Tintoretto's *Madonna with the Treasurers* of 1567 (fig. 268), which also hung originally at the Camerlenghi, the mask is laid aside. The group portrait had developed into a genre and a commission in its own right.[60] But the religious form of the picture remained, the clients doubtless having few objections to associations that brought them into the proximity of the three kings. We meet here with an iconographic technique of innuendo that pins nothing down and leaves everything in the air—a technique that did not exclude its richest expression from appearing in the Doge's Palace. Again and again types, arrangements of figures, and motifs from sacred art were taken over and used with new content in

the hope, never articulated, that something of the dignity acquired by the type in its original context would adhere to its new content. However, Tintoretto probably believed that this change of function not only served to enhance prestige but to impose obligations. While on one hand treasurers who bent their knees to the Madonna, to the city patrons St. Mark and St. Theodore, and to St. Sebastian may have been glorified thereby, they were also visibly admonished to serve the state. The coats of arms, inclined towards each other below a laurel branch, and the inscription (TRES ET UNUS UNANIMIS CONCORDIAE SIMBOLUS) further reinforce the binding ideal.

With pictures of this kind Tintoretto created examples that might have founded a picture type of their own, had they been taken as models by colleagues and clients. But that did not happen, since no one, obviously, was willing to submit, even pictorially, to the demands and obligations formulated by Tintoretto. On the contrary, in pictures of officials the portraits grew larger and more dominant, until finally only a tiny residue of Christ or the Virgin was left as an alibi. Still more significantly, the relationship also changed: the officials no longer appear before Christ and Mary; it is they who have to come to the officials—who then often insolently ignore them.

The most significant portraits politically were those of the doges. The state function of these portraits was twofold: for the outside world they served to represent republican continuity, and internally they were an important means of constantly reformulating the doge's conception of himself and his position in the state. Exactly how this was done we know only for the last quarter of the sixteenth century, since the earlier paintings were destroyed in 1574 or 1577.

The constitution and tradition set the doges tight limits. Nevertheless, not a few of them tested these limits, and as the tendencies of early absolutism gained ground in Italy, it must have seemed a particularly urgent task to reaffirm repeatedly the traditional role of the doge. The means of so doing ranged from the oath of office, reformulated on each occasion, to a strict review of a doge's conduct in office after his death.[61] When a doge visited offices and committees housed in the Doge's Palace at the end of the sixteenth century, he constantly confronted portraits of his predecessors. He knew that the series of half-length portraits in the Sala del Maggior Consiglio and the Sala dello Scrutinio would be continued with his own likeness at state expense, and he also knew that he himself would have to pay for a "votive picture" in the senate or the collegio. In addition, he knew from his long political career that the paintings in the palace did not spring from the free-ranging artistic imagination but were subject to evaluation by political committees who took advice from experts. To that extent each new

doge was aware that he stood little chance of becoming the hero of a history painting, for in the palace these generally related to events long past.

One exception was the victory at Lepanto in 1571, in which the republic, in its own view, had played the decisive part. The Turkish peril seemed to have been disposed of, and preponderance in the eastern Mediterranean was once again near. The *capitano al mar* at Lepanto had been Sebastiano Venier, who became doge in 1577. His portrait was given an especially distinguished place on the front wall of the collegio (fig. 269), and the commission to Veronese ensured an artistically satisfactory result. What instructions the artist was given is not known. Perhaps he made suggestions of his own that were corrected. At any rate, there are considerable differences between a sketch that has survived by chance (fig. 270) and the finished painting. In the sketch political aspects were predominant, in the execution religious ones. To begin with Venetia was the main figure. She was to have the doge's cap in her hand, holding it out to Venier

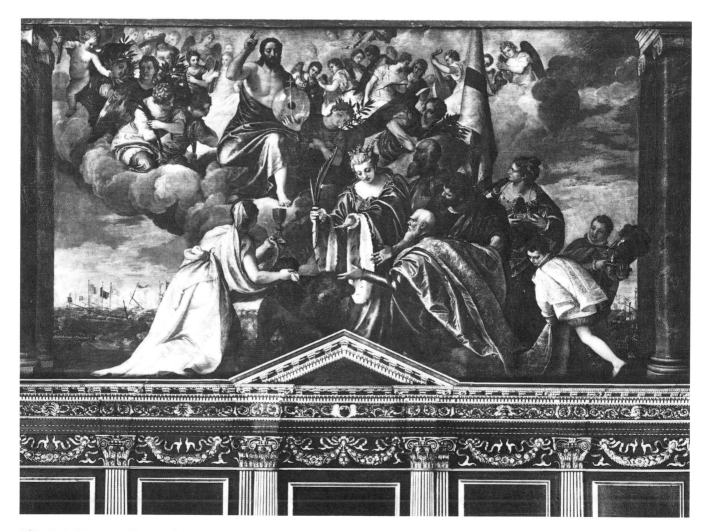

269 Paolo Veronese, *Allegory of the Battle of Lepanto.* Venice, Doge's Palace

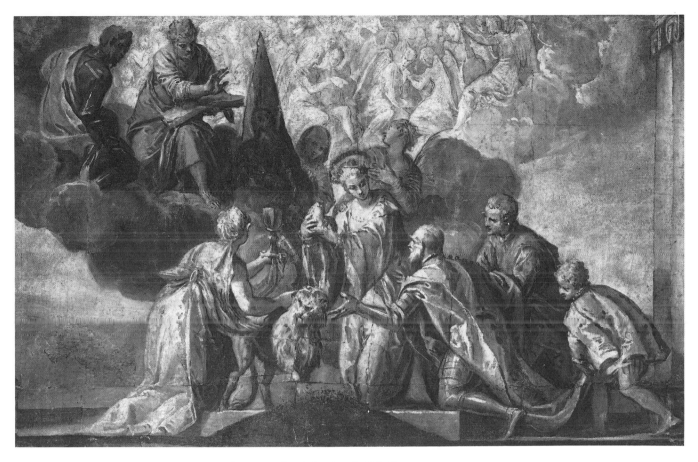

270 Paolo Veronese, *Allegory of the Battle of Lepanto,* sketch. London, British Museum

but not putting it on his head. Thus, not the coronation itself would have been shown, but the constellation of events leading up to it; the Faith who holds her attribute near the doge's cap looks towards St. Mark, who blesses Venetia and the future doge. In the collegio today one sees Christ in place of St. Mark and St. Giustina in place of Venetia, for it was on her feast day that the battle of Lepanto was fought. St. Mark has moved behind the doge, and Venetia with her doge's cap has taken her position still farther back, near St. Mark. It is no longer Doge Venier and the heavenly sanction of his choice that are the theme, but the pious submission of a champion of the faith, who receives the divine blessing through the mediation of Faith and St. Giustina. Venier died in the spring after his election, so that the changes were probably not instigated by him. They relativize the legitimacy of his claim to the office and bring the theme—the doge kneeling before the Redeemer—into line with that of the other wall paintings in the sala.

Such paintings, now called votive pictures, were described earlier as portraits of a doge with other figures. They have a long prehistory, known only sporadically as a result of the fires, which begins outside the Doge's Palace.[62] One of the pictures painted by Tintoretto after

1577 reconstructs a work by Titian that was finished in 1531. In it Doge Gritti was seen before the Madonna, in strict profile, like a donor. Its origin in the *sacre conversazioni* on the altars is obvious. While the theme was at first sight religious, its function and meaning had long since become political. Beside the doge stood the city saint as his advocate. The doge was celebrated, but the laurel wreath was given to the lion of St. Mark, the symbol of the state. What is difficult to understand is the choice of the saints. St. Andrew, the patron of the doge, was missing, whereas St. Louis, St. Bernardino, and St. Marina crowd round Mary's throne. This combination seems to have puzzled even the painting's contemporaries. The historian Sanudo tells in 1531 of an interpretation discussed in the collegio, the beauty of which is said to have equalled that of the painting:[63] the three saints did not agree which of them was to award Gritti the dogate. St. Bernardino: "He was elected on my feast day"; St. Marina counters by saying that Gritti had only been elected because he had won back Padua on her feast day; St. Louis, in Venetian "S. Alvise," was the name patron of Procurator Alvise, without whose help Gritti would not have become doge. To end the dispute, St. Mark himself presented Gritti to the Madonna. No doubt this

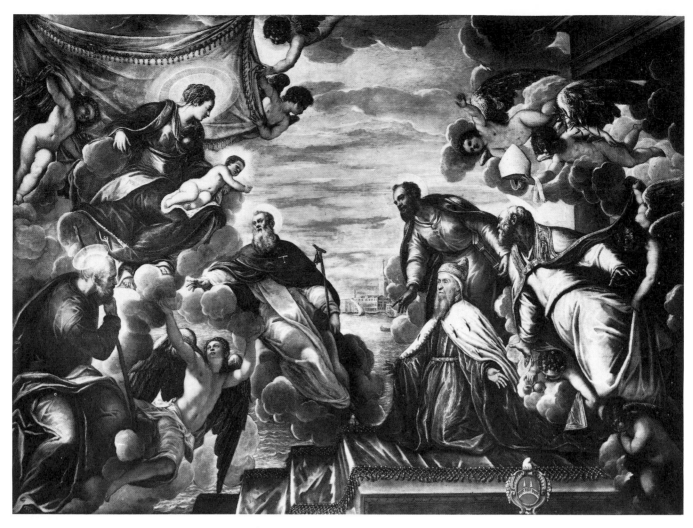

271 Jacopo Tintoretto, *Doge Niccolò da Ponte before the Madonna*. Venice, Doge's Palace

272 Jacopo Tintoretto, *Doge Alvise Mocenigo before Christ,* sketch. New York, The Metropolitan Museum of Art, John Stewart Kennedy Fund

273 Jacopo Tintoretto, *Doge Alvise Mocenigo before Christ.* Venice, Doge's Palace

was expressed rather differently in Titian's contract, but Sanudo's account shows how politically such pictures were read by men who saw them daily.

In the paintings of the later doges the positions of the main personages have changed fundamentally: the doge no longer appears before the Madonna, but the saints—and even Christ—appear before the doge. Although he still kneels, in most cases he does not even notice the divine and holy personages gathered around him. The lavish setting becomes an alibi for a lavish portrait. The only exception is Niccolò da Ponte (fig. 271), to whom Tintoretto has given an expression of real religious feeling. His portrait is also the only one in this room that Tintoretto designed entirely himself and even executed in some parts.[64] The painting of Doge Mocenigo (fig. 273), by contrast, is composed entirely of stock workshop motifs. However, the fact that neither eyes nor gestures really relate to each other, that postures, movements, and positions—quite unlike those of the da Ponte portrait—have neither coherence nor meaning, did not prevent the painting from being hung in the collegio. The painting is, in fact, not really worse than the average of the works that came to the Doge's Palace after 1577. The only difference is that in this case there is an original color sketch, a *modello,* by Tintoretto (fig. 272) that shows how the picture might have turned out. This *modello* is in its turn a correction of an earlier sketch, for X rays show another St. Mark between the doge and Christ.[65] The saint is not shown from the front or in profile, nor is he standing, kneeling, or floating. He is shown

from the back, the book under his arm, hurrying, indeed hurtling towards the scene and drawing the attention of the doge, who is looking straight ahead, to Christ, who has just appeared. The X rays are not entirely unambiguous. But if this is the correct reading, Tintoretto's first version would have contained a vehement criticism of the doges who, in the paintings at any rate, were trying to throw off all their bonds. It is no wonder that Tintoretto withdrew the attack and returned St. Mark to his usual place between the doge and Christ. Of course, this removed part of the reason for the behavior of the saints on the right, who, unlike the doge, react in different but always appropriate ways to Christ's appearance. Despite the retraction of St. Mark the New York *modello* is incomparably the better picture. The only puzzle is why Tintoretto failed to carry over any of its originality into the final version. The saints executed there are examples of the most superficial *varietà:* one bends forward, another backward, a third kneels, and the fourth is doing something else. The putti accompanying Christ have disappeared along with the music-making angel, and the strikingly youthful Christ of the *modello* has reached the usual age. His gracefully hesitant flight has become a tumultuous apparition that has its optical equivalent in the curtain at the top right. Whatever went on in Tintoretto's mind—whether anger, resignation, or a cynical "You deserve nothing better"—one can only speculate mournfully on how often the same thing may have happened in cases where the loss was not documented by the accidental survival of a *modello.*

274 Federico Zuccari, *Subjection of Barbarossa.* Venice, Doge's Palace

302

History in Pictures

The depiction of historical events was regarded in Venice, as elsewhere, as the highest task of art. The subject matter of history paintings, taken from the Bible, legends of the saints, state history, or mythology, was known as a rule from two sources: from the texts and from earlier paintings that both painters and clients took as a starting point. The goals and priorities formulated by the Council of Ten for historiography in 1577 also applied to political history paintings: "It is of great importance for a prince as for a republic that history is written faithfully, honestly, and with judgment, and in a good and elegant style."[66]

What we see today on the walls of the Doge's Palace is the result of an energetic, large-scale campaign that soon caused the fire damage of 1574 and 1577 to be forgotten. How often elements of the old compositions were retained along with their themes is uncertain.[67] But there are several examples, found in the most important room of the palace, the Sala del Maggior Consiglio. Within Federico Zuccari's *Subjection of Barbarossa* (fig. 274), for example, one detects marked stylistic differences. The staggered arrangement of the portraits is as old-fashioned and the main group as awkward as the framing figures, in their complex movements, are modern and even fashionable. This discrepancy would never have been seen as an artistic merit. But it was accepted, perhaps even sought, because the formal difference itself made the documentary character of such a painting directly perceptible. And for the clients, the history paintings in the palace were not in the first place works of art but pieces of evidence in the argument over the correct interpretation of history. The older the document, the greater its value in this regard. It was probably for this reason that Federico Zuccari, who first wanted to paint a more attractive picture,[68] was instructed to retain at least the main features of Titian's lost work: the Emperor Barbarossa subjecting himself in the presence of the doge to the pope, who has put his foot on his neck. However, only the initiated would notice this. For most it looked rather as if the emperor was paying homage to the doge—an error the Venetians are sure to have readily forgiven.

The decision on the themes was far too important to be left to the artists. It is impossible now to disentangle completely how the choice was influenced, and possibly there were no procedures fixed once and for all.[69] Even the written programs that have survived, which do not necessarily agree with the final text of the contract, are not mutually consistent. In the case of history paintings, they usually describe only the event to be depicted. But with allegories they give direct instructions on how something is to be painted. In the text for Zuccari's painting we read of the emperor's kissing of feet and the words spoken by the pope when he put his foot on the neck of the vanquished leader in front of S. Marco. That Zuccari had to paint this exact moment is not explicitly stated.

The experiences Tintoretto endured at the court at Mantua seem to have been spared him in the Doge's Palace.[70] On 1 October 1579 the Marquess Sangiorgio instructed his Venetian envoy to contact Tintoretto and to make sure, above all, that he would make haste; the marquess wanted the paintings in Mantua by Christmas. Tintoretto was informed of the dimensions and lighting conditions of the room that was to house the paintings. He was to apply the priming to the canvas while the description of the events to be portrayed was still being composed in Padua. On its arrival Tintoretto was immediately to send a sketch of the composition planned, so that it would not be necessary—as in an earlier series—to alter the placing of the main figures later. The painter was to lose no time in detailed presentation, for the people in Mantua knew how to read sketches. While the conversion of the history into an *invenzione* is first left to the artist, it is immediately checked, even at the preparatory stage of the painting. This was done with no mincing of words. While the sketches were well done, the marquess wrote to the painter in the middle of November, he had overlooked in picture A that the batteries were on the wrong side, so that he would simply have to invert the picture laterally. Picture B was unnecessary and could become a part of picture C. "I should also like you to put some more figures beside that of the duke, as it is improper for him to be so isolated. Since horsemen would take up the whole picture, you may show foot soldiers, as I have roughly drawn them with a pen." The painter is sent coins and views of some important buildings that are supposed to ensure the historical authenticity of the paintings. Despite these instructions and controls the Mantuans were dissatisfied with the result. His master, the envoy declared, wished to have everything properly finished. Tintoretto was therefore to retouch the paintings. No matter that the marquess urged the artist to make haste, he wanted pictures that were "finished" in terms of craftsmanship all the same. In September Tintoretto was in Mantua to deliver his works but had to retouch them a second time. At last the client was satisfied enough to be able to write to a potential new customer of the painter that he had "in the meantime revised the paintings in several places as I directed. They now seem well painted, at least in comparison to his usual incomplete manner." The artist would be glad to accept a new commission, he wrote, and would work much faster than any other.

The pictures painted for the Doge's Palace after 1574 and 1577 do not follow any systematic program in which each picture has a predetermined place and a clear function that it alone can fulfill. However, there are a number of clear basic themes that are touched upon and para-

phrased again and again. Venice's claim to equal status with the emperor and the pope is one such theme; others are the claim to preponderance in the eastern Mediterranean, the continuity of Venetian freedom, and the exemplary nature of the constitution.[71]

As the individual themes had often been fixed centuries before, direct references to day-to-day politics in the years about 1580 were a rare exception. In general, however, the portrayal of history in the paintings was no less in the service of the present than the writing of history in books. To the outside world, the paintings illustrated the power, splendor, and success of the republic, while for the Venetians they were an incitement to fol-

low the example of their ancestors and to enhance the welfare of the state. How much the individual legate or senator understood in detail of the pictures surrounding him is very uncertain, but none could fail to discern the general themes.

The rich embellishment of the official rooms would have been impressive in itself and was without parallel elsewhere. Only a flourishing state—such was the subliminal message—could decorate its palace so luxuriously and replace the countless burnt pictures so quickly and so completely. The extent and speed of this campaign seem to have been as important as the artistic quality. The many gigantic areas to be painted demanded

275 Francesco Bassano, *Battle Scene.* Venice, Doge's Palace

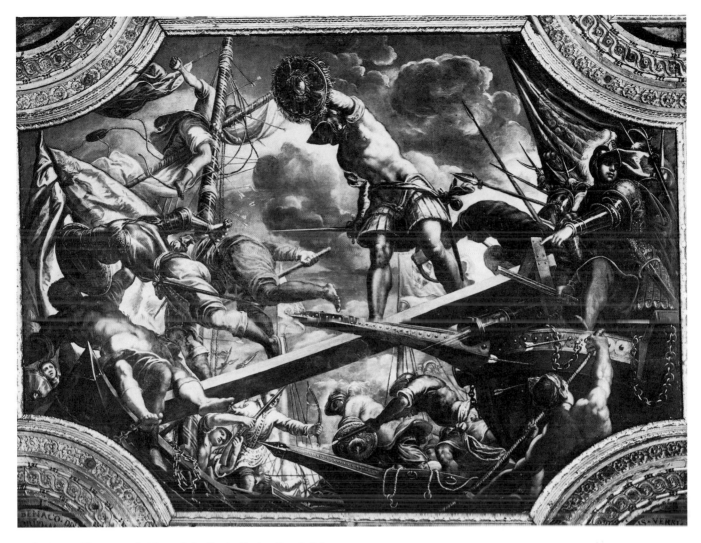

276 Jacopo Tintoretto, *Battle on Lake Garda*. Venice, Doge's Palace

efficiency above all else of the painters, assuming a certain minimum standard of quality. As Tintoretto and Veronese were overstretched, young painters who were almost untried obtained commissions that were often beyond their means and their strength. But the patrons, in their haste, were in a weak position, which gave the painters astonishing scope. Admittedly, very few of them took advantage of it—in fact, only Tintoretto and Veronese, and, with some reservations, Francesco Bassano. He, with some others, had to paint a number of battles for the ceiling of the Sala del Maggior Consiglio (fig. 275). The viewing angle from below favored the repertory of persons he took over from his father, as they came from the lower classes. Whether victory or defeat was the theme, what one saw above all in Bassano's work was the burden of fighting and the toil of the camps, trenches, and fortifications. Probably this resulted less from critical ideas than from artistic economy, for Francesco Bassano only pro-

duced what he had painted in many different contexts before and so had in his mind in any case.

This seems to have been different with Tintoretto. For example, if he had to show Stefano Contarini defeating the Milanese on Lake Garda (fig. 276), he painted no brilliant victory but a brutal struggle of life and death, and he did not show it from the viewpoint of the commander or even of those who were winning.[72] Rather, out of the necessity of viewing the action as an onlooker he made the virtue of a new theme: we see the battle as it was seen not by the admiral, but by the wounded soldier who was its victim, floundering in the water. Tintoretto did not necessarily take sides but showed that, if the Venetians had managed to decide the battle in their favor, the sole cause was not General Stefano Contarini, although the program talked only of him. The official war hero's position, his gestures, and the look in his eyes are too timid to warrant such a conclusion—quite apart from the fact

that they pass the actual battle by. This was despite the program,[73] which had specifically instructed the painter that only the valor of the Venetian general had been able to bring Visconti, so many times victorious, to his knees. Even the foundation of Contarini's success, his skill in sailing maneuvers, is merely touched on in the top left corner.

In the majority of his paintings in the Doge's Palace, however, Tintoretto took the easy course. The pressure of business probably left him no other choice. Next to many routine productions and a few masterpieces there are also pictures that start brilliantly and end in banality, such as the *Capture of Zara* (fig. 277) in the Sala dello Scrutinio. According to the program this battle had cost so many lives that the gravediggers could not keep pace, and the rotting corpses infested the city and countryside with pestilence.[74] Tintoretto filled the entire foreground with these dead and wounded, whether Hungarians or Venetians, who had paid the price of the victory. In this area, just above eye level, one encounters so much wretchedness that even the proud Venetian flag can bring no solace.

The program tells of a Hungarian king who, with 120,000 armed men, defended Zara, which had risen against the republic in 1346, against the advancing troops of the Serenissima. Thanks to the skill of their sappers, the Venetians, although numbering only 16,000, were able to encircle the city and establish themselves in fortifications of their own. These were attacked and would have fallen, had not the Venetian cavalry at the last moment terrified those trapped in the city. The city is seen in the background, before it a flag with the coats of arms of three military leaders of the Venetians. The arena chosen by Tintoretto is the field before the city. The viewpoint is raised. A similar view might have been had from a wall of the provisional Venetian fort. The fort might have had towers like the one on the extreme left of the picture, which the Hungarians are storming. But the Venetian bowmen have already advanced so far on the left that their victory can no longer be doubted, particularly as at the same time the infantry and cavalry have pushed the enemy on the right almost out of the picture. That Tintoretto did not even attempt to show the whole battle, concentrating on one event within it, links him to most of his colleagues in the Doge's Palace. The patrons would have been concerned above all that the harbor in the background showed enough of the expensive equipment of the sappers which the program praises. The rain of arrows with which the Venetians reply to the attacks of the opposing bowmen would also have earned applause, as would the valiant way in which the infantrymen at the left are confronting the enemy horsemen. But did the patrons also understand that Tintoretto had framed these scenes in such a way that an attentive

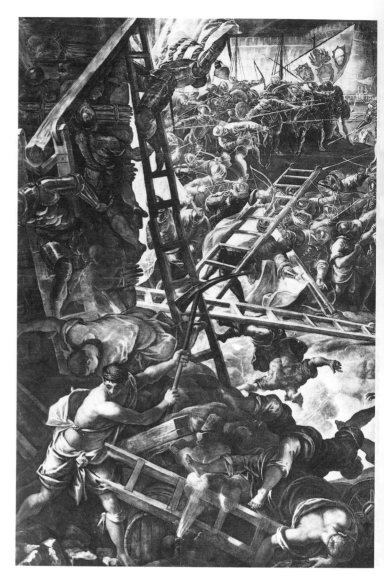

277 Jacopo Tintoretto, *Capture of Zara*. Venice, Doge's Palace

viewer would see them not as acts of heroism but as part of a massacre of doubtful purpose and justification? The framing scenes at the left and bottom edges, for example, usually as full of movement in the sixteenth century as they were empty of content, are used by Tintoretto for an unsparing portrayal of a struggle in which he hardly distinguished between friend and foe, all uniforms and insignia being discarded. In war, injury, and death, all become alike. Particularly on the left Tintoretto shows stupendous powers of invention: in the interlocking of the siege equipment, which is just being drawn up or is already out of action, in the ladders that, fallen, falling, or still just upright, form as brilliant a configuration as the five figures on the left. While the first is still blithely swinging his pick, the third is trying to support one of the rams, and the man at the top, close to his goal, has

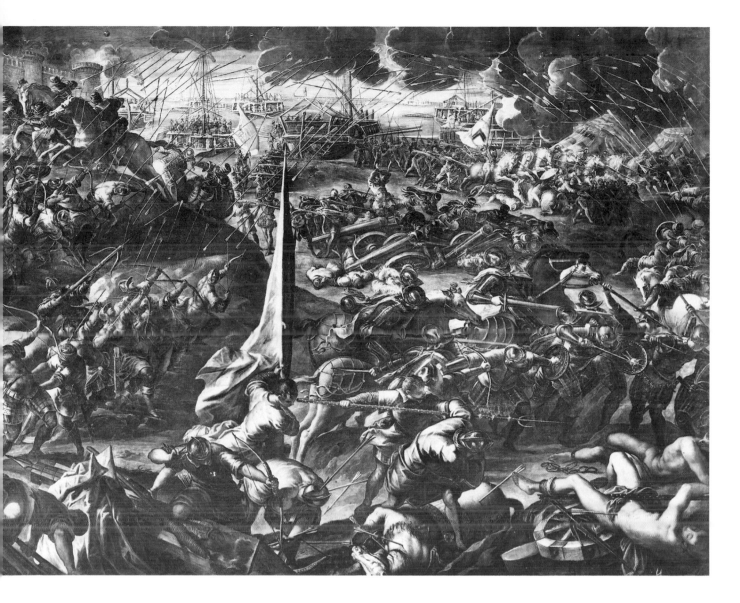

just received a fatal blow. In these parts at least, the theme developed by Tintoretto contradicts the picture's function of broadcasting Venetian military art and valor.

The judges who summoned Paolo Veronese before the Inquisition in 1573 had looked more closely at such a painting, in their terms at least.[75] The corpus delicti was the "Last Supper" (fig. 278) that Veronese had painted in 1571–73 for the front wall of the refectory of SS. Giovanni e Paolo. More than twelve meters wide, it may well have been the largest canvas picture the Venetians had seen up to then. The monumental decoration of the three large arches of the picture architecture filled one end of the room and at the same time marked out the theater for Christ and his followers. This was divided into a proscenium, the banqueting table, and a background that, defined by architecture on left and right, is made up at

the center by an evening sky of the kind that can sometimes be seen in Venice soon after sunset.

It was not his stage set that brought Veronese before the judges, but his direction of the play. Unlike the Dominicans of the monastery, who had accepted the work without complaint, the ecclesiastical judges deemed some fundamental demands of art and religion to have been disregarded. It is worth noting that it was the artist who was called to account, not the abbot, who should have been theologically the more competent of the two. Clearly, the Inquisition saw more in the painter than merely the craftsman who executed the design. The core of the charges concerned offenses against propriety. The incriminating evidence was a man with a blood-stained handkerchief and another who is cleaning his teeth with his fork. The presence of the dwarf fool and the dog also

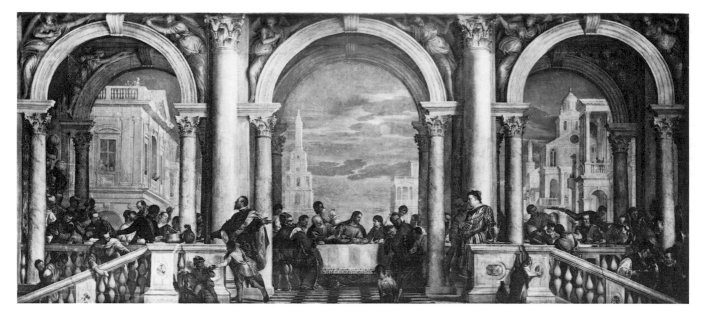

278 Paolo Veronese, *Feast in the House of Levi.* Venice, Gallerie dell'Accademia

caused displeasure. In their place a Magdalen was called for, although according to the Bible she was not present and had no place in this scene in pictorial tradition. Curiously, Veronese describes without contradiction as the painting's theme an event that does not occur in the New Testament at all: "the last supper in the house of Simeon." Simeon, sitting before Christ on the left, has no place in a banquet—or a banquet in his house, although a Magdalen would have been appropriate. The judges had already demanded suitable changes of the prior, but he had met resistance from the painter: "I replied that I should gladly have done this or something else to secure my honor and that of the painting, but that I did not believe that a Magdalen figure would have looked good." The armed men on the steps had particularly incensed the Inquisitors, to which Veronese replied, "We painters allow ourselves the license enjoyed by poets and fools." In his view such halberdiers could quite properly be part of a household as large as Simeon's in this picture. Veronese conceded that the troopers were his own invention: "the commission was to embellish the painting as I thought fit, and it seemed large enough to accommodate many figures." As a specialist in composition Veronese could not or would not understand the tacit concerns behind the interrogation: one of the "Germans" was drinking wine and holding a plate in his hand. While this was no doubt a simple snack for Veronese, for the Inquisition— in the context of a supper—it might have been a subversive reference to Protestant communion practices, which allowed not only the priest but the congregation to drink the consecrated wine. The spiritual interrogators saw the other artistic liberties in connection with the confessional struggles: "Know you not that in Ger-

many and other regions infected by heresy, the Holy Catholic Church is mocked, calumniated, and reviled with frightful pictures full of such scurrilous fancies, to instruct stupid and ignorant people in false doctrines?" Veronese also thought this an evil but insisted on his own duty to follow what his ancestors and predecessors ("maggiori") had done. Invocation of the *maggiori* was always a powerful argument in Venice, and now the judges became involved in a disputation with the accused, who enlisted the authority of Michelangelo, particularly his violently controversial *Last Judgment* in the Sistine Chapel. In all this, Veronese was merely following a long-established custom, and he could even have quoted from some of his own contracts. For example, in 1555 the priest of Montagnana had ordered from him a *Transfiguration of Christ,* "with the figures that contribute most to the beauty and ornament of the table," and in the contract with the Benedictines of S. Giorgio Maggiore for the *Wedding at Cana,* now in the Louvre, the document of 1562 had required the painter to provide the number of figures that fitted comfortably into the picture and were necessary for the theme.[76] With such arguments Veronese now defended the suspect motifs. Such things were part of a rich household, he asserted, and in any case none of them was near to Christ. He therefore argued from the inner logic of the scene portrayed, a logic that was not only aesthetic but social, and he put his case with surprising self-confidence.

Although Veronese probably failed to convince his judges, he got his way, for in its final wording the verdict was little more than a laboriously disguised admission of defeat by the prosecution. The original text that the picture was to be altered "as befits the Last Supper" was de-

leted. It was ruled that the painting should be corrected within three months, and Veronese seems to have met and evaded this by the expedient of renaming the scene, saying that it referred to Luke 5, that is, the "feast at the house of Levi." Even this solution made it hard for the Inquisition to save face, for behind its seeming innocence there was a possible irony: at Levi's house Christ had supped with a throng of sinners, publicans, and beggars. People of low state were thus being advanced. And at Levi's house, according to Luke 5:9, they had been at the table with Christ, not just on the steps. Of this Veronese's picture actually shows nothing, just as he has not depicted a "proper" Last Supper. Neither the announcement of betrayal is shown, nor the inauguration of the sacrament. Although Peter is in the act of preparing a meal that might be the Easter lamb, this is far from certain, just as the presence of "Levi," previously Simeon, lacks an explanation. Perhaps Veronese was not intending to show a particular event fixed in space and time but, more generally, Jesus in company with his disciples.

The controversy between Veronese and the Inquisition was not least about what was fitting in a picture like the one for the refectory of SS. Giovanni e Paolo. It was generally recognized that the painter was entitled and indeed obliged to reinterpret known events and even to embellish them and that he had to find new images both for the actors and for the event. For this contemporary art theory had the notion of *invenzione,* the overall invention (and the power of conceiving it), which is realized through single partial inventions, the *invenzioni.* The guiding principles were to be *ordine* and *convenevolezza.* If the artist had to paint Christ, or Paul preaching, it would have been unfitting to show them as nudes or dressed as soldiers or sailors. The artist had to find the appropriate costume in each case, but above all he had to "give Christ a face that is dignified but marked by kindness and sweetness, while St. Paul has an appearance that suits him."[78] Analogously, Moses should not look puny, but majestic and tall. At least in theory, these principles had consequences affecting details, for not only was the *qualità* of persons to be respected, but also the countries and epochs in which they lived.

All these requirements presupposed a stable society free of internal conflict, in which the existing hierarchy is accepted as legitimate and the only goal is to know and respect it. In pictures, therefore, the old should be dignified, "women beautiful, children charming, soldiers brave, and maidens virtuous."[79] On the other hand, demands like the one for appropriateness only formulate relationships but leave open, at least in principle, what the norm of such appropriateness should be in a particular case.

In the sixteenth century, and especially in Venice, painters gave very different answers to this question. On one side was Paolo Veronese and on the other, diametrically opposed to him, Jacopo Tintoretto. Their relationship was not one of rigid antithesis. In terms of motifs, style, and conception there was more frequent and more intense interaction between their oeuvres than one would expect at first sight. But this did not efface basic differences. The most important of them arose from the social sphere in which the two painters located biblical events. The painted worlds of both are the product of imagination, but in Tintoretto it was nourished by the reality of the lower classes and in Veronese by that of the aristocracy. It is not without irony that Veronese got into difficulties while Tintoretto did not. The fact that Veronese included so much detail of the daily life of an upper-class household, even finding room for a keeper of the wine cellar, may have been a result of his productive rivalry with Tintoretto.

In his earlier history paintings Veronese's spectrum had been considerably narrower, being restricted entirely to the genteel aspects of the life he depicted. The *Feast in the House of Simeon* (plate 31) originally decorated the refectory of SS. Nazaro e Celso in Verona[80] but was sold to a collector as early as the seventeenth century. In its original place it was enclosed at the sides by double columns and above by a pediment. The stage skillfully devised by Veronese was thus given a continuation, or at least an echo, in the frame. Today one looks directly into an entrance hall containing some beggars; it seems part of a street, and fine buildings are to be seen further along. Near the middle a projecting balcony gives room to a high priest voicing his indignation at the scene and accompanied by beautiful women. On the opposite side—in pointed contrast to the openness and brightness of the sky—a dark palace front gives sonorous backing to the Christ group with its dense composition and color. The very attitude of Christ's antagonist, the Pharisee, shows his hypocrisy, and further to the left the viewer is shown what to think of the argument that Magdalen's oil should be sold to pay for food for the poor. Directly behind the priest, seated at the other end of the table, in front of a column but in shadow, Veronese has placed a man who, if only because of the dog emerging from under the table at just this point, can only be Judas. In a short while he will rise from the table and betray Jesus to the high priest (Mark 14:10–11).

The director who stage-managed this scene was on the way to becoming a great storyteller. Compared to later paintings, some elements in this early work are still an end in themselves. The serene objectivity of the mature and later periods was still a long way off. Infatuated with his own skill, Veronese still gave way to virtuoso effects when indulging his architectural imagination, or fetching the most opulent costumes from the properties room, or manipulating the light as with the Pharisee and Judas, or discovering new coloristic charms in what are normally "ugly" colors or color combinations. The com-

pressed areas of the composition should also be mentioned, where elements divergent in content are drawn together formally. Examples are the parts around the Pharisee's left hand, around Judas, and around the head of the old Simeon, who is sitting opposite Christ. However, Veronese was already trying almost everywhere to bring such effects into the service of representation. The management of light goes beyond mere virtuosity when the main figure is left in half shade, giving him an inner luminosity that proves superior to both the darkness of Judas and the radiance of Magdalen. Even the placing of the gold carafe between the columns against the sky is not just a bravura effect reminiscent of Titian: the servant balancing it looks up to the high priest on the balcony, who in turn points at Christ. Indirectly this large vessel prepares the eye for Mary Magdalen's small one, interpreting the scene, if in a somewhat superficial sense, as a dispute about vessels and their contents.

Vessels also play a part in the *Last Supper* (plate 32) painted about the same time by Tintoretto for S. Trovaso.[81] These do not come from the goldsmith, but from the weekly market. They belong like the chairs to the world of those who are not able to celebrate the Passover meal among the columns seen in the background, nor in the raised place the Bible tells of, but have to be content with a cellar. Tintoretto's milieu and the elegance of dress and manners that we find in Veronese are worlds apart. Here the voices are loud and the gestures vehement. Overturned chairs disturb no one, and in any case there are no servants to pick them up. The food—for example, bread of the kind that can still be bought from Venetian bakers—is as simple as the clothes. Such might have been the scene at any Venetian fisherman's or publican's table as the hour advanced. Even Burckhardt was incensed to see the Last Supper "debased to a vulgar feast."[82] The painter, he complained, had interpreted the sacred story from beginning to end in terms of absolute "naturalism," "perhaps to move us more directly," but he lacked a higher sense of order. Tintoretto would have seen something apt in this very paradox, however, for according to the New Testament Jesus and his followers came from the lower classes. And had not Jesus again and again extolled the poor, the burdened, and the despised—just as the painter Tintoretto did by celebrating the objects of everyday life with a light and a color otherwise reserved for objects of value in themselves, and by applying principles of movement derived from studies of Michelangelo to the depiction of simple people?

The tension between extreme artifice and the emphasis on veristic detail, between the closeness of the events depicted to the actual world of the viewer and a highly artificial composition, runs through Tintoretto's work up to the threshold of his late period. Almost all the people he painted are on one hand defined by their real context,

but on the other they are placed in compositional configurations that were constructed by the defining, arranging, and controlling narrator. In contrast to those of Titian, these people have relatively little life of their own. The main figures, particularly, are stamped by their constellations. Goethe's diary of his Italian journey notes, for the same reason, that the paintings would have had more charm if they had been smaller: "His figures first appeared to him, if I might put it thus, in a smaller format, and he has enlarged only their dimensions and not their inner natures. His figures, his compositions, have not the *sodezza* [solidity] demanded by large figures. They please the eye and make a happy impression on a small scale, but they have not enough inner content to take up such a large space, or to impress us with their presence." Goethe's criterion was the notion of the sublime evolved in the eighteenth century: "It is not enough for a figure to be colossal, to be nine or ten feet high; its nature must be colossal. It must impress on me not only by its size but by its existence, that I should not equal it even if I enlarged myself."[83]

The foundations of this kind of narrative are to be found in Tintoretto's early works. In the *Washing of the Feet* (fig. 279) for S. Marcuola of 1547, for example, the artist, scarcely thirty years old, attempted to include all the groups in a single sequence. The most commonplace actions, like taking off sandals or trousers or putting on clothes, are painted with the same broad deployment of motif and composition as if they were highly significant actions. This is not an end in itself, but a narrative means of making clear what the washing of feet signified: it was originally not a ritual but a real service. Hence the exactness and prominence of the tub, the broad table, and the sturdy benches. Compared to Tintoretto's later skill the use of motifs is still excessive and some of the contrasts are crude, as between the refined architecture and the unrefined behavior of some of Christ's followers, presented as rude-mannered folk who do not fall into contemplation and prayer, but loll at the table and look on curiously. Nor is the linking of the groups without a degree of formalism, as can be seen from the position of the dog and the arrangement of the garments on the right.

In the museum the group on the right, undoubtedly the most important because of Christ, looks like an alibi added later. But in the choir of S. Marcuola, where the picture was seen not from the front but from the side, it was the goal of the composition, and the genrelike motifs were part of an expansive exposition that set out the everyday scene in a leisured, even retarding way, before coming to the main point. The introductory apostle on the left, about whom one is not sure whether he is tying or untying his sandal, at once establishes with his cloak a formal link with Christ, to which the dog and the basin contribute. The *Last Supper* (fig. 280) on the opposite

side of the choir[84] is still very awkward in composition but in its conception shows some distinguishing marks of the later interpretations. Christ's posture is ambivalent; it can be understood as announcing the betrayal or as founding the sacrament. The composition, in which substantial groups had to find room at a small table, has a number of unsolved problems. Symbolism is added extraneously in the form of the allegories of Faith and Charity.

In the *Last Supper* of S. Polo (fig. 281), however, the symbolic becomes the direct theme of the scene depicted.[85] Tintoretto presents the founding of the sacrament through the eloquent configuration of Christ administering and two disciples receiving communion while all the others step back. Only a fourth apostle, di-

rectly opposite Christ, is emphasized to the same degree: the movement motif of the man reaching for the wine in S. Trovaso has become a representation of Charity. It is not just anything that the poor man is given, but a piece of the very bread Christ is administering. That this is not an ornamental ancillary motif but a central one is shown by the donor, who looks not at Christ but at the gift of bread.

The number of Venetian Last Supper paintings seems to have risen sharply in the 1540s. About the individual clients we know little, but they would have to be sought in the same groups that were active in the scuole grandi and contained the different reform groups, which ranged from the Anabaptists to the reformist elements within the Catholic church and included adherents of Luther as

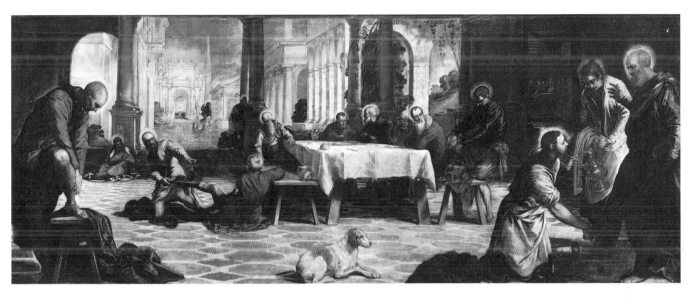

279 Jacopo Tintoretto, *Washing of the Feet.* Madrid, Prado

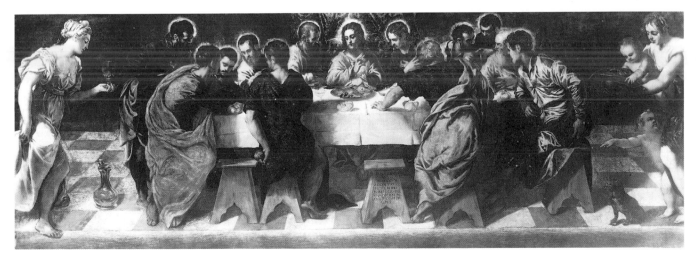

280 Jacopo Tintoretto, *Last Supper.* Venice, S. Marcuola

well as Calvinists and followers of Zwingli. Several of these groups seem to have come together both for communal readings of the Scriptures and to reinstate the early Christian function of the supper as a charitable meal. It is not by chance that doctrines of the Last Supper that bear an extraordinary resemblance to Tintoretto's representation are found in these groups. Filippo Lando wrote in 1552,

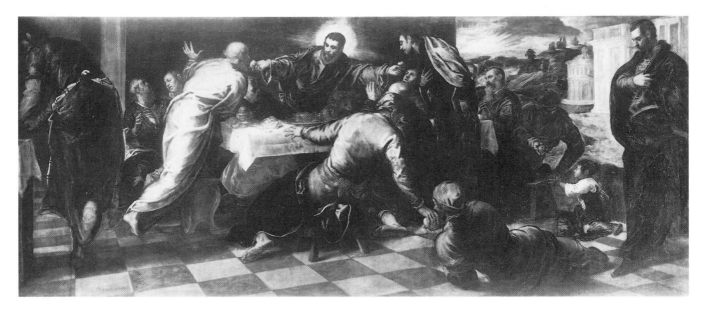

281 Jacopo Tintoretto, *Last Supper.* Venice, S. Polo

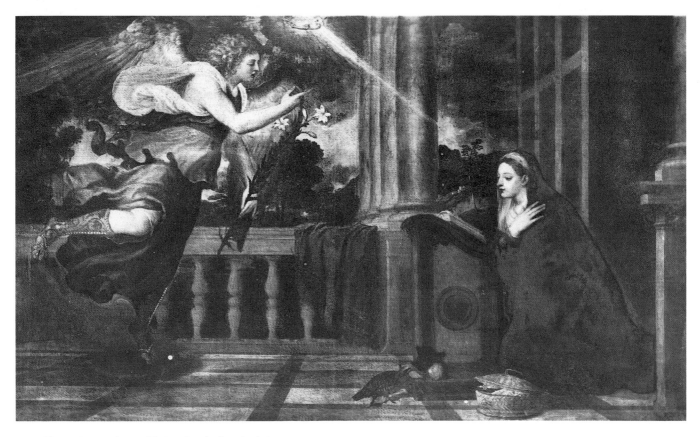

282 Titian, *Annunciation.* Venice, Scuola Grande di S. Rocco

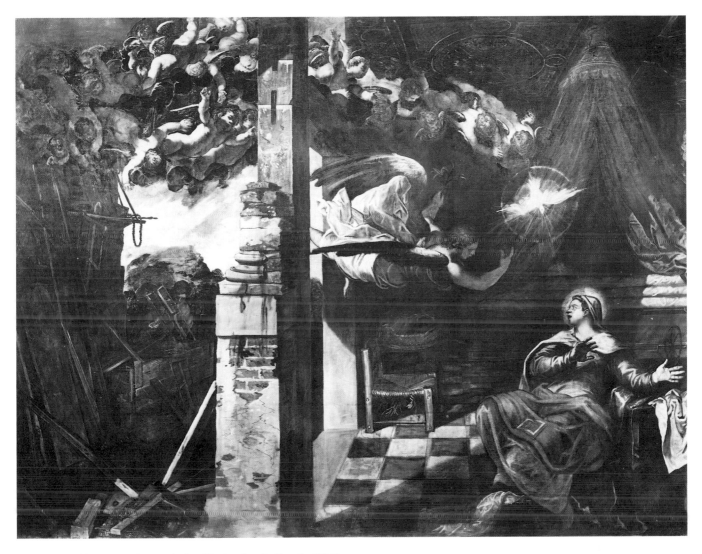

283 Jacopo Tintoretto, *Annunciation*. Venice, Scuola Grande di S. Rocco

What does the Last Supper actually mean? It means that all those who eat and drink together partake of the body and blood of Christ, so that they are bound to Christ by faith and charity [fede et charità] like a body to its head, and are also bound together by love as one limb of a body is joined to the others. No one, therefore, who is not bound to Christ by faith and love and to his neighbors by love, can worthily partake of the supper. . . . What, therefore, is the true utility of this sacrament? It is that a man proves to himself that he has true faith and true repentance for his sins, and that he bears love for his neighbor.[86]

Two paintings of the Annunciation are still to be seen today in the Sala Grande of the Scuola Grande di S. Rocco (fig. 282, 283). The one by Titian was donated to the scuola in 1555.[87] It had therefore been before the members' eyes for three decades before they saw Tintoretto's picture for the first time in 1587. Despite the spatial proximity the differences could hardly have been greater.

Titian's picture is correct by all the criteria of the doctrine of decorum: the architecture and costumes, the behavior of the persons depicted, the costliness of the accessories, all made it a picture fully in the high style, as befits the importance of the Annunciation in the story of salvation. In Tintoretto, by contrast, we see a once genteel place that has suffered serious decline:[88] the column broken, the chair worn out, and only the desk, ceiling, and bed recalling the former glory. Mary herself is no fine lady, and not only in her clothes. The short fingers, a face lacking nobility by all the standards of beauty of the time, the reddened skin: by the conventions of the sixteenth century she has all the characteristics of a maid, not a mistress. Before the house in which she lives there is neither a fine courtyard nor a well-tended garden, but the rather untidy workshop of Joseph, the carpenter. Engrossed in sawing, he is separated from Mary both spatially and inwardly as the Archangel Gabriel, followed by

a throng of putti, bursts into this poor dwelling, which has nothing cosy or genrelike about it, though it has a certain dignity and solemnity of its own.

Tintoretto depicted biblical scenes as if they were part of Venetian everyday life, but he did so with the means and eloquence of the high style, which has its origin not in daily life but in the religious significance of the events portrayed. He thus developed a kind of painting that found in the Bible not only its themes but the model for its style. For the Bible was not afraid to show "everyday reality combined with the tragic and sublime" because, in it, "the sublime, the tragic, and the problematic is given domestic, commonplace form." As in Tintoretto, in the Bible the "sublime impact of God . . . is felt so deeply in everyday life that the two realms of the sublime and the quotidian are not only undivided in fact, but indivisible in principle."[89]

Ceiling Paintings

The practice fashionable throughout Italy of painting not only walls but ceilings with narrative pictures, which were done as far as possible in an illusionistic manner, came to Venice in the second third of the sixteenth century.[90] The reputation a painter could gain through such paintings was considerable, for these were works for important places like the Doge's Palace, the churches, and the scuole grandi, and pictures with important themes that, moreover, demanded special skill because of the necessary foreshortening. Only history painters were equal to this task, and of them only those who had deep knowledge of the developments outside Venice that supplied the models.

The first famous examples were produced in the years when many young Tuscans were trying their luck in Venice. But what they had learned in Rome or Florence was not immediately applicable to Venice, since Venetian ceilings were for constructional reasons generally flat, and it was also the custom to decorate them with expensive carving. For this reason the decorations by the Rosa brothers based entirely on illusionist painting, one of which has survived in the anteroom of the Libreria, had only a brief success.[91] Even in the later sixteenth century the splendid frames were not painted but carved. Not uncommonly the framework seems to have been under construction before the client began to think about themes of paintings. The designer of the frame decided the number, size, and arrangement of the picture areas, setting ground rules that the artist could not easily escape. Many pictures undoubtedly owe their existence to the symmetry of the ceiling system rather than to any thematic necessity. From about 1560 the frames were given more and more relief, so that large parts of the pictures are in shadow or invisible in normal light.[92]

A further problem was the relatively low height of most Venetian rooms, which did not favor strict illusionism. Many foreshortening effects that might have been quite convincing in higher rooms were prevented by their low position from creating their illusory effect even for the most well-disposed viewer. By experimenting over many years the Venetians finally discovered forms of composition and techniques from which the painters of the baroque were to learn. Pietro da Cortona is said to have entirely changed the conception of his ceiling in the Palazzo Barberini after seeing Veronese's ceiling paintings in Venice.[93]

The difficulty lay not only in adjusting to the viewer's angle of view, but in doing justice to the scene to be portrayed. For ceiling painting was not a genre in its own right, but history painting under special conditions. It soon became clear that it was not expedient for reasons of illusionist logic to show the protagonists from a worm's-eye view, so that the equation of the viewing axis with the axis of the picture world was soon abandoned.

The painted world confronts that of the viewer but is not a continuation of it. This benefits the main theme of this and subsequent ceiling painting, "the representation of a realm between the weightless heaven of God and the earth, the cloud-filled realm of the weightless. Ringed by airy illusory architectures and populated by angels, saints, gods, and allegorical figures, it is the sphere of rapture and epiphanies."[94]

Paolo Veronese had gained his first experience of ceiling decoration in urban Venice in the rooms of the Council of Ten.[95] One of those responsible for the decoration of the Doge's Palace was Procurator Vettor Grimani, who had played a leading part in the renovation of the Piazza S. Marco. In the politics of art, Grimani was one of the leaders of the "Roman" party, who could imagine progress and renewal only as an emulation of Roman developments. He seems to have had so little faith in Venetian artists that he gave preference to the third-rate Ponchino, whose only qualification was that he had been trained in Rome. Even so, Ponchino showed more understanding of art than his protector and secured the support of Zelotti and Veronese before returning to Rome some years later. The thematic concept of the ceiling paintings in the rooms of the Council of Ten has not yet been deciphered in detail. But it is certain that they relate to the activities of the council whose rooms they adorn: vices are driven out, virtues crowned; Venetia appears before Juno flanked by Neptune and Mars and is showered with riches. We see allegories of justice and peace, victory and revenge, as well as embodiments of rivers and territories.

In all probability the relationships between the figures are governed by more subtle iconographic considerations, but the figures themselves are so common in Venetian state painting and their significance is so general that they might have peopled any other room in the Doge's

Palace. However, perhaps the authorities were satisfied as long as visitors understood that Venetian rule, and especially the actions of the council, were always virtuous, so that opposition could arise only from vice and stupidity.

The low ceilings in the palace were not to be changed, nor did the young painters have any influence on the framework systems that dictated their spaces and formats. To begin with they were almost helpless in face of these difficult conditions. Even Veronese learned only later to take his starting point from the perspective of the viewer. To begin with he submitted to the dictates of the illusory space generated within the picture, simulating a direct view, as if from the depths of a dungeon. That this favored neither Venetia's face nor the gifts that plunged past her into the depths was a drawback he had to accept. Only when he had liberated himself from the dictates of the strict view from below and arrived at a combination of various upward and oblique viewing angles was he able to narrate more freely. He always remained aware, however, that the histories were being narrated above for a public that could see the action only from below. Depending on their experience and sophistication, the public could either naively abandon themselves to the illusion of viewing from below, or enjoy the game the artist was playing with his aesthetic limits.

There was never a fusion of the painted and the real worlds in the Venetian Renaissance. It was prevented by the wide, deep frames in which most of the pictures were recessed. However, contemporary viewers, who were not yet immunized by the illusionistic devices of the baroque, are likely to have been far more susceptible to the deceptions. In addition, they would have had far more appreciation for frames, stucco, and gilding than the modern viewer, who tends to find the opulent frames an obstacle to immersion in the pictures.

Veronese demonstrated his newly won mastery as a ceiling painter for the first time in S. Sebastiano (fig. 284). The first of the three ceiling paintings shows the expulsion of Queen Vasti, who had fallen from grace and whose path could only be downward. Of the king, at the top right, only part of his shoulder is visible, while one sees the whole back of the courtier supervising the departure of the banished queen, standing with his feet apart next to the doorway. The buildings are reduced to small sections, so that the painter can manipulate the pictorial architecture according to the needs of the narrative. Veronese's virtuosity in this area allowed him to achieve a tight meshing of setting and action among the beggar, the staircase, and Queen Vasti. The beggar's leg, in contrast to the upright but leftward-turned head of the dog, marks a direction from bottom left to top right. This preludes, by contrast, the direction of Vasti's movement, which formally subsumes the forward-bent torso of the beggar, who, although he does not look at her, is closely related to the queen by analogies to her leg and through the contrast to the upward-leading staircase, which his head intersects just below Vasti.

Veronese's development is part of a process affecting the whole of Venetian ceiling painting, which changed the traditional picture forms so as to make them suitable for history paintings while at the same time organizing the settings of the histories to take advantage of the special conditions of ceiling painting. In addition, as his ceiling paintings were to be seen only from a distance, Veronese dispensed more and more with the nuances of composition, color, and narrative that distinguish his history paintings. The central picture in S. Sebastiano, the *Triumph of Mordecai,* is set up in the manner of an opera spectacle. The viewer is imagined to be in the pit in which the victory procession will meet its abrupt ending. Mordecai himself as yet knows nothing of it, unlike the spectator, who in addition is startled by the shying horse. The people in this picture are stereotyped by Veronese's standards: the heroes are in shining armor, the villains wicked, the maidens blonde and beautiful.

For an artist like Tintoretto the ceiling painting must have been a special challenge. The picture for the *albergo* of the Scuola Grande di S. Rocco of 1567 proves that the painter had studied Correggio's and Michelangelo's ceiling paintings with equal profit; his figure of God the Father is reminiscent of the latter.[96] St. Roch is seen as one would expect to see someone in this position, and Tintoretto was shrewd enough to base his foreshortening on this expectation, not on optical reality, which would have been far less fertile in pictorial and narrative terms. Since Tintoretto always took the location of the work, and so the observer's viewpoint, as a primary factor in his artistic calculations, in his case the differences between wall and ceiling painting were of degree rather than of principle. For this reason Tintoretto's large ceiling paintings are less remarkable as contributions to perspectivist composition than for the narrative perspectives they open.

In the ceiling paintings in the main hall of the Scuola Grande di S. Rocco a part of his development can be traced.[97] His first picture for the scuola showed St. Roch steeply from below—perhaps with an eye to the awarding committees that he hoped to impress with some powerful effects. This was his usual trick, which had its usual effect. The ceiling paintings for the sala, which Tintoretto himself proposed, probably without much regard for the ideas of the scuola, quickly showed a significant change. While the solution in the *Gathering of the Manna* (fig. 285) is fairly conventional, that in the *Brazen Serpent* (fig. 286) is bold and effective in narrative terms. In the *Gathering* the two framing figures, stretching upward and bending backward, measure at least half the height of the picture. The left-hand figure has formal links to both right and left, behind and above,

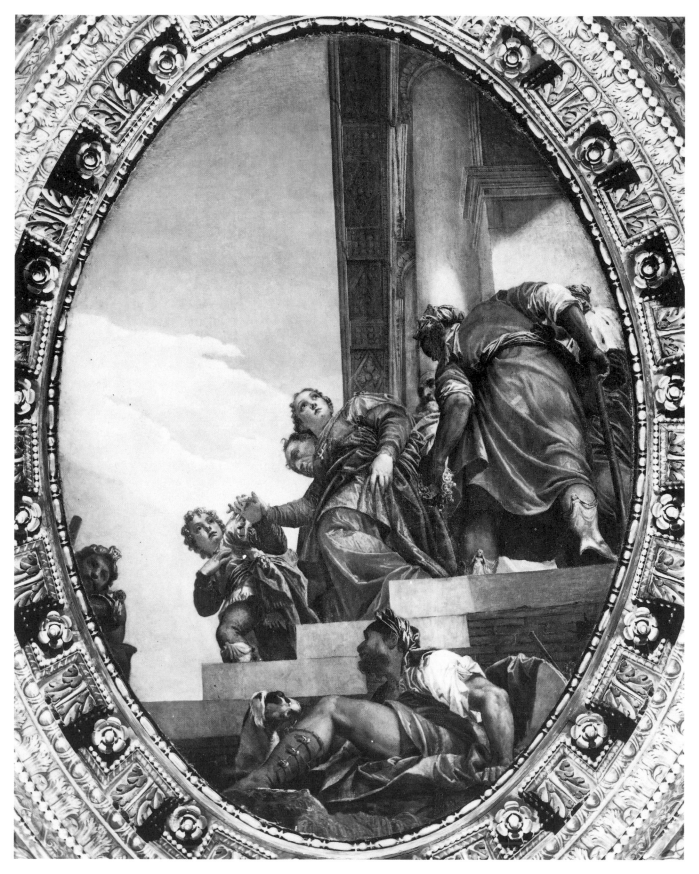

284 Paolo Veronese, *Expulsion of Vasti*. Venice, S. Sebastiano

which shape the composition and open it at the same time. This figure receiving the basket is followed in the middle-ground by another who is carrying a full basket towards the back. This youth in turn is formally a part of a group of three who demonstrate different postures by walking, crouching, and sitting and also form a link to those lying in the middle-ground, a group that begins with the hip of the left framing figure and ends with a seated figure below the arm of the framing figure on the right. This seated man, following Moses' arm, looks up past the canopy to the place where God the Father is appearing. The third basket carrier, in the top left corner, also points to this area. The background group is almost touched by Moses' finger and forms a second light center corresponding to the epiphany of God the Father. The viewer looks into the scene from outside. The identifica-

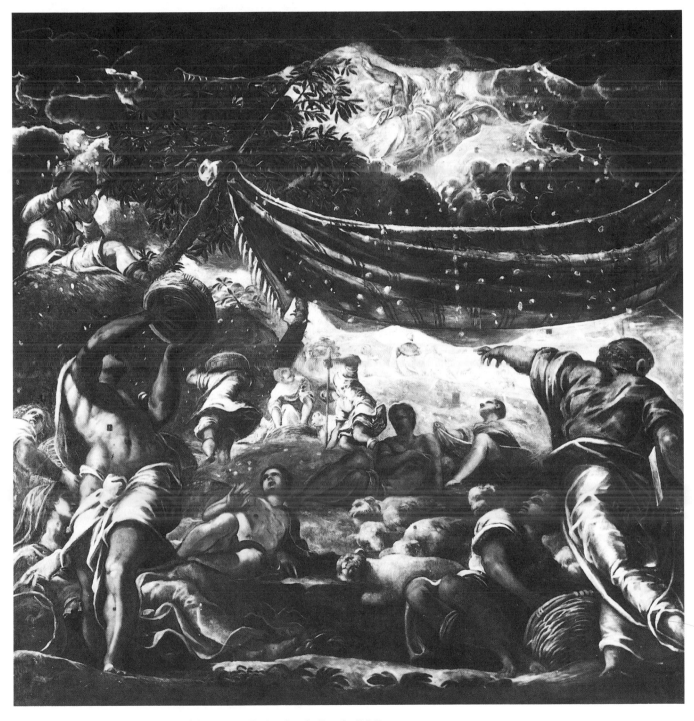

285 Jacopo Tintoretto, *Gathering of the Manna.* Venice, Scuola Grande di S. Rocco

tion figures are Moses and the basket carrier on the left. But the oversize treatment of the framing figures, which excludes comparison with the people in the sala, has the effect of distancing the action once more. In addition, the place where God the Father appears is cut off from direct comparisons of size by the canopy.

In the *Brazen Serpent* only the view appearing in the bottom right corner reminds us that the events are taking place on a hill, or at least an elevated place. Again, several elements of composition unfold from the bottom left corner, opening up the picture area to the right, towards the top and obliquely to the back. Here all are attacked by snakes; terror and suffering fill the bottom half of the picture. Only at the top of the middle group is there a seated figure who is looking at the maiden shown without intersections in a hollow and pointing emphatically towards the serpent crucified by Moses. The hollow where she appears corresponds formally to the group of

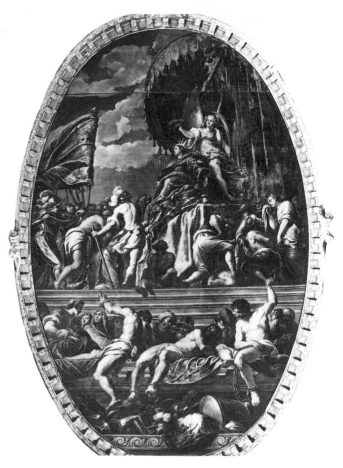

287 Jacopo Palma the Younger, *Triumph of Venetia*. Venice, Doge's Palace

angels accompanying God the Father, who has saved them. It allows Tintoretto to link the lower zone to the middle one and to the very variegated groups on the crest of the hill.

The three most important paintings in the Doge's Palace are those in the middle axis of the Sala del Maggior Consiglio.[98] The two at the sides being nine meters high and the middle one ten, they are also among the largest. The outer pair show Venetian acts of heroism. The middle painting summarizes allegorically what such deeds lead to and demonstrates that they are not an end in themselves but have meaning and justification only in the service of the state. The program states laconically that the large pictures show the results of such undertakings and examples of virtue.[99] The common theme of the large middle pictures is the glorification of Venetian rule, asserting that it is based not on oppression and force but on the voluntary, enthusiastic agreement of the ruled.

The young Palma had to paint a Venetia "sitting on

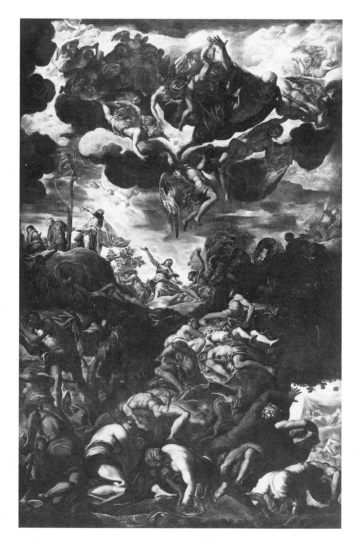

286 Jacopo Tintoretto, *Worship of the Brazen Serpent*. Venice, Scuola Grande di S. Rocco

288 (*Opposite*) Jacopo Tintoretto, *Voluntary Submission of the Provinces under Venice*. Venice, Doge's Palace

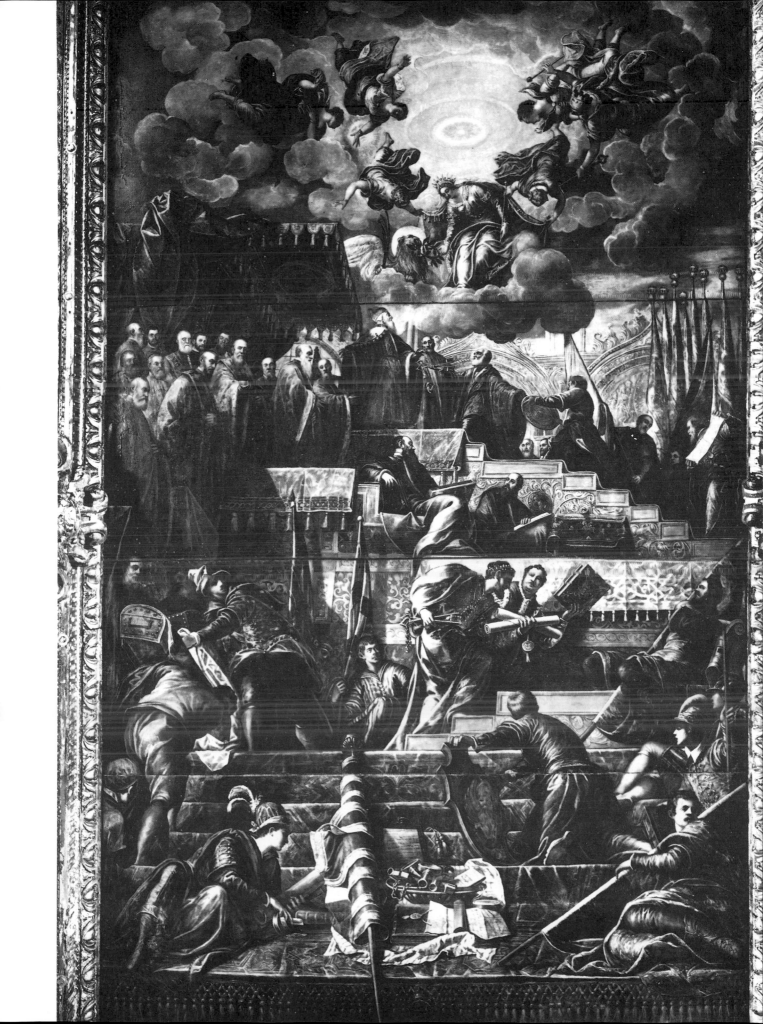

war trophies. Behind her is a winged Victory, who is crowning her with the laurel wreath" (fig. 287).[100] Below Victory there were to be, partly sitting, partly standing, many fettered prisoners, all looking downcast. Also required were some women who were to represent the united provinces. Armed men lead them, with many trophies, to Venetia. In his preparatory drawings Palma had been primarily concerned with the prisoners and their fate.[101] The close intertwining of the picture zones made it apparent that their suffering was the precondition of Venetia's triumph. In the final picture little remains of such restrictions. Divided in two by a stair wall, the picture shows the required coronation in its top half and prisoners from many lands in the bottom. Their melancholy has almost entirely vanished; despite their chains, and below Venetia, they seem almost comfortable on their former armor and drums. Far from being a disturbing element, they delight the viewer with a varied sequence of heads and three nude figures interestingly arranged. The Venetia above is also skillfully deployed. A general, buoyant sense of movement leads the people and accessories to her, which saves the painter precise elaboration and the viewer close scrutiny.

This is not the case with Tintoretto (fig. 288). His painting does not enjoy a good reputation. Ridolfi considered that Tintoretto had reeled it off "con poco studio,"[102] and the last cleaning vindicated those who saw in the execution only the work of assistants, and not always the most competent of them. This can easily distract attention from the multitude of inventions and ideas in the design of the work, which must in all important aspects be by Tintoretto himself. The program was concerned primarily with what happened in the top half: "The painting shall have a Venetia dressed in white in the air, with two nymphs at her side." The lion beside her was to hold "in one paw a palm branch that it appears to be giving to Venetia, and a laurel wreath in its mouth."[103] Somewhat below that, the authors of the program envisage a high and richly adorned platform for the doge and the officials in whose presence he receives foreign envoys.

Tintoretto has given each of the two nymphs two further companions, which enlarge Venetia's entourage and heighten the contrast with the circles of light that indicate Venetia's place of origin beyond the reality of the picture. For Venetia is not permanently present, but has been borne here on a bank of cloud. A great honor, confirming his conduct in office, is thus done to Doge da Ponte, but at the same time he is subordinating himself to the incarnation of the state. The figure of the doge is the common reference point of the various groups: all the people, Venetia, the envoys, the officials, relate to him. Although appearing towards the top in a photo, in the Sala del Maggior Consiglio itself, from the normal viewpoint, he is undoubtedly at the center. Is this therefore an apotheosis? Against this interpretation is the fact

that, as in a votive picture, the doge is subordinated to Venetia. He is not kneeling, however, as he would in such works. He is standing, not in a reverent or humble posture but erect, pointing with his right hand to his attendants and so recalling the collective structure of state affairs. The officials look down or at the doge, Venetia's presence being concealed from them, since dialogue with her is the privilege of the doge.

The general layout of the picture binds da Ponte to the government—as the official state doctrine would demand—while in the detailed execution he departs from it. As the arrangement was preordained by the program, the painter's contribution is likely to be found in the detail, where the relationships envisaged by the program's authors are exactly reversed: while the lion holds out his wreath for Venetia, she does not take it. Instead, her hand opens in a gesture of showing, and the object of this showing is the doge.

The scene of the action and the situation, although fictional in the form chosen by Tintoretto, could relate to experiences with which the public in the Sala del Maggior Consiglio was familiar. Envoys were usually received in the Sala del Collegio, where the doge, surrounded by advisers, was enthroned on a high "tribunal," a bench, while the secretaries performed their duties below. It is an open question whether the special emphasis given to the doge by Tintoretto's treatment referred to the office in general or the person of this particular doge. It is worth noting that he painted a votive picture of da Ponte, in which he was involved to an unusual extent from the design to the execution.

Below the doge nothing of the ambiguities and subtleties of the upper part of the picture is to be seen, Tintoretto having adopted his patrons' ideas without reservations. The program wanted the envoys to be shown here in their national costume: Greeks are mentioned, Dalmatians, Istrians, and Italians. They are supposed to turn spontaneously to the republic, to present their seals and documents and the keys of their cities. Tintoretto presented this as a large operation: people resting, packing, and climbing the stairs are shown, until they all form the ceremonial procession that pays homage to the doge at the top. Tintoretto has rendered the costumes and accessories with visible satisfaction and has shown off his effortless mastery of all the techniques of foreshortening.

The third large ceiling painting in the Sala del Maggior Consiglio, the one above the "tribunal" of the doge and the signoria (fig. 289), was supposed to show the general renown of Venetian rule in a final apotheosis, after its foundation and growth. It was entrusted to Veronese. His task was not easy: Venetia was to be placed above cities and towers as Roma had presided over the globe on ancient coins. Flying Victories were to crown her with laurel, and peace, abundance, fame, happiness, honor, security, and freedom were to surround her. Richly varied

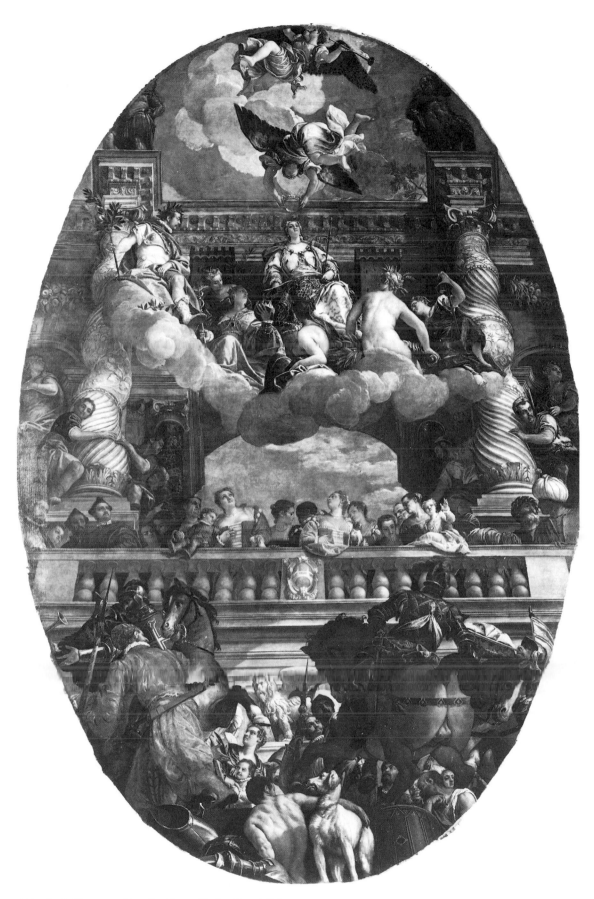

289 Paolo Veronese, *Venetian Peace*. Venice, Doge's Palace

people were also required, who would form jubilant crowds. Finally, in a separate place, four putti were to recall the seasons.[104]

Veronese designed a ceremonial fantasy architecture of extreme splendor for his patrons. On a balcony with the richly adorned women usual on special occasions in Venice, he placed a large arch embellished with two twisted columns. Before this arch, between the columns and above the aristocratic ladies, Venetia has appeared with her attendants, followed by a first Victory with the laurel wreath and a second blowing the fanfare of fame. As no definite person is painted, many could have related the picture to themselves. But despite such generality the work contains at least one motif based on the politics of the day. The allegory of Honor, who is placed above the other Virtues and almost on the same level as Venetia, has the features of Henri III of France, whom the republic had received with utmost ceremony in 1574 in the hope of a lasting alliance.[105]

"Moltitudine de populi festeggianti" (applauding multitudes) the program demanded of Veronese, and some of them are to be found on the balcony. But in the lower part of the picture the necessary jubilation seems harder to arouse. Here there are some dark tones unknown to the program, and if we look closely, even its chief assertion is called into question. The foreground with the prisoner and the discarded armor recalls war and defeat, and the lion of St. Mark above looks angry rather than benevolent. Few signs of celebration are to be seen in the serious faces, but the armed men and horsemen keeping the crowd in check leave it in no doubt that the basis of Venetian rule, as of any other, was the presence and use of force.

Gods and Landscapes

Altarpieces, portraits, and histories had a secure existence in Venice because a demand for them with fixed places and functions existed independently of the artistic supply. No such institutional guarantee existed for genre paintings, mythological pictures, and landscapes. On the other hand, many histories took place in the open air, and as long as the setting was to be shown in detail there were landscapes to be painted. However, the development of narrative painting with large-scale figures and reduced, often fragmentary settings did not favor the development of landscape painting. In the late sixteenth century, above all, its general status declined considerably, and not uncommonly it was left as the domain of the *oltramontani* from Germany and the Netherlands. Their supremacy, which was emphasized everywhere, was explained by Paolo Pino in 1548 on the grounds that they simply painted the landscapes where they lived, and that these were particularly suitable subjects because of their wildness: "We Italians, however, live in the gar-

den of the world, which is far more pleasant to see than to paint. Nevertheless, I have seen wonderful landscapes by Titian, of far greater charm than those of the Flemish. Master Girolamo of Brescia [Savoldo] was highly skilled at this task. I saw a number of sunrises by his hand, with reflections, dark places, and a thousand rare and ingenious observations that give a far truer picture of their subject than the Flemish."[106]

The points of contact between landscape painting and natural science seem to have been few and artistically unproductive. All the same, it was a Venetian cartographer who wrote the first text exclusively devoted to landscape painting. But Cristoforo Sorte's *Osservazioni* were completed only in 1580, at a time when the most important Venetian landscape paintings had already been done. Sorte demanded among other things that the colors should be chosen according to the special nature of the landscape to be painted, and that the depiction of rivers should conform to the knowledge established by science about their sources and their relation to mountains. Sorte's artistic models were undoubtedly the landscapes of Titian.[107] Their reputation was unquestioned and universal in Italy. The theoretician Lomazzo praised Titian not only as the greatest master of color but also as "the first inventor of thunderbolts and rain showers, winds, sun, lightning, and storms. And above all, Titian has lent magnificent color to mountains and plains, trees, bushes, shadow and lights, floods and earthquakes, stones, beasts, and everything else that is a part of landscape.[108] Rhetorical as this passage may be, it gives an idea of the late Titian's ability not only to depict the details of nature but to make the elements of water, air, or earth palpable and to bring these elements together—at least in the distance—so that their inner connection, thought at the time to be comparable to a living being, is made visible. At the end of this critical tradition, in the eighteenth century Francesco Algarotti, in an admirable formulation, called Titian the greatest intimate of nature, the Homer of landscape painters.[109]

Landscape, and nature in general, is one of the great themes of Titian's late work, although there are no autonomous landscapes by him, not even—as in earlier years[110]—in the form of prints. He placed saints like St. Jerome of the Brera[111] in a landscape devoid of civilization, as the theme of the hermit's life demands. But this life itself and its landscape are shaped entirely by the forces and violence of nature, which are presented in the form of growth and destruction in several areas: the distant past of *natura naturans* appears in the rock formations, but its present manifestation is in the clouds, the water, and the Ruysdaelesque tree on the left.

An important stimulus to the Renaissance in turning to landscape was the literary tradition that landscape painting had existed in antiquity. Giovanni Andrea Gilio— otherwise a doctrinaire figure who believed it his chief

task to combat what he saw as the undue liberties being taken by the artists of his time, above all Michelangelo—told his readers in 1564 about ancient landscape painting, generously conceding that in such "cose poetiche e finte" the artist should keep his freedom.[112] For example, in the landscapes "invented by the painter Ludius at the time of Augustus. First of all he painted the sea with ships; in paintings of country homes he included farmers at work, wanderers, people resting, standing, and sleeping. He also painted towns, palaces, villas, and the charms and freedom of the country, as the Flemish do admirably today. The artist should also have the freedom to paint day or night, a clear or cloudy sky, sun, moon, or stars, the sea and rivers, lakes and springs."

It is no wonder that most of the relatively autonomous landscapes are to be found where the painter was attempting to reconstruct the life of the ancients, particularly their villas. Much of this world has vanished today.[113] The village of Treville near Treviso seems to have had a special significance: Giuseppe Salviati worked there in 1542, and in 1551 Veronese produced a cycle for the Villa Soranzo in Treville, fragments of which have survived. Both painters were at the beginning of their careers, neither having yet established himself in the metropolis, and both are reported to have owed their commissions to the mediation of the architect Michele Sanmicheli.[114] No other villa decoration by Salviati is known, but a few years later Veronese produced decoration for the villa of the Barbaro brothers in Masèr,[115] which remained exemplary even after Veronese, now established in Venice, had withdrawn from villa decoration, leaving this field to able specialists like Giovanni Battista Zelotti.

None of these pictures dwells on the beauty of the countryside around Masèr (fig. 290). They show cultivated landscapes that, like the English gardens later, are the setting for ancient buildings and situations. The figures are too small and their costumes too unspecific for the use of the land to be accurately located in time. The great skill with which Veronese has presented these landscapes as illusionistic perspectives heightens their distance from the surrounding reality, to which not only the topography but the often ruined architecture is in contrast. Informed visitors to the Villa Barbaro might have known these to be antique buildings through engravings.[116] In his skies and views, however, Veronese contrasted natural phenomena like water, earth, and air to the accessories and buildings. The paintings thus offer a reconstruction not only of a Roman style of decoration but also of nature as shaped by antiquity. Everywhere Veronese and the Barbaros put their thematic and formal inventiveness on display.[117] The simulated architecture is replete with complex foreshortening effects and elaborate breaches of an illusion of space only just established. The sophisticated Barbaro brothers and their visitors

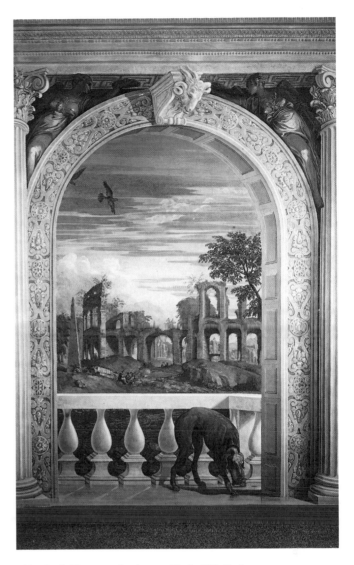

290 Paolo Veronese, landscape. Masèr, Villa Barbaro

would probably have been little impressed by simple optical illusions, preferring an art that plays with the possibilities and limits of perception and an illusion that recognizes itself as such. That is no reason why right at limits are carefully respected in the important places: in the ceiling paintings nothing overlaps the frames in a way that would have created a direct contact with the viewer's actual reality, although this device is not uncommon in landscapes and simulated statues. Such games also go back to the villas of antiquity described by the classical writers, which had such a hold on the imagination because practically nothing was left of them in the sixteenth century.

Veronese produces no simulated reality but an art world in a stage setting that owes its sophistication not least to its admitted fictitiousness. Its ideal viewer is one who is willing to be fascinated but not deceived, who takes delight in skillful foreshortening and in the

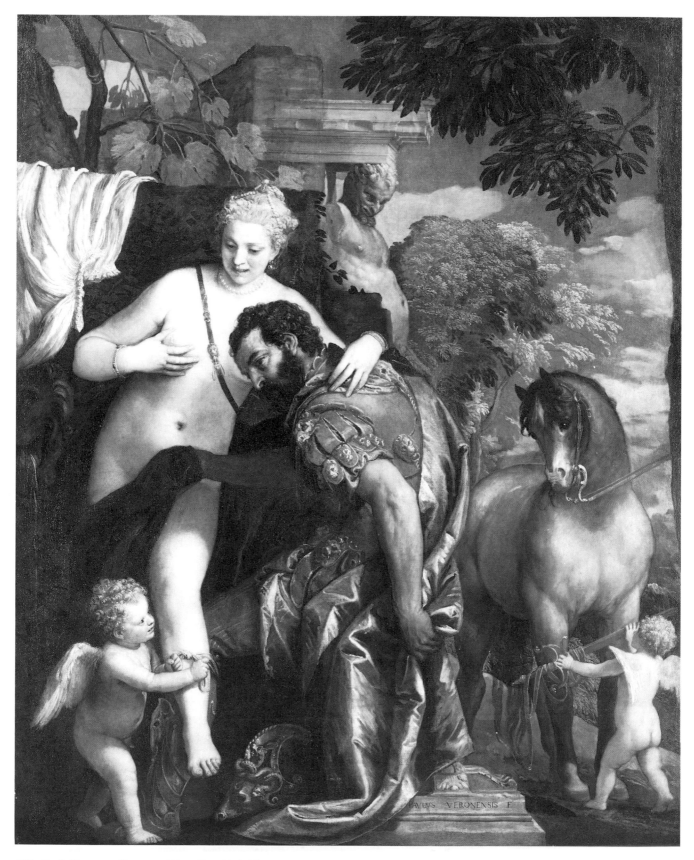

291 Paolo Veronese, *Venus and Mars*. New York, The Metropolitan Museum of Art, John Stewart Kennedy Fund

calculated breaks and abrupt transitions, and who, in the ceiling figures, appreciates the mingling of spheres, the learned quotations, and the combinations of figures. No doubt paintings like *Venus and Mars* (fig. 291) were meant for viewers of this kind. It is thought to have been painted for the court at Prague,[118] where the affected preciosity of the arrangement, the brushwork, postures, and gestures would have been admired. Armor is opposed to nakedness, skin to iron, darkness to fairness. A putto has taken charge of the sword to block the way of a horse which, for its part, shows not the slightest inclination to leave its place—just as the serious-faced Mars looks on with composure as the other putto ties his leg to that of Venus. The still life behind the couple culminates in an architectural caprice with Silenus as a caryatid. He is stone-colored but nevertheless alive—a spectator who puts the doings of the divine couple in a somewhat ironic light.

Unlike the Christian themes, the mythological ones did not involve serious responsibilities, since no one believed in the divinity or even the existence of the persons shown. Meanings could be grafted onto them, but usually they gave free rein to the artist's imagination. Extreme formalism was often combined with esoteric meanings. If Tintoretto's *Three Graces* (fig. 292) were hung in isolation in a museum and nothing else was known about them, one would have to suppose that their original destination was the cabinet of a collector. The artificiality of the poses, each of which shows a different aspect of the female body, would be one of several arguments in favor of such a conclusion. But in fact the three women were painted in 1576 for the Doge's Palace, where they shared the Atrio Quadrato with three other paintings by Tintoretto (*Vulcan and the Cyclopes, Minerva Expelling Mars,* and the *Wedding of Bacchus and Ariadne in the Presence of Venetia*).[119] All four were meant as political allegories, Vulcan, as he works with his Cyclopes, being a symbol of the unanimity of the Venetian senators. The *Three Graces* were to remind the viewer of the benefits (*gratie*) that the senators bestowed on the deserving: one of them supports herself on a dice because the distribution of offices was officially decided by chance in Venice. The others are holding, in myrrh and rose, the attributes of the goddess of love, as

292 Jacopo Tintoretto, *Three Graces.* Venice, Doge's Palace

293 Jacopo Tintoretto, *Venus, Vulcan, and Mars.* Munich, Alte Pinakothek

signs of lasting love. The Graces are accompanied by Mercury, since the allocation of benefits must be guided by reason.

Beside works like these, however, there are paintings by Tintoretto that take the stories of the mythographers[120] literally and then parody them. The most brilliant example is the Munich painting of *Venus, Vulcan, and Mars* (fig. 293), in which the divine story is staged as a piece of popular theater.[121] The setting is not a timeless place but the bedroom in an aristocratic Venetian house. Between Vulcan and his unfaithful wife Cupid is seen fast asleep, his work done. The lover, his helmet already on, is waiting beneath the drapery for a suitable moment to flee. That, however, will not arrive, for the dog, as a symbol of marital fidelity, is about to bark at the intruder. The rest was known to Tintoretto's public. But it was not the subject that mattered but its treatment: a woman's body whose charms were displayed, a god of war in an embarrassing situation, and a husband whose inspection of his wife lacks nothing in explicitness. The risky nature of the content is allied to audacities of form, for example the repetition of the postures from the other side in the mirror. This was a contribution to the contemporary dis-

cussion about the preeminence of art forms, in which painting was accused of being easy because, unlike sculpture, it showed its figures from only one side. This induced painters to demonstrate at every opportunity how many and varied views they were able to offer if they so wished. Moralizing pictures that taxed the gods with their lack of virtue had a long tradition. But now the horizon was changing, for unlike Bellini Tintoretto was not moralizing. As in his *Susanna,* whose toenails are being cut, or his *Leda,* in whose boudoir the wooden cage in which the swan was transported can still be seen, the viewer can be indignant and amused at the same time.[122]

Tintoretto had to paint mythological subjects only occasionally, as the demand for them in Venice outside the Doge's Palace was not very great. But the painter who supplied courts had much more to do with gods than his colleague who worked for the city. An artist with mythological interests therefore had to try to win the favor of princes. The most successful at this was Titian, who at regular intervals over a ten-year period sent to Spain not only religious paintings but mythological ones as well.[123]

Titian had painted the young Philip's portrait not only as a prince, but as one of the cavaliers playing the organ in

the presence of Venus. In all these couples the organ player sits on the left, seen from the back, while an *ignuda,* seen from the front, lies beside him, in some cases clearly identified by attributes as the goddess of love, in others not. She can look to the front, upward, or downward, but never at the cavalier. Between the organ and the curtains of the bed are seen landscapes that may be gardens or views of a heroic distance. The conduct of the men, all in contemporary clothes, is similar but not identical. All are moved by the beauty of the naked woman, some finding its highest intensity in her face, others in her loins. Allegorical interpretations that claim to see in these paintings the academic *paragone* of the senses of sight and hearing are possible and even plaus-

ible with regard to the attributes; but the raison d'être of such paintings is more likely to be found in the confrontation between men and feminine beauty in a social situation that may have been most commonly found in the boudoirs of famous courtesans, who combined beauty and culture in their persons and in whose houses there was much music making.[124]

The *Danaë* in the Prado, the first of a series of pictures that Titian painted for Philip II in the 1550s, is in both conception and execution one of the freest and most perfect of his works. Whether the Habsburg monarch had much understanding for the artistic brilliance displayed here is open to doubt. The model was the *Danaë* for Alessandro Farnese, in which the audacity of the

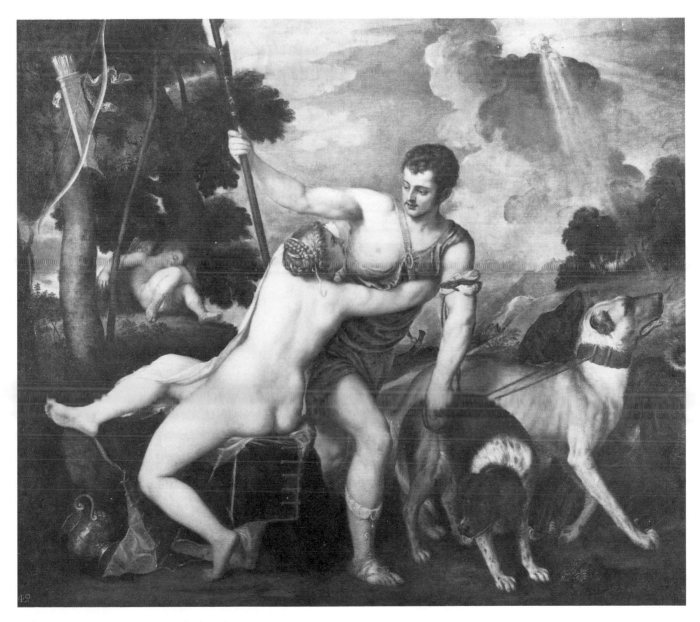

294 Titian, *Venus and Adonis.* Madrid, Prado

motif would have made more impression on Philip—and the cardinal—than the painting. The later version with the relaxed posture of the legs, the play with the hand, and the exchange of the Cupid for an old woman catching the golden rain is a good deal bolder.

Titian himself called his works for King Philip "poesie." Whether he had a concrete, precisely formulated commission for these poetic paintings or created them in order to pursue themes and motifs that would not have been possible otherwise, we do not know for certain.[125] In the judgment of the worldly Titian, at any rate, the king was more interested in the variety of the naked women than in their names. In announcing one painting he did not even mention the theme: "After the Danaë

seen from the front that I have already sent your Majesty, I have done a variation and shown the opposite side of the body, so that the room in which the pictures hang will be more pleasing to the eye." To judge by the number of copies and variants, *Venus and Adonis* is the most successful painting that Titian ever produced (fig. 294). In 1557 Lodovico Dolce devoted to it the most detailed analysis that is to be found in early Venetian writings on art.[126]

But even if the Venus-Adonis story was chosen only because it provided an opportunity for a nude seen from the back, the result was a depiction of the pain of love and separation not previously to be found even in Titian's work. The helplessness of her beautiful body, which can

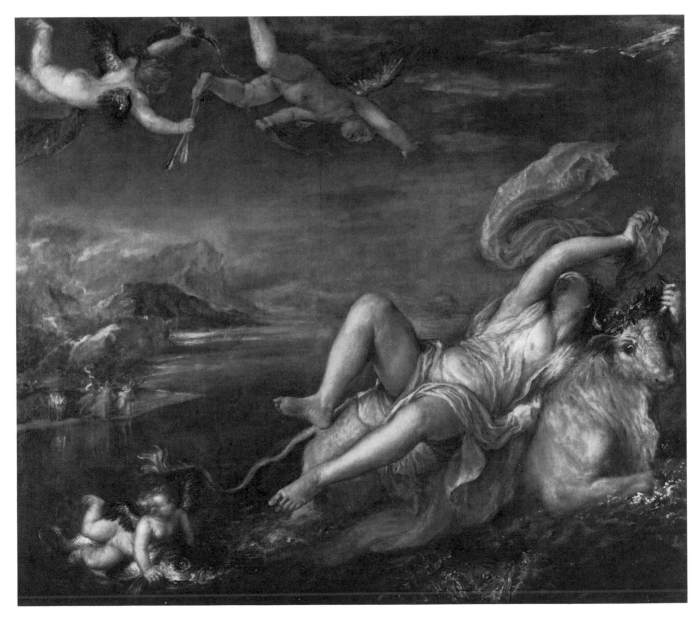

295 Titian, *Rape of Europa*. Boston, Isabella Stewart Gardner Museum

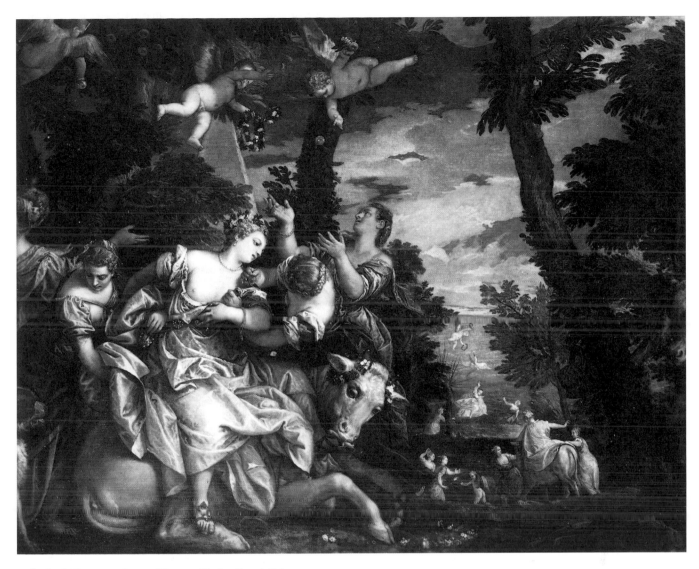

296 Paolo Veronese, *Rape of Europa.* Venice, Doge's Palace

no longer seduce an Adonis preoccupied with his thirst for deeds; her clinging embrace, which the upright body of the young man is shaking off; the menace of the big dogs; the sleep of Cupid, who alone could have helped her; and the echo of her pain in the turbulent sky portending catastrophes: all this no longer shows idyllic joy but the irruption of death and suffering. In these features the copyists did not as a rule follow Titian, and even in the replicas produced under his supervision in his workshop much was trivialized and reduced.[127] Paolo Veronese avoided such dramatic effects from the outset.[128] The goddess in his picture is cooling the lover asleep in her lap with her fan. Although his dog is awake, it is held back by the obliging Cupid. Danger is visible, but it lies in the future, and the goddess's happiness still lasts.

How great the differences could be is shown by the two Europa paintings by Titian and Veronese, which were produced at about the same time (figs. 295, 296). In Veronese we have again the enlightened, detached, playful attitude (as compared to the passion of Titian), which translates the theme wholly into the social categories of Venetian life. It shows not a rape but the wedding preparations of a princess who is being adorned by servants and amoretti. As always in Veronese, more is at issue than a bazaarlike display of splendor and luxury. Anyone who looks more closely will notice not only the libertine relish of the bull, but the face of the heroine betraying anxious anticipation and dejection above the exposed breast and the busy hands of the servants.

Titian's bull, too, is not dangerous but seems a stupidly trustful animal that calmly goes its way. In sharp contrast is the woman, no longer beautiful and no longer modest, dragged by the appearance of Cupid from her sidesaddle posture (impudently paraphrased by the putto on the dolphin) into one of abandonment.[129]

In Veronese's picture the landscape has no value of its own. It provides a setting and a view, so combining the two themes of the adornment of Europa and her disappearing into the distance. The foreground setting is without coherence of its own—unlike that of Titian's *Venus and Adonis.* But this gave Veronese a free hand in his treatment of the fragments of tree and sky, of which, being without obligations towards a complete stage setting, he could show only as much as he needed. So there are parts of a copse in the foreground with amoretti flying about them, each in a characteristically different relationship to its fragment of tree and sky. In the landscape view Veronese has painted even the large, therefore near, trees as if they were seen from a distance. They provide protection and at the same time frame the view into the distance, where the myth is transported entirely into fairy tale. It is actually an ancient narrative mode—perhaps used for this reason—to show the future in small figures. But the solution was worthy of the admiration of a Watteau: distance seen not as a goal but as a suspension: "As often happens in fairy tales, time seems to be abolished: all that matters is to show the fabulous events in a miraculous way, simply to show them." It was a presupposition of such pictures that "Veronese did not understand them in terms of a large mythology governing the world, which was certainly their original meaning, but as a tender idyll in a world accessible only by magic."[130]

Titian, by contrast, placed the scene by means of landscape in a setting of almost cosmic grandeur embracing all the realms of nature and created above all by a merging and glazing of colors that no reproduction can convey. Firm ground is painted loosely, while clouds are given solidity. Thus formations of different material consistency are made similar and even continuous. This merging is not asserted as "objective" but is shown unmistakably as the result of an artistic manner of perceiving, seeing, interpreting, and finally behaving, which abolishes "objective" boundaries, subverting or overleaping them. The perception first lingers with something it has noticed, the bull or the putto, then speeds up and rushes on, fixing some things in unlovely naturalness while transfiguring or dissolving others in the fire and mist of the colors. Titian, Carl Fernow wrote, in 1806 in his letters on landscape painting, "linked landscape and figures in such a way that it remains doubtful whether the landscape or the figures are the main subject of the painting, or whether such works make up an intermediate genre of their own, belonging to neither landscape nor dramatic painting alone, as they are a combination of both."[131]

One of Titian's last works, and one of his most mysterious, is the *Flaying of Marsyas* (plate 33). In the mid-eighteenth century it was in an English collection, then went to Olmütz, and is now in the episcopal palace at Kremsier. In some places, for example the fiddler and the boy at the bottom right, Titian accepted help, but most of the picture, a good two meters high with somewhat over-life-size figures, is original. When and for whom Titian began this work is uncertain.[132] Perhaps he painted it primarily for himself, as the mythological counterpart of his *Pietà.*

Depictions of suffering, torment, and death play a major part in Titian's late work, not only as a task set by others but as a theme of his own. None of the other paintings, however, is so pitilessly cruel, so clear in its siding with the victim, or so moving as that in Kremsier. No victory of the sun god over the satyr is celebrated here, nor a victory of art over half-animal coarseness: even St. Bartholomew could not have borne the torment with more dignity than Marsyas. No tormenter could have wielded his knife with more sadistic care than Apollo and his helper, who sets about the legs with professional coolness while the god, to the sounds of a violin, starts his work close to Midas.

As often happened in his old age, Titian did not entirely invent this scene but recalled a fresco by Giulio Romano in the Palazzo del Tè in Mantua. There too Marsyas is hung upside down, but not like a piece of butchered meat and not at the center. Titian also took over the other persons, only adding the two dogs, one of which licks the blood from the ground while the other, greedy for the exposed raw flesh, can be held back only with difficulty. It is not known whether the artist regarded his work as finished; on the left side, in the area of Apollo's body, he probably had some more work to do.

It is not Midas who is the barbarian in this picture, but the immature Apollo, whose violence the old man watches with stoical equanimity. Did Titian use himself as the model for this old man saddened by death? The similarity with the self-portrait in Madrid[133] is considerable, and the theme of this *poesia,* more than of others, may have had a personal meaning for the artist. Apollo and Marsyas embody opposite artistic poles: Apollo clarity, Marsyas an art close to nature, indeed part of it. But "nature" for friends and foes alike was also the formula for Titian, whose imprint showed a female bear liberating the true form of her young by incessant licking. When Titian saw the successes of Tintoretto's *disegno,* for example, or read the contemptuous comments on his late paintings in Giorgio Vasari's successful art history of 1568—is it entirely farfetched to suppose that he compared his fate to that of Marsyas and, like Midas, inwardly identified himself with this victim?[134]

About 1590

Venice saw few of the artistic meditations of the old Titian. Most stayed in his studio or went abroad. What the aged master thought of the painting of his contemporaries or whether he took serious notice of it is un-

certain. But he is supposed to have owned a painting by Jacopo da Ponte, called Bassano. This *Embarkation in the Ark* (fig. 297) shows a night scene that is likely to have become much darker in the interval. After his sometimes hectic efforts to keep pace with developments outside Venice, Bassano developed his style and themes away from the metropolis in his native province. Finally, his far from provincial work found an audience even in Venice, where connoisseurs appreciated not only his impasto textures influenced by Titian but also his novel subjects. In 1592, probably shortly before Bassano's death, his son Leandro created a monument to his almost blind father: "The large, pleasing music picture in the Uffizi [fig. 299] with piano, lute, song, and listeners, ten persons in all, is at the same time a family portrait of the aged Jacopo Bassano, a work truly venerable in the eyes of posterity, which presents us, in the portrayal of the old artist and his sons Francesco and Leandro, with a fine

piece of late Venetian art . . . it is the Hesiod of Venice with his family." [135]

Although the themes and tasks of Venetian painting changed extensively in the course of the sixteenth century, specialization never developed to the extent seen later in the Netherlands. Special themes that were able to survive for a period did not develop a history of their own and related less to each other than to history painting, which continued to provide the norms. The lack of continuity indicates that it was not the patrons and collectors but the artists who were primarily interested in such themes.

Without a fixed place or a prescribed function, the depiction of everyday life in Venice had been a theme from time to time before Bassano, but never a task in itself. A first peak was the paintings produced about the turn of the century in Giorgione's circle, but a special medium for these themes existed for only a short time. Soon the

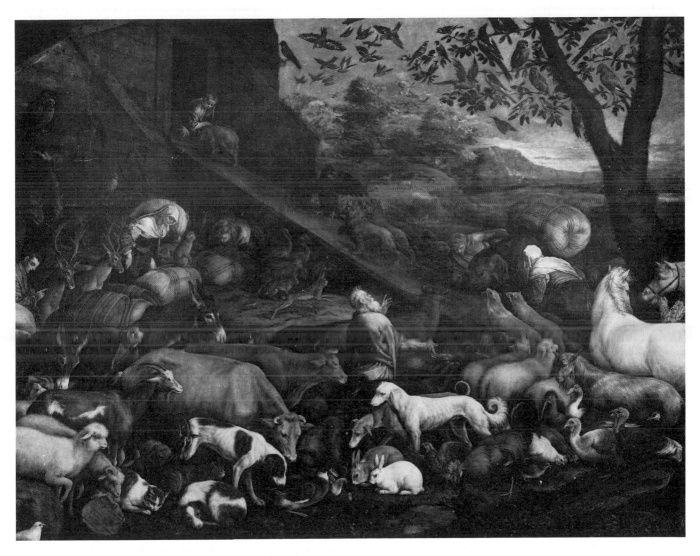

297 Jacopo Bassano, *Embarkation in the Ark*. Madrid, Prado

298 Jacopo Bassano, *Adoration of the Shepherds*. Windsor, Royal Collections

painters had to find biblical pretexts if they were interested in everyday situations. They thus became an important ingredient—and fermenting agent—in history painting, first in the work of Bonifazio de' Pitati and above all in Veronese and Tintoretto.

Jacopo Bassano's "genre" also evolved as a special area within history painting. The horizontal-format pictures in fashion at the beginning of Jacopo's career had favored scenes like the *Adoration of the Shepherds* (fig. 298). The young painter tried to distinguish himself on one hand by complex foreshortening and on the other by a verisimilitude that Italy knew only from Dutchmen like Pieter Aertsen. The heads of simple folk and animals, in particular, seem to be taken directly from life.

A genre came into being that—"to judge by the mass of works existing, as well as imitations and prints from all schools including those of the north—must have met a real need: the picture of the prosperous rural existence of farmers and shepherds with their animals, often painted with great mastery, with a biblical or mythological pretext. The ideal, Arcadian pastoral world was left almost entirely to the poets."[136] Jacopo Bassano seems to have arrived at the specific pictorial world of his pastorals in the mid-1560s. In 1571 he is celebrated as "miracoloso in pingere cose pastorali." About 1577 the highly

successful night pieces were added, and about this time too Bassano began to adapt his workshop to mass production. He himself concentrated on elaborating a series of pattern paintings, in which he was helped in his later years by his eldest son, Francesco. His estate included 188 paintings. Some were only rough drafts, while others, probably the models for workshop replicas, are explicitly described as older.[137] A stock had clearly been built up. Jacopo's biographer distinguishes between the altarpieces painted to order and the new kind of histories for sale in Venice, which the dealers often snapped up before they reached the city. The source of these paintings was said to be the Scriptures, where the creation of the world, Adam and Eve in paradise, or Noah's ark gave the opportunity to paint many animals.[138]

Bassano's pictures were anything but farm paintings. Their public was not found in the country but in Venice, where they were valued not only for their subjects but for an artificial composition recognizable by anyone. Jacopo himself was an educated man. His father had laid stress on a humanistic education, "which was of much benefit to him in his art. When he needed to know histories and fables or to invent pictures, he did not need to ask others for advice, as many stupid painters have to do."[139] His successes and his position outside the Vene-

299 Leandro Bassano, *Music Scene.* Florence, Uffizi

tian art world brought Bassano further independence. But to keep his market he had to be on the lookout for new subjects, to awaken new demand by new products. Cycles like the *Seasons,* requiring at least four paintings, proved particularly suitable for this purpose. About a *Winter* especially popular for its exoticism Ridolfi writes, "Land and mountain are covered in snow; a farmer is cutting wood and a woman carrying a log on her shoulder. Under thatched roofs one sees in the distance a villager who has stuck a pig; women light a fire and prepare a rustic meal. Bassano made many such seasons to be sent for sale to Venice."[140]

The Bassani, especially the sons, transformed the social world they claimed to represent with a superficial bravura style of brushwork and a multiplicity of picturesque effects and interesting motifs, transfiguring it in a diffuse way that did not respect its special character. However, this would have helped rather than hindered their sales in the city. Unlike Pieter Breughel, Jacopo Bassano attached little importance to the work, social structure, or specific behavior of the country population. The facial expressions and gestures remain unspecific and are often typified to the point of becoming stereotypes. Postures and positions are combined, but not to form connected narratives. Single inventions like the re-

cumbent figure, which permitted large figures even with the customary horizontal format, can take on the most diverse roles and appear in the most varied combinations. Although "realistic" attributes, which had appeared as an additional formal attraction in mannerist paintings, increase and often become predominant, on close inspection their coherence proves to be very loose. Unlike those in the works of Tintoretto or Veronese, they are not integrated into a narrative context but remain arrangements. Tools, for example, are grouped around their owners according to painterly criteria and never in such a way that they could actually be used for work. New motifs like the night sky or moonlight widen the repertory, but they too are interchangeable.

Jacopo's sons moved to Venice. There they helped satisfy the extraordinary demand for paintings following the fires in the Doge's Palace. Anyone who could use a brush with any degree of competence and could promise prompt delivery had excellent prospects. Areas of wall for which a Pordenone and even a Titian had had to struggle for years, now went to beginners who had yet to prove their qualifications. Few were troubled by the fact that art could not benefit from this. Many would have welcomed paintings in which the work revealed everything it had to say at first glance. The officials certainly had no objec-

tions to the preponderance that group portraits gave them over divine and sacred personages who were reduced to ciphers and alibis. Nor would many have mourned the complexity of Tintoretto's battle paintings, as long as the Venetians were victorious and at least some bloodthirsty scenes were shown.

The individual late works of Titian, Veronese, and Tintoretto bear an erratic relation to this flood of paintings. They did not have a great influence, since their assistants did not as a rule emulate their masters' personal development. Even the two Caliaris, who after Veronese's death in 1588 did not appear under their own name but as "haeredes Paoli," did not continue either the seriousness or the delicacy of Veronese's late works and perhaps did not even perceive them. The heirs and followers of Titian and Tintoretto took a similar course, offering the stylistic elements and inventions of their masters in smaller and smaller coinage, and avoiding the challenge of the most significant commissions. These currencies became more and more alike, as the masters' forms, once detached from their original contexts, rapidly hardened into formulae.[141] Differences founded on world views and interpretations of themes, like those between Veronese and Tintoretto, were eroded more and more. Towards the end of the century the predilection for the quickly assimilated arrangement was to be found in every studio. A detailed composing and shaping committed to the theme was dispensed with from the outset. A glib eclecticism established itself, only superficially comparable to the ambitious syntheses that the Carracci brothers were laboring at in Bologna. When they travelled to Venice, it was as a pilgrimage to the masterpieces of the preceding generation.[142] They did not study the old painters to extract recipes from them but in order to counter the decline that they saw around them, by returning to their principles.

The only hint of a comparable reform in Venice that deserves mention occurred in the work of only one painter, only once, and half-heartedly even there (fig. 300). And its driving force may not have been the artist but the hospice for which he worked. The Ospedaletto dei Crociferi had been under construction since 1582, and had its new rooms decorated until 1592 by Palma the Younger. When he signed the picture of the doge in 1585, Palma was about forty.[143] He had behind him periods of work in Rome and ten successful years in Venice. According to Ridolfi the painting shows the doge then in office, Pasquale Cicogna, "in a senator's robe, worshipping the Holy Sacrament, which is administered by Father Priamo Balbi, the head of the hospice at that time." The doge had learned of his election during a mass at the Ospedaletto dei Crociferi and had a special attachment to it ever since. Some women from the hospital are shown "according to nature." This is therefore a piece of contemporary history, not heightened allegorically or

transposed to one of Tintoretto's fictional settings, but shown as a part of reality. The scene and the setting are easy to grasp. The everyday objects, whether candles, vases, or the crucifix, are an essential part of the narrative. Even the Host, almost exactly at the center of the picture, is easily made out. The picture shows the opposition of two scenes and two heroes: in the foreground the senator, who is distracted from the mass at one of its most important moments to learn of his election as doge, and the old women, whose care was the most important task of the hospice. Why the woman is kneeling, whether she is doing homage to the new doge or only pointing to something unseen by the viewer, we do not discover. Her head is uncovered, so that she is not dressed for mass, and she has come in from the right. Her face, like those of the other old women and in keeping with the Venetian conventions of the time, is of extreme individuality and animation. But her pose and attitude are so supple and so skillfully done, the folds of her dress so ideal, the naked foot so well formed, that they really call for a quite different face—conversely, what would Caravaggio have made of this woman?

For Palma, however, such a picture, though a compromise at heart, represented a position so advanced that he made haste to evacuate it and put himself at the head of the Venetian eclectics. His biographer tells of the fear of destitution in old age that drove him to work ceaselessly. Palma had no lesser objective than to cover every paintable area, in which he resembled Tintoretto.[144] Since Palma often merely accumulated figures, Tintoretto seems to have taken a sceptical view of his self-appointed heir. He remarked of Palma's *Last Judgment* in the Sala dello Scrutinio in the Doge's Palace, that it made him want to improve it "without adding anything, but simply by leaving out a number of figures who seemed superfluous. Perfection, he said, did not reside in the number of figures, but in placing them in the required order without confusion.[145]

One of the most important projects in Venice about 1590 was the furnishing of S. Giorgio Maggiore. Here Tintoretto found his last great tasks. He left the altars of the aisles to his assistants, including the design, when they did not go in any case to the Bassani or Palma. He concentrated on the two histories in the chancel and the altarpiece in the Cappella dei Morti. In 1588 he had delivered his last painting to the Scuola Grande di S. Rocco, and four years later the gigantic *Paradise* on the front wall of the Sala del Maggior Consiglio in the Doge's Palace had been completed. The unparalleled inner and outer pressure under which he had worked for more than a decade was somewhat relieved, and two years before his death Tintoretto had the time and strength to produce three works that have always been seen as a kind of summation of his art.

VT PRÆSENTEM VIRVM AMPLISS.D.MARCI PROCVRAT.IN LOCVM DEMORTVI PRINCIPIS SV
STITVAS . TE ROGAMVS DOMINE. XV. AVGVSTI M.D.LXXXV.

300 Jacopo Palma the Younger, *Doge Cicogna during Mass.* Venice, Oratorio dei Crociferi

The altarpiece in the Cappella dei Morti is, as befits its setting, an *Entombment* (fig. 301), that is, a history painting by its theme but a devotional picture by its form and function. The opening of the grave is concealed, for the walls of the tomb are shaped to recall an altar table.[146] Tintoretto shows from where the youth and the old man have brought the heavy body and also reminds us of the fainting of the Mother of God. But he has not brought them together, as was usual, below the cross at Golgotha, but on the way to the tomb. Her body paraphrases the ambiguous posture of the son, which might mean that the body is being held up—as with Mary—or that it is being lowered. This leaving of the body in midair puts before the congregation's eyes the sacrifice that is

301 Jacopo Tintoretto, *Entombment of Christ.* Venice, S. Giorgio Maggiore

celebrated in the mass and that is the precondition of redemption.

The tension between the narration of the event and the representation of its meaning, which are not wholly identical, also characterizes the two paintings beside the main altar. The *Jews Refusing the Manna* (fig. 302) and the *Last Supper* (fig. 303), both over 5.50 meters wide and over 3.50 meters high, must have taxed the physical and mental powers of the painter, then over seventy, to breaking point. Naturally, he had help in the execution of these gigantic paintings, but his personal contribution was far greater than in most of his works in the Doge's Palace or the Scuola Grande di S. Rocco.

The two paintings are parts of an ensemble, the centerpiece of which is the high altar executed by Girolamo Campagna.[147] The thematic center of the whole choir decoration was the reaffirmation of the Catholic doctrine of communion and particularly of the dogma of transubstantiation, which the Protestants contested.

The donor, at the far right in the *Manna* picture, looks outward, not at what is happening in the picture. But Tintoretto composed his paintings for a viewpoint in front of the choir rail, a position accessible to the ordinary congregation. It was not mannerism that made Tintoretto move the Christ of the *Last Supper* from the center axis of the picture, but consideration of the actual viewing conditions in S. Giorgio Maggiore. Thus the composition was guided not by any abstract pictorial logic but by the goal of making the meaning of the scene truly visible. Much that looks artificial and extravagant in the photos, necessarily taken from the front, is clear and natural in S. Giorgio when seen from the right place. Admittedly, there is not only one "right" viewpoint, but Christ is without doubt seen to best advantage if the *Last Supper* is viewed obliquely. One then feels directly opposite him, and despite his smallness he becomes the central figure. The woman with the bowl of manna points to him, formally and in terms of content, as does the steward, in whose clothes the blue and red prepare for the colors of Christ. His movement, which remains isolated when seen from the front, links up with that of one of the angels approaching from the right, if viewed from the side.

The gathering of the manna is regarded by Christian tradition as prefiguring communion and was often shown in conjunction with it in Venice. But the learned Benedictines of S. Giorgio Maggiore did not choose the usual scene (Exodus 16:15) of the miraculous feeding of the Jews, but a passage that tells of an uprising of the people of Israel, who had tired of the divine food (Numbers 21:5).[148] The reason for this choice is likely to have been the theological controversy about communion that raged in the sixteenth century, for even the symbolic introductory figure, with the table on which she supports herself,

302 Jacopo Tintoretto, *Refusing the Manna*, detail. Venice, S. Giorgio Maggiore

alludes to the communion table in the picture opposite.
Moses, on the far right, is undoubtedly supposed to be
recognized, through his age, face, and dress, as a pre-
figuration of Christ. In the front zone of the picture,
therefore, there are figures that are not merely a part of
the event depicted but also interpretations of it. Viewed
from the front, a quite strong difference persists between
this zone and the scenes in the middle-ground and back-
ground. When seen from the side the links are consider-
ably closer, but a gap still exists. Tintoretto has not adhered
at all exactly to the text, which tells of the discontent of
the Jewish people arising from the lack of water and nor-
mal bread; had he done so he would not have located the
camp beside a stream teeming with fish. On the other
hand, the depiction of camp life gave him a last oppor-
tunity to make the daily life of simple people the subject
of his art in a large-scale work mounted in an important
place. He neither painted them in a heroic light nor belit-
tled them; he took them seriously, even if they were
doing nothing more—at the center of a history paint-
ing—than washing clothes or delousing themselves.

The *Last Supper* on the opposite wall shows not the
revelation of Judas's betrayal but the first administering

of the sacrament, which is shown here as an eruption of
the divine into ordinary reality. The theme of charity is
secondary, the beggar on the left not receiving a gift but
being held back by the first disciple because something
more important is happening. The depiction of transub-
stantiation, which cannot, of course, be narrated directly
but has to be conveyed by indirect means, confronted
even Tintoretto with difficult problems: the luminous fig-
ures of the angels are merely drawn, not painted, and the
light sources around Christ are hidden behind the ceiling
lamp. The sequential unfolding of the composition lays
great stress on the introduction. Daily events are shown
at length: the meal is drawing to a close, the fruit is about
to be served. A cat peers into the large basket from which
a maid has filled a plate with manna—a link with the pic-
ture opposite—but the steward refuses it as it is clearly
not expected and the table next to him is full. His hand
leads compositionally over the bowl, which recalls the
preceding washing of feet and is waiting to be cleaned, to
Judas. Then, tightly compressed and formally linked by
overlapping, although the strongest contrasts of meaning
are preserved, there follow Judas, John, and finally Christ,
whose halo, at the moment when the sacrament is ad-

303 Jacopo Tintoretto, *Last Supper.* Venice, S. Giorgio Maggiore

ministered, becomes the center of the light which touches everything.

Such a complete permeation of daily life by religious meaning was something new even in the oeuvre of Jacopo Tintoretto. For that reason alone the paintings in the choir of S. Giorgio Maggiore were not only an ending but a beginning. What might have become of Venetian painting if Tintoretto, the last of the great Venetians, had been granted Titian's ninety years? But it was not to be. On 30 May 1594 Tintoretto dictated his will, and his death is entered the next day in the records of the Provveditori alla Sanità: "Deceased, the *magnifico* Jacopo Robusti, called Tintoretto, aged seventy-five. He had been feverish for a fortnight."

NOTES

ARCHITECTURE & SCULPTURE

Wolfgang Wolters

1 FORMA URBIS

1. Facsimile: Mazzariol and Pignatti 1963. Cf. Schulz 1978 especially.

Kretzschmayr's *Geschichte von Venedig* (1906–34) is still unsurpassed as a general account. It is complemented by Molmenti's important cultural history (1927–29). The monumental *Storia della cultura veneta* (1971ff.) was written almost entirely without regard to art history and so is notably inferior to Molmenti in this area. Among the older town guides, Sansovino's *Venetia, città nobilissima et singolare* (1581, 1663 edition) is a rich source of information. Overall accounts of Venetian Renaissance architecture have been attempted more than once. Still worth reading are Temanza ([1778] 1966), Selvatico (1847), and Mothes (1859). Paoletti's *L'architettura e la scultura del Rinascimento a Venezia* (1893) is still the standard work for the period 1450–1530. On the architecture of the period, McAndrew (1980) has written a valuable book dealing primarily with aesthetic aspects. Lotz and Heydenreich (1974) and Howard (1980, 102ff.) should also be consulted. There are a number of guides to Venice, some of them excellent. I consider Douglas (1907), Lorenzetti (1926, 1956), Hubala (1965), Piamonte (1966), and Bellavitis (1980) particularly important. The many historical plans and views of the city have been well presented by Schulz (1970) and Cassini (1971, 1982). The land registers give an idea of the structural changes to the city in the nineteenth century (*I catasti storici,* 1981); the only modern city plan (1 : 2,000) of practical value was published by Visceglia in 1970. Research into the evolution of Venice is still rudimentary, but Muratori (1960), Trincanato and Franzoi (1971), Maretto (1978), and Concina (1982) are worth consulting. The volumes by Perocco and Salvadori (1977) are very useful on questions relating to the appearance of the city. The earlier literature on Venetian art is listed in the bibliographies of Cicogna (1847) and Soranzo (1885). A more recent bibliography is to be found in *Arte veneta* from 1947. A bibliography on the lagoon has been compiled by Pellizzato and Scattolin (1982).

Since the publication of the German edition of our book a great number of studies on Venetian architecture and sculpture have been published. I consider the following titles particularly important: Elena Bassi, *Ville della provincia di Venezia,* Milan, 1987; Donatella Calabi and Paolo Morachiello, *Rialto: Le fabbriche e il ponte,* Turin, 1987; Bertrand Jestaz, *La Chapelle Zen à Saint-Marc de Venise: D'Antonio à Tullio Lombardo,* Wiesbaden and Stuttgart, 1986; Ennio Concina, *Venezia nell'età moderna, struttura, e funzioni,* Venice, 1989. On patrons and architecture: Manfredo Tafuri, *Venezia e il Rinascimento,* Turin, 1985.

2. Cf. Wolters 1983, 49ff., 52.

3. Sansovino 1663, 389.

4. Sansovino 1663, 382.

5. Cicogna 1824–53, 1.133.

6. *Dietro i palazzi* 1984, 45ff.

7. Much material in Sandri and Alazraki 1971. Cf. Sansovino 1663, 368ff.

8. In 1451 Lorenzo Giustiniani became patriarch of Venice. Before that the patriarch of Grado had his residence on the Rialto.

9. Sansovino 1663, 210.

10. Crovato and Crovato 1978.

11. Rizzi 1981, 40.

12. Wichmann 1979, 33ff.

13. Wichmann 1979, 40ff.

14. Fogolari 1924, 63ff., document of 1442.

15. Paoletti 1893, 2:90.

16. Rompiasio 1733, 185ff.; Mazzi 1973, 1974.

17. Tentori 1792, 138ff.; Gallicciolli 1795, 1:216ff.

18. The Servites built a bridge in 1353 (Vicentini 1920, 8).

19. On bridges as part of a street system: Mazzi 1973, 1974. Rizzo 1983 is unsatisfactory.

20. Gianighian and Pavanini 1984.

21. Wichmann 1979, 34.

22. Sanudo, *Diarii* 55, col. 435–36.

23. Tramontin 1968, 11.

24. Pavanello 1932.

25. Rompiasio 1733, 185ff.; Tentori 1792, 136ff.; Pavanello 1932, 13.

26. Gallicciolli 1795, 1:108.

27. V. Fontana 1981; *Architettura e utopia,* 1980, cat. 133. Cf. Tafuri 1982.

28. Pavanello 1932, 14.

29. Nani-Mocenigo 1877, doc. 277.

30. Mazzi 1973, 28.

31. Bonfanti 1930, 55., document of 1521.

32. Courtyard of Cà Magno: Guiotto 1943.

33. E.g., in front of the Scuola Grande di S. Maria della Carità. Fogolari 1924, 63ff.

34. Commynes 1924–25, 3:109.

35. *Marco Cornaro* 1919, 151ff.

36. Pavanello 1932, 14.

37. Examples in Perocco and Salvadori 1977, 1:250ff. In sources, *iunctorium.* Cecchetti 1871.

38. Vio 1984. Further examples in Wichmann 1979, 111ff.

39. Rompiasio 1733, 4.

40. A. Favaro 1905.

41. Rompiasio 1733, 166.

42. "Venetorum urbs divina disponente providentia aquis fundata aquarum ambitu circum aquis pro muro munitur. Quisquis igitur quoquo modo detrimentum publicis aquis inferre ausus fuerit hostis patriae justicetur nec minori plectatur poena quam quis sacros muros patriae violasset hujus edicti jus ratum perpetuumque esto." Crovato and Crovato 1798, introduction.

43. G. Zorzi 1967, 248ff.

44. Corner 1749, 11:279). Also discussed in Wichmann 1979, 38ff.

45. Gianighian 1983.

46. Sanudo the Younger 1880, 63. On the water supply: M. Costantini 1984. On the wells: Rizzi 1981.

47. Tassini 1872.

48. Niero 1979, 45.

49. Wichmann 1979, 45.

50. *Marco Cornaro* 1919, 153, n. 2; Rompiasio 1733, 252ff. On public health arrangements: Rodenwald 1956.

51. Gallicciolli 1795, 1:232ff.

52. Niero 1979.

53. Wichmann 1979, 14ff. On side vestibules: Paoletti 1893, 45 n. 5. On inspection: Tramontin 1967, 521. On S. Maria Mater Domini: Tramontin 1962, 24 n. 9.

54. Piana 1984.

55. On building materials: Connell 1976, 89ff.; Lazzarini 1978, 1981; Dalla Costa and Feiffer 1981.

56. Sansovino 1663, 383.

2 THE BEGINNINGS

1. Sansovino 1663, 219: "ma non gli fu permesso per convenienti rispetti." On the library: Fabriczy 1904.

2. Valcanover 1979b.

3. Fogolari 1924, 77.

4. See Wolters 1976 on these sculptures and those mentioned later.

5. On Bartolomeo Buon: Wolters 1976; an entirely different view is taken by Markham Schulz 1978a, 1978b.

6. Wolters 1974.

7. L. Beltrami 1906, Greppi 1913.

8. R. Gallo 1961–62a.

9. Pincus 1976; Wolters 1976, 292ff.

10. Concina 1984a, 51ff.

11. Hemsoll 1982, 121.

12. Ricci 1909.

13. Dellwing 1970, 124.

14. R. Gallo 1961–62a; Zava Boccazzi 1965, 34.

15. Sansovino 1663, 382.

16. Sansovino 1663, 387ff.

17. But cf. Sansovino 1663, 388.

18. Arslan 1970.

19. Morosini 1969, 98ff. See also Cozzi 1970, 449.

20. Dellwing 1974.

21. Paoletti 1893, 1:68.

22. Marzemin 1912, 351ff.

23. On choir of Padua Cathedral modelled on St. Peter's, Rome (1486): Bresciani Alvarez 1980, 58. On campanile of S. Chiara modelled on S. Michele (1473): Meneghin 1962, 38. On "banchi" of S. Gaetano in Treviso modelled on the Cappella di S. Giovanni in S. Maria dei Frari (1509): Biscaro 1898a, 143. On decree of senate to model the cathedral of Palmanova on SS. Cosma e Damiano (Guidecca) (1599): Timofiewitsch 1977, 256 n. 9.

3 CIVIC ARCHITECTURE

1. Sansovino 1663, 381ff. On house and palace: cf. Cecchetti 1871, 72ff.; Trincanato 1948; Hubala 1965, 749ff.; Rosci 1967; Bassi 1976; Huse 1979; Lorenz 1980; Lieberman 1982; Lauritzen and Zielcke 1980 (with many illustrations); *Dietro i palazzi* 1984. On the furnishings: Ludwig 1906; P. Pavanini 1981; Palumbo Fossati 1984.

2. Quoted from Burckhardt 1930ff., 6:15.

3. Scamozzi 1615, pt. 1, bk. 3, chap. 6.

4. Statistics from Beltrami 1954, especially 38, 57ff., 71ff.

5. Scamozzi 1615, pt. 1, bk. 3, chap. 6: "meastà" and "belleza."

6. Rosci 1967, xvi.

7. Machiavelli 1843, 309ff.

8. Fiocco 1965, 156ff., 165.

9. *Dietro i palazzi* 1984, 98ff., contains further examples.

10. P. Pavanini 1981, 98 n. 67.

11. P. Pavanini 1981, Palumbo Fossati 1984.

12. Ambrosini 1981.

13. R. Gallo 1938.

14. Howard 1975, 146ff.

15. Trincanato 1948, 306ff.; *Dietro i palazzi* 1984, 110ff.

16. Royal Institute of British Architects, London, 16, 9 v.; Puppi 1973, fig. 370.

17. Armani and Piana 1984.

18. Serlio 1978, bk. 6. Cf. Serlio 1584, bk. 4, fol. 153v.

19. Serlio 1978, bk. 6: "la maggior parte degli ornamenti sono licensiosi: et anche le cose disordinate."

20. Sansovino 1663, 381ff.

21. On drainage: Gianighian 1983.

22. Sansovino 1663, 383: "apportano maggiore ornamento."

23. L'Eremita 1891, 115; Urbani de Gheltof 1892.

24. Scamozzi 1615, pt. 2, bk. 6, chap. 35.

25. Scamozzi 1615, pt. 1, bk. 3, chap. 6, 242, called them "sottoportico."

26. Scamozzi 1615, pt. 1, bk. 3, chap. 6, 243.

27. All sources in L. Beltrami 1900 and 1906. Bibliography in Foscari and Tafuri 1981.

28. "Due torri": Greppi 1913.

29. Galicciolli 1795, 1:235.

30. Cf. Piana 1984.

31. Molmenti 1927–29, 1:296.

32. Most recently, Sgarbi 1984.

33. Cf. Schulz 1982.

34. Terms for the entrance area vary. Apart from *portico* we find *sottoportico* (Scamozzi 1615, pt. 1, bk. 3, chap. 6, 242) and *entrata* (Palladio 1570, bk, 1, chap. 21). But the porticos on Venetian streets and in front of sacred buildings were also termed *portico*.

35. Sanudo 1879–1911, 13, col. 246. Cf. Galicciolli 1795, 1:340, 396.

36. Bassi 1976, 200.

37. Ridolfi 1914–24, 1:324. On the building now demolished: Bassi 1964.

38. Guiotto 1943; Rizzi 1981, 154.

39. Dal Mas 1976.

40. Palladio 1570, bk. 1, chap. 21: "luoghi pubblici."

41. Schulz 1982, 111 n. 51.

42. Wolters 1968d, 58.

43. Sansovino 1663, 383.

44. Scamozzi 1615, pt. 1, bk. 3, chap. 5, 237; Vitruvius 1964, 6:3: "lumina valvata."

45. See 00.

46. Paoletti (1893, 1:34) drew a comparison with the monk's choir in S. Maria dei Frari.

47. Fiocco 1965, 162.

48. On Mauro Codussi and the following: Paoletti 1893; McAndrew 1969, 1980; Puppi and Olivato Puppi 1977; Hirthe 1982; Odenthal 1985.

49. Hirthe 1982.

50. Illustrated in A. Zorzi 1972, 2:459.

51. Niero 1965.

52. Cesariano 1521, 1969 ed., iv, lxiii.

53. On the buildings discussed below: see Bassi 1976 (with extensive bibliography).

54. F. Gilbert 1973, 277.

55. Bassi 1976, i, 9–10.

56. Bassi 1976, ii, 5–6.

57. Serlio 1970, bk. 6, lvi.

58. Usually attributed to Sante Lombardo. Bassi 1976, 493ff.

59. Cf Boni 1883.

60. Commynes 1924–25, 3:109–10.

61. Piana and Armani 1981; Biscontin, Piana and Riva 1981; Armani and Piana 1984; Piana and Armani 1984.

62. Serlio 1584, bk. 4, fol. 191v.

63. Dolce 1960, 163.

64. Serlio 1619, bk. 4, fol. 191v.

65. Cicogna 1824–53, 4:322: "frixo a la crotescha."

66. Paoletti 1893, 2:236.

67. On a possible interpretation: Forster 1969.

68. See Wolters 1968d, 5ff.

69. Stepan 1982, 9.

70. On the question of Serlio and Venice: Rosci 1967, Günther 1981.

71. Howard 1973.

72. Timofiewitsch 1963a.

73. Serlio 1584, bk. 4, fol. 155v.

74. Fiocco 1965, 158.

75. Vasari 1878–85, 5:268.

76. No investigation of the building has been made, and the date of the courtyard is not known; parts have been renewed. Tassini 1885, 39–40; McAndrew 1980, 209.

77. Simonsfeld 1887, 2:107ff; Paoletti 1893, 2:282; Dazzi 1939–40.

78. P. Contarini's attribution to Fra Giocondo in his *Argo Volgar* (ca. 1542) might be based on a confusion.

79. On the history of the previous building: Simonsfeld 1887, 2:6ff.

80. McAndrew 1980, 400ff.

81. On similar (?) work of 1400 on the campanile of S. Giovanni on the Rialto, still extant at the time: L'Eremita 1891, 61.

82. Wolters 1983, 20ff.

83. Berchet 1892; Miozzi 1957–69, 2:379ff.

84. Most recently on this building: Hamilton 1983.

85. R. Cessi and Alberti 1934.

86. On the history of the Piazza and the adjoining buildings: Lotz 1967; *Piazza S. Marco* 1970; Tafuri 1972; Howard 1975; Wolters 1983, 23ff.

87. Barbaro 1567, 5: ii.

88. Apart from the studies mentioned in note 86 above, see Thies 1982 (corner treatment) and Hirthe 1985.

89. Wolters 1968d, 13ff.

90. Wolters 1983, 26.

91. R. Gallo 1958–59.

92. Illustrated in *Il campanile di S. Marco* 1912, 239ff.

93. Wolters 1983, 19.

94. Cf. Concina 1983, 38ff., 1984a.

95. Bellavitis 1983; Concina 1984a, 154ff.

96. V. Fontana 1981.

97. "Per andarvi a desinare, a cena e diversi spassi." See V. Fontana 1981.

98. Selvatico 1847, 360ff.; Haug 1969; Franzoi 1970; Scarabello 1979.

99. Palladio 1570, bk. 3, 16.

100. Palladio 1570, bk. 4, 31.

101. Cf. Sanudo the Younger 1980, 54, 170–71; R. Gallo 1938. On Tiepolo: *Difesa della Sanità* 1979, 62ff.; Semi 1983, and the monograph on the Ospedale dei Crociferi, *Hospitale S. Mariae Cruciferorum* 1984.

102. Rodenwald 1956. On public health: Da Mosto 1937–40, 1:205 (organization).

103. Pilo 1979.

104. Bassi 1963 is fundamental.

105. On hospital building in Italy: Foster 1973.

106. G. Zorzi 1967, Gardani 1961, A. Foscari 1975.

107. Cadorin 1838, 21.

108. Bardi 1587, fol. 2r.

109. Cadorin 1838; *Andrea Palladio* 1975, 158ff.

110. Cf. Wolters 1968d on this and the following.

111. Lewis 1981, 1982b has a different view.

112. Palladio 1570, bk 1, chap. 20.

113. Most recently on Sorte: Tisato 1978.

114. On these festivals: Tamassia Mazzarotto 1961, Muir

1981. Most recently on Palladio's festival architecture: Wolters 1979.

115. Talamini 1970.

116. Scamozzi 1615, pt. 1, bk. 3, chap. 6, 243. Probably following Vitruvius 1964, bk. 6, chap. 7, 290.

117. Lorenzetti 1942–43.

118. A fundamental study on the redesign of the Rialto: R. Cessi and Alberti 1934. Cf. G. Zorzi 1967, Puppi 1973, Huse 1979, Maschio 1980, Morachiello 1983, Calabi 1982.

119. Perry 1972. On the connection between the Libreria and antiquities collection: Busch 1973, 155.

120. Olivato 1971, Concina 1984b.

121. Caiani 1968, Prosperetti 1984.

122. Paoletti 1893, 2:295.

123. G. Zorzi 1954–55, 159.

124. Paoletti 1893, 2:295.

125. "Fabrica honestamente bella ma perfettamente commoda" as against "[fabrica] bellissima et incommoda." Fiocco 1965, 156.

126. Sansovino 1663, 309.

127. Cadorin 1838, 17.

128. On Sansovino as an architect: Tafuri 1972, Howard 1975.

129. Meli 1965, 31ff.: "modello de certo palacio ch'è per un huomo da ben rico." On the design: Lewis 1972 (Sanmicheli); Huse 1979, 92 n. 6 (possibly a dilettante); A. Foscari and Tafuri 1981 (J. Sansovino).

130. Scamozzi 1615, pt. 1, bk. 3, chap. 18, 303.

131. There are no studies on the painting of Sansovino's architecture.

132. Bassi 1976, 88.

133. Serlio 1584, bk. 4, fol. 197v.ff.

134. R. Gallo 1957, 94ff.

135. Howard 1984; A. Foscari 1983, 149ff.

136. On Sanmicheli's Venetian buildings: R. Gallo 1960, Puppi 1971.

137. Documents in Boschieri 1931, 477ff.; cf. V. Fontana 1980.

138. Wolters 1968d.

139. Huse 1979.

140. Huse 1979, fig. 4.

141. A. Foscari and Tafuri 1981.

142. Kurneta 1976 with reference to the type of the "imperial staircase."

143. Palladio 1570, bk. 2, chap. 1.

144. The known material on the palaces as well as much new information is to be found in Bassi 1976. Also see Lorenz 1980.

145. R. Gallo 1957, 94ff.

146. On the buildings mentioned in the following pages: *Dietro i palazzi* 1984.

147. Concina 1982.

148. Siebenhüner 1981.

149. Monographs on these architects are lacking. But cf. Cadorin 1838, 14ff. (Rusconi); Temanza [1778] 1966, 499ff. (Da Ponte); Barbieri 1967 (Zamberlan).

150. Paoletti 1893, 2:255; Muraro 1970; Bassi 1976, 81–82.

151. Ridolfi 1914–24, 1:303; Bassi 1976, 75–76.

152. Serlio 1619, bk. 4, fol. 188v.

153. Bassi 1976, 77–78.

154. L. Foscari 1936.

155. Bassi 1976, 73–74.

156. Voltelini 1892, doc. 8812: "ipsum practicam potius certam quam architecturae scientiam possidere."

157. Bassi 1976, 29–30.

158. Cf. Damerini n.d.; Bassi 1976, 21–22; Bassi 1982, 39ff.

159. Illustrated in Bassi 1982, 61.

160. Sansovino 1663, 382.

161. Cadorin 1838.

162. Summary in Mangini 1974, 19ff.

163. G. Zorzi 1954–55.

164. On the ceiling decoration: Wolters 1968b, 1968d; Schulz 1968.

165. Gallo 1960, 125ff.; Stefani Mantovanelli 1984.

166. Perry 1978, 1972.

167. Cf. the document in Busch 1973, 298, n. 86.

168. Illustrated in Bassi 1976, 233. On the Venetian chimneypiece: Mariacher 1958, passim.

169. Scamozzi 1615, pt. 2, bk. 6, chap. 35, 164.

170. Bassi 1976, 229.

171. Paolillo and Dalla Santa 1971, 13.

172. Sansovino 1663, 369; Bassi 1976, 52.

173. But cf. Pauly 1916.

174. Voltelini 1892, docs. 8812, 8814.

175. Bassi 1976, 37–38.

176. Wolters 1966. Incorrectly referred to as "villa."

177. Bassi 1976, 142 (loggia of the Palazzo Coccina).

4 SACRED BUILDINGS

1. Corner 1749, Paoletti 1893, Gallimberti 1963, Franzoi and Di Stefano 1975, McAndrew 1980, Ackerman 1980. There are also numerous architectural monographs in the series *Venezia Sacra*.

2. Sansovino 1663, 3.

3. Scamozzi 1615, pt. 1, bk. 3, chap. 6, 242. Cf. Stella 1958, 74ff.

4. Sansovino 1663, 290; Corner 1749, 14:282ff.

5. Connell 1976, 33ff.

6. Illustrated in Franzoi and Di Stefano 1975.

7. Rambaldi 1920, 79ff. Jacopo Bellini also drew a façade of this kind in his Paris sketchbook. Degenhart and Schmitt 1984, ser. 20v.

8. Meneghin 1962, 1:309.

9. Meneghin 1962, 1:300ff.

10. Thoenes 1980, 463, referring to Vitruvius bk. 4, chap. 2, 174: "sunt autem capitulorum genera variis vocabulis nominata."

11. Cf. Gosebruch 1958 on these systems.

12. Many illustrations in Mercklin 1962, figs. 967ff.

13. Cecchetti 1886, 496.

14. Sagredo 1856, 291, document of 1465.

15. Meneghin 1962, 1:300 n. 11.

16. Cf. Paoletti 1893; Hubala 1965, 946ff.; Dellwing 1974; Puppi and Olivato Puppi 1977, 190ff.; Connell 1976.

17. Sansovino 1663, 82.

18. Grendler 1977, 50. On the structure: Saccardo 1887, 109.

19. Lieberman 1972.

20. Detailed discussion in Connell 1976, 109ff.

21. Alberti 1966, 6:6, 10. Filarete (1972, 74) described a "figura . . . in forma di romito colla barba e col ciliccio" that he saw on one of the marble slabs of S. Marco.

22. Dittmar 1984.

23. Vasari 1878–85, 6:128.

24. Rotondi 1950, 279ff.

25. Niero 1982.

26. Document in A. Foscari and Tafuri 1983, 210: "quadri."

27. Braun 1924, 2:661ff.

28. Vio 1972, 241.

29. Bosisio 1943; Lorenzetti 1956, 523.

30. Puppi 1980, 54.

31. Timofiewitsch 1977, 256, n. 9.

32. Saccardo 1887, 109.

33. Malsburg 1976, 58ff.; McAndrew 1980, 507ff. (S. Rocco); Tramontin 1962 (S. Maria Mater Domini); Franzoi and Di Stefano 1975, 92ff. (S. Maria Maggiore) Jacopo Bellini also drew triangulated pediments in his Paris sketchbook. Degenhart and Schmitt 1984, fol. 15, fol. 16v., fol. 23.

34. Marzemin 1912, 393ff. (S. Gregorio); Paoletti 1893, 2:119 (S. Teodoro) and 2:118 (SS. Filippo e Giacomo).

35. A. Foscari and Tafuri 1982, 52.

36. Wolters 1968d, 11.

37. Schulz 1968.

38. Cf. *Bollettino d'Arte*, supp. 5, 1984, 9–64. Piana (42) sees similarities between the capitals and those of the spiral staircase of the Palazzo Contarini del Bovolo (1499).

39. L. Gallo 1964, 48. Built soon after 1530 (?).

40. Cicogna 1824–53, 325 (ca. 1523).

41. Timofiewitsch 1964, 1980; Krautheimer 1965, 284.

42. Sansovino 1663: "parte di mezzo" (121); "cuba" (204, S. Maria Mater Domini); S. Giacomo di Rialto as a model for S. Marco (197).

43. McAndrew 1969 and 1980, 253ff.

44. Most recently on this building: Odendal 1985.

45. Dorigo 1983, vol. 2, fig. 268.

46. Frankl 1914, 37.

47. Pavanello 1921; McAndrew 1980, 282ff.

48. Paoletti 1893, 2:288ff; Vio 1977.

49. Orlandini 1914.

50. On the centralized hall with freestanding corner columns: Fehring 1956, 99ff. On Sansovino's distinction: Thies 1982, 182, n. 50.

51. Dorigo 1983, vol. 2, fig. 269.

52. Cecchetti 1886, 496.

53. Paoletti 1893, 2:242 n. 6.

54. Cecchetti 1886, 496: "architectus et gubernator."

55. Cecchetti 1886, 497 (previous building); Stedman Sheard 1977, 256 (Sanudo).

56. Wolff Metternich 1957.

57. Pedani 1984, 66.

58. On campaniles generally: L'Eremita 1891; Gattinoni 1910, 3ff. S. Paternian: illustrated in A. Zorzi 1972, 1:201. On S. Secondo: Fiocco 1953, 378, with references to other round towers. On S. Pietro di Castello: Puppi and Olivato Puppi 1977, 187ff.; McAndrew 1980, 262ff. On Madonna dell'Orto: Lorenzetti 1956, 404. On the Campanile of S. Marco: Gattinoni 1910 and *Il campanile* 1912, 6ff.

59. There is no separate study. However, see Cope 1979.

60. But cf. the illustration of the baptistry of S. Pietro di Cas-tello in the view by J. de'Barbari (1500). Franzoi and Di Stefano, 1975, 528.

61. Cf. Fehring 1956, 99ff., on this motif.

62. Niero 1982.

63. G. Costantini 1912, 39.

64. The history of the Venetian rood screen has yet to be written.

65. Moschini Marconi 1955, vol. 1, cat. 107.

66. Wilk 1978, 138ff.

67. Meneghin 1962, 1:325ff.

68. Hall 1974.

69. On the fragments: Mariacher 1959.

70. Meneghin 1962, 1:333ff.

71. Caffi 1884; Malsburg 1976, 134ff.

72. On Jacopo Sansovino as architect: Tafuri 1972, Howard 1975. On the other buildings see the literature mentioned in note 1 above.

73. On S. Francesco della Vigna: A. Foscari and Tafuri 1983.

74. Cf. Lorenz 1980.

75. A. Foscari and Tafuri 1982.

76. Lieberman 1977, 41ff.

77. Illustrated from *Forestiere illuminato* 1765, 340. To my knowledge the remains of the building have not been studied. Further illustrations in Crovato and Crovato 1978.

78. On the history of building: cf. Weddingen 1974, 62ff. A competing design by Giovanni Antonio Rusconi was not executed.

79. Wolters 1968d, 79ff.

80. Bassi 1963.

81. "Ovato bislungo." Sansovino 1663, 324.

82. Lovarini 1899; Bresciani Alvarez 1980, 59.

83. Caffi 1892, 161, n. 1.

84. Arslan 1957.

85. Tramontin 1962, 44.

86. Markham Schulz 1984a, 258, fig.

87. Barbaro 1567, bk. 4, chap. 8, 125.

88. Extensive material on these questions is in Hiesinger 1976.

89. Pavanello 1921; Franzoi and Di Stefano 1975, 414.

90. Puppi 1980, 54.

91. On Andrea Palladio's churches see especially G. Zorzi 1967, Timofiewitsch 1968b, Isermeyer 1968, 1972, Puppi 1973, Ackerman 1977.

92. On S. Maria della Carità: Bassi 1971.

93. Doni 1555, 155.

94. Palladio 1570, bk. 2, chap. 6, 29ff.

95. G. Zorzi 1967, 36ff.

96. Cavazzana Romanelli 1983, 15.

97. Wolters 1968d, 31ff.; Tafuri 1983, 20.

98. Royal Institute of British Architects, London, 14, 12.

99. Palladio 1570, bk. 4, 5.

100. Bresciani Alvarez 1980, 59.

101. De Tolnay 1965.

102. Palladio 1570, bk. 4, 7: "con gli animi sospesi."

103. G. Zorzi 1967, 89.

104. Timofiewitsch 1969 (monograph).

105. Palladio 1570, bk. 4, 13.

106. Puppi 1973, 431ff.; A. Foscari 1975.

107. Buddensieg 1976, 345; Gleria 1983.

108. Gallo 1955, 36ff.

5 SCUOLE

1. On Scuole in general: Pullan 1971. On the building and furnishing of the scuole piccole: Gramigna, Perissa, and Scarabello 1981. On property ownership: Pullan 1984. On furnishing: Ridolfi 1914–24; Levi 1895; *Le scuole di Venezia* 1981; Hüttinger 1962; Wolters 1983, 153ff. On membership of women: R. Gallo 1961–62b, 464.

2. Scarabello 1981.

3. Sansovino 1663, 281ff. Cf. Pullan 1971, 72ff., 131.

4. Pullan 1984.

5. Rosand 1976.

6. On the functional aspect: Malsburg 1976, 43ff.; Sohm 1978a, 57ff.

7. Paoletti 1893, 2:124 n. 146 (Scuola Grande di S. Rocco) and 90 (Scuola dei Fiorentini); Fogolari 1924, 63 (Scuola Grande di S. Maria della Carità). Cf. R. Gallo 1961–62a, 466 (Scuola di S. Teodoro).

8. Gallo 1961–62a, 465 (Scuola di S. Teodoro, 1430). Ludwig and Molmenti 1910, 200ff.

9. Paoletti 1893, 2:102ff., document of 1491.

10. Wolters 1983, 153ff.

11. Tassini 1885, 22ff.

12. Stedman Sheard 1984, Blake-Wilk 1984. On Bramante as a possible model: Stedman Sheard 1984b.

13. Paoletti 1929, 27: "jnstoria granda de relievo."

14. On documents on the painting of the façade burned in 1485: Paoletti 1929, 17.

15. On the staircases: Sohm 1978b.

16. Paoletti 1893, 1:90.

17. Paoletti 1893, 2:289: "la principal cosa et fundamento."

18. Cf. Malsburg 1976 on the following.

19. There were comparable conflicts between Alessandro Leopardi and the convent of S. Giustina in Padua. Cf. Baldoria 1891, 184ff., doc. 30.

20. Vio 1972, 242.

21. Cesariano 1521, bk. 5, ser. 74.

22. Paoletti 1893, 2:247; Tafuri 1972, 16ff.; Howard 1975, 96ff.

23. Malsburg 176, 108ff.

24. Caravia 1541, ser. 12v.ff., unpag.

25. Pullan 1971, 125ff.

26. Tafuri (1973, 152ff.) sees a connection with the "basilica romana."

27. Gallo 1961–62b.

28. Vio 1972.

29. Rambaldi 1913, 45ff.

6 VILLAS FOR VENETIANS

1. Puppi 1969a.

2. Wolters 1963, F. E. Keller 1971, Carpeggiani 1977. Of the vast literature on the Venetian villa the following titles deserve special mention: Molmenti 1927–29, 2:109ff.; Mazzotti 1954; Rupprecht 1964; Muraro 1966; Ackerman 1967; Bentmann and Müller 1970, 1972. On villas in the province of Vicenza: Cevese 1971. Polesine: A. Canova 1975, Semenzato 1975. On pictures of fifteenth-century buildings: Kubelik 1977. On land ownership: D. Beltrami 1961, Ventura 1969, Soragni 1982. On Ma-

gistrato dei Beni Inculti: Mozzi 1927. On villas by Palladio: Burger n.d., Forssman 1965, G. Zorzi 1969, Puppi 1981.

3. *Andrea Palladio* 1975, 180.

4. On what follows: Molmenti 1927–29, 196ff.; Schulz 1982, 108, nn. 24–25.

5. Sansovino 1663, 210.

6. V. Lazzarini 1920.

7. Soragni 1982.

8. D. Beltrami 1961, 45ff.

9. V. Lazzarini 1920: "scandali et errori."

10. Freely translated from Puppi 1972b, 13.

11. The direction of the gaze of the lion of St. Mark on the column in the Piazzetta could be interpreted in this way. Wolters 1983, 233.

12. Fiocco 1965, 102.

13. Serlio 1978, bk. 6.

14. Extant or documented farmhouses are described by Cavalca 1959.

15. Bellocchi 1969.

16. Puppi 1962.

17. Kolb Lewis 1977, 157ff., n. 326.

18. Kolb Lewis 1977.

19. Molmenti 1927–29, 217.

20. Serlio 1978, bk. 6.

21. Sanudo 1847.

22. *Ville del Brenta* 1960, 79ff.

23. Kolb Lewis 1969 was the first to draw attention to Du Ry's 1713 edition of Scamozzi (1615).

24. Wolters 1963, F. E. Keller 1971.

25. Günther 1981.

26. Caffi 1885, 9–10.

27. Puppi 1961; Rupprecht 1963; Puppi 1969b; Rosci 1967, 40ff.

28. Serlio 1978, bk. 6.

29. G. Zorzi 1954–55, 175.

30. Rupprecht 1968.

31. On Gradenigo: *Ville del Brenta* 1960, 85. On Soranza: ibid., 145. On Grimani-Morosini: ibid., 85. On Contarini: Brunelli and Callegari 1931, 43ff.; Mazzotti 1954, 115 (ca. 1558).

32. On Grompo di Concadirame: Semenzato 1975, 72ff.; A. Canova 1975, 122ff. The lack of inventories of the important catchment areas near Padua and the country around Treviso makes a survey impossible at present.

33. Berger 1978, 32.

34. Burger n.d., 9.

35. Palladio 1570, bk. 2, chap. 13.

36. Kolb 1984 recently proved landownership.

37. "Grandezza e magnificenza." Palladio 1570, bk. 2, chap. 16.

38. Huse 1974.

39. This is a controversial question. Cf. Wolters 1968a, 1968d; Forssman 1967a; Lewis 1981, 1982b.

40. Cf. Rupprecht 1966, Crosato 1962, and many individual studies of the picture program of the Villa Barbaro (Masèr).

41. Bassi 1976, 528ff.; Prosperetti 1984.

42. Wolters 1966. The restoration is almost complete.

43. Bassi 1976, 2:79–80 (Palazzo Vendramin), 2:77–78 (Palazzo Dandolo), 2:81–82 (Palazzo Mocenigo).

44. Serlio 1584, bk. 4, fol. 177.

45. Günther 1981, n. 124.

7 SCULPTURE

1. Fundamental work on Venetian Renaissance sculpture: Paoletti 1893. General studies: Planiscig 1921, 1927, Pope-Hennessy 1958, 1970. On workshops: Wolters 1976, 12ff.; above all Connell 1976 (sadly unpublished).

2. Sagredo 1856, 292, doc. 36. They became "cittadini de intra."

3. Cf. Beltrami 1900, 18, with respect to Milan.

4. Sagredo 1856, 283, doc. 4: "forestieri cioè milanex et de le terre aliene." Cf. especially Maek-Gérard 1980.

5. Biscaro 1899, 186: "more veneto."

6. Wyrobisz 1965.

7. Luzio and Renier 1888, 434.

8. But in 1517 a relief by A. Minello for the Cappella dell'Arca in the Santo, Padua, was rejected as "goffo." Sartori 1976, 160.

9. Connell 1976, 65: "per li lavori mal fatti molte litte et differentie nasseno ct sc fano tra li patricii et citadini cum li maistri mal pratici et mal instructi in l'arte nostra cum danno et vergogna dell'arte."

10. Sagredo 1856, 291, doc. 24.

11. Meli 1965. Erection of the altar in the Cappella Colleoni, Bergamo, by Pietro Lombardo.

12. Bertolotti 1890.

13. Caffi 1884.

14. Puppi 1980, 75.

15. On the contract drawing by Giovanni Minelli for the tomb of Cristoforo da Recanati from S. Bernardino (Padua): Carpi 1930, 67ff., fig. 22.

16. Lorenzetti 1929, 28.

17. Blake-Wilk 1984, 123. On a further sheet that might be a design by Tullio Lombardo: Stedman Sheard 1979, cat. 118.

18. Sartori 1976, 172.

19. Stepan 1982, 100ff.

20. Paoletti 1893, 2:116.

21. Caffi 1884, 41–42.

22. Luzio and Renier 1888, 435.

23. On the Zen tomb: Pope-Hennessy 1958, 356ff.; Jestaz n.d. On the altar: Boucher 1976–79, 559.

24. Paoletti 1893, 2:149. On another example for which the design was probably by the painter B. Diana and the execution by G. M. Mosca: Hadley in Vermeule, Cahn, and Hadley 1977, cat. 176.

25. Huse 1974, Puppi 1980.

26. Timofiewitsch 1972b, 134.

27. Gronau 1930.

28. Paoletti 1893, 2:105.

29. The tomb of Doge F. Foscari (died 1457), which was gilded all over, is likely to have been an exception. Markham Schulz 1978a, 13.

30. Biscaro 1898a, 138.

31. Caffi 1884, 42.

32. Meli 1965, 25ff.

33. Stepan 1982, 123ff.

34. Mason Rinaldi 1975. There was also a stonemason called Cesare.

35. Timofiewitsch 1968a, 342ff.

36. Weihrauch 1935, 61.

37. Campori 1873, 10ff.

38. Many documents in Predelli 1908 and Gerola 1924–25.

39. Still unsurpassed on Antonio Rizzo: Paoletti 1893. But see Planiscig 1921; Pohland 1971; Pope-Hennessy 1958, 107ff., 348ff.; Markham Schulz 1983a.

40. Grigioni 1910, 44ff.

41. L. Beltrami 1900, 22: "quale fa fare ogni lavorerio in Vinexia per Sancto Marcho."

42. Markham Schulz 1978a has attributed these works and the Foscari tomb, it seems to me with insufficient reason, to a Niccolò Fiorentino who worked in Dalmatia and for whom Schulz assembles a heterogeneous oeuvre in Venice.

43. Sagredo 1856, doc. 45.

44. Maek-Gérard 1980.

45. Cicogna 1824–53, 6:728ff.

46. Paoletti 1929, 16.

47. Cf. Pincus 1981 on the iconography.

48. Frizzoni 1884, 155.

49. On the medieval tradition of this type: Milani 1900.

50. Hirthe 1982.

51. For a more detailed discussion with supporting evidence see Wolters 1983, 81ff.

52. Cf. Mariani Canova 1969, figs. 40, 54.

53. Paoletti 1893, 2:157ff. (Rizzo); Pope-Hennessy 1958, 350 (Master of S. Trovaso).

54. Munman 1977; McAndrew 1980, 76ff.; Markham Schulz 1981 (P. Lombardo).

55. The fundamental work on this period is Paoletti 1893. On the Lombardi: Moschetti 1913–14, Planiscig 1921, 1937. On Pietro: Brand 1977 (especially for the tombs). On Antonio: Ruhmer 1974, Blake-Wilk 1984. On Tullio: Stedman Sheard 1971, 1978.

56. Beck 1967–68.

57. Brand 1977, 35ff.

58. In the sources Pietro is first mentioned in Venice on 11 August 1474. Moschetti 1927–28, 1496.

59. Munman 1976, 1979, Markham Schulz 1983c.

60. Boni 1887.

61. Wolters 1983, 72.

62. Bernicoli 1929.

63. This practice was described as "more veneto" in Treviso in 1485. Biscaro 1899, 186.

64. Caffi 1884, 35.

65. Marx 1978; Wolters 1983, 265ff.

66. Wolters 1974.

67. Rizzi 1979, 11ff.

68. Perry 1978 (D. Grimani Coll.); Perry 1972 ("Statuario Pubblico").

69. Summary in Franzoni 1981 (with large bibliography).

70. Planiscig 1921, 313ff.; Olivato 1973; Perry 1975 ("Adorante"); Paul 1982.

71. Sartori 1964, 194, doc. 8 (1545); Sartori 1976, 236ff.

72. R. Gallo 1952, 74.

73. Busch 1973, 309 n. 178.

74. Pincus 1979.

75. Verdon 1978, 69ff., 332ff.

76. On the terminology: Godby 1980.

77. Gaurico 1969, 185.

78. Stedman Sheard 1984a.

79. Baxandall 1971, 81ff.

80. Mango 1963.

81. E.g., "far una soaza e lavoro alantiga" (1486). Document in Biscaro 1899, 191.

82. Gaurico 1969, 255.

83. On the double portraits: Wilk 1978 with reference to Golubew 1908–12, vol. 2, plate 43.

84. Puppi 1972a, 103 (letter of 1526).

85. Dittmar 1984.

86. Examples from antiquity in Vermeule 1959–60.

87. Cf. Hubala 1965, 680.

88. Wilk 1978, 88.

89. Demus 1960, 55ff. (*renovatio*), 171ff. (*Traditio Legis*).

90. Cf. Mango 1963, 59.

91. "Pictores." Baxandall 1971, 124, 129.

92. Heidrich 1908, 124.

93. Sources now in Sartori 1983. Cf. Blake-Wilk 1984.

94. Wolters 1968d.

95. Sartori 1976, 140.

96. Blake-Wilk 1984, 123.

97. Cf. Pope-Hennessy 1958, 356ff. Much new material in Jestaz n.d.

98. Paoletti 1893, 2:267.

99. Documents in Zava Boccazzi 1965, 343, n. 81.

100. According to Sansovino 1663, 42, the figures from S. Giustina were by Antonio Lombardo and Paolo Milanese (Stella).

101. Bailey 1977.

102. Documents in Paoletti 1893, 2:268ff. Cf. Jestaz (1982); Wolters 1983, 241ff. (picture program).

103. On Venetian bronzes: Planiscig 1921, Pope-Hennessy 1958, Weihrauch 1967.

104. Tramontin 1962, 35.

105. Markham Schulz 1980, 1983b.

106. Grigioni 1910, 45. On Lorenzo Bregno: Markham Schulz 1984b.

107. Grigioni 1899.

108. On Fantoni: Markham Schulz 1984a, 258ff. On Mosca: Planiscig 1921, 259ff.; Sartori 1976, 171ff.; Stepan 1982, 59ff. On Stella: Paoletti 1893, 2:241. On Bartolomeo di Francesco: Markham Schulz 1984a.

109. Planiscig 1927, 143ff.

110. Meller 1977, Schlegel 1979.

111. Bertolotti 1890, 55ff.

112. Cicogna 1824–53, 1:171; Paschini 1943, 156.

113. Fapanni 1880–81; Wilk 1978, 145ff.

114. "In platea nostra Sancti Marci ad perpetuam memoriam." Cf. the monograph by Isermeyer 1963.

115. Paoletti 1893, 2:263ff.

116. Puppi 1982.

117. Tramontin 1967, 522.

118. Wolters 1983, 190ff.

119. On Jacopo Sansovino as sculptor: Lorenzetti 1910a; Planiscig 1921, 349ff.; Sapori 1928; Lorenzetti 1929; Weihrauch 1935; Pope-Hennessy 1970, 350ff., 404ff.; Lewis 1982a.

120. D'Arco 1857, 99: "empie di libidine." Meli 1965, 31ff.

121. This fate was shared by Tullio Lombardo's *Eve*, a *Venus* by Cristoforo Solari (Frizzoni 1884, 233) and a *Venus* by Danese Cattaneo (Campori 1871, 7 of offprint).

122. D'Arco 1857, 104.

123. Bertolotti 1890, 106ff.

124. Summary in Markham Schulz 1984a.

125. Timofiewitsch 1972a.

126. Weihrauch 1935, 49ff.; Blake-Wilk 1984, 136ff.

127. Weihrauch 1935, 50ff.

128. Aretino 1957–60, vol. i, li.

129. Sansovino 1663, 307ff.

130. Timofiewitsch 1972b, 248ff.

131. Dolce 1960, 177, 194ff.; Boucher 1984.

132. Ripa 1970, 375.

133. On the north Italian oeuvre: Kinney 1976, 83ff.

134. There is no modern monograph. Cf. Campori 1871; Planiscig 1921, 411ff.; Macchioni 1979.

135. Vasari 1878–85, 7:456.

136. Timofiewitsch 1972b, cat. 24.

137. Planiscig 1921, 389ff.; Rigoni 1970; Wolters 1963.

138. Vasari 1878–85, 7:520.

139. Ravà 1920, 158.

140. Davis 1976, Puppi 1978.

141. Bush 1976, 139ff.

142. Wolters 1976, 137, n. 21.

143. Degenhart and Schmitt 1984, pl. 8.

144. Cf. especially Weddingen 1974.

145. Illustrated in Bialostocki 1983.

146. Boucher 1976–79.

147. Weihrauch 1935, 68ff.

148. Sansovino 1663, 101: "le prospettive dei paesi di basso rilievo, fatte a sembianza di pittura." Cf. Stolt 1982.

149. Campori 1873, 10ff.

150. Completed in 1561. Lorenzetti 1929, 27.

151. Weihrauch 1935, 76.

152. Voltelini 1892, doc. 8812.

153. For documents not specifically referred to in the text see Predelli 1908; Planiscig 1921, 435ff.; Serra 1921; Gerola 1924–25; F. Cessi 1960–62; Leithe-Jasper 1963–65; Pope-Hennessy 1970, 415ff.; Wolters 1968d (stucco decoration).

154. "Nettare." Weihrauch 1935, 61.

155. "Pazzo bestiale." Campori 1873.

156. Wolters 1968d.

157. Campori 1873.

158. On the Rubini: G. Zorzi 1951.

159. Predelli 1908, 131.

160. Timofiewitsch 1968a, 345ff. A study of Venetian Renaissance altars is still needed.

161. Identified with a bust in the Cà d'Oro by Markham Schulz 1984a. Cf. Cicogna 1824–53, 6:110.

162. Sapori 1928, 128.

163. Cicogna 1824–53, 6:108ff.

164. Cicogna 1824–53, 4:412 n. 1.

165. Da Mosto 1939, 193ff. Cf Timofiewitsch 1972b, fig. 126.

166. Schwarzenberg 1969 (on the "Alessandro morente" and its imitators).

167. Olivato 1978.

168. Timofiewitsch 1972b, cat. 8.

169. Vasari 1878–85, 6:516, 519.

170. *Delle cose notabili della città di Venezia* 1583, 52: "diletta manco che la pittura."

PAINTING

Norbert Huse

8 BETWEEN 1460 AND 1505

1. On Veronese see chapter 10, "History in Pictures." On the social history of Venetian painting the basic work is Rosand 1982, 1ff.. On guilds: F. Favaro 1975.

On Venetian Renaissance painting: Jacob Burckhardt's *Beiträge zur Kunstgeschichte von Italien: Das Altarbild—Das Porträt in der Malerei—Die Sammler,* Basel, 1898 (in Burckhardt, vol. 12, 1934) is a fundamental and exemplary work, and one that could not be equalled; see Huse (1977). By far the best modern general study is found in the passages on Venice in Freedberg (1975). Rosand (1982a) is as of now the definitive work on many areas of the sixteenth century. On questions of the public reception of art see Baxandall (1972). On the drawings, the masterful study by Tietze and Tietze-Conrat (1944) is, by and large, still unsurpassed. The same is true of the source publications by Ludwig (1905, 1911), which are far from exhausted. Lorenzo Lotto's account books (Lotto, 1969) are also important. Among the earlier literature on art Ridolfi (1914–24) and Boschini (1966) are still outstanding. The Renaissance pictures are covered in the general context of Venetian art by Hubala (1965). There are important individual studies in Tietze (1937). Among monographs devoted to the interpretation of important works, artists, or complexes, Lauts (1962), Settis (1978), Badt (1981), Rosand (1982), and Wolters (1983) deserve special mention. Of the many congresses, "Lorenzo Lotto" and "Tiziano e Venezia" were the most productive. Of the museum catalogues, Davies (1965), Gould (1975), and Kultzen and Eikemeier (1971) should be mentioned.

2. Crowe and Cavalcaselle 1877–78, 2:351 n. 1.

3. Ridolfi 1914–24, 1:354. The division of labor is described by Benedetto Caliari in a letter: "da me dissegnato, da Carlo abosiato, e da Gabriel finito" (Cicogna 1824–53), 4:197. Cf. Tietze 1952 on workshops generally.

4. Schütz-Rautenberg 1978, 271ff.; Mason Rinaldi 1984, 70.

5. Paoletti 1929, 167.

6. Rosand 1982, 241 n. 22.

7. Degenhart and Schmitt 1984 is now the basic work. Illustrations of all Jacopo Bellini's books of drawings are in Golubew 1908–12; Jacopo's will is in Paoletti 1894, 11; on Jacopo generally see Schmitt 1965b, 708ff.

8. Paoletti 1894, 11ff.

9. Paoletti 1894, 17; Sohm 1978a, 34ff., 240ff., 259ff.; Meyer zur Capellen 1985, 25ff.

10. Lorenzi 1868, 92.

11. Braghirolli 1877, 370ff.; Fletcher 1971; Verheyen 1971; Huse 1972, 82ff.

12. Braghirolli 1877, 377.

13. Braghirolli 1877, 382ff.

14. Gaye 1839–40, 2:71.

15. Moschini Marconi 1955, 77ff.; *Le scuole di Venezia* 1981, 27; Robertson 1968, 39ff.; Meyer zur Capellen 1985, 77ff., 135; Huse 1972, 14 n. 42.

16. Humfrey 1983, 199ff. In general: C. Gilbert 1977. On drawings, e.g., Steer 1982, 170ff.; Degenhart and Schmitt 1984, fig. 7 verso.

17. Schmitt 1961, 110; Robertson 1968, 47ff.; Huse 1972, 12f.

18. Moschini Marconi 1955, 41ff.; *Venezia e la peste* 1979, 227ff.

19. Burckhardt 1930ff., 4:187ff., is fundamental.

20. R. Pallucchini 1962, figs. 149, 150, 154, 169, 171, 175, 183.

21. *Antonello da Messina* 1982, 161ff.; Robertson 1968, 56ff.; Huse 1972, 26ff.

22. Moschini Marconi 1955, 67ff.; Robertson 1968, 83ff.; Hubala 1969; Huse 1972, 26ff., 48ff.

23. *Venezia e la peste* 1979, 212; *Antonello da Messina* 1982, 182ff. On the altar painting of S. Cassiano: *Antonello da Messina* 1982, 176ff.; Wilde 1929; Robertson 1977.

24. Reconstructions in Robertson 1968, fig. 67, and Hubala 1969, fig. 11.

25. Burckhardt 1930ff., 4:331–32, 335.

26. Braghirolli 1877, 375.

27. Huse 1972, 93ff.

28. Menegazzi 1981, 99–100; Humfrey 1983, 199ff.

29. Campana 1962, 419. Generally on the devotional picture: Burckhardt 1930ff., 12:296ff.; Ringbom 1965; Suckale 1977; Belting 1981, 1985.

30. Berenson 1957b, 88.

31. Paoletti 1894, 15.

32. Berenson 1957a, vol. 1, figs. 81, 360, 373, 390, 391; Moschini Marconi 1955, figs. 95, 100, 144.

33. Dürer 1956, 1:43ff.

34. On the Bergamo *Pietà*: Huse 1972, 1–2. On the Milan *Pietà*: Robertson 1968, 54–55; Huse 1972, 15ff.; Belting 1985.

35. Translation from Belting 1985, 29.

36. One example is Crivelli's *Madonna* in Verona. Berenson 1957a, vol. 1, fig. 130.

37. Moschini Marconi 1955, 65–66; Huse 1972, 3–4; C. Gilbert 1952, 206–7.

38. Huse 1972, 78ff. Attributions depend decisively on how this matter is viewed—and vice versa. Gronau 1930 is the most generous, unlike Dussler 1935, 5.

39. Belting 1981, 1985.

40. *Anonimo Morelli* 1888, 80.

41. Anderson 1977, 186ff.
42. Vasari, 1963, 2:171.
43. Lorenzi 1868, 85–86, 88–89.
44. Lorenzi 1868, 109; Cessi and Alberti 1934, 185.
45. Braghirolli 1877, 375.
46. Vasari 1878–85, 3:157.
47. Tietze-Conrat 1940; Huse 1972, 56ff.
48. Lorenzi 1868, 102.
49. Ludwig 1905, 53.
50. Ridolfi 1914–24, 1:53; Paoletti 1894, 10ff.; Sohm 1978a, 8ff.
51. Lauts 1962, 23ff.
52. Lauts 1962, 238ff.; Roberts 1959. On the evaluation of Carpaccio: Lauts 1962, 48; Tietze and Tietze-Conrat 1944, 138ff.
53. Mason Rinaldi 1978, 299.
54. Moschini Marconi 1955, figs. 56, 62, 63, 64, 139, 144; Brown 1984.
55. Moschini Marconi, 1955, 134; Tietze and Tietze-Conrat 1944, 69.
56. Wolters 1983, 45ff.
57. Cf. the depiction in the town plan by Jacopo de' Barbari and Meyer zur Capellen 1985, 77ff., 83, 135.
58. Gibbons 1963, but cf. Meyer zur Capellen 1985, 77ff.
59. Vasari 1963, 2:51. In general: Burckhardt 1930ff., 12:141ff.; Pope-Hennessy 1966.
60. Ridolfi 1914–24, 1:72. On Giovanni Bellini's portraits: Dussler 1949, 43ff.; Robertson 1968, 106ff.
61. *Antonello da Messina* 1982, 105ff.
62. Cf. Gronau 1930.
63. Da Mosto 1966, 267; Davies 1965, 55–56; Lauts 1962, 248; Meyer zur Capellen 1985, 66–67, 187ff.
64. Anonimo Morelli 1888, passim.
65. Davies (1965, 58ff.; Robertson 1968, 32ff.; Huse 1972, 7ff.
66. Davies 1965, 335ff.
67. Huse 1972, 43ff. In general on Bellini's landscapes: Clark 1962, 23ff.; Turner 1966, 57ff.; Pochat 1973, 339ff.
68. Meiss 1964. On Carpaccio: Hartt 1940.
69. Anonimo Morelli 1888, 88.

9 BETWEEN 1505 AND 1550

1. Dürer 1956, 1:44.
2. Dürer 1956, 1:55.
3. Mayekawa 1979, 105.
4. Ridolfi 1914–24, 1:100; Wethey 1969–75, 3:5ff.; but cf. Nordenfalk 1952 and Muraro 1975.
5. Vasari 1878–85, 4:91.
6. Crowe and Cavalcaselle 1877–78, 1:68 n. 1.
7. Ridolfi 1914–24, 2:42. Cf. also ibid., 1:248, 97–98.
8. Luzio 1888, 47.
9. Gentili 1980a, 15ff.
10. Fomiciova 1980.
11. Humfrey 1983, 161ff.
12. Pignatti 1978, 102.
13. Settis 1978, 19ff.
14. Anonimo Morelli 1888, passim.
15. Ludwig 1911, 73.
16. Pino 1960, 108ff., 119.

17. Wronski 1977, 1ff., summarizes the facts, but her assessment of Lotto as a member of the solid middle class seems questionable. Access to the sources in Lotto 1969.
18. Wronski 1977, 104–5.
19. Lotto 1969, 286.
20. Lotto 1969, 268.
21. Lotto 1969, 280.
22. Lotto 1969, 272.
23. Lotto 1969, 291.
24. Lotto 1969, 286.
25. Lotto 1969, 286.
26. Cali 1980, 243ff.; R. Fontana 1980, 279ff.
27. Lotto 1969, 212.
28. Lotto 1969, 237.
29. Lotto 1969, 18–19.
30. Lotto 1969, 128.
31. Pino 1960, 137.
32. Ridolfi 1914–24, 2:16.
33. Aretino 1957–60, 2:218–19.
34. Aretino 1957–60, 2:221.
35. Aretino 1957–60, 2:232–33.
36. Aretino 1957–60, 2:204–5.
37. Schulz 1967, Friedländer 1965. Good survey in *Da Tiziano a El Greco* 1981, 71–72.
38. Ludwig 1911, 134.
39. *Il Pordenone* 1984, 144–45.
40. Ridolfi 1914–24, 1:123; *Da Tiziano a El Greco* 1981, 76.
41. Friedländer 1965.
42. Roskill 1968, 182.
43. Pino 1960, 115.
44. Schulz 1968, 15ff.
45. McTavish 1981; good characterization in R. Pallucchini 1950, 41–42.
46. Coletti 1941, Pallucchini 1950; most recently: *Da Tiziano a El Greco* 1981, 11ff.; however, J. F. Freedberg 1975, 532, rightly has reservations.
47. Huse 1972, 73ff.
48. *Giorgione: La pala di Castelfranco Veneto* 1978.
49. Hirst 1981, 23ff.
50. Robertson 1968, 128ff.; Lattanzi 1981.
51. Wethey 1969–75, 1:143ff.; *Venezia e la peste* 1979, 237.
52. Ridolfi 1914–24, 1:163; Wethey 1969–75, 1:14ff.; Meyer zur Capellen 1971, 124ff.; Rosand 1982, 51ff.
53. Wethey 1969–75 1:126ff.
54. Crowe and Cavalcaselle 1877–78, 1:205ff., 219.
55. Burckhardt 1930ff., 12:415ff.
56. Meyer zur Capellen 1980b; Wethey 1969–75, 1:101ff.; Rosand 1982, 58ff.; Valcanover 1979a.
57. Sinding-Larsen 1962, 151ff.; Huse 1972, 87ff.; Wolters 1983, 92ff.
58. Ludwig 1905, 69; Wethey 1969–75, 1:153ff.
59. Burckhardt 1930ff., 4:335.
60. Gaye 1839–40, 2:223.
61. Wethey 1969–75, 1:143ff.
62. Aretino 1957–60, 1:17; Gaye 1839–40, 2:179.
63. Lotto 1969, 12, 120; Berenson 1957, vol. 1, fig. 318.
64. Panofsky 1969, 42ff.

65. Pignatti 1978, 108.
66. Wethey 1969–75, 1:98; Hetzer 1920, 37–38.
67. Wethey 1969–75, 1:99; Hetzer 1920, 39ff.
68. E.g., those in Madrid, Dresden, Paris, and Vienna (Wethey 1969–75, vol. 1, figs. 13ff.).
69. Palumbo Fossati 1984, 128ff.
70. Berenson 1957, 1:88.
71. Moschini Marconi 1962, 174–75.
72. Lotto 1969, 236.
73. Mazza 1981, 347ff.
74. Ridolfi 1914–24, 1:148; Boschini 1966, 360.
75. Aretino 1957–60, 1:17; Crowe and Cavalcaselle 1877–78, 1:285.
76. Crowe and Cavalcaselle 1877–78, 1:377, 2:247.
77. Aretino 1957–60, 1:154.
78. Crowe and Cavalcaselle 1877–78, 2:187.
79. Burckhardt 1930ff., 12:242–43.
80. Moschini Marconi 1962, 131ff.
81. Wronski 1977, 233ff.; Gentili 1980b, 420–21.
82. Wronski 1977, 225ff.
83. Wethey 1969–75, 2:75–76.
84. Aretino 1957–60, 2:107–8.
85. Aretino 1957–60, 1:107–8.
86. Wethey 1969–75, 2:76–77; Hope 1980b, 107 n.8.
87. Wethey 1969–75, 2:118; Wronski 1977, 224ff.; Gentili 1980b, 422.
88. Lotto 1969, 286, 291.
89. Hegel 1975, 283ff 2:866–67.
90. Wethey 1969–75, 2:81–82, 134; Gronau 1935, 98.
91. Hetzer 1957, 1:56.
92. Gould 1975, 284ff.; Hetzer 1957, 1:89ff.
93. Wethey 1969–75, 2:142.
94. Wethey 1969–75, 2:87ff.
95. Aretino 1957–60, 2:221ff.
96. C. Justi 1933, 576.
97. Wethey 1969–75, 2:125ff.; Hetzer 1957, 1:43ff.
98. Moschini Marconi 1962, 119ff.; Settis 1978.
99. Anonimo Morelli 1888, passim.
100. Fundamental is Ferriguto 1933, 183ff., corrected and complemented by Settis 1978, 1981. Survey in Battilotti and Franco 1978.
101. Incomplete survey in Settis 1978, 74–75. Reference to Pliny in Marek 1985, 28 n. 161.
102. Wethey 1969–75, 3:10ff.
103. Tanner 1978, 61ff.
104. Lotto 1969, 213, painted a *Susanna Bathing,* "da accompagnar la Venere" that he had delivered earlier.
105. Burckhardt 1958, 261.
106. On the *camerino:* Hope 1971, Marek 1985.
107. Walker 1958, 48ff.; Huse 1972, 103–4.
108. Muraro and Rosand 1976, cat. nos. 7, 8, 28–30.
109. Burckhardt 1930ff., 4:335.
110. Gould 1975, 187; Wethey 1969–75, 3:154.
111. But cf. Ginzburg 1980, Haskell 1980, Hope 1980a, Ost 1983.
112. Posse 1931.
113. Wethey 1969–75, 3:203.
114. Heinse 1975, 331ff.
115. Hope 1977.

116. Vasari 1963, 4:206–7.
117. Tietze-Conrat 1940; Huse 1972, 56ff.
118. Panofsky 1969, 179ff.; Wolters 1983, 193ff.
119. Wolters 1983, 193ff.
120. Muraro and Rosand 1976, 13ff.
121. Rosenbaum 1966–67.
122. C. Gilbert 1980.
123. Hirst 1981, 13ff.
124. Appuhn and Heusinger 1976, 26ff.
125. Muraro and Rosand 1976, 19ff.; Olivato 1980, 529ff.
126. Wethey 1969–75, 1:79–80.
127. Rosand 1982, 85ff. On the scuole: Pullan 1971, 99ff.
128. Rosand 1982, 234.
129. Rosand 1982, 235.
130. Moschini Marconi 1962, 70ff.
131. R. Pallucchini and Rossi 1982, 136–37.

10 BETWEEN 1550 AND 1590

1. Ridolfi 1914–24, 2:42.
2. Sansovino 1561, fol. 18r.; Vasari 1878–85, 6:387ff.; cf. Sartre 1968.
3. Berliner 1919–20, 469.
4. On the planning history: Berliner 1919–20, Hüttinger 1962.
5. Pignatti 1976, 39ff.
6. Crowe and Cavalcaselle 1877–78, 277–78, 370.
7. Cadorin 1833, 9.
8. Gaye 1839–40, 3:242ff.
9. Vasari 1878–85, 7:439–40.
10. Tucci 1973, 369ff.; Palumbo-Fossati 1984, 131.
11. Moschini Marconi 1955, fig. 107.
12. Wolters 1983, 32ff.
13. Wethey 1969–75, 3:231ff.
14. Dreßner 1915, 69ff.
15. Roskill 1968.
16. Sansovino 1561, ser. 18r.ff.
17. Vasari 1878–85, 7:452, 459.
18. Roskill 1968, 88, 90, 108, 160ff., 170ff., 186, 194.
19. Aretino 1957–60, 2:205.
20. Pino 1960, 119.
21. Roskill 1968, 156.
22. Armenini 1587, 130, 135.
23. On Veronese: cf. Cicogna 1824–53, 4:197. On Tintoretto: Eikemeier 1969, 126ff.; Wolters 1983, 115ff.
24. Armenini 1587, 188–89; Tucci 1973, 369ff.; P. Pavanini 1981, 94ff., 125ff.; Palumbo-Fossati 1984, 128ff.
25. Da Holanda 1964, 30.
26. Wethey 1969–75, 1:86ff.; Hope 1980b, 109–10.
27. Aretino 1957–60, 2:191.
28. Wethey 1969–75, 1:85.
29. Wethey 1969–75, 1:139ff.; *Da Tiziano a El Greco* 1981, 110.; Rosand 1982, 71ff.
30. Boschini 1966, 710ff.
31. Moschini Marconi 1962, 260ff.; Meyer zur Capellen 1971; Schütz-Rautenberg 1978, 231ff.; Rosand 1982, 75ff.; Niero 1984.
32. Ridolfi 1914–24, 2:138.
33. Kultzen and Eikemeier 1971, 182ff.

34. Cf. Niero 1984.

35. Cf. the self-portrait in Madrid (Wethey 1969–75, 2:144.

36. On the last restoration cf. the forthcoming issue of the *Quaderni della Sopraintendenza ai Beni Artistici e Storici di Venezia.*

37. Cf. paintings like the *Last Supper* in S. Martino of 1548; cf. Heinemann 1962, figs. 648ff.

38. R. Pallucchini and Rossi 1982, 218.

39. Pignatti 1976, 143–44; Badt 1981, 103.

40. Hetzer 1957, 1:121ff.; Pignatti 1976, 104; Badt 1981, 68.

41. Pignatti 1976, 126; Hadeln 1978, 60.

42. Moschini Marconi 1962, 86; Pignatti 1976, 137; Hadeln 1978, 69ff.; Badt 1981, 101ff.

43. Pignatti 1976, 166; Hadeln 1978, 200; Badt 1981, 203. The identification of the central figure—Christ or James the Less—is controversial, the halo that the two other saints lack being in favor of Christ.

44. Pignatti 1976, 167; Badt 1981, 204.

45. Wethey 1969–75, 2:144.

46. Dilthey 1957, 2:417–18.

47. Lomazzo 1584, 433.

48. Barocchi, 1971–77, 2:2715, 2723.

49. Hetzer 1957, 1:98ff.; Pignatti 1976, 129; Cocke 1980, 44; Badt 1981, 172ff.

50. Wethey 1969–75, 2:115ff.

51. Pignatti 1976, 121; Badt 1981, 176–77.

52. Pignatti 1976, 106–7; Badt 1981, 176.

53. Rossi 1973, figs. 45, 46, 123, 161ff., 168; Wolters 1983, 70.

54. Ridolfi 1914–24, 2:55.

55. Wolters 1983, 124.

56. Badt 1981, 170.

57. Hetzer 1957, 1:87ff.; Pignatti 1976, 133; Badt 1981, 160ff.

58. Moschini Marconi 1962, 228–29; R. Pallucchini and Rossi 1982, 165–66.

59. E.g., Moschini Marconi 1962, figs. 61, 64ff., 72, 84, 85, 91, 108ff.

60. Ludwig 1905; Sinding-Larsen 1974; Kleinschmidt 1977; Wolters 1983, 137ff.

61. Wolters 1983, 75ff.

62. Sinding-Larsen 1974, 84ff.; Wolters 1983, 92ff.

63. Wolters 1983, 111 n. 1.

64. Wolters 1983, 117ff.

65. Wolters 1983, 119ff.

66. Wolters 1983, 161 n. 2.

67. Tietze-Conrat 1940; Huse 1972, 56ff.; Wolters 1983, 164ff.

68. Wolters 1983, 179.

69. Wolters 1983, 311ff.; Sinding-Larsen 1974, 7ff., takes a different view.

70. Luzio 1890, Eikemeier 1969.

71. Wolters 1983, and cf. his chapter headings.

72. Wolters 1983, 198ff.

73. Wolters 1983, 314.

74. Wolters 1983, 206, 309.

75. Fehl 1961, German text from Hadeln 1978, 24ff.

76. Caliari 1888, 24, 55.

77. Hausherr 1982.

78. Roskill 1968, 118.

79. Armenini 1587, 145.

80. Ridolfi 1914–24, 1:307–8; Hadeln 1978, 181; Badt 1981, 156ff.

81. R. Pallucchini and Rossi 1982, 187.

82. Burckhardt 1930ff., 4:353.

83. Goethe, diary of his Italian journey, 8 October 1786.

84. R. Pallucchini and Rossi 1982, 155ff.; C. Gilbert 1974; Cope 1979, 90ff.; Rosand 1982, 206ff.; Hills 1983.

85. R. Pallucchini and Rossi 1982, 194ff.

86. Quoted from Grendler 1969, 122.

87. R. Pallucchini and Rossi 1982, 225; Wethey 1969–75, 1:70.

88. Hüttinger (1962, 176–77) sees the influence of Aretino's religious writings in such features.

89. Auerbach 1959, 25–26.

90. Schulz 1968.

91. Schulz 1961a.

92. Wolters 1968.

93. Boschini 1966, 521.

94. Schöne 1961, 146.

95. Wolters 1983, 247ff.

96. R. Pallucchini and Rossi 1982, 188–89.

97. Schulz 1968, 86ff.

98. Wolters 1983, 275ff.

99. Wolters 1983, 315.

100. Wolters 1983, 315–16.

101. Wolters 1983, fig. 286.

102. Ridolfi 1914–24, 2:47.

103. Wolters 1983, 277ff.

104. Wolters 1983, 282–83, 316.

105. Wolters 1983, 285.

106. Pino 1960, 133–34.

107. Sorte 1960, 279, 288.

108. Lomazzo 1590, 50.

109. Algarotti 1831, 511.

110. Dreyer n.d., cat. nos. 7, 8, 20.

111. Wethey 1969–75, 1:135.

112. Gilio 1961, 22.

113. S. Romano 1983.

114. Vasari 1878–85, 6:369.

115. Pignatti 1976, 56ff.

116. Oberhuber 1968; Bentmann and Müller 1970, 38ff.

117. Cocke 1972, Huse 1974.

118. Pignatti 1976, 148–49.

119. Wolters 1983, 245ff.

120. Seznec 1953, 219ff.

121. Kultzen and Eikemeier 1971, 133ff.

122. R. Pallucchini and Rossi 1982, 211.

123. Wethey 1969–75, 3:195ff.

124. Panofsky 1969, 121ff.; Haskell 1980. Hope 1980a, and others take a different view.

125. H. Keller 1969, 113, 116–17, sees this differently.

126. Roskill 1968, 212ff.

127. H. Keller 1969, 129ff.

128. Badt 1981, 242.

129. Illustration in Wethey 1969–75, vol. 3, fig. 209.

130. Badt 1981, 99.

131. Fernow 1806, 92.

132. Fehl 1969; Wethey 1969–75, 3:153–54; Gentili 1980a, 147ff.

133. Neumann 1962, 19, with a different interpretation.
134. Vasari 1878–85, 7:459; Rosand 1982.
135. Rearick 1968; Baldass 1955; Burckhardt 1930ff., 12:298.
136. Burckhardt 1930ff., 12:405.
137. Ridolfi 1914–24, 1:390 n. 1.
138. Ridolfi 1914–24, 1:392–93.
139. Ridolfi 1914–24, 1:385.
140. Ridolfi 1914–24, 1:398.
141. Survey in R. Pallucchini 1981, 19ff.

142. Posner 1971, 47ff.
143. Mason Rinaldi 1984, 138ff.; Ridolfi 1914–24, 2:180–81.
144. Ridolfi 1914–24, 2:203.
145. Ridolfi 1914–24, 2:179.
146. Graeve 1958; R. Pallucchini and Rossi 1982, 234.
147. Timofiewitsch 1972b, 134ff.; R. Pallucchini and Rossi 1982, 234; Swoboda 1971; Cope 1979, 204ff.
148. Ivanoff 1975.

BIBLIOGRAPHY

Abbreviations used in the bibliography

Atti Ist. Ven.	Atti dell'Istituto Veneto di Scienze, Lettere ed Arti
Boll. C.I.S.A.	Bollettino del Centro Internazionale di Studi di Architettura "Andrea Palladio"
Boll. M.C. Correr	Bollettino dei Musei Civici Veneziani
Boll. M.C. Correr, N.S.	Civici Musei Veneziani d'Arte e di Storia, Bollettino
J.W.C.I.	Journal of the Warburg and Courtauld Institutes
Jb. Preuss. Ksln.	Jahrbuch der Königlich Preussischen Kunstsammlungen
Mitt. K.I.F.	Mitteilungen des Kunsthistorischen Institutes in Florenz
N. Arch. Ven.	Nuovo Archivio Veneto
Not. Pal. Alb.	Notizie da Palazzo Albani
Quad. Sopr. BB. AA. SS. Ven.	Quaderni della Sopraintendenza ai Beni Artistici e Storici di Venezia
Saggi Mem.	Saggi e Memoria di Storia dell'Arte
Zsch. Kg.	Zeitschrift für Kunstgeschichte

Ackerman, James S. 1967. *Palladio's Villas.* New York.

————. 1977. "Palladio e lo sviluppo della concezione della chiesa a Venezia." *Boll. C.I.S.A.* 19:9–34.

————. 1980. "Observations on Renaissance Church Planning in Venice and Florence, 1470–1570." In *Florence and Venice: Comparisons and Relations,* vol. 2, *The Cinquecento,* 287–307. Florence.

————. 1982. "The Geopolitics of Venetian Architecture in the Time of Titian." In *Titian: His World and His Legacy,* ed. David Rosand, 41–71. New York.

Alberti, Leone Battista. 1966. *L'architettura (De re aedificatoria).* Ed. G. Orlandi and P. Portoghesi. Milan.

Albrecht-Bott, Marianne. 1976. *Die Bildende Kunst in der italienischen Lyrik der Renaissance und des Barock: Studien zur Beschreibung von Porträts und anderen Bildwerken unter besonderer Berücksichtigung von G. B. Marinos "Galleria."* Wiesbaden.

Algarotti, Francesco. 1831. "Saggio sulla pittura." In *Scrittori di belle arti,* 499–530. Milan.

Ambrosini, Federica. 1981. "'Descrittioni del mondo' nelle case venete dei secoli XVI e XVIII." *Archivio Veneto,* 5th ser., 112, no. 152:67–79.

Anderson, Jaynie. 1977. "*Christ Carrying the Cross* in San Rocco: Its Commission and Miraculous History." *Arte Veneta* 31:186–88.

————. 1978. "The Giorgionesque Portrait, from Likeness to Allegory." In *Giorgione: Convegno Internazionale di Studi,* 140–53. Castelfranco Veneto.

————. 1979. "A Further Inventory of Gabriele Vendramin's Collection." *Burlington Magazine* 121:639–44.

Andrea Palladio: The Portico and the Farmyard. 1975. Catalogue by H. Burns in collaboration with L. Fairbairn and B. Boucher. London.

Anonimo Morelli. *Notizie d'opere di disegno.* 1888. Ed. Frimmel. Vienna.

Antonello da Messina. 1982. Exhibition catalogue, Messina.

Appuhn, Horst, and Christian von Heusinger. 1976. *Riesenholzschnitte und Papiertapeten der Renaissance.* Unterschneidheim.

Architettura e utopia nella Venezia del Cinquecento. 1980. Milan.

Aretino, Pietro. 1957–60. *Lettere sull'arte.* Ed. F. Pertile and E. Camesasca. Milan.

Armani, Emanuele, and Mario Piana. 1984. "Primo inventario degli intonaci e delle decorazioni esterne dell'architettura veneziana." *Ricerche di Storia dell'Arte* 24:44–54.

Armenini, Giovanni Battista. 1587. *Dei veri precetti della pittura.* Ravenna.

Arslan, Edoardo. 1957. "Un documento del Sansovino e Giangiacomo de' Grigi." In *Studi in onore di Mons. Carlo Castiglioni,* 27–30. Milan.

————. [1960]. *I Bassano.* Milan.

————. 1970. *Venezia gotica: L'architettura civile gotica veneziana.* Milan.

Auerbach, Erich. 1959. *Mimesis: Dargestellte Wirklichkeit in der abendländischen Literatur.* 2d ed. Bern.

Badt, Kurt. 1981. *Paolo Veronese.* Cologne.

Bailey, Stephen. 1977. "Metamorphoses of the Grimani *Vitellius.*" *J. Paul Getty Museum Journal* 5:105–22.

Bailo, Luigi, and Gerolamo Biscaro. 1900. *Della vita e delle opere di Paris Bordone.* Treviso.

Baldass, Ludwig. 1955. "Les tableaux champêtres des Bassanos et la peinture réaliste des pays bas au XVIe siècle." *Gazette des Beaux-Arts* 45:143–60.

Baldoria, N. 1891. "Andrea Briosco ed Alessandro Leopardi architetti." *Archivio Storico dell'Arte* 4:180–94.

Banks, Elaine. 1978. "Tintoretto's Religious Imagery of the 1560s." Diss., Princeton University.

Barash, Moshe. 1978. *Light and Color in the Italian Renaissance Theory of Art*. New York.

Barbaro, Daniele. 1556. *I dieci libri dell'architettura di M. Vitruvio tradotti e commentati da Mons. Daniele Barbaro* Venice.

————. 1567. *M. Vitruvii Pollionis De architectura libri decem*. Venice.

Barbieri, Francesco. 1967. "Francisco Zamberlan architetto de la Rotonda." In *La Rotonda di Rovigo*, 37–72. Vicenza.

Bardi, Girolamo. 1587. *Dichiaratione di tutte le Istorie che si contengono nei quadri posti nuovamente nelle sale dello Scrutinio e del Gran Consiglio del palagio ducale della Serenissima Repubblica di Vinegia*. Venice.

Barocchi, Paola, ed. 1960–62. *Trattati d'arte del Cinquecento: Fra manierismo e controriforma*. Bari.

————. [1971–77]. *Scritti d'arte del Cinquecento*. Milan and Naples.

Bassi, Elena. 1963. "Il Sansovino per l'ospizio degli Incurabili." *Critica d'Arte*, n.s., 10, nos. 57–58:46–62.

————. 1964. "Palazzo Morosini dal Giardin." *Critica d'Arte* n.s., 11, nos. 65–66:31–39.

————. 1971. *Il Convento della Carità*. Vicenza.

————. [1976]. *Palazzi di Venezia: Admiranda Urbis Venetae*. Venice.

————. 1982. *Tre palazzi veneziani della Regione Veneto: Balbi, Flangini-Morosini, Molin*. Venice.

Battilotti, Franca, and Maria Teresa Franco. 1978. "Registro di committenti e dei primi collezionisti di Giorgione." *Antichità Viva* 17, no. 4–5:58–86.

Baxandall, Michael. 1971. *Giotto and the Orators: Humanist Observers of Painting in Italy and the Discovery of Pictorial Composition, 1350–1450*. Oxford.

————. 1972. *Painting and Experience in Fifteenth-Century Italy*. Oxford.

Beck, James H. 1967–68. "A Notice for the Early Career of Pietro Lombardo." *Mitt. K.I.F.* 13:189–92.

Bellavitis, Giorgio. 1980. *Venezia*. [Vincenza].

————. 1983. *L'Arsenale di Venezia: Storia di una grande struttura urbana*. Venice.

Bellocchi, Ugo. 1969. *Le ville di Anton Francesco Doni*. Modena.

Belting, Hans. 1981. *Das Bild und sein Publikum im Mittelalter: Form und Funktion früher Bildtafeln der Passion*. Berlin.

————. 1985. *Giovanni Bellini: Pietà, Ikone, und Bilderzählung in der venezianischen Malerei*. Frankfurt.

Beltrami, Daniele. 1954. *Storia della popolazione di Venezia dalla fine del secolo XVI alla caduta della repubblica*. Padua.

————. 1961. *Forze di lavoro e proprietà fondiaria nelle campagne venete dei secoli XVII e XVIII*. Civiltà veneziana, studi 12. Venice and Rome.

Beltrami, Luca. 1900. *La Cà del Duca sul Canal Grande ed altre reminiscenze sforzesche in Venezia (Nozze L. Albertini–P. Giacosa)*. Milan.

————. 1906. *La Cà del Duca sul Canal Grande ed altre reminiscenze sforzesche in Venezia*. 2d ed. Milan.

Bentmann, Reinhard, and Michael Müller. 1970. *Die Villa als Herrschaftsarchitektur: Versuch einer kunst- und sozialgeschichtlichen Analyse*. Frankfurt am Main.

————. 1972. "Materialien zur italienischen Villa der Renaissance." *Architectura* 2:167–91.

Berchet, Federico. 1892. "Relazione sugli scavi in Piazza S. Marco." In *Monumenti storici pubblicati dalla R. Deputazione Veneta di Storia Patria*, 4th ser., vol. 12. Venice.

Bercken, Erich von der. 1942. *Die Gemälde des Jacopo Tintoretto*. Munich.

Bercken, Erich von der, and August L. Mayer. 1923. *Jacopo Tintoretto*. Munich.

Berenson, Bernard. 1957a. *Italian Paintings of the Renaissance: Venetian School*. London.

————. 1957b. *Lorenzo Lotto: Gemälde und Zeichnungen*. Cologne.

Berger, Ursel. 1978. *Palladios Frühwerk: Bauten und Zeichnungen*. Vienna.

Berliner, Rudolf. 1919–20. "Die Tätigkeit Tintorettos in der Scuola di S. Rocco." *Kunstchronik und Kunstmarkt*, n.s., 31, no. 55:468–73, 492–97.

Bernicoli, Silvio. 1929. "Nel vecchio sepolcro di Dante." *Felix Ravenna*, no. 33:90–91.

Bertolotti, A. 1890. *Figuli, fonditori, e scultori in relazione con la corte di Mantova nei secoli XV, XVI, XVII: Notizie e documenti raccolti negli archivi mantovani*. Milan.

Bertos, R. N. 1976. "A Short Note on the Bacchanal of the Andrians." *Mitt. K.I.F.* 20:407–10.

Bertotti Scamozzi, Ottavio. 1776. *Le fabbriche e i disegni di Andrea Palladio raccolti ed illustrati da O. B. S.* Vicenza.

Bialostocki, Jan. 1978. "Le vocabulaire visuel de Jacopo Bassano et son stilus humilis." *Arte Veneta* 32:169–73.

————. 1983. "Die Kirchenfassade als Ruhmesdenkmal des Stifters: Eine Besonderheit der Baukunst Venedigs." *Römisches Jahrbuch für Kunstgeschichte* 20:3–16.

Biscaro, Gerolamo. 1898a. "Lodovico Marcello e la chiesa e commenda Gerosolomitana di S. Giovanni dal Tempio ora S. Gaetano di Treviso." *N. Arch. Ven.* 8, no. 16, pt. 1:111–49.

————. 1898b. "Lorenzo Bregno e l'altare di S. Sebastiano." *Gazzetta di Treviso*, May 7–8.

————. 1899. *Note storico artistiche sulla Cattedrale di Treviso*. Offprint. Venice.

Biscontin, Guido, Mario Piana, and Gianna Riva. 1981. "Research on Limes and Intonacoes of the Historic Venetian Architecture." In *Symposium, Mortars, Cements, and Grouts Used in the Conservation of Historical Buildings*, November 3–6, ICCROM. Offprint. Rome.

Blake-Wilk, Sarah. 1984. "La decorazione cinquecentesca della Cappella dell'Arca di S. Antonio." In *Le sculture del Santo a Padova*, ed. G. Lorenzoni, 109–71. Vicenza.

Bonfanti, Sicinio. 1930. *La Giudecca nella storia, nell'arte, nella vita*. Venice.

Boni, Giacomo. 1883. "Il colore sui monumenti." *Archivio Veneto* 25, no. 13, pt. 1:344–60.

————. 1887. "Santa Maria dei Miracoli in Venezia." *Archivio Veneto* 33, no. 16, pt. 1:236–74.

Bonicatti, Maurizio. 1964. *Aspetti dell'umanesimo nella pittura veneta dal 1455 al 1515*. Rome.

Bordone, Benedetto. 1528. *Libro di Benedetto Bordone nel quale si ragiona di tutte l'isole del mondo con li lor nomi antichi et moderni*. Venice.

Borghini, Raffaelo. 1584. *Il Risposo*. Florence.

Boschieri, Giacomo. 1931. "Il Palazzo Grimani a San Luca." *Rivista di Venezia* 10:461–90.

Boschini, Marco. 1966. *La carta del navegar pittoresco.* Ed. Anna Pallucchini. Venice and Rome.

Bosisio, Achille. 1943. *La chiesa di S. Maria del Rosario o dei Gesuati.* Venice.

Bottari, Giovanni, and Stefano Ticozzi. 1822–25. *Raccolta di lettere sulla pittura, scultura, ed architettura.* Milan.

Botteon, V., and A. Aliprandi. 1893. *Ricerche intorno alla vita e alle opere di Giambattista Cima.* Conegliano.

Boucher, Bruce. 1976–79. "Jacopo Sansovino and the Choir of St. Mark's." *Burlington Magazine* 118:552–65, and 121:155–68.

———. 1984. "Jacopo Sansovino e la scultura veneziana del manierismo." In *Cultura e società nel Rinascimento tra riforma e manierismi,* ed. V. Branca and C. Ossola, 335–50. Florence.

Braghirolli, Willelmo. 1877. "Carteggio di Isabella d'Este Gonzaga intorno ad un quadro di Giambellino." *Archivio Veneto* 13:370–83.

Brand, Hans Gerhard. [1977]. *Die Grabmonumente Pietro Lombardos: Studien zum venezianischen Wandgrabmal des späten Quattrocento.* Diss. print, Augsburg.

Braun, Joseph. 1924. *Der christliche Altar in seiner geschichtlichen Entwicklung.* Munich.

Braunfels, Wolfgang. 1964. "Die 'inventio' des Künstlers: Reflexionen über den Einfluss des neuen Schaffensideals auf die Werkstatt Raffaels und Giorgiones." In *Festschrift Ludwig H. Heydenreich,* 20–28. Munich.

Bresciani Alvarez, Giulio. 1980. "Alvise Cornaro e la fabbrica del Duomo di Padova." In *Alvise Cornaro e il suo tempo,* 58–62. Padua.

Brown, Patricia Fortini. 1984. "Painting and History in Renaissance Venice." *Art History* 7:263–94.

Brunelli, Bruno, and Adolfo Callegari. 1931. *Ville del Brenta e degli Euganei.* Milan.

Buddensieg, Tilman. 1976. "Criticism of Ancient Architecture in the Sixteenth and Seventeenth Century." In *Classical Influences on European Culture A.D. 1500–1700: Proceedings of an International Conference Held at Kings College, Cambridge, 1974,* ed. R. R. Bolgar, 335–48. Cambridge.

Burckhardt, Jacob. 1930ff. *Gesamtausgabe.* Ed. Heinrich Wölfflin. Berlin and Leipzig.

———. 1950. *The Civilization of the Renaissance in Italy.* Translated by S. G. C. Middlemore. New York.

Burger, Fritz. N.d. *Die Villen des Andrea Palladio: Ein Beitrag zur Entwicklungsgeschichte der Architektur.* Foreword dated 1909. Leipzig.

Burke, Peter. 1972. *Culture and Society in Renaissance Italy 1420–1540.* London.

Burns, H. See *Andrea Palladio.*

Busch, Renate von. 1973. *Studien zu deutschen Antikensammlungen des 16. Jahrhunderts.* Diss. print, Tübingen.

Bush, Virginia. 1976. *The Colossal Sculpture of the Cinquecento.* New York.

Cadorin, Giuseppe. 1833. *Dello amore ai veneziani di Tiziano Vecellio.* Venice.

———. 1838. *Pareri di XV architetti e notizie intorno al Palazzo Ducale di Venezia.* Venice.

Caffi, Michele. 1884. "Guglielmo Bergamasco ossia Vielmo Vielmi d'Alzano." *Archivio Veneto* 28, no. 14, pt. 1:30–42.

———. 1885. *I Solari: Artisti lombardi nella Venezia.* Special printing. Milan.

———. 1892. "Guglielmo Bergamasco ossia Vielmo Vielmi di Alzano, architetto e scultore del secolo XVI." *N. Arch. Ven.* 3, no. 2, pt. 1:157–79.

Caiani, Anna. 1968. "Un palazzo veronese a Murano: Note e aggiunte." *Arte Veneta* 22:47–59.

Calabi, Donatella. 1982 [published 1985]. "La direzione del nuovo ponte di Rialto e il 'negotio' degli stabili di San Bartolomeo." *Boll. M.C. Correr,* n.s., 27:55–66.

Cali, Maria. 1980. "La 'religione' di Lorenzo Lotto." In *Lorenzo Lotto: Atti del Convegno Internazionale di Studi,* 243–77. Asolo.

———. 1984. "Loreto: La conclusione della vicenda religiosa di Lorenzo Lotto." *Not. Pal. Alb.* 13:113–32.

Caliari, Pietro. 1888. *Paolo Veronese: Sua vita e sue opere.* Rome.

Campana, Augusto. 1962. "Notizie sulla *Pietà* Riminese di Giovanni Bellini." In *Scritti di storia dell'arte in onore di Mario Salmi,* 2:405–27. Rome.

Il campanile di San Marco riedificato: Studi, ricerche, relazioni. 1912. 2d ed. Venice.

Campbell, Lorne. 1981. "Notes on Netherlandish Pictures in the Veneto in the Fifteenth and Sixteenth Centuries." *Burlington Magazine* 123:467–73.

Campori, Giuseppe. 1871. "Danese Cattaneo: Scultore e poeta del XVI secolo." Offprint from *Il Buonarotti,* 2d ser., vol. 6 (1871). Rome.

———. 1873. *Una statua di Jacopo Sansovino.* Modena. Reprinted from *Atti e memorie delle R. Deputazioni di Storia Patria per le Provincie Modenesi e Parmensi.*

———. 1874. "Tiziano e gli estensi." *Nuovo Antologia* 27:581–620.

Canova, Antonio. 1975. *Ville del Polesine.* Rovigo.

Canova, Giordana. 1964. *Paris Bordone.* Venice.

Caravia, Alessandro. 1541. *Il sogno del Caravia.* Venice.

Carpeggiani, Paolo. 1977. "G. M. Falconetto: Temi ed eventi di una nuova architettura civile." In *Padova: Case e palazzi,* ed. L. Puppi and F. Zuliani, 71–99. Vicenza.

Carpi, Piera. 1930. "Nuove notizie e documenti intorno a Giovanni Minello e all'arte del suo tempo." *Bollettino del Museo Civico di Padova,* n.s., 6, 10–21.

Cassini, Giocondo. 1971. *Piante e vedute prospettiche di Venezia (1479–1855).* Venice.

———. 1982. *Piante e vedute prospettiche di Venezia (1479–1855).* Venice.

I catasti storici di Venezia: 1803–1913. 1981. Ed. I. Pavanello with an introduction by E. R. Trincanato and text by E. Concina. 1981. Rome.

Cavalca, Carla. 1959. "Evoluzione della casa rurale veneta: Brevi cenni storici." *Candida,* 25–44.

Cavazzana Romanelli, Francesca. 1983. "Il refettorio d'estate nel convento dei Frari a Venezia ora sede dell'archivio di stato: Storia e restauri." *Bollettino d'Arte,* supp., 5:13–32.

Cecchetti, Bartolomeo. 1871. "La vita dei veneziani fino al secolo XIII." *Archivio Veneto* 2, pt. 1:63–123.

———. 1886. "Documenti per la storia della fabbrica della

chiesa di S. Zaccaria, della Cappella Emiliana nell'isola di S. Michele, e della chiesa di S. Salvatore in Venezia." *Archivio Veneto* 31, no. 16, pt. 1:495–97.

Cesariano, Cesare. 1521. *Vitruvius Lucius Pollio: De architectura lib. X: Tradotto dal latino in volgare da C. C.* Como. Cf. the annotated edition by H. Krinsky, 1969, Munich.

Cessi, Francesco. 1960–62. *Alessandro Vittoria.* Trento.

Cessi, Roberto, and Annibale Alberti. 1934. *Rialto: L'isola, il ponte, il mercato.* Bologna.

Cevese, Renato. [1971]. *Ville della provincia di Vicenza.* Milan.

Chambers, D. S. 1971. *Patrons and Artists in the Italian Renaissance.* Columbia, S.C.

Chiminelli, Caterina. 1912. "Le scale scoperte nei palazzi veneziani." *Ateneo Veneto* 1, no. 35:209–53.

Cian, V. 1887. "Pietro Bembo e Isabella d'Este Gonzaga." *Giornale storico della letteratura italiana* 9:81–136.

Cicogna, Emmanuele Antonio. 1824–53. *Delle iscrizioni veneziane.* Venice.

———. 1847. *Saggio di bibliografia veneziana.* Venice.

Cicognara, Leopoldo, Antonio Diedo, and Giannantonio Selva. 1815–20. *Le fabbriche più cospicue di Venezia misurate, illustrate, ed intagliate dai membri della Veneta Reale Accademia di Belle Arti.* Venice.

Clark, Kenneth. 1962. *Landschaft wird Kunst.* Cologne.

Cocke, Richard. 1972. "Veronese and Daniele Barbaro: The Decoration of Villa Maser." *J.W.C.I.* 35:226–46.

———. 1977. "Veronese's Independent Chiaroscuro Drawings." *Master Drawings* 15:259–67.

———. 1980. *Veronese.* London.

———. 1984. *Veronese's Drawings.* London.

Cohen, Charles E. 1980. *The Drawings of Giovanni Antonio da Pordenone. Corpus Graphicum 3.* Florence.

Coletti, Luigi. 1941. "La crisi manieristica nella pittura veneziana." *Convivium* 13:109–26.

———. 1953. *Pittura veneta del Quattrocento.* Novara.

Commynes, Philippe de. 1924–25. *Mémoires.* Ed. Joseph Calmette. Paris.

Concina, Ennio. 1982. *Structure urbaine et fonctions des bâtiments du XVIe au XIXe siècle: Une recherche a Venise.* Venice.

———. 1983. *La macchina territoriale: La progettazione della difesa nel Cinquecento veneto.* Bari.

———. 1984a. *L'Arsenale della Repubblica di Venezia.* 2d ed. Milan.

———. 1984b. "Fra oriente e occidente: Gli Zen, un palazzo e il mito di Trebisonda." In *"Renovatio urbis," Venezia nell'età di Andrea Gritti (1523–1538),* ed. Manfredo Tafuri, 265–90. Rome.

Connell, Susan Mary. 1976. "The Employment of Sculptors and Stone Masons in Venice in the Fifteenth Century." Thesis, Warburg Institute, London.

Contarini, Pietro. [1542]. *Argo Volgar.* Venice.

Cope, Maurice Erwin. 1979. *The Venetian Chapel of the Sacrament in the Sixteenth Century.* New York and London.

Corner, Flaminio. 1749. *Ecclesiae venetae antiquis monumentis nunc etiam primum editis.* Venice.

Cortesi Bosco, Francesca. 1983. "Est in una carta disegnato el coro de le sedi da torno . . . per l'adaptar de le istorie." *Not. Pal. Alb.* 12:103–26.

Costantini, Giovanni. 1912. *La chiesa di S. Giacomo dall'Orio.* Venice.

Costantini, Massimo. 1984. *L'acqua di Venezia: L'approvvigionamento idrico della Serenissima.* Venice.

Cozzi, Gaetano. 1970. "Domenico Morosini e il *De bene instituta Re Publica.*" *Studi Veneziani* 12:405–58.

———. 1980. "La donna, l'amore, e Tiziano." In *Tiziano e Venezia: Convegno Internazionale di Studi, Venezia 1976,* 47–63. Venice.

Crosato, Luciana. 1962. *Gli affreschi nelle ville venete del Cinquecento.* Treviso.

Crovato, Giorgio and Maurizio. 1978. *Isole abbandonate della laguna: Com'erano e come sono.* Padua.

Crowe, J. A., and G. B. Cavalcaselle. 1877–78. *Tiziano: La sua vita e i suoi tempi.* Florence.

Da Holanda, Francesco. 1964. *Dialoghi romani con Michelangelo.* Ed. E. A. Barelli. Milan.

Dalla Costa, Mario, and Cesare Feiffer. 1981. *Le pietre dell'architettura veneta e di Venezia.* Venice.

Dal Mas, Mario. 1976. "Giovanni Candi, architetto veneziano." *Quaderni dell'Istituto di Storia dell'Architettura,* 22d ser., nos. 127–32:27–54.

Damerini, Gino. N.d. *Il Palazzo Balbi "in volta de Canal" a Venezia nel restauro dell'architetto S. Mantegazza.* Milan and Rome.

Da Mosto, Andrea. 1937–40. *L'archivio di Stato di Venezia: Indice generale, storico, descrittivo, ed analitico.* Rome.

———. 1939. *I dogi di Venezia con particolare riguardo alle loro tombe.* Venice.

———. [1966]. *I dogi di Venezia nella vita pubblica e privata.* Milan.

D'Arco, Carlo. 1857. *Delle arti e degli artefici di Mantova: Notizie raccolte ed illustrate con disegni e documenti.* Mantua.

Da Tiziano a El Greco: Per la storia del manierismo a Venezia 1540–1590. 1981. Exhibition catalogue, Venice.

Davies, Martin. 1965. *National Gallery Catalogues: The Earlier Italian Schools,* 2d ed. London.

Davis, Charles. 1976. "'Colossum facere ausus est': L'apoteosi d'Hercole e il colosso padovano dell'Ammannati." *Psicon* 3:33–47.

Dazzi, Manlio. 1939–40. "Sull'architetto del Fondaco dei Tedeschi." *Atti Ist. Ven.* 99, pt. 2:873–96.

Degenhart, Bernhard, and Annegrit Schmitt. 1984. *Jacopo Bellini: Der Zeichnungsband des Louvre.* Munich.

Delle cose notabili della città di Venezia etc. 1583. Venice.

Dellwing, Herbert. 1970. *Studien zur Baukunst der Bettelorden im Veneto: Die Gotik der monumentalen Gewölbebasiliken.* Munich and Berlin.

———. 1974. "Die Kirche San Zaccaria in Venedig: Eine ikonologische Studie." *Zsch. Kg.* 37:224–34.

Demus, Otto. 1960. *The Church of San Marco in Venice: History, Architecture, Sculpture.* Washington.

De Tolnay, Charles. 1965. "A Forgotten Architectural Project by Michelangelo: The Choir of the Cathedral of Padova." In *Festschrift für Herbert von Einem zum 16.2.1965,* 247–51. Berlin.

Dietro i palazzi: Tre secoli di architettura minore a Venezia, 1492–1803: Itinerari di storia e arte, ed. Giorgio Gianighian and Paola Pavanini. 1984. Venice.

Difesa della sanità a Venezia (secoli XIII–XIX): Mostra documentaria. 1979. Venice.

Dilthey, Wilhelm. 1957. "Weltanschauung und Analyse des Menschen seit Renaissance und Reformation." In *Gesammelte Schriften,* vol. 2. Stuttgart and Göttingen.

Dionisotti, Carlo. 1976. "Tiziano e la letteratura. *Lettere Italiane* 28:403–9.

Dittmar, Peter. 1984. "Die dekorative Skulptur der venezianischen Frührenaissance." *Zsch. Kg.* 47:158–85.

Dolce, Lodovico. 1960. "Dialogo della pittura intitolato l'Aretino, Venezia, 1557." In *Trattati d'arte del Cinquecento,* ed. Paola Barocchi, 1:143–206. Bari.

Doni, Anton Francesco. 1555. *La seconda libreria del Doni.* Venice.

Dorigo, Wladimiro. 1983. *Venezia origini: Fondamenti, ipotesi, metodi.* Milan.

Douglas, Hugh A. 1907. *Venice on Foot with the Itinerary of the Grand Canal and Several Direct Routes to Useful Places.* London.

Dresdner, Albert. 1915. *Die Entstehung der Kunstkritik.* Munich.

Dreyer, Peter. N.d. *Tizian und sein Kreis. 50 venezianische Holzschnitte aus dem Berliner Kupferstichkabinett, Staatliche Museen Preussischer Kunstbesitz.* Berlin.

Dürer, Albrecht. 1956. *Schriftlicher Nachlass.* Vol. 1. Ed. H. Rupprich. Berlin.

Dussler, Luitpold. 1935. *Giovanni Bellini.* Frankfurt am Main.

———. 1949. *Giovanni Bellini.* Vienna.

———. 1942. *Sebastiano del Piombo.* Basel.

Dvořák, Max. 1927–28. *Geschichte der italienischen Kunst.* Munich.

Egan, Patricia. 1959. "'Poesia' and 'Fête Champêtre.'" *Art Bulletin* 41:303–13.

———. 1961. "'Concert' Scenes in Musical Paintings of the Italian Renaissance." *Journal of the American Musicological Society* 14:184–95.

Eikemeier, Peter. 1969. "Der Gonzaga Zyklus des Tintoretto in der Alten Pinakothek." *Münchener Jahrbuch der Bildenden Kunst,* 3d ser., 20:75–142.

Einem, Herbert von. 1960. *Karl V. und Tizian.* Cologne and Opladen.

Fabriczy, Cornelius von. 1904. "Michelozzo di Bartolomeo." *Jb. Preuss. Ksln.,* supp., 25:34–110.

Fapanni, F. 1880–81. "Degli some [?] di terra dalla Repubblica di Venezia." *Bullettino di Arti, Industrie, e Curiosità Veneziane* 3:72–84.

Favaro, Antonio. 1905. "Notizie storiche sul Magistrato Veneto alle Acque." *N. Arch. Ven.,* n.s., 9, no. 5, pt. 2:179–99.

Favaro, Elena. 1975. *L'arte die pittori a Venezia e i suoi statuti.* Florence.

Fechner, Heinz. 1969. *Rahmen und Gliederung venezianischer Anconen aus der Schule von Murano.* Diss. philosophy, Munich.

Fehl, Philipp. 1957. "The Hidden Genre: A Study of the Concert Champêtre in the Louvre." *Journal of Aesthetics and Art Criticism* 16:153–68.

———. 1961. "Veronese and the Inquisition: A Study of the Subject Matter of the So-called 'Feast in the House of Levi.'" *Gazette des Beaux-Arts* 58:325–54.

———. 1969. "Realism and Classicism in the Representation of a Painful Scene: Titian's *Flaying of Marsyas* in the Archepiscopal Palace at Krosmericz." In *Czechoslovakia Past and Present,* 2:1387–1415.

———. 1974. "The Worship of Bacchus and Venus in Bellini's and Titian's Bacchanals for Alfonso d'Este." *Studies in the History of Art* 6:37–95.

———. 1977. "Iconography or Ekphrasis: The Case of the Neglected Cows in Titian's *Rape of Europe.*" In *Actas del XXIII congreso de historia del arte, Espana entre el Mediterraneo y el Atlantico,* 260–77. Granada.

Fehl, Philipp, and Paul F. Watson. 1976. "Ovidian Delight and Problems in Iconography: Two Essays on Titian's *Rape of Europe.*" *Storia dell'Arte* 26:23–30.

Fehring, Günter P. 1956. *Studien über die Kirchenbauten des Francesco di Giorgio.* Diss. print, Würzburg.

Fernow, Carl Ludwig. 1806. *Römische Studien,* 2d pt. Zurich.

Ferriguto, Arnaldo. 1933. *Attraverso i misteri di Giorgione.* Castelfranco Veneto.

Filarete, Antonio. 1972. *Trattato di architettura.* Ed. Maria Finoli and Liliana Grassi. Milan.

Fiocco, Giuseppe. 1939. *Giovanni Antonio da Pordenone.* Udine.

———. 1953. "Da Ravenna ad Aquileia: Contributo alla storia dei campanili cilindrici." In *Studi aquileiesi offerti il 7 ott. 1953 a Giovanni Brusin etc.,* 373–83. Aquileia.

———. 1965. *Alvise Cornaro: Il suo tempo e le sue opere.* Vicenza.

Fisher, M. Roy. 1976. *Titian's Assistants during the Later Years.* New York.

Fletcher, Jennifer M. 1971. "Isabella d'Este and Giovanni Bellini's 'Presepio.'" *Burlington Magazine* 113:703–12.

Fogolari, Gino. 1924. "La chiesa di Santa Maria della Carità di Venezia." *Archivio Veneto-Tridentino* 5:57–119.

———. 1949. *I Frari e i SS. Giovanni e Paolo.* Milan.

Fomiciova, Tamara. 1980. "Giorgione e la formazione della pittura di genere nell'arte veneziana del XVI secolo." In *Giorgione: Convegno Internazionale di Studi,* 159–64.

Fontana, Renzo. 1980. "'Solo, senza fidel governo et molto inquieto de la mente': Testimonianze archivistiche su alcuni amici di Lotto processati per eresia." In *Lorenzo Lotto: Atti del Convegno Internazionale di Studi,* 279–97. Asolo.

Fontana, Vincenzo. 1978. "'Arte' e 'Isperienza' nei trattati d'architettura veneziani del Cinquecento." *Architectura* 8:49–72.

———. 1980. "Costruire a Venezia nel Cinquecento: Progetto, materiali, cantiere, e teoria in Palazzo Grimani a S. Luca." In *Atti del 1o congresso nazionale di storia dell'arte, Consiglio Naz. delle ricerche (Quaderni del "La Ricerca scientifica," 106), Roma 1978,* 41–53. Rome.

———. 1981. "Venezia e la laguna nel Cinquecento." *Casabella* 45, no. 465:12–15.

Forestiere illuminato intorno le cose più rare e curiose antiche e moderne della città di Venezia, e dell'isole circonvicine. 1765. Venice.

Forssman, Erik. 1965. *Palladios Lehrgebäude: Studien über den Zusammenhang von Architektur und Architekturtheorie bei Andrea Palladio.* Stockholm.

———. 1967a. "Palladio e la pittura a fresco." *Arte Veneta* 21:71–76.

———. 1967b. "Über Architekturen in der venezianischen

Malerei des Cinquecento." *Wallraf-Richartz-Jahrbuch* 29: 105–39.

Forster, Michael. 1969. "Zur gegenständlichen Deutung zweier Blätter aus dem Londoner 'Skizzenbuch' des Marco Zoppo." *Wiener Jahrbuch für Kunstgeschichte* 22:167–68.

Foscari, Antonio. 1975. "Per Palladio: Note sul Redentore a S. Vidal e sulle Zitelle." *Antichità Viva* 14, no. 3: 44–56.

———. 1983. "Altre schede veneziane su Jacopo Sansovino." *Not. Pal. Alb.* 12:135–52.

Foscari, Antonio, and Manfredo Tafuri. 1981. "Un progetto irrealizzato di Jacopo Sansovino: Il Palazzo di Vettor Grimani sul Canal Grande." *Boll. M.C. Correr,* n.s., 26, nos. 1–4: 71–87.

———. 1982 (published 1984). "Evangelismo e architettura: Jacopo Sansovino e la chiesa di San Martino a Venezia." *Boll. M.C. Correr,* n.s., 27:34–54.

———. 1983. *L'armonia e i conflitti: La chiesa di San Francesco della Vigna nella Venezia del '500.* Turin.

Foscari, Lodovico. 1936. *Affreschi esterni a Venezia.* Milan.

Foster, Philip. 1973. "Per il disegno dell'ospedale di Milano." *Arte Lombarda* 18:1–22.

Frankl, Paul. 1914. *Die Entwicklungsphasen der neueren Baukunst.* Leipzig.

Franzoi, Umberto. 1970. "Le prigioni." In *Piazza San Marco,* 173–75. Padua.

Franzoi, Umberto, and Dina Di Stefano. 1975. *Le chiese di Venezia.* Venice.

Franzoni, Lanfranco. 1981. "Antiquari e collezionisti nel Cinquecento." In *Storia della cultura veneta,* 3:207–66. Vicenza.

Freedberg, J. F. 1975. *Painting in Italy, 1500 to 1600.* 2d ed. Harmondsworth, England.

Freedberg, S. J. 1980. "Disegno versus Colore in Florentine and Venetian Painting of the Cinquecento." In *Florence and Venice: Comparisons and Relations,* vol. 2, *The Cinquecento,* 309–22. Florence.

Friedländer, Walter. 1965. "Titian and Pordenone." *Art Bulletin* 47:118–21.

Frizzoni, Gustavo. 1884. *Anonimo Morelliano: Notizie d'opere di disegno pubblicata e illustrat da D. J. Morelli.* 2d ed., rev. etc. Bologna.

Galicciolli, Giambattista. 1795. *Delle memorie venete antiche, profane ed ecclesiastiche.* Venice.

Gallimberti, Nino. 1963. "La tradizione architettonica religiosa tra Venezia e Padova." *Bollettino del Museo Civico di Padova* 52:115–92.

Gallo, Luigi. 1964. *Lido di Venezia, Abazia S. Nicolò.* Venice.

Gallo, Rodolfo. 1938. "Corte Colonne a Castello e le case della Marinarezza veneziana." *Ateneo Veneto* 123, no. 129:5–12.

———. 1952. "Le donazioni alla Serenissima di Domenico e Giovanni Grimani." *Archivio Veneto* 50–51:34–77.

———. 1955. "Andrea Palladio e Venezia: Di alcuni edifici del Palladio ignoti o mal noti." *Rivista di Venezia,* n.s., 1:23–48.

———. 1957. "Contributi su Jacopo Sansovino." *Saggi Mem.* 1:83–105.

———. 1958–59. "La loggia e la facciata della Chiesa di S. Basso e B. Longhena." *Atti Ist. Ven.* 117:179–202.

———. 1960. "Michele Sanmicheli a Venezia." In *Michele Sanmicheli: Studi raccolti dall'Accademia di Agricoltura,*

Scienze, e Lettere di Verona per la celebrazione del IV centenario della morte,* 97–160. Verona.

———. 1961–62a. "L'architettura di transizione dal Gotico al Rinascimento e Bartolomeo Buon." *Atti Ist. Ven.* 120:187–204.

———. 1961–62b. "La Scuola Grande di San Teodoro di Venezia." *Atti Ist. Ven.* 120:461–95.

Gandolfo, Francesco. 1978. *Il "Dolce Tempo": Mistica, ermetismo, e sogno nel Cinquecento.* Rome.

Gardani, Dante Luigi. 1961. *La Chiesa di S. Maria della Presentazione (delle Zitelle) in Venezia.* Venice.

Gattinoni, Gregorio. 1910. *La Campanile di San Marco.* Monografia storica. Venice.

Gaurico, Pomponio. 1969. *De sculptura (1504).* Edited, annotated, and translated by A. Chastel and R. Klein. Geneva.

Gaye, Giovanni. 1839–40. *Carteggio inedito d'artisti dei secoli XIV, XV, XVI.* Florence.

The Genius of Venice 1500–1600. 1964. London.

Gentili, Augusto. 1980a. *Da Tiziano a Tiziano: Mito e allegoria nella cultura veneziana del Cinquecento.* Milan.

———. 1980b. "'Virtus' e 'Voluptas' nell'opera di Lorenzo Lotto." In *Lorenzo Lotto: Atti del Convegno Internazionale di Studi,* 415–24. Asolo.

Gerola, Guiseppe. 1924–25. "Nuovi documenti veneziani su Alessandro Vittoria." *Atti Ist. Ven.* 84:339–59.

Gianighian, Giorgio. 1983. "Scarichi veneziani in epoca moderna: Canoni da acqua, canoni da necessario." *Studi Veneziani,* n.s., 7:161–82.

Gianighian, Giorgio, and Paola Pavanini. 1984. "I terreni nuovi de Santa Maria Mazor." In *Dietro i palazzi,* 45–52. Venice.

Gibbons, Felton. 1963. "New Evidence for the Birth of Gentile and Giovanni Bellini." *Art Bulletin* 45:54–58.

———. 1965. "Practices in Giovanni Bellini's Workshop." *Pantheon* 23:146–55.

———. 1977. "Giovanni Bellini's Topographical Landscapes." In *Studies in Late Medieval and Renaissance Paintings in Honor of Meillard Meiss,* 174–84. New York.

Gilbert, Creighton. 1949. "Antique Frameworks for Renaissance Art Theory: Alber and Pino." *Marsyas* 3:87–106.

———. 1952. "On Subject and Non-subject in Italian Renaissance Pictures." *Art Bulletin* 34:202–16.

———. 1974. "Last Suppers and Their Refectories." In *The Pursuit of Holiness in Late Medieval and Renaissance Religion,* ed. Charles Trinkaus and Heiko A. Oberman, 371–402. Leiden.

———. 1977. "Peintres et menuisiers au début de la Renaissance en Italie." *Revue de l'Art* 37:9–28.

———. 1978. "Bonifazio and Bassano ca. 1533." *Arte Veneta* 22:127–33.

———. 1980. "Some Findings on Early Works of Titian." *Art Bulletin* 62:36–75.

Gilbert, Felix. 1973. "Venice and the Crisis of the League of Cambrai." In *Renaissance Venice,* ed. John R. Hale, 274–97. London.

Gilio, Giovanni Andrea. 1961. *Dialogo nel quale si ragiona degli errori e degli abusi de' pittori circa l'istorie* In *Trattati d'arte del Cinquecento,* ed. Paola Barocchi, vol. 2. Bari.

Ginzburg, Carlo. 1980. "Tiziano, Ovidio, e i codici della figurazione erotica nel '500." In *Tiziano e Venezia: Convegno Internazionale di Studi, Venezia, 1976,* 125–35. Venice.

Fra Giocondo. 1513. *Vitruvius iterum et Frontinus a Iocondo revisi repurgatique quantum ex collatione licuit.* Florence.

Giorgione: Convegno Internazionale di Studi. 1978. Castelfranco Veneto.

Giorgione e l'umanesimo veneziano. 1981. Ed. R. Pallucchini. Florence.

Giorgione: La Pala di Castelfranco Veneto. 1978. Venice.

Gleria, Giovanni Battista. 1983. "Il progetto Scamozziano per la chiesa della Celestia a Venezia." *Ricerche di Storia dell'Arte* 21:97–109.

Godby, Michael. 1980. "A Note on Schiacciato." *Art Bulletin* 62:635–37.

Goffen, Rona. 1975. "Icon and Vision: Giovanni Bellini's Half-Length Madonnas." *Art Bulletin* 57:487–518.

Golubew, Victor. 1908–12. *Die Skizzenbücher Jacopo Bellinis.* Brussels.

Gombrich, Ernst H. 1966. "The Renaissance Theory of Art and the Rise of Landscape." In *Norm and Form: Studies in the Art of the Renaissance,* by Gombrich. London.

———. 1967. "Celebrations in Venice of the Holy League and of the Victory of Lepanto." In *Studies in Renaissance and Baroque Art Presented to Anthony Blunt,* 62–68. London and New York.

Gosebruch, Martin. 1958. "Florentinische Kapitele von Brunelleschi bis zum Tempio Malatestiano und der Eigenstil der Frührenaissance." *Römisches Jahrbuch* 8:63–193.

Gould, Cecil. 1967. "Observations on the Role of Decoration in the Formation of Veronese's Art." In *Essays in the History of Art Presented to Rudolf Wittkower,* 123–27. London.

———. 1975. *The Sixteenth-Century Italian Schools.* National Gallery Catalogue. London.

———. 1976. *Titian as a Portraitist.* London.

Grabski, Josef. 1980a. "The Group of Paintings by Tintoretto in the Scala Terrena in the Scuola di San Rocco in Venice and Their Relationship to the Architectural Structure." *Artibus et Historiae* 1:115–31.

———. 1980b. "Sul rapporto fra ritratto e simbolo nella ritrattistica del Lotto." In *Lorenzo Lotto: Atti del Convegno Internazionale di Studi,* 383–92. Asolo.

Graeve, Mary Anne. 1958. "The Stone of Unction in Caravaggio's Painting for the Chiesa Nuova." *Art Bulletin* 40:223–38.

Gramaccini, Norbert. 1982. "Wie Jacopo Bellini Pisanello besiegte." *Idea* 1:27–53.

Gramigna, Silvia, Annalisa Perissa, and Gianni Scarabello. 1981. *Scuole di arti e mestieri e devozione a Venezia.* Venice.

Grendler, Paul F. 1969. *Critics of the Italian World (1530–1560): Anton Francesco Doni, Nicolò Franco, and Ortensio Lando.* Madison, Wis.

———. 1977. *The Roman Inquisition and the Venetian Press, 1450–1605.* Princeton, N.J.

Greppi, Crescentio. 1913. "Le case degli Sforza a Venezia a Fra Simone da Camerino." *N. Arch. Ven.,* n.s., 26, no. 13, pt. 1:324–59.

Grigioni, Carlo. 1899. "Jacopo Bianchi scultore veneto del secolo XVI." *Rassegna Bibliografica dell'arte Italiana* 2:1–8.

———. 1910. "Un'opera ignota di Lorenzo Bregno." *L'Arte* 13:42–48.

Gronau, Georg. 1928. *Spätwerke des Giovanni Bellini.* Strasbourg.

———. 1930. "Die Statue des Federigo da Montefeltre im herzöglichen Palast von Urbino." *Mitt. K.I.F.* 3:254–67.

———. [1935]. *Documenti artistici urbinati.* Florence.

Guiotto, Mario. 1943. "I resti di Cà Magno in Corte della Terrazza." *Le Tre Venezie* 18:75–76.

Guisconi, Anselmo [Francesco Sansovino]. 1556. *Tutte le cose notabili e belle che sono in Venetia etc.* Venice.

Günther, Hubertus. 1981. "Studien zum venezianischen Aufenthalt des Sebastiano Serlio." *Münchener Jahrbuch der Bildenden Kunst* 32:42–94.

Hadeln, Detlef von. 1911. "Beiträge zur Tintorettoforschung." *Jb. Preuss. Ksln.* 32:25–58.

———. 1925. *Venezianische Zeichnungen der Hochrenaissance.* Berlin.

———. 1978. *Paolo Veronese.* Florence.

Hall, Marcia B. 1974. "The Ponte in S. Maria Novella: The Problem of the Road Screen in Italy." *J.W.C.I.* 37:157–73.

Hamilton, Paul C. 1983. "The Palazzo dei Camerlenghi in Venice." *Journal of the Society of Architectural Historians* 42:258–71.

Hartt, Frederick. 1940. "Carpaccio's Meditations on the Passion." *Art Bulletin* 22:25–35.

Haskell, Francis. 1980. "Titian: A New Approach?" In *Tiziano e Venezia: Convegno Internazionale di Studi, Venezia 1976,* 41–46. Venice.

Haug, Ingrid. 1969. *Pete Speeth Architekt (1772–1831).* Diss. print, Bonn.

Haussherr, Reiner. 1982. *Convenevolezza: Historische Angemessenheit in der Darstellung von Kostüm und Schauplatz seit der Spätantike bis ins 16. Jahrhundert.* Mainz and Wiesbaden.

Hegel, Georg Wilhelm Friedrich. 1975. *Aesthetics: Lectures on Fine Art.* Trans. T. M. Knox. Oxford.

Heidrich, Ernst. 1908. *Albrecht Dürers schriftlicher Nachlass.* Berlin.

Heinemann, Fritz. [1962]. *Bellini e i Belliniani.* Venice.

Heinse, Wilhelm. 1975. *Ardinghello.* Ed. M. L. Baeumer. Stuttgart.

Hemsoll, David. 1982. "A Celebration of Venetian Architecture." Review of *Venetian Architecture of the Early Renaissance* by John McAndrew. *Art History* 5:120–24.

Hetzer, Theodor. 1920. *Tizian: Die frühen Gemälde; Eine stilkritische Untersuchung.* Basel.

———. 1935. *Tizian: Geschichte seiner Farbe.* Frankfurt am Main.

———. 1957. *Aufsätze und Vorträge.* Vol 1. Leipzig.

Hiesinger, Kathryn B. 1976. "The Fregoso Monument: A Study in Sixteenth-Century Tomb Monuments and Catholic Reform." *Burlington Magazine* 118:283–93.

Hills, Paul. 1983. "Piety and Patronage in Cinquecento Venice: Tintoretto and the Scuole del Sacramento." *Art History* 6:30–43.

Hirst, Michael. 1981. *Sebastiano del Piombo.* Oxford.

Hirthe, Thomas. 1982. "Mauro Codussi als Architekt des Dogenpalastes." *Arte Veneta* 36:31–44.

———. 1985. "Die Markusbibliothek in Venedig: Studien zu ihrer Architektur und Ausstattung." Diss. T. U. Berlin.

Hood, William E., Jr. 1977. "Titian's Narrative Art in Some Religious Paintings for Venetian Patrons 1518–1545." Diss., New York.

Hood, William, and Charles Hope. 1977. "Titian's Vatican Altarpiece and the Pictures Underneath." *Art Bulletin* 59: 534–52.

Hope, Charles. 1971. "The 'Camerini d'Alabastro' of Alfonso d'Este." *Burlington Magazine* 113:641–50, 712–21.

———. 1977. "A Neglected Document about Titian's *Danaë* in Naples." *Arte Veneta* 31:188–89.

———. 1980a. "Problems of Interpretation in Titian's Erotic Paintings." In *Tiziano e Venezia: Convegno Internazionale di Studi, Venezia 1976*, 113–23. Venice.

———. 1980b. *Titian.* London.

———. 1980c. "Titian's Role as Official Painter to the Venetian Republic." In *Tiziano e Venezia: Convegno Internazionale di Studi, Venezia 1976*, 301–5. Venice.

———. 1985. Review of *Der Bilderschmuck des Dogenpalastes* by Wolfgang Wolters. *Kunstchronik* 38:331–36.

Hospitale S. Mariae Cruciferorum: L'ospizio dei Crociferi a Venezia. 1984. Ed. Silvia Lunardon. Venice.

Howard, Deborah. 1973. "Sebastiano Serlio's Venetian Copyrights." *Burlington Magazine* 115:512–16.

———. 1975. *Jacopo Sansovino: Architecture and Patronage in Renaissance Venice.* New Haven and London.

———. 1980. *The Architectural History of Venice.* London.

———. 1984. "Jacopo Sansovino's House at San Trovaso." In *Interpretazioni veneziane*, ed. David Rosand, 241–55. Venice.

Hubala, Erich. 1965. "Venedig." In *Reclams Kunstführer Italien II*, 1:606–1006. Stuttgart.

———. 1969. *Giovanni Bellini: Mutter und Kind.* Stuttgart.

Humfrey, Peter. 1983. *Cima da Conegliano.* Cambridge.

Huse, Norbert. 1972. *Studien zu Giovanni Bellini.* Berlin.

———. 1974. "Palladio und die Villa Barbaro in Maser: Bemerkungen zum Problem der Autorschaft." *Arte Veneta* 28:106–22.

———. 1977. "Anmerkungen zu Burckhardts 'Kunstgeschichte nach Aufgaben.'" In *Festschrift Wolfgang Braunfels*, ed. Friedrich Piel and Jörg Träger, 157–66. Tübingen.

———. 1979. "Palladio am Canal Grande." *Städel Jahrbuch*, n.s., 7:61–99.

Hüttinger, Eduard. 1962. *Die Bilderzyklen Tintorettos in der Scuola di S. Rocco.* Zurich.

Interpretazioni veneziane: Studi di storia dell'arte in onore di Michelangelo Muraro. 1984. Ed. David Rosand. Venice.

Isermeyer, Christian Adolf. 1963. *Verrocchio und Leopardi: Das Reiterdenkmal des Colleoni.* Stuttgart.

———. 1968. "Le chiese del Palladio in rapporto al culto." *Boll. C.I.S.A.* 10:42–58.

———. 1972. "La concezione degli edifici sacri Palladiani." *Boll. C.I.S.A.* 14:105–35.

Ivanoff, Nicola. 1975. "Il ciclo eucaristico di S. Giorgio Maggiore a Venezia." *Not. Pal. Alb.* 4:50–57.

Jestaz, Bertrand. 1982. "Requiem pour Alessandro Leopardi." *Revue de l'Art* 55:23–34.

———. N.d. "La Chapelle Zen a Saint-Marc de Venise: D'Antonio a Tullio Lombardo."

Jung, Eva Maria. 1953. "On the Nature of Evangelism in Sixteenth-Century Italy." *Journal of the History of Ideas* 14: 511–27.

Justi, Carl. 1933. *Velazquez und sein Jahrhundert.* Zurich.

Justi, Ludwig. 1926. *Giorgione.* 2d ed. Berlin.

Kahr, Madlyn. 1966. "Titian's Old Testment Cycle." *J.W.C.I.* 29:193–205.

———. 1970. "The Meaning of Veronese's Paintings in the Church of San Sebastiano in Venice." *J.W.C.I.* 33:235–47.

Karpinski, Caroline. 1976. "Some Woodcuts after Early Designs of Titian." *Zsch. Kg.* 39:258–74.

Keller, Fritz Eugen. 1971. "Alvise Cornaro zitiert die Villa des Marcus Terentius Varro in Cassino." *L'Arte* 9–10:29–53.

Keller, Harald. 1969. *Tizians "Poesie" für König Philipp II. von Spanien.* Wiesbaden.

Kemp, Martin. 1977. "From 'Mimesis' to 'Fantasia': The Quattrocento Vocabulary of Creation, Inspiration, and Genius in the Visual Arts." *Viator* 8:347–98.

Kemp, Wolfgang. 1974. "Disegno: Beiträge zur Geschichte des Begriffs zwischen 1547 und 1607." *Marburger Jahrbuch für Kunstwissenschaft* 19:219–40.

Kinney, Peter. 1976. *The Early Sculpture of Bartolomeo Ammannati.* New York and London.

Klauner, Friederike. 1958. "Venezianische Landschaftsdarstellung von Jacopo Bellini bis Tizian." *Jb. Kh. Sln. Wien* 54:121.

Klein, Robert. 1967. "Die Bibliothek von Mirandola und das Giorgione zugeschriebene 'Concert Champêtre.'" *Zsch. Kg.* 30:199–206.

Kleinschmidt, Irene. 1977. *Gruppenvotivbilder venezianischer Beamter (1550–1630): Tintoretto und die Entwicklung einer Aufgabe.* Venice.

Knöpfel, Dagmar. 1984. "Su i dipinti di Tintoretto per il coro della Madonna dell'Orto." *Arte Veneta* 38:149–54.

Kolb Lewis, Carolyn. 1969. "Portfolio for the Villa Priuli: Dates, Documents, and Designs." *Boll. C.I.S.A.* 11:353–69.

———. 1977. *The Villa Guistiniani al Roncade.* New York and London.

———. 1984. "New Evidence for Villa Pisani at Montagnana." In *Interpretazioni veneziane*, ed. David Rosand, 227–39. Venice.

Körte, Werner. 1937. "Deutsche Vesperbilder in Italien." *Kunstgeschichtliches Jahrbuch der Biblioteca Hertziana* 1:3–138.

Krautheimer, Richard. 1965. *Early Christian and Byzantine Architecture.* Baltimore.

Kretschmayr, Heinrich. 1905–34. *Geschichte von Venedig.* Gotha and Stuttgart.

Kubelik, Martin. 1977. *Die Villa im Veneto: Zur typologischen Entwicklung im Quattrocento.* Munich.

Kultzen, Rolf, and Peter Eikemeier. 1971. *Venezianische Gemälde des 15. und 16. Jahrhunderts, Bayerische Staatsgemäldesammlungen, Alte Pinakothek München.* Munich.

Kurneta, Anthony Edwards. 1976. "The Palazzo Loredan in the Campo Santo Stefano: Counter-currents in Sixteenth-Century Venetian Architecture." Diss., Boston University.

Lattanzi, Marco. 1981. "La pala di San Giovanni Crisostomo di Giovanni Bellini: Il soggetto, la committenza, il significato." *Artibus et Historiae* 4:29–38.

Lauritzen, Peter, and Alexander Zielcke. 1980. *Venezianische Paläste.* 2d ed. Munich.

Lauts, Jan. 1962. *Carpaccio: Gemälde und Zeichnungen, Gesamtausgabe.* Cologne.

Lazzarini, Lorenzo. 1978. "La frequenza, le cause e forme di degrado dei marmi e delle pietre di origine greca a Venezia." *Quad. Sopr. BB. AA. SS. Ven.* 7:139–50.

———. 1981. "I materiali lapidei delle vere da pozzo veneziane e la loro conservazione." In *Vere da pozzo di Venezia*, ed. Alberto Rizzi, 373–84.

Lazzarini, Vittorio. 1920. "Antiche leggi venete intorno a proprietari nella terraferma." *N. Arch. Ven.*, 2d ser., 21, no. 38:5–31.

Leithe-Jasper, Manfred. 1963–65. "Alessandro Vittoria: Beiträge zu einer Analyse des Stils seiner figürlichen Plastiken unter Berücksichtigung der Beziehungen zur gleichzeitigen Malerei in Venedig." *Mitteilungen der Gesellschaft für vergleichende Kunstforschung in Wien* 16–17:26–33.

Lenz, Christian. 1969. *Veroneses Bildarchitektur*. Bremen.

L'Eremita. 1891. "Dissertazione sui Campanili di Venezia con un appendice sopra i comignoli ed Alture." *La Scintilla* 4, no. 30. Extract.

Levey, Michael. 1965. "Tintoretto and the Theme of Miraculous Intervention." *Journal of the Royal Society of Arts* 113:707–25.

Levi, Cesare Augusto. 1895. *Notizie storiche di alcune antiche scuole d'arti e mestieri scomparse o esistenti ancora in Venezia.* 3d ed. Venice.

———. 1900. *Le collezioni veneziane d'arte e d'antichità dal secolo XVI ai nostri giorni.* Venice.

Lewis, Douglas. 1972. "Un disegno autografo del Sanmicheli e la notizia del committente del Sansovino per S. Francesco della Vigna." *Boll. M.C. Correr*, n.s., 17, nos. 3–4:7–36.

———. 1981. *The Drawings of Andrea Palladio (Exhibition Washington DC, 1981–1982).* Baltimore.

———. 1982a. "Jacopo Sansovino, Sculptor of Venice." In *Titian: His World and His Legacy*, ed. David Rosand, 133–90. New York.

———. 1982b. "Palladio's Painted Architecture." In *Vierhundert Jahre Andrea Palladio (1580–1980)*, 59–74. Heidelberg.

Lewis-Kolb. See Kolb Lewis.

Lieberman, Ralph Eric. 1972. "The Church of Santa Maria dei Miracoli in Venice." Doctoral diss., New York University. Microfilm.

———. 1977. "Venetian Church Architecture around 1500." *Boll. CISA* 19:35–48.

———. 1982. *Renaissance Architecture in Venice.* New York.

Logan, Oliver. 1972. *Culture and Society in Venice 1470–1790: The Renaissance and Its Heritage.* London.

Lomazzo, Giovanni Paolo. 1584. *Trattato dell'arte della pittura.* Milan.

———. 1590. *Idea del tempio della pittura . . .* Milan.

Longhi, Roberto. 1946. "Viatico per cinque secoli di pittura veneziana." Florence.

———. 1978. *Ricerche sulla pittura veneta 1946–1969.* Florence.

Lorenz, Hellmut. 1976. "Zur Architektur L. B. Albertis: Die Kirchenfassaden." *Wiener Jahrbuch für Kunstgeschichte* 29:65–99.

———. 1980. "Überlegungen zum venezianischen Palastbau der Renaissance." *Zsch. Kg.* 43:33–53.

Lorenzetti, Giulio. 1910a. "'Jacopo Sansovino Scultore': Note ed appunti." *N. Arch. Ven.*, n.s., 20, no. 10, pt. 1:314–40.

———. 1910b. "La Loggetta al Campanile di S. Marco." *L'Arte* 13:108–33.

———. 1925. "Gli affreschi della facciata del Palazzo Trevisan a Murano." In *Scritti storici in onore di Camillo Manfroni nel XL anno di insegnamento*, 431–42. Padua.

———. 1926. *Venezia e il suo estuario: Guida storico artistica.* Venice.

———. 1929. *Itinerario Sansoviniano a Venezia.* Venice.

———. 1932. "Il palazzo cinquecentesco dei Coccina-Tiepolo-Papadopoli ed il suo autore." *Rivista d'Arte* 14:75–109.

———. 1942–43. "Di un disperso cielo pittorico cinquecentesco nel vestibolo della Libreria di San Marco a Venezia." *Atti Ist. Ven.* 102:419–70.

———. 1956. *Venezia e il suo estuario: Guida storico-artistica.* 2d ed. Rome.

Lorenzi, Giambattista. 1868. *Monumenti per servire alla storia del Palazzo Ducale di Venezia . . .* Venice.

Lotto, Lorenzo. 1969. *Il "Libro di spese diverse" con aggiunta di lettere ed altri documenti.* Ed. P. Zampetti. Venice and Rome.

Lotz, Wolfgang. 1967. "Sansovinos Bibliothek von San Marco und die Stadtbaukunst der Renaissance. In *Kunst des Mittelalters in Sachsen: Festschrift Wolf Schubert*, 336–43. Weimar.

Lotz, Wolfgang, and Ludwig Heinrich Heydenreich. 1974. *Architecture in Italy, 1400 to 1600.* Harmondsworth, England.

Lovarini, Emilio. 1899. "Intorno un progetto del Sansovino per il Duomo di Padova." *Atti e Memorie della R. Accademia di Scienze, Lettere, ed Arti in Padova* 15:221–29.

Ludwig, Gustav. 1901–2. "Bonifazio de Pitati da Verona: Eine archivalische Untersuchung." *Jb. Preuss. Ksln.* 22:61–87, 23:36–66.

———. 1905. "Archivalische Beiträge zur Geschichte der venezianischen Malerei." *Jb. Preuss. Ksln.*, supp., 26:1–159.

———, in collaboration with F. Rintelen. 1906. "Venezianischer Hausrat zur Zeit der Renaissance: Restello, Spiegel, und Toilettenutensilien in Venedig zur Zeit der Renaissance." In *Italienische Forschungen*, ed. Institute of Art History in Florence, 1:171–387.

———. 1911. *Archivalische Beiträge zur Geschichte der venezianischen Kunst aus dem Nachlass Gustav Ludwigs. Italienische Forschungen*, ed. Kunsthistorischen Institut Florenz, vol. 4. Berlin.

Ludwig, Gustav, and Pompeo Molmenti. 1910. *Vittore Carpaccio: La vie et l'oeuvre du peintre.* Paris.

Luzio, A. 1888. "Isabella d'Este e due grandi quadri di Giorgione." *Archivio Storico dell'Arte* 1:47–48.

Luzio, Alessandro. 1890. "Fasti gonzagheschi dipinti dal Tintoretto." *Archivio Storica dell'Arte* 3:397–400.

Luzio, Alessandro, and Rodolfo Renier. 1888. "Di Pietro Lombardo architetto e scultore veneziano." *Archivio Storico dell'Arte* 1:433–38.

McAndrew, John. 1969. "Sant'Andrea della Certosa." *Art Bulletin* 51:15–28.

———. 1980. *Venetian Architecture of the Early Renaissance.* Cambridge, Mass., and London.

Macchioni, S. 1979. "Danese Cattaneo." In *Dizionario biografico degli italiani* 22:449–52.

Machiavelli, Niccolò. 1843. "Discorsi sopra la prima deca di Tito Livio." In *Opere complete.* Florence.

McTavish, David. 1981. *Giuseppe da Porta Called Salviati.* New York and London.

Maek-Gérard, Michael. 1980. "Die 'Milanexi' in Venedig: Ein Beitrag zur Entwicklungsgeschichte der Lombardi-Werkstatt." *Wallraf-Richartz-Jahrbuch* 41:105–30.

Malsburg, Raban von der. 1976. *Die Architektur der Scuola Grande di San Rocco in Venedig.* Diss. print, Heidelberg.

Mangini, Nicola. 1974. *I teatri di Venezia.* Milan.

Mango, Cyril. 1963. "Antique Statuary and the Byzantine Beholder." *Dumbarton Oakes Papers* 17:53–75.

Marco Cornaro (1412–1464): Scritture sulla Laguna. 1919. Ed. Giuseppe Pavanello. Venice.

Marek, Michaela J. 1985. *Ekphrasis und Herrscherallegorie: Antike Bildbeschreibungen bei Tizian und Leonardo.* Worms.

Maretto, Paolo. 1978. *L'edilizia gotica veneziana.* 2d ed. Venice.

Mariacher, Giovanni. 1958. *Camini d'ogni tempo e paese.* Milan.

———. 1959. "Contributi sull'attività di scultori Caronesi e Comaschi a Venezia ne sec. XV–XVI." In *Arte e artisti dei laghi lombardi,* 1:191–206.

Mariani Canova, Giordana. 1969. *La miniatura veneta del Rinascimento 1450–1500.* Venice.

Markham Schulz, Anne. 1978a. *Niccolò di Giovanni Fiorentino and Venetian Sculpture of the Early Renaissance.* New York.

———. 1978b. *The Sculpture of Giovanni e Bartolomeo Bon and Their Workshop.* Transactions of the American Philosophical Society. Philadelphia.

———. 1980. "Giambattista Bregno." *Jahrbuch der Berliner Museen* 22:173–202.

———. 1981. "Pietro Lombardo's Barbarigo Tomb in the Venetian Church of S. Maria della Carità." In *Art the Ape of Nature: Studies in Honor of H. W. Janson,* ed. M. Barasch, L. F. Sandler, and P. Egan, 171–92. New York.

———. 1983a. *Antonio Rizzo: Sculptor and Architect.* Princeton, N.J.

———. 1983b. "The Bettignoli Bressa Altar and Other Works by Giambattista Bregno." *Arte Cristiana* 71, no. 694:35–48.

———. 1983c. "Giovanni Buora lapicida." *Arte Lombarda* 65:49–72.

———. 1984a. "Bartolomeo di Francesco Bergamasco." In *Interpretazioni veneziane,* ed. David Rosand, 257–74. Venice.

———. 1984b. "Lorenzo Bregno." *Jahrbuch der Berliner Museen* 26:143–79.

Marx, Barbara. 1978. *Venezia: Altera Roma? Ipotesi sull'umanesimo veneziano.* Venice.

Marzemin, Giuseppe. 1912. "Le abbazie veneziane dei SS. Ilario e Benedetto e di S. Gregorio." *N. Arch. Ven.,* n.s., 23, no. 12:96–162, 351:407.

Maschio, Ruggero. 1980. "Rialto." In *Architettura e utopia nella Venezia del Cinquecento,* 119–22. Milan.

Mason Rinaldi, Stefania. 1975. "La Capella del SS. Sacramento in San Zulian." *Atti Ist. Ven.* 134:439–56.

———. 1978. "Contributi d'archivio per la decorazione pittorica della Scuola di San Giovanni Evangelista." *Arte Veneta* 32:293–301.

———. 1979. "Le immagini della peste nella cultura figurativa veneziana." In *Venezia e la peste 1348–1797,* 209–86. Venice.

———. 1984. *Palma il Giovane: L'opera completa.* Milan.

Mayekawa, Seiro. 1979. "Giorgiones *Tempesta* und Dürer." In *Giorgione: Convegno Internazionale di Studi,* 105–8. Castelfranco Veneto.

Mazza, Angelo. 1981. "La pala dell' 'Elemosina di Sant'Antonio' nel dibattito cinquecentesco sul pauperismo." In *Lorenzo Lotto: Atti del Convegno Internazionale di Studi,* 347–64. Asolo.

Mazzariol, Giuseppe, and Terisio Pignatti. 1963. *La pianta prospettica di Venezia del 1500 disegnata da Jacopo de' Barbari.* Venice.

Mazzi, Giuliana. 1973. "Note per una definizione della funzione viaria di Venezia." *Archivio Veneto,* 5th ser., 104, no. 99: 5–30.

———. 1974. "Gli esemplari della pianta prospettica di Jacopo de' Barbari al Museo Correr: Esercizio di lettura sui modi di viabilità pedonale a Venezia." *Boll. M.C. Correr,* n.s., 19: 17–36.

Mazzotti, Giuseppe. 1954. *Le ville venete.* 3d ed. Treviso.

Meiss, Millard. 1964. *Giovanni Bellini's St. Francis in the Frick Collection.* Princeton, N.J.

———. 1976. "Sleep in Venice." In *The Painter's Choice: Problems in the Interpretation of Renaissance Art,* by Meiss, 212–40. New York.

Meli, Angelo. 1965. "Capella Colleoni: I tre santi dell'ancona." *Bergomum* 59:3–46.

Meller, Peter. 1977. "Marmi e bronzi di Simone Bianco." *Mitt. K.I.F.* 21:199–210.

Menegazzi, Luigi. 1981. *Cima da Conegliano.* Treviso.

Meneghin, Vittorino. 1962. *S. Michele in Isola di Venezia.* Venice.

Mercklin, Eugen von. 1962. *Antike Figuralkapitelle.* Berlin.

Meyer zur Capellen, Jürg. 1971. "Überlegungen zu Tizians *Pietà.*" *Münchener Jahrbuch für Bildende Kunst,* 3d ser., 22:117–32.

———. 1980a. "Bellini in der Scuola Grande di San Marco." *Zsch. Kg.* 43:104–8.

———. 1980b. "Beobachtungen zu Jacopo Pesaros Exvoto in Antwerpen." *Pantheon* 38:144–52.

———. 1981. "Zum venezianischen Dogenbildnis in der zweiten Hälfte des Quattrocento." *Konsthistorisk Tidskrift* 50: 70–86.

———. 1985. *Gentile Bellini.* Stuttgart.

Milani, Luigi A. 1900. "Il motivo e il tipo della Vergine de' Medici illustrati da due monumenti inediti." In *Strena Helbigiana,* 188–97. Leipzig.

Miozzi, Eugenio. 1957–69. *Venezia nei secoli.* Venice.

Molmenti, Pompeo. 1888. "I pittori Bellini: Ricerche e documenti." *Archivio Veneto* 38:219–34.

———. 1892. "I pittori Bellini: Ricerche e documenti." In *Studi e ricerche di storia e d'arte,* 107–36. Rome.

———. 1927–29. *La storia di Venezia nella vita privata dalle origini alla caduta della repubblica.* 7th ed. Bergamo.

Monticolo, Giovanni. 1905. *I capitolari delle arte veneziane sottoposte alla Giustizia e poi alla Giustizia Vecchia.* Rome.

Morachiello, Paolo. 1983. "Rialto: Le misure del ponte in legno e il primo progetto di Andrea Palladio." *Arte Veneta* 37: 175–79.

Moro, M. 1859. *Venezia monumentale pittoresca.* Ed. G. Kier. Venice.

Morosini, Domenico. 1969. *De bene instituta Re Publica.* Ed. Claudio Finzi. Milan.

Moschetti, Andrea. 1913–14. "Un quadriennio di Pietro Lombardo a Padova (1464–1467) con una appendice sulla data di nascita e di morte di Bartolomeo Bellano." *Bollettino del Museo Civico di Padova* 16:1–99, 17:1–43.

———. 1927–28. "Pietro e altri lapicidi lombardi a Belluno." *Atti Ist. Ven.* 87, pt. 2:1481–1515.

Moschini Marconi, Sandra. 1955. *Gallerie dell'Accademia di Venezia: Opere d'arte dei secoli XIV e XV.* Rome.

———. 1962. *Gallerie dell'Accademia di Venezia: Opere d'arte del secolo XVI.* Rome.

Mothes, Oscar. 1859. *Geschichte der Baukunst und Bildhauerei Venedigs.* Leipzig.

Mozzi, Ugo. 1927. *I magistrati veneti alle acque e alle bonifiche.* Bologna.

Muir, Edward. 1981. *Civic Ritual in Renaissance Venice.* Princeton, N.J.

Munman, Robert. 1976. "Giovanni Buora: The 'Missing' Sculpture." *Arte Veneta* 30:41–61.

———. 1977. "The Last Work of Antonio Rizzo." *Arte Lombarda,* n.s., 47–48:89–98.

———. 1979. "The Sculpture of Giovanni Buora: A Supplement." *Arte Veneta* 33:19–28.

Muraro, Michelangelo. 1961. "The Statutes of the Venetian "Arti" and the Mosaics of the Mascoli Chapel." *Art Bulletin* 153:263–74.

———. 1966. "Civiltà delle ville venete." In *Arte in Europa: Scritti di storia dell'arte in onore di Edoardo Arslan,* 533–43. Milan.

———. 1970. *Palazzo Contarini a San Beneto.* Venice.

———. 1971. "Vittore Carpaccio o il teatro in pittura." In *Studi sul teatro veneto fra Rinascimento ed età barocca,* ed. M. T. Muraro. Florence.

———. 1975. "The Political Interpretation of Giorgione's Frescoes of the Fondaco dei Tedeschi." *Gazette des Beaux-Arts* 76:177–84.

Muraro, Michelangelo, and David Rosand. 1976. *Tiziano e la silografia veneziana del Cinquecento.* Venice.

Muratori, Saverio. 1960. *Studi per una operante storia urbana di Venezia.* Rome.

Muttoni, Francesco. 1740–47. *Architettura di Andrea Palladio vicentino di nuovo ristampata . . . con le osservazioni dell'architetto N. N.* Venice.

Nani-Mocenigo, Filippo. 1877. *Capitulare dei Signori di Notte.* Venice.

Neumann, Jaromir. 1962. *Titian: The Flaying of Marsyas.* London.

Newett, Margaret. 1902. "The Sumptuary Laws of Venice in the Fourteenth and Fifteenth Centuries." In *Historical Essays of the Owens College Manchester,* 245–78. London.

Niero, Antonio. 1965. *La Chiesa dei Carmini: Storia e arte.* Venice.

———. 1979. "Il capitello nella storia della religiosità popolare veneziana." In *I capitelli e la società religiosa veneta,* 21–60. Vicenza.

———. 1982. "I pergoli palladiani di San Zulian." In *Palladio e Venezia,* ed. L. Puppi, 133–38. Florence.

———. 1984. "Pietà liturgica e pietà popolare nel 'Vesperbild'

di Tiziano." In *Interpretazioni veneziane,* ed. David Rosand, 323–29. Venice.

Niero, Antonio, and Gastone Vio. 1981. *La Chiesa dello Spirito Santo in Venezia.* Venice.

Nordenfalk, Carl. 1952. "Titian's Allegories on the Fondaco dei Tedeschi." Gazette des beaux-arts, 6 pér., 11:101–8.

Oberhuber, Konrad. 1968. "J. H. Cock, Battista Pittoni, und Paolo Veronese in der Villa Maser." In *Minuscula discipulorum: Festschrift für Hans Kauffmann,* 207–14. Berlin.

Odenthal, Anna Maria. 1985. *Die Kirche San Giovanni Crisostomo in Venedig: Ein Beitrag zur venezianischen Sakralarchitektur des späten 15. Jahrhunderts.* Diss. print, Bonn.

Olivato, Loredana. 1971. "Per il Serlio a Venezia: Documenti nuovi e documenti rivisitati." *Arte Veneta* 25:284–91.

———. 1973. "'Sententiato a morir hozi de marti . . . ,' nota su Bartolomeo Sforza, miniatore e falsario padovano del Rinascimento." *Bollettino del Museo Civico di Padova* 62:7–28.

———. 1978. "Castelli, Francesco." *Dizionario biografico degli italiani* 21:714–16.

———. 1980. "La submersione di Pharaone." In *Tiziano e Venezia: Convegno Internazionale di Studi, Venezia 1976,* 529–37. Venice.

Orlandini, G. 1914. *La Capella Corner nella Chiesa dei Santi Apostoli in Venezia.* Venice.

Ost, Hans. 1983. "Tizians sogenannte 'Venus von Urbino' und andere Buhlerinnen." *Festschrift für Eduard Trier zum 60. Geburtstag,* 129–50. Berlin.

Paleotti, Gabriele. 1961. "Discorso intorno alle immagini sacre e profane." In *Trattati d'arte del Cinquecento,* ed. Paola Barocchi, 2:117–509. Bari.

Palladio, Andrea. 1570. *I quattro libri dell'architettura.* Venice.

Pallucchini, Anna. 1972. "Venezia religiosa nella pittura del Cinquecento." *Studi veneziani* 14:159–84.

Pallucchini, Rodolfo. 1950. *La giovinezza del Tintoretto.* Milan.

———. 1959. *Giovanni Bellini.* Milan.

———. 1962. *I Vivarini (Antonio, Bartolomeo, Alvise).* Venice.

———. 1969. *Tiziano.* Florence.

———. 1981. *La pittura veneziana del Seicento.* Milan.

———. 1984. *Veronese.* Milan.

Pallucchini, Rodolfo, and Paola Rossi. 1982. *Tintoretto: Le opere sacre e profane.* Milan.

Palumbo Fossati, Isabella. 1984. "L'interno della casa dell'artigiano e dell'artista nella Venezia del Cinquecento." *Studi veneziani,* n.s., 8:109–53.

Panofsky, Erwin. 1969. *Problems in Titian: Mostly Iconographic.* New York.

Paoletti, Pietro. 1893. *L'architettura e la scultura del Rinascimento a Venezia.* Venice.

———. 1894. *Raccolta di documenti inediti per servire alla storia della pittura veneziana nei secoli XV e XVI.* Padua.

———. 1929. *La Scuola Grande di San Marco.* Venice.

Paoletti, Peitro, and Gustav Ludwig. 1899. "Neue archivalische Beiträge zur Geschichte der venezianishcen Malerei." *Repertorium für Kunstwissenschaft* 22:252–78, 427–57.

Paolillo, Domenico Roberto, and Carlo Dalla Santa. [1971]. *Il Palazzo Dolfin Manin a Rialto: Storia di una antica dimora veneziana.* Venice.

Paschini, Pio. 1943. *Domenico Grimani, Cardinale di San Marco (†1523).* Rome.

Paul, Eberhard. 1982. *Gefälschte Antike von der Renaissance bis zur Gegenwart.* Vienna and Munich.

Pauly, Charlotte Elfriede. 1916. *Der venezianische Lustgarten: Seine Entwicklungen und seine Beziehungen zur venezianischen Malerei.* Strasbourg.

Pavanello, Giuseppe. 1921. *La Chiesa di S. Maria Formosa nella Via sua ricostruzione (639–1921).* Venice.

———. 1932. "La Riva degli Schiavoni e in particolare del suo ampliamento nel secolo XVIII." In *La Riviera di S. Marco,* ed. Magistrato alle Acque. Venice.

Pavanini, Mario. 1971. "Traditional House Construction." *Architectural Review* 149:297–300.

Pavanini, Paola. 1981. "Abitazioni popolari e borghesi nella Venezia cinquecentesca." *Studi Veneziani,* n.s., 5:63–143.

Pedani, Maria Pia. 1984. "La Chiesa di Santa Croce alla Giudecca in Venezia: Notizie storiche e documenti." *Bollettino d'Arte,* supp. 5, Studi veneziani, 65–82.

Pellizzato, Michele, and Margherita Scattolin. 1982. *Materiali per una bibliografia sulla laguna e sul golfo di Venezia.* Chioggia.

Perocco, Guido, and Antonio Salvadori. 1977. *Civiltà di Venezia.* 3d ed. Venice.

Perry, Marilyn. 1972. "The Statuario Publico of the Venetian Republic." *Saggi Mem.* 8:75–253.

———. 1975. "A Greek Bronze in Renaissance Venice." *Burlington Magazine* 117:204–11.

———. 1978. "Cardinal Domenico Grimani's Legacy of Ancient Art to Venice." *J.W.C.I.* 41:215–44.

Piamonte, Giannina. [1966]. *Venezia vista dall'acqua: Guida dei rii di Venezia e delle isole.* Venice.

Piana, Mario. 1984. "Accorgimenti costruttivi e sistemi statici dell'architettura veneziana." In *Dietro i palazzi,* 33–37. Venice.

Piana, Mario, and Emanuele Armani. 1981. "Research on the Plasters of Venetian Historical Buildings." In *Symposium, Mortars, Cements, and Grouts Used in the Conservation of Historical Buildings.* ICCROM, Rome.

———. 1984. "Le superfici esterne della architettura veneziana." In *Facciate dipinte: Conservazione e restauro,* Atti del convegno di studi, Genova 1982, ed. G. Rotondi, and T. and F. Simonetti, 75–78. Genoa.

Piazza San Marco: L'architettura, la storia, le funzioni. 1970. Padua.

Pietrogrande, Luisa. 1942–54. "Francesco Segala." *Bollettino del Museo Civico di Padova* 31–43:111–36.

Pignatti, Terisio. 1973. "The Relationship between German and Venetian Painting in the Late Quattrocento and Early Cinquecento." In *Renaissance Venice,* ed. John R. Hale, 244–73. London.

———. 1976. *Veronese: L'opera completa.* Venice.

———. 1978. *Giorgione.* 2d ed. Venice.

———, ed. 1981. *Le scuole di Venezia.* Milan.

Pilo, Giuseppe Maria. 1979. "Jacopo Sansovino, Baldassare Longhena, Matteo Lucchesi, Bernardino Maccaruzzi: Interventi edilizi di tre secoli alla Cà di Dio di Venezia: Lettura di documenti inediti o rivisitati sul 'pio luogo.'" *Not. Pal. Alb.* 8:100–112.

Pincus, Debra. 1976. *The Arco Foscari: The Building of a Triumphal Gateway in Fifteenth Century Venice.* New York and London.

———. 1979. "Tullio Lombardo as a Restorer of Antiquities: An Aspect of Fifteenth Century Venetian Antiquarianism." *Arte Veneta* 33:29–42.

———. 1981. "The Tomb of Doge Nicolò Tron and Venetian Renaissance Ruler Imagery." In *Art the Ape of Nature: Studies in Honor of H. W. Janson,* ed. M. Barash, L. F. Sandler, and P. Egan, 127–50. New York.

Pino, Paolo. 1960. "Dialogo di pittura." In *Trattati d'arte del Cinquecento,* ed. Paola Barocchi, 1:93–139. Bari.

I pittori bergamaschi dal XIII al XIX secolo: Il Cinquecento. 1976. Bergamo.

Planiscig, Leo. 1921. *Venezianische Bildhauer der Renaissance.* Vienna.

———. 1927. *Andrea Riccio.* Vienna.

———. 1937. "Pietro, Tullio, und Antonio Lombardo: Neue Beiträge zu ihrem Werk." *Jahrbuch der Kunsthistorischen Sammlungen Wien,* n.s., 11:87–115.

Plesters, Joyce, and Lorenzo Lazzarini. 1976. "Preliminary Observations on the Technique and Materials of Tintoretto." In *Conservation and Restoration of Pictorial Art,* ed. N. Bromelle and P. Smith, 7–26. London and Boston.

Pochat, Götz. 1973. *Figur und Landschaft: Eine historische Interpretation der Landschaftsmalerei von der Antike bis zur Renaissance.* Berlin and New York.

Pohland, Wiebke. 1971. "Antonio Rizzo." *Jahrbuch der Berliner Museen* 13:162–207.

Pope-Hennessy, John. 1958. *Italian Renaissance Sculpture.* London.

———. 1966. *The Portrait in the Renaissance.* New York.

———. 1970. *Italian High Renaissance and Baroque Sculpture.* 2d ed. London and New York.

Popham, A. E., and Philip Pouncey. 1950. *Italian Drawings in the Department of Prints and Drawings in the British Museum: The Fourteenth and Fifteenth Centuries.* London.

Il Pordenone. 1984. Ed. Caterina Furlan. Milan.

Posner, Donald. 1971. *Annibale Carracci: A Study in the Reform of Painting around 1590.* London.

Posse, Hans. 1931. "Die Rekonstruktion der Venus mit dem Cupido von Giorgione." *Jb. Preuss. Ksln.* 52, no. 11:29–35.

Pozzi, Giovanni. 1979. "Il ritratto della donna nella poesia d'inizio Cinquecento e la pittura di Giorgione." *Lettere Italiane* 31:3–30.

Predelli, Riccardo. 1908. "Le memorie e le carte di A. Vittoria." *Archivio Trentino* 23:5–74, 129–265.

Prosperetti, Francesco. 1984. "Il Palazzo Trevisan a Murano: Note sull'architettura." *Bollettino d'Arte,* supp. 5, Studi veneziani, 109–18.

Pullan, Brian. 1971. *Rich and Poor in Renaissance Venice: The Social Institutions of a Catholic State to 1620.* Cambridge, Mass.

———. 1984. "Abitazioni al servizio dei poveri nella Repubblica di Venezia." In *Dietro i palazzi,* 39–44. Venice.

Puppi, Lionello. 1961. "La Villa Garzoni a Pontecasale di Jacopo Sansovino." *Prospettive* 24:51–62.

———. 1962. "Il Barco di Caterina ad Altivole." *Prospettive* 25:52–64.

———. 1969a. "Le residenze di Pietro Bembo 'in padovana.'" *L'Arte* 7–8:30–65.

———. 1969b. "La Villa Garzoni ora Carraretto a Pontecasale di Jacopo Sansovino." *Boll. C.I.S.A.* 11:95–112.

———. 1971. *Michele Sanmicheli: Architetto di Verona*. Padua.

———. 1972a. "Per Tullio Lombardo." *Arte Lombarda* 17, no. 1:100–103.

———. 1972b. *La Villa Badoer di Fratta Polesine*. Vicenza.

———. [1973]. *Andrea Palladio*. Milan.

———. 1978. "Il 'colosso' del Mantova." In *Essays Presented to Myron P. Gilmore*, 2:311–29.

———. 1980. "Per Paolo Veronese architetto: Un documento inedito, una firma, e uno strano silenzio di Palladio." *Palladio* 3:53–76.

———. 1981. *Andrea Palladio*. 2d ed. Milan.

———. 1982. "Il tempio e gli eroi." In *La grande vetrata di SS. Giovanni e Paolo: Storia, iconologia, restauro*, 21–35. Venice.

Puppi, Lionello, and Loredana Olivato Puppi. 1977. *Mauro Codussi*. Milan.

Puttfarken, Thomas. 1971. *Massstabfragen: Über die Unterschiede zwischen grossen und kleinen Bildern*. Hamburg.

Rambaldi, Pier Luigi. 1913. *La Chiesa dei SS. Gio. e Paolo e la Cappella del Rosario in Venezia*. Venice.

———. 1920. "Nuovi appunti sui maestri Jacobello e Pietro Paolo da Venezia." In *Venezia. Studi di arte e storia*, 1. 63–88.

Ravà, Aldo. 1920. "Il 'Camerino delle Anticaglie' di Gabriele Vendramin." *N. Arch. Ven.*, n.s., 39, no. 22:155–81.

Rearick, Roger W. 1958–59. "Battista Franco and the Grimani Chapel." *Saggi Mem.* 2:107–39.

———. 1962. "Jacopo Bassano 1568/69." *Burlington Magazine* 104:524–33.

———. 1968. "Jacopo Bassano's Later Genre Paintings." *Burlington Magazine* 110:241–49.

———. 1976. *Tiziano e il disegno veneziano del suo tempo*. Florence.

———. 1977. "Jacopo Bassano and Changing Religious Imagery in the Mid-Cinquecento." In *Studies in the History of Art in Honor of Myron P. Gilmore*, 495–507. Florence.

———. 1978. "Early Drawings by Jacopo Bassano." *Arte Veneta* 32:161–68.

———. 1980a. "The Portraits of Jacopo Bassano." *Artibus et Historiae* 1:99–114.

———. 1980b. "Tiziano e Jacopo Bassano." In *Tiziano e Venezia: Convegno Internazionale di Studi, Venezia 1976*, 371–74. Venice.

Ricci, Corrado. 1909. "Marmi Ravennati erratici." *Ausonia* 4:247–48.

Richardson, Francis L. 1980. *Andrea Schiavone*. Oxford.

Richter, George Martin. 1937. *Giorgio da Castelfranco*. Chicago.

Ridolfi, Carlo. 1914–24. *Le meraviglie dell'arte, Venezia 1648*. Ed. von Hadeln. Berlin.

Rigoni, Erice. 1970. "Notizie sulla vita e la famiglia dello scultore Tiziano aspetti detto minio." In *L'arte rinascimentale in Padova: Studi e documenti*, by Rigoni, 201–15. Padua.

Ringbom, Sixten. 1965. *Icon to Narrative: The Rise of the Dramatic Close-up in Fifteenth-Century Devotional Painting*. Abo.

Ripa, Cesare. 1970. *Iconologia overo discrittione di diverse imagini cavate dall'antichità, e di propria inventione*. With an introduction by E. Mandowsky. Hildesheim and New York.

Rizzi, Alberto. 1979. "S. Giorgio che combatte il drago nei rilievi esterni a Venezia." In *Scuola Dalmata dei SS. Giorgio e Trifone: Numero unico pubbl. in occasione del convocato generale del 2 sett. 1979*, 9–24. Venice.

———. 1981. *Vere da pozzo di Venezia: I puteali pubblici di Venezia e della sua laguna*. Venice.

Rizzo, Tiziano. 1983. *I ponti di Venezia*. Rome.

Roberts, Helen I. 1959. "St. Augustine in *St. Jerome's Study*: Carpaccio's Painting and Its Legendary Source." *Art Bulletin* 41:283–97.

Robertson, Giles. 1954. *Vincenzo Catena*. Edinburgh.

———. 1968. *Giovanni Bellini*. Oxford.

———. 1977. "The Architectural Setting of Antonello da Messina's San Cassiano Altarpiece." In *Studies in Late Medieval and Renaissance Painting in Honor of Millard Meiss*, 368–72. New York.

Rodenwald, Ernst. 1956. "Die Gesundheitsgesetzgebung des Magistrato della Sanità Venedigs: 1486–1550." *Sitzungsberichte der Heidelberger Akademie der Wissenschaften, Math.-naturwiss. Klasse, 1956*. Heidelberg.

Romano, Giovanni. 1976. "La Bibbia di Lotto." *Paragone*, nos. 317–19:82–91.

Romano, Serena. 1981. "I paesaggi di Paolo Veronese in Palazzo Trevisan." *Arte Veneta* 35:150–52.

Rompiasio, Giulio. 1733. *Metodo in pratica di sommario osia compilazione delle leggi, terminazioni, ed ordini appartenenti agl'Illustrissimi et Eccellentissimi Collegio, e Magistrato alle Acque*. Venice.

Ronchini, Amadio. 1864. "Delle relazioni di Tiziano coi Farnese." In *Atti e memorie di Deputazione di Storia Patria per le Provincie Modenesi e Parmensi*, 2:129–46.

Rondelet, Antonio. 1841. *Saggio storico sul Ponte di Rialto in Venezia*. Mantua.

Ronzani, Francesco, and Girolamo Luciolli. N.d. *Le fabbriche civili, ecclesiastiche, e militari di Michele Sanmicheli disegnate ed incise da F. R. e G. L. con testo illustrativo di F. Zanotto*. Genova.

Rosand, David. 1970. "The Crisis of the Venetian Renaissance Tradition." *L'Arte* 11–12:5–33.

———. 1976. "Titian's Presentation of the Virgin in the Temple and the Scuola della Carità." *Art Bulletin* 58:55–84.

———. 1979. *Titian*. New York.

———. 1982a. *Painting in Cinquecento Venice: Titian, Veronese, Tintoretto*. New Haven and London.

———, ed. 1982b. *Titian: His World and His Legacy*. New York.

Rosci, Marco. [1967]. *Il trattato di architettura di Sebastiano Serlio, pres. di A. M. Brizio*. Milan.

Rosenbaum, Alan. 1966–67. "Titian and Giotto in Padua." *Marsyas* 13:1–7.

Roskill, Mark W. 1968. *Dolce's "Aretino" and Venetian Art Theory of the Cinquecento*. New York.

Rossi, Paola. [1973]. *Jacopo Tintoretto: I Ritratti*. Venice.

———. 1975. *I disegni di Jacopo Tintoretto. Corpus Graphicum 1*. Florence.

Röthlisberger, Marcel. 1958. "Studi su Jacopo Bellini." *Saggi Mem.* 2:41–89.

Rotondi, Pasquale. 1950. *Il Palazzo Ducale di Urbino*. Urbino.

Ruhmer, Eberhard. 1974. "Antonio Lombardo: Versuch einer Charakteristik." *Arte Veneta* 28:39–73.

Rupprecht, Bernhard. 1963. "Die Villa Garzoni des Jacopo Sansovino." *Mitt. K.I.F.* 11:1–32.

———. 1964. "Ville venete del '400 e del primo '500: Forme e sviluppo." *Boll. C.I.S.A.* 6, no. 2:239–50.

———. 1966. "Villa: Zur Geschichte eines Ideals." In *Wandlungen des Paradiesischen und Utopischen: Studien zum Bild eines Ideals: Probleme der Kunstwissenchaft,* 2: 210–50.

———. 1968. "Sanmichelis Villa Soranza." In *Festschrift Ulrich Middeldorf,* 324–32. Berlin.

Saccardo, Giovanni. 1887. "L'antica Chiesa di S. Teodoro in Venezia." *Archivio Veneto* 34, no. 17, pt. 1:91–113.

Sagredo, Agostino. 1856. *Sulle consorterie delle arti edificative in Venezia.* Venice.

Sandri, M. G., and Paolo Alazraki. 1971. *Arte e vita ebraica a Venezia, 1516–1797.* Florence.

Sansovino, Francesco. 1561. *Dialogo di tutte le cose notabili che sono in Venetia etc.* Venice.

———. 1581. *Venetia, città nobilissima et singolare descritta in XIII libri.* Venice.

———. 1663. *Venetia, città nobilissima et singolare descritta in XIII libri da M. Francesco Sansovino, con aggiunta di tutte le cose notabili della stessa città, fatte, et occorse dall'anno 1580, fino al presente 1663: Da D. Giustiniano Martinioni etc.* Venice.

S. Antonio 1231–1981: Il suo tempo, il suo culto, e la sua città. 1981. Padua.

Sanudo, Marino. 1847. *Itinerario per la terraferma veneziana nell'anno 1483.* Padua.

———. 1879–1911. *I diarii (1496–1533).* Venice.

———. 1886. *Cronachetta.* Venice.

Sanudo the Younger, Marino. 1980. *De origine, situ, et magistratibus urbis venetae ovvero la città di Venezia (1493–1530).* Critical edition by Angela Caracciola Aricò. Milan.

Sapori, Francesco. 1928. *Jacopo Tatti detto il Sansovino.* Rome.

Sartori, Antonio. 1964. "Le acquasantiere della Basilica del Santo." *Il Santo* 4:177–95.

———. 1976. *Documenti per la storia dell'arte a Padova.* Ed. Clemente Fillarini with an essay by Franco Barbieri. Vicenza.

———. 1983. *Archivio Sartori: Documenti di storia e arte francescana.* Vol 1.: *Basilica e Convento del Santo.* Padua.

Startre, Jean-Paul. 1968. "Der Eingeschlossene von Venedig." In *Porträts und Perspektiven,* by Sartre, 233–76. Reinbek.

Scamozzi, Vincenzo. 1615. *Idea della architettura universale divisa in X libri.* Venice.

Scarabello, Giovanni. 1979. *Carcerati e carceri a Venezia nell'età moderna.* Rome.

———. 1981. "Caratteri e funzioni socio-politiche dell'associazionismo a Venezia sotto la repubblica." In *Gramigna-Perissa-Scarabello,* 5–24.

Schlegel, Ursula. 1979. "Simone Bianco und die venezianische Malerei." *Mitt. K.I.F.* 23:187–96.

Schmitt, Ursula. 1961. "Francesco Bonsignori." *Münchner Jahrbuch für Bildende Kunst,* 3d ser., 12:73–152.

———. 1965a. "Gentile Bellini." In *Dizionario biografico degli italiani,* 7:695–99. Rome.

———. 1965b. "Jacopo Bellini." In *Dizionario biografico degli italiani,* 7:708–12.

Schöne, Wolfgang. 1961. "Zur Bedeutung der Schrägsicht für die Deckenmalerei des Barock." In *Festschrift Kurt Badt zum siebzigsten Geburtstag,* 144–72. Berlin.

Schulz, Jürgen. 1961a. "A Forgotten Chapter in the Early History of 'Quadratura' Painting: The Fratelli Rosa." *Burlington Magazine* 103:90–102.

———. 1961b. "Vasari at Venice." *Burlington Magazine* 103: 500–511.

———. 1967. "Pordenone's Cupolas." In *Studies in Renaissance and Baroque Art Presented to Anthony Blunt,* 44–50. London.

———. 1968. *Venetian Painted Ceilings of the Renaissance.* Berkeley and Los Angeles.

———. 1970. *The Printed Plans and Panoramic Views of Venice (1486–1797). Saggi Mem.* 7.

———. 1978. "Jacopo Barbari's View of Venice: Map Making, City Views, and Moralized Geography before the Year 1500." *Art Bulletin* 60:425–74.

———. 1982. "The House of Titian, Aretino, and Sansovino." In *Titian: His World and Legacy,* ed. David Rosand, 73–118. New York.

Schütz-Rautenberg, Gesa. 1978. *Künstlergräber des 15. und 16. Jahrhunderts in Italien.* Cologne and Vienna.

Schwarzenberg, Erkinger. 1969. "From the *Alessandro Morente* to the Alexandre Richelieu: The Portraiture of Alexander the Great in Seventeenth-Century Italy and France." *J.W.C.I.* 32:398–405.

Schwarzweller, Kurt. 1935. *Giovanni Antonio da Pordenone.* Göttingen.

Scirè, Giovanna. 1969. "Appunti sul Silvio." *Arte Veneta* 23: 210–17.

Le scuole di Venezia. Ed. Terisio Pignatti. 1981. Milan.

Selvatico, Pietro. 1847. *Sulla architettura e sulla scultura in Venezia dal medio evo sino ai nostri giorni.* Venice.

Semenzato, Camillo. 1975. *Le ville del Polesine.* Vicenza.

Semi, Franca. 1983. *Gli "ospizi" di Venezia.* Venice.

Serlio, Sebastiano. 1584. *Tutte l'opere d'architettura di S. S. bolognese etc. et hora di nuovo aggiunto (oltre il libro delle porte) gran numero di case private nella città, et in villa et un indice copiosissimo raccolto per via di considerationi da M. Gio. Domenico Scamozzi.* Venice.

———. 1619. *Tutte le opere d'architettura et prospettiva . . . con un indice copiosissimo . . . raccolto da M. Gio. Domenico Scamozzi.* Venice.

———. 1978. *Sebastiano Serlio on Domestic Architecture: Different Dwellings from the Meanest Hovel to the Most Ornate Palace: The Sixteenth-Century Manuscript of Book VI in the Avery Library of Columbia University.* Ed. M. N. Rosenfeld. Foreword by A. K. Placzek, introduction by J. S. Ackerman, text by M. N. Rosenfeld. Cambridge, Mass., and London.

Serra, Luigi. [1921]. *Alessandro Vittoria.* Rome.

Settis, Salvatore. 1978. *La "Tempesta" interpretata: Giorgione, i committenti, il soggetto.* Turin.

———. 1981. "Giorgione ed i suoi committenti." In *Giorgione e l'umanesimo veneziano,* 373–98. Florence.

Seznec, Jean. 1953. *The Survival of the Pagan Gods: The Mythological Tradition, Its Place in Renaissance Humanism and Art.* New York.

Sgarbi, Vittorio. 1984. *Mito e storia di Giovanni Dario e del suo palazzo tra oriente e Venezia.* Introduction by L. Puppi.

Shearman, John. 1967. *Mannerism.* Harmondsworth, England.

Siebenhüner, Herbert. 1981. *Der Palazzo Barbarigo della Terrazza in Venedig und seine Tizian-Sammlung.* Munich and Berlin.

Simonsfeld, Henry. 1887. *Der Fondaco dei Tedeschi in Venedig und die deutsch-venetianischen Handelsbeziehungen.* Stuttgart.

Sinding-Larsen, Staale. 1962. "Titian's Madonna di Cà Pesaro and Its Historical Significance." *Acta ad Archaeologiam et Artium Historiam Pertinentia* 1:139–69.

———. 1974. *Christ in the Council Hall: Studies in the Religious Iconography of the Venetian Republic. Acta ad Archaeologiam et Artium Historia Pertinentia* 5. Rome.

Smirnova, Irina. 1978. "Alcuni appunti sulle 'scene campestri' di Tiziano." *Arte Veneta* 32:117–22.

Smyth, Craig Hugh. 1979. "Venice and the Emergency of the High Renaissance in Florence: Observations and Questions." In *Florence and Venice: Comparisons and Relations,* vol. 1, *The Quattrocento,* 209–249. Florence.

Sohm, Philip Lindsay. 1978a. *The Scuola Grande di San Marco 1437–1550: The Architecture of a Venetian Lay Confraternity.* Diss., Johns Hopkins University, Baltimore.

———. 1978b. "The Staircases of the Venetian Scuole Grandi and Mauro Coducci." *Architectura* 8:125–49.

———. 1979–80. "Palma Vecchio's *Sea Storm:* A Political Allegory." *Revue d'Art Canadienne/Canadian Art Review* 6:85–96.

Sonnenburg, Hubert von. 1974. "Beobachtungen zur Arbeitsweise Tintorettos." *Maltechnik* 3:133–43.

Soragni, Ugo. 1982. "L'agricoltura come professione: Trattatistica, legislazione, e investimenti in territorio veneto (sec. XVI)." *Storia della Città* 24:25–44.

Soranzo, Girolamo. 1885. *Bibliografia veneziana compilata da G. S. in aggiunta e continuazione del "Saggio di E. A. Cicogna."* Venice.

Sorte, Cristoforo. 1960. "Osservazioni nella pittura." In *Trattati d'arte del Cinquecento,* ed. Paola Barocchi, 1:271–301. Bari.

Stedman Sheard, Wendy. 1971. "The Tomb of Doge Andrea Vendramin in Venice by Tullio Lombardo." Doctoral diss., Yale University, New Haven.

———. 1977. "Sanudo's List of Notable Things in Venetian Churches and the Date of the Vendramin Tomb." *Yale Italian Studies* 1:219–68.

———. 1978. "'Asa adorna', The Prehistory of the Vendramin Tomb." *Jahrbuch der Berliner Museen* 20:117–56.

———. 1979. *Antiquity in the Renaissance: Catalogue of the Exhibition Held . . . 1978, Smith College Museum of Art, Northampton, Mass.* Northampton.

———. 1984a. "The Birth of Monumental Classicising Relief in Venice of the Facade of the Scuola di San Marco." In *Interpretazioni veneziane,* ed. David Rosand, 149–74. Venice.

———. 1984b. "Bramante e i Lombardo: Ipotesi su una connessione." In *Venezia-Milano,* 25–56. Milan.

Steer, John. 1982. *Alvise Vivarini: His Art and Influence.* Cambridge.

Stefani Mantovanelli, Marina. 1984. "Giovanni Grimani Patriarca di Aquileia e il suo palazzo di Venezia." *Quaderni Utinensi* 3–4:34–54.

Steinberg, Leo. 1983. *The Sexuality of Christ in Renaissance Art and in Modern Oblivion.* New York.

Stella, Aldo. 1958. "La proprietà ecclesiastica nella Repubblica di Venezia dal secolo XV al XVII (Lineamenti di una ricerca economico-politica)." *Nuova Rivista Storica* 42:50–77.

Stepan, Peter. 1982. *Die Reliefs der Cappella del Santo in Padua: Quellenstudien und Untersuchungen zu ihrer Ikonographie.* Diss. print, Munich.

Stolt, Deborah. 1982. "Fatte a sembianza di Pittura: Jacopo Sansovino's Bronze Reliefs in San Marco." *Art Bulletin* 64:370–88.

Storia della cultura veneta. 1976ff. Vicenza.

Suckale, Robert. 1977. "Arma Christi: Überlegungen zur Zeichenhaftigkeit mittelalterlicher Andachtsbilder." *Städel Jahrbuch,* n.s., 6:177–208.

Summers, David. 1977. "Contrapposto: Style and Meaning in Renaissance Art." *Art Bulletin* 59:336–61.

Swoboda, Karl M. 1970. "Zum Arbeitsgang Tintorettos im grossen oberen Saal der Scuola di San Rocco." *Wiener Jahrbuch für Kunstgeschichte* 23:169–207.

———. 1971. "Wechselbeziehungen gegenüber geordneter Bilder Tintorettos." In *Festschrift Antonio Morassi,* 125–28. Venice.

———. 1982. *Tintoretto: Ikonographische und stilistische Untersuchungen.* Vienna and Munich.

Tafuri, Manfredo. 1972. *Jacopo Sansovino e l'architettura del '500 a Venezia.* 2d ed. Padua.

———. 1973. "Sansovino 'versus' Palladio." *Boll. C.I.S.A.* 15:149–65.

———. 1982. "Alvise Cornaro, Palladio, e Leonardo Donà: Un dibattito sul bacino marciano." In *Palladio e Venezia,* ed. L. Puppi, 9–27. Florence.

———. 1983. "'Pietas' repubblicana, neobizantinismo e umanesimo: Giorgio Spavento e Tullio Lombardi nella Chiesa di San Salvador." *Ricerche di Storia dell'Arte* 19:5–36.

Talamini, Tito. 1970. "Le Procuratie nuove." In *Piazza S. Marco,* 177–84. Padua.

Tamassia Mazzarotto, Bianca. 1961. *Le feste veneziane, i giochi popolari, le ceremonie religiose e di governo.* Florence.

Tanner, Marie C. 1976. "Titian: The "Poesie" for Philipp II." Diss., New York.

———. 1978. "Ubi Sunt: An Elegiac Topos in the 'Fête Champêtre.'" In *Giorgione: Convegno Internazionale di Studi,* 61–66. Castelfranco Veneto.

Tassini, Giuseppe. 1872. "Tre case di Venezia." *Archivio Veneto* 4, pt. 1, 154–57.

———. 1885. *Edifici di Venezia distrutti o volte ad uso diverso da quello a cui furono in origine destinati.* Venice.

Temanza, Tommaso. [1778] 1966. *Vite dei più celebri architetti e scultori veneziani che fiorirono nel secolo decimosesto.* Ed. Liliana Grassi. Milan.

Tentori, Cristoforo. 1792. "Della legislazione veneziana sulla preservazione della laguna." Diss. storico-filosofico-critica, Venice.

Testi, Laudedeo. 1915. *La storia della pittura veneziana.* 2 vols. Bergamo.

Thies, Harmen. 1982. "Zum Cantonale der Markusbibliothek des Jacopo Sansovino in Venedig." *Architectura* 12:164–83.

Thode, Henry. 1900–1904. "Tintoretto: Kritische Studien über des Meisters Werke." *Repertorium für Kunstwissenschaft* 23:427–42, 24:7–35, 426–47, 27:24–25.

———. 1901. *Tintoretto.* Bielefeld and Leipzig.

Thoenes, Christof. 1980. "'Spezie' e 'ordine' di colonne nell'architettura del Brunelleschi." In *Filippo Brunelleschi: La sua opera e il suo tempo*, 2:459–69. Florence.

Thornton, Joy A. 1979. "Renaissance Color Theory and Some Paintings by Veronese." Diss., University of Pittsburgh.

Tietze, Hans. 1936. *Tizian: Leben und Werk*. Vienna.

———. 1948. *Tintoretto: Gemälde und Zeichnungen*. London.

———. 1952. "Meister und Werkstätte in der Renaissancemalerei Venedigs." *Alte und Neue Kunst* 1:89–98.

Tietze, Hans, and Erika Tietze-Conrat. 1944. *The Drawings of the Venetian Painters of the Fifteenth and Sixteenth Centuries*. New York.

Tietze-Conrat, Erika. 1940. "Decorative Paintings of the Venetian Renaissance Reconstructed from Drawings." *Art Quarterly* 3:15–39.

———. 1946. "Titian's Workshop in His Last Years." *Art Bulletin* 28:76–88.

Timofiewitsch, Wladimir. 1963a. "Ein Gutachten Sebastiano Serlios für die Scuola di S. Rocco." *Arte Veneta* 17:158–60.

———. 1963b. "Ein neuer Beitrag zu der Baugeschichte von S. Giorgio Maggiore." *Boll. C.I.S.A.* 5:330–39.

———. 1964. "Genesi e struttura della chiesa del Rinascimento veneziano." *Boll. C.I.S.A.* 6:271–82.

———. 1968a. "Ein Entwurf für den Altar der Scuola di San Rocco in Venedig." In *Festschrift für Ulrich Middeldorf*, ed. A. Kosegarten and P. Tigler, 342–49. Berlin.

———. 1968b. *Die sakrale Architektur Palladios*. Munich.

———. 1969. *La Chiesa del Redentore*. Vicenza.

———. 1972a. "Die Arsenal-Madonna: Anmerkungen zur künstlerischen Entwicklung des Jacopo Sansovino." In *Festschrift Luitpold Dussler*, 223–36. Munich and Berlin.

———. 1972b. *Girolamo Campagna: Studien zur venezianischen Plastik um das Jahr 1600*. Munich.

———. 1977. "Ein Beitrag zur Baugeschichte des Duomo in Palmanova." *Arte Veneta* 31:250–59.

———. 1980. "Bemerkungen zur venezianischen Sakralarchitektur der Renaissance." In *Festschrift für Wilhelm Messerer zum 60. Geburtstag*, 193–203. Cologne.

Tisato, Maria Simonetta. 1978. "Profilo di Cristoforo Sorte." *Vita Veronese* 31:9–16.

Tiziano: Le lettere. 1977. Ed. Celso Fabbro. Pieve di Cadore.

Tiziano e il manierismo europeo. 1978. Ed. R. Pallucchini. Florence.

Tiziano e la Corte di Spagna nei documenti dell'Archivio General di Simancas. 1975. Madrid.

Tiziano e Venezia: Convegno Internazionale di Studi, Venezia 1976. 1980. Venice.

Tolnay, Charles de. 1960. "L'interpretazione dei cicli pittorici del Tintoretto nella Scuola di San Rocco." *Critica d'Arte* 7:341–76.

Tramontin, Silvio. 1962. *S. Maria Mater Domini: Storia e arte*. Venice.

———. 1967. "La visita apostolica del 1581 a Venezia." *Studi Veneziani* 9:453–533.

———. 1968. *S. Giovanni Crisostomo*. Venice.

Tressidder, Warren D. 1975. "New Evidence in Support of Wind's Interpretation of the *Tempesta*." *Burlington Magazine* 117:599–600.

———. 1979. "The Classicism of the Early Work of Titian: Its Sources and Character." Diss., University of Michigan, Ann Arbor.

Trincanato, Egle Renata. 1948. *Venezia minore*. Milan.

Trincanato, Egle Renata, and Umberto Franzoi. 1971. *Venise au fil du temps*. Boulogne and Billancourt.

Tucci, Ugo. 1973. "The Psychology of the Venetian Merchant in the Sixteenth Century." In *Renaissance Venice*, ed. John R. Hale, 346–78. London.

Turner, Richard. A. 1966. *The Vision of Landscape in Renaissance Italy*. Princeton, N.J.

Urbani de Gheltof, G. M. 1892. *I camini (fumajuoli)*. Venice.

Valcanover, Francesco. 1969. *L'opera completa de Tiziano*. Milan.

———. 1978. "Il classicismo cromatico di Tiziano." In *Tiziano e il manierismo europeo*, ed. R. Pallucchini, 43–56. Florence.

———. 1979a. "La pala Pesaro." *Quad. Sopr. BB. AA. SS. Ven.* 8:57–67.

———. 1979b. "Il San Giovanni Battista di Donatello al Frari." *Quad. Sopr. BB. AA. SS. Ven.* 8:23–30.

Vasari, Giorgio. 1878–85. *Le vite de' più eccellenti pittori, scultori, ed architettori*. Ed. G. Milanesi. Florence.

———. 1963. *The Lives of the Painters, Sculptors, and Architects*. London.

Vecchi, Alberto. 1975–76. "L'iconografia aulica veneziana nell'età della controriforma." *Studi Veneziani* 17–18:249–64.

Venezia e la peste (1348–1797). 1979. Venice.

Ventura, Angelo. 1969. "Aspetti storico-economici della villa veneta." *Boll. C.I.S.A.* 11:65–77.

Verdon, Thimothy. 1978. *The Art of Guido Mazzoni*. New York and London.

Verheyen, Egon. 1971. *The Paintings in the Studiolo of Isabella d'Este in Mantua*. New York.

Vermeule, Cornelis C. 1959–60. "Hellenistic and Roman Cuirassed Statues." *Berytus* 13:1–82.

Vermeule, Cornelis C., Walter Cahn, and Rollin van Hadley. 1977. *Sculpture in the Isabella Stewart Gardner Museum*. Boston.

Vicentini, Antonio M. 1920. *S. Maria de' Servi in Venezia*. Treviglio.

Ville del Brenta nelle vedute di Vicenzo Coronelli e Gianfrancesco Costa. 1960. With an introduction by Guido Piovene and notes by L. Magagnato. Milan.

Vio, Gastone. 1972. "Inediti su artisti nella chiesa veneziana dello Spirito Santo." *Ateneo Veneto*, n.s., 10:241–52.

———. 1977. "I 'mistri' della chiesa di S. Fantin in Venezia." *Arte Veneta* 31:225–31.

———. 1984. "Una delle isole che formano Venezia: Da Palazzo Dario agli Incurabili." In *Interpretazioni veneziane*, ed. David Rosand, 89–96. Venice.

Visceglia, Enzo. 1970. *Guida toponomastica di Venezia, Lido, Murano*. Rome.

Vitruvius. 1964. *Zehn Bücher über Architektur*. With notes edited by the translator, C. Fensterbusch. Darmstadt.

Voltelini, Hans von. 1892. "Urkunden und Regesten aus dem K. u. K. Haus-, Hof- und Staats-Archiv in Wien." *Jahrbuch der Kunsthistorischen Sammlungen des AH Kaiserhauses* 13:xxvi–clxxvi.

Wackernagel, Martin. 1938. *Der Lebensraum des Künstlers in der florentinischen Renaissance: Aufgaben und Auftraggeber, Werkstatt und Kunstmarkt*. Leipzig.

Walker, John. 1958. *Bellini and Titian at Ferrara*. London.

Warburg, Aby. 1932. *Gesammelte Schriften*. Leipzig and Berlin.

Weddingen, Erasmus. 1974. "Thomas Philologus Ravennas: Gelehrter, Wohltäter, Mäzen." *Saggi Mem.* 9:8–76.

———. 1983. "Zur Wiederkehr eines Unbekannten: Jacopo Tintoretto." *Artibus et Historiae* 4:29–39.

Weihrach, Hans R. 1935. *Studien zum bildnerischen Werke des Jacopo Sansovino*. Strasbourg.

———. 1967. *Europäische Bronzestatuetten*. Braunschweig.

Westphal, Dorothee. 1931. *Bonifazio Veronese (Bonifazio dei Pitati)*. Munich.

Wethey, Harold. 1969–75. *The Paintings of Titian*. 3 vols. London.

Wichmann, Petra. 1979. "'Campi veneziani': Studien zur Entwicklungsgeschichte venezianischer Plätze." Diss., Munich.

Wilde, Johannes. 1929. "Die 'Pala di San Cassiano' von Antonello da Messina." *Jahrbuch der Kunsthistorischen Sammlungen Wien* 25:57–72.

———. 1974. *Venetian Art from Bellini to Titian*. Oxford.

Wilk, S. See also Blake-Wilk.

Wilk, Sarah. 1972–73. "Tullio Lombardo's 'Double Portrait' Reliefs." *Marsyas* 16:67–86.

———. 1978. *The Sculpture of Tullio Lombardo: Studies in Sources and Meaning*. New York and London.

Willmes, Ulrich. 1985. *Studien zur Scuola di San Rocco in Venedig*. Munich.

Wind, Edgar. 1948. *Bellini's Feast of the Gods: A Study in Venetian Humanism*. Cambridge, Mass.

———. 1969. *Giorgione's "Tempesta," with Comments on Giorgione's Poetic Allegories*. Oxford.

Wolff Metternich, Franz Graf. [1957]. "Der Entwurf Fra Giocondos für Sankt Peter." In *Festschrift Kurt Bauch: Kunstgeschichtliche Beiträge zum 25.11.1957*, 155–70. N.p.

Wolters, Wolfgang. 1963. "Tiziano Minio als Stukkator im Odeo Cornaro zu Padua." *Pantheon* 21:20–28, 222–30.

———. 1966. "Una villa cinquecentesca in rovina a Murano." *Antichità Viva* 5, no. 3:27–33.

———. 1968a. "Andrea Palladio e la decorazione dei suoi edifici." *Boll. C.I.S.A.* 10:255–69.

———. 1968b. "La decorazione plastica delle volte e dei soffitti a Venezia e nel Veneto nel secolo XVI." *Boll. C.I.S.A.* 10:268–78.

———. 1968c. "Due capolavori della cerchia di Donatello a Trogir e a Sibenik." *Antichità Viva* 7, no. 1:11–24.

———. 1968d. *Plastische Deckendekorationen des Cinquecento in Venedig und im Veneto*. Berlin.

———. 1974. "Eine Antikenergänzung aus dem Kreis des Donatello in Venedig." *Pantheon* 32:130–33.

———. 1976. *La scultura veneziana gotica (1300–1460)*. Venice.

———. 1979. "Le architetture erette al Lido per l'ingresso di Enrico III a Venezia nel 1574." *Boll. C.I.S.A.* 21:273–89.

———. 1983. *Der Bilderschmuck des Dogenpalastes: Untersuchungen zur Selbstdarstellung der Republik Venedig im 16. Jahrhundert*. Wiesbaden.

Wronski, Galis Diana. 1977. "Lorenzo Lotto: A Study of His Career and Character, with Particular Emphasis on His Emblematic and Hieroglyphic Works." Diss., Bryn Mawr, Pa.

Wurthmann, William. 1976. "The Scuole Grandi and Venetian Art 1260–c. 1500." Diss., University of Chicago.

Wyrobisz, Andrzé. 1965. "L'attività edilizia a Venezia nel XIV e XV secolo." *Studi Veneziani* 7:343–97.

Yriarte, Charles. 1896. "Isabella d'Este et les artistes de son temps." *Gazette des Beaux-Arts* 15:215–28.

Zanetti, Anton Maria. 1771. *Della pittura veneziana e delle opere pubbliche de' veneziani maestri libri V*. Venice.

Zava Boccazzi, Franca. 1965. *La Basilica dei Santi Giovanni e Paolo in Venezia*. Venice.

Zorzi, Alvise. 1972. *Venezia scomparsa*. Milan.

Zorzi, Giangiorgio. 1951. "Alessandro Vittoria a Vicenza e lo scultore Lorenzo Rubini." *Arte Veneta* 5:141–57.

———. 1954–55. "Rivendicazione di alcuni scritti giovanili di Vincenzo Scamozzi." *Atti Ist. Ven.* 113:139–208.

———. 1965. *Le opere pubbliche e i palazzi privati di Andrea Palladio*. Venice.

———. 1967. *Le chiese e i ponti di Andrea Palladio*. N.p.

———. 1969. *Le ville e i teatri di Andrea Palladio*. Venice.

PHOTO CREDITS

371

INDEX